PENGUIN BOOKS

# BETWEEN HEAVEN AND HELL

W. Bruce Lincoln, a Distinguished Research Professor of History at Northern Illinois University, has been a Research Fellow at the Russian Academy of Sciences, a Fulbright Research Fellow, a Senior Research Fellow at Columbia University's Harriman Institute, a Visiting Fellow at the Hoover Institute, and a John Simon Guggenheim Fellow. He has held visiting appointments at the University of Chicago, the University of Illinois at Chicago, and the Universities of Moscow, St. Petersburg, and Warsaw. Among his many acclaimed books are *Nicholas I*, *Red Victory*, *The Romanovs*, and *In War's Dark Shadows*.

W. BRUCE LINCOLN

*Between*
Heaven
*and*
~Hell~

THE STORY OF A
THOUSAND YEARS OF
ARTISTIC LIFE IN RUSSIA

PENGUIN BOOKS

PENGUIN BOOKS

Published by the Penguin Group

Penguin Putnam Inc., 375 Hudson Street,

New York, New York 10014, U.S.A.

Penguin Books Ltd, 27 Wrights Lane, London W8 5TZ, England

Penguin Books Australia Ltd, Ringwood, Victoria, Australia

Penguin Books Canada Ltd, 10 Alcorn Avenue,

Toronto, Ontario, Canada M4V 3B2

Penguin Books (N.Z.) Ltd, 182–190 Wairau Road,

Auckland 10, New Zealand

Penguin Books Ltd, Registered Offices:

Harmondsworth, Middlesex, England

First published by Viking Penguin,

a member of Penguin Putnam Inc. 1998

Published in Penguin Books, 1999

1  3  5  7  9  10  8  6  4  2

THE LIBRARY OF CONGRESS HAS CATALOGED

THE HARDCOVER EDITION AS FOLLOWS:

Lincoln, W. Bruce.

Between heaven and hell: the story of a thousand years of

artistic life in Russia/ W. Bruce Lincoln.

p.  cm.

Includes bibliographical references and index.

ISBN 0-670-87568-6 (hc.)

ISBN 0 14 02.6773 5 (pbk.)

1. Arts, Russian.   2. Arts and Society—Russia.

3. Art and state—Russia.   I. Title.

NX556.A1L53   1998      97–22436

700'.947—dc21

Printed in the United States of America

Set in Simoncini Garamond

Designed by Pei Koay

*TO MARY, WITH LOVE*

# PREFACE

❧❦❧

*MY FIRST EXPERIENCE* with living suspended between heaven and hell began during the week after my birthday in 1964, a scant eleven years after Stalin died. The day I turned twenty-six, the *Nadezhda Krupskaia* landed in Leningrad, where several squads of hard-eyed border guards, tight-lipped and holding their submachine guns at port arms, lined the dock while I and a couple of hundred other passengers walked uneasily down the gangplank into a grimy reception area draped with red bunting. There, two surly customs officials spent five minutes looking through my luggage and the better part of an hour thumbing through a handful of magazines and newspapers I had brought from London. Apprehensive about contact with the West but fascinated by the new vistas it opened, they eventually stamped my papers and waved me through after confiscating a copy of *Vogue* that I had brought for a friend of a friend. Here, with its instruments of repression shamelessly displayed, was the Russia I had expected: a police state in which suspicion tempered curiosity and fear dampened the normal human thirst for new experiences.

Just beyond the well-guarded, dilapidated gate that divided the dock area from the rest of Russia, I took a taxi into the city, where I caught the overnight train to Moscow. The next day, I was assigned two tiny dirty rooms in the Stalinesque skyscraper that housed the main offices and dormitories of Moscow State University on Lenin Hills and was told where to collect my all-important identity papers. "Welcome to Moscow," an unsmiling woman in the passport office said as she handed over my documents. "I hope that your stay will be pleasant." Her cold greeting reflected the drab, boring sameness that made life in Russia seem

like the antithesis of everything I had known in the West. At that moment, the old Russian peasant saying that "God is high above and the Tsar is far away" seemed particularly appropriate.

Like most visitors to Moscow in those days, my first stop after I got settled was Red Square, where, after bypassing Lenin's Tomb and St. Basil's Cathedral, I followed a small group of Russians through the Spasskii Gate into the heart of the Kremlin. For no apparent reason—because I had no particular set of preferences in mind—I went first to the Dormition Cathedral, in which every Russian sovereign had been crowned since the days of Ivan the Terrible. I entered expecting only to see some of the important icons and frescoes I knew it contained, but nothing I had read had prepared me for what I found as I stepped through the doorway.

For the better part of an hour, I stood in stunned silence as I gazed at some of the most dramatic medieval art the world has ever seen. Set against a swirling background of monks, fighting knights, saints, and angels, and painted on a majestic scale that no art book had ever managed to convey, brilliant paintings of Christ and his disciples vied with depictions of the Virgin Mary and the terrors of the Last Judgment to catch the slanting rays of the early-afternoon sun. It was humbling and inspiring—and completely at odds with the drab Soviet world in which I had chosen to spend the next year of my life. In this place, one could not doubt God's presence. It was as if He had deliberately chosen to make Himself known at the nerve center of a nation whose rulers' power depended upon their continued denial of His existence.

During the next twelve months, the juxtaposition of opposites that had marked my first days in Russia seemed to appear at almost every corner I turned. I found stunning medieval churches being used to store grain, people who told of rescuing sixteenth-century icons from piles of stacked cordwood, and museum janitors who traded their nation's treasures for recordings made by the Beatles and the Rolling Stones. Psalters that had seen three or four centuries of Russia's history could be bought for a bottle of scotch or cognac. Pieces of porcelain that once had adorned the tables of Catherine the Great and Nicholas and Alexandra cost a pair of well-worn jeans, and seventeenth-century icons portraying the Madonna of Kazan could be had for a copy of *Playboy* magazine.

All of Russia seemed like a beautiful woman disfigured by warts that were invisible from some angles and starkly obvious from others. At any moment, one could trade the drabness of Soviet life for the brilliance of Russia's past by walking into a "church-museum" or by buying a fifty-kopek ticket to the Bolshoi or Kirov theater, just as one could bring the ugliness of the present back into focus by attending a production of *Swan Lake* in the vapid modern setting of the Kremlin's Palace of Congresses or by watching bored actors perform a Socialist Realist play at Leningrad's sparkling Pushkin Theater.

The naïveté of being an American who had never before crossed the Atlantic left me unprepared to discover that these contradictions stretched far beyond the realm of physical objects. I found that the rude, narrow-minded bureaucrats

who plied their trade with such a blatant lack of compassion could be warm and generous friends, and that the very people who defended the official line most forcefully in public could become its most cynical critics over a bottle of vodka. I learned that men and women who helped to perpetuate the ugliness of Soviet life by creating the propaganda that denied its failings knew and cared about beauty and truth, and that the very people who exchanged so readily the treasures of their past for the baubles of the present had a more abiding passion for the objects they traded away than they ever acquired for any of the symbols of Western life they received in return.

Whence came this fascination with things foreign that could overwhelm the love of things Russian? The conflicting emotions I observed among Soviet people in search of the trappings of Western culture reminded me of those earlier times in Russia's history when, after borrowing from Byzantium and the West on a massive scale, its people had turned against foreign influence with a passion that left them no room for compromise. Even as they borrowed the knowledge and technology they needed from abroad in those earlier times, Russians had expressed disdain for their sources, and the tension that resulted had raised their own creativity to greater heights. As I walked through Russia's great museums, admired the grandeur of its cathedrals, and took in the beauty of its smaller churches and chapels, I found myself asking how a country with such a tormented past had brought into being such brilliant works of art.

How did the creative process work in a land in which politics and art had never been kept apart and where artists had never been entirely free? What did it mean for an artist to bow to dictates from above, regardless of whether they assumed the brutal form of open persecution or the subtler shapes of a sovereign's "suggestions"? And what did it mean for a Russian artist to search for identity among people who sometimes could not agree about what it meant to be Russian or even say for certain what Russia really was? I had first encountered some of these questions as a graduate student at the University of Chicago, but the experience of life in Russia posed them more starkly and with greater force.

Now, after having spent well over thirty years exploring the myriad political and social forces that have shaped Russia's past and present, I have come back to the dilemmas that my first visit forced me to consider. I am now convinced that we cannot understand how the vital processes of borrowing, assimilation, transformation, and creation shaped the arts in Russia unless we look at its painters, writers, composers, architects, and sculptors in the context of the times and places in which they lived and worked. The opportunities they enjoyed, the challenges they faced, and the forces that molded their lives all played parts in shaping the art they created. Taken together, these form the fabric of Russian life and make it certain that the novels of Dostoevskii, Tolstoi, and Solzhenitsyn, the paintings of Ilia Repin, the icons of Andrei Rublev, and the music of Musorgskii and Rimskii-Korsakov can only have come from Russia.

Knowing this has obliged me (at the risk of seeming arrogant, naïve, or both) to look beyond literature and the fine arts as they are usually studied by experts

in their fields in order to see them as part of a broader phenomenon that we can call Russia's artistic experience. A history of Russia's artistic experience (as opposed to a history of its arts, or a history of its painting, literature, sculpture, and so on) thus has to encompass the social and political forces that surrounded both creations and creators. The ever-present link between politics and the arts, the ongoing conflict between foreign influence and native experience, and a firm belief that rulers have a duty to shape the arts of their people all have to be taken into account if we want to understand what fueled Russia's creative processes and made them unique.

The abiding torment that lies at the center of Russia's artistic experience is the product of an inner anguish that is uniquely and perversely Russian. Whether we are looking at the struggle to attain in art those sorts of spiritual perfection that medieval icon painters believed only God could achieve, the soul-searing search for truth and inner freedom that drove the eighty-two-year-old Tolstoi to find death at an out-of-the-way railroad station, or the uncertain impulses that compelled the aging Solzhenitsyn to abandon the comfort of Vermont and try to rediscover the meaning of life in the turbulence of his crime-ridden homeland, there is a level of suffering in Russia's artistic experience that exceeds that of Western nations. Artists as diverse as Rublev, Dostoevskii, Pasternak, Musorgskii, and the dancers of the Ballets Russes all share this intense aesthetic and psychological anguish that stems from living suspended between East and West, past and future, and the sacred and the profane in a realm between two worlds in which they all have endured outward oppression in the hope of finding inner freedom. Chronically uncertain of their place and fate, Russia's artists have been perpetual seekers trying to extract the true meaning of art and beauty from the contradictions that form the fabric of their nation's life and history. Because the urgency and exaltation of their quest have obliged them to live perpetually at the poles of human experience, I have called this book *Between Heaven and Hell*.

Among the many libraries, archives, and institutions to which I am indebted for helping me to complete the research for this book in the course of half a dozen long visits to Russia and a score of sojourns to Europe and the two coasts of the United States, the following come most quickly to mind: the Academy of Sciences of the USSR, Leningrad (now St. Petersburg) branch; the Bakhmeteff Archive of Russian and East European History and Culture, Columbia University, New York; the Fulbright-Hays Faculty Research Abroad Program, U.S. Department of Education, Washington, D.C.; the Harriman Institute, Columbia University, New York; the Hoover Institution, Stanford, California; the Institute of Russian Literature (Pushkinskii Dom), the Academy of Sciences, St. Petersburg; the International Research and Exchanges Board, Washington, D.C.; the Kennan Institution, Woodrow Wilson Center, the Smithsonian, Washington, D.C.; the Library of Congress, Washington, D.C.; the Lenin Library, Moscow;

the National Endowment for the Humanities, Washington, D.C.; Northern Illinois University, DeKalb; the Russian and East European Center, the University of Illinois at Urbana-Champaign, Urbana; the Regenstein Library, the University of Chicago; the Russian National Library, St. Petersburg; the Russian Central State Historical Archive, St. Petersburg; the Russian State Archive of Literature and Art, Moscow; St. Antony's College, Oxford; and the Slavic Library, University of Helsinki.

Besides the help of these many institutional benefactors, I have incurred larger personal and intellectual debts that require further acknowledgment. I owe a great deal to Marc Raeff for the encouragement he has provided during the many years since our first meeting in Leningrad in 1965. As friend, critic, and adviser, Marc has served as a sounding board on more occasions than either of us can remember, and he has never failed to do so with patience, good humor, and genuine gentlemanly grace.

Among the many other people with whom I have had the good fortune to discuss Russia's artistic experience in Moscow, St. Petersburg, Helsinki, Paris, Oxford, London, New York, Palo Alto, and Washington, D.C., I am grateful first of all to Jacqueline Kennedy Onassis, who served as the editor of this book until her untimely death. Her enthusiasm encouraged me to begin what I knew would be a daunting task, and her questions and comments had much to do with shaping my manuscript's early chapters. Much gratitude is also due to Don Fehr, who shouldered the lion's share of the task of editing this book. Don is one of the most sensitive and insightful editors with whom I have ever had the good fortune to work. Finally, I must thank my present editor, Wendy Wolf, whose boundless energy and good humor have helped see this book into publication. Wendy has played a key part in choosing the illustrations that accompany this volume, and they reflect her good taste and keen sense of what is insightful and appropriate.

By sharing with me his wide-ranging insights into Russia's cultural and political past, Samuel Ramer offered special help and encouragement, as did Christine Worobec, who urged me not to forget Russia's lower classes. I owe a special note of thanks to my friend and colleague Stephen Kern, whose passion for understanding the relationship between ideas, images, and reality has taught me to pay attention to the many seemingly unrelated forces that have shaped the human cultural experience, and thanks are also due to my former colleague and longtime friend George Gutsche, who has shared his knowledge of Russian literature with me over nearly two decades. Kathleen Parthé and Greta Slobin have both given me much-needed advice about twentieth-century Russian literature, and Alma Law has done noble service as an outstanding source of information about the theater. Finally, Susan Walker, manager of the Junction Bookstore here in DeKalb, has served for several years as an amazing source of new books, often obtaining just-published materials within days after they came off the press.

At the University of Illinois Library, the Slavic Reference Service's legendary Helen Sullivan deserves a special note of thanks for efforts far above and beyond the call of duty. Able to find the unfindable in libraries halfway around the world

and to supply information almost at a moment's notice, Helen is a researcher's dream come true. Having her and her colleagues Bob Burger, Jan Adamczyk, and Julia Gauchman just a phone call away has made the writing of this book easier and helped to make my progress a great deal quicker.

Among the people at Northern Illinois University to whom I owe special thanks, John LaTourette, Carroll Moody, James Norris, Jerrold Zar, and George and Elaine Spencer all know the benevolent roles they have played behind the scenes in coming to my aid when the need arose, and Jeffrey Plaks, my teaching assistant and computer expert for much of the time when I was writing this book, deserves his own special mention. I also should express my appreciation to the Northern Illinois University Foundation for support and recognition that have meant a great deal to me.

I continue to be very grateful to Robert Gottlieb, who has been a part of my work for almost twenty years. As one of those rare literary agents who dispenses enthusiasm, reassurance, and genuine insight with never-failing grace and confidence, Robert has helped me in more ways than I can count and on more occasions than he can remember. He has been with me through the good times and the bad, and it is in large measure thanks to his efforts that there have been many more of the former than the latter.

As generous and helpful as all these people have been, my wife, Mary, towers above them all. As friend, consultant, and editor extraordinaire, she has given more to me than she will ever know, and I am more grateful than I can ever say. I have not always taken her advice, but I have usually regretted those times when I did not. Dedicating to her this book that has profited so much from her exacting, persistent criticism is but another small payment against a large and growing debt that is destined never to be fully paid.

W. Bruce Lincoln
DeKalb, Illinois
Spring 1997

# Contents

❦

*Between*
Heaven
*and*
~Hell~

<div style="text-align:center">

# PROLOGUE

</div>

*SO STUNNING WAS THE PROCESSION* in which Russia's young sovereigns rode during the afternoon of May 9, 1896, that the onlookers would remember it for the rest of their lives. Leading the way down Moscow's main thoroughfare came the Imperial Guards, a few thousand men chosen from among Russia's millions for their height, features, and bearing. Behind them rode scarlet-coated horsemen from Siberia's steppes, heirs of the Mongol warrior armies that once had ruled an empire on three continents. Descended from freebooters who had bowed to no sovereign, Cossacks dressed in long red and purple coats and soft black leather boots now had a place in the Tsar's special guard, riding directly behind the Siberians. Then came Russia's great lords, the diamonds encrusting their orders of knighthood blazing in the sun.

With no inkling of the decades of turmoil that lay ahead, the crowds who cheered their sovereigns as they rode to the Kremlin that afternoon seemed to think that the best days of Imperial Russia were still to come. The Industrial Revolution was in full swing, prosperity was on the rise, and the painters, poets, and writers of their land were beginning to shape the masterpieces that would mark their time as a Silver Age. Once scorned by Europeans as a "rude and barbarous kingdom," Russia now stood as a leader among them. The land that had just produced Dostoevskii, Tolstoi, Musorgskii, and Ilia Repin in a single generation was about to dazzle the world with paintings, ballet, and poetry such as could be found nowhere else on earth.

Dressed in the uniform of the Semenovskii Imperial Guards, Russia's twenty-eight-year-old Tsar, Emperor, and Autocrat Nicholas II rode a white, silver-shod

mare just behind a cluster of diplomats who had come to Moscow from every corner of the globe. Already feeling the strain of "the first hard day for us," as he confided to his diary,[1] Nicholas was slender, nervous, and pale, his right hand stiffly raised in an awkward salute. More regal in appearance than their sovereign, three of Russia's senior grand dukes rode behind him, followed by more than a score of foreign princes. Then came the Dowager Empress and, after her, the Empress Aleksandra Feodorovna, her golden-red hair set off by a white gown and a brilliant diamond necklace. Each woman sat alone in a gilded carriage drawn by eight white horses. After two days of rain, the weather had turned magnificent, to make a bright beginning for the last great festival the people of Imperial Russia would ever see.[2]

As they stood on the brink of a new reign and a new century, the Russians looked ahead to an era "from which the whole world expects miracles of beauty and comfort."[3] The hundred years just past had unlocked the secrets of immunization, anesthesia, and sterile surgery that promised to extend human life as never before, while telephones, the telegraph, railroads, and steamships had given people a sense of common interest that their ancestors had never known. The world's great nations, Winston Churchill later wrote of these last shining decades before the Great War, had been "fitted and fastened . . . into a great cantilever"[4] that could be kept in balance by the mere glances and whispers of the statesmen who had designed it. In this delicately balanced community, the Russians stood proudly as the possessors of untold natural resources and a dynasty that was one of the oldest in Europe. In less than two decades, the Romanovs would celebrate their three-hundredth year on the throne, and the nine-hundred-year anniversary of the Russians' conversion to Christianity had passed just eight years before. Russia ruled a sixth of the earth's surface, boasted the world's largest army, and, in the fifteen years since its Industrial Revolution had begun, had already risen from fifteenth to fifth place among the great industrial powers of the planet. Courted by France and England, and feared by Germany, Austria, and their allies, Russia seemed about to rise to even greater heights.

According to a running count published by a leading Russian newspaper, a queen, two reigning princes, three grand dukes, twelve crown princes, sixteen princes and princesses, dozens of the world's leading statesmen, and hundreds of courtiers had poured into Moscow during the week before Nicholas and Aleksandra made their formal entry into the city. The Kaiser's brother had come for his cousin's crowning, and so had a dozen of Germany's lesser princes and dukes. Queen Victoria had sent the Duke of Connaught, and Austria-Hungary's aging Emperor Franz Josef had sent the Archduke Ludwig Viktor. Not to be outdone by sovereigns more powerful than they, Italy's Crown Prince Vittorio Emmanuele, Queen Olga of Greece, Prince Nicholas of Montenegro, and Prince Ferdinand of Bulgaria all had come to Moscow. From the other side of the world, the Emperor of Japan had dispatched Prince Fushimi and Field Marshal Marquis Yamagata to present his gift of a magnificent eagle made of nearly two thousand intricately carved plates of ivory that fitted together as if they were

natural feathers.[5] China's Dowager Empress sent her First Chancellor, Li Hung Chang, but Li bore a gift of a different sort, for he was about to grant Russia permission to build a railroad across Manchuria in return for a bribe of three million rubles in gold.[6] In less than a decade, this Chinese Eastern Railway would open vast horizons for Russia in Asia, putting Moscow within a fortnight's journey of the Pacific and moving the Tsar's government onto a collision course with Japan.

While the dignitaries from West and East assembled, Moscow had dressed in its finest. Just one year away from celebrating its 750th anniversary, Moscow had entered the world as a frontier outpost from which the most humble of Russia's princes had ruled a realm half the size of Rhode Island and smaller than Luxembourg. From this remote corner, Moscow's princes had raised their land to greatness, leading the fight to throw off Russia's Mongol yoke, welding the Russians into a nation, and conquering the five and a quarter million square miles of Eurasia that became known as Siberia. Briefly the heirs of Moscow's first princes had stretched their empire to Alaska, California, and the Hawaiian Islands, and then had raised their scepters above the khanates of Central Asia and the kingdoms of the wild Transcaucasus. Once their rival, Poland had become their vassal, and the lands that once had given the Ottoman Empire undisputed command of the Black Sea's northern coast had become theirs too.

The immensity of this triumph had never been celebrated as it should have been, for every coronation of the nineteenth century had come at an awkward or stormy moment. Alexander I and Alexander III had ascended the throne after their predecessors had been assassinated; Nicholas's grandfather Alexander II had been crowned at the end of Russia's first lost war in more than a century; and his great-grandfather, the iron Tsar whose name he bore, had been obliged to take his crown "at the price of his subjects' blood,"[7] when the flower of the Russian nobility had risen against him in 1825. The first to occur under entirely normal circumstances in a hundred years, the coronation of Nicholas and Aleksandra was to proclaim Russia's greatness and serve notice of greater things to come. Russia's young sovereigns looked for it to usher in a new century and celebrate a way of life that men and women had never dreamed of in the days when their country had not yet won its place in Europe and her envoys had been obliged to bribe court chamberlains to announce them as ambassadors of the Tsar of All the Russias, not as agents of the Grand Prince of Muscovy.

Although their capital had long since been moved to St. Petersburg, the famed "Window on the West" that Peter the Great had opened at the beginning of the eighteenth century to bind his nation closer to Europe, the Russians continued to cherish Moscow as their nation's heart. To live up to that honor, proud Muscovites had started to shine and polish their city months ahead of time, giving every building that could be seen from the route of the imperial procession a coat of paint, and piling freshly cut evergreens against fences and façades thought too broken to repair. Rebuilt to hold four thousand people in 1854, the Bolshoi Theater had been entirely refurbished, and there were rumors that it was going to cost fifty thousand rubles for the flowers needed to decorate the newly

enlarged imperial box for a special coronation performance. Blue-white-and-red bunting, the national colors of Russia, hung from Moscow's windows and balconies. Everywhere, the monograms "Н" for Nicholas and "Я" for Aleksandra decorated plates and cups made especially for the occasion. In Moscow's center, tens of thousands of electric lights had been strung to outline the Kremlin walls and towers. The "illuminations" of the coronation festival would leave the Russians breathless, enthralled by the technology that the passing century had brought into being.

While Muscovites decorated their city, Europe's ambassadors planned celebrations that would reflect their nations' relationship to Russia. Rumor had it that France's ambassador was planning a ball at the exclusive Hunt Club that was going to cost almost a quarter of a million rubles, more than a weaver in the city's textile mills could earn in a thousand years.[8] Knowledgeable Muscovites already were starting to look down their noses at the Germans, who had rented a palace too far from the center of the city to be convenient and too small for a grand ball. After more than a century of being allied to the Romanovs by diplomacy and marriages, the Germans had recently driven their former ally into the arms of France by strengthening their bonds with Austria-Hungary. Unlike republican France's Count Montebello, who was sparing no expense to celebrate his nation's new alliance with the autocratic Russians, the ambassador of Kaiser Wilhelm II was planning a more modest musicale instead of a ball to celebrate the coronation.[9]

For weeks on end, preparations had moved at a feverish pace. By buying up all the rooms in the city's best hotels for high officials and foreign dignitaries, the government had left visiting Russians to the tender mercies of landlords who squeezed every square foot of living space for every ruble it was worth. Small apartments that cost a thousand rubles a year now commanded 2,500 rubles a month—$1,250 at the exchange rate of 1896. To rent a balcony overlooking the parade route cost almost a hundred times what a factory worker earned in a week, and even tattered student rooms were going at ten times their usual price if they had windows looking out on the boulevard that Russia's sovereigns would follow to the Kremlin. Hiring an equipage for the month of May cost several times the price of a good pair of horses in normal times, and the lucky merchant who still had a French gown in stock at the beginning of the month could count on selling it at several times more than the original asking price.[10]

There seemed to be no end to the excitement nor any wish to see it end. Proudly wearing the blue-and-gold correspondent's badge that the government had struck to mark the occasion, Vladimir Nemirovich-Danchenko, "a suave man of the world who had tasted life's passions deeply and widely,"[11] took in the sights and sounds of Moscow's streets. Soon to join Konstantin Stanislavskii in organizing the famed Moscow Art Theater, Nemirovich was a novelist, playwright, and critic—or whichever combination of the three struck his fancy at any particular moment. In years to come, he would be revered as the brilliant extrovert whose artistic vision had enticed Chekhov into the Moscow Art Theater af-

ter *The Seagull* had failed so miserably in St. Petersburg. When the Moscow Art Theater transformed Chekhov's plays into masterpieces cheered around the globe, Nemirovich would receive the world's acclaim. For the month of May 1896, however, he was content to be a special correspondent assigned to report on the coronation for the illustrated St. Petersburg weekly magazine *Niva* (*The Cornfield*).

More than ever before, the coronation of 1896 was to be a celebration of and by the people, and Nemirovich found the masses everywhere. Sweeping him along, they poured into the streets at dusk, their mood of celebration contrasting to their irritation at the crowds that clogged every square and street. "Watch out!" "Get over to the right!" "Stay on the left!" In jumbled Russian fashion, Moscow's masses pushed in all directions at once. Just for a moment, Nemirovich heard an ominous note that seemed almost too far away to notice. "Take off your hat, you damned Jew!" he heard someone snarl in the distance. "Can't you see that you're passing the Savior's Gate?" A Russian through and through, Nemirovich knew that the remark had not been for him, and he hardly gave it another thought. "Not only was I not afraid of the crowd," he wrote in his first report, "I loved it."[12]

Brimming with national pride and feelings of common cause with the masses, the critic-turned-correspondent watched from atop the ancient walls of the Kremlin as Russia's young sovereigns made their triumphal journey down the Tverskaia Boulevard toward Red Square on the afternoon of May 9. He had come there that morning after a late breakfast at the famous Slavianskii Bazar restaurant, and had made his way across Red Square to the Nikolskaia Gate, which took its name from St. Nicholas of Mozhaisk, Russia's patron saint of the afflicted. With some three score of his fellow correspondents, Nemirovich had climbed the steep steps to the ramparts from which Russian arrows had driven back Tatar invaders in days long past, and upon which triumphant Polish lords had stood in the days before the first Romanov had been chosen to rule Russia. "All of Red Square spread out before me," he told his readers. Behind him, the cathedrals and palaces of the Kremlin rose against the afternoon sky, their golden onion domes glistening against the azure brightness that spread behind them.

In the Kremlin, Nemirovich stood at the very source from which had sprung the greatness that the world's emissaries had gathered to celebrate. Whichever way he turned, monuments marking Russia's rise to power spoke of times long past and the promise of glories yet to come. At the far end of the square to his right stood the Cathedral of the Virgin Protectress and Intercessor, more commonly called St. Basil's, its domes and spires painted in all the colors of the rainbow. Built to celebrate the victory of Tsar Ivan the Terrible over the Tatars at Kazan in 1552, St. Basil's had stood as a monument to Russia's power in the East for almost 350 years. Europeans thought it "quaint and fantastic in the extreme."[13] Legend had it that the terrible Tsar had blinded its architects so that they could never build another.

North and west of St. Basil's stood the larger-than-life bronze figures of

Kuzma Minin and Dmitrii Pozharskii, the provincial butcher and Muscovite prince who had taken up arms to free Russia from the Poles in 1612. Minin and Pozharskii had driven the Poles from the Kremlin and raised the Romanovs to Russia's throne, their triumph signaling the rise of a new power in Eastern Europe that would bring all of Poland to its knees. About halfway between their statues and the cathedral, the low stone balustrade of Lobnoe Mesto marked the spot on which Peter the Great had executed hundreds of his rebellious musketeers in the year 1699 to show that even a Tsar who strived to win respect among the more "civilized" Europeans could be as wrathful and unforgiving as Ivan the Terrible himself. As a parade ground of tsars and commissars in the years ahead, Red Square would stand as a monument to Russia's power—and a reminder of the brutality by which it had been brought into being.

Behind Nemirovich, the great buildings of the Kremlin had been polished and painted for the events of the coming week. Forming the points of an approximately equilateral triangle, three of Russia's greatest cathedrals stood in its center: the Cathedral of the Annunciation, in which the nation's tsars were christened and wed, that of the Dormition, in which they were crowned, and the Cathedral of Mikhail the Archangel, in which they had been buried from the days of Ivan III until the time of Peter the Great. Russian in form, the cathedrals of Mikhail the Archangel and the Dormition had been built by Italians, a symbol of the debt that Russia's artistic experience owed to the cultures of East and West. Along the eastern edge of the Cathedral Square, the huge bell tower of Ivan the Great soared to a height of 265 feet to commemorate the prince who had done the most to gather the Russian lands. To its west, Italian masters had built the Palace of Facets, which had served Moscow's sovereigns as an audience chamber and banquet hall. From a golden-framed window on its upper floor, Moscow's tsarinas and their ladies-in-waiting had watched celebrations on the square below in the long-ago days when custom had forbidden them to appear in public.

From his vantage point, Nemirovich could see the Arsenal, the Treasury, the Grand Kremlin Palace, and a dozen more landmarks that marked out the center of the city that had become the Third Rome—the imperial metropolis of the Orthodox East—after the Turks had stormed Constantinople in 1453. As their procession approached the Kremlin, Nicholas and Aleksandra stopped to pray at the tiny Chapel of the Iberian Virgin, in which hung the most celebrated miracle-working icon in Moscow. After that, Nemirovich watched his sovereigns cross Red Square and enter the Kremlin through the Savior's Gate. Now officially in residence in Moscow, Nicholas and Aleksandra would make their home in the Grand Kremlin Palace until the coronation celebrations ended. Their procession had touched all the chords of Russia's past and stirred new dreams for the future. "Everyone who stood on this huge square that day," Nemirovich promised *Niva*'s readers, "would remember the sight for the rest of their lives."[14]

For the next four days, Moscow seethed with excitement as imperial heralds visited each of the city's gates and public places to announce the coming corona-

tion. On May 12, there was the consecration of Nicholas's coronation banner and, the day after that, the ceremony of bringing the coronation regalia from the Kremlin Armory. Receptions, meetings, and audiences filled every moment. On May 10, Nicholas and Aleksandra received ambassadors extraordinary and plenipotentiary from Korea, Spain, France, Japan, and the United States. Wearing the broad crimson sash of the Russian Order of St. Aleksandr Nevskii, the Chief of France's General Staff, General de Boisdeffre, spent half an hour with the Emperor, while America's Clifton Breckinridge, arriving "without any ceremonial in his own carriage and without any Court attendants in accordance with the laws of his country" according to Nemirovich's report, was granted only twenty minutes. More audiences followed—and a flurry of church services. At one o'clock on the day before the coronation, Moscow's priests said public prayers in every church. That evening, each church held an all-night vigil.[15]

At the center of events stood the Grand Kremlin Palace, a huge three-story structure that the Russo-German architect Konstantin Thon had built for Nicholas's great-grandfather between 1838 and 1849. Costing over twelve million rubles to build (more than a twentieth part of Russia's entire state income at the time),[16] Thon's creation stretched for 395 feet along the Moscow River, its great expanse being topped by a massive dome. The palace's magnificent granite staircase rose for fifty-eight steps, and its Hall of St. George covered fourteen thousand square feet. Built as a tribute to the Russian officers who had won their nation's highest honor for valor, the hall's white marble walls bore the name of every hero inscribed in golden letters. The name of Suvorov, the field marshal who had preferred cold steel to bullets, was there. So was that of Kutuzov, the conqueror of Napoleon in 1812.

To the west of the palace's main building in a separate wing facing the Kremlin's Imperial Square, the famed Armory housed some of Russia's greatest treasures. Including the goblet of Ivan the Terrible with which Nicholas would propose toasts at his coronation banquet, more than a thousand pieces of gold and silver plate filled the Armory's silver room, and smaller chambers held the weapons and trophies of Russia's tsars. Half a dozen thrones and twice that many crowns filled the room that held the coronation regalia of Russia's sovereigns. More than 2,200 precious stones and pearls studded the golden plates that covered the throne of Tsar Boris Godunov, while 876 diamonds and half again as many other gems adorned the famed Diamond Throne of Tsar Aleksei Mikhailovich. Precious stones the size of pigeon eggs filled the crowns of Peter and Catherine the Great, Ivan the Terrible, and (oldest of all) Vladimir Monomakh. There was the Ivory Throne upon which Ivan the Terrible had sat, and an orb overlaid with flowers and fruits made of diamonds, rubies, and emeralds.

Nearby, swords, sabers, armor, and helmets forged in medieval times to fight the heavily armored knights of Germany and the fast-moving cavalry of the Mongols showed the impact that fighting against East and West at the same time had made upon the shape of Russian arms, and trophies from Russia's greatest battles spoke of the triumphs that the men wielding those weapons had won. Words

could not describe it all, Nemirovich told his readers as he wrote of the Kremlin's sights. What a pity, he added, that photography had "not yet reached the point where these could all be captured in color."[17]

The coronation of the Emperor Nicholas II, the eighteenth Romanov to wear Russia's crown, began at nine o'clock on the morning of May 14, 1896. As tradition demanded, the oldest and most famous of Russia's Imperial Guards regiments—the bottle-green-coated Preobrazhenskiis, who would admit no man shorter than six feet to their ranks—stood guard, faces to the crowd, weapons at "present arms." Diplomats, correspondents, a handful of artists, and a crowd of other official guests had begun to make their way to the Dormition Cathedral just after eight and, as he took his place among the nineteen other correspondents who had been given places of honor there, Nemirovich noted that "not a spot of ground could be seen anywhere" outside. "The weather was warm, like June," he told his readers. "The sun flooded everything with light."[18]

Every detail of the day's events had been calculated to glorify Russia's history. The art and ritual of Byzantium, the uncompromising political absolutism of the Mongols, and the secular art forms of the West all had been assimilated at different times by the Russians and transformed into the awe-inspiring icons of the Dormition Cathedral, the architectural monuments of the Kremlin, and the pomp and circumstance of court ceremony. Two hundred and eighty-three years after the first Romanov had ascended Russia's throne, the sum total of the nation's artistic and political experience was being brought to bear to adorn the coronation of Nicholas and Aleksandra.

While Nemirovich observed the spectators in the cathedral, fifty-seven separate segments of the coronation procession awaited their sovereigns in the Throne Room of the Grand Kremlin Palace.[19] Precisely on schedule they appeared, Nicholas wearing the uniform of the Preobrazhenskii Guards, and Aleksandra in a silver-and-white gown set off by a single strand of rare pink pearls. Both had been up since dawn, which came very early in that part of the world on the eve of the summer solstice. Nicholas had chain-smoked cigarettes along with his morning coffee, while Aleksandra had waited impatiently for her nervous hairdresser to put the finishing touches on her hair.[20] Once outside their private apartments, both had to struggle to conceal their anxiety. Still trying to come to grips with the "terrible reality" of being Tsar,[21] Nicholas consulted his mother too often and tried—or so some claimed—to speak with the ghost of his father through the medium of spiritualists.[22]

Less than a month away from her twenty-fourth birthday, Aleksandra had come to Russia from her native Germany a scant eighteen months before, and had not yet gotten used to the language and ways of her adopted country. She had already been criticized for "holding herself as if she had swallowed a yardstick" when she received visitors,[23] and the mean-spirited old peasant women of St. Petersburg had been heard to mutter too often that she had entered Russia "behind a coffin" (a reference to her first public appearance in Russia at the fu-

neral of Nicholas's father).[24] Knowing that any slip would be noted and every misstep remarked upon, Aleksandra and her "Nicky" would have to be at their best for more than six hours, all the while wearing coronation mantles heavy with gold thread and embroidered with the double-headed eagle that Russia had taken from Byzantium as its imperial crest. Aleksandra's crown would be light; Nicholas's would weigh a full nine pounds.

From the Throne Room, the procession made its way into the Hall of St. Aleksandr Nevskii, passing beneath a dome that soared to a height of seventy feet. Through this mirror- and window-lined passageway leading into the Hall of St. George, it moved on to the smaller octagonal Chamber of St. Vladimir, named after the Knights of St. Vladimir that Catherine the Great had founded in 1782 in memory of the Grand Prince of Kiev, who had brought Christianity to Russia almost eight hundred years before. From Grand Prince Vladimir's conversion had flowed the brilliant artistic creations that adorned the cathedral that Russia's sovereigns were about to enter. To cover every square inch of its walls and ceiling, the greatest artists of the fifteenth and sixteenth centuries had painted depictions of the Last Judgment, scenes from the life of the Virgin Mary, and colossal figures of Christ and God Almighty. Not one work had been signed, for medieval Russian artists had believed that the hand of God guided their brushes, making it as if God Himself had painted the icons and frescoes in the cathedral.

The cathedral's huge iconostasis was said to contain more than five tons of gold. Here, in a frame of gold, silver, and jewels, resided the icon of the Madonna of Vladimir, the oldest and most precious of Russia's icons. Of Byzantine origin, but popularly believed to have been painted by St. Luke, this had been brought to Moscow from the northeast Russian town of Vladimir in the year 1395, and its presence had proclaimed Moscow as the center of Russian Orthodoxy ever since. In medieval Moscow, the art of the Orthodox East had acquired a uniquely Russian character. Only much later had Western forms modified what had by then come to be thought of as purely Russian.

Beyond the Chamber of St. Vladimir, court marshals escorted Nicholas and Aleksandra down the Red Staircase upon which Ivan the Terrible had once received a messenger from the traitorous Prince Kurbskii. Fearsome and cruel, the terrible Tsar had thrust the iron point of his staff through the emissary's foot, leaning upon it while he listened to Kurbskii's message. From this same Red Staircase, rebellious musketeers had thrown more than three score of the Regent Sofiia's opponents onto upraised pikes in 1682, another reminder of the violence that had scarred so much of Russia's history. But, on the morning of May 14, everyone's thoughts turned upon the brilliance, beauty, and power of Russia, not the means by which they had been achieved. In that spirit, Nicholas and Aleksandra crossed the short stretch of pavement that separated the Red Staircase from the Cathedral's great porch to be welcomed by the Metropolitan of Moscow. "There is no greater or heavier burden to be borne than the Tsar's du-

ties," the dean of Russia's churchmen intoned. "May the invisible might of the Almighty descend upon You through Your anointing and guide Your way as You seek to serve the welfare and happiness of Your true and faithful subjects."[25]

After acknowledging the Metropolitan's greeting, Russia's sovereigns entered the cathedral to begin a five-hour service, during which Nicholas would crown himself with the great imperial crown that glowed with diamonds, rubies, and pearls, some of them an inch or more in diameter. "Enlighten Him and make great His service to You," the Metropolitan of St. Petersburg implored after Nicholas had read the coronation prayer. "Grant Him reason and wisdom so that He may judge Your people according to the law, so that He may keep Your kingdom in peace and protect it from sorrow." Calling upon God to make Nicholas and Russia fearsome to their enemies, generous to their friends, and charitable to those in need, the Metropolitan intoned: "Do not turn Your face from us!"[26] At the liturgy's end, the newly crowned Tsar, Emperor, and Autocrat of All the Russias stood, removed his crown, and was anointed by both metropolitans. Then, while 101 cannon roared in salute, the Metropolitan of St. Petersburg led Nicholas to the altar to receive Holy Communion. "From that moment," one commentator wrote, "the Sovereign was God's truly Anointed. . . . He had been betrothed to Russia since early childhood. This day, it was as if he had been wed to her."[27] Now Nicholas was "Tsar-Batiushka," the "Little Father-Tsar" of all the Russians. In that spirit, he knelt alone to pray for Russia before the ceremony ended.

Other Russians shared their Tsar's feelings. In St. Petersburg, a huge crowd had gathered early that morning on the Winter Palace Square and along the Neva River Embankment to await the three cannon shots from the Peter and Paul Fortress that would signal that the coronation procession had begun in Moscow. Then came services in St. Isaac's Cathedral, the largest domed structure in the world after St. Peter's and St. Paul's, its interior a kaleidoscope of lapis lazuli, malachite, silver, and gold. When they received word that the Emperor had been crowned and anointed, the crowds knelt in the city's streets and squares to pray that God would bestow His guidance upon Nicholas and Russia. Thanks to the telegraph, which had shrunk the dimensions of time and space to a fraction of what they had been at earlier coronations, all of the Russian Empire received word of their Emperor's anointing within minutes.[28] At virtually the same moment, all Russians cheered their sovereign's coronation for the first time, being united as never before by the wonders of modern technology.

With the coronation over, the celebrations began. Seven thousand guests dined at the Kremlin that evening, and the ambassadors of the world's greatest powers rose one after another to toast the health of Russia's newly crowned rulers. At the ball that followed, Nicholas's sister and sister-in-law wore emeralds, and the Empress Aleksandra a girdle of diamonds around her waist. Their gowns too far off the shoulder for the tastes of some foreign visitors, the other ladies of the imperial court sparkled in rubies, sapphires, and diamonds, the likes of which could come only from Siberia's faraway mines. Some foreign guests

who did not know that tradition allowed the descendants of anyone who had saved a tsar's life at any time in Russia's history to have a place at the nation's coronations were amazed to see common folk scattered among Russia's greatest lords and ladies.[29]

Nor was the rest of Moscow forgotten. When Nicholas and Aleksandra stepped onto the balcony of the Great Kremlin Palace at precisely nine o'clock that evening, the Empress lifted a bouquet of roses from a golden salver that concealed an electric switch. As she did so, thousands of electric bulbs burst into light on the Bell Tower of Ivan the Great as if to signal the wonders of technology that these new sovereigns could bring to Russia. All across a city hitherto lit by gaslights and kerosene lanterns, churches and public buildings began to glow, each likewise illuminated for the first time by the century's newest source of power. Everywhere, Moscow's crowds marveled at the sight. "Did you see the illuminations?" "Where were you standing when you saw them?" were the questions friends asked each other in the days that followed. "The squares and embankments were jammed with people," Nemirovich wrote as he described the next few evenings in central Moscow.[30] Carriages could not get through. People had to go everywhere on foot.

Among the representatives of the common people invited to the coronation festivities, none were more honored than the descendants of Ivan Susanin, the peasant who, according to legend, had been killed by Russia's Polish invaders when he had refused to reveal the hiding place of the not-yet-crowned Mikhail Romanov in 1612. In 1836, Mikhail Glinka had immortalized Susanin in *A Life for the Tsar*, an opera that quickly became a favorite for patriotic holidays and functions of state. On the evening of May 17, the Bolshoi therefore gave a special performance of Glinka's opera, the imperial box having been enlarged to accommodate sixty-three guests for the occasion. For four hours, the leading singers from St. Petersburg's Imperial Mariinskii Opera joined their counterparts at the Bolshoi in offering an unforgettable performance to an audience which, Nemirovich wrote, "simply blazed with the orders of St. Andrei and St. Anna, the dress uniforms of general officers, and the red uniforms of senators."[31] That night, Pierre d'Alheim, Russian correspondent for *Le Temps* of Paris, thought that the red, blue, green, and orange of the officers' uniforms made it seem as if the parterre had been covered by "a carpet of spectacularly-colored flowers." The sight of so many women "covered with diamonds from head to toe" left both correspondents breathless. In the dispatch he filed a short time later, d'Alheim confessed that his heart had "beat faster" the entire evening.[32]

Enthusiastic "Hurrahs!" greeted Nicholas and Aleksandra when they entered the imperial box just before the curtain rose and the patriotic harmonies of Glinka's great overture filled the theater. With the audience turning their eyes to their young sovereigns as often as they did to the stage, *A Life for the Tsar* became a festival of Old Russian patriotism, rich in meaning and heavy with emotion.[33] When the last refrains of its epilogue faded away, the audience cheered again and stood to sing "God Save the Tsar," the powerful national hymn that

had been Russia's anthem since the days of Nicholas's great grandfather. "God save the Tsar / Powerful and mighty / Reigning in glory / For the glory of us all!" Here in the anthem's first four lines were the mysterious and mystical forces that had raised the Russians to greatness during war and famine. Love of their Orthodox Tsar had helped them to drive the Polish invaders from their land in 1612. Ninety-seven years later, it had defeated the Swedish armies of Charles XII, and, in 1812, it had given Russia's soldiers the strength to drive Napoleon out of their land in headlong retreat. Love of their Orthodox faith had summoned Russians to battle even before there had been a tsar in the long-ago days when Prince Aleksandr Nevskii had led them in the great "Battle on the Ice" of Lake Peipus against the Teutonic Knights in the spring of 1242 and Grand Prince Dmitrii of Moscow had marched against the Tatar armies of Khan Mamai at Kulikovo Field in 1380. Tsar and Church, God and Country—these had welded the Russians into the colossus whose presence beyond their eastern frontiers had gnawed at the hearts of Europe's statesmen and kings since the time of Peter the Great.

If Muscovites sensed that the Bolshoi's magnificent performance belonged mainly to Russia's aristocrats, they knew that the next day had been promised to the common people. Even before Glinka's opera ended, throngs of workers and peasants had started toward Khodynskoe Field, a military training ground that spread out for several square miles beyond the city's northern outskirts. Used for parades by the Moscow garrison, one corner of the field was hard-packed and smooth. Crisscrossed by ditches and shallow trenches used by military engineers during their summer maneuvers, the remainder had been covered with boards and dirt to give it the appearance of similar smoothness. To renew their age-old union with their "Tsar-Batiushka," the masses of Russia had been invited to Khodynskoe Field to gorge themselves on bread, sausage, and sweet cakes marked with the Tsar's monogram, and to slake their legendary thirst for alcohol with thousands of gallons of beer. All this would be given away to the masses who had gathered to cheer their sovereigns in a modern-day festival that promised to rival the bread and games of ancient Rome.

Seeing the throngs heading out of Moscow as he left the theater, Nemirovich decided to follow. At Khodynskoe Field, he found people from all over Russia sitting around bonfires, drinking, singing, and playing accordions and balalaikas. Some wandered among the still-silent carousels, stopped at the platforms upon which gypsy dancers soon would perform, and looked curiously into the special tent that had been set up for the famous clown Durov. "It was impossible to estimate the size of the crowd," he wrote later. "Perhaps there were only a hundred thousand—or maybe as many as three or even four hundred thousand." There was no way of knowing, but everyone seemed at ease. To be a Russian among Russians stirred feelings of deep common bonds, which, in those days, were beginning to bridge the huge chasm that the transformation wrought by Peter the Great had opened between Russia's upper classes and her common people almost two hundred years before. Longing to enjoy these feelings to the utmost, Nemirovich let himself feel the pull of the massive inner strength of the *narod,* as

the common people were called in Russian. Like the more ardently expressed patriotism celebrated in Glinka's opera, here was a force that had moved Russia's history for a thousand years and would continue to shape it for all time to come. The forces of Europe and Old Russia blended for a single memorable moment. Then, shaking off its spell, Nemirovich drove back to Moscow, intending to sleep for a few hours before returning to observe the celebrations later that day.[34]

As a foreigner not fully attuned to the mysteries of Russian life, Pierre d'Alheim had gotten caught up in the same crowd that Nemirovich had followed. Good-naturedly moving with a single purpose, young and old, halt, blind, infirm, and robust, they had swept him along toward their common destination. The Frenchman was enthralled. "One's heart reached out to them," he confessed as he described to his readers the old man who had hobbled by his side and the women who had crossed themselves and offered up prayers at every church. "I loved them all." A few moments after the city slipped into the darkness behind them, the highway reached Khodynskoe Field, where stars filled the sky and d'Alheim watched the human tide that had carried him from Moscow "spread out ahead into . . . a veritable sea of people." There in the ancient heart of the Russian land, far from the modern world of Europe, d'Alheim too felt the pull of the *narod*. "I was stunned and my temples throbbed," he wrote. "Oh, how wonderful it all was!"[35]

Here were people who had traveled hundreds and thousands of miles for a single day's celebration. Put within reach of Moscow for the first time by the miracle of steam power, they had come from Siberia, Central Asia, and the mountains of the Caucasus to pay homage to their "Little Father" at the time of his crowning. From the shores of the Black Sea, the Baltic, and the Pacific they had come, and from the grainfields of Ukraine and the forests of the Far North, too. In olden times, hardy travelers had needed more than a year to cross the Russian Empire. Now, a peasant with a fourth-class ticket on the slowest train could make the journey in a few weeks' time. It cost less than nine rubles to travel to Moscow from Kiev, the "Mother of Russian Cities," which stood in the heart of Ukraine. It cost even less to ride the specially subsidized trains that carried settlers between European Russia and the western lands of Siberia.

And so the *narod*—a legion of simple folk wearing high leather boots, sweaty foot cloths, greasy sheepskins, calico-print dresses, and faded rusty-black trousers—had come to Moscow. Once described by a British journalist as a "tatterdemalion throng . . . carrying bedding, bundles of clothing, chunks of bread, a jangling kettle, and often a big flapping-tailed dried fish which would slap the face of the next person,"[36] they had come on foot, ridden on the tailgates of creaking two-wheeled carts, sat on the lower decks of river boats, or squatted in boxcars bearing the stenciled words "to carry twelve horses or forty-three people." Now they were looking forward to eating their fill of the Tsar's food and guzzling as much of his beer as they could hold. Their thirst was as huge and old as time itself. Kiev's Grand Prince Vladimir, the ancient chronicles said, had rejected the teachings of Islam in the year 988 by telling the missionaries who had

pleaded Mohammed's cause that "drinking is the joy of the Rus."[37] Nine hundred years later, Vladimir's words still rang true. Complete inebriation—*zapoi* the Russians called it—remained a fond dream for every Russian peasant. Some of the people around d'Alheim looked forward to its coming true later that day.

"Old men lying on their stomachs and chatting peacefully, maidens dancing in a ring, lads lustily singing comical ditties, and everyone roaring with laughter"— d'Alheim found them all as he wandered through the crowd, looking, listening, and feeling its pulse.[38] Around him was everything a foreign correspondent in search of the "real" Russia could hope for. Here were the "real" Russians, whose motivations had posed enigmas for Europeans since before the days of Peter the Great. As coincidence would have it, Nemirovich's cook was among them. A fat, middle-aged woman who had risen early to join the throng of which d'Alheim had become such an enthusiastic part, she would bring her employer his first news of the events that history would remember as the "Khodynskii horror."[39]

Just before dawn, d'Alheim felt "something seize the crowd suddenly and without any warning." A sixth sense warned him to get away, but people hemmed him in on all sides. Struggling to work his way free, the Frenchman took refuge in an all-night restaurant, from which he watched the *narod* press toward the food stalls that had been set up on the far side of the field. Then he heard "a terrible, long, drawn-out wail" and saw people struggling to break away from the human mass that held them fast. "People are falling," he heard someone shout as the boards the authorities had laid over the field's trenches began to give way. "They say they are simply vanishing!"[40] With the milling throng blocking his way, d'Alheim got no closer than the near edge of the field, where the reviewing stands were filling up with hundreds of invited guests who had no sense of the tragedy that was unfolding beyond their line of sight. Only later that morning would he be able to reconstruct a clearer account of what had taken place.

Nemirovich heard about the trouble at Khodynskoe Field some three hours later, when he got up to find his shaken cook back home and weeping. "May the Kingdom of Heaven be theirs!" she kept saying as she crossed herself. "Thousands were being crushed!"[41] Not certain how much stock to put in his cook's story but hoping to get to the bottom of it without too much trouble, Nemirovich returned to Khodynskoe Field. At first, he felt certain that the woman had exaggerated, but his sense of doom deepened as he saw the crowds returning. No longer the joyous throng he had seen surging along the road the night before, they now moved in twos, threes, fives, and tens, silent and sphinxlike, their feelings hard to read. Now on its guard, the *narod* was wary, forming a crowd of which Nemirovich no longer could feel a part. The chasm that had separated educated Russians from the masses since the days of Peter the Great had opened once again, destroying the sense of oneness in which Nemirovich had taken such delight a few days before. As he neared Khodynskoe Field, he therefore quickened his pace, fearful that his cook had been right after all.

Prepared for the worst, Nemirovich found a festival in full swing as the direc-

tor of the Moscow Conservatory conducted a chorus of several thousands from a pavilion heaped with flowers. Their uniforms shining with orders of merit, officers and bejeweled ladies stood in the reviewing stand along with representatives of the Russian clergy, a cluster of portly merchants and their well-fed wives, and a group of elders who represented those Old Believers whose ancestors had broken away from the official church in 1667. As these people waited to present their sovereigns with a silver platter in which their initials had been marked out in diamonds, no one gave the least indication that anything out of the ordinary had happened. When Nicholas and Aleksandra appeared on the balcony of the imperial pavilion, the cheers went on for half an hour.[42]

Still, Nemirovich sensed an undertone of tragedy. Had anything out of the ordinary happened? he asked a correspondent who had been there all morning. Yes, his acquaintance replied, there had been a stampede. People had been hurt. Some had been killed.

"But did you actually see a lot of bodies?" Nemirovich asked.

"There wasn't any official count," the other journalist replied as he motioned toward the far side of the field, "but I would guess that somewhere between five and six hundred are still lying there."

"His words," Nemirovich remembered, "left me feeling that cold water had been poured over me."[43] The cook had not exaggerated after all.

As Nemirovich made his way toward the place his acquaintance had indicated, he found a handful of peasants halfheartedly watching Durov perform, while a few others stared listlessly at the gypsy dancers. Then, just beyond the broken stalls that were to have served the Tsar's food and beer, Nemirovich found row after row of corpses. Until just a few hours before, these had been men, women, and children looking forward to greeting their Tsar and Tsarina. Now their faces were "dark purple, blue-black, or violet," he remembered, and "caked blood filled their nostrils and the corners of their mouths." Left by simple men and women who muttered prayers as they filed by, a small heap of copper coins lay at the feet of each body. A taunting contrast to the wailing of peasants searching for loved ones, the gay music of the orchestras at the reviewing stand still drifted across the field.[44] According to official estimates, always understated by Russian officials in reports of disasters, 1,389 people lost their lives that day; another 1,300 suffered injuries.[45]

What had happened and how? As Nemirovich looked at the turf that more than half a million feet had beaten into dust, the answer to the first question seemed obvious. Unwary people had stumbled into the poorly covered trenches, falling beneath the feet of those who continued to press against them from behind. Why the accident had happened proved to be harder to sort out. The best answer seemed to be that a feud between the Governor-General of Moscow and the Minister of the Imperial Court about which one had the responsibility for keeping order had limited the number of police assigned to control the crowd at Khodynskoe Field to a handful. Nicholas's uncle Grand Duke Sergei Aleksandrovich earned the popular epithet "Prince Khodynskii" for his part in the

bungling that led to the tragedy.[46] In this first major test at the bar of public opinion, Nicholas fared only slightly better.

Although some of his advisers urged him to cancel the rest of the celebrations, Nicholas let them continue, in the belief (according to his uncle) that the "misfortune at Khodynskoe Field must not cast a shadow upon the coronation."[47] To that end, an official communiqué asked all correspondents "to refrain from any sort of rhetoric in describing the sad incident of May 18th,"[48] and preparations went ahead for the French ambassador's ball that evening. For some who had come to Moscow to cheer Russia's sovereigns, this playing-down of the tragedy left a lingering sour taste. D'Alheim did not enjoy his ambassador's ball that night, and left soon after he had arrived. "I wasn't myself," he explained. "I was ashamed to be there." After he walked through the city for a few hours, the Frenchman's dark mood eased. "I no longer felt ashamed," he wrote. "I simply felt sick."[49]

Intimates later claimed that the Tsar had wanted to replace the celebrations with memorial services for the victims, but that inept councilors had convinced him not to do so. By giving pensions to families of the victims, visiting hospitals, and paying for the care of those who had been hurt, both Nicholas and Aleksandra showed their concern in the days ahead, but the empty celebrations that filled the week after the tragedy erased the effects of their charity before anyone had time to notice.[50] Then, just eight days later, Nicholas held a military review on the same Khodynskoe Field and took the salute of 67 generals and 40,525 men as they marched by.[51] As the soldiers' boots stirred the dust onto which the victims had fallen, the world saw once again that a nation whose history had been marked by a thousand years of famines, plagues, wars, and suffering could not be expected to mourn one tragedy more. Although now a part of Europe, Russia was still Russia after all.

"As if in a mirror," Nemirovich mused as he looked back on what he had seen, "the long string of pictures of the coronation days reflected the enormous strength of the Russian people and the place they are fated to hold in the scheme of human history."[52] Here, in the events of May 1896, the Tsar and the *narod,* the great nobles and the masses, the ways of the East and the life of the West all stood juxtaposed. Signaling the high point of nearly a millennium of political and artistic experience for which the events of the coronation had formed such a brilliant setting, these embodied the essence of Russia herself, in which the disconnected heritages of Byzantium and the West had combined with the inner life of the *narod* to become fully and indisputably Russian.

# GENESIS

*A THOUSAND YEARS* before Nicholas II crowned himself Emperor and Autocrat in the Kremlin's Dormition Cathedral, there was no Russia, no Moscow, and no tsar. Charlemagne's successors ruled the Holy Roman Empire in the West, while the Empire of the Byzantines held sway over the remnants of Rome in the East. As defenders of God's holy faith, both wielded enormous power in the Christian world but each faced challenges from the south, where the followers of Mohammed ruled lands that stretched from Gibraltar to the frontiers of India and China. Combining absolute submission to the will of Allah with a warlike tradition that stretched back for hundreds of years, armies of scimitar-wielding Muslim cavalry had conquered the southern and eastern shores of the Mediterranean in the seventh century, and their warships had cut the trade routes that had linked East and West since the time of Alexander the Great. Commerce had shrunk to a trickle, and the urban centers that had shaped life in Europe since the days of the Romans had begun to crumble. Unable to drive back Islam's armies, compete with its commerce, or match the vibrance of its arts and learning, the West had languished. When Charlemagne began in the 770s the conquests that would make him master of the West and Holy Roman Emperor, the forces of Christianity had stood deeply in Islam's shadow.

As town life revived under Charlemagne's protection and commerce started to come alive once again, merchants of the West began to look to the remote Slavic lands in the East, where the half-merchant, half-bandit cousins of those Vikings who had plundered the coasts of Europe in earlier times had opened

a new trade route from the Black Sea to the Baltic. Called Varangians by the people of the lands they conquered, these fearsome raiders soon shifted the axis of East-West trade to the north and south, sending the products of the fields and forests of central and northern Europe to Constantinople, where they exchanged them for the treasures of the Orient. By the late ninth century, trade flowing "from the Varangians to the Greeks" began to restore the economic links between East and West that the Muslim onslaught had sundered. As commerce drew them into the mainstream of Western European and Byzantine history, the people of the once-isolated lands of Eastern Europe encountered the outside forces that would shape their political and artistic experiences for hundreds of years to come.

Pagan princes descended from Riurik, the semilegendary Varangian founder of Russia's first dynasty, ruled the lands through which Europe's revived trade began to flow. Among them, the Prince of Novgorod was the strongest in the North, where the river routes leading to and from the Caspian Sea formed another vital artery between East and West. With the great Volga River at its heart, this two-thousand-mile-long chain of rivers, lakes, and portages carried the silks and spices from Persia and the Muslim empires of Central Asia that would enable Novgorod to extend its empire from the Baltic to the edge of Siberia and to provide its merchants with the wealth needed to fill their city's churches with some of the greatest art that early Russia would ever see. As cultural currents from Orthodox Byzantium and Catholic Europe began to mix with those of the Orient in the late tenth century, Novgorod's artistic monuments began to reflect a rich blending of foreign and native influences that would soon transform the city into one of the great centers of medieval Russian art. Well before its golden age came to an end late in the fifteenth century, Novgorod's brilliant-colored icons and distinctively designed churches had begun to shape the art of the lands that Moscow's princes were about to gather into the kingdom that the world would one day know as Russia.

Further south, at the point where the great grass road from Inner Asia intersected with the rivers that flow between the Baltic and Byzantium, the Grand Prince of Kiev ruled a prize of even greater value than Novgorod, for at Kiev the caravans from the Orient met the high-prowed ships that made their way along the great Dnieper River highway to the Black Sea and the bazaars of Constantinople. Because its princes commanded the gateway through which much of the trade from the Near and Middle East flowed between East and West, furs, honey, wax, spices, amber, gems, rare woods, gold, silver, precious silks, and treasures wrought by the master craftsmen of the East all made their way through Kiev, and the wealth that this commerce produced soon enabled its rulers to blend great political authority with generous patronage of the arts. As the point at which the politics, commerce, and cultures of the Eurasian steppes blended with those that flowed from Europe and Constantinople, Kiev was a prize worth having, and the sovereigns who ruled Byzantium, the Holy Roman Empire, and the lands of Islam all dreamed of adding it to their domains. When Grand Prince

Vladimir mounted its throne in the year 980, Kiev faced enemies to its south, east, and west, and its armies had been almost continually at war for nearly half a century.

As the tenth century neared its end, shifting political sands in the Near East and the Balkans obliged Kiev's Grand Prince Vladimir to seek new alliances to defend his kingdom. Portrayed in Russia's ancient *Primary Chronicle* as a great seeker, who went in quest of a true faith for his people, Vladimir in fact set out to anchor Kiev in the treacherous political currents that swirled around it by using its international trade as a golden chip in bargaining with the sovereigns whose lands lay beyond his own. When in return for their Emperor's promise of his sister's hand in marriage Vladimir accepted the faith of the Byzantines, he bound to Eastern Orthodoxy for all time to come the lands that many centuries later would lie at the heart of the Russian Empire.

Combining the heritage of pagan Rus (as the parts of modern-day Russia and Ukraine ruled by Kiev were called at the time) with Christian influences that flowed from Byzantium, a new vision of arts and politics came into being in the lands that lined Europe's eastern frontier as the eleventh century opened. Cathedrals and churches replaced pagan shrines, and icons took the place of hewn wooden idols. As the people of Rus devoted themselves to glorifying God in those early days, a thirst for color began to define their vision, and the artistic tradition that would one day produce Marc Chagall and Vasilii Kandinskii began to take shape. The "living soul of colors" to which Kandinskii so often paid homage found early expressions in frescoes that now-forgotten native painters created to adorn some of Russia's early churches, just as abstract modern paintings shared a common heritage with the long-ago artists who struggled to erase every trace of human expression from their icons.

Vladimir's alliance with Byzantium formed part of a broader effort to confirm the authority of Riurik's descendants to rule the lands of the eastern Slavs. As part of a plan to establish the Prince of Kiev as the first among a dozen equals whose ranking within the ruling hierarchy of ancient Rus shifted as their power ebbed and flowed, Vladimir sent one of his sons to take command of each of Rus's major towns. This brought stability to Rus in his lifetime, but it set the stage for almost four centuries of civil wars as the generations of brothers, uncles, cousins, and sons who followed him fought to determine who would reign in Kiev. Power was at stake, but so was divine favor, for the men who reigned in the principalities that controlled the greatest wealth would have the means to glorify God with churches and works of art that would last far beyond their lifetimes. Patronage of the arts, therefore, flowed from triumphs in war, commerce, and politics. It would be no accident that, in the years between Vladimir's death in 1015 and the accession of Moscow's Grand Prince Ivan III in 1462, the merchants of Novgorod and the princes of Kiev and Suzdalia would shape an artistic experience that produced some of the most stunning monuments to the glory of God ever to appear in the lands in which Eastern Orthodoxy reigned supreme.

Because medieval men and women best understood the forces that shaped

their daily lives in religious terms, Russia's ancient chroniclers explained Vladimir's turn to Byzantium as an event that had its origins in faith instead of politics. In the year 986, these monkish scribes later wrote, the Grand Prince of Kiev had sent envoys to the south and west to observe the rituals of Islam, Roman Catholicism, and Greek Orthodoxy, and decide which faith best served the needs of the people of Rus. The Prince's messengers returned to report that they had "beheld no glory" in Roman Catholicism, and felt only disgust when they had watched the devotions of the Muslims. But what they had seen in the golden cathedrals of Byzantium, they said, filled them with awe and devotion. "We knew not whether we were in heaven or on earth," they told their Prince. "On earth there is no such splendor or beauty, and we are at a loss to describe it." To spokesmen for a people whose unbridled love of color continues to be displayed as vividly in the paintings of its modern masters as in its medieval frescoes and icons, the pageantry and brilliance of Byzantine ritual must have seemed truly irresistible. "We only know that God dwells there among men," Vladimir's men concluded. "We cannot forget the beauty [that we saw in Constantinople]."[1]

On a material level, nothing that Vladimir's envoys had seen in the West or the lands of Islam could compete with the grandeur of the public buildings and palaces of Constantinople, nor could any temple, mosque, or Roman Catholic church rival its great Cathedral of St. Sofiia. In choosing to ally with Byzantium instead of the Holy Roman and Saracen empires, Kiev's Prince established the foundation for an artistic experience that would amaze the world by the speed with which it assimilated foreign influences and reshaped them into masterpieces of its own.[2] Late in the twelfth century—and less than two hundred years after its people learned to write—Rus would produce an unknown poet equal to those Western masters who had composed *Beowulf* and the *Song of Roland*. Two centuries after that, the icons of Kiev, Novgorod, and the northeastern Russian lands of Suzdalia challenged those of Byzantium's masters to take their place among the most beautiful in the Christian world.

In the spring of 990, some two years after he had accepted the faith of the Byzantines, Vladimir destroyed the temple of the Rus thunder god Perun and cast down Kiev's pagan idols. When the other principalities of Rus followed his example, the brilliantly eclectic civilization of the "Second Rome" poured into their lands, bringing with it all the art, architecture, church music, and learning that had made Byzantium the envy of all Christendom. Along with these treasures of the East came the literary language created by the Thessalonican brothers Kyril and Mefodii, who had preached the gospel to the southern Slavs more than a hundred years earlier. Old Church Slavonic, the language in which the monks of medieval Christian Rus wrote their chronicles and which the poets of Kiev used for their handful of literary masterpieces, evolved from these beginnings. Blending the sacred and profane to reflect a broader Eurasian vision, the scribes of Kiev used Russia's first written language to project themselves and their times into the fabric of history.[3]

Yet, if the people of Rus saw their lives as a part of history, they did not set their past and present into a theological framework. Medieval Christian Rus never found its St. Augustine or Thomas Aquinas, and not a single dogmatic treatise ever emerged from the monastic communities of Kiev, Novgorod, and Suzdalia during the half-millennium before Moscow's princes began to gather the Russian lands. The men and women of Rus preferred to praise God with their hearts rather than build theological foundations for their beliefs in works of philosophy and literature, and their artistic experience, therefore, centered upon churches, frescoes, and icons that proclaimed God's glory to everyone who saw them.[4] Quickly moving away from the styles of painting and architecture that their teachers had brought from Constantinople, the artists of medieval Rus created icons and frescoes that became windows through which pious men and women could glimpse the realm of the spirit, while their churches became monuments to a Russian style of architecture that had become second to none in the Orthodox East by the time the Mongols overran their land in the thirteenth century. Brilliant in their ornamentation and adapted by their builders to the climate and building materials at hand, the churches of Old Rus became unique expressions of the vision that would transform Moscow into the Third Rome in years to come.

The year after Grand Prince Vladimir tore down the pantheon that had housed Kiev's pagan gods, the first Byzantine builders arrived in Kiev to begin work on the Church of the Virgin of the Tithe, the first of the city's many churches and the one destined to reflect in its history the turmoil of the land into which Eastern Christianity had come. Built in less than a decade upon the desecrated remains of a pagan cemetery that had overlooked the city in the days of Vladimir's ancestors, the church boasted marble columns and mosaic floors surrounded by slate detailing that surpassed anything the city had ever seen. The first monument to Kiev's new Christian faith and a channel through which the artistic experience of the Byzantines flowed into Rus, the Church of the Virgin of the Tithe burned in 1017 and was rebuilt in 1039. Russians from the north looted it twice during the next two centuries. Then, when the Mongols sacked Kiev in 1240, they reduced it to a pile of rubble from which it was destined never to rise again. By that time, greater monuments to the glory of God had taken shape in the Russian land. To the north and east of Kiev, new builders working with different materials had begun to create the cathedrals that would find their final form in the center of Moscow's Kremlin.[5]

The turmoil that swept the lands of Rus after Grand Prince Vladimir's death in 1015 obliged his second son and heir, Iaroslav the Wise, to consolidate his power before beginning to build new and greater monuments to the glory of the God his father had chosen to serve. Then, after twenty-one years of war, Iaroslav set builders to work on the Cathedral of St. Sofiia, which was to become the greatest of Kiev's churches. Dedicated to the Mystery of Divine Wisdom and with thirteen cupolas signifying Christ and His twelve apostles, St. Sofiia became

in Iaroslav's declining years the "great and holy house of God," which represented the finest effort of Kiev's Prince to proclaim that the land of Rus could keep pace with every other Christian state in building monuments to glorify its faith.[6]

The builders of St. Sofiia mixed secular and sacred themes in exuberant profusion in their cathedral's decoration. Mosaics showing Christ surrounded by His disciples dominated its central dome, while a huge fresco that portrayed the ceremonies and entertainments of the Byzantine court covered the walls of the staircase that led to its galleries. Acrobats, gladiators, and hunters thus joined Christian saints, the Blessed Virgin, and Christ Himself to bind Kiev's Grand Prince to the world in which the Emperor of Byzantium lived.[7] Was the readiness of Kiev's sovereigns to surround themselves with such vivid reminders of Byzantine royal life an early vision of Russia's coming triumph over Byzantium? Or was it simply an effort to bask in the reflected glory of Byzantium as the Second Rome? When the Byzantine Empire fell four hundred years later, the grand princes of Moscow, who had risen to rule the newly unified Russian land as the heirs of Kiev's princes, would replace Byzantium's emperors as the sovereigns of Eastern Christendom. With Constantinople in the hands of the infidel Turks, Moscow became the Third Rome, which was expected to stand as the eternal center of the true Christian Church.

While frescoes and mosaics proclaimed the glory of God in Kiev's churches, paintings done on panels of well-seasoned alder, cypress, or lime (over which a layer of linen had been stretched and covered with several thin coats of gesso) became the windows through which the people of Rus entered the world of the spirit to receive the grace of God.[8] Painted in the flat, two-dimensional forms that disappeared from medieval European painting long before the Renaissance, icons became the points at which divine grace and human need intersected in the Russians' daily lives.[9] Sometimes said to have been painted "without human hands" by artists whose brushes were guided only by God, these stark red, green, blue, ocher, and gold images became the anchors of the Russians' faith and bound together a people whose suffering equaled their piety during some of the most trying moments of their history. Icons of the Madonna, the apostles, and Heaven's archangels led the armies of Russia's greatest captains into battle, and the Russians attributed victory, healing, and the promise of salvation to their miraculous powers. Ivan the Terrible, Peter the Great, and Nicholas and Aleksandra all bowed in prayer before them. Throughout Russia's history, they represented a powerful intuitive tradition, which stood at odds with the rational intellectual forces that shaped the teachings of Rome.

In the religious life of the Russians, the icons' most prominent place was in an iconostasis, a screen of sacred paintings mounted in metal or carved wooden frames, which, by the fifteenth century, reached almost to the ceiling in some of the greatest churches.[10] Symbolizing the integration of living Christians with the entire company of Heaven, the iconostasis stood at "the boundary line between the Divine and the human" and divided the sanctuary (where the sacrament of

the Eucharist was celebrated) from the congregation so as to link the realm of man with the Kingdom of God.[11] Every church's most precious icons had their places in this sacred screen. With rare exceptions, only less treasured copies found their way into the specially designed icon corners that claimed places of honor in Russian homes (and which, in Soviet times, became transformed into the "Red Corners" in which devout believers in the Bolshevik vision displayed carefully crafted likenesses of Lenin and Stalin). Before their icons at home, Russians said their daily prayers, asked God's blessing, and sought divine intervention in resolving problems that seemed beyond their strength. In icon corners and iconostases, such sacred images served as daily reminders to a superstitious and uneducated people that God's power to shape their lives exceeded even that of the absolute and autocratic sovereigns who reigned over them.

Although limited mainly to embroidered cloths and a few icons in Kievan times, iconostases eventually grew to hold five tiers of sacred paintings, the largest being at the bottom, where the Royal Doors through which priests approached the altar held icons portraying the Annunciation, the four evangelists, St. Basil the Great, and St. John Chrysostom. To the left of these hung an icon of the Blessed Virgin, and to the right one of Christ or the saint or event to which the church was dedicated. Images of archangels and sainted deacons decorated the smaller northern and southern doors that stood to each side, leaving places along the outer edges of the screen for icons of local importance. Above this first tier, the Deesis (or prayer) row held an image of Christ in Majesty flanked by the Blessed Virgin, St. John the Baptist, the Archangels Gabriel and Michael, and other important saints. Higher still hung the feast tier, which depicted the twelve major feasts of the Church, and, above that, a row that portrayed Old Testament prophets holding open scrolls upon which foretellings of the Divine Incarnation had been written. The tier of patriarchs, the forefathers of the Old Testament, who represented the history of the Church from Adam to Moses, stretched across the very top. Together, the paintings presented a pictorial history of Christianity, depicting the sacred moments when "God had come out of His holy place to redeem His people."[12] Destined to become a much more prominent feature in the churches of Russia than in Byzantium or Rome, the iconostasis stood as a permanent monument to the sacred history of which the recently Christianized people of Rus had become a part. In time, the beauty and brilliance of the awe-inspiring iconostases of Moscow and the cities of Russia's Northeast would help to set the national Russian Church apart from all others.

Legend has it that Grand Prince Vladimir brought the first icons to Kiev when he returned from the Byzantine Black Sea port city of Kherson not long after his conversion. Anxious to bring to Rus the splendor that his envoys had seen in Byzantium, Vladimir summoned artists from Kherson to Kiev, and their influence remains even today among the shadows that the icons of Russia's greatest native masters cast across the interiors of its churches. In no case is that more evident than in the icon of the Madonna of Vladimir, which was brought to twelfth-century Kiev from Byzantium to celebrate the city's central place in early

Slavic Christianity. Painted with classic Byzantine features, which took the form of a sharp, aristocratic nose, almond-shaped eyes, and a small mouth, this most precious of all Russian madonnas still stands as a striking example of the manner in which medieval painters diffused light so as to suggest that its source lay in the divine realm of the spirit. Even though only the face of the Child and the face and neck of the Virgin have survived the cycles of damage and repair it endured over the centuries, no other icon in Russia radiates such human warmth or attains such spiritual depths. "The pervading gentleness of this image," one observer concluded, "not only accounts for the unreserved affection in which it was held . . . by the Russian people, but may also be considered as [being] in some measure responsible for the quality of affectionate tenderness which constantly reappears in later Russian religious painting."[13]

Just as the rise and fall of Kiev's Church of the Virgin of the Tithe reflected the city's turbulent heritage of fire, political upheaval, and warfare against the horsemen of the steppe, so the history of the icon of the Madonna of Vladimir chronicled the turmoil that brought a unified Russia into being. Carried away from Kiev into Russia's Northeast when the Suzdalian armies of Prince Andrei Bogoliubskii looted the capital of old Rus in 1169, it was moved some two hundred years later to Moscow's Kremlin to strengthen that city's claim to being the new center of the Russian Church. Legend credits its miraculous powers with turning back Tatar invaders from the gates of Moscow on three different occasions. Popular belief also attributes some of Russia's greatest victories to it, including the liberation of Moscow from the Polish invaders in 1612 and the defeat of the armies of Napoleon two centuries later.

Although the artistic experience of medieval Rus centered more on the visual arts than on letters, the first stirrings of literature coincided with the early days of Kievan art. Supplemented by translations of tales and sermons from Byzantine and Bulgarian chronicles, lives of saints formed the main products of Kievan literature until well into the twelfth century. Then, as Vladimir Nabokov pointed out in one of his periodic forays into Russia's literary past, a single poem catapulted Kievan letters into the literary stratosphere. To this day, *The Song of Igor's Campaign* remains, in Nabokov's enthusiastic words, "a uniquely poetical structure created in a sustained and controlled surge of inspiration by an artist with a fondness for pagan gods and a percipience of sensuous things."[14] Here, in a single masterpiece, faith, a newly developed written language, the forces of nature, and a noble pagan heritage blended into a work of genius that stands among the greatest literary creations of the medieval Christian world.

In fewer than three thousand words arranged into just more than 850 lines, *The Song of Igor's Campaign* tells of Prince Igor's defeat by invaders from Russia's eastern steppe in the spring of 1185. As the warriors of Rus march against their enemies, an eclipse darkens the sun and storms fill the night with mysterious forces and omens that create the backdrop for a tragedy such as never again would appear in the literature of the Kievan era. After a night of troubled waiting, during which the nightingales cease to sing and the crows begin to caw,

Igor's soldiers throw themselves upon their foes, the clanging of their swords and lances creating a fearsome accompaniment to the screams and groans of their enemies. Before nightfall, the men of Rus stand triumphant on the field of battle and fill their camp with the spoils of war. Then, to the accompaniment of black clouds and blue lightning, the enemies of Rus return the next morning in a rain of arrows and a cloud of spears. Igor is captured and his men, unable to fight on, fall in defeat, their bodies strewn across the field and their banners trampled beneath the hooves of their enemies' horses. In despair at this sudden turn of events, the unknown poet of ancient Rus summons the flowers, trees, and grasses to mourn Igor's defeat, and only after nature has had its say does he permit the women of the land to bewail the loss of their husbands, fathers, sons, and brothers. Not until Igor escapes his captors many months later does joy return to Rus. Only then does the poet allow the nightingales to resume their song and the sun to shine once again. Only when Igor returns to his wife and people can the land of Rus begin to think again of glory and the promise of better times.[15]

In calling upon the heroes and princes of Rus to lay aside the differences that had made them weak, the author of *Igor's Song* made it clear that more than a passing moment of weakness lay behind Igor's defeat. While the princes of Rus continued to squabble over pride and precedence, wars and politics began to shift the forces of civilization to more distant corners of the land, and when the Crusaders reopened the Near East to Western commerce in the twelfth century, the trade patterns that had made Kiev prosperous shifted back to the Mediterranean. No longer did the rich trade of Europe and the Orient flow through the city's gates as it had in the days of Grand Prince Vladimir's first descendants, nor could its rulers count on obedience from other princes in the lands of Rus. The economic and political forces that would bring about Kiev's downfall were well at work by the middle of the twelfth century, even though the city continued to struggle against them for another hundred years. Because the sure and certain processes of decay still moved slowly, foreigners who visited Kiev in the 1180s and 1190s continued to see its forest of gilded domes rising above a shining band of white stone walls as proof that the "Mother of Russian Cities" still guarded the western edge of the Eurasian steppe.

A great steppe metropolis that had brought together the rich influences of Byzantium and the Middle East, integrated them with its Slavic and Varangian past, and seasoned the resulting mixture with freely used borrowings from the cultures of Central and Western Europe, Kiev ranked as one of the most beautiful cities in Christendom when the forces of discord began to undermine it. Great brick buildings adorned its center, and libraries, hospitals, and schools enriched the lives of its people to an extent unknown in London or Paris at the time. The great epics of the medieval West often mentioned Kiev, and well-chosen marriages had allied its rulers to nearly every important royal family in the West. Kievan princesses had married kings of France, Hungary, Poland, Bohemia, Sweden, Norway, and the Emperor of Byzantium, and princesses from those lands had married Kievan princes. After England's last Anglo-Saxon king

fell at the Battle of Hastings, his family sought asylum in Kiev, as did deposed rulers from Hungary and Norway. The law code of Kiev's Grand Prince Iaroslav the Wise was known for its sophisticated treatment of trade and finance, the mildness of its punishments, and its preference for fines to death sentences at a time when execution by a grim array of barbarous methods was the punishment for scores of crimes in the West. These and a host of other accomplishments proclaimed the greatness Kiev had achieved in the scant two hundred years since Vladimir had accepted the law of Christ. Even as the twelfth century drew to an end, there were few outward signs to indicate how fragile the kingdom's brilliance had become.

When the Mongol hordes of Batu Khan stormed out of Asia, the people of Kiev faced their greatest trial, while the kings and princes of Europe looked on in silence. Unmindful of the debt they owed for more than three hundred years of Kievan protection against the feared horsemen of the steppe, Europe's sovereigns hoped only that Batu would not lead his armies farther west, and they left the people of Kiev to stand alone against the Mongols' siege. After three months of fighting, Kiev fell just before Christmas in 1240, and the Mongols reduced the "Mother of Russian Cities" to ruins as a warning to all who dared refuse their demands for surrender and tribute.[16] Evidence of the Mongols' brutality lay strewn across the Kievan steppes for years to come. "We came across countless skulls and bones of dead men lying about on the ground," the Franciscan friar Giovanni del Plano Carpini reported when he visited the ruins six years later. "There are, at the present time," he added, "scarcely two hundred houses left."[17]

While the Mongols ground Kiev's greatest buildings into rubble, the devastation they wrought across the lands of Rus caused other treasures to disappear. *The Song of Igor's Campaign* slipped from sight only to be discovered five and a half centuries later by scholars who thought it a modern forgery because so much about Kiev's artistic achievements had been forgotten. Its roof having collapsed beneath the weight of the terrified women and children who had taken refuge upon it (according to some accounts), the Church of the Virgin of the Tithe never rose again, while the Cathedral of St. Sofiia remained empty until it was restored in the style of the Ukrainian Baroque at the end of the seventeenth century.[18] Yet, even as its monuments crumbled and its treasures slipped from sight, Kiev's heritage found new life in the forest kingdoms that ruled the lands to its north and east, where trade and treasure had transformed into thriving centers of commerce and art regions once thought to be no more than frontier outposts.

Even before the Mongols stormed Kiev, the centers of power in the lands of Rus had shifted to cities in the northern wilderness. First and foremost among these new centers of wealth and art stood Novgorod, the "new town" to which Varangian warrior traders had come in 860, almost a quarter of a century before they had settled in Kiev. By the time Kiev fell in 1240, Novgorod had grown from a small trading hub that had exchanged amber, salt, and furs for the goods of the South and East into an empire with commercial links that stretched from Byzan-

tium and Cathay to Bremen and Cologne, and its population numbered more than thirty thousand. Anxious to assure their place in the world to come by building churches in the here and now, its wealthy merchants brought into being some of the most brilliant art that medieval Russia had ever seen by turning to native artists when the numbers of painters and builders from Byzantium had proved to be too small to meet their needs. As men conditioned by success to be impatient called for art on a comparatively vast scale, artists flocked to seek their fortunes in Novgorod from all across Rus. Nowhere else in Rus were churches and art produced in such quantities as in thirteenth-century Novgorod.

Governed by men who were prosperous, individualistic, and free, Novgorod flourished under a democratic form of government that stood as a rare exception to the tyranny that thrived all across Europe and Asia, but it was not the only new center of politics and culture to arise from the ruins of Kievan Rus. By threatening to cut the flow of goods and grain upon which Novgorod's prosperity depended, the northeastern princes of Suzdalia, through whose lands the river trade routes between the Middle East and Europe passed on their way to the West, sometimes coerced the *veche,* or popular assembly, of Russia's famed "commercial republic" to elect them as its rulers until invasions by more powerful enemies in the thirteenth century made them less arrogant and more willing to work with their neighbors. Then, Novgorod's merchants and Suzdalia's princes made common cause against those Swedes and Teutonic Knights who invaded their lands from the West, while they agreed to pay tribute to the Mongols in the East. So long as their leaders could hold their European foes at bay and kept peace with the Mongols, the prosperity of both regions enabled the artists of Russia's northern wilderness to transform the Byzantine cultural heritage of Kiev into an artistic experience that could be called truly Russian for the first time.

Like its namesake in Kiev, Novgorod's Cathedral of St. Sofiia owed its beginnings to Iaroslav the Wise, the Grand Prince who dedicated both cathedrals to the sacred mystery of Divine Wisdom. Built to tie the people of Rus more closely to their new faith in Constantinople, these became the best-known creations of their cities' first master builders, and each helped to shape the history of the people who worshiped within its walls. Topped by the five domes that would become traditional in Russia instead of the thirteen that rose above its counterpart in Kiev, Novgorod's St. Sofiia had none of the elaborate mosaics of the South, but boasted exquisite frescoes and bronze castings that integrated the art of Byzantium and Germany. Artists brought directly from Constantinople adorned the cathedral's walls with full-length frescoes of the Byzantine Emperor Constantine and his mother, and they painted the awe-inspiring image of Christ the All-Ruler that dominated its central dome. From Germany came the exquisite bronze doors of the cathedral's west portal, which had been cast in the famed medieval town of Magdeburg for the Varangian fortress of Sigtuna, where they had hung until a victorious Novgorodian army had borne them home in triumph

in 1117.[19] As symbols of the city's economic ties to East and West, neither the frescoes nor the doors had any equal in Kiev. Nor, after the beginning of the thirteenth century, could Kiev maintain the trade that made such artwork possible.

As they built more churches, the Novgorodians found that narrower windows, lower doors, and more steeply pitched roofs topped by single onion-shaped domes met the needs of their northern climate better than the flattened roofs that had shaped church architecture in the warmer, more open lands of the South. At the same time, shortages of brick and quarried stone spurred them to discover that walls built of odd-sized stones set into mortar that had been reinforced by brick could be raised more quickly and cheaply than could solid brick structures glazed with stucco. Urged on by merchant princes, whom success had taught to be impatient, Novgorod's native builders used these new techniques to build churches at a rate unknown in the South.[20] Between the twelfth and fifteenth centuries, more than a score of large churches and cathedrals rose in the city's commercial district, each and every one of which would stand as a brilliant monument to the artistic experience of medieval Rus until Hitler's armies destroyed them during World War II. Clustered around them, and requiring the services of architects and artists on a scale not seen in other parts of Rus, the onion domes of dozens of smaller churches built by individual merchants sprouted in profusion. Then, just outside the city but within plain sight of it, the churches of the Iurev Monastery completed the vision of Novgorod as a city that rivaled Kiev as a place where merchants and princes could afford to lavish fortunes in glorifying God.

Although they built more than one new church of mortar, stones, and brick every year in the twelfth century and even more in the century after that, Novgorod's builders often worked more imaginatively with the wood that their ancestors had used to build their homes, boats, and streets since the beginning of time. Long before such characteristically Russian monuments as the cathedrals of St. Dmitrii and St. Basil took shape in Vladimir and Moscow, straight fir logs notched, planed, stacked, and pegged in the northern manner created the first uniquely Russian architecture in the wooden churches of Novgorod. Shaped mainly by the axes with which, as Tolstoi once said, Russia's peasants could "build a house or shape a spoon,"[21] deftly cut shingles and decorations added lightness and complexity to otherwise simple buildings, while ornately shaped spires, onion domes, and interiors showed the full extent to which the woodworker's art could be used to glorify God in the northern forests. In no other place did the enchantment of wooden architecture surpass that found in Novgorod and its colonies in the Far North. Yet, in the lands that lined parts of the great Volga River trade route on which the prosperity of Novgorod's merchants depended, other visions and other resources were destined to play a part in helping Russia's builders to challenge the brilliance of the Byzantines.

Some four hundred miles to Novgorod's east in what has been called the "coldest and most remote frontier region of Byzantine-Slavic civilization,"[22] Suzdalia was part of wilderness Russia too, for the settlers who cleared the forests

that lined the Kliazma, Oka, and Volga rivers in the eleventh century built homes, churches, and fortifications of wood in the same manner as the Novgorodians. But, in contrast to the rough stones dug from fields and riverbanks that Novgorod's builders supplemented with mortar and brick, an abundance of white limestone made it possible for the builders of Suzdalia to create churches that shone like gems against the blue of the northern sky. Beginning about a hundred years before Kiev fell to the Mongols, three princes whose wealth and vision matched their love of the arts set out to transform their realm from a region of farmers and traders into a land of fine art and treasures. In the space of half a century, they created an architectural legacy that gave real meaning to the term "Russian."

As Suzdalia's first independent prince, Iurii Dolgorukii (whose name meant Iurii of the Long Arm in Russian) made Suzdal the chief city of his realm even as he reached out for new lands to rule. His founding of Moscow in 1147 marked the extent of his reach toward the Southwest, while the brilliantly executed churches that took shape in his capital showed that his kingdom could no longer be dismissed as a crude outpost on the northeastern frontier. As Prince Iurii's builders designed an entirely new style of church, with a single drum and an elongated onion dome rising high above it, they declared their independence from their mentors in Kiev and set the architectural styles of Russia apart from their Byzantine predecessors for all time to come. Sometimes left to stand as white stone gems, at others painted inside and out, the churches of Suzdalia became the models from which the builders of Moscow shaped the Kremlin cathedrals that formed the heart of the Russian faith, while their royal masters forged the lands to their northwest, northeast, and southeast into a Russian nation.

The citadel palace and cathedral that Prince Iurii's eldest son Andrei built at Bogoliubovo in the 1150s and 1160s won acclaim for the architects of Russia's Northeast as builders of the first magnitude. Joined by white stone walls and galleries in its center, Bogoliubskii's royal residence stood in striking contrast to those palaces that his rivals had built of wood in other parts of Rus, while the Cathedral of the Nativity of the Virgin, which took shape nearby, was "all of gold" (in the words of the ancient chronicles) and "adorned with precious icons, gold and valuable stones, with a priceless pearl of great size."[23] Then, across the river that flowed nearly, Prince Andrei's builders created the Church of the Protection and Intercession of the Virgin, which stands to this day as one of the most stunning monuments to the glory of medieval Rus.[24] Seemingly carved from a single square block of sparkling white stone and topped by a flattened green dome, this small architectural jewel survived for three-quarters of a millennium without shedding any of its medieval vibrance. Even the disdain of Russia's Soviet rulers so entirely failed to mar its beauty that it still stands as the classic monument to the harmony of shape and form that medieval builders created in the Russian Northeast.

After drunken assassins killed Prince Andrei in the summer of 1174, his half-brother Vsevolod returned from exile in Constantinople to take up the work he

had left unfinished. Like the sovereign he replaced, Vsevolod III understood that great cathedrals and palaces enhanced a prince's authority in ways no other undertaking could match, but he had a more dramatic sense of how Russian and Byzantine influences could be blended in the lands he ruled. While the builders of Kiev and Novgorod had used very little sculpture because of the rigid manner in which the Russians interpreted the Church's prohibition against graven images, Vsevolod drew upon the rich array of three-dimensional art he had seen in Byzantium as he planned the Cathedral of St. Dmitrii that would take shape in the mid-1190s. For the first time in the history of Rus, Vsevolod's cathedral would display images of saints and angels "in the round," even as the artists who painted its frescoes and icons worked to strip all traces of the third dimension from their painting.

Although Vsevolod dreamed of building a cathedral that would one day stand as the finest in all of Rus, he first set his builders to work on restoring the Dormition Cathedral that his half-brother had set in the center of his capital city of Vladimir a quarter of a century before. Built on a high bluff in the late 1150s, Prince Andrei's Dormition Cathedral had dwarfed the creations of his father and had shown how close the contacts between northeast Russia and the West had become. Yet, if its massive dome had risen as a symbol of its builder's power on earth, the huge fire that consumed the Dormition in 1185 showed the impotence of all earthly forces against the power of nature. As if to counteract the image of its frailty in the face of the powers no man could restrain, Vsevolod's builders expanded its fire-damaged walls into medieval Russia's largest cathedral and then added four new cupolas to the massive dome that had towered above its center in earlier times. In years to come, the greatest of Russia's icon painters, Andrei Rublev, would set some of his best work into its iconostasis and would add a brilliant fresco of the Last Judgment, which covered its entire west wall. By the time of the Mongol invasion, the rebuilt Dormition had surpassed the cathedrals of St. Sofiia in Novgorod and Kiev as the greatest house of God in Rus. When Russia's Grand Prince Ivan III sought to transform Moscow into an imperial city after Constantinople had fallen to the Turks some two hundred years later, the Dormition became the model upon which his Italian architects based their work. In that way, Vladimir's rebuilt Dormition provided the inspiration for the Kremlin's greatest cathedral, in which every Russian tsar and emperor would be crowned until the Bolshevik Revolution.

Even more impressive than the restoration of the Dormition, the Cathedral of St. Dmitrii that Vsevolod built as his own tribute to the glory of God became the greatest monument to the artistry of Suzdalia's builders. Reliefs of King David enthroned, seated apostles, and standing saints vied for attention on its walls with portrayals of the baptism of Christ and the sacrifice of Isaac. A curious ensemble that resembled the Adoration of the Magi proved to be a stone representation of Vsevolod holding his son Dmitrii in his arms,[25] but no amount of such work could express the full authority wielded by this prince, who, the author of

*The Song of Igor's Campaign* proclaimed, had the power to "scatter in drops the Volga" and "scoop dry the [River] Don." Unlike so many of his predecessors, Vsevolod was a truly Russian prince, and his cathedral—along with his half-brother's church at Bogoliubovo—signaled the final Russification of those fading architectural memories that had drifted into the Northeast from Kiev. Less than a quarter of a millennium after their conversion to Christianity, Russia's builders had created a style of church architecture that equaled the best to be found anywhere in Eastern Christendom. Having been among the last of Europe's pagans to accept Christianity, the people of Russia's Northeast had all but closed the gap that their late entrance into the world of Christian art had created.

Local artisans built the churches that transformed twelfth- and thirteenth-century Suzdalia and Novgorod into new centers of religious and artistic experience, but the merchants and princes who became their patrons preferred to have foreigners paint the icons and frescoes that adorned their interiors until the Mongol invasion of 1237–1240 split Byzantium and Rus apart. Then, as the foreign masters fled to escape Batu Khan's advance, the painters of Russia's North replaced the subtle shadings of the Byzantines with their own vibrant reds, greens, whites, and blacks to create an intense new artistic style. Such artists replaced curves with straight lines and rendered highlights with sharply drawn streaks that removed all hint of a third dimension. By the end of the thirteenth century, the native artists of Russia's Northeast and Northwest had developed a style that had become so characteristically Russian that no one could doubt its independence.[26]

In hundreds of faces that stared past Russian believers from the iconostases of the great and small churches of Novgorod and Suzdalia, forms flattened out and eyes lost their expression as Russia's masters replaced the three-dimensional paintings of their Byzantine mentors with images that lacked any sense of depth. No longer part of the world as the human mind could know it, the images of Russia's saints now looked beyond the circumstances of earthly life to the world of the spirit, which pious men and women aspired to enter by means of prayer and devotion. Absorbed by their own inner visions, the figures portrayed in icons of thirteenth-century Rus all shared that quality in common as if seeking to remind the men and women who prayed before them that the true meaning of life lay beyond the grave.

Less than a century and a half after Russia's artists first created their own independent style of painting, Feofan Grek, a Russified Greek, who was deeply steeped in the spirit of the "Paleologos Renaissance" that was breathing new life into art all across the Orthodox Christian East, restored a hint of a third dimension in the heads of his figures even as he continued the Russian practice of reducing their bodies to flat, two-dimensional forms. First in Novgorod and then in Moscow, Feofan boldly proclaimed that an artist must work beyond stereotypes and give free rein to his own passions and inspiration.[27] As fragile monuments to the new wave of Byzantine artistic influence that flooded into Russia in

the fourteenth century, his frescoes and icons marked the beginning of a new era in Russian painting. Andrei Rublev drew his early inspiration from the work of Feofan Grek. So did every other painter of icons who followed him.

We know very little about Feofan Grek (or Theophanes the Greek, as he was known outside of Russia) before he appeared in Novgorod in the 1370s, and most of the information we have about the years he spent in Russia comes from a single letter that the monk Epifanii the Wise wrote to one of his disciples. An artist who was said to have painted the interiors of more than a dozen churches in Constantinople, Feofan set to work in 1378 on the frescoes of Novgorod's Church of the Transfiguration, where he colored the wet plaster with bold, sweeping brush strokes that produced overpowering, elongated images. Working mainly with browns and reds, he used white highlights to impose serenity upon his angels and to impart a disquieting ascetic character to the patriarchs and Biblical characters who looked down from his majestic paintings. By placing his characteristic bold white lines around the eyes rather than on the cheeks, neck, and forehead, he gave his rendering of Christ a haunting otherworldly image that to this day challenges the warm and human Christ whom the theologians of Western Christianity had created. Like the anchoritic monks of the Orthodox East, Feofan's Christ stood above and outside the world that swirled below him.[28] His stark asceticism forced the men and women of Russia's North to look into themselves and confront the realization that divine punishment awaited them just as surely as did God's grace and forgiveness.

The powerful emotions that flowed from Feofan's paintings reflected the turbulent events that shaped Russia's artistic experience during the late fourteenth and fifteenth centuries. Time had weakened the stern authority with which Chingis Khan and his sons had built the world's largest contiguous empire, and the state that their Tatar descendants had established to collect tribute in the southeastern lands of European Russia was beginning to come apart. When the moment came for the Russians to challenge their Tatar overlords, the Grand Prince of Moscow, whose ancestors had once been the least of Russia's rulers, led them to victory. Then, as Moscow's princes proceeded to weld the lands and people of Russia into a unified state, their power to shape the arts increased. By the sixteenth century, they would become the greatest patrons of the arts anywhere in the Russian land.

In the lands along Europe's eastern frontier, Moscow's rise to become the capital of Russia stood out as the most striking political event of the fourteenth and fifteenth centuries. At first supported by the Tatars (to whom they remained scrupulously subservient) and backed by the Russian Church, whose Metropolitan settled in their city in 1328, Moscow's princes used force to gather wealth and territory only when deceit and diplomacy failed. As one of the most fervent Muscovite patriots ever to head the Russian Church, the Metropolitan Aleksei threatened to excommunicate anyone who opposed Moscow's advance, and he then urged its Grand Prince Dmitrii to test his strength against the Tatars. At the battle of Kulikovo Field, fought on the banks of the Don River on the feast day

of the Nativity of the Virgin, September 8, 1380, Dmitrii led the ar
than a dozen still-feuding Russian princes to a historic victory. The ..
their new champion the name of Dmitrii Donskoi, that is, "Dmitrii of the ..
and chroniclers called him the "king of kings," "lord of sovereigns," and likened
him to the sun and a shining star. Some described him as "an earthly angel or a
heavenly man." A "slave of God," he became godlike among men and a saint
who, the chronicles said, was truly the "first Russian Tsar."[29]

Although another century would pass before the Russians threw off the Tatar
yoke entirely, Dmitrii's victory opened a new era in Russia's history. Military tales
and poems written to celebrate the triumph at Kulikovo Field marked a new
stage in Russia's artistic experience, for they focused on a *national* victory, not a
regional princely triumph.[30] Written by a priest from Riazan who had ridden
with the armies of Moscow even though his own prince had fought on the side of
the Tatars, the prose poem *Zadonshchina* stands out among these writings as evi-
dence of Russia's quest for the identity that would transform her from a confed-
eration of feuding princes into a new and powerful nation. In language similar to
*The Song of Igor's Campaign*, the patriotic poet priest told his readers how Prince
Dmitrii, with "courage and zeal for the land of Rus and for the Christian faith,"[31]
had summoned a mighty host to fight the infidels. Confident of divine protec-
tion, Dmitrii had led his soldiers south, where they proved "eager to sacrifice
their lives for the Christian faith" against the foe who had ravaged their land for
almost 150 years. "Russians," he proclaimed, were bound to "seek honor and
glory" against their foes.[32] By giving their lives in God's service to shatter the
armies of the Tatar Khan Mamai at Kulikovo, the first soldiers to fight for Russia
had the chance to win eternal salvation.

*Zadonshchina* followed the form of *The Song of Igor's Campaign* so closely that
a number of modern critics have dismissed it as a bad copy or, in Nabokov's even
harsher words, "a preposterous mixture of inchoate bombast."[33] Yet, whatever
its limits as a work of art, the poem celebrated a turn of events that changed the
course of Russia's political and artistic history. During the battle fought on Ku-
likovo Field, where the corpses of Russians (in the words of the poet) covered
the land "even as a field is covered with haystacks," more than five hundred great
lords gave up their lives "for the holy Church, for the Russian land, and for the
Christian faith" to free their people from the Tatars' grip. No longer would Rus-
sians bow to foreign masters. "The sons of Russia pillaged the Tatars of cloths
and silks, weapons and horses, oxen and camels, wines and sugars, jewelry and
velvets," the author of *Zadonshchina* wrote with pride. "Russian glory was ex-
alted and shame was brought upon the Tatars."[34]

Written sometime between the 1380s and the 1450s, *Zadonshchina* celebrated
the first efforts of Moscow's princes to forge the lands of Old Rus into a nation.
Yet, before their task could be finished, the political allegiance of the people of
Russia had to be won and the emotional ties that bound them to their native re-
gions shifted to Moscow. Beginning with the Madonna of Vladimir, which
Grand Prince Vasilii I installed in Moscow's newly built Dormition Cathedral in

1395, grand princes and metropolitans began to bring to the Kremlin those art treasures around which regional loyalties had grown up at the same time as the city's builders and artists began to blend the styles of Kiev, Novgorod, and Suzdalia to create truly Russian forms of art and architecture. The brilliant colors and stark two-dimensional images of Novgorod, the more muted shades of Kiev, and the brilliant white stone churches of Suzdalia all came together in Moscow to give a stronger national focus to Russia's artistic experience at the same time as they strengthened Moscow's political base.[35] Cathedrals, monasteries, palaces, chronicles, and the strongest citadel (or kremlin) to be found anywhere in Russia proclaimed Moscow's new importance. Well before the end of the fifteenth century, Moscow had become what Kiev had never been: a *national* capital and the sacred home of a *Russian* Church.

From this city of a thousand churches, the Tsar would reign over "Holy Russia" in the years that lay ahead. Only in holy Moscow, devout Russians believed, did Christ still walk in spirit, and only within Holy Russia's boundaries could men and women be sure of saving their eternal souls. Convinced that their land remained the last bastion of true Christianity on earth, fifteenth-century Russians believed that the future of the entire world hinged upon their ability to preserve its purity, and the arts of Moscow reflected their firm dedication to that compelling mission. Towering over its former rivals, Moscow the Third Rome would reign supreme at Holy Russia's center. Because all earthly power flowed from it even as the promise of salvation shone above it, everyone and everything in Russia gravitated toward it. From the fifteenth through the seventeenth centuries, Moscow stood at the very center of the artistic experience of the nation it ruled. Combining the best they could borrow from Asia and Europe with their own national vision, Moscow's artists and writers transformed the heritages of Byzantium, Kiev, Novgorod, and Suzdalia into forms of art that were uniquely and compellingly Russian.

1054 - pope + patriarch split
Great Schism
1st Rome falls into heresy

1453 - Turks captured
Constantinople
2nd rome is conquered

*CHAPTER III*

Moscow →
3rd rome

# HOLY
# MOSCOW

Roman
Christian

Russian

Ottoman
(conquered parts)

THE CITY OF A THOUSAND ONION DOMES from which Russia's tsars one day would rule a sixth of the world, Moscow entered history's pages as a cramped log outpost on Suzdalia's southwestern frontier. With barely enough room within its walls for a man to walk a hundred paces in any direction, the town grew slowly, and it still ranked as one of Russia's least important provincial centers when the armies of Batu Khan burst through its gates in January 1238. For more than a century after its founding in 1147, Moscow remained so insignificant that no one cared to rule it. Then, perhaps sensing that its proximity to the far-flung river trade routes of European Russia would one day make it great, Russia's famed hero-saint Aleksandr Nevskii bequeathed it to his youngest son in 1263. From Moscow's tiny log kremlin, Prince Daniil Aleksandrovich began to rule a realm that covered less than six hundred square miles. The centers of power, piety, and wealth that were bringing some of Old Russia's greatest art into being stood hundreds of miles to its northwest and northeast. Nothing in the backwoods hamlets over which Prince Daniil reigned gave any indication that Moscow would one day become the holy city of Holy Russia.

Moscow's rise began at the end of the 1320s, when the Metropolitan of All Russia moved there from Vladimir and Prince Daniil's son Ivan I became a tribute collector for the Tatars. Known as Ivan Kalita (the moneybags) because he parted so reluctantly with the treasure he collected, Prince Ivan doubled the area within the Kremlin's walls, replaced its rough palisades with stout oak logs, and extended his authority deeper into the lands of Russia's Northeast. Backed by the Metropolitan, who used the power of the Russian Church to support their

political aims, Ivan and his immediate successors made the outlying territories of Novgorod one of their particular concerns at the same time as they made inroads into the lands of Riazan to the south. Yet, until well after Ivan's grandson Dmitrii Donskoi defeated the Tatars at Kulikovo, Moscow remained only one of several principalities that vied for power in the lands between Novgorod and Suzdalia. Compared to its humble beginnings, it had grown stronger by the time Dmitrii challenged the Tatars. It had yet to be seen how quickly its princes would overcome their rivals in the century that lay ahead.

To celebrate his victory over Russia's one-time masters, Dmitrii Donskoi replaced Moscow's oaken fortifications with walls of stone and brick, only to have them destroyed by an army of avenging Tatars less than two years later. Yet the Tatars' short-lived triumph did not alter the course of Russia's history or slow Moscow's progress. Gathering the Russian lands at a quicker pace, Dmitrii's successors lifted the Tatar yoke and exacted an oath of allegiance from every prince in the Russian land, making Moscow the center from which all authority flowed in Russia. By the time Grand Prince Vasilii III ascended the throne in 1505, Novgorod's rich merchants had bowed to Moscow's power and so had the haughty princes of Tver, Rostov, Iaroslavl, and Chernigov. Now the sovereign of lands that stretched from the Lithuanian frontier to the edge of Siberia, and from the White Sea's frozen coast to the Tatar khanates on the Volga, Vasilii reigned not as Grand Prince of Moscow, but as Grand Prince of All Russia. Combining the political heritages of the Mongols and the Byzantines into a form of autocracy that permitted no challenges, he wielded power in ways that his predecessors in Kiev, Novgorod, and Suzdalia had never dreamed of doing. Not only did the stern political authority of Russia's new Grand Prince require absolute obedience from every lord and peasant who owed him allegiance, but he and his successors began to insist that the arts must make it clear that, as sovereigns whose power raised them high above the people they ruled, they bowed only to God. From the time that Vasilii's son Ivan the Terrible established the first of the Kremlin's famed workshops in the 1550s, Russia's rulers would insist upon having a say about what their nation's artists created and what principles guided their work.

Yet, if the power of Moscow's sovereigns to shape politics, life, and art was becoming unlimited as the fifteenth century drew to a close, the wealth they could devote to those purposes was not. Russia still suffered from the shortages of gold and silver that had plagued the West in the Middle Ages, and it had yet to develop the instruments of international commerce with which the bankers of South Germany and Northern Italy moved fortunes across the boundaries of Europe. Nor could Moscow's rulers and merchants engage in trade on the scale that had become common by that time in the West. As the Hanseatic League, whose ships had carried so much of Europe's trade through the Baltic in the days of Novgorod's greatness fell into decline, the commerce of the West moved south to flow once again through the Mediterranean, as it had in Roman times. And, just as the Crusades' reopening of the Mediterranean trade routes had relegated Kiev to the edge of European affairs in the twelfth and thirteenth centuries, so the ris-

ing maritime power of England and Holland combined with the financial strength of the Italian and South German bankers two hundred years later to keep the instruments of Europe's new wealth beyond the reach of Moscow's grand princes.

If the grand princes of Moscow could not rival the wealth and patronage of the sovereigns who reigned in Florence, Paris, Vienna, and Amsterdam, neither could the metropolitans of early modern Russia compete as patrons of the arts with the Pope and the princes of the Catholic Church. In terms of their size, even the greatest cathedrals of Muscovite Russia suffered by comparison to St. Peter's and the Duomos of Florence and Milan, and no Russian metropolitan or patriarch ever endowed a work of art that equaled the ceiling that Michelangelo painted in the Sistine Chapel.

At the beginning of the fifteenth century, Andrei Rublev's icons stood on a par with the paintings of his Italian contemporary Fra Angelico, but the declining talents of his successors and the deepening conservatism of the Church meant that nothing in Russia ever rivaled the later creations of Leonardo da Vinci, Michelangelo, or the scores of artists who embellished the churches of Europe with life-like images during the Renaissance. Although indisputably the greatest paintings produced in fifteenth-century Russia, Rublev's brilliant icons seem medieval and painfully limited in their vision when compared to "The Last Supper" and the ceiling of the Sistine Chapel. Because the Church condemned all realistic representations of the human form, Russia's artists continued to distort the shape and perspective of the human form in order to avoid painting it in any way that seemed true to life. The third dimension therefore remained beyond their reach even as the fifteenth century drew to an end. Still viewed as windows through which pious men and women might glimpse the realm of the spirit, Russia's greatest paintings remained untouched by those forces of modernism that had already begun to transform art in the West.

While fifteenth- and sixteenth-century Russians dedicated their art to preserving the purity of their faith, their counterparts in the West began to inquire seriously into the mysteries of human anatomy and to transmit their discoveries to marble, canvas, and plaster. Europeans' resolute first steps toward the beginnings of the scientific revolution that would burst forth a hundred years later therefore heightened their sense of perspective and allowed them to portray the human form more accurately. The introduction of painting in oils (which would not reach Russia until the beginning of the eighteenth century) supplemented those achievements by making possible more complex shadings and textures. Leonardo's insistence that painting must reproduce "all the known works of nature," stood a world away from the Russians' belief that art must lift its viewers above and beyond the world of the flesh.[1] Even before the sixteenth century opened, Russia was falling behind the West in every area of human endeavor. In science, technology, the creation of new wealth, and the production of art, life in the West had unleashed new forces that would set Russia outside the mainstream of modern human experience for at least the next two hundred years.

Stirred by newfound wealth and newborn passions, the arts raced ahead in sixteenth-century Italy, France, Germany, and the Low Countries, while Moscow's princes and patriarchs slowed their development in Russia by demanding greater conformity and imposing more rigid control. New ways of thinking about science and philosophy, a more energetic vision of how men and women ought to live, and great new wealth—three factors that helped to bring the Renaissance into being in Europe—remained all but absent from early modern Russia. The country therefore turned further inward while the nations of the West were looking outward for new frontiers to conquer. As they struggled to keep their faith pure from all foreign contamination, Russia's churchmen insisted that every icon and fresco must conform to tradition's most rigid dictates, and the sovereigns of Moscow insisted that artists must project in their work the political principles they wanted their subjects to embrace. In the newly united Russian land, the arts thus became the victims of the Church's deepening obscurantism at the same time as they were obliged to serve as instruments of Moscow's rulers' efforts to strengthen their authority. Both cost artists in sixteenth-century Russia the freedom to test the limits of tradition and conformity at the very moment when their counterparts began to do so on a daring scale in Europe.

The key to Russia's turning inward at the very moment when the men and women of the West began to explore new philosophic and scientific frontiers lay in a powerful spiritual revival that swept across the crumbling Byzantine Empire and put down firm roots in the Holy Trinity Monastery, which St. Sergei of Radonezh had founded in the depths of Moscow's Sokolniki Forest during the second quarter of the fourteenth century. Seeking to attain through solitude, fasting, and prayer the "inner calm" that would lead him directly to God, St. Sergei had summoned his disciples to follow him into the wilderness, and his monastery became a refuge in which men of talent found the inner spiritual peace to rededicate their lives to God's greater glory. As the first to transfer the spiritual intensity of St. Sergei's teachings to the arts, Feofan Grek reflected the renewed striving for a deeper awareness of God's presence that many fourteenth-century fundamentalists shared, and his frescoes showed the impact that such newly awakened spiritual forces were to have on Russia's artistic experience. The ascetic portrayals of Christ and his saints in the frescoes Feofan painted in Novgorod expressed the passion with which St. Sergei's followers struggled to come nearer to God. At the same time, his restoration of the third dimension in the faces of his paintings helped to re-create a link between the world of the flesh and the realm of the spirit that would turn Russian painting onto a new and dramatic path.

When Feofan moved to Moscow at the end of the fourteenth century, the icons he painted for the Annunciation Cathedral brought the intensity of St. Sergei's revival into the very heart of the Kremlin.[2] Yet there was still too much Byzantine abstraction in Feofan's work, before it could become deeply and

and public buildings that owed a great deal to the example of the northe
Italians.

Although Moscow was in those days built largely of wood, Ivan III set out to
transform it into a capital that would reflect the grandeur of an eternal Christian
empire from which all the blessings of Orthodox purity flowed. Yet he soon dis-
covered that Russian architects could neither design nor construct the kinds of
buildings he required. When the new cathedral he had ordered for the Kremlin
collapsed partway through construction in 1474, he turned to Italy, where his
agents discovered Aristotele Fioravanti, an architect and builder who once had
served as the official engineer of Renaissance Bologna. Like many of the artists
who would follow him to Russia in the centuries ahead, Fioravanti had known
good times and bad in the West. He had left his native Bologna to work in Milan
and then had gone on to Budapest, where he had built bridges and fortifications
for Hungary's King Matthias Corvinus. He then had made his way to Rome,
where he had worked on excavating the Forum before being arrested on charges
of counterfeiting. A year or two later, Ivan III's offer of work in Moscow gave the
sixty-year-old Fioravanti his last chance for fame and fortune—provided that he
could complete the staggering task that awaited him. To succeed required all of
his genius as an architect and all of the engineering skill he had acquired during a
lifetime of work on cathedrals, public buildings, and fortifications.[9]

When Fioravanti arrived in Moscow late in the winter of 1475, the Grand
Prince ordered him to build the greatest cathedral Russia had ever seen. His
model was to be the Cathedral of the Dormition in Vladimir, but he was to build
a mightier successor that would reflect the glory of the city that had replaced
Constantinople and Rome in the minds of Orthodox men and women. Fiora-
vanti had first to clear away the rubble of his predecessors' efforts that lay piled
in the Kremlin's center, construct a more solid foundation to bear the weight of
the cathedral's walls and roof, and assemble the materials needed to build on a
scale hitherto unknown in Russia. So as to give his cathedral the effect of having
been cut from a single mass of shining white stone, he planned to work with mas-
sive limestone blocks in the same manner as the builders of Andrei Bogoliubskii
and Vsevolod III had done in the days before the Mongols had ravaged Russia.
To do so, he had to restore to Russia the techniques of solid-bond masonry that
had been known before the invasion of Batu Khan's hordes but forgotten during
the centuries that followed, at the same time as he had to create the sorts of con-
struction machinery that were well known in Europe but unknown in Russia.
The modern techniques and technologies that built the great Renaissance cathe-
drals of the West thus helped to create their counterpart in Russia, but while they
would be used to create scores of monuments to the glory of God in Italy,
France, and Germany, they would do little more in Russia than create the build-
ings of Moscow's Kremlin.

Once the rubble had been cleared, Fioravanti sank masses of huge oaken piles
into the ground to form a base for the deepest foundation walls that the Russians

had ever seen, and he built special kilns to make bricks of better quality than the Russians knew how to produce. As the limestone walls took shape, he strengthened them with iron tie rods in ways that the builders of Russia had not yet discovered, and therefore made them thinner than Russian practice dictated. Faithful to Ivan's wishes, he used the Dormition Cathedral of Vladimir as his model, but some of his innovations suggested a debt to the builders of Novgorod, whose work he first saw when he accompanied his grand princely employer on his triumphant campaigns in 1476 and 1477. The result of Fioravanti's borrowings was a cathedral more spacious and more soaring than any of the models upon which he drew. Without the traditional choir gallery to bar its path, natural light flooded the cathedral's interior to make the icons and frescoes that adorned its walls seem more vibrant than any others in Russia.[10]

Starting in 1476, Fioravanti completed in four years the cathedral in which Russia's tsars would be crowned until 1917. Before its altar, Ivan the Terrible proclaimed himself Russia's first tsar in 1547, and there, in 1613, the first Romanov accepted the crown that his descendants would wear for 304 tumultuous years. On the spot where Ivan had stood, Peter the Great would be crowned at the age of ten, and after him ten more emperors and empresses would take their vows before Nicholas and Aleksandra, the last of the Romanovs, swore to serve Russia and the Russians during the shining spring days of 1896. At the altar of Fioravanti's Dormition, metropolitans and patriarchs offered up prayers for Russia's safety and celebrated masses of thanksgiving. For them all, the Italian master had built a masterpiece that was light, spacious, and majestic. While he did so, his workshops in the Kremlin trained the young Russian builders who would expand sixteenth-century Moscow far beyond the Kremlin's walls and transform it from a medieval fortress town into a city that rivaled the leading urban centers of early modern central and eastern Europe.[11]

Five years after Fioravanti finished the Kremlin's Dormition, Ivan III put architects from Novgorod's recently conquered sister city of Pskov to work on rebuilding the dilapidated Annunciation Cathedral that stood just across the square to its south and west. Although the frescoes that Feofan Grek and Andrei Rublev had painted at the beginning of the century were destroyed when they razed the old cathedral's crumbling walls, the Pskov builders preserved the iconostasis that the two artists had painted and enlarged it into a partitioning wall. Beneath this glowing treasure, which included the famed icon of the "Madonna of the Don" that Dmitrii Donskoi had fastened to his black banner on the day he led the Russians to their first triumph against the Mongol armies, Russia's tsars and tsarinas were christened and wed for the next four hundred years. Here in this more intimate setting that Fioravanti's Russian rivals had created, Ivan the Terrible confessed his weaknesses to God before going forth to impose a reign of terror upon his people. Peter the Great, the empresses Elizabeth and Catherine the Great, and the Emperor Alexander the Blessed all bowed to the power of God, Christ, and the Holy Spirit during their visits to Moscow, and so did every other sovereign who ruled Russia between 1485 and 1917.[12]

In rebuilding the Kremlin, Fioravanti and the builders from Pskov did not work alone. A full two years before the Pskov builders finished their work, Ivan III invited the Italian architects Pietro Antonio Solari and Marco "Friazin" (that is, "the Italian") to build a royal audience chamber. Perhaps the most talented of all the Italians whom the grand prince brought to Moscow, Solari came in search of adventure at the age of thirty-four, despite the brilliant future that the favor of the Duke of Milan had assured him in his native land. Four years later, in 1493, Solari was dead, but his brief stay in Moscow had produced some of the most striking parts of the Kremlin's architectural ensemble, which to this day remains among the most dazzling in the Orthodox world.[13]

Solari and Marco "Friazin" built their famed Rusticated Palace along the western edge of the Kremlin's central square at right angles to Fioravanti's Dormition and gave it a faceted façade of white stone that deepened the sense of mass and majesty that surrounded it. Supported by a single central pillar, the vaulted ceiling of its second-floor audience chamber reminded foreign dignitaries that the world they had entered was neither European nor Oriental, and that the rules of each must be modified to suit the tastes of the sovereign into whose presence they had come. Here Russia's first tsars presided on occasions of state, raising their hands for foreign ambassadors to kiss and then washing away the contamination in the gold basin that always stood to their right.[14] In a manner that left the Jesuit diplomat Antonio Possevino feeling as if he had come into the presence of a true pontiff-king or, perhaps, "a god in a temple,"[15] Ivan the Terrible sometimes performed this ceremony while seated on the ivory throne that his grandmother Sofiia Paleologa had brought to Moscow from Byzantium.

A hundred years later, Tsar Aleksei Mikhailovich greeted dignitaries in the same chamber from a throne set with 876 diamonds and 1,223 other precious stones, and the ten-year-old Tsar Peter the Great spoke to foreign diplomats from an even larger throne that included a hidden chamber from which his half-sister, the Regent Sofiia, told him and his half-witted half-brother what to say and when to say it. Some of Russia's greatest triumphs would be celebrated beneath the chamber's great stone arches, and so would its tragedies. In 1709, Peter the Great toasted Russia's first victory over an army of modern Europe beneath its vaulted ceiling. A hundred years later, Napoleon strode across its carpeted stone floors as master of Moscow's Kremlin.[16]

To create a proper backdrop for the Kremlin's churches, the fortifications that fifteenth-century Moscow required for protection against the modern armies of Sweden, Poland, Lithuania, and Turkey demanded both art and science. Using the castles and fortresses of northern Italy as their models, Solari and Marco "Friazin" reshaped the Kremlin walls during the 1490s to produce an impression of impregnability tempered by imperial grandeur. Laid out roughly in the shape of a triangle that covered the seventy-acre crest of Borovitskii Hill, the brick walls rose to a height of sixty-five feet, their twenty-foot thickness being reinforced along the mile and a quarter of their length by twenty towers and gates. Built to withstand the modern artillery of Europe's new scientific age, the

Kremlin's defenses resembled the ramparts of the Ponte Scaligeri in Verona and projected a similar impression of lightness despite their thickness and height. Together with the cathedrals that rose above them, they created an unforgettable panorama. Within these walls, tsar and people joined with Church and State to create Holy Russia in all its majesty.

To add variety to the architectural ensemble that the Kremlin's walls enclosed, Ivan's builders designed their towers and gates in different styles. At one corner stood the Beklemishev Tower, tall, imposing, and round. Farther on, the Arsenal Tower rose higher still, and on the third corner the Vodozvodnaia (so named because of the machine that a sixteenth-century Englishman installed in it to pump water for the Kremlin gardens) stood closest to the intersection of the Moscow and Neglinnaia rivers. "By the grace of God, Grand Prince of Vladimir, Moscow, Novgorod, Tver, Pskov, Viatka, Ugorsk, and Perm, Lord of the Bulgars and others, and Sovereign of All Russia," the proud Latin and Slavonic inscription upon one of them read, "Ivan Vasilievich ordered this tower to be built in the thirtieth year of his reign by Pietro Antonio Solari."[17] No one could doubt the greatness of the power that had raised such fortifications, for Russia's unique blend of ecclesiastical and imperial authority was nowhere more dramatically expressed than in the Kremlin's defenses and the churches they enclosed. Five hundred years later, visitors still marvel at the sight. "There is nothing above Moscow except the Kremlin," an old Russian folk saying explained, "and nothing above the Kremlin except Heaven."

Not long before he died in 1505, Ivan III turned his attention to the Cathedral of St. Michael the Archangel, the third of the Kremlin's great churches. Still unable to find Russians who could work in the imperial style he demanded, he employed the Venetian architect Alevisio Novi to build the cathedral that would become the burial place of Russia's sovereigns until Peter the Great moved the capital to St. Petersburg in 1703. Ornate portals, bold horizontal cornices placed beneath scallop shells, Venetian windows, rosettes, and garlands gave Alevisio's cathedral more the look of a two-story palace of Renaissance Italy than an imperial necropolis. Perhaps ahead of its time in that sense, St. Michael's became a reference point from which later architects worked their way across Russia, scattering the scallop shells and rosettes of the Italian High Renaissance wherever they went.[18]

Around 1510, one of the Italians who had come with Alevisio to Russia built the first three stories of the huge bell tower that would one day soar above the Kremlin. A quarter-century later, Ivan the Terrible's builders added what the Russians call a *zvonnitsa*—a many-tiered structure with great arched openings for hanging bells—just a few feet to the north, but it was not until 1600 that Tsar Boris Godunov's architects raised the original bell tower to a height of 265 feet to make it the tallest structure in Russia. Called the Bell Tower of Ivan the Great, the name given to Ivan III in recognition of his many triumphs, its white shaft split the Moscow sky to stand as a beacon for the Orthodox city of God that spread out around its feet. Sunlight glancing off its gold-capped dome was the

first sight seen by friends and foes as they approached the city, at the same time as its commanding height gave the sentries of Moscow advanced warning of their approach. Lookouts standing at the top of its 236 steps were the first to see the advancing armies of Poland that occupied the city in 1611, just as their descendants saw the vanguard of Napoleon's fearsome Grand Army assemble on Sparrow Hills overlooking the city 201 years later.

Far more than in the West, the resonant tones of bells played a part in shaping the artistic experience of medieval and early modern Russians, for the Church prohibited all music except for that created by the human voice and the ringing of bells. From the earliest days of Christian Kiev until revolution swept the Romanovs from their throne in 1917, Russians saw bells as a means to enrich those visual splendors that had first drawn Grand Prince Vladimir's envoys to the beauties of Byzantine Orthodoxy, and they used them to embroider in resonant and sonorous tones upon the spirituality that radiated from a liturgy that pointed the way directly to God. Bells were "a means of bringing the word of God into the presence of men," and their ringing seemed to some "like the rejoicing of the Gospel, radiating out of all the corners of the universe." Like the icons in their iconostases, they allowed the faithful to see—if only briefly and imperfectly—the transfigured world that lay above and beyond the realm of everyday human experience.[19]

In early times, Novgorod had led the way in learning the science of casting bells, and it was there that the *zvonnitsa* that so obviously paralled the iconostasis in its hierarchically arranged tiers had taken shape in the Middle Ages.[20] Bells proclaimed Novgorod's freedom each time they summoned its citizens to meetings of its popular *veche* assembly, and it was, therefore, Ivan III's first thought after his armies subdued the city in 1478 to have its *veche* bell taken away to Moscow. With the victorious grand prince declaring that "the veche bell in my patrimony, in Novgorod, shall not be,"[21] the city's days of freedom ended, even though its church bells continued to ring.

Yet bells were a part of life in Moscow, too, and the culture of the bells flourished in Russia's holy city long after Novgorod had fallen. In the days of Ivan the Terrible, Moscow had more than five thousand bells in its churches, and by the time the artisans of Boris Godunov finished the Bell Tower of Ivan the Great, the rich ringing of bells in changes drowned out conversation on church feast days. "Nothing affected me so much as the united clang of all the bells on the eves of Sundays and great festivals," the Archdeacon Paul of Aleppo wrote of his visit to Moscow in 1655. "The earth shook with their vibrations," he continued. "Like thunder, the drone of their voices went up to the skies."[22] In more recent times, one churchman thought Moscow's bells capable of "lifting one's thoughts to the angelic trumpets of the last day"[23] as they rang through the many-shaded harmonies that drew their hearers closer to God.

Always fixed rigidly in place and rung by a heavy clapper being struck against them, Russian bells eventually overshadowed their Western counterparts in size and tone. The largest bell cast in sixteenth-century Moscow exceeded 36 tons,

but it was dwarfed some 60 years later by a 180-ton giant cast for Tsar Aleksei Mikhailovich in the middle of the seventeenth century. Finally, in a dramatic effort to draw attention to Russia's recently won place among the Great Powers of Europe, the Empress Anna in the 1730s ordered one of Moscow's master bell makers to cast the largest bell in the world. Cracked by a fire before it could be hung, the Tsar Bell weighed 216 tons, stood just over 19 feet high, measured 66 feet in circumference, and in places was 2 feet thick.[24] Like the huge, never-fired Tsar Cannon that now stands near it in the Kremlin, the Tsar Bell never sounded.

Along with the imperial Christian vision of which Moscow's new Kremlin and its great bell and cannon eventually became a part, Russia's Church and sovereign accepted the obligation to keep the Orthodox faith pure. This added a powerful religious dimension to the Tsar's greater mission at the same time as it imposed a crippling constraint upon Russia's artistic experience, for it transformed the mystical strivings that had inspired Feofan Grek, Rublev, and Dionysii into an oppressive body of dogma that stifled the mind and spirit.[25] This new puritanism soon yielded a rigid code that set the limits within which Russia's artists could work, and allowed them to paint only according to prescribed models drawn from manuals of certified patterns that stated precisely how each figure in an icon must be portrayed.[26] "The holy and venerable icons, conformable to divine rules, must reproduce the image of God, his likeness, and be faithful to the consecrated type," the stern injunctions issued in 1551 by what is remembered as the Hundred Chapter Council decreed. Every artist was warned against giving way to inspiration under pain of punishment in this world and the next. "He who shall paint an icon out of his imagination," a proscription of the next century warned a younger generation of painters, "shall suffer endless torment."[27]

As conformity began to rule art in Russia, faith no longer moved artists' brushes as it had in earlier times. Icons ceased to serve as windows through which the faithful might glimpse the world of the spirit and became instead objects of veneration to which pious men and women bowed in prayer. This, in turn, had a profound impact upon art in the Orthodox world's new city of God. Inspiration and passion now gave way to technical perfection that deprived sixteenth-century icons of the inner beauty and spiritual power that radiated from the earlier works of Rublev, Dionysii, and Feofan Grek. No longer did icons serve as a means by which believers could escape the limits of the material world. From the middle of the sixteenth century onward, the Church's own injunctions moved icons firmly into the realm of beautiful physical objects to make of them monuments of art rather than reflections of the strivings of the human spirit.

The Hundred Chapter Council's stern pronouncements came at a critical moment in the history of Russia's artistic experience because Tsar Ivan the Terrible had just summoned painters to Moscow from all over Russia to replace the great religious treasures that a terrible fire had destroyed four years before. Lavishly supported by the Tsar himself, and bringing Western influences from Pskov and Novgorod, Greek and Near Eastern influences from the Balkans, and even Mid-

dle Eastern and Tatar influences from the lands of Russia's Southeast, this gathering of artists might well have brought into being an era of artistic ferment akin to the Renaissance in the West. Yet, as would happen so often in the history of Russian art, the dangers of nonconformity overwhelmed the promises of innovation. Combined with Ivan's demand that art now must serve the State as well as the Church, the proscriptions of the Hundred Chapter Council wilted the promise of Russia's incipient Renaissance before it flowered. As Russia's first government-supported art schools, the Tsar's newly organized Kremlin workshops yielded the first art and artists who served the ideological aims of the Russian state. Supported and encouraged by the ruler they served, specially chosen artists now worked to raise Russian painting to new heights of technical perfection at the same time as they erased from it the inner power to transmit faith and belief.

To support his claim to being the divinely appointed successor to the emperors of Byzantium and ancient Rome, Ivan the Terrible demanded art that celebrated Russia's greatness and proclaimed the glory of its triumphs in a world far removed from the other spiritual centers of the Orthodox world. No work of art accomplished that purpose with greater drama or brilliance than the huge "Church Militant" icon that celebrated the storming of Kazan and the reopening of Russia's way to the trade routes of the Caspian Sea and the furs of Siberia during the first decade of Ivan's reign. Hung in the Tsar's own palace, this painting placed religious figures in a secular, political setting by portraying the Archangel Michael leading a victorious Christian army toward the heavenly city of Moscow, while Ivan the Terrible rode directly behind him, clad in golden armor and a scarlet cloak to emphasize his new God-given status as Tsar of All the Russias. In the same painting, Russia's hero-saints Aleksandr Nevskii and Dmitrii Donskoi led other columns of troops, while Kazan burned in their rear to show that Orthodox Russia had destroyed this infidel city of Sodom according to God's plan. In the work of the Kremlin's officially sponsored artists, the Tsar of Russia, upon whom the Archangel Michael had bestowed his blessings, had become God's chief agent on earth.[28]

The injunctions that constrained Moscow's icon painters throughout the entire second half of the sixteenth century did not prevent Russia's builders from working with the same new influences from East, South, and West that had been forbidden to artists. Renaissance building styles from northern Italy and southern Germany, North European influences that flowed through the old trading centers of Novgorod and Pskov, and Middle Eastern patterns that Russians had seen in the Tatar khanates of Kazan and Astrakhan all found places in the new buildings that rose in Moscow after the fire of 1547. None displayed this striking confluence of new influences more vibrantly than did the Cathedral of the Virgin Protectress and Intercessor that the Russian architects Barma and Postnik built to celebrate Russia's victory at Kazan. Set just beyond the Kremlin's Spasskii Gate, at the point where the southeastern end of Red Square began to slope away toward the Moscow River, Barma and Postnik's cathedral immediately became the counterpart in architecture to the "Church Militant" and a monument to the

sovereign whose excesses of cruelty and contrition had no equal in Russia's history.

In building the terrible Tsar's cathedral, Barma and Posnik crowded nine smaller churches beneath tent roofs and onion domes to create an inspired excess of porches, onion-shaped gable ends, intricate brickwork patterns, and colored tiles that mixed the Russians' favorite decorative devices with a complex, overall Middle Eastern pattern reminiscent of an Oriental carpet. Swirling, fluted, and serrated domes, domes covered with tiles that resembled the shingles of Novgorod's wooden churches, and domes that displayed the faceted designs that Solari and Marco "Friazin" had brought to the Kremlin from Renaissance Italy mixed exuberant pinks, greens, oranges, reds, blues, and yellows in the riotous display of color that Russians have always loved. Popularly named for St. Basil the Blessed, the holy fool who publicly castigated Ivan the Terrible for his sins, the cathedral still fascinates Moscow's visitors. Despite its many foreign elements, there is no more Russian church than St. Basil's anywhere in Russia.[29]

The sins against which St. Basil spoke with such passion took a heavy toll on Russia when the triumphs that brightened the first half of Ivan's reign turned into defeats. Throughout the 1560s and 1570s, the Tsar who had once dreamed of opening a pathway for Russia to the West unleashed a relentless reign of terror that wiped out scores of Russia's greatest noble families and claimed the lives of thousands of their followers. Imagining that treason lurked in the hearts of even his most loyal servitors, Ivan destroyed entire towns in retribution. Then, when he died in 1584, the Russians faced twenty-nine years of even greater turmoil, for Russia's fearsome sovereign had killed his eldest son in a fit of rage and left only a feeble-minded heir, whose death in 1598 brought the ancient dynasty of Riurik to an end. Sensing an opportunity to gain territory at their fallen rival's expense, Sweden, Poland, and the Tatars of the Crimea all sent armies into Russia at the same time as tens of thousands of serfs and Cossacks rose in revolt. As famine and plague took an added toll, Russia plunged into a fifteen-year-long Time of Troubles, during which two great lords, a defrocked monk, and a Polish king all struggled to seize the throne.

Yet the Time of Troubles also brought new foreign influences that would transform Russia's political and artistic experience by turning it toward the West. Certainly the English strengthened their foothold in Russia at this time, and so did the Dutch and the Swedes, all of whom made it clear to the Russians that the instruments of modern technology could no longer be opposed by poorly armed levies of feudal serfs and retainers. To counteract these new forces, Russia would eventually be drawn into the political and cultural life of Europe in much the same way that Vladimir's conversion and Riurik's opening of the river highway "from the Varangians to the Greeks" had brought the lands of Rus into the mainstream of Byzantine life seven hundred years before. The focus of Russia's future was beginning to shift from South to West, and it was there that its seventeenth-century rulers would find their greatest challenge.

The century after 1492—the year in which Columbus discovered America

and the Metropolitan Zosima proclaimed Moscow to be the Third Rome—made clear the distance that had come between Russia and the West during the centuries after the Mongol invasion. Inferior in technology and military strength, the Russians had taken refuge in the belief that their superiority in matters of faith marked them as God's chosen people, for they had remained undefiled while the "godless" West had fallen into heresy. Only when the merchants and armies of the West began to reach deeper into their land did the Russians see the danger that a medieval nation faced in confronting a modernizing world. At that moment, they began to feel the first pains of technological backwardness that would plague them for the next four hundred years.

Starting around 1600, a new sense of inferiority began to reshape the Russians' relations with Europe. At times, the insecurity of backwardness led them to reject everything Western. At others, it impelled them to embrace the ideas and culture of the West as superior by definition. How to strike a balance between East and West, between modernization and tradition, tormented each of Romanov Russia's novelists, composers, and poets, as well as its statesmen, sovereigns, and revolutionaries. Tradition offered a time-tested refuge to some, but others feared that that haven, which seemed so secure from the turmoil of the modern world, also harbored the forces that would lead Russia to ruin. Some means had to be found to open the way to innovation and preserve tradition if the Russians were to keep the heritage upon which their national identity was based.

Designed to bind children to their fathers, wives to their husbands, and subjects to their Tsar, a widely quoted volume of sixteenth-century aphorisms called the *Domostroi* supplied seventeenth-century Russians with a beacon upon which to take their bearings as the technology and energy of the Europeans threatened to overwhelm them.[30] To reinforce the pronouncements of the *Domostroi*, Russia's newly crowned Romanov Tsar created a court in which life revolved around the Russian land, the Russian Tsar, and the Russian Church, and emphasized a hierarchy of temporal authority that began at the humblest peasant's hearth and ended at the throne of the Tsar. At the same time, the Orthodox Church tightened its grip upon the faithful, lest they succumb to the lure of the modern, godless West, where, freed from the medieval fear of sin, Europeans had begun to live more pleasantly and comfortably in the here and now without losing hope of life in the hereafter.[31] In the minds of the men and women who hoped to define Russia's course, the pleasures of modern vice threatened to overwhelm the constraints of medieval virtue. In terms of the forces that shaped everyday life, it became a question of whether men and women would be able to let their minds and talents run free, or whether the proscriptions that had so long held them in check would continue to fetter new ideas and artistic inspiration.

While Russia's priests condemned the ways of the West, Europeans regaled each other with tales of the barbarity of the men and women who sought to escape the rigid moral order of the *Domostroi* in periodic bouts of depravity and vice. "If I would describe the whole, I fear my pen would faint," an Englishman

of fashion wrote after he had visited Ivan the Terrible's Russia. "I never saw a . . . people so beset with saints," he added, "yet all but vile and vain."[32] A few years later, the Danish envoy Jakob Ulfeldt condemned the Russians for being "inclined to every sort of wickedness [and] divorced from all virtue,"[33] and many others embroidered upon his account in the years to come. To them all, this land to which European kings and princes had sought to tie their dynasties by marriage in the days of Kievan Rus, and which so recently had proclaimed itself to be the Third Rome, had become a "rude and barbarous kingdom"[34] in which "churches, icons, crosses [and] bells" combined with "painted whores and garlic smells"[35] to form a way of life that combined piety and puritanism with prurience and perversion.

As the letters and memoirs of disgusted Europeans made clear, Russians' experience with the West in the days of the early Romanovs reached well beyond the handful of foreigners who served the Tsar or traded in Moscow's suburbs. Ever since the time of Ivan the Terrible, English and Dutch traders had been bringing their ways of life to the White Sea ports of Kholmogory and Arkhangelsk, and by the beginning of the seventeenth century their settlements had spread their influence for hundreds of miles to the South and East. None knew the importance of European ways better than the Stroganovs, those sixteenth-century Russian Midases who built a substantial part of their fortune by welcoming traders whose ships brought such wonders of European science as the maritime compass to Russia's northern ports. While their Tsar and Church continued to debate whether European learning and technology stood at odds with God's will, the Stroganovs used the forces of progress to open up the vast natural wealth of the continent that stretched eastward from the Ural Mountains to the Pacific. Rare furs and common salt formed the basis of the fortune they built. With it, they financed the private army that conquered the western lands of Siberia in the name of the Tsar for their own greater glory.

The richest family in all of Russia when the Time of Troubles ended, the Stroganovs dedicated a part of their wealth to bringing great art into being in much the same way as the Florentine Medicis and Roman Borgias had done in earlier times. Far away from the control of the Tsar and the Church, the cousins Maksim and Nikita Stroganov organized large, well-endowed workshops near Siberia's western borderlands at the beginning of the seventeenth century, and invited to them some of Russia's finest artists to paint icons that combined superb draftsmanship with brilliant colors and lavish overlays of gold.[36] To the rich heritage of Feofan Grek, Rublev, and Dionysii, the men who worked in the Stroganov workshops added modern elements that hinted at their patrons' many points of contact with the West, at the same time as they used their art to alter the relationship between devout Russians and the icons before which they prayed. By portraying saints in prayerful poses that transformed them from objects of veneration into participants in worship, the Stroganov masters directed the prayers of the faithful to their icons themselves rather than create windows through which worshipers might perceive the world of the spirit. The most beau-

tiful of all premodern Russian painting in a technical sense, Stroganov icons no longer projected that aura of deep, unquestioning faith that had convinced people of an earlier age that the hand of God had made the artist into His willing instrument. Instead, they drew the attention of the faithful to the brilliance of their creators' achievements and focused their eyes and thoughts upon the very human qualities of talent and artistic genius.[37]

As the possibilities for portraying human experience in art broadened in the 1620s and 1630s, the spiritual and intellectual world of Russia's artists lost its simplicity. Touched by the currents of European art and thought that were beginning to filter through Poland, Ukraine, and the English settlements of the Far North, icons from the Kremlin and Stroganov workshops began to show a naturalism in the painting of trees and the arrangement of living things that would have left artists in Rublev's time aghast with horror. East and West were beginning to blend more compatibly in Russian painting than in Russian life. The new humanistic spirit at which the Stroganov and Kremlin painters hinted in their work made that very clear.

A similar blending of architectural influences led to the Kremlin's Terem Palace's being rebuilt in an Italianate form at the same time that native craftsmen Europeanized its furnishings by adding such innovations as cupboards and shelves and replacing the ubiquitous Russian benches and stools with furniture from the West. When the Holy Roman Emperor's ambassador visited the Court of Tsar Aleksei Mikhailovich in 1661, he found the walls of the Terem Palace covered with gilded Dutch leather and Flemish tapestries, all of which showed that the European impact upon Russia's artistic experience was beginning to deepen.[38] In Russia's churches, the richly carved window frames and complexly ornamented brick and stucco work produced by Western influences that had filtered through Poland and Ukraine in the 1660s and 1670s gave birth to the Moscow Baroque, which flourished during the quarter-century before Peter the Great began to rule Russia in his own right in 1689. As in painting, the form of its new churches showed that Russia was moving closer to the West and that the Church's ability to dictate the form and content of art had become seriously weakened.[39]

Much of this stemmed from the Great Schism that split the Russian Church in 1667 and destroyed its power to shape life and art ever afterward. The struggle had begun almost two decades earlier, when the Patriarch Nikon—a huge, raw-boned, six-foot-six-inch giant—had set out to "purify" church books by removing all the errors in translation and ritual that had occurred since Christianity first came to Russia. Citing as their source an Orthodox missal that the advocates of reuniting the churches of East and West had published in Roman Catholic Venice in 1602, Nikon and his followers banned the prayers and rituals that Russians had venerated since the days of Aleksandr Nevskii and Dmitrii Donskoi. Now it became a sin to make the sign of the cross with two fingers (as had been done for centuries) rather than the three upon which they insisted.[40] Insisting that the texts the Patriarch was seeking to "purify" comprised the essence of the

true faith that set the Russians apart from the rest of Christ's followers, Nikon's opponents rejected his reforms and cursed everyone who supported them.

A stubborn man of fervent faith and iron will, the Archpriest Avvakum rallied Russia's faithful against Nikon's reforms with a passion that led men and women to choose torment and death rather than abandon the traditions that underlay their faith.[41] Like Nikon, Avvakum had grown up among the peasants of the lonely Russian Northeast, but that marked their only common ground, for the archpriest advocated a puritanical morality that made the precepts of the *Domostroi* seem permissive by comparison. "I am excrement and pus, an accursed man—just plain shit!" he once wrote in a dramatic passage of penitential self-abasement. "So help me," he concluded, "it's good this way!"[42] Xenophobic and obscurantist, Avvakum and his followers rejected all things foreign and demanded that Russia remain apart from those nations and influences that modern ways had made impure. Condemning all secular art—and all religious art that in any way was true to life—as the work of the Devil, they insisted that any attempt to follow the profane example of the West could lead only to sin. Thundering that "heretics love sensuality and do not care for higher things,"[43] Avvakum consigned all who followed the path of the official Church to eternal damnation. Only the old ways, the old beliefs, and the old rituals could keep men and women free from sin.

Among the painters who struggled to absorb the influences that Avvakum and his followers condemned, Simon Ushakov came closest to making the art of the West his own. Far and away the greatest artist of seventeenth-century Russia, he did his first works in the miniaturelike manner of the later Stroganov artists, but he soon began to work on a larger scale that followed the example of sixteenth-century Flemish and German Mannerists. His rendition of Christ's image as it appeared on St. Veronica's veil, therefore, displayed a three-dimensional naturalistic quality that invited his viewers to think of Christ and his followers as a part of the everyday world and stood an age ahead of the two-dimensional portrayals that had reflected viewers' gazes back into the depths of their souls in the days of Rublev and Dionysii. Such paintings showed that the Russians had at last begun to understand that secular themes could be as edifying as sacred ones and that artists had the right to think creatively about the here and now rather than concentrate their vision only on the hereafter. As they proceeded to defy the Church's prohibition against painting the human form, Ushakov and a handful of his contemporaries, therefore, portrayed real people and everyday events. Ready to oppose their work, but unable to enforce its prohibitions, the Church was losing its authority to dictate the form and content of art for the first time in Russia's history.

The human portrayals of religious figures that Ushakov and his followers painted during the second half of the seventeenth century especially offended those opponents of Nikon's reforms who struggled to keep their Church centered on the past and away from the present. "They paint the image of Our Savior Emmanuel with a puffy face, dark red lips, curly hair, thick arms and muscles,

chubby fingers and legs, and heavy hips that make him resemble a pot-bellied and fat German," Avvakum exploded in a fit of anger. "The only difference is that there is no sword painted at his hip!"[44] As xenophobic critics such as he insisted that modern icons worked against the beliefs upon which the Russians had built their church since the days of Grand Prince Vladimir, the struggle between tradition and innovation added more fuel to the flames that had begun to engulf the Church. And, as the confrontation between innovation and tradition split the Orthodox faithful as irreparably as the Reformation had done two hundred years earlier in the West, the impact of that schism began to reach far beyond the art that filled Russia's churches.

How men and women behaved in public and in private, how they spent their leisure hours, and even what they ate and how they dressed all became part of the secular revolution that transformed the Old Russia that had faced south and east toward Byzantium into a nation and a culture that looked firmly westward to Europe. With surprising speed, this secular revolution, which struck with full force during the reign of Peter the Great, lifted the arts in Russia from the medieval world into the modern. When the Great Schism split their Church irreparably apart in 1667, the Russians had yet to find their Rabelais or Machiavelli, much less their Rembrandt, Lully, or Purcell. Within a century and a half, they found them all, and then proceeded to give the world Dostoevskii, Tolstoi, Musorgskii, and the brilliant painters and poets who dominated Europe's world of art at the beginning of the twentieth century.

# RUSSIA'S SECULAR REVOLUTION

૯ઢ✣ટે૭

DURING THE THREE-QUARTERS of a century between the Great Schism and the accession of Peter the Great's daughter Elizabeth in 1741, a secular revolution touched every corner of Russian life. Fashions, manners, the art of making war, the practice of government, the way upper-class men and women related to each other, and the manner in which they viewed the world around them all changed. Russians' vision of how to lead their lives shifted from pious and passive contemplation to the energetic pursuit of conquest, knowledge, and progress. In response to the secular revolution, Peter the Great built the "window on the West" that became Russia's new capital city of St. Petersburg, and the men he sent to study in Europe began in earnest to develop a modern written language that could express in Russian the ideas and technology of the West.

Although at first staffed mainly by Germans, an Academy of Sciences helped to bind Russia more closely to the learning of Europe, and secular themes began to overshadow religious ones in the arts. Poetry, novels, and narrative history written by such well-remembered authors as Vasilii Trediakovskii and Mikhail Lomonosov replaced spiritual testaments, epistles, and chronicles written by anonymous monks. In architecture, builders began to celebrate the grandeur of the State as well as the glory of God. And, as the Church fathers' prohibition against musical instruments lost its force, the folksingers and choirs that had ruled the world of Russian music gave way to symphonies, operas, and the music of military marching bands.

In the homes of Russia's aristocrats, orchestras entertained guests in salons and at dinners. As minuets and quadrilles drew into each other's arms men and

women who had been kept apart in the days when the *Domostroi*'s precepts reigned supreme, music changed the social relationships that had ruled Russia for centuries. Even the masses felt the new force of Europe in their arts, as cheap popular *lubok* prints took their places just a few feet away from the sacred icon corners in peasant cottages. One such print portrayed an officer from Peter the Great's famed Preobrazhenskii Imperial Guards cutting off the beard of an old-fashioned townsman in order to make him more like a European, while others illustrated town and country life, proclaimed political messages, or commemorated triumphs won by Russia's newly modernized armies. In art, music, literature, and even architecture, the secular concerns of daily life pushed God and His Church aside. Beauty and artistic genius moved decisively into the sphere of secular accomplishment as men and women began to see the arts as ways to enrich their earthly lives rather than edify their eternal souls.

Except among those Old Believers who condemned everything Western as anathema, the life and technology of Europe touched every Russian in some way during the secular revolution. Yet, even as they drew closer to Europe, the Russians tempered its influence with the Eastern heritage that had shaped their artistic experience for more than seven hundred years. The cultural, political, and personal dilemmas posed by the never-to-be resolved question of whether their nation should look east or west continued to torment the Russians ever after, but those two mystical, never clearly defined forces now began to combine in ways that never again allowed them to stand entirely apart.

As the first of a new breed of men and women who saw the science, rational thought, secular art, and modern literature of Europe as the keys that could free his country from the medieval constraints that had turned it inward for so long, the monk Simeon Polotskii led the way in summoning the Russians to look westward in the 1660s and 1670s. Convinced that only modern technology and the spirit of scientific inquiry could lift Russia to a higher material and cultural plane, Polotskii urged his countrymen to set aside their medieval certainty that faith stood higher than knowledge, and he called upon the Tsar to lead his people into the modern world by setting an example for them to follow. Only the rational thought of the West, he argued in the sermons he preached in the Tsar's private chapel, could open the way to progress, and only the absolute power of the Tsar could lead Russia to the full realization of its imperial destiny.[1] To the Tsar and his counselors, he insisted that the Muscovite absolutism of Ivan the Terrible needed to assume a more modern guise that would help to impose the learning, technology, and arts of the rapidly modernizing West upon the Russians from above.

As an aggressive spokesman for the art and literature of Europe, Polotskii devoted his life to writing a huge corpus of poetry and prose that brought the images of the modern, more active West to Russia.[2] As the "father of Russian syllabic poetry" and the first major poet in Russia's history whose name and biography have come down to us, he praised the early Romanov tsars Aleksei Mikhailovich and Fedor Alekseevich in Baroque panegyrics and greeted the

birth of Peter the Great in 1672 as a sign that Russia soon would free Constantinople from the Turks. Yet, unlike his eighteenth-century successors, who succeeded in transforming Russian to meet the needs of modern life, Polotskii could not wrest from the rigid, antiquated vocabulary of Old Church Slavonic the language needed to express modern European ideas. Eventually, he turned to the theater, which provided a visual means for portraying the feelings and ideas that the written word could not. There, for the first time in Russian history, he created the images of a new world in which visions of change and progress moved Russia from the contemplative, unchanging life of the Middle Ages toward the dynamism of modern times.

Spurred by Polotskii's dramas, Tsar Aleksei Mikhailovich and the head of Russia's Foreign Office, Artamon Matveev, became Russia's first patrons of the theater. As one of the most westernized Russians of his day, Matveev lived in the grand European style and shared Polotskii's belief that Russia must turn to the West to escape the medieval constraints that had slowed its progress for so long. In the spring of 1672, he therefore commissioned Johann Gottfried Gregory, the Lutheran pastor of Moscow's Foreign Quarter, to write *The Comedy of Artaxerxes*, which was first performed on October 17, 1672, at a special theater that the Tsar had built on his suburban estate at Preobrazhenskoe. Although the young Germans, Dutchmen, and Scots whom Gregory assembled to act the parts in his comedy spoke in thick foreign accents, the play scored such a smashing success that the Tsar was said to have sat through the entire ten-hour performance without getting up even once.[3] To add to the wondrous sights and sounds that assaulted the senses in the Tsar's theater, flutes, clarinets, trombones, kettledrums, and an organ produced what one viewer called "elegant bursts of music" to introduce the first orchestral arrangements—hitherto forbidden by the Church—into Russia. "To the Russians it appeared to be something extraordinarily artistic," one German visitor remarked. "The new, unheard-of costumes, the unfamiliar sight of the stage, even the foreign idiom . . . [all] aroused amazement."[4]

Obliged to view the play from a special lattice-covered box because tradition forbade them from being seen in public, the Tsar's teen-aged daughters and young second wife must have found the contrast between their way of life and the play especially striking. *The Comedy of Artaxerxes* challenged the very foundations upon which Old Russian society stood by revealing an energetic world in which women moved in its mainstream, but there was more in the play than a vision that challenged the centuries-old assumptions that shaped the world of the Russians. The foreign actors who spoke its clumsily translated lines in heavily accented mumbles and mispronunciations stood as living proof that a modern and energetic world flourished less than a fortnight's journey to the west, and that indisputable fact now posed the thorniest of the questions that the Russians had to face. How would they—or did they even dare to—cross the gap in time and space that separated them from this brave new world of individualism and secular freedom? With neither the words nor the syntax to convey the subtle shades

of feeling that shaped everyday life in the world that Gregory and his actors struggled to portray, the secular revolution shifted its focus to other aspects of Russian life. Foremost among them was the setting in which Russia's sovereign and his courtiers lived, worked, and amused themselves.[5]

The first hint of change in the unsubtle ways of daily life that surrounded Russia's tsars and aristocrats came when Tsar Aleksei Mikhailovich's passion for the hunt encroached upon the dawn-to-dusk religious ritual that had governed court life since the days of Ivan the Great. Away from the eyes of Moscow's rigid traditionalists, the Tsar built two suburban palaces that symbolized the beginnings of a world in which the pursuit of pleasure and comfort began to replace the quest for piety and godliness. Like Versailles in the days before Louis XIV, the palaces on the Romanov estates at Izmailovo and Kolomenskoe began as rustic hunting lodges. And, like the palace of France's Sun King at about the same time, their royal master transformed them into monuments to a style of life that stood well beyond the vision of even his richest subjects. At Kolomenskoe and Izmailovo, the sovereign whom history would remember as Russia's "most pious and gentle Tsar" set in motion changes that would shatter the walls of medieval piety with which his subjects had surrounded themselves for the better part of five hundred years.

Scarcely ten miles northeast of the Kremlin but well beyond the limits of seventeenth-century Moscow, the gardens that surrounded Izmailovo marked the symbolic beginnings of the Tsar's first efforts to use European science and technology to conquer the physical world around him. Here, thanks to ingenious devices that warmed the earth and air, melons brought from the desert oases of Central Asia and date palms transported from the Caucasus flourished in the harsh climate of northern Eurasia to show that science could control nature more certainly than prayer. Some three decades later, Aleksei Mikhailovich's son, Peter the Great, would show the power that a modern tsar could wield over the forces of nature when he built St. Petersburg on the inhospitable Neva River delta against the will of the elements, but it was at Izmailovo that Russia's sovereign first defied the Church-dominated, tradition-centered culture that had ruled his people's lives since Moscow's earliest days. The Izmailovo gardens showed that change was in the wind, and the winds of change were about to unleash a tempest that would use the forces of science, technology, and progress to raise Russia into the ranks of the world's greatest powers. A new pulse of life was starting to throb in the gardens of the Tsar's hunting lodge. In half a century it would transform Russia's entire artistic experience and bring portraits, modern buildings, minuets, and marching bands to a nation that had recently disdained them all.[6]

To celebrate his second marriage in 1671, Tsar Aleksei Mikhailovich built a palace at Kolomenskoe, the royal estate set high above the Moscow River, from which, in days gone by, Ivan the Terrible had watched the armies of Muscovy march in review on the plains below. Once called a "gigantic dictionary of all the architectural terms invented by Russian carpenters," Kolomenskoe Palace mixed

the styles of Russia's North, South, East, and West into such a jumble of domes, onion-shaped gable ends, towers, turrets, and carvings that one commentator compared it to the sets of Rimskii-Korsakov's *Le Coq d'Or*.[7] With brightly painted wooden shingles setting off its many carvings, the palace seemed Old Russian to the core. Three thousand mica windows, which in a land known for low doors, small windows, and dark interiors flooded the 250 rooms of Kolomenskoe Palace with light, gave the first hint that it was not.

Laid out in the European manner, the state apartments of Kolomenskoe Palace displayed portraits of such heroes as Alexander the Great, Julius Caesar, and Persia's great King Darius, in defiance of the Church's long-standing prohibition against "graven images," and maps of the continents of Asia, Africa, and Europe hung prominently on the walls. A huge painting of the zodiac decorated one of its anterooms to show that even in the innermost reaches of his household the Tsar had begun to find science in the heavens in addition to signs of God's presence. Polotskii once called Kolomenskoe Palace Russia's eighth wonder of the world. Compared to the magnificent palace and gardens that Louis XIV was building at Versailles in those days, it fell far short of that claim, but it had no equal anywhere in Russia. Bright, modern, and spacious, Kolomenskoe Palace represented a world of energetic activity and openness that no more than a few of the most daring Russians had even begun to think about.[8]

Among the handful of Russians who shared the Tsar's interest in things modern, Prince Vasilii Golitsyn made his fascination with Western culture, art, and technology into a way of life. As the chief adviser to the Tsarevna Sofiia even before she became Russia's regent in 1682, Golitsyn was among the first to build in the style that would be remembered as the Moscow Baroque, and he furnished his fifty-three-room city mansion in a way that few of his countrymen dared to copy. "Everything was arranged according to the European style," the great nineteenth-century historian Vasilii Kliuchevskii wrote in describing the surroundings in which Golitsyn lived. "Paintings, portraits of Russian and foreign monarchs, and German geographical maps in gilded frames lined the walls . . . and the ceiling [of one room] was painted to represent the planetary system."[9] Seventy-six mirrors gave an impression of even greater spaciousness. The prince's bedchamber contained a carved German bed, and his collection of 216 books, half of them on secular topics, comprised one of the largest private libraries anywhere in Russia.[10] Compared to the mansions and palaces of Germany, England, France, or Italy, none of this was at all out of the ordinary, but in Moscow such European luxuries as mirrors (which the Church prohibited as invitations to vanity) or half a dozen books in German and Latin posed a daring challenge to the traditions of Church and piety.

While Golitsyn had hoped to avoid a catastrophic clash between old and new by integrating the culture and technology of the West into Russia's experience slowly, Peter the Great believed there was not a moment to lose. A towering six-foot-seven-inch giant who seized Russia's throne at the age of seventeen in 1689, Peter had a vision of his nation's role in world affairs that was every bit as

extraordinary as his stature. Sensing that Russia must either enter the mainstream of modern life or be overwhelmed by it, Peter, therefore, wasted no time in driving his subjects into the modern world at maximum speed. Under his relentless prodding, Russia acquired a modern army, factories, a modern system of taxation, and a taste for the life and culture of Europe. His "grandiose forcible experiment" in creating a "regulated" police state sacrificed the private personal interests of his subjects to the "common good" by placing all of their lives and resources at the beck and call of the State. But he made the individual preeminent in the arts by urging that critical thought—not the forces of tradition and habit—shape the course of life.[11]

Peter the Great's policies unleashed a new wave of creativity among the Russians. Superstitiously pious, fearful, and illiterate, Russia's common folk continued to look to the past, but their masters and mistresses began to speak the languages of Europe, live comfortably in the present, and look to science, technology, and critical thought to change their future. Russia's educated classes took greater command of their destinies as their nation moved firmly into the modern world, while its peasants continued to combine paganism with the rituals of Orthodoxy to explain famine, plague, and a host of natural calamities as the products of God's anger.[12] Not until the end of the nineteenth century would Russia's great writers, painters, and composers turn again to the people, but it would be the Bolsheviks, finally, who closed the chasm between upper and lower classes that the secular revolution had opened.

In the meantime, the new individualism that the secular revolution unleashed in the fine arts took root among those educated Russians who modeled their artistic and cultural experience upon the West. Nowhere was that more evident than in the rise of St. Petersburg, the "window" that Peter opened to the West at the beginning of the eighteenth century. Built on the swampy marshlands of the Neva River delta, Peter's city celebrated the triumph of man over nature on a scale that no seventeenth-century Russian could have imagined. In less than half a century, parks and gardens flourished where bogs had covered the landscape, brackish streams became majestic canals, and the huts that had sheltered fishermen drying their nets gave way to magnificent palaces in which lords and ladies drank champagne and danced until dawn.

Never more than a remote Swedish outpost before Peter's time, St. Petersburg by the end of the eighteenth century became a monument to the new culture of Russia's secular revolution and the nerve center of a mighty empire that covered a dozen time zones and a sixth of the earth's surface. Art that had lifted the souls of men and women toward the realm of the spirit had signaled the glory of Moscow. Now, art of the mind and the heart—the poetry of Pushkin, the novels of Dostoevskii, the operas of Chaikovskii, the portraits of Levitskii and Borovikovskii, and the fabulous buildings of Rastrelli, Quarenghi, and Rossi— would mark the brilliance of St. Petersburg and proclaim the strength of the ties with which Peter the Great had bound Russia to the West.

At the beginning of the eighteenth century, Peter's conquest of the delta

through which the Neva River flowed from Lake Ladoga into the Finnish Gulf regained for Russia the northern outlet of the famed river highway that had flowed "from the Varangians to the Greeks" in the ancient days of Riurik. Trade in those long-ago times had brought the products of the Baltic forests to Constantinople in exchange for the treasures of Byzantium and the Orient. Now Peter's conquest shifted the flow of trade from the South to the West, and brought the goods of Europe to St. Petersburg in exchange for Russian grain, hemp, canvas, and tar. Blending a cacophony of influences from London, Paris, Amsterdam, Vienna, and Rome, the builders of St. Petersburg created a city that was unlike any other in the world. Over the next three centuries, it would be called Sankt Pieter Burkh, St. Petersburg, Petrograd, Leningrad, and, then St. Petersburg once again by the men and women who ruled it, but to the Russians themselves it would be forever known as Piter, the Russified form of the Dutch version of its founder's name.

Peter the Great's chief lieutenant, Aleksandr Menshikov, laid the first stone for "Sankt Pieter Burkh" on May 16, 1703. Far from Russia's center, the city stood closer to the lands of the Tsar's enemies than to Moscow, and several times nearer to Paris and London than to Siberia and Russia's Pacific coast. Floods, disease, a foul climate, and lands that stood only four to six feet above sea level made the region anything but the "paradise" to which Peter referred in his letters, and a century would pass before the new city could protect itself from the spring floods that turned its streets into rushing streams. In the beginning, more than fifteen thousand forced laborers had to be assembled every year from the ranks of serfs, prisoners of war, and common criminals to set foundations in its bogs and raise dry land from its swamps. Yet, as happened so often in Russia's history, what had seemed impossible came to pass. In 1712, Peter moved his court and key government offices to St. Petersburg from Moscow. Not long afterward, the new capital could boast some sixteen thousand buildings, most of them of slab wood and wattle and huddled along the mainland bank of the Neva and on the large island immediately behind the fortress.[13]

Although formally proclaimed Russia's capital, St. Petersburg seemed more like "a heap of villages linked together like some plantation in the West Indies" when the Hannoverian secretary of legation Friedrich Weber arrived there in 1714. Peter still dreamed of a city of brick and stone, and had recently forbidden all masonry construction throughout his empire so as to give his new capital a monopoly on Russia's supply of masons and building materials, but Weber quickly discovered that most of St. Petersburg's buildings were made "all of wood, beam upon beam, rough without, and smoothed within by the help of a hatchet." Like Peter's own modest cottage, some had wooden outer walls that had been painted to resemble brick and mortar, but most were so flimsy, Weber said, that "in two hours' time, [they] may be taken to pieces and put up again in another place."[14] Stone continued to be so scarce in the bogs of St. Petersburg that the material for paving streets and laying foundations had to be obtained by levying a "stone tax" on every wagon or ship that arrived in the city.[15]

The inspiration for St. Petersburg's early designs may well have come from the impressions that Peter himself gathered on his journeys to Germany, France, England, and Holland,[16] but he had to rely on professional architects to give his vision form and substance. Just as Ivan the Great had found the Kremlin's chief builder in Aristotele Fioravanti of Bologna, so Peter found Dominico Trezzini, a thirty-three-year-old Italian-Swiss architect and engineer from Lugano, a city whose builders had helped to shape Baroque architecture all across northern Italy and southern Germany. As one of the first European architects to reach Russia in the eighteenth century, Trezzini came to St. Petersburg in 1703 when it was no more than a handful of scattered huts. More diligent than creative, he nonetheless translated Peter's undisciplined tastes into a coherent vision and workable designs. Until Jean Baptiste Alexandre Le Blond, a widely acclaimed pupil of the famed André Lenôtre and a member of the Royal Academy of Architecture in Paris, arrived in 1716, Trezzini bore the burden of designing Russia's new capital, even though several architects of greater reputation came and went during those years.[17]

Trezzini began by building the Peter and Paul Fortress and the church that stood in its center, after which he went on to design Peter the Great's Summer Palace and the Admiralty that served as the headquarters for Russia's new navy. To create order and uniformity as St. Petersburg's wattle-and-daub shelters were rebuilt of brick, stucco, and stone, Trezzini incorporated his master's infatuation with the façades of Amsterdam into model designs for different styles of private houses, and trained an entire generation of Russian architects, including Mikhail Zemtsov, the first Russian builder ever to work according to European designs and principles. Just before Le Blond arrived in St. Petersburg in 1716, Trezzini drew up the first comprehensive plan for the city, which Peter evidently preferred to the more elaborate one that Le Blond prepared a few months later.[18]

The European architects who followed Trezzini and Le Blond to St. Petersburg also worked in Moscow, Novgorod, and Kiev, but one of their most dazzling creations took shape at Peterhof, on the southern coast of the Finnish Gulf just eighteen miles west of St. Petersburg. Begun by Johann Braunstein, work on the main palace at Peterhof was taken over by Le Blond not long before he died of smallpox in 1719. Then, Niccolo Michetti, who had just finished the beautiful Kadriorg Palace in the newly conquered city of Reval (now Tallinn) in Estonia, took up Le Blond's assignment, while Braunstein continued to work on several smaller country houses set in the vast parks that surrounded the main palace. Named Marly, Mon Plaisir, and the Hermitage, each of these recalled in some special way the architectural jewels that dotted the gardens at Versailles, and so did Peterhof's huge gardens and massive fountains, for which a twenty-four-kilometer-long canal had to be dug to supply the water.[19] Here once again was proof of the Russian Emperor's power to harness nature on an even larger scale than the builders of Versailles had done. As if to emphasize that point, during the next fifty years the Russians built within reach of St. Petersburg three more country palaces on the scale of Versailles.

The palace at Peterhof made it clear that if the life of the West was to become the Russians' model for living in the brave new secular world into which their Emperor had thrust them, reason had to triumph over superstition and the Church—as the force that had stood for so long as a bulwark against modernization—had to be swept aside. When the Patriarch Adrian died in 1700, Peter the Great turned to Feofan Prokopovich, an Orthodox priest who had studied in Rome before he became Archbishop of Novgorod, to transform Russia's Church into a servant of the State. Convinced that churchmen must serve "the supreme state power"[20] in the same way as soldiers and civil servants, Prokopovich drafted the famous Ecclesiastical Statute of 1721, which made the Church, whose Patriarch had once dared to consider himself the Tsar's equal, into another branch of Russia's civil government. A Holy Synod supervised by a high-ranking army officer now ruled the Russian Church and made it an instrument of the autocrat's policies.[21] The Church's days of hurling anathemas like thunderbolts against those Russians who dared to place reason before belief now were past.

To enter the European world that the Church's loss of authority opened for them, the Russians had to emulate Western manners, customs, and culture. Peter made clear in 1718 the course he expected his courtiers to follow, when he gave orders that *The Mirror for Honorable Youth* be written to instruct young Russians how to sit at table, use a knife and fork, and converse in polite society. Russians in those days had to be told not to blow their noses with their fingers or spit on the floor at the social gatherings that Peter required them to attend. At these *assemblées,* St. Petersburg's aristocrats danced the minuet, played cards, and engaged in polite conversation. On other occasions, they entertained guests at dinners served by pages who strutted proudly in elegant uniforms while orchestras played the music of Purcell, Lully, and Monteverdi. Prince Menshikov's palace on Vasilevskii Island served as a center of this new European world on the Neva and so did that of Peter's wife, Catherine, the Lithuanian peasant who would take his place as Russia's autocrat when he died in 1725.[22] The stage seemed set for transforming all of Russian life, even though the thin veneer of westernization that Peter had imposed still overlay centuries of Muscovite cultural and artistic experience. Whether the veneer could be thickened to prevent Old Muscovite culture from breaking through from beneath remained a question to which no one dared to respond at the time of Peter's death.

For the next several years, it seemed that the Old Muscovite world might triumph after all, for when the Empress Catherine I chose to follow the course her husband had set, the grumbling among her courtiers deepened. No matter how much they might have enjoyed the pleasures of European life, Russia's lords complained bitterly about the huge sums it cost to live in St. Petersburg. In earlier times almost every family at court had at least one estate in the vicinity of Russia's old capital in order to have food and supplies within easy reach of their Moscow townhouses. Now the expense of shipping those necessities over the hundreds of miles that separated their estates from St. Petersburg imposed a

burden that Russia's high aristocrats resented beyond all imagining. When Catherine died in 1727, her successor, Peter II, gave Russia's nobles their wish and returned the capital to Moscow. Was Russia about to return to the old ways of life she had so recently set aside? Or had the secular revolution advanced too far to be reversed? In 1728, no one could estimate just how resilient the veneer of westernization had become. Nor could anyone judge the strength of the traditional cultural forces that lay trapped beneath its surface. It would not take long for both questions to be answered, and the Russians' response would shape their nation's artistic experience for all time to come.

Although historians often have painted the court's return to Moscow as a triumph for the culture and society of Old Russia, it in fact did little to restore the old ways, for Peter II's courtiers devoted even more time and attention to living in the European manner once they had been freed from the high costs of life in St. Petersburg. Young lords and ladies now concentrated on acquiring European fashions, learning Western manners, and sprinkling their conversations with French and German phrases. Life in Amsterdam, Vienna, and London became their models, and that meant that they, like everyone else in Europe, followed the lead of the French court at Versailles. Seeing in European life only something to be imitated, such people had not yet sensed the broader cultural meanings of the lifestyle with which they had become infatuated. But in less than fifty years portraits would have replaced icons, chronicles and lives of saints would have yielded pride of place to novels, and European fashions would have created a liberated style of life that the men and women who had worn floor-length kaftans in the days of the first Romanovs could not have imagined.

By the time Peter II died unexpectedly at the age of fourteen at the beginning of 1730, young Russians' infatuation with things European had become so intense that Prince Antiokh Kantemir, a friend of Prokopovich and a diplomat-turned-poet-and-essayist, penned caricatures of them in his first satirical portraits. Living only for fashion and convinced that anything European surpassed everything Russian, Kantemir's powdered young fops and overdressed coquettes stood on the verge of becoming foreigners in their own land. Their belief that the life of Europe must be copied slavishly and uncritically placed the arts in Russia in a sort of limbo, for the secular revolution could begin to transform literature, music, and painting only after its cultural precepts had been integrated into Russia's national experience. In the meantime, Kantemir's satires, written in French because written Russian still lacked the versatility to convey subtle nuances, would be published first by a London printer. A Russian edition would not appear until 1762.[23]

Certain that the close contact with the culture and technology of Europe needed to sustain Russia's secular revolution could not be maintained from the remoteness of landlocked Moscow, Peter II's cousin and successor, the Empress Anna, moved Russia's capital back to the banks of the Neva at the beginning of 1732. Once again, Western palaces and government buildings shone as symbols of the new Russia, in which European fashions, manners, and luxury goods

shaped the lives of the upper classes. Yet the transformation from a culture of physical objects to one of feelings and higher thoughts could not be accomplished overnight. It would take several more decades before literature, music, and painting reflected the Europeanized physical world that the secular revolution had brought into being and more time still for the Russians to produce operas, paintings, poetry, and novels that equaled those of their European mentors.

Although Europeanized in a superficial sense, the crudely derivative culture of the Empress Anna's court allowed the grotesqueries of Old Russia to break through far more often than those who followed the ways of Europe might have wished. Observers noted that "Italian and German comedies pleased [the Empress Anna] extremely" and that the court saw its first Italian opera midway through her reign. Yet Anna also dedicated each anniversary of her accession to Bacchus and insisted that her courtiers become properly drunk to celebrate the occasion. Just as in the days of Ivan the Terrible, jesters remained a part of court life long after they had disappeared in the West, and Anna had no fewer than six, four of whom she chose from the ranks of Russia's most ancient noble families.

Russia's new Empress had a long history of supplementing European entertainments with dwarfs, who suffered from an array of sad afflictions, and she used them to relieve the awkwardness that some of her court still felt in the European world that was taking shape around them. "The mere sight . . . was enough to provoke laughter," one guest wrote about a wedding of dwarfs whose "comical capers, strange grimaces, and odd postures" crowned the festivities that had celebrated Anna's nuptials in 1710.[24] Nor were comically dressed dwarfs the only excursion the Empress allowed herself to make into the crude forms of entertainment that had once been common at the court of Old Russia. Toward the end of her reign, Anna had a small palace built entirely of ice to celebrate the wedding of her jester Prince Golitsyn to the peasant woman she had chosen to be his bride. Built on the frozen surface of the Neva River, the Ice Palace became the ultimate expression of the grotesque mixing of European life and Old Russian humor at Anna's court. At the Empress's invitation, guests arrived in sleighs pulled by reindeer, hogs, goats, and oxen to watch the unhappy couple be placed in a wedding bed carved from ice in an icy chamber in which they were locked to spend the winter's night.

Despite such harkings to the Old Muscovite past, the trappings of European life inevitably followed once the Russians began to live in European settings. European palaces required European furniture. Ballrooms made it necessary to learn the minuet, and the minuet required European music, just as dining in the European manner created the setting for European orchestras. In the days of Peter the Great, games of cards and chance had dominated St. Petersburg's *assemblées*, but by the end of Anna's reign in 1740 polite conversation had begun to take their place. Especially at court, the preconditions for an artistic experience that followed the path of modern Europe were well in place when Peter the Great's daughter Elizabeth mounted the throne in 1741, and from that broadening base the Russians began to create literature, music, and art on the model of

Europe's masters as the eighteenth century passed its midpoint. In this new setting, the secular revolution's emphasis on individualism began to shape Russia's artistic experience in new and striking ways. Once innovation began to count for more than tradition, the products of individual creativity replaced works of literature and art produced by monks who believed that the hand of God guided their brushes and pens. As painters and writers emerged from the anonymity that had surrounded them in earlier times, the Russians began to celebrate artistic accomplishment as a fruit of human creativity rather than a gift from God.

Founded by the Empress Anna in 1732, the Aristocratic Infantry Cadet Corps (with a student body of somewhat over two hundred) provided the first formal setting in which the Russians pursued their new passion for the art and lifestyles of Europe. Here young men from the families most closely linked to Peter the Great's efforts to transform Old Russia learned German, French, dancing, fencing, and music—the subjects that formed the core of an aspiring courtier's education anywhere in Europe—and developed a sense of themselves as a cultural elite.[25] Yet their example was not followed by many of Russia's lesser aristocrats, most of whom continued to be ignorant and unlettered. Considerably fewer than one out of every thousand Russians was in school when Anna came to the throne in 1730, and the number of men and women who read for amusement or edification was so small that no more than three hundred titles (not counting laws, official regulations, books on religion, and calendars) were published during the entire second quarter of the eighteenth century. Many more primers were published in the Old Slavonic alphabet than in the new orthography that Peter had introduced for the purpose of making secular books more usable, and as the 1730s progressed it seemed that some of the ground gained during Peter the Great's reign was being lost. If the Russians were beginning to look more like Europeans, the tiny number of readers and the crude entertainments that Anna's court enjoyed from time to time showed that many of them still thought and felt like men and women from an earlier, Muscovite age.[26]

Before the reign of the Empress Elizabeth, it was rare for any secular book to be printed in more than a thousand copies, and even *The Mirror for Honorable Youth* sold barely more than 250 copies a year during its first half-decade in print. Once described as "the largest single infusion of western literature into . . . Russian culture up to that time," the translations of the librettos of thirty-eight Italian operas that Anna commissioned in the mid-1730s appeared in printings of a scant hundred copies each, and the first Russian translation of *Aesop's Fables* sold fewer than sixty copies a year.[27] Translations of the European novels that acquainted Russia's upper classes with the broad panoramas of daily life needed to become truly Europeanized still stood more than a decade away in 1740, and the first Russian novel did not appear until 1763.[28] For the upper classes, a transition from the Church-centered life of Old Moscow to the materialist experience of Western Europe was under way, but it had yet to acquire the depth that could yield paintings, literature, and music that were more than crude imitations of poorly understood European models. At the same time, the masses remained

firmly positioned in the mainstream of Old Russian culture, where they remained for another two hundred years. Among the common folk, superstition, ancient beliefs, and time-honored traditions still defined a world that stood as far from the frontiers of rationalism and secular thought as the France of Louis XIV had stood from Charlemagne's Holy Roman Empire.

Archbishop Feofan Prokopovich, who had organized the so-called Learned Guard of men dedicated to bringing European ideas to Russia during the uncertain days after the death of Peter the Great, was the first to take up the awesome task of shaping an intellectual base for Russia's secular revolution. Although he coined the term "Imperial Russian" to describe the new men and women whom the secular revolution had brought into being, Prokopovich held them in low esteem and thought that their debased nature made it essential that any sovereign who reigned over them be an absolute monarch. He insisted that only secular education could lead Russians into the modern world, and as the author of a *Primer* from which his countrymen would draw their basic moral and religious precepts for the next century, he led the way in shaping the contours of Russian thought until his death in 1736.[29]

The two men who helped Prokopovich form the Learned Guard played only slightly less illustrious parts in shaping the intellectual life of Russia during the decade after Peter the Great. Vasilii Tatishchev and Antiokh Kantemir both defended the secular revolution and urged Russians to move closer to the West in the arts and sciences. Tatishchev wrote the first great secular history of Russia (although its first volume did not appear in print until 1768), and his famous *Dialogue on the Value of Learning* helped to introduce those who shaped Russian letters during the Age of Elizabeth to the corpus of modern European thought. A quarter of a century younger than Prokopovich or Tatishchev, Kantemir defended the secular revolution in poetry and satire but died at the age of thirty-six before he could fully make his mark.[30] All three understood that Russian letters could not follow the path of Europe without a modern literary language, and each saw in the autocrat a patron who could bring Russian art and thought firmly into the modern world. "The perfection of the Russian language, its purity and beauty," Tatishchev explained, was the key to shaping a true national consciousness in Russia.[31] To lead the way in that vital enterprise, he looked to the Academy of Sciences that the Empress Catherine I had opened in St. Petersburg just a few months after Peter the Great had breathed his last.

A long-cherished dream of Peter the Great, the Russian Academy of Sciences began in 1725 as an enterprise in which Germans educated Germans at the expense of the Imperial Russian Treasury. For advice on choosing its founders, Peter had turned to Christian von Wolff, the philosopher, scientist, and close colleague of the renowned Prussian philosopher Leibnitz, who had urged that the first men to be granted full membership be brought in from the West. Although too many of these early academicians used their appointments only to win sinecures for friends, a few left a lasting impact upon Russia and the Russians.[32] Thanks to the decade he spent with the Academy's Great Northern Ex-

pedition in the 1730s, Gerhard-Friedrich Müller, the Westphalian scholar who outlived seven Russian autocrats, continues to be remembered as the father of Siberian history, and the mathematicians Hermann and Eyler both enjoyed wide respect among their contemporaries in Europe while they lived and worked in Russia.[33] Such men helped to guide the Academy toward the brighter future in which it eventually became the arbiter of language that Polotskii and Tatishchev had envisioned.

Although its scholars were German, as were its students until 1735,[34] the Academy of Sciences broadened the intellectual base of Russia's secular revolution as its growing corps of translators produced the first editions of modern European fiction for the Russians. Such work was a passion for Vasilii Trediakovskii, a poet and professor of rhetoric during the Age of Elizabeth, who understood that modern Russia must have a literary language. Certain that vernacular Russian could be made to express all the new ideas and learning that Russia needed to acquire from Europe if only it could be properly developed and standardized, Trediakovskii asked why Russians preferred "the barrenness and narrowness" of European languages over their own.[35] To prove the "richness, strength, beauty, and pleasantness" of Russian, he translated Paul Tallemant's *Lycidas's Voyage to the Isle of Love*, which became the first work of modern fiction ever to be published in Russia.[36] Even though the *Voyage*'s sexual overtones shocked some of Russia's handful of readers when the book appeared in 1730, Trediakovskii's language remained stiff, artificial, and too often archaic because he tried to bend modern Russian to fit Latin syntax.[37] A way had to be found to give literary Russian a form that would reflect the fluidity of modern speech. When Trediakovskii failed, the task fell to Mikhail Lomonosov, the son of a peasant who had grown up on the distant shores of the White Sea in Russia's Far North, who became the first Russian to be granted full membership in the Academy of Sciences.

Lomonosov shared Trediakovskii's intense linguistic patriotism but tried to create a modern literary language in a different way. A prime product of Peter the Great's secular revolution, he had become one of the very first Russians to study at the Academy of Sciences and had gone on to the universities of Marburg and Freiburg in Germany, where he had specialized in chemistry, mining, and metallurgy. While he studied science, Lomonosov also experimented with mixing contemporary Russian speech and Old Church Slavonic to produce the modern literary language Russia needed. "To create a written Russian language that could express the widest possible range of ideas called for a genius," his first biographer explained on the eve of World War I. "That genius," he concluded, "was Lomonosov."[38]

Not long before his twenty-eighth birthday, Lomonosov sent a lengthy criticism of Trediakovskii's work to the Academy of Sciences along with an ode he had written to illustrate how his own views could be applied to writing Russian poetry. "Everyone read [Lomonosov's ode] and was amazed," one of the academicians remembered. "We were very much surprised," he added, "at this meter

of verse, which had never before existed in the Russian language."[39] In contrast to Trediakovskii, who called for all foreign words to be eliminated from Russian, Lomonosov proposed to remove only those superfluous "wild and strange words, those absurdities, which have come to us from alien languages."[40] Russian, he promised, possessed "the majesty of Spanish, the vivacity of French, the firmness of German, the delicacy of Italian, and the richness and concise imagery of Greek and Latin," adding that "the most subtle philosophical speculations and concepts . . . all find in Russian appropriate and expressive terms. If something should be found incapable of expression," he concluded, "the fault is not that of the language but of our own incapacity."[41]

Perhaps even more important than his efforts to create a literary language, Lomonosov eventually codified proper spellings and set down rules of speech in what became modern Russian's first grammar. Nearly a century passed before his famed *Russian Grammar* was improved upon, and his textbook on rhetoric also became the first of its kind. "I cannot rejoice enough that our Russian language not only does not lack the vigor and heroic tone of Greek, Latin, and German but that, like them, it has its own natural and peculiar genius for versification," he wrote while still a student at Freiburg.[42] His writings on language made it possible for other Russians to prove the truth of that statement in the first flood of poetry, plays, and novels that poured forth to adorn the ages of Elizabeth and Catherine the Great.

But Lomonosov was more than a translator, linguist, and patriot. "Historian, rhetorician, specialist in mechanics," the nineteenth-century poet Pushkin once wrote, he was also "chemist, mineralogist, artist, and poet" all rolled into one.[43] Lomonosov dreamed of the day when "a Russian Academy comprised of the sons of Russia" would come into being, and promised that "Mother Russia can give birth to her own Platos and acute-minded Newtons."[44] As Russia's first Renaissance man, he personified the new forces of art and intellect that the secular revolution had brought into being. In the Age of Elizabeth, he and his contemporaries would produce poetry, painting, and music demonstrating that Russia's fine arts, as products of its artists' responses to the world around them, had finally become a part of the modern, materialist world.

# THE AGE
# OF
# ELIZABETH

*DRESSED IN THE CUIRASS* of an imperial guardsman and holding a silver cross as she rode at the head of 360 Preobrazhenskii grenadiers, Peter the Great's daughter Elizabeth seized the Russian throne on the night of November 25, 1741. Her daring act cut short the intrigues of the foreign advisers in whose hands her cousin, the Empress Anna, had placed Russia's destiny when she had died the year before, and it ushered in the first era of stability that the Russians had known in more than seventy years. For men and women whose parents and grandparents had suffered the soul-shaking torments of the Great Schism in the church, endured the turmoil of Peter the Great's secular revolution, and had themselves struggled through the upheavals that had brought five sovereigns to their country's throne in the sixteen short years since Peter's death, the Elizabethan Age would offer a chance to come fully to grips with the new ways of life that had been thrust upon them. In politics, war, and trade, and in their tastes in manners, fashions, and culture, the Russians of Elizabeth's time would become more European than ever before.

Pious, fun-loving, and sensual—and dedicated to her father's belief that her people needed to follow the path of the West—Elizabeth would make Russia a European power in every sense. Between 1741 and 1761, her diplomats would play a key part in reshaping the alliance system of the West, and her armies would fight all the way from Russia's western frontiers to the gates of Berlin. At the same time, the ways of Europe would begin to become an integral part of upper-class Russian life. Perhaps because the way to the future had at last started to become clear—or perhaps because the present simply seemed more sure and

certain—upper-class Russians began to derive genuine pleasure from the Western world of arts and letters of which they were becoming a part. For them, Elizabeth's reign became a time of celebration and exuberance, in which the stern religiosity of Muscovite times and the single-minded practicality of the Petrine era would give way to concerns about extracting creature comforts and cultural pleasures from days and nights lived almost entirely in the here and now.

Nothing reflected the exuberance of Russia's Elizabethan Age more dramatically than the changing face of St. Petersburg, and no one played a greater part in bringing that about than the gifted Florentine architect Bartolomeo Francesco Rastrelli. Between the accession of the Empress Anna in 1730 and the death of Elizabeth thirty-one years later, Rastrelli transformed Russia's new capital from a collage of huts and palaces into the sparkling city that became the Palmyra of Europe's North. More than a score of the city's greatest buildings bore the stamp of his genius, and dozens more showed the impact of his influence on other builders. Parks, squares, townhouses, palaces, cathedrals, and even artfully constructed ruins all owed their beginnings to this builder, whom the Empress Elizabeth praised above all others. Except for Bernini in Rome, no architect ever had a greater opportunity to shape the character of a city, and no one ever produced a more dazzling result.

Rastrelli built his first palace just before he turned twenty-one and was not quite thirty-five when he finished the "third" Winter Palace, in which the Empress Anna celebrated her forty-first birthday in January 1734. Although the bulging mansard roof and lumpy façade that resulted from incorporating several smaller buildings into a larger one made its exterior less than perfect, the grand staircase, great hall, theater, and apartments of state that he designed in the Baroque style for a monarch whose tastes had been shaped by the two decades she spent as the Duchess of Courland produced an unprecedented triumph. For the Empress's birthday, the architect decorated the palace's 180-foot-long Great Hall with myrtles and orange trees that had been nursed to full bloom in specially built hothouses to create a magical springtime in the dead of winter. "The beauty, fragrance, and warmth of this new-formed grove, when you saw nothing but ice and snow through the windows, looked like enchantment," the English ambassador's wife wrote to a friend. "The walks and trees," she explained, "made me fancy myself in a Fairy-land."[1] Here the Empress lived on a scale that surpassed all others in her empire as she began to assemble the treasures of art, architecture, and literature that would make the Romanovs the most lavish patrons of the fine arts in Russia's history.

What Rastrelli accomplished during the decade of Anna's reign proved to be but a modest prologue to the architectural gems he created for her successor, whose patronage carried him across the line that separates men of talent from artists of genius. For the Empress Elizabeth he built churches and palaces, and scattered pavilions, hermitages, and grottoes around them. He planned many of

the great celebrations for which her reign became famous, and he created breath-taking interiors that blazed with mirrors and gold-leafed Rococo decorations. At the Catherine Palace at Tsarskoe Selo, he paneled an entire room with the exquisite amber panels that the King of Prussia had traded for fifty of Peter the Great's tallest Preobrazhenskii grenadiers. Elsewhere he catered to the Empress's passion for chinoiserie by covering walls with watered silk set off by lacquer paneling. Perhaps responding to the Russians' age-old passion for color, Rastrelli painted the stucco of these buildings in almost every shade of the rainbow, using orange, pistachio, pink, and gray-green with a flair, and coloring the walls of his Smolnyi Convent in brilliant turquoise set off by white. Whether large or small, each of his buildings radiated the gaiety that Elizabeth brought to Russia's court. In Rastrelli's brilliant creations, Russia and the West blended into a Russian Baroque, the scale, exuberance, and color of which set it apart from every rival in Europe.[2]

Soaring above the exquisite townhouses and palaces that Rastrelli built for such magnates as the Stroganovs, Naryshkins, and Razumovskiis towered five architectural monuments that he created especially for the Empress, who became his greatest patron. The first of these was a summer palace in the center of St. Petersburg, not far from where the Fontanka River flowed into the Neva. One of the city's favorite landmarks until the Emperor Paul I tore it down to make room for his gloomy Mikhailovskii Castle in 1797, St. Petersburg's Summer Palace delighted Russians and foreigners alike with its pale pink wooden walls, which glowed against the background of the elaborate park with which Rastrelli had surrounded it. Artfully placed sculpture and fountains created a sense of enchantment, especially during the summer's white nights, when more people than could dance at Versailles swirled around its ballroom floor in the ethereal glow of the midnight sun and a thousand candles.[3] A French diplomat remarked toward the end of Elizabeth's reign that the "beauty and sumptuousness" of this palace "were much to be wondered at."[4] Even in the more elegant, less exuberant days of Catherine the Great an English visitor still thought it "a truly delightful residence."[5]

After completing the Summer Palace in 1744, Rastrelli turned his attention to St. Petersburg's suburbs. Starting at Peterhof in 1747, he began to transform the intimate country palace that Michetti had created from Le Blond's designs into a breathtaking masterpiece that fairly shimmered with Baroque splendor. To Michetti's artfully conceived beginning Rastrelli added two low-lying wings, each nearly two hundred feet in length, at the ends of which he placed pavilions whose gilded onion-shaped cupolas evoked memories of Aleksei Mikhailovich's palace at Kolomenskoe and gave the first hint of the extravagant Baroque reinterpretation of Old Russian forms that would influence the structural fabric of his Smolnyi Cathedral a decade later. Set on the site that Peter the Great himself had chosen, Peterhof became an Italian's homage to the spirit of Old Russia and the genius of Le Blond and Michetti, as well as a monument to the dynamic

prince whose secular revolution had opened the way for the exuberance of his daughter's reign. Peterhof's fountains rivaled those of Versailles and contained much more gold. Until that time, no one in Russia had seen anything like it.[6]

While some of Rastrelli's best craftsmen worked at Peterhof, others began to transform the small suburban palace at Tsarskoe Selo that had sheltered Elizabeth during most of Anna's reign. In a region scourged by cholera almost every summer, the pure water and woodland vistas of Tsarskoe Selo had drawn the future Empress Catherine I there in 1717, when she had commissioned the architect Johann Braunstein to build the small wooden house that would appeal to Peter the Great's love of enclosed spaces and things Dutch. Peter and Catherine spent some of their happiest moments there during the last years of their lives, and when their daughter Elizabeth inherited it she quickly grew to share her parents' feelings.

At Tsarskoe Selo, the twenty-year-old Elizabeth sought refuge during the difficult brief reign of her nephew Peter II and the decade during which her cousin Anna sat on Russia's throne. Especially as the childless daughter of Peter the Great's half-brother Ivan V, Anna dreamed of keeping Russia's crown out of the hands of her uncle's descendants. For that reason she had passed the throne on to an infant nephew named for her father, and had entrusted his safekeeping to the hands of regents chosen from among her German favorites. Feared as a rival by everyone who sat upon Russia's throne between 1727 and 1741, Elizabeth had therefore stayed in the seclusion of her parents' rural retreat at Tsarskoe Selo, where she was not a constant reminder that another candidate for the crown was alive and well during the reigns of an irresponsible adolescent, a widowed, childless Empress, and an infant surrounded by a clique of squabbling foreigners.

After Elizabeth seized Russia's throne in the fall of 1741, she assigned the task of transforming her parents' country house at Tsarskoe Selo into a summer palace to a succession of architects, none of whom succeeded in pleasing her. When the brick palace built during the first decade of her reign fell short of her dreams, she turned to Rastrelli, who razed much of what had been done and began again on a grander, loftier scale. To satisfy his Empress's extravagant tastes, Rastrelli built a palace that was nearly a fifth of a mile long, festooned its exterior with Rococo decoration, gilded all of the capitals, pilasters, window pediments, and statuary, and set off its yellow (now turquoise) walls with shining white columns.[7] The palace's 156-foot-long Grand Hall blazed with gilt, and in the evening the light of fifty-six chandeliers gleamed in the mirrors with which its builder had filled the spaces between its huge French windows.

In the best Baroque manner, Guiseppe Valeriani (from Rome) and Antonio Peresinotti (from Bologna) painted the eight thousand square feet of the Great Hall's ceiling with an allegorical scene that showed Russia enjoying the bounties of civilization. Nothing in Europe could equal the Amber Room that Rastrelli designed for birthday parties and intimate receptions, where a ceiling painting by the distinguished Italian artist Francesco Fontebasso complemented the rare

carvings that master craftsmen from Berlin had cut into the amber panels that covered each wall. The furniture was so exquisite that even Elizabeth's hard-to-please successor Catherine the Great allowed it to remain almost entirely intact when she set out to transform the interiors of the palace from Baroque to neoclassical in the 1770s.

Completed in the mid-1750s, the Catherine Palace, which sparkled so brightly in Russia's sunlit northern woodlands, fairly bubbled with the gaiety that Elizabeth so adored. To many who visited it, Rastrelli's creation proved that Russia had become a part of Europe, and Lomonosov emphasized that fact by calling it "the Russian Versailles."[8] Yet Rastrelli's uniquely Russian version of the Baroque showed that the influences of Europe could not remain in Russia unscathed and that the Russian artistic experience would always transform in some special way whatever art and literature its practitioners acquired.[9] Eventually, that transformation produced the fiction of Dostoevskii and Tolstoi, the poetry of the Silver Age, and the brilliance of the Ballets Russes, all of which raised the arts of Europe to a newer, higher plane.

Together, Rastrelli and Elizabeth scattered grottoes and elegant pavilions throughout the hundreds of acres of woodlands that surrounded the Catherine Palace. Marble statues done by the masters of seventeenth-century Italy clustered in groves, nestled in glades, and stood along carefully laid-out walks. Bridges and bowers, and a huge lake upon which Russia's rare naval triumphs would be reenacted, all added new dimensions to the palace gardens, which Elizabeth's successors would reshape according to their whims in years to come. Catherine the Great added a Chinese village, Alexander I dedicated a triumphal arch to his "dear comrades-in-arms" after they had defeated Napoleon, and Nicholas I built Turkish baths in the Moorish style. Not far away, in the woodlands that became the grounds of the Alexander Palace at the beginning of the nineteenth century, Russia's last Tsar, Nicholas II, would fill the empty days of his imprisonment, during the winter, spring, and summer of 1917, in chopping and stacking wood.

Nestled in a natural hollow at the far end of the park's central *allée* stood one of Rastrelli's greatest miniature masterpieces. Designed for intimate gatherings, this Hermitage became known all over Europe for its dining room, in which a table fixed to the floor was equipped with a series of lifts that removed all of the plates and serving dishes and replaced them with ones holding the next course whenever the host or hostess gave the proper signal. If the Empress wished to entertain her guests after dinner, the table sank beneath sections of parquet that transformed the salon into a miniature ballroom. In a symbolic and technological sense, nothing could have shown more dramatically the distance Russia had traveled since Elizabeth's grandfather Tsar Aleksei Mikhailovich had built Polotskii's "eighth wonder of the world" at Kolomenskoe less than ninety years before.[10]

Beyond the Hermitage, Rastrelli built pavilions at which intimate suppers could be served in the open air while Elizabeth's lords and ladies rested during

promenades or after hunts. Once described as "the quintessential late Baroque monument in Russia,"[11] the most dazzling of these was called Mon Bijou and stood in the center of the Tsarskoe Selo game preserve. Originally built as a hunting lodge in the days before Elizabeth became Empress, Mon Bijou stood in the midst of a small formal park that had been carved out of the wilder lands around it. Rastrelli transformed it into a sea-green forest gem of such splendor that even Catherine the Great's efforts to mute the exuberance of her predecessor's Baroque left it untouched. In the nineteenth century, Mon Bijou was not so fortunate. In the 1830s, Russia's "iron tsar," Nicholas I, demolished it to make way for a pseudo-Gothic casteletto of red brick that housed his massive collection of medieval and Renaissance arms and armor.[12]

One might be tempted to remember Rastrelli only for his lighterhearted creations at Tsarskoe Selo, Peterhof, and the Summer Palace in St. Petersburg, were it not for the last two monuments he built for his vivacious and exuberant Empress. As she crossed the threshold of middle age in the late 1740s, Elizabeth became more devoted to the Church and set in motion plans to build St. Petersburg's first convent. Sharing her father's predilection for building in unlikely places, she assigned two thousand soldiers to drive fifty thousand pilings into the marshy ground that surrounded the storehouses in which the Imperial Admiralty had stored its tar on the Neva's mainland bank since the days of Peter the Great. Once they had transformed the site into solid ground, she named it Smolnyi and ordered Rastrelli to build there a complex of buildings that would include a bell tower at least twice the height of Moscow's Bell Tower of Ivan the Great, a convent, and the brilliant turquoise Baroque cathedral that became one of his greatest masterpieces.

Because of the immense cost, Rastrelli's bell tower at Smolnyi would never be built, and the cathedral's interior would not be finished until almost a century after he drafted his first plans. But the exterior of the cathedral and convent (which Catherine the Great transformed into a boarding school for the daughters of Russia's aristocrats) proved to be more than enough to win him credit for having built the city's most beautiful religious ensemble. So dramatic was Smolnyi's effect that Giacomo Quarenghi, an architect who served Catherine the Great and shared her distaste for the Baroque, reportedly used to remove his hat each time he passed it and exclaim: "There is a *real* cathedral!"[13]

Rastrelli's greatest monument to Russia's Elizabethan Age stood in a class by itself apart from his cathedrals, chapels, and vivacious summer palaces. In 1754, he began to build the "fourth" Winter Palace to replace the "third," which he had created twenty years before. This Winter Palace was to be the last, destined to survive into the present as Russia's great Hermitage Museum. From its main gate Alexander I would march forth against Napoleon in 1812, and from the balcony overlooking its square, Nicholas II would summon his people to march against the armies of Imperial Germany and the Habsburg Empire in 1914. To the survivors of the Bloody Sunday massacre, when the Tsar's soldiers shot more than five hundred workers on January 9, 1905, the Winter Palace stood as a sym-

bol of tsarist oppression. This was the citadel of Romanov power that Bolshevik Red Guards would "storm" in October 1917, an event that the Soviet filmmaker Sergei Eisenstein would immortalize at the end of his unforgettable *October*, better known in the West as *Ten Days That Shook the World.*

During the last six years of her life, Elizabeth centered all her passion for building upon this greatest of her enterprises, and it became a rare opportunity for Rastrelli to redo an earlier work that had reflected his lack of experience and the limited funds that the Empress Anna had placed at his disposal. Planning extravagantly and working opulently, he now shaped each of the Winter Palace's huge façades in a different way, and ornamented them with shining white columns, high-relief sculptures, and gilded statues on the roof. He painted the walls a shining turquoise and stretched them along the Neva River embankment for more than 650 feet to create a palace that enclosed nearly a quarter of a million square feet of ground, had 1,054 rooms, and boasted several times that many windows. As his greatest creation, the Winter Palace was a gem for which any sovereign ought to have paid generously, yet Elizabeth's successor did not. When Rastrelli finished the imperial apartments a few months after her death, the new Emperor, Peter III, granted him the rank of major general but offered not so much as a single ruble to ease the aging architect's retirement. When asked the reason, Russia's new Emperor reportedly said that he simply wanted the money for himself.[14]

Although Rastrelli's preeminence sometimes eclipsed their work, other architects produced striking buildings during Russia's Elizabethan Age. Savva Chevakinskii combined tradition and innovation with such brilliance in St. Petersburg that his Cathedral of St. Nicholas became "one of the most sublime monuments of the Russian Baroque" and the only Baroque church in the capital that could rival Rastrelli's ensemble at Smolnyi.[15] In Moscow, Chevakinskii's counterpart was Dmitrii Ukhtomskii, who built everything from lower-class "eateries" and fire stations to bridges, palaces, and churches because his clients had not the means to allow him to work only in Rastrelli's unrestrained grand manner. Some of Ukhtomskii's students eventually made Moscow second only to St. Petersburg in the brilliance of its new buildings, while others went on to build in the European style in Kiev, Novgorod, and a dozen other cities. By the middle of the century, the architectural revolution that Peter the Great had set in motion had crossed the Urals. By the time of Elizabeth's death in 1761, it had spread well into Siberia as the upper classes left the world of Old Russia behind and entered the Age of Louis XIV.[16]

As buildings of European design rose all across the Empire, the new way of life for which they stood spread across Russia as well. Cuisine, fashions, and manners all began to reflect the new European settings in which Russia's upper classes lived, and, as the heavy soups and such Old Russian delicacies as cold roast pig soaked in sour cream gave way to the cuisine of Western Europe, the scope of Russia's westernization broadened. Elizabeth's weakness for the partridge and truffle-filled pâtés of Périgord that her ambassador sent from Paris

was widely known, and her love of sweet champagnes and rich desserts, one observer noted, obliged her figure to "run many risks."[17] Nonetheless, she replaced the table-bending medieval banquets of her Muscovite ancestors with foods that were artfully prepared and strikingly presented. To a favorite chef she once gave the rank of brigadier general and wages that amounted to hundreds of times what an average serf family earned in a year, and she replaced the raw vodka that her father had offered as toasts at state dinners with fine Tokay and the wines of Bordeaux and Champagne. Ready to enjoy all the pleasures that Europe produced, Elizabeth saw more to life than the prayers that had filled the days of her ancestors or the practical concerns of statecraft that had dominated the life of Peter the Great. Some of her fetes cost in the tens of thousands of rubles, but she borrowed more and entertained as she liked. The court of Russia, she maintained, must stand with any in Europe.

As extravagant receptions and elegant dinners opened new pathways to success, Elizabeth's courtiers hurried to follow her example. Count Petr Shuvalov became the envy of St. Petersburg society for being the first to serve pineapples at one of his dinners, and others vied for acclaim by introducing their guests to oysters, bananas, and other delicacies not previously served in Russia. Before he rode away in the company of half a dozen French chefs to take up his new post as Hetman of the Ukrainian Cossacks, Count Kyril Razumovskii, brother of Elizabeth's favorite and president of the Academy of Sciences, ordered a hundred thousand bottles of French wine, sixteen thousand of which were the best champagnes, and others followed his example on a smaller but growing scale. Sugar replaced honey on aristocrats' tables, and tea began its rise to become the national drink of Russian aristocrats, although the samovar industry did not get fully under way until the 1770s. The very fact that social standing could be measured by culinary successes showed how much the values of the Elizabethan Age had changed from those that had ruled Russia fifty years earlier. Peter the Great's pragmatism had given way to an exuberant love of luxury that transformed extravagance from a vice into a virtue.

If the opulence of Elizabeth's court encouraged courtiers to squander fortunes on dinners and wines, her passion for fashion cost even more. She loved silver taffeta, cloth of gold, and hand-embroidered silks trimmed with silver lace and would sometimes require all her ladies-in-waiting to dress in a particular style on a moment's notice. It was said that Russia's ebullient Empress never put on the same dress twice, and she was known to change her gown as many as three times in the course of a single ball. Even though a fire destroyed four thousand of her dresses in 1744, she still left fifteen thousand more at her death seventeen years later. Such extravagance found willing practitioners so long as the Empress provided the gifts and loans needed to pay the cost. Her lover (and, some said, husband) Aleksei Razumovskii wore buckles, buttons, and epaulets set with diamonds, and when he set off to command Russia's armies at the beginning of the Seven Years' War, Field Marshal Count Apraksin had to comman-

deer five hundred horses to carry his baggage. Apraksin went to battle with a jeweled snuff box in his luggage for every day of the year, and Count Sergei Naryshkin, one of the Empress's relatives, was said to have spent nearly thirty thousand rubles (equal to the entire yearly allowance of the grand Duchess Catherine) on a single carriage. As a young Grand Duchess, Catherine the Great clucked disapprovingly at the extravagance she observed at Elizabeth's court. When she became Empress, she spent even greater sums on her own fashions and favorites.[18]

No amount of wealth squandered on fashion and cuisine in the middle of the eighteenth century could make life at court entirely comfortable, for, although palaces could be built at impressive speed, their furnishings proved harder to acquire. Medieval Russians had lived with a minimum of furniture, and native artisans in the days of Ivan the Terrible and Peter the Great's father, Aleksei Mikhailovich, had produced little beyond benches, stools, tables, and cots. Beds imported from Germany and Poland had been considered luxuries in seventeenth-century Russia, and Peter the Great had found furniture in such short supply that he had set the carpenters of the imperial navy to work making it during winters and in times of peace. A shortage of European furniture continued to plague Russia's upper classes into the 1760s. Almost none of the great palaces that Rastrelli and his students built along the streets and canals of St. Petersburg had enough furnishings to fill them. Proud owners of new country houses had to use the crude benches and tables left over from the Muscovite era, since European furniture could not be had in the provinces at any price. Even the Empress had to carry furniture with her when she moved from one palace to another. Like the monarchs of Europe, Elizabeth ordered hundreds of carts laden with dresses, plate, china, tables, beds, chairs, and sofas to follow her when she visited Moscow or went to one of the many monasteries and convents at which she liked to pray. Even in St. Petersburg, Russia's Empress had so little furniture that Rastrelli was obliged to design and manufacture most of the furnishings for the palaces he built at Peterhof, Tsarskoe Selo, and St. Petersburg. When the Grand Duke Paul, son of the future Peter III and Catherine the Great, was christened in 1754, Elizabeth had to have her own furniture moved into the couple's apartments for the reception. Then, as soon as the guests had departed, her servants whisked it away.[19]

From the beginning of the Elizabethan Age, aristocratic Russians' taste for Western fashions and furnishings increased the demand for secular art. Interest in modern painting had helped to set the secular revolution in motion at the time of the Great Schism, but Russians did not learn to paint in the oils that were essential for modern portraits until the reign of Peter the Great. As with so much else during the Petrine era, modern painting first attracted Russians on a practical level, and portraits that illustrated the European styles in which successful men and women ought to dress enjoyed the greatest popularity during the first half of the eighteenth century. In a very real sense, portraits of the lords and ladies at the

Russian court—dressed in Western fashions and set against a background of European furnishings—became secular icons through which eighteenth-century aristocrats could perceive the worldly realm in which they hoped to live, just as earlier icons had offered their ancestors brief glimpses into the world of the spirit and the kingdom of God.

Nowhere was this new secular iconography more evident than in the mosaics that Lomonosov produced in the decade before his death in 1765. Taking an art form that had been used almost exclusively for religious themes during the Christian era, Lomonosov produced first a portrait of the Empress Elizabeth and then a huge mosaic of "The Battle of Poltava" that still hangs above the grand staircase in the main building of St. Petersburg's Academy of Sciences. As the first great scientist of Russia's modern age, Lomonosov set out to raise the technology of the West to a higher level in the service of art, and he turned his attention most of all to the problems of shaping modern materials into the ancient mosaic form. Fascinated by the process of coloring glass, he learned to produce particularly intense shades and then used the thousands of tiny bits he had made to create a battlefield portrait of Peter and his generals in colors more intense than any yet known in Europe.[20] For the first time, a Russian had improved upon the technology of the West. Eventually, Lomonosov's countrymen would repeat his performance across the entire spectrum of their national artistic experience.

Yet Lomonosov's mosaics were more an experiment with bringing an ancient art form into the modern world than a serious attempt to transform the methods of Russian art. Just as Byzantine masters had been obliged to teach the techniques of religious painting to the artists of Kiev, Novgorod, and Suzdalia in the Middle Ages, so European masters taught the Russians the techniques of working with oils and pigments. Although Peter the Great had recruited several minor European painters to work in Russia, the first Western artist of note to accept his invitation was Louis Caravacque, a portrait painter from Marseilles, who came to St. Petersburg with the architect Le Blond in 1716. Caravacque first won the Tsar's favor with portraits of his children, especially the future Empress Elizabeth, whom he painted as Venus in the nude at the age of seven. As a Soviet critic later remarked, "there was nothing in any way childlike" in Caravacque's child portraits, for he portrayed the royal children as small adults in the typical manner of the early French Rococo.[21] His work won wider popularity when the Empress Anna commissioned him to paint several portraits and ceiling paintings for Rastrelli's "third" Winter Palace, and, by the time of Elizabeth's accession in 1741, Caravacque had become so popular that the new Empress paid him twelve thousand rubles (five times Rastrelli's yearly salary) to paint her portrait for Russia's twelve foreign embassies. Yet, despite his popularity, Caravacque's work rarely rose above the ordinary. His greatest contribution to the arts in Russia was to train the first generation of Russian-born painters, which included Ivan Vishniakov, Aleksei Antropov, and Ivan Argunov.

The first three Russians who excelled under Caravacque's teaching showed

that the time had come for native artists to replace foreign masters in painting their countrymen, although none had any formal training abroad and all of them began as draftsmen and copyists in the Office of Public Works, which drew up architectural plans for the government. The oldest of the three, Vishniakov, did not begin his studies in art until the age of thirty-two, and like his teacher he first won renown as a painter of children. Although his portraits lacked the depth and complexity of those created by painters who worked a quarter-century later, he won a following at court, especially after the Empress Elizabeth chose him as "the very best" in Russia to paint her portrait for Rastrelli's Summer Palace in 1743. After the middle of the 1740s, Vishniakov devoted most of his time to painting sets for his Empress's theater and decorating the ceilings and walls in her palaces at a yearly salary of five hundred rubles. By that time, younger and more talented men had begun to win greater acclaim. The first to do so was Aleksei Antropov.[22]

Almost twenty years younger than Vishniakov, Antropov rose to fame thanks to the new system that Peter the Great had created to reward merit. The son of a metalworker at St. Petersburg's Armory, he first produced panels and room decorations for Elizabeth's palaces and then went on to paint icons in the style of the late Italian Baroque for Rastrelli's Cathedral of St. Andrei in Kiev. Antropov's fortunes changed after he began to work with Pietro Rotari, the Italian master of Rococo portraiture, who filled the famed Gallery of the Graces at Peterhof with portraits of the three hundred most beautiful women at the Russian court. Combining an iconographer's meticulous concern for detail with Rotari's schooling in painting in the Rococo style, Antropov became a distinguished painter of portraits, but only in the Age of Catherine the Great.[23]

Ivan Argunov, the third of Russia's first generation of native painters, began life as a serf in the household of one of Russia's most famous princes. He then moved to the household of the Sheremetievs as part of the dowry that one of their sons received, and that gave him opportunities to develop his talents that he might otherwise never have had. On their way to becoming prominent patrons of the arts, the Sheremetievs arranged for their new serf to study with some of the best European masters then at work in Russia, and several of the portraits he painted in those days came to rank among the finest to be done in the eighteenth century. Argunov's work showed a faithfulness to the details of face and form that was unusual among the Russians, for he made no effort to hide the wrinkles, unfocused eyes, and double chins of his subjects. Argunov's portraits showed a depth and sophistication that his predecessors' work had not yet acquired. Midway through the reign of Catherine the Great, his brilliant "Portrait of Peasant Girl in Russian National Dress" radiated an intimacy and warmth that none of Russia's earlier painters had managed to achieve.[24]

Like the foreigner Rotari, who had painted peasant girls even as he worked on his portraits of the three hundred most beautiful women at Elizabeth's court, Argunov found in his "Portrait of a Peasant Girl" the subject that would stir the

sensibilities of the upper classes at the end of the century, when clear-eyed and rosy-cheeked peasant women made their way onto Russia's canvases and into its novels. Searching for the elusive peasant "folk" to whom the poet Herder had paid such glowing homage in Germany, such sentimentalist writers as Aleksandr Radishchev would draw from Russia's backwaters the first idealized images of village maidens free of "the pestilence of debauchery," who represented "the beauty of youth in full bloom, smiling, or their lips parted in hearty laughter, showing rows of teeth that were whiter than the purest ivory."[25] Pure of heart and clean of spirit, such simple folk kept alive in Russia's countryside (so "naturalist" critics claimed) the lost virtues that the cities of modern civilization had destroyed.

Like their counterparts in the West, Russia's late-eighteenth-century writers and artists found in the idealized lives of simple country folk a way for the worldly upper classes to regain contact with those emotional treasures of the past that had been lost in the process of embracing modern "civilization." But they did not begin to do so until they could bask in the nostalgia of times fondly remembered without risking a return to their Muscovite past. As the Age of Elizabeth opened, that time of warm remembrances still stood several decades in the future, and the literary language that would make it possible for late-eighteenth-century writers to evoke tender images of idealized peasants was only beginning to take shape. Stiff, archaic, pompous, and complex, written Russian still needed to develop "the naturalness, simplicity and facility of modern French," as one observer explained, without becoming "merely a feeble copy."[26] Not until the Elizabethan Age neared its end did Russia's writers make the common speech of the upper classes into a national literary language that could express all the shades of feeling that lay within the realm of human experience.

Although Trediakovskii, Lomonosov, and the playwright Aleksandr Sumarokov all clashed bitterly over the form that Russia's literary language should take, each shaped the artistic experience of the Elizabethan Age in different ways. The son of a poor priest from the Caspian port of Astrakhan, Vasilii Trediakovskii was the oldest and most criticized of the three.[27] Legend has it that Peter the Great once called him a "lifelong drudge," and his detractors have painted him as a hopeless pedant, whose verse (as a critic wrote not long after the Bolshevik Revolution) was "devoid of all poetical merits."[28]

Both Lomonosov and Sumarokov wrote poetry in a more modern idiom, and thanks to Elizabeth's patronage their plays were performed at the Imperial Theater, while Trediakovskii's remained unpublished until after his death. Catherine the Great so disdained his translation of Fénelon's *Télémaque* (called by some "a byword for all that is pedantic and ugly") that she was said to have punished courtiers who spoke Russian improperly by making them recite a hundred of its lines to remind them of the pompous, bookish, bombastic language she abhorred.[29] Nonetheless, Trediakovskii managed to become the first nonnoble Russian to study the arts in Paris, where he learned to speak French perfectly and to write some bits of poetry that displayed a genuine lyrical quality that was rare in

Russian letters at any time before the middle of the century. His greatest tragedy, one modern critic explained, was that he "spent a lifetime wrestling with the form and spirit of a language not advanced enough to perform as he desired,"[30] and he lacked the insight and inner sense of artistry to determine how to create a modern literary language that was versatile and subtle enough to compete with the languages of Western Europe.

While Trediakovskii's pedantry earned him the scorn of his contemporaries, Lomonosov's greater talents won wider acclaim.[31] In every way a product of Peter the Great's secular age, Lomonosov built the first chemical laboratory in Russia, developed a "corpuscular theory," which anticipated by more than a century those molecular theories that formed the basis of modern chemistry, and in his famed text on metallurgy provided the Russians with their first clues on how to unlock the secrets of Siberia's gold.[32] He did brilliant experimental work in electricity, optics, and the theory of heat, and played a key part in the founding of Moscow University in 1756.[33] "Poetry," he once wrote, "is my solace—physics, my profession."[34] Without doubt eighteenth-century Russia's greatest scientist, he also became one of its best midcentury poets.

As a scientist, Lomonosov viewed the world with a skeptical, critical eye, yet as a poet he extolled the beauties of natural phenomena in raptures that seemed entirely genuine. The brilliant flames of dawn, "this brightest of all torches / Kindled, God, by You alone," became the centerpiece for his "Morning Meditation on the Majesty of God,"[35] while the vastness of the universe came to stand at the center of his meditations for the evening. "Pray tell us," the scientist-poet asked, "how vast is the world? / What lies beyond the smallest stars? / Is creatures' end unknown to You?"[36] Even in poetry, Lomonosov held knowledge sacred as he dreamed of the day when Mother Russia would bring into being "a Russian Academy comprised of the sons of Russia."[37] Such was the hope of a man whose brilliance in poetry and science contrasted so sharply with his wild, undisciplined personal life. At war with the German scholars who still ruled the Academy of Sciences thirty years after its founding and hopelessly at odds with the critics who challenged his views about poetry and language, Lomonosov found satisfaction in his laboratory and in the patronage of the Empress to whom he dedicated some of his greatest odes. "Give rest to all, O Empress," he wrote during some of his most painful feuds with his superiors and critics. "Elizabeth will guarantee / Gladly our rest and comfort in tranquillity."[38]

Precisely because Aleksandr Sumarokov had the instinct for graceful language that he never acquired, Lomonosov despised him more than any other critic.[39] One of the first Russians to be educated at the Empress Anna's Aristocratic Infantry Cadet Corps, Sumarokov became the first Russian nobleman to devote his life to letters and he won literary success in poetry and journalism before he found his true calling as a playwright. As the founder and editor of his country's first privately owned literary journal, *The Industrious Bee*, Sumarokov urged Russian aristocrats to serve their country and insisted that moral superiority came from service, not the accident of birth.[40] "If there is no duty that I can well per-

form," he wrote in one of his essays, "it means that I am not a nobleman."[41] Fame, he concluded, should not be won "except through merit," and talent alone must be the force that raises men to high office.[42]

Sumarokov denounced the language of Trediakovskii as hopelessly archaic, and rejected Lomonosov's efforts to modernize it as too bookish. At the same time, he warned the champions of modernizing Russia's literary language against drowning in the flood of foreign intrusions that had been pouring into their language since the days of Peter the Great. It was enough, he once said, for Russia's writers "to feel truly, to think clearly, [and] to sing simply and harmoniously" in the language of polite society. Once the speech of literate Russians was purged of unnecessary borrowings from the languages of the West, he believed that it could be used to establish a fixed standard for a national literary language.[43]

As Director of Russian Theaters during the last years of the Elizabethan Age, Sumarokov insisted that the eternal literary models of Western civilization all had been created in ancient Greece and that each genre had rules and usages governed by the universalities of thought and feeling. Russian dramatists, he believed, needed only to follow such themes as the conflicts between love and duty, reason and passion, and instinct and will.[44] In his own plays, he copied the formal structure of French seventeenth-century tragedy "almost photographically," in the words of one critic,[45] yet he could not provide the subtlety and depth that gave the works of his European models their brilliance. Still, contemporaries hailed his work in the West, and his plays became the first by any Russian to be translated into French and reviewed by the newspapers in Paris. The moderate praise Sumarokov received in the West then led him to expect an excessive measure of it at home.

In Russia, Sumarokov demanded adulation as the greatest living Russian playwright, published translations of his favorite foreign reviews of his works in the journal he edited, and in the years immediately after Elizabeth's death made such a nuisance of himself that Catherine the Great counseled him to save his complaints for the stage, "where they are far more amusing."[46] Another critic wrote parodies of Sumarokov's plays "in which all the roles were taken by personified sex organs,"[47] but the playwright's self-proclaimed reputation as the "Russian Racine" persisted for several more decades until men clearly greater than he claimed the field for themselves. By then, no one doubted that his creations surpassed those of Lomonosov in brilliance. "This is your crown of triumph, O Lomonosov," Aleksandr Radishchev wrote at the end of his famed *Journey from St. Petersburg to Moscow*. "You brought forth Sumarokov!"[48]

Sumarokov's chief contribution to Russia's artistic life therefore stemmed from his willingness to import the foreign literary forms that others would later build upon. As the first Russian to write prose comedies patterned after those of Europe, he paved the way for such brilliant successors as Denis Fonvizin in the age of Catherine the Great, and in his passion to bring seventeenth-century French tragedy to Russia he presided over a truly pivotal event in the history of Russian drama. Sumarokov and his rivals Lomonosov and Trediakovskii brought

a truly Europeanized theater into being. From their efforts sprang the brilliant theatrical tradition which, at the beginning of the twentieth century, produced Stanislavskii and the Moscow Art Theater, Diagilev and the Ballets Russes, the experimental theater of Meyerhold, and in the 1970s Iurii Liubimov's Moscow Theater on the Taganka.

Fun-loving, enthusiastic, and delighted to be entertained, the Empress Elizabeth supported foreign theatrical companies while she presided over the birth of Russia's national theater. In 1749, the cadets of the Aristocratic Infantry Cadet Corps, who had been acting in foreign plays since the days of the Empress Anna, performed one of Sumarokov's tragedies at court at almost the same time as Elizabeth brought to St. Petersburg the theatrical company that a young merchant by the name of Fedor Volkov had organized in the provincial town of Iaroslavl. Choosing the best actors from Volkov's company, the Empress sent them to the Cadet Corps, where they joined the most talented of the cadets in organizing the first professional Russian acting company when they graduated in 1756. In addition to the five tragedies that Sumarokov wrote between 1747 and 1751, their new enterprise performed plays by Corneille, Racine, Voltaire, and a host of lesser Italians and Germans to create a truly Russian repertoire for the first time in history.[49]

The Elizabethan Age saw ballet and opera flourish along with theater. The Empress celebrated her coronation with *The Joy of the People on the Appearance of Astrea on the Russian Horizon*, a lavish allegorical ballet and opera, whose patriotic message obviously centered upon herself. Her enthusiasm for *Astrea* made Italian operas (with ballets as *divertissements*) a regular part of St. Petersburg's cultural life all through the 1740s and 1750s, and the first Russian opera (written by the Neapolitan composer Francesco Araja from a text supplied by Sumarokov) had its first performance at the court theater in 1755. Russian and foreign companies performed over forty operas and ballets in St. Petersburg and Moscow during Elizabeth's reign.[50] While the Empress Anna had spent less than nine thousand rubles on ballets, operas, and concerts in the last year of her reign, Elizabeth spent more than four times that amount on musical entertainments each year after 1755. Every year, she spent double that sum to support theaters that performed Russian, French, German, and Italian plays in St. Petersburg and Moscow.[51] Peter the Great had insisted that the autocrat must be the first servant of Russia, and Anna had made the court into the yardstick by which opulence and grandeur would be measured. Now Elizabeth demanded that Russia's sovereigns be recognized as the nation's greatest patrons of the arts. For the rest of the century, no one would be more generous as a patron, or play a greater role in shaping Russia's artistic experience than the resident of the Winter Palace.

While the Byzantine heritage had united the Russians in earlier times, Elizabeth's passion to bring the artistic experience of Europe to Russia divided her people as never before because the nobility became increasingly European while the lower classes remained unchangingly Russian. By 1760, what printed words the masses saw continued to be mainly in Old Church Slavonic, the language

of the Church and the tiny handful of Russian country folk who knew how to read, while the literary language of Lomonosov and Sumarokov was well on its way to becoming the written language of the upper classes. With neither the means nor the desire to make the others' way of life their own, the lords and peasants of Russia no longer shared the same visions of the future and the world to come as they had in the days of Old Russia. Even as writers and painters began to idealize the life of Russia's peasants, they stood nearly as far from them in language and custom as did England's lords from the lower classes of Ireland.

The impressive artistic achievements of the Elizabethan Age split the cultural personalities of Russia's courtiers in ways that left them struggling to extract some clear sense of direction from the world around them. Contradictions and uncertainties replaced the uniform, unchallenged precepts that had reigned in Muscovite times and left those Russian Elizabethans who had bound their futures to the West to suffer the perpetual turmoil of split emotions and rootless lives. Thanks to Rastrelli's genius, such men and women sat in Chinese pagodas that nestled in Russian birch groves and danced the night away among orange trees and myrtles that flowered in the dead of the northern winter. In summer, St. Petersburg's far northern location flooded them with sunlight at midnight, only to submerge them in darkness at noon six months later. Wherever one went in the vastness of Russia, the immense distances transformed all sense of time and space. As if to underscore the unreality and contradictions of the time, the Academy of Sciences established a Chair of Allegory during Elizabeth's reign. Perhaps nothing emphasized the strange and exotic contrasts of the Elizabethan Age more starkly than the Empress's own masquerade balls—"metamorphoses" in her words—in which women dressed as men and men wore the gowns of women.

Even the reality of noble rank for a time seemed uncertain in this realm of perpetual conflict between nature, art, and life. Although Peter the Great's new merit system had created seven times as many nobles as there had been in the days before the secular revolution had taken hold, it at first had failed to bestow upon them a clear public identity. The dilemma of determining how such men and women could be recognized in a society in which aristocrats bore no badge of rank deepened in the 1730s, when the Empress Anna bestowed nobility upon the Germans who had come with her from Courland and thus transformed men and women who did not even speak Russian into some of Russia's highest aristocrats. A solution began to emerge only when Russia's Elizabethans began to identify as aristocratic whoever dressed, acted, and spoke in the style of Europe. At the same time, anyone who did not adopt the ways of the West came to be seen as lower class as the Elizabethan Age came to an end.

In the days when its churchmen had called Moscow the Third Rome, Russia had established its political and artistic identity by emphasizing the differences that set it apart from the West. Now, by shaping an artistic experience from the foreign elements their forebears had despised, Russia's upper classes defined their nation as embracing the very culture that their ancestors had rejected as im-

pure. "Russia is a European state," Catherine insisted. "By introducing the manners and customs of Europe among a people who are fundamentally European," she explained, "Peter the Great found opportunities such as even he did not expect to find."[52] To Peter's manners and customs Catherine added the firm and powerful belief (which had brought the Europeans through the Age of Reason to the Enlightenment) that the individual human personality lay at the root of all artistic experience. In broadening the course that Peter the Great had set, Catherine became the greatest patron of the arts and letters ever to sit on Russia's throne.

<div style="border: solid">

# THE ARTS
# AND CATHERINE
# THE GREAT

</div>

⟨⟨⟨§✶⟩⟩⟩

WELL TRAINED IN THE ART of politics as practiced in one of the most
intrigue-ridden courts in Europe, the one-time Princess Sophia Augusta Freder-
icka of Anhalt-Zerbst ascended the Russian throne as Catherine II at the end of
June 1762, just four months after her thirty-third birthday. Supported by the Im-
perial Guards as Elizabeth had been twenty-one years earlier, she had just driven
her much-disliked husband Peter III from the throne in a coup that had led to
his death. Her instincts were finely attuned to the ways in which the game of
politics had to be played at a court in which powerful families and clans were
perpetually making and breaking alliances in an effort to offset the absolute
power of their sovereign, and she had no qualms about wielding the power she
had so recently acquired. "She was not only imposing, majestic, and terrible," an
enthusiastic biographer once remarked, "but also seductive [and] beautiful."[1]
Less generous observers have complained that she bought acclaim at any price,
had a passion for self-promotion, and kept her son Paul from his rightful throne
during the thirty-three years in which she reigned. Yet, however one balances
Catherine's genius and shortcomings, history continues to remember her as "the
Great," the only ruler of Imperial Russia to be so named except for Peter the
Great himself.

A small, slender woman when she seized Russia's throne, Catherine impressed
her contemporaries by her regal bearing and the "astonishing magic [with
which] she inspired respect and affection."[2] The young Polish Count Stanislaw
Poniatowski thought her eyes were "the bluest and merriest in the world," and

wrote of the "dazzling whiteness" that the contrast with her thick chestnut hair gave her complexion.[3] Men spoke of Catherine's keen wit and excessive vanity in the same breath, and the brilliance of her conversation, "so full of fire, spirit, and vivacity,"[4] impressed friend and foe alike. Voltaire called her the Semiramis of the North after the ancient Assyrian queen renowned for her beauty, charm, and wisdom,[5] and Frederick the Great compared her to England's Elizabeth and Austria's Maria Theresa. "The Empress of Russia," he once said in a moment of candor, "is very proud, very ambitious, and very vain,"[6] but those faults rarely blinded Catherine to her adopted country's best interests, which she pursued with a tenacity matched in the eighteenth century only by Peter the Great. An obscure German princess who rose to play a major role in the affairs of Europe, Catherine saw herself as a philosopher on the throne with a mission to bring joy and prosperity to her people. She saw the object of autocracy as being "not to deprive men of their natural liberty, but to direct their actions in a way that will achieve the greatest good for all."[7] That meant making European law, European ideas, and European forms of the arts a part of the Russian experience on every level of human endeavor.

While Peter the Great earned his title for transforming Russia from a nation of little consequence into one of Europe's greatest powers, much of Catherine's claim to greatness rested upon the passion with which she supported the arts. As a patron, she had no equal in her nation's history, and she presided over an age in which Russian poetry, comic opera, theater, portraiture, and novels all came into their own. The author of letters, plays, satires, and memoirs that eventually filled twelve volumes, she used her sense of the arts to preside over their flowering. The poetry of Mikhail Kheraskov and Gavriil Derzhavin, the comic operas of Iakov Kniazhnin, and the plays of Denis Fonvizin all owed some of their immense popularity to the enthusiasm with which she supported their authors. The acclaim won by the painters Dmitrii Levitskii and Vladimir Borovikovskii also stemmed from Catherine's patronage, and so did that enjoyed by the architects Giacomo Quarenghi, Charles Cameron, and half a dozen others.

Most of all, Catherine the Great was a builder. Dedicated to leaving a mark that no amount of time could wipe away, she endowed architects of genius with the means to create some of the most elegant and beautiful buildings Russia would ever see. With a sureness of purpose that few sovereigns could match, she presided over the rise of massive public buildings, elegant private residences, and shining palaces for her favorites, all of which stood as eternal reminders of the larger world of which she had vowed to make Russia a part. "The more you build, the more you want to build," she once confessed. "It's a sickness that's somewhat like being addicted to alcohol," she added. "Or, maybe it's just a habit."[8] Her sure and certain eye knew the value of elegance and simplicity. Perhaps more than any other palace ever built in Russia, the Taurida Palace, which she commissioned the architect Ivan Starov to build for her favorite Grigorii Potemkin, became the byword for neoclassical elegance all across her empire.

Ending the exuberant royal masquerade over which Elizabeth had presided for twenty years, Catherine sought to mute her predecessor's boisterous Baroque with her own restrained neoclassicism. Russian by conviction, she remained German in spirit, and her disciplined ways separated the sovereign's private and official lives for the first time in Russia's history. By putting herself on formal display, she set an example for her subjects to follow in fashion, manners, politics, and learning, insisting as she did so that Russia must become the equal of its rivals in the West. Catherine the Great lived the Russian artistic experience at the same time that she urged others to help her transform it, and she made her court one of the greatest centers of patronage and the arts anywhere in Europe. No sovereign could match the resources she devoted to that task, and no one equaled the dedication with which she worked to transform into a champion of the modern arts an aristocracy that had been known for its backwardness just a few decades before.

Catherine's agents combed the West for ancient and modern treasures, and she bought everything of value and beauty they could find. In 1768, she purchased the famous Dresden gallery of Count Brühl for 180,000 rubles and went on to acquire the even more renowned Crozat collection in Paris for half a million francs just four years later. Three months after that, she paid the Duke of Choiseul another half million francs for fifty more great paintings, and then swept up the Duke of Orleans's entire collection of rare engraved gems in one avid swoop. She hung masterpieces by Raphael, Van Dyck, Teniers, Rembrandt, and Poussin in her Hermitage gallery, and she never allowed the parlous state of Russia's treasury to cool her passion for acquiring new treasures.[9] "[My museum] at the Hermitage," she wrote toward the end of her reign, "consists of [more than a thousand] paintings, the panels of Raphael [which she had arranged to have copied at the Vatican], thirty-eight thousand books, ten thousand engraved gems, [and] nearly ten thousand drawings."[10] Yet her thirst to acquire remained unquenched. Along with great works of art, she also collected men and women of talent, who could sing her praises and add to her glory. Voltaire, Diderot, Frederick the Great, and the Emperor Joseph of Austria all figured prominently on her list of correspondents. She sent Gavriil Derzhavin a diamond-encrusted gold snuffbox as a mark of favor after she read one of his poems, and to others she sent money, portraits, and additional tokens of goodwill to show her love for the arts and her passion for collecting the people who created them.

To strengthen her image as an enlightened monarch, Catherine courted the *philosophes* of France and basked in the acclaim they heaped upon her. "Come here with all your friends," she wrote to Diderot and D'Alembert when the French authorities suspended the publication of their world-famous *Great Encyclopedia*. "I promise all of you every comfort and pleasure which I have the power to grant and, perhaps, you will find here more freedom than you have now."[11] Even though the two men refused her invitation, Catherine continued to

shower them with favors. When Diderot put his library up for sale to pay his creditors, she purchased it for the huge sum of 16,000 francs on the condition that he keep it for the rest of his life and receive a handsome salary for serving as its "caretaker." At Voltaire's death, she bought all seven thousand of the beautifully bound and copiously annotated volumes that had filled his library at Ferney, and proclaimed that she had done so "to avenge the philosopher's ashes from the insults that he had received in his own country."[12] Enlightenment, she vowed, was the key to reigning well. Upon that belief, she based her expectation of fame in Russia and acclaim in Europe.

Yet an enlightened sovereign could only bestow the benefits of learning upon her people if enlightened subjects stood ready to become her instruments. In England, perhaps as many as one person out of twenty could read by the end of the eighteenth century,[13] and in Western Europe generally the teachings of the Enlightenment spread quickly among men and women who read for pleasure and were moved by what they read. By contrast, fewer than one Russian in two hundred could claim to be literate,[14] as the empire's primitive system of schools continued to keep learning from nobles as well as merchants, peasants, and even priests. Too many of the lords who served Russia remained apart from the world of books and learning even at the end of Catherine's reign. Judges who could not read, army officers who could not write, and tutors whose command of the arts and sciences was entirely open to question all remained commonplace in eighteenth-century Russia despite Catherine's dreams of pressing learning upon her people.

Still, Russia had its readers, and their numbers increased as the century moved ahead. By the time Catherine came to the throne, the number of secular books published every year had tripled to fifty-two from what it had been forty years earlier, and a quarter-century after that the number had tripled again.[15] Magazines called *The Artist, Musical Entertainments, Mirror of the World,* and *Medicine for Boredom and Worries* showed that the Russians no longer viewed the West in the narrow, pragmatic terms that had prevailed in the days of Peter the Great, when reading had been seen only as a means for acquiring practical knowledge. Ideas, the arts, and a civilized way of life all had become important to the Russians by the time Elizabeth died, and they were beginning to read for pleasure, too. At that point, the novel—the new form of entertainment and moral instruction that Europeans had discovered at the beginning of the century— began to enrich the Russians' vision of daily life. Nowhere in Europe did literate men and women comb novels with greater passion than in Russia for the examples that could serve as models for the ways of life to which they aspired.

Around 1760, newly westernized Russians still faced a host of urgent new questions that neither personal experience nor practical guides could answer. In a society in which they had been kept separate until the time of Peter the Great, men and women still needed to learn how to make friendships, conduct love affairs, and relate to each other in dozens of other ways. They needed to know how

their European counterparts spent their days and evenings, how they treated their servants, and what sorts of conversations took place in salons and at dinners. Short of following through their daily and nightly rounds the handful of Europeans who lived and worked in Russia, there had seemed to be no way to answer such questions during the 1730s and 1740s. Then novels that painted broad vistas of life in Europe gave the Russians the models they needed to follow. "Even the most mediocre novels aid the cause of enlightenment," one writer concluded. "[The reader] will undoubtedly learn something from the ideas expressed or the manner in which they are set forth."[16]

For one young nobleman, "the life of high society . . . seemed much clearer," after he discovered the novels of Europe. "I thus acquired a much better grasp of many things that I had known about only in a vague and imprecise way," he confessed, "[and] I began to see everything from a much more elegant perspective."[17] From such reading, Russia's lords and ladies began to develop a clearer sense of their place in the modern world, along with a sensitivity to the good manners, fine breeding, and elevated feelings that set them apart from the people who served in their palaces or worked in their fields. Nobility was becoming a matter of feelings, education, and attitudes, all of which made Russians more European at the very moment they were struggling to discover what it meant to be Russian. Patriotism or, more precisely, *"romantic patriotism,"* one writer explained some years later, had become the mark of a true Russian aristocrat. "Only that nation can be great and respected," he concluded, "which can promote the successes of humankind in its glorious march toward moral and spiritual perfection by means of the noble arts, literature, and science!"[18] As the bearers of enlightenment and modern values, Russia's aristocrats needed to set an example that would help to elevate their people among the nations of Europe. To do that, they needed to understand more clearly who they were and where they—and their nation—were going.

Led by Catherine herself, educated Russians began to define their places in the westernized world that had taken shape around them in autobiographies and memoirs modeled after those that had expressed the self-awareness of Europeans nearly a century earlier. Written in several versions that reflected the changing political and propagandistic purposes that shaped her views at different times in her life, Catherine's memoirs offered readers a vision of how she saw herself, not an accurate record of the events in which she had taken part. A similar sort of blatantly selective reporting shaped the reminiscences and autobiographies of her contemporaries. As the story of the writer's "life and adventures" (the actual title of one set of memoirs), each of these accounts provided a very personal report of what its writer had done to shape Russia's destiny and thus created for its author a clear sense of self-importance that Russians had never known before. No longer did literate men and women define themselves only as inconsequential and groveling servants of their sovereign as they had in earlier times. During Catherine's reign, they began to see themselves as people whose identities reached beyond the shadow of the ruler they served.

Yet eighteenth-century memoirists' definitions of self still remained slightly out of focus, for Peter the Great had cut the Russians off from their Muscovite past in order to thrust them more quickly into a European present. If they wanted to find that broader sense of national identity that was so familiar to the eighteenth-century Europeans, aristocrats at the court of Catherine the Great, therefore, had to ask what it meant to be a Russian and what part they should play in giving form and substance to the artistic experience of a nation in the midst of transformation. For too long, Russia's upper classes had tried to be "at home among foreigners and succeeded only in becoming foreigners at home."[19] Now comfortable with the styles and manners of the West but still cut off from their past, these Russian "foreigners" had to find ways to identify themselves as "Russian." What they found had to be good, worthy, pure, "national," and very different from what it had meant to be Russian in the days when Moscow had been the Third Rome and Russia the last vessel of pure Orthodoxy on earth.

Now closely tied to the experiences of the West, educated Russians followed their European mentors away from the city to search for their roots in the idealized and romanticized countryside. While William Cowper urged his countrymen to turn their thoughts to the fields and groves of England and the radical *philosophe* Jean Jacques Rousseau instructed the French in the virtues of natural man, Mikhail Kheraskov, whose *Rossiad* would make him eighteenth-century Russia's leading epic poet, looked to his nation's peasant villages for people who had been kept pure in heart and spirit by the innocence of rural life. Vowing to write of "heroes and bagatelles,"[20] Kheraskov painted a world in which pure and demure women gave their hearts to sturdy and true-hearted men, where lords and peasants were at one with the land, and where the cruelties of serfdom intruded only when masters who lived in the city returned to exploit the gentle Arcadians who tilled their lands. Here was a "Russia" with which literate men and women could identify and yet remain far enough away from to avoid the harsh realities that rural life might reveal if they viewed it too closely. "In the village there is no artificial beauty," one of Kheraskov's contemporaries concluded, "but only singing birds, budding groves, and meadows filled with flowers."[21] The world he had described in such enchanting terms was "Russian," but it did not include the backbreaking toil demanded from those serfs who had to eke out a living and support their masters' way of life.

Once poets had discovered "Russianness" in the countryside, Kheraskov set out to link it to the glories of his nation's past in an epic dedicated to "people who know how to feel and who know how to love their fatherland." Reaching across the secular revolution's temporal gulf to the tumultuous times of Ivan the Terrible, his *Rossiad* told the tale of Russia's final liberation from the Tatars, when the armies of Moscow had stormed Kazan in 1552 and opened the way into the Middle East and Siberia. Here, Kheraskov proclaimed, Russia had come into her own and fulfilled her destiny, but his portrait of the Russians' victory differed markedly from that which sixteenth-century artists had portrayed in the "Church Militant" icon they had painted for Ivan the Terrible's Kremlin palace.

No longer focused upon Russia as the kingdom of God, Kheraskov insisted that a true Russian now had to know of past glories so as to appreciate the achievements of the present and the promises of the future. "Woe to the Russian," he warned, "who does not appreciate how great an advantage, how pleasant a tranquillity, and how magnificent a glory accrued to our Fatherland from the destruction of the kingdom of Kazan."[22]

The writings of Kheraskov and the generation who followed him made it clear that the era of Catherine the Great would be known more for its poetry and plays than for its prose, and the Empress herself helped to set that priority even though her abilities as a memoirist far surpassed her talents as a playwright. That the plays which make up more than a third of her published works—some of which she commissioned others to write in her name—never rise above the ordinary makes it all the more remarkable that she anticipated so many currents that developed in the Russian theater long after her death. Three-quarters of a century before folk themes became fashionable, some of Catherine's plays explored the uses to which Russian folklore could be put in the theater, and the remodelings of Shakespeare's plays to which she attached her name in the 1770s anticipated Pushkin's historical dramas by a good fifty years. Librettos that the Empress wrote for a series of admittedly mediocre comic operas brought to life some of Russia's greatest folk heroes a century before Rimskii-Korsakov succeeded in doing so, and others featured peasant songs long before Musorgskii worked them into *Boris Godunov*. Catherine's librettos of the 1780s introduced folk themes and images that later appeared in such diverse works as Pushkin's *Ruslan and Liudmila* and Stravinskii's *Firebird*.[23] Her dabblings encouraged others to write and perform more than a hundred Russian comic operas before the end of the century.

Comic opera came to Russia from France in the 1770s and quickly found several energetic practitioners, the best-remembered of whom was Iakov Kniazhnin, a provincial nobleman who left his home in the province of Pskov to be educated in St. Petersburg at the end of the Elizabethan Age. Kniazhnin served in the army for the better part of a decade before he wrote the libretto that made him famous, but once he had done so he abandoned his military calling for the theater. His *Misfortune from a Coach* told how a serf was spared from being separated from his fiancée only because the couple knew two words of French, and their francophile master and mistress could not bear to sell people who spoke "their" language. On that level, Kniazhnin's libretto pointed to the brutish side of Russian life that separated peasant families and lovers if capricious masters and mistresses so desired. Set to music by Vasilii Paskevich, one of eighteenth-century Russia's best-known composers, *Misfortune from a Coach* had its first performance at Catherine's own Hermitage Theater in 1779 before an audience of lords and ladies who betrayed no sense of seeing in it a deeper meaning. Certainly they did not view Kniazhnin's plot as an indictment of serfdom, and the opera seems to have been a favorite that nobles asked their serf actors to perform

on many occasions. Frequently repeated at the Empress's request, the opera became the first work in Russian theater to have a life beyond its own time. For at least half a century, audiences continued to cheer its performances even though its author had by that time won greater acclaim for other reasons.[24]

After his success in comic opera, Kniazhnin wrote several popular verse comedies that are now best remembered for their improbable plots and unbelievable characters. Eventually, he became best known for having written *Vadim of Novgorod*, a play about an unsuccessful uprising in medieval Novgorod, which was denounced by Catherine's lover Platon Zubov and burned in public by the imperial executioner. For years afterward, students read privately circulated copes of *Vadim* in secret and thought it filled with "profound ideas, harsh truths, and powerful lines,"[25] until literary historians proved conclusively in the second half of the nineteenth century that subversion had never been Kniazhnin's purpose. Nonetheless, the play's complete text was not published again until 1914, more than 120 years after its first appearance and almost a decade after censorship had been virtually abolished in Russia. Even now, Russians usually forget that Kniazhnin's unusually modern language was more important in the long run than the revolutionary sentiments that were attributed to him so long ago. As one of America's leading critics once complained, *Vadim of Novgorod* still "keeps on concealing Kniazhnin's far more important plays from view."[26]

Even more than Kniazhnin, Denis Fonvizin helped Russian comedy to stand on its own among its rivals in Europe. Surrounded by serfs from the moment of his birth in 1744, this high-born creator of eighteenth-century Russia's greatest comedies learned to read at four, developed an adolescent passion for the theater, and graduated from Russia's newly founded Moscow University at the age of seventeen. Two years later, he wrote his first play. Then, not long before he turned twenty-four, he finished *The Brigadier*, which as an unrelenting satire about upper-class Russians' mindless adoration of everything French became one of the most popular plays of the Catherinian era. Because Fonvizin had spent his childhood among serfs and masters, he portrayed the stupidity, avarice, lust, and hypocrisy of rural aristocratic life with a sensitivity that was unmatched in eighteenth-century Russian literature. His real genius lay in using his characters' absurd belief that everything French surpassed its Russian counterpart to illustrate that the absolute power they exercised over their serfs had corrupted them absolutely.[27]

Fifteen years after *The Brigadier*'s first performance, Fonvizin finished *The Minor*, the very best of his works. As the greatest play to be written in Catherine's time, *The Minor* allowed some of Russia's finest actors and actresses to embroider upon themes that posed some of the key cultural and artistic dilemmas of the age. Lesser writers later produced adaptations, sequels, and imitations for the better part of thirty years, and a steady stream of comedies, comic operas, and even ballets revived its chief characters in major and minor roles until well into the nineteenth century. The greatest of Russia's Romantic poets, Aleksandr

Pushkin, drew upon Fonvizin's work, and so did some of the great realists who followed him.[28] "You might as well die," one of Catherine's favorites complimented its author soon after he had seen *The Minor* at St. Petersburg's court theater. "You'll never write anything better!"[29]

Because he thought writers had a moral duty "to give lessons to sovereigns,"[30] Fonvizin used *The Minor* to point up Russians' failures to live according to the principles he thought important. In depicting life in the provinces, he went a step further than his Empress (who had written satires on the foibles of provincial aristocrats a decade earlier) and explained that backwardness was an inevitable product of a primitive, despotic world in which stupid masters crushed innocent serfs. Too arrogant to learn and too corrupt to understand how the power they wielded eroded the human spirit, Fonvizin's brutish and boorish lords and ladies were destined to wallow in the petty meanness that had deadened life in Russia's provinces for centuries.[31] Yet he made it clear that so long as serfdom and autocracy remained a part of Russian life it could not be otherwise, for those two institutions undercut even the best intentions to make the Russians progressive, modern, and free.

Poetry played an even greater part in shaping Russia's artistic experience during the reign of Catherine the Great than did comic opera and the theater. Patriotism and a sense of national mission had long been the message of Russia's poets, but Gavriil Derzhavin, the poet laureate of Catherine's age, gave new intensity and meaning to both. As the master of the Russian ode, Derzhavin ruled his country's literary scene from the 1770s through the 1790s, while his genius raised him from the ranks of Russia's poor country squires to stand among its richest lords. Some saw him as a poet whose words captured the brilliance of sunlight, the power of nature, and the glory of combat, while others admired the daring with which he condemned tyranny and injustice in a land so accustomed to both. The great nineteenth-century literary critic Belinskii called Derzhavin "the hero of our poetry," and Dostoevskii often spoke of his ode "To Rulers and Judges" as a monument to the arts of the eighteenth century.[32] So long as Catherine tolerated his self-righteous preachings as the price to be paid for his genius, he lavished paeans to her greatness upon her.

Derzhavin penned his first poems only after he turned thirty, and he was just a year shy of forty when he wrote the "Ode to the Wise Princess Felitsa," which transformed the style of Russian poetry and brought him to Catherine's attention. Like Lomonosov, he wrote in iambic tetrameter set into ten-line stanzas, but he replaced his predecessor's lofty language with a lighter tone of humor and satire that broke away from the conventions that had ruled poetry in Russia and Europe until that time. In the lofty manner of the eighteenth century, he praised Catherine as the perfect enlightened monarch who lived to serve her people at the same time as he condemned her courtiers as corrupt and greedy servants. With the disdain of a moralist who dared to set himself above the world around him, Derzhavin wrote of aristocrats who gambled "from morn 'til morn," made

vacations of their workdays, ate too much, drank too freely, and governed too corruptly. Future generations, he promised, would condemn those aristocratic men and women who had served themselves before serving Russia. Only "the wise princess Felitsa" stood above this self-serving world, in which "every person is a lie" and all lived " 'twixt sinfulness and vain delusion." In the years ahead, only she would be able to boast of deeds that would "shine as the stars in the heavens do."[33]

Combining grand effects and noble sentiments with true poetic exuberance, Derzhavin extolled the pleasures of the flesh, lauded the deeper feelings of the spirit, and wrote of God, Homeland, Glory, and Duty. Set against the blare of trumpets, crashes of thunder, and the tenderness of love's whispers, his ode "The Waterfall" used musings about the beauties of a cascade in Russia's Far North to comment about the human condition and to warn that whoever served vanity alone must inevitably see his achievements washed away by time. Written to commemorate the death of Prince Grigorii Potemkin, whom history remembers as one of Catherine's greatest statesmen, the poem insisted that immortality could be found only in achievements that reached beyond the sphere of everyday life. "Is it not better to be famed less / And be more useful to all men?" Derzhavin asked his readers. Like the "lovely streamlet" whose gentle waters nourished "gardens, groves, and fields," deeds done for the good of humankind would bring greater glory in the end.[34]

At the beginning of the nineteenth century, Derzhavin retired to the birch-filled countryside around Novgorod, not far from the ancient church domes that once had risen above the only true republic in Russia's history. Now seeing his poetry as a greater contribution to his homeland than the years spent in Russia's service, he wrote "The Clouds," "The Rainbow," and "The Swallow," as he continued to celebrate the glories of Catherine's reign. Reminded by the nearness of death to enjoy the pleasures of life as he passed sixty, he celebrated the aromas of food, the joys of fishing, and the pleasures of country life. "What need have I for cities?" he asked from the quiet of Russia's ancient countryside. "I have no need of treasure. / Peace with my wife is my wealth."[35]

Yet the style that had seemed so daring and fresh in the 1780s now recalled a bygone age, for Derzhavin still wrote in the stilted language of Lomonosov raised to a higher, more artful level. To express the thoughts and feelings that ruled their minds and hearts as they entered the Napoleonic Age, Russians required simpler, more supple language that would be more subtle and less grandiose than eighteenth-century poets had dared to imagine. Even so, changing tastes could not diminish the brilliance of Derzhavin's achievement or dim the luster of his legacy, for the scenes he had painted in his vigorous, sonorous verse remained as vividly etched in the minds of Russians as if he had worked with oil and canvas. "What Horace was to Caesar Augustus," an admiring critic concluded, "Derzhavin was to the age of Catherine the Great."[36] As Russia entered its Romantic Age, Derzhavin's legacy paved the way for poetry to soar to newer and greater heights.

That artists who worked with oil and canvas came close to rivaling the brilliance of Derzhavin's poetry was in part the result of Catherine's devotion to Russia's newly founded Academy of Fine Arts. Rather than continue to have aspiring painters taught by those lesser European masters who had sought their fortunes in Russia earlier in the century, Catherine urged the Academy to send its best graduates to the West, just as Peter the Great had encouraged a flock of his "fledglings" to study technology, science, and industry in Italy, Holland, England, and France. No longer would the early work of Russia's young painters and sculptors reflect the trends and tastes of an earlier generation in Europe. Catherine now urged the best of them to spend their formative years in the *ateliers* of Paris, Venice, and Rome, where the paintings of Europe's greatest masters could work their magic upon them while contact with the leading artists of the modern age could teach them to paint in the latest style. Especially in painting portraits and designing buildings, Russians came to hold their own among the artists of Europe during the 1780s and 1790s in large measure owing to their Empress's insistence that they study in the West.[37]

Among the first of the Academy-trained painters to study in Europe, the Ukrainian Anton Losenko was one of the most gifted artists to paint during the early years of Catherine's reign. Left an orphan at the age of seven, he had come to St. Petersburg to sing in the same chapel choir from which, in earlier days, the Empress Elizabeth had chosen her lifelong lover Count Razumovskii. Later, Losenko left the choir to study with Argunov, the serf painter whose portraits were winning acclaim among the lords and ladies of Elizabeth's court, and Argunov arranged for him to enter the Academy of Fine Arts soon after it opened its doors in 1757. Sent abroad four years later as one of the Academy's best graduates, Losenko worked with a passion that enabled him to mix, as one critic wrote, "equal doses of Poussin and Raphael with a measure of the antique"[38] in painting historical subjects in the grand manner. After his "Sacrifice of Abraham" won acclaim in Paris, he moved to Rome, where he became one of the first Russians to paint nudes in detail. Committed to painting grand themes on a grand scale, Losenko drew inspiration from the work of Rome's ancient masters. While painters in St. Petersburg continued to concentrate on portraits and charming Baroque allegories, he began to dream of vast canvases that would present his nation's history on a Roman, imperial scale.

Under the influence of the masters of ancient Greece and Rome, Losenko abandoned the Baroque at precisely the moment when Catherine, as Russia's new Empress, resolved to turn her nation's artistic experience in the same direction. Determined to become the first Russian artist to present his nation's history on a grand classical scale, Losenko returned to St. Petersburg in 1769 to paint "Vladimir and Rogneda," a huge work that portrayed Kiev's Grand Prince Vladimir trying to force the Princess Rogneda of Polotsk to marry him against her will. Yet artists who had dedicated their lives to painting portraits did not take kindly to Losenko's effort to work with larger, more dramatic themes, and they criticized it more harshly than it deserved. That the Empress herself

purchased his painting for her own collection when the artists at the Academy spoke against it did not prevent Losenko from dying a disappointed and disillusioned man at the age of thirty-six. Only after Napoleon's armies had been driven from Russia almost fifty years later would his artistic heirs proclaim him the "Lomonosov of Russian painting" and take up his experiments with monumental historical subjects once again.[39] In the meantime, portraits continued to dominate Russia's world of art, mainly because the tastes of the court insisted that it be so.

A painter of the rich and famous who preferred the ancient sprawl of Moscow to the European grandeur of St. Petersburg, Fedor Rokotov was the first portraitist to win fame at the beginning of the Catherinian Age. Born in the outskirts of Moscow in 1736, he painted Peter III's seven-year-old son and heir not long after he turned twenty-five and then went on to create the portraits of nearly a score of Russia's best-known courtiers and ladies-in-waiting. A full-fledged academician at the Academy of Fine Arts before he was thirty, Rokotov in the mid-1760s seemed about to take St. Petersburg by storm. Then he turned his back on the capital and settled down in his native Moscow, where he developed an intimate style that incorporated some of the classical influences that were just making their way into Russia. Free from St. Petersburg's pressures to conform to the court's tastes, Rokotov set his more delicately shaded bust-length portraits against neutral backgrounds and portrayed his subjects' character in more candid, less stereotyped ways. Yet, if distance from the court gave his work an originality and freshness that his St. Petersburg contemporaries found difficult to match, it also kept him from challenging the fame of Levitskii and Borovikovskii, the two reigning masters of Russian portraiture. While Rokotov ruled in Moscow without challenge, Levitskii and Borovikovskii began to shape Russian painting in ways that only artists who worked at court could do.[40] Like Thomas Gainsborough and Sir Joshua Reynolds in England, they became the portraitists of the generation of men and women who carried Russia from the certainty of the eighteenth century into the turmoil of the French Revolution and the era that saw the rise and fall of Napoleon.

Of the two masters who dominated Russian painting during the last third of the eighteenth century, Dmitrii Levitskii was Borovikovskii's senior by more than two decades. The son of a priest who had worked as an engraver, Levitskii came to St. Petersburg from Ukraine during the last years of Elizabeth's reign at the urging of Aleksei Antropov, who had heard of his talent while painting the iconostasis for Kiev's Cathedral of St. Andrei. Like his countryman Losenko, Levitskii studied at Russia's new Academy of Fine Arts, but chose to work with Antropov on painting the scenes and portraits needed for the four great triumphal arches that celebrated Catherine's coronation in Moscow, rather than continue his studies abroad. Only mildly appreciated during the 1760s, he came into his own in a single burst of brilliance in 1770, when six of his portraits won rave reviews at the Academy of Fine Arts' first public exhibition. In the same way that Sir Anthony Van Dyck's renderings of the lords and ladies of Charles I's

court had created the image to which England's aristocracy conformed until at least the time of Gainsborough, so Levitskii's portraits reflected the self-image of St. Petersburg's high society for the rest of the eighteenth century.

Levitskii's portraits showed how far Russian art had traveled in the scant three generations that had passed since the beginning of the secular revolution. When Ushakov's naturalistic portrayals of Christ had first stirred the anger of Moscow's devout churchmen in the 1660s, centuries of artistic experience seemed to stand between the still-medieval Russians and the modern West. Scarcely a century later, Levitskii's renditions of Russia's lords and ladies so appealed to the Europeans that an engraving of one of his best-known early portraits was published in Vienna.[41] With no trace of the self-satisfied piety of the seventeenth century remaining in its art, Russia had moved firmly into the mainstream of European painting on the strength of Levitskii's canvases.

A master at capturing the character of his subjects, Levitskii won Catherine's confidence in the early 1770s, when she commissioned him to paint seven students at the Smolnyi Institute for whom she had developed a particular affection. His masterly renderings of these *Smolianki* (as the young ladies who attended the Institute were called) have been described as "some of the most beguiling delineations of childhood and adolescence" to be found anywhere in eighteenth-century Europe,[42] for they blended candor, charm, and innocence in a manner that viewers found enchanting. Contrary to the conventions which dictated that children should be painted as young adults, Levitskii allowed traces of adolescent awkwardness to show that his *Smolianki* had not yet become entirely comfortable with the worldly ways in which they had been schooled. Viewers were charmed, and the painter's fame soared. For most of the next two decades, Levitskii remained the leading portraitist in Russia and the premier chronicler of the Catherinian Age.[43]

Levitskii painted several full-length portraits of Catherine the Great that ranked among the most majestic state portraits of the age, and his renderings of statesmen and *grandes dames* captured the essence of Catherine's Russia in ways that no other writer or artist ever equaled. The Golitsyns, Orlovs, Naryshkins, Dolgorukiis, Vorontsovs, Saltykovs, Razumovskiis, and scores of others who shaped Catherine's Russia all sat for him at one time or another, and so did the Countess Dashkova, who helped Catherine seize the throne and reigned as president of the Imperial Russian Academy of Sciences for more than a decade. Nikolai Novikov, whose pen challenged Catherine's vision of Russia in the 1770s and 1780s, sat for Levitskii twice, and so did Prokofii Demidov, the industrial magnate whose family enterprises made Russia for a brief time the world's leading producer of pig iron. Painted on the occasion of Diderot's visit to Russia in 1773, Levitskii's portrait of the great French *philosophe* revealed much of the essence of the man who shaped the writing and thinking of his age, although the dozen portraits he painted of his Empress revealed much less of her personal character than they did of her majesty.[44]

As Levitskii shifted his search for inspiration from France to England in the

1790s, his later portraits began to reflect some of the sentimentalism that was beginning to work its way into Russian painting and literature. A simpler English manner without imperial trappings and telling gestures dominated the portraits he painted of Catherine's grandchildren during his early twilight years, and by the time he died at the age of eighty-eight in 1822, Russian painting had moved onto a very different course from the days when his portraits had set the standard by which all other art was judged.[45] With the death of Levitskii's student and rival Borovikovskii just three years later, the last of Russia's great eighteenth-century artists passed from the scene, leaving the field to painters with different visions and other purposes that had little to do with the men who had reigned over Russia's golden age of portraiture between 1770 and 1810.

If Levitskii's brilliant portraits represented the crowning achievement of eighteenth-century painting in Russia, those of Vladimir Borovikovskii, the son of a Ukrainian Cossack icon painter, displayed the self-indulgent, melancholic romanticism that eroded the rationalism of the Enlightenment after the French Revolution. A Cossack cavalryman who dabbled in painting until Catherine discovered him during her visit to Russia's newly conquered provinces on the Black Sea coast in 1787, Borovikovskii studied briefly with Levitskii as he moved from painting miniature copies of well-known portraits to working on a life-size scale. Then, as Russia's Catherinian Age came to an end, he found favor with Paul I just as Levitskii was slipping into the shadows, and his portraits of middle-aged ladies-in-waiting and aging *grandes dames* captured a true sense of the uncertainties that followed the passing of Catherine's time. Like Levitskii, Borovikovskii adopted the English manner as the century drew to a close, especially in the portraits of young girls and women, which he painted in languid poses against the parklike backgrounds that Gainsborough and Reynolds had made so popular. With large eyes and sentimental expressions, these became the quintessential models for *fin-de-siècle* Slavic maidens as Russia moved toward the heroic age of Alexander I, during which it would acquire the trappings that set it firmly into the imperial tradition that sprang from ancient Greece and Rome.[46] In the new century, Russia would gain a new sense of mission, as symbols of power replaced signs of civility and grandeur overwhelmed the elegance that Catherine had set above all else.

Nothing spoke more compellingly of the elegance of Catherine's time than the buildings with which she adorned Russia's capital and provincial cities, for she built more brilliantly and with a broader vision than any of her predecessors. To give majesty and permanence to St. Petersburg's waterfront, she commissioned Georg Friedrich Velten, whose father had come to Russia from Danzig to serve Peter the Great as a "master-cook," to tear down the wooden quays that lined the Neva River and face its embankments with red Finnish granite. Because many of St. Petersburg's most impressive government buildings and palaces stood on the Neva Embankment, Velten's facings had to provide continuity and architectural unity for the entire waterfront at the same time as they served as landing stages for traffic that flowed along the main river of a city that still lacked

permanent bridges to connect its several islands with the mainland. Velten built carefully planned oval stone stairways from the river's surface to the top of his embankments to aid the lords and ladies whose yachts and barges plied St. Petersburg's waters, and he designed gracefully arched bridges to form gateways through which the city's canals and smaller rivers flowed into the Neva. Once his plan had defined the character of St. Petersburg's center, Catherine proceeded to shape it into one of the capital's most striking architectural features by adding to the city's waterfront several massive buildings and the famed "Bronze Horse-man," which she commissioned the sculptor Etienne Falconet to cast in memory of Peter the Great.[47]

Of the new buildings with which Catherine graced Velten's granite embank-ments, the Marble Palace ranked as the most impressive. Its architect, Antonio Rinaldi, had come to Russia from his native Italy in 1751 to build a palace at Count Kyril Razumovskii's huge Ukrainian estate of Baturino before moving on to St. Petersburg's suburbs late in the decade to build a small palace on the grounds of Oranienbaum. Seeing in Rinaldi the architect who could move Russia away from Elizabeth's flamboyant Baroque to the more elegant classical forms that she associated with good taste and enlightenment, Catherine turned to him in 1768 to plan the Marble Palace she intended to bestow upon Grigorii Orlov, her handsome lover from the Imperial Guards, who had helped to lead her *coup d'état* against her husband.[48] Rinaldi's creation was to set the tone for the Catherinian Age and remain one of the most striking residences anywhere in the city.

While Rastrelli had coated his brick palaces with heavy layers of stucco painted in the blues, greens, yellows, and pinks for which St. Petersburg became famous, Rinaldi insisted upon working with natural stone. For the lower portions of the Marble Palace's walls, he chose rough-cut red Finnish granite, similar in texture to the material Velten had used in the embankment near which it stood. He then built the palace's two main stories out of gray granite, adorned them with Corinthian pilasters of pink marble from Karelia, and shaped the capitals, festoons, and panels around them from white and bluish-gray marble that spe-cially assembled battalions of workers brought from newly discovered quarries in Siberia. A special expedition had to travel a thousand miles across the Urals for the stone, and master masons had to be brought from all over Russia to cut and set it in place. Weighing more than 160 tons, the palace's sheet-copper roof gave the appearance of pure gold (so observers claimed) when it was first put into place, and a set of marvelously wrought iron gates adorned the entrance to the courtyard that faced the Summer Gardens, which Peter the Great had filled with Italian marble statues nearby. By the time the palace was finished in 1785, Orlov was long dead, but his palace stood as a monument to the success with which Catherine had used restrained neoclassical designs to replace Rastrelli's exuberant Baroque. Not long afterward, Rinaldi slipped so deeply into obscurity that the date and place of his death still remain clouded in the same uncertainty that surrounds the life he lived before he came to Russia.[49]

Along with the Roman genius Giacomo Quarenghi, the Scotsman Charles Cameron set firmly in place the transition from the Baroque to neoclassicism that Rinaldi had begun. Judging by her letters, Catherine greeted Cameron's arrival in St. Petersburg during the summer of 1779 with high expectations,[50] and she immediately engaged him to design a series of private rooms in the style of Pompei and Rome for Rastrelli's Catherine Palace at Tsarskoe Selo. In the Lyon Salon, Cameron heightened the effect of walls covered with lapis lazuli and silken damask by inlaying a stunning parquet floor with mother-of-pearl. He decorated the Empress's bedroom with milk-glass walls set off by slender lilac glass columns and medallions designed by Josiah Wedgwood, and his Green Dining Room featured stucco bas-reliefs in the Wedgwood style, set against pale green walls.[51] Although obliged to work with less costly materials, Cameron then designed similar apartments for the Grand Duke Paul and his young wife, and he used neoclassical parquetry, ceiling painting, and wall decoration to such advantage that one critic recently pronounced the result to be an even "greater achievement" than Catherine's own.[52]

Cameron's success won him a flood of new commissions. His greatest work at Tsarskoe Selo became the Colonnade (later renamed the Cameron Gallery), which extended to the south of the palace and offered a breathtaking view of the natural park and great pond that lay beyond. Once called "one of the happiest conceits in eighteenth-century Russian architecture,"[53] Cameron's creation featured a peristyle of forty-four Ionic columns, which held more than fifty bronze busts of the great men of antiquity and from which one of the greatest of all neoclassical staircases descended to a park below. A masterpiece of wrought iron and stone that fully justified Catherine's expectations, the Colonnade and its staircase went far beyond being a decorator's triumph. Not even the Pavlovsk Palace that Cameron built for the Grand Duke Paul at about the same time surpassed the Colonnade's brilliance. "However exquisite the Palladian details," one commentator remarked of the Pavlovsk Palace, which still stands atop a hill that rises a few miles beyond Tsarskoe Selo, "it is obviously the work of an inspired decorator rather than an architect."[54]

Whatever Cameron's strengths and limitations, Giacomo Quarenghi soon eclipsed his achievements. As one of Europe's preeminent eighteenth-century builders, the Italian won the hearts of the Russians and their Empress so quickly that Catherine heaped commissions upon him faster than he could fill them. "I am very glad that this clever architect will not lack opportunities to use his talents, for the passion for building continues here at a frenzied pace,"[55] she wrote enthusiastically to the agent who had recommended Quarenghi to her. "This Quarenghi," she added in another letter, "is producing delightful things. . . . The whole town is filled with his buildings: the Bank, and quantities of stores, shops, and private townhouses, and they are all the best."[56]

"Without paying attention to . . . habits and local circumstances," Quarenghi once warned, "one will produce only mediocre things."[57] He therefore drew his "foundation of simplicity and antique grandeur" from the ancients, but modified

their principles to fit the time and place in which he worked. In Rome, Florence, Verona, and Venice he had measured the great works of ancient and Renaissance masters, and he now moderated those designs to create buildings that were "antique without being archaeological and grandiose yet human in scale."[58] Quarenghi came closer than any other builder to becoming Russia's court architect during the last half of Catherine's reign, yet he never achieved the unchallenged supremacy that Rastrelli had enjoyed in earlier times. The wealth of talent at work in Catherine's Russia meant that even he had to suffer disappointments from time to time.

Quarenghi's first major undertaking was to build an English palace at Peterhof. In less than a decade, he added the State Bank, the Academy of Sciences, and the Hermitage Theater to his list of commissions and then built the Smolnyi Institute for Young Noblewomen, the Horse Guards Riding School, and palaces for several of Russia's greatest aristocrats. His crowning achievement became the famed Alexander Palace that he built at Tsarskoe Selo for Catherine's eldest grandson, Alexander I, but he also applied his talents to dozens of lesser creations, such as a concert hall and an outdoor kitchen disguised as ancient ruins in the Catherine Palace gardens. In nearly all of his work, Quarenghi relied upon a "cubical mass enlivened by a central portico" and set off by Corinthian, Ionic, or Doric columns. "For him," a commentator once concluded, "the circle, triangle, cylinder, and cube in the form of arch, pediment, column and mass were the figures with which he composed his geometrical equations."[59] With them, he created the epitome of Catherinian neoclassicism, which paved the way for the truly grand imperial style that appeared in Russia at the beginning of the nineteenth century.[60]

While Quarenghi and his foreign predecessors brought European neoclassical designs to Russia from Europe, the native-born architects Starov, Bazhenov, and Kazakov defined the Russian neoclassical style that would dominate the cities of the empire in the years ahead. In contrast to the men who had dominated Russian architecture since the days of Peter the Great, all three grew up in Moscow and each studied with Russian masters before he began to work with foreign teachers in St. Petersburg. An awareness of Russia's past figured strongly in their work, and all of them retained some connection to Moscow or the provinces throughout their lives. Bazhenov and Kazakov spent their entire careers in Moscow. Only Starov chose to work for most of his life in Russia's "window to the West," St. Petersburg.

The youngest of the three, Starov, proved to be the most decisive in shaping Russia's transition to neoclassical from the Baroque. The son of a scribe who had moved his family to Moscow after leaving the civil service to become a deacon in the Orthodox Church, Starov studied with the Russian master Savva Chevakinskii before going on to become one of the most promising students at the Academy of Fine Arts. Like his contemporary Anton Losenko, Starov spent most of the 1760s in Paris and Rome before returning to St. Petersburg to teach at the Academy and design country mansions for several of Catherine's favorites.

Then, because his talent for working in the neoclassical style offered another means for overshadowing the Baroque buildings of Rastrelli, Catherine chose him to build the Trinity Cathedral at St. Petersburg's Aleksandr Nevskii Monastery in 1776. In it, Starov would test the ideas about structure and design that soon would make him famous.[61]

The thirty-one-year-old Starov modeled his Trinity Cathedral on a Roman basilica shaped on the plan of a Latin cross. Abandoning any pretense of keeping the traditional five domes that had risen above Russia's greatest churches since the days of Iaroslav the Wise and Iurii Dolgorukii, he built a huge rotunda that he topped with a great ribbed dome, which stood in vivid contrast to the Baroque towers of Rastrelli's cathedral at nearby Smolnyi. Relying on the beauty of interrelated geometrical shapes to replace Rastrelli's jubilant excesses, the Trinity Cathedral personified Russian neoclassicism in its noblest, most compelling form. Because no complex designs or excessive decorations marred its straightforward elegance, the architect's clean lines and simple shapes spoke clearly for themselves. Together with the panels on biblical themes that the sculptor Fedot Shubin installed after the cathedral was completed, Starov's cathedral announced the full-blown arrival of neoclassicism in Russia. From St. Petersburg to the towns of faraway Siberia, this new vision set the style for the civic architecture which, in the days of Catherine's grandsons Alexander I and Nicholas I, would proclaim all across Russia the grandeur of the empire that had defeated Napoleon. Yet, even as the neoclassical style spread across the empire, the greatest monument to Starov's genius remained in St. Petersburg in an out-of-the-way part of the city that had been thought too isolated to receive builders' attention before that time.

So different from Rastrelli's recently completed cathedral at Smolnyi, Starov's Trinity Cathedral won his Empress's heart so quickly that he barely had time to complete it before she ordered him to build a huge palace for Gregorii Potemkin, the lover and statesman whom she had named Prince of Tauris. Set along the Neva near the Smolnyi Convent, the famed Tauride Palace had the look and feel of a country mansion, with splendid gardens that stretched from its main façade to the river. Although a Tuscan portico and rotunda with a low dome dominated its front, the overall effect seemed less Roman than Greek, especially since its creator used Ionic columns to adorn its interior. Using a minimum of architectural decoration to achieve great elegance, this design touched every corner of Russia, as aristocrats and country gentlemen reproduced the Tauride Palace in smaller versions all across the empire's countryside for the better part of half a century after he finished it in 1789. Using wood and brick to achieve on a more limited scale the brilliance that Starov had created with his instinctive "poetry of columns" on the far bank of the Neva, such lords identified the Tauride Palace with what the Russian aristocracy aspired to become, and they used its elegant design to bring a sense of grandeur to the backward, still Muscovite lands of rural Russia. In the meantime, in a fit of rage against his mother and the lovers he blamed for keeping him from the throne for so long,

Catherine's son Paul I turned Starov's masterpiece into a stable and barracks for the Imperial Horse Guards as soon as he mounted the throne. When the Emperor Alexander I ordered its restoration half a decade later, the interior had been so defaced that most of it had to be rebuilt.

The neoclassical forms that Starov spread across Russia's towns and countryside were brought to Moscow by Vasilii Bazhenov, the son of a priest who had grown up in the shadow of the Kremlin. Like Losenko, with whom he entered the Academy of Fine Arts, Bazhenov won an opportunity to study for half a decade in Paris and Rome, and when he returned in 1765 he was ready to build on a scale that surpassed any of his Russian predecessors. Choosing to work in Moscow, he began his career by tearing down Tsar Aleksei Mikhailovich's sprawling wooden palace at Kolomenskoe and then went on to design a huge four-story imperial residence that would have occupied the Kremlin's entire frontage along the Moscow River.[62] Planning on a scale not seen since the days of the Caesars, Bazhenov dreamed of transforming the Kremlin into a Russian acropolis that would rekindle the fifteenth-century vision of Moscow as the Third Rome. It cost sixty thousand rubles just to make his models and would have consumed nearly a fifth of the Imperial Treasury's entire yearly income to build the palace. Yet Russia could not afford such grandeur, and the cost of Catherine's first Russo-Turkish War left the Imperial Treasury too poor to pay for Bazhenov's grandiose plans. Catherine therefore decided to leave the Kremlin's more ancient buildings intact rather than to order their destruction. By a twist of fate, the cost of Russia's first truly decisive victory over its age-old enemy in the South made it necessary to preserve the buildings that still stand as one of its greatest national monuments.[63]

If Bazhenov's plans for rebuilding the Kremlin would have destroyed a vital part of Russia's architectural heritage, his vision for a huge palace at the royal estate of Tsaritsyno revived the building styles of medieval Muscovy in more modern form. Here Bazhenov sought "to summon an aura of the past through a carefully contrived aesthetic vision"[64] that shaped the traditional Muscovite building materials of limestone and red brick into Russo-Gothic form. Although conceived on a scale that rivaled the palaces at Tsarskoe Selo and Peterhof, Bazhenov's effort at Tsaritsyno fared badly. After he had worked there for almost a decade, Catherine decided that his design was too somber, ordered his unfinished palace to be razed, and commissioned his former assistant Matvei Kazakov to rebuild it. Of the handful of Bazhenov's lesser structures that remained standing on Tsaritsyno's grounds the most notable was the famous "Patterned Gate." There he combined an ornamental limestone arch with elaborate brickwork in a particularly artful manner that called forth visions of medieval Russia and Europe at the same time.[65]

Although interesting as a precursor to the "national" revival that flourished a century later, Bazhenov's design for Tsaritsyno remained apart from the rest of his work. Even if it cannot be proven conclusively to have been of his design because the archives relating to it were destroyed by the great fire of 1812, the mag-

nificent Pashkov Palace that still stands atop a height overlooking a corner of the Kremlin has long been attributed to Bazhenov, and continues to be regarded as the best monument to his genius. Often compared to the country houses of the same period in England and France, the Pashkov Palace has no equal in Moscow or St. Petersburg and remains one of the most brilliant neoclassical structures anywhere in Russia. Built during the second half of the 1780s, it housed the family of retired Life Guards Captain Pashkov until after Napoleon's defeat, when its second owner, Count Nikolai Rumiantsev, filled it with rare antiquities before he bequeathed it to the people of Russia fifteen years later. During the second half of the nineteenth century, the Pashkov Palace became one of Russia's greatest libraries, and in Soviet times it served as the Lenin Library until a modern replacement was finished in 1940. Even today, its portico still bears the inscription "To Virtuous Enlightenment," with which its builder had adorned it nearly 150 years ago.[66]

The work of his pupil Matvei Kazakov extended the impact of Bazhenov's vision far beyond the limits imposed by the bad luck and financial troubles that had plagued so many of his efforts.[67] Born in the same year as his mentor, Kazakov worked side by side with Bazhenov while he designed the huge Kremlin palace that would never be built. Vowing to work only in Moscow, Kazakov received his first assignment in 1775, when Catherine commissioned him to build the Petrovskii Palace, at which she would stay during her visits to Russia's ancient capital, and in it he blended the limestone-and-brick designs of old Moscow's builders that allowed him to connect Russia's imperial present with its Muscovite past. The rest of Kazakov's work followed the neoclassical style that he had learned during his years with Bazhenov. With none of the bad luck and disappointments that had tormented his mentor, he placed a stamp on Moscow that even the many urban reconstruction efforts of the Soviet era could not entirely erase.

The year after Kazakov began the Petrovskii Palace, he won a commission to build the Moscow offices of the Imperial Ruling Senate, after which he designed the Assembly of the Nobility, the main building of Moscow University, the Golitsyn Hospital, nearly a dozen churches, and an even larger number of urban estates and townhouses for aristocrats and rich merchants. Although either a strong pediment or a rotunda topped by a dome defined the central mass of his buildings, Kazakov's interiors varied as widely as his patrons' wealth and taste would permit. In some, his lavish use of gold leaf and painted ceilings recalled the height of Rastrelli's St. Petersburg Baroque. Elsewhere, he combined neoclassical and neo-Egyptian motifs of stone and stucco with ornate carvings and rich fabrics to create an impression of opulence and grandeur that few others could match. In them all, he created a readily identifiable style that made him the best-remembered of the architects whose work carried Russia into the nineteenth century. Perhaps more than any other, his designs connected Quarenghi's elegant neoclassicism with the monumental imperial grandeur created by Andreian Zakharov and Carlo Rossi a quarter of a century later.

Because of the way in which his designs fitted any structure from cathedrals and palaces to the modest townhouses of lesser merchants, Moscow became Kazakov's city just as surely as St. Petersburg had been Rastrelli's in the days of Elizabeth, even though the fires of 1812 destroyed some of his greatest achievements. Although those who built on the ruins of his buildings would alter his designs dramatically, strong reminders of Kazakov's genius survived in his Golitsyn Hospital, Church of the Metropolitan Philip, Assembly of the Nobility, and most of all the Moscow offices of the Imperial Ruling Senate in the very heart of the Kremlin. Together, these still stand as monuments to the grandeur of Moscow's Catherinian Age and reminders of the brilliant cultural world that the greatest royal patron of the arts in Russia's history brought into being. Although the years in which the giants of Russian painting, music, and literature would tower above their eighteenth-century predecessors still lay ahead when Catherine died in 1796, the Russians would never again know a ruler who worked so tirelessly to shape their national artistic experience. Nor would they ever again see one who became so much a part of it.

The quest for uncluttered elegance that shaped Russia's architecture also molded the contours of its literature during the latter years of Catherine's reign as the lofty forms that had figured so prominently in the literary life of the Elizabethan Age gave way to simpler, more elegant prose. The heavy Latinate syntax of Lomonosov and Sumarokov now gave way to forms of grammar and expression that resembled more closely those used by Voltaire and Rousseau, and educated Russians responded to the new literary currents that emphasized feeling over reason by trying to express their ideas with greater sensitivity. The compilation of the first comprehensive national dictionary by the newly founded Russian Academy at the end of the 1780s showed the progress that had been made in modernizing and enriching Russian since the days of Peter the Great, yet the dictionary's six oversize volumes also revealed that the language still did not have the versatility to express all the shades of meaning that writers had acquired from their contact with the arts and letters of Europe. "A language that is truly rich," the writer Nikolai Karamzin explained at the turn of the century, "is one in which you can find words to explain not only significant ideas but also to express their differences, nuances . . . and complexity."[68] Karamzin, therefore, set out to bring Russia's literary language closer to the spoken language of educated society and broaden its ability to express subtle nuances and abstract concepts.

Just as Sumarokov and Lomonosov in the 1740s had transformed the language of Russian verse and used it in ways that their literary grandparents had never dreamed of, so Karamzin created the language of polite discourse and secular knowledge that divided Russia's educated classes from its masses at the turn of the new century. Born in 1766 into a family of nobles who lived in Simbirsk, Karamzin stood as living proof that Catherinian Age culture had spread deep into Russia's provinces, even though its leading practitioners remained in Moscow and St. Petersburg. Brought up in a backwater that was a thousand miles from the capital, Karamzin spoke German, French, and Russian by the age

of ten. His formal education, which began in one of Moscow's boarding schools just after he turned eleven, set him firmly into the world of European arts and letters at a time when an "awakening of the heart"[69] was beginning to provide literate men and women with a new and more contemplative vision of the world around them. As they put intuition ahead of reason and chose contemplation over politics, such Russians entered an era of emotional awakening, yet their language could not express the shadings of feeling in which the more flexible, subtle languages of the West were so rich. "What is left for an author to do?" Karamzin inquired as he compared the deficiencies of Russian with the subtleties of English, French, Italian, Spanish, and German. "Invent new words," he urged his countrymen as the new century began. "Work out expressions, guess at the best choice of words, [and] give old words new meanings."[70]

As someone who wanted the Russian language to express the thoughts and feelings of modern men and women as precisely as those spoken by Europeans, Karamzin created the first works of Russian fiction to stand on a par with the literature of Europe. First published in 1792, his novelette *Poor Liza* told the story of a peasant maid who drowned herself in a village pond after being cast aside by the young lord to whom she had given her love. Mawkishly overdrawn by today's standards and shaped around one of the most conventional plots in European literature, its prose set the course that Russian literature would follow for the next quarter of a century. "The link between the mind of the old and new Russia is broken for all time," Karamzin rejoiced a few years later. "We do not want to imitate foreigners," he added. "[We want] to write as they write because we live as they live."[71]

Karamzin once wrote that "Peter the Great made . . . [Russians be] like other Europeans,"[72] but it had taken all of the eighteenth century before writers appeared who had the language to express in prose and poetry the thoughts and sensitivities of their European counterparts. Yet, even if Russia's writers and artists at the beginning of the nineteenth century acted and felt as their counterparts did in Europe, they remained somehow different, for the Romanovs' empire was approaching the height of its glory while France was on the decline. Girding themselves in the trappings of empire as the new century opened, the Russians began to shape the destinies of people and nations that had disdained them a scant century before. Theirs was to be an empire greater than those of the Ottomans and Habsburgs combined, the rival of England in the Near and Middle East, and the gendarme of Europe east of the Rhine. Just as the Russians' artistic experience during the century of Peter and Catherine the Great had been shaped by their sovereigns' efforts to make them a part of Europe, so that of the first half of the nineteenth century would reflect their efforts to stand above Europe as one of the greatest empires in the history of the world.

# TRAPPINGS

# OF

# EMPIRE

*AT THE END OF THE EIGHTEENTH CENTURY,* Russia stood proudly among the great nations of the Western world. No longer the tiny principality of less than six hundred square miles, whose scepter Moscow's first prince had taken up in the middle of the thirteenth century, Imperial Russia now encompassed more than a sixth of the land surface of the globe. Half of the continent of Europe, all of Siberia, all of Alaska, three rivers larger than the Mississippi, mountains steeper than the Rockies, and untold riches in minerals, precious metals, and gems all lay within Russia's borders. Introspective, Orthodox Muscovy had become a multinational empire with a self-proclaimed mission to transform into Russians the millions of Poles, Estonians, Latvians, Lithuanians, Ukrainians, Buriats, Kirghiz, Tungus, Chukchi, and dozens of others whom fate had forced to pay homage to the Autocrat of All the Russias. No other power between the Urals and the Pacific even remotely equaled Russia's strength, and as the events of the next quarter-century would show, not even Napoleon could stand against it in the West. From the Vistula River in central Poland to the edge of Canada's Yukon Territory, Russia's autocrat reigned supreme over a realm so vast that the sun never set upon it.

In the hundred years that had passed since Peter the Great had led his Grand Embassy into Europe, Russia had moved from the medieval world into the modern. So poor in resources and technology that it had imported iron and had its best weapons made abroad in the seventeenth century, Russia now led the world in the production of pig iron, and its soldiers carried arms that equaled those of the best armies anywhere. Schooled in the latest tactics, and sent to war on the

side of Austria and France by a reluctant Empress who preferred peace to war, Russian soldiers had reached the gates of Berlin just before the end of the Seven Years' War in 1761, and in 1814 they would march in triumph down the Champs d'Elysées of Paris to celebrate their victory over Napoleon. Few at home or abroad dared to dispute that Russia had reached the heights of greatness. Even fewer believed that future generations would not see Russia become more powerful still.

If the Russians rivaled Europe in the practice of arms at the end of the eighteenth century, they were well on their way to creating a culture whose greatest monuments vied with some of the best the West had to offer. In St. Petersburg, Moscow, and a score of lesser towns and cities, palaces built by Rastrelli, Quarenghi, Starov, and their imitators could hold their own alongside the grandest residences in Europe. On the tables of Russia's aristocrats, subtly flavored and elegantly served French cuisine had replaced the heavy, uninspired fare of their ancestors, and French wines had long since taken the place of the Muscovites' cloying meads. The manners and styles of Europe had become so much a part of daily life among the lords and ladies of Russia's capitals that native dress was judged fit to wear only at masked balls, and living *à la russe* was thought to be quaint but decidedly crude. Europeans who once had scoffed at the Russians' backwardness now praised their civility. "The brilliance of their conversations," a French aristocrat wrote after visiting St. Petersburg's drawing rooms at the beginning of the new century, "made me forget the [geographical] distance that separates us."[1] Accustomed for so long to think of themselves as inferior to the West, even the Russians had by that time begun to sense the magnitude of their achievement. "If we look at the rapid successes that Russians have made in the arts and sciences," one of them wrote, "we shall have to conclude that they will be brought to perfection in a shorter time than in France."[2]

Nonetheless, when the Russians became the saviors of Europe and the conquerors of Napoleon in 1814, just thirteen years after the Emperor Alexander I had mounted the throne, they found it difficult to comprehend how their nation had so quickly become the most powerful member of the European community after having been its poorest relation for so long. The Romanovs still doubted the reality of their power, and the size and diversity of their empire only deepened their concerns. Did they command obedience everywhere within the empire's frontiers? Or was it true (as some had said) that the Emperor's absolute power reached no further than the room in which he stood and affected no one but the person to whom he spoke? As this need to be reassured on such questions kindled a passion for militarism and the trappings of empire in Paul I and the sons who followed him, they all fell victim to paradomania, the love for parade-ground command that made them drillmasters as much as sovereigns. As the decades passed, scores of battalions wheeling in precise order continued to reassure the Romanovs that they still wielded the power that had made them the conquerors of Napoleon, for how better could an autocrat observe his absolute authority than to see tens of thousands of men obey his commands in an instant?

First Alexander I and then, after his sudden death in 1825, his brother Nicholas I transformed St. Petersburg's center into an immense parade ground to create an arena for such maneuvers. Beginning at the Winter Palace Square and extending along the broad Admiralty Boulevard to the Senate Square some three-quarters of a mile away, the builders who served Russia's sovereigns laid out an L-shaped area of more than four and a quarter million square feet on which up to a hundred thousand troops could maneuver at one time.[3] From the second-floor balcony of Rastrelli's Winter Palace, the nineteenth-century Romanovs could see Russia's best fighting men marching in formation for as far as the eye could see, and as they reviewed these armies from the palace in which their ancestors had reigned and died, they identified their dynasty all the more closely with Russia's military power.

To emphasize the ties that bound the army and sovereign to Russia's government and Church, the two imperial brothers erected some of the most grandiose buildings in their nation's history along the outer limits of the huge square upon which their armies marched in review. Each was an imperial monument conceived and executed on an immense scale, and the massive three-dimensional renderings of pagan deities and Russian national heroes that their builders set against backdrops of soaring columns and massive façades left no doubt that Russia's emperors identified their triumphs with the glories of ancient Rome. Because no other sovereign in Europe was building on such a scale, the opportunities in Russia attracted architects from all across the continent. To the Italian and English masters who had built the graceful masterpieces of Catherine the Great's reign and to the Russians who owed their training to them, Russia's emperors now added more masters from Italy, France, and Switzerland. Working together—and with the immense resources that the rulers of Russia now could provide—they transformed St. Petersburg into a truly imperial city.

The first of these monumental buildings to take shape was the rebuilt Imperial Admiralty. Designed by Ivan Korobov in the 1730s, the original Admiralty building had been nearly a fifth of a mile long and had boasted an ornate central section that contrasted sharply with its decrepit, uninspired wings. The old Admiralty thus entered the nineteenth century as the longest building in St. Petersburg, with two monotonous rows of windows that stared dully out on the more elegant palaces and townhouses beyond it. Of all the buildings in the vicinity of the Winter Palace, it cried out the loudest for repair and redesign. In 1805, the centennial of the creation of the Admiralty by Peter the Great marked the occasion to begin.[4]

In the spring of 1805, Alexander I appointed as "Chief Architect of the Admiralty" Andreian Zakharov, a middle-aged professor of architecture at the Academy of Fine Arts. Born a year before Catherine the Great had seized Russia's throne, Zakharov had studied for four years in Paris with the man who would create Napoleon's Arc de Triomphe, and he approached the task of transforming Korobov's ponderous building with the confidence and naïveté that be-

fitted a man who had taught for nearly two decades the tasks he was about to undertake. From the beginning, Zakharov worked on a colossal scale, yet, except for the central pavilion that stood beneath its shining golden spire, he kept his building amazingly simple and relied mainly on groupings of towering Greek columns to ornament the façade that he had extended to just ninety-eight feet short of a quarter mile. "Perhaps the most radical attempt to achieve the monumental purity of volume idealized at the end of the eighteenth century" according to some,[5] Zakharov's Admiralty has been called an essay in "solid geometry"[6] which, more than any other building of the era, bore the accent of Alexandrine classicism.[7]

The sculptures and bas-reliefs with which Zakharov ornamented the central pavilion of his Admiralty left no doubt that the building was meant to commemorate an empire whose lands touched a dozen of the world's seas. Twenty-eight statues representing the elements and the seasons ornamented its cornices, and four monumental sculptures of Alexander the Great, Achilles, Ajax, and Pyrrhus stood proudly above the corners of its attic. Not since Grand Prince Vsevolod III's thirteenth-century Cathedral of St. Dmitrii had any Russian building combined sculpture and architecture with such dazzling effect, and from the moment of its completion in 1823 Zakharov's new Admiralty stood as an awe-inspiring expression of the power of the new century's largest contiguous empire. With the Winter Palace on its east, it defined the northern boundary of imperial St. Petersburg's huge parade ground. As such, it became a reference point on which the creators of other imperial buildings all took their bearings.[8]

Compared to the structures around it, St. Isaac's Cathedral was to become the most unusual of the buildings that framed the interconnecting squares that lay to the Admiralty's west, south, and east. Rebuilt from an earlier church that Rinaldi had designed half a century before, it celebrated the Russians' triumph over Napoleon and proclaimed again the imperial power that ruled nearly seven million square miles of Eurasia. With the exception of Zakharov, who had died in 1811, the greatest architects of the Alexandrine era submitted plans for the competition held to determine who would build the largest cathedral in Russia, but the commission went to August Ricard de Montferrand, lately of Napoleon's Imperial Guard, who presented as his only credentials a beautifully bound book of gemlike miniature paintings that showed how the rebuilt cathedral might look if it were done in the typical architectural styles of China, India, Byzantium, Greece, Rome, and Renaissance Italy. No blueprints or any other specifications accompanied his volume, but for an autocrat accustomed to having his orders carried out the detailed miniatures were enough to win Montferrand the commission. "Draft a decree . . . appointing Montferrand Court architect," the official who processed his appointment was told in the spring of 1818. "What sort of an architect can he be? He's never built anything at all!" the surprised bureaucrat asked. "Never mind," his superior replied. "Just be quiet and draw up the papers."[9]

Alexander's choice of Montferrand brought protests from architects who knew the dangers of raising great buildings on St. Petersburg's marshy subsoil. Work on the cathedral had to be halted for several years while a commission of architects corrected the structural errors in Montferrand's initial plans, which had to be amended again and again over the next four decades on the basis of designs done by others.[10] Even though this "semi-collective design" of the cathedral proved less than satisfying, the massive dome that Monferrand raised above its huge central drum provided a much-needed focal point for the center of Russia's imperial capital at the same time as it fixed the shape of the southwest corner of St. Petersburg's central square for all time. Reminiscent more of St. Paul's in London than of St. Peter's in Rome, St. Isaac's was only slightly smaller than either. Fundamentally different from the other buildings that lined the huge parade ground of which it was a part, it complemented them in a way that only the eclecticism of the Russian artistic experience could make possible.

Built entirely of marble and granite, St. Isaac's Cathedral cost more than twenty-five million rubles before it was finished in 1858, and the opulence of Montferrand's materials helped to compensate for the shortcomings in his design. Columns of polished red Finnish granite, which were seven feet thick and fifty-four feet tall, supported four great porticoes modeled on the Pantheon in Rome, and the huge ribbed dome, which weighed over two thousand metric tons (not counting the maze of cast-iron girders that supported it), was one of the largest anywhere in Europe. Aside from smaller quantities of such semiprecious stones as lapis lazuli and porphyry, nearly nine hundred pounds of gold, a thousand tons of bronze, and sixteen tons of precious Siberian malachite adorned the cathedral's interior.[11] Not even Quarenghi or Rastrelli had been allowed to build on such a scale, and both had been obliged to adjust their designs to take into account the limits that their imperial patrons imposed on their spending. Now, as his imperial vision came more clearly into focus, Russia's sovereign had different concerns. Size and opulence took precedence over the grace and elegance of the age of Catherine the Great so as to provide "grandeur of form, nobility of proportion, and indestructibility." At least that was the view of Carlo Rossi, the nineteenth-century architect who was destined to leave a greater mark on St. Petersburg than any builder since Rastrelli. Asking "why should we fear to be compared with [the Romans] in magnificence?"[12] Rossi set out to transform St. Petersburg into a truly imperial city.

Born at the end of 1775, Rossi was the son of an Italian dancer, who had settled in the royal suburb of Pavlovsk after a career during which she had been the prima ballerina of St. Petersburg. While still in his teens, he had studied with the noted architect Vincenzo Brenna, whose chief claims to fame were the brilliant interiors he had designed for Cameron's Pavlovsk Palace and the gloomy Mikhailovskii Castle that Paul I had commissioned at the beginning of the new century. Thanks to the hospitality that Brenna offered after retiring to Italy in 1802, Rossi spent two years in Florence and Rome, where he acquired a passion

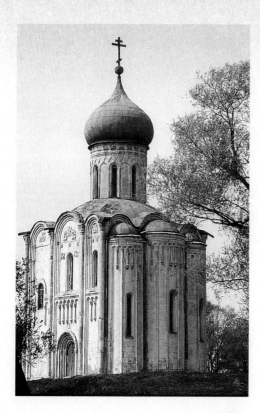

Built in 1165 on the bank of the Nerl River just beyond the village of Bogoliubovo, the Church of the Protection and Intercession of the Virgin still retains its medieval beauty.

*Photo courtesy of Jack Kollmann.*

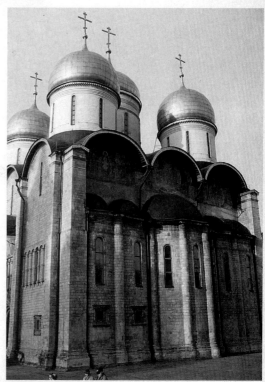

Beginning with Grand Prince Vasilii III in 1505, every Russian sovereign was crowned in the Dormition Cathedral, which Vasilii's father, Ivan III, hired the Bolognese architect Aristotele Fioravanti to build in the center of Moscow's Kremlin between 1476 and 1479.

*Photo courtesy of Jack Kollmann.*

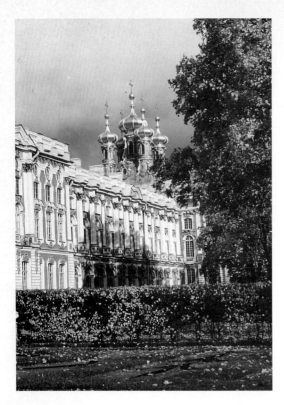

Nearly a fifth of a mile long, the Catherine Palace at Tsarskoe Selo (present-day Pushkin) embodies the uniquely Russian version of the Baroque that made its creator Bartolomeo Rastrelli the favorite architect of the Empress Elizabeth.

*Photo courtesy of Jack Kollmann.*

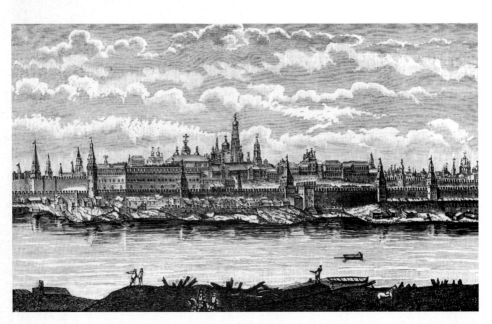

This eighteenth-century engraving shows the Moscow Kremlin as it appeared when Peter the Great moved Russia's capital to St. Petersburg.

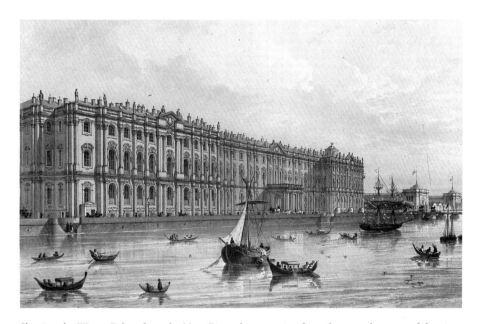

Showing the Winter Palace from the Neva River, this engraving from the second quarter of the nineteenth century portrays the full brilliance of what is perhaps the greatest accomplishment of architect Bartolomeo Rastrelli.

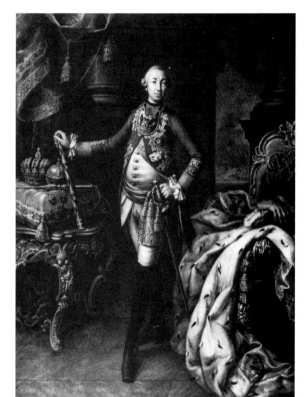

A distinguished painter of portraits during the reign of Catherine the Great, Aleksei Petrovich Antropov (1716–1795) first rose to prominence as the artist who painted Emperor Peter III (1762) just a few months before Catherine drove him from the throne.

*From: Grand Duke Nikolai Mikhailovich, ed., Russkie portrety XVIII i XIX stoletii (St. Petersburg, 1905).*

Set against the backdrop of St. Petersburg's huge St. Isaac's Cathedral and immortalized by Aleksandr Pushkin in his poem *Bronze Horseman*, this monument to Peter the Great was created by the French sculptor Etienne Falconet on orders from Catherine the Great. Completed in 1775, it was installed seven years later atop an enormous block of rough-hewn granite that hundreds of serfs and soldiers dragged from a forest in nearby Finland.

*Photo courtesy of Jack Kollmann.*

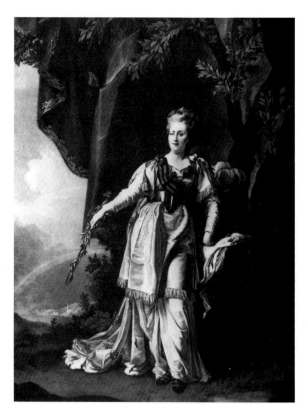

Dmitrii Grigorevich Levitskii's (1735–1822) portrait of the Empress Catherine the Great reflects the self-image of high society in St. Petersburg during the last third of the eighteenth century.

*From: Grand Duke Nikolai Mikhailovich, ed., Russkie portrety XVIII i XIX stoletii (St. Petersburg, 1905).*

One of Russia's most brilliant practitioners of neo-classicism, Mikhail Ivanovich Kozlovskii (1753–1802), created the famed Samson Fountain in the year of his death. As the centerpiece of the Peterhof Palace's Grand Cascade, Kozlovskii's *Samson* served as an allegorical symbol of Imperial Russia's early-eighteenth-century triumphs.

*Photo courtesy of Jack Kollmann.*

A Cossack cavalryman who dabbled in painting until Catherine the Great discovered him on a trip to South Russia, Vladimir Lukich Borovikovskii (1757–1825) won favor at the Russian court at the very end of the eighteenth century. This 1799 painting of the Princess Elena Aleksandrovna Suvorova shows Borovikovskii's preference for painting young women in languid, romantic poses against the backdrops that Sir Joshua Reynolds and Thomas Gainsborough had made popular in England.

*From: Grand Duke Nikolai Mikhailovich, ed., Russkie portrety XVIII i XIX stoletii (St. Petersburg, 1905).*

As is evident from these self-portraits (1824), the greatest of Russia's Romantic poets, Aleksandr Sergeevich Pushkin (1799–1837), had the habit of sketching himself and his friends in the margins of his manuscripts as he worked.

This sketch forms the manuscript title page for *The Tale of the Golden Cockerel*, which Aleksandr Pushkin wrote early in the fall of 1834 at Boldino, an estate to which he often retreated in search of poetic inspiration.

"An Official on the Morning after Receiving His First Decoration," which Pavel Andreevich Fedotov (1815–1852) painted in 1846, satirizes the unhealthy passion with which mid-nineteenth-century Russian officials worshiped all badges of rank and recognition.

*From:* Istoriia Rossii v XIX veke (*Moscow, 1907–1911*), *Vol. 5.*

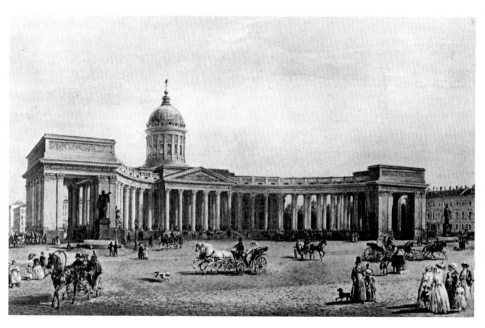

An artist who became famous for the precision with which he portrayed the streets and buildings of St. Petersburg, Vasilii Sadovnikov (1800–1879) began life as a serf of the same Princess Natalia Golitsyna who served as the model for the willful dowager in Aleksandr Pushkin's famous short story *Queen of Spades.* In this watercolor of the Kazan Cathedral dating from the mid-1840s, Sadovnikov emphasizes how the pantheon of Imperial Russia dominated the city's main thoroughfare.

Not long before Dostoevskii and Tolstoi rose to dominate Russian letters, the novelist Ivan Sergeevich Turgenev (1818–1883), shown here in an engraving from the 1860s, wrote *A Hunter's Sketches* (1852), which became the most influential abolitionist tract ever to appear in Russia.

for building in the grand manner of the Romans. He returned to St. Petersburg at the end of 1803 to be consigned to the Imperial Porcelain Works "because," the Emperor Alexander explained, "of his talent for drawing."[13] Three years later, Rossi found work as an architect in Moscow. After that, he worked in the provincial city of Tver until 1815, when he returned to St. Petersburg to proclaim that the time had come for Russia to build in a manner that would "surpass that which the Romans [had] considered sufficient for their monuments."[14] Flushed with his victories over the once-invincible armies of Napoleon, Alexander I now found Rossi's readiness to link the glory of modern Russia to the greatness of ancient Rome very much in keeping with his own vision of his empire's future. During the next twenty years, Rossi would build several of Russia's greatest buildings of state.

Almost from the beginning, Rossi worked on a scale that was worthy of the emperor he served and the Romans from whom he drew his chief inspiration. So as to create a proper setting for the stunning Mikhailovskii Palace, which he designed for the Grand Duke Mikhail Pavlovich and his beautiful Württemberg bride in 1819, he reshaped the façades of the buildings on the three sides of the square it faced as well as those on the street that led from the square opposite its main entrance. Between 1828 and 1832, he rebuilt the façades of the buildings facing the square in front of the Alexandrine Theater and then proceeded to construct housing for its schools and training facilities behind it. Monumental in themselves, such ensembles marked only a small part of Rossi's legacy to St. Petersburg, for his genius demanded larger squares and greater buildings before it could express itself in full measure. The three great buildings that gave final form to the vast imperial complex that Zakharov's Admiralty had begun, therefore, became Rossi's crowning achievement.[15]

In 1819, Rossi began to rebuild Russia's General Staff Headquarters and redesign the square that separated it from the Winter Palace. To resolve the dilemmas of space and scale that had baffled architects ever since Rastrelli's time, he cast the façade of General Staff Headquarters in the form of a huge arc that stretched the length of six football fields. He then punctuated its center with three towering arches, one behind the other, to fill the passage that connected the Palace Square to the nearby Nevskii Prospekt.[16] Topped by a colossal figure of "Victory" in a six-horse chariot that was restrained by two giant warriors, Rossi's huge façade created a spectacular backdrop for the tens of thousands of troops that marched in massed formations on the Palace Square. Between 1829 and 1834 he repeated many of its architectural elements in the two buildings he created to house Russia's highest judicial, administrative, and ecclesiastical offices at the opposite end of St. Petersburg's imperial parade ground.

Rossi built in a straight line the offices that would hold the Imperial Senate and the Holy Synod until the revolution of 1917, divided them with another great arch, and used paired free-standing columns to highlight their façades. Although some have seen a certain stagnation in these last of Rossi's creations,[17] the

Senate and Synod buildings in fact marked the brilliant culmination of a project that had been begun three decades earlier with no master plan to integrate its diverse elements. As such, Rossi's last buildings defined the final boundaries of an imperial arena that had no equal anywhere in Europe.[18] Now tied as closely to Imperial Rome by its architecture as to Imperial Byzantium by the faith of its people, St. Petersburg had become the capital of one of the greatest empires in the history of humankind and a very different city from the one over which Catherine the Great had reigned less than half a century before.

Even before Montferrand, Zakharov, and Rossi started to lay out the Romanovs' imperial arena, other builders began the transition from the elegant, muted neoclassicism of Catherine's era to the imperial style that Russia would adopt as the conqueror of Napoleon. Among the first in Russia to build in the monumental style of the ancients, Thomas de Thomon, a French-educated Swiss, brought the influence of the towering Greek temples at Paestum to the heart of St. Petersburg at the very beginning of the nineteenth century. Ever since the days of Peter the Great, Russia's court architects had debated how to shape the easternmost tip of the capital's Vasilevskii Island into a focal point that would welcome ships arriving from the West, and their efforts had produced one dismal failure after another. In the 1780s, Quarenghi had tried to highlight the island's tip with a Bourse, but the cost of Catherine's second war with the Ottoman Empire had brought an end to his effort long before it was finished. For more than a decade, the project had languished. Dissatisfied with the shell of Quarenghi's building, Alexander I had it razed and turned to de Thomon, who had only recently come from Europe to seek his fortune in Russia.[19]

Between 1805 and 1810, de Thomon created a masterpiece that would dominate the waterfront of St. Petersburg in much the same manner as the Parthenon ruled the hills of Athens. After taking several years to perfect his plans, he surrounded his Bourse with forty-four towering Doric columns in the grandest manner of the ancient Greeks and then framed his "free essay in temple architecture"[20] with two rostral columns held in place by huge sitting figures that personified Russia's major rivers. Set apart from St. Petersburg's mainland, the Bourse and its columns presented a breathtaking view, especially during the "white nights" of early summer, when sunlight at midnight washed the entire city with the silvery glow of the Arctic. "A stroll along the Bourse Embankment has matchless charm," one Russian wrote not long after de Thomon had finished his work. "The melancholy accent of a Russian ballad, or the call of a nightingale, are the only sounds that break the silence."[21] On holiday nights at other times of the year, the rostral columns spouted pillars of flame that seemed to sear the sky and lighten the heavens to show that, almost directly across the river from the Winter Palace, de Thomon had transformed an unused spit of land into a sight whose drama had no equal anywhere else in Europe.[22]

While de Thomon brought the imperial vision of Greece's ancient builders to St. Petersburg, Andrei Voronikhin built a cathedral that rivaled the magnificence of St. Peter's in Renaissance Rome. In all probability the son of Count Aleksandr

Stroganov and a serf girl from the faraway province of Perm, Voronikhin grew up in the household of one of Russia's wealthiest and best-known patrons of the arts. Stroganov sent him to work with Bazhenov and Kazakov in Moscow while he was still in his teens, brought him to St. Petersburg not long after he turned twenty, and then sent him to study in Europe for most of the 1780s. Voronikhin returned to Russia an accomplished artist, decorator, and builder, who soon became known as one of the most talented young architects of the generation that was beginning to challenge the men who had served Catherine the Great. When the Emperor Paul I decided to build a cathedral to the famed icon of the Madonna of Kazan, Stroganov had no difficulty in winning the commission for Voronikhin, and at the beginning of 1801 the former serf began to design the building that was to become Russia's pantheon.[23]

As St. Petersburg's *Northern Post* proudly reported, the Kazan Cathedral was designed and built entirely by "native Russian artists."[24] Dedicated to a wonder-working icon that had been found in Kazan in 1579, brought to Moscow to bless the Russians' victory over the Poles in 1612, and transferred to St. Petersburg by Peter the Great, the Kazan Cathedral became a monument to the Russians' messianic mission, the triumphs of their empire, and the special protection that God had bestowed upon them and their sovereigns. For ten years Voronikhin worked to refine his plans. Then, with thousands of serfs and stonemasons toiling through St. Petersburg's dark winter days and sunlit summer nights, he set to work until, in 1811, the cathedral was complete.

Laid out in the shape of a cross, the Kazan Cathedral was 236 feet long and 180 feet wide. Fifty-six Corinthian columns of polished granite ornamented its interior, and its iconostasis contained nearly two tons of silver. Borovikovskii painted several of its largest icons, but the Madonna of Kazan, which resided in the place of honor just to the left of its Royal Doors, held pride of place. Colossal statues of St. John the Baptist, St. Andrew, and the sanctified grand princes Vladimir and Aleksandr Nevskii stood in niches along the cathedral's walls, and 144 Corinthian columns fanned outward from its center to create a huge semicircular courtyard like that of St. Peter's.

Voronikhin's cathedral became a pantheon to Russia's heroes and a monument to its imperial power. As his armies drove Napoleon from Russia and continued their march toward Paris, Alexander I enshrined more than a hundred captured French banners and eagles in its sanctuary, along with the baton of Napoleon's great Marshal Davout and the keys to twenty-five captured cities and fortresses. In July 1813, a saddened nation laid to rest the body of Field Marshal Prince Mikhail Kutuzov on the spot at which he had knelt to pray for God's guidance before he had marched against Napoleon the year before.[25] Even after Montferrand completed St. Isaac's, the cathedral dedicated to the wonder-working icon of the Madonna of Kazan continued to stand for Russian glory and Russian power in ways that no other church in the empire ever could.

The aristocracy's readiness to share the imperial vision to which the builders of St. Petersburg paid homage made it all the easier to connect provincial Russia

to the imperial vision of its sovereigns. Their façades ornamented with columns that towered over the wooden cottages that huddled near them, structures resembling Rossi's Imperial Senate arose in Vladimir, Novgorod, and Tver, not to mention such frontier areas as Simbirsk, Perm, and Orenburg, and the distant towns of Siberia. Nobles of substantial means in all parts of the empire imitated Ivan Starov's Tauride Palace in the designs they used for their country homes, and they followed the examples of Quarenghi, Kazakov, and dozens of their students in the townhouses they built in those 738 settlements in the empire that bore the title of town or city.[26] One French diplomat had noted at the end of the eighteenth century that Russia's nobles had begun "to imitate the Patricians of Rome" to such an extent that "one could meet more than one Lucullus in Moscow."[27] Thirty or forty years later, "Lucilluses" who reveled in aping the great lords and ladies of St. Petersburg in the style of their provincial townhouses numbered in the hundreds.

In addition to townhouses, country manors, and the official buildings that proclaimed Russia's power from St. Petersburg to the Pacific, other forms of art emphasized the new imperial vision that the Romanovs shared with the upper classes. These years saw the high point of heroic sculptures that reconnected Imperial Russia to the glories of its Muscovite past at the same time as they underlined its new sense of kinship with the empires of the ancient world. Towering likenesses of Grand Prince Vladimir, the national heroes Minin and Pozharskii (who had liberated Russia from the Poles in 1612), Peter the Great, and Kutuzov took their places in cathedrals and public squares along with Ajax, Diana, Hercules, Venus, Mars, and scores of other figures drawn from the mythology of ancient Greece and Rome. If sculpture had a golden age in Russia, it occurred between the 1780s and the 1830s, when the Russians' awakening sense of their Muscovite past and their sovereigns' new imperial vision created a surging demand for three-dimensional art in public places.

Although church ornamentation in bas-relief had been done from time to time in premodern Russia, sculpture in the full three-dimensional meaning of the term had come into being only at the time of Peter the Great, when the State had finally set aside the Church's stern prohibition against the production of graven images. As in modern architecture and painting, the first to practice the art of sculpture in Russia had been foreigners, the best known of whom was the architect Rastrelli's father, Carlo, whose full-length likeness of the Empress Anna is remembered as his best work. But unlike the Europeans who transformed the way in which the Russians practiced painting and architecture, the elder Rastrelli found few disciples. The art of sculpture developed so slowly in Russia over the next half-century that Catherine the Great had to invite the sculptor Etienne Falconet from Paris to create a monument to the memory of Peter the Great in the late 1760s because she could find no one in Russia with enough talent and training to do the work.

The son of a poor joiner, Falconet was one of many competent sculptors who

worked in Paris during the half-century before the French Revolution. When he arrived in Russia at the age of fifty in 1766, he had no great works to his credit, and he had never worked on the colossal scale that Catherine would demand. Yet the high expectations of the Empress gave him a vision that elevated his work to a level he had never imagined in the West. With the help of his pupil and future daughter-in-law Marie Collot, Falconet produced a statue of Peter the Great that became Imperial Russia's best-known monument. Astride a rearing charger and crowned with a laurel wreath, this famed "Bronze Horseman" wore simple Roman garb, but the inscription "To Peter the First from Catherine the Second" made it clear that the horseman had been cast to commemorate the empire of the here-and-now, not one from the faded past. "There he stands," Russia's great Romantic poet Aleksandr Pushkin exclaimed half a century later. "What mighty thoughts engrave his brow! What hidden power lies within!"[28] Like Marcus Aurelius, whose towering statue atop the Capitoline Hill in Rome had stood as the model in which the greatest heroes would be cast ever since the time of Donatello, Peter had become immortal. Falconet had cast the first of the many lines with which Russian sculptors in the years ahead would bind Russia to the glories of ancient Rome.

At the beginning of the nineteenth century, three young men followed the course Falconet had set by producing monumental works in the classical style that would rule the world of Russian sculpture for more than fifty years. Ranging in age from ten to thirteen, Ivan Martos, Mikhail Kozlovskii, and Feodosii Shchedrin all entered the Imperial Academy of Fine Arts in 1764. With Kozlovskii being the son of a trumpeter in the navy, Shchedrin the son of a private soldier, and Martos (the youngest) the son of a junior officer who served in Russia's provinces, their backgrounds underlined Catherine the Great's belief that talent should be fostered wherever it could be found. In 1772, Shchedrin won the Academy's coveted gold medal at its annual competition and went on to study in Rome. The next year, Martos and Kozlovskii shared the medal and followed him. Fascinated by the rich heritage of three-dimensional art they found in the West, the three young Russians began to interpret the artistic treasures left by the ancients in ways that would make the work of each of them different when they returned to Russia.[29]

During the six years he spent in Paris and Rome, Kozlovskii took his first themes from Roman and Greek mythology and the pages of ancient history. Apollo, Hercules, Ajax, Hymen, and Cupid all commanded his attention, and so did Alexander the Great and Achilles. After he returned to St. Petersburg, he portrayed Catherine the Great as Minerva and won acclaim during the reign of Paul I for the marble caryatids he carved for the throne room at Pavlovsk. He did his two best-known statues during the three years before he died in 1802, and both showed the extreme perfection of form and figure that marked his work. In 1800, Kozlovskii began his memorial to the great Marshal Prince Aleksandr Suvorov, victor in Catherine the Great's Turkish wars and the campaign

that Paul I sent his armies to wage against Napoleon in Northern Italy. At almost the same time, he started work on the huge statue of Samson for the Grand Cascade at the imperial palace at Peterhof.

Small, with sharp features and wispy hair, Suvorov in real life had been the antithesis of the heroic, perfectly proportioned figure that Kozlovskii cast in the form of Mars in full armor. Holding a shield that bore Russia's famed two-headed eagle, the sculptor's image radiated a powerful sense of national pride, and if it did not portray Suvorov accurately in physical terms it captured perfectly the daring confidence that this first hero of Russia's imperial age had imparted to the troops he had led so often to victory. There was a "deep inner truth," one observer wrote, in the "calm courage" that Kozlovskii's heroic statue displayed.[30] Therein lay the vision of Imperial Russia's power that the artist sought to project in the monument that took its place at the edge of St. Petersburg's Field of Mars in 1801.

The sense of physical power that radiated from Kozlovskii's memorial to Suvorov found even more dramatic expression in the statue of Samson that he finished the following year. Perfectly built and with every muscle straining, Kozlovskii's Samson forced open the jaws of a lion, from which a jet of water thicker than a man's arm spurted more than fifty feet into the air. Cast of bronze and gilded with pure gold, the statue stood in the center of Peterhof's Grand Cascade as an allegorical symbol of Imperial Russia's first triumphs. In Kozlovskii's rendering, the Old Testament figure stood for St. Samson, one of the protectors of Russia, while the lion (which also formed the national crest of Sweden) symbolized the enemy Peter the Great had confronted at the beginning of the eighteenth century. On St. Samson's day, June 27, 1709, Peter the Great had defeated the Swedes at the battle of Poltava to win for Russia a place among the great powers of Europe. To the Russians of Kozlovskii's time, the titanic figure of Samson in the Grand Cascade proclaimed their nation's greatness every bit as powerfully as did his monument to Suvorov.[31]

Kozlovskii's "Samson" had been part of a turn-of-the-century undertaking that had brought St. Petersburg's leading sculptors together to repair and redesign Rastrelli's deteriorating Grand Cascade at Peterhof. In addition to casting several of the original marble statues in gilded bronze, the artists had produced nearly a dozen new ones in the best neoclassical manner, of which Kozlovskii's had been the largest. As part of the project, Feodosii Shchedrin designed two groups of gilded bronze mermaids and an allegorical statue of a maiden who bore the name of Neva, all of which he completed within three years of Kozlovskii's death.[32]

But, while work on the Grand Cascade had come at the end of Kozlovskii's career, it had marked only the beginning of Shchedrin's finest decade. From the Grand Cascade, he went on to carve for Voronikhin's Kazan Cathedral a huge frieze of Christ carrying his cross to Golgotha. Working on such a scale for the first time, Shchedrin cut nearly fifty figures into his huge stone canvas to convey the full sense of the tragedy that had filled Christ's final hours.[33] At the same

time, its massive scale reflected the growing scope of Russia's new imperial vision. Placed in the pantheon of Russia's heroes, Shchedrin's frieze united his nation's recent triumphs with the resurrection of Christ and marked the beginning of a movement that would eventually bind Russia's past and present to a messianic vision of its future.

Shchedrin carried the massive sense of scale that he had used in his work at the Kazan Cathedral to the two groups of three caryatids, each supporting a massive sphere, which he placed on granite pedestals outside the main entrance to Zakharov's Admiralty just weeks before Napoleon invaded Russia in 1812. Elegant, powerful, and cold, these marked his greatest achievement, for the six huge classical figures did not bend beneath the weight of the spheres they supported and projected a powerful sense of Russia's world mission.[34] Larger than life but entirely without emotion, Shchedrin's caryatids became monuments in the fullest sense of the word. In that way, they paved the way for Ivan Martos to produce the first monument to a national historical figure whose achievements lay at the very heart of Russia's glory.

Rather than divide his student years between Rome and Paris as his comrades had done, Martos had spent all of his time in Rome, where he acquired a very strict sense of the neoclassicist manner. He returned to St. Petersburg at the end of the 1770s to teach at the Academy of Fine Arts and spend the next quarter-century designing funeral monuments for some of Russia's greatest aristocrats. He was well past fifty when he submitted a design in the competition for a bronze monument to mark the bicentennial of Russia's liberation from the Polish yoke, which Alexander I announced at the beginning of 1808, and nearly fifty-five when his design was chosen to be placed on Moscow's Red Square near St. Basil's Cathedral. Martos's monument was to commemorate the historic moment when the people of Russia had risen as one under Prince Dmitrii Pozharskii and the Nizhnii-Novgorod tradesman Kuzma Minin to throw off the yoke that the armies of Poland had imposed upon them. Yet, when Martos received the commission, no one in Russia foresaw that the two-hundredth anniversary of the Poles' defeat would be celebrated by a second Russian liberation. The defeat of Napoleon's armies in 1812 would add to the sense of national glory that Martos's monument was expected to reflect. Cast in St. Petersburg, but moved to Moscow in a four-month journey that recalled the transfer of the Madonna of Vladimir from Kiev to Vladimir by the armies of Prince Andrei Bogoliubskii 650 years earlier, Martos's monument to the heroes of Russia's liberation in 1612 was cheered by crowds all the way from Russia's new capital to its old.[35]

More than Kozlovskii's Suvorov, more, even, than Voronikhin's Kazan Cathedral, Martos's huge bronze tribute to Minin and Pozharskii drew attention to a pivotal moment in Russia's history that lay far enough from the present so that living memory could not dispute the artist's vision. The imperial vision that had obliged Peter the Great to turn his back on his nation's isolationist, Church-centered past now began to bring its history back into focus, and for the first time Holy Moscow and Imperial Russia joined into one. The Russians' new

vision of the past now reached back for 850 years to unite the conquerors of Napoleon with the now-sainted Grand Prince Vladimir the Blessed of Kiev. What Russia's first emperor had dismissed as centuries of backwardness now became part of Russia's imperial greatness.

Nothing proclaimed Imperial Russia's reunion with its Muscovite past more dramatically than the twelve-volume *History of the Russian State*, which Nikolai Karamzin published between 1818 and 1825 (the final volume appeared posthumously in 1829). Seeing it as "the holy book of a people [and] . . . the mirror of their being and actions,"[36] Karamzin vowed that he would use history to instruct Russia's princes and citizens in the lessons to be learned from the past. In prose worthy of Tacitus and Gibbon, he transported his readers back to the time when Europe had been "an arena of feudal tyrants, of feeble monarchs, insolent barons, people in slavery, superstition and ignorance,"[37] and Kiev had been a center of learning and the arts. Russia had looked south and east in those long-ago days, and the Russians had bowed to the will of the stern princes whose rule had brought them greatness. Novgorod had been the exception. It had fallen, Karamzin insisted, when "the increase in wealth which disposes people to peaceful delights" had undermined the strength of its armies. In the end, the "frail freedom of Novgorod" had been crushed by Moscow's autocratic Ivan the Great to ensure "steady welfare for all Russia."[38]

Insisting that "history is not a novel and the world is not a garden in which everything must be pleasant,"[39] Karamzin introduced nineteenth-century Russians to the heroes and villains of their past. He wrote of Iaroslav the Wise, the eleventh-century grand prince who had built libraries that surpassed those of Paris and London and had marshaled the armies of Kiev to form Europe's eastern bastion against the fearsome nomads of the steppes. He explained how a decline in civic virtue after Iaroslav's time had condemned the Russians to centuries of civil war and how autocracy alone had restored Russia's strength. "If Rome was saved time and time again by a dictator in cases of great danger," he asked his readers, "could Russia . . . revive and resurrect her greatness in any other way?"[40] As the rulers of Moscow extended their power across the lands of Old Russia, Russians came to "prefer the tranquillity of the unlimited power of the sovereign."[41] The rights of man, so beloved by disciples of the Enlightenment, had to give way to order and regulation. Because "public welfare, justice, and security," in Karamzin's view, comprised "the three pillars of civil happiness," civic order had to take precedence over personal rights. "Wise people love order," he told his readers, "and there is no order without autocratic power."[42]

While Peter the Great and his successors had struggled to make Russia a part of Europe, Karamzin now acclaimed the uniqueness of the Russian heart and spirit and promised that God would bless Russia's people if they kept faith with their traditions. Fresh from the killing grounds of the Napoleonic wars, in which battles at Borodino, Leipzig, and Dresden had claimed tens of thousands of lives in a single day, the Russians were ready to see in the new vision of history that Karamzin laid before them a promise of even greater days to come. In a society

in which publishers measured literary success in hundreds of copies, all three thousand of the first eight volumes of his *History* sold out in less than a month.[43] Karamzin's tales of bygone days became the topic of conversations at formal dinners and intimate private gatherings, and for the better part of a decade the discovery of Russia's history held a place of honor in the salons of St. Petersburg and Moscow. No longer obliged to apologize for being last among the Europeans, the Russians for the first time in memory acquired heroes with whom they could identify, enemies whom they could hate, and a past of which they could be proud. "Everyone, even the ladies of high society, rushed to read the hitherto unknown history of their homeland," the poet Pushkin wrote. "Old Russia," he explained, "had been discovered by Karamzin, just as America had been discovered by Columbus."[44] Almost overnight, Karamzin became the cultural and intellectual savior of Russia. "He saved Russia from the onslaught of oblivion," one reader concluded. "He summoned her to life and showed us that we did have a homeland after all."[45]

The heroes whom the Russians discovered in Karamzin's *History* had died for the True Faith, the Tsar, and the Russian Land. One of the most striking among them was Ivan Susanin, a peasant from the tiny Kostroma village of Domnino, who had suffered a martyr's death rather than reveal to a squadron of Polish invaders the hiding place of the not-yet-crowned Mikhail Romanov during the dark days of 1612. "A Russian heart . . . dies joyfully for a just cause," Susanin proclaimed (according to one poetic account) as the Poles fell upon him with their sabers. "I have no fear of dying for Tsar and Rus!"[46] Here, restated in modern terms, was the medieval theme of salvation through death for Holy Russia. As their ancestors had done with the heroes of *Zadonshchina* and *The Song of Igor's Campaign*, Russians of the 1820s bestowed immortality upon the newly found Susanin because he had given his life for the Tsar.

To Russians exploring their past in search of lessons for the present, Susanin personified the union of Tsar and People that had made their nation the rival of Rome. The composer Musorgskii once called Susanin "an idea, a legend, the powerful creation of necessity,"[47] and most nineteenth-century Russians saw in his life's story the triumph of patriotism and the rugged spirit of the common people. The famed revolutionary poet Kondratii Ryleev devoted several pages of verse to Susanin in *Thoughts* he composed on the eve of the uprising in December 1825, which cost him his life, but the work that truly engraved Susanin's name upon the public imagination came in the form of an opera written by a thirty-two-year-old aristocrat, who had been too young to follow Ryleev's banner. Marking the beginning of modern Russian music, Mikhail Glinka's first opera elevated Susanin's story into a legend that memorialized the Russians' struggle to free their land from the Poles in the same way that Tolstoi's *War and Peace* would celebrate the national crusade that drove the armies of Napoleon in retreat.[48]

Unlike so many of the plebeian architects and sculptors whose work had projected the trappings of empire across Russia during the first four decades of the nineteenth century, Mikhail Glinka was born to a life of wealth and comfort. Set

in the West Russian province of Smolensk, his childhood home lay in the path of Napoleon's armies and he therefore knew the torment of invasion and the elation of victory at first hand. Raised by serf servants and nursemaids (his first teachers were the musicians in his uncle's serf orchestra), Glinka grew up amidst the music of Russia's common folk, whose harmonies and melodies were destined to appear again and again in his work. "Perhaps the songs which I heard in my childhood . . . were the first reason why I began to develop mostly Russian national music," Glinka once remarked.[49] These formed the thread from which he wove the fabric of his "national-heroic-tragic opera."[50]

After spending three years in Italy, a year in Vienna, and another in Berlin, Glinka returned to St. Petersburg in the spring of 1834 with the promise that he planned to "give our stage a work on a large scale."[51] When the court poet Vasilii Zhukovskii suggested the theme of Susanin, Glinka threw himself into the work with such frenzy that he wrote the Trio of Act I on the eve of his marriage to a young woman from whom he found it "intolerable" to be parted for a single minute.[52] In the spring of 1835, he took the libretto for Acts I and II on his honeymoon and wrote most of Act III during the summer he spent with his young wife at the estate he had inherited from his father. That fall, he and his wife returned to St. Petersburg, where he continued to work with such passion that he was well into the final act by the time winter set in. "The scene of Susanin in the forest with the Poles was written during the winter," he remembered. "I . . . so vividly imagined myself in the position of my hero that my hair stood on end and I felt frozen with fear."[53] Scarcely a year after he had begun, Glinka finished the opera *Ivan Susanin*, which the Emperor Nicholas I immediately renamed *A Life for the Tsar*. Although a few sniffed at it as "*la musique des cochers*"—the music of coachmen— many cheered its premiere on November 27, 1836, as a national event. "A new period is beginning in the history of art," one of St. Petersburg's most respected critics wrote. "It is now the era of *Russian* music."[54] Even more lavish praise came from abroad. "This is more than an opera," the French critic Henri Mérimée concluded. "This is a national epic."[55] So much a part of the ethos of Old Russia, Tsar and People had now been symbolically reunited at the heart of the Russian Empire by Glinka's music.

Although Glinka's opera revived the symbolic union of Tsar and People, the men and women who stood at the center of Russia's national awakening still faced the question of how modern Russia could be united with its past so long as the larger-than-life figure of Peter the Great stood between them. Scarcely more than a year after Glinka finished his *Life for the Tsar*, Aleksandr Pushkin, the greatest of Russia's Romantic poets, resolved that dilemma in an amazing piece of verse, which, had he written nothing else in the course of his turbulent life, would have won him immortality in his country's literary annals. Pushkin was killed in a duel fought to defend his wife's honor just a few months before his *Bronze Horseman* appeared in print, but his poetic vision of Peter the Great and his imperial city transformed the barrier that had separated Imperial Russia from its Muscovite past into a bridge that joined the national-liberation movement of

1612 and the crusade of 1812 across the centuries. Represented in Pushkin's poem by Falconet's huge equestrian statue, the Emperor whose iron will had changed Russia's course became in every sense a man of bronze.

Shaped around the seemingly trivial plot of a government clerk who cursed Peter for having built his capital on the banks of a river whose flood had claimed the life of his beloved, Pushkin's *Bronze Horseman* set forth the tragic and heroic history of the Russian Empire's first century as reflected in its capital and Falconet's stunning statue. This was a hymn to the Emperor who had made Russia great in the eyes of the world while destroying the lives of tens of thousands of its people in the process, and a eulogy to the man who had raised one of Europe's most beautiful cities on the bones of the thousands of bodies that had filled its bogs. Pushkin came to grips with these terrible visions by seeing in Peter's actions a higher purpose that muted the misery he had brought upon his people.[56] Thus the Tsar-Transformer, Tsar-Artisan, and Tsar Antichrist all became the Bronze Horseman, larger than life and awe-inspiring in his power, but insulated from the realities of time and space because he was cast of metal, not made of flesh and bone. In this new incarnation, Peter the Great entered Russia's national pantheon not as the proud and powerful sovereign who had humbled the Russians' hearts, but as a Romantic abstraction that wielded the same force as the myths of Tsar and People.

If the events of 1812 gave the Russian Empire a true national and popular base (just as the struggles of 1612 had created a national foundation for the new Romanov dynasty) they also created its first pantheon of imperial heroes. In olden times, such princes as Aleksandr Nevskii and Dmitrii Donskoi had been memorialized by icons that celebrated their deeds, but Peter the Great's demand that the Church forfeit its place at the center of Russian life now made it necessary to create secular, imperial substitutes for such Old Russian forms of national veneration. Since no events in Imperial Russia's history had bound people and empire together until the battles of 1812 against Napoleon, they became the background for the secular icons that would reflect Russians' new national pride. To recognize the valor of the heroes of 1812, Alexander I created in the Winter Palace the Gallery of 1812, in which the portraits of the generals who had led Russia's armies to victory would be hung to celebrate the salvation of the empire. As in the imperial parade ground he had placed in the center of St. Petersburg, Russia's Emperor commemorated the deeds of these first heroes of the empire on a massive scale.

Designed by Rossi and filled with portraits painted by the English artist George Dawe, the Gallery of 1812 was the work of foreigners, even though it commemorated Russia's greatest national triumph.[57] Red, white, and gold dominated the gallery's walls and vaulted ceiling, and the floor was a parquet formed of rare woods gathered from forests all across the empire. Twelve Corinthian columns made of false marble lined its walls to set off a collection of 332 life-sized head-and-shoulders gilt-framed portraits of the heroes of 1812 that hung in five rows, one above the other. Among them larger representations of such heroes

as Alexander I and Field Marshals Kutuzov and Barclay de Tolly were interspersed, in the same manner that special representations of the Mother of God, Christ, and the archangels interrupted the symmetry of the tiers of saints, forefathers, and prophets in the huge iconostases that had evolved in fifteenth-century Russia's cathedrals. From the moment it opened on December 25, 1826, the fourteenth anniversary of the day when the remnants of Napoleon's tattered armies had retreated across Russia's western frontier, the Gallery of 1812 captured Russians' imaginations. Higher and lower ranks in the army so completely took the Gallery to their hearts that, when the Winter Palace burned in 1837, not one portrait suffered harm. While the building flamed around them, the grenadiers of the palace guard removed the paintings from their frames and carried them all to safety. When Vasilii Stasov rebuilt the Gallery a year later, the secular icons of modern Russia were all returned to their proper places.

Although such first-rate Russian portraitists as Aleksei Venetsianov and Orest Kirpenskii were at the height of their careers at the time, the Emperor Alexander chose Dawe to paint the portraits of his nation's heroes in another of those coincidences that so often shaped Russia's artistic experience. When the Allies' leading statesmen had gathered at the Westphalian town of Aachen to discuss the shape of postwar Europe in 1818, Dawe had painted the portrait of the Chief of Alexander's General Staff, General Prince Petr Volkonskii, while sovereigns and statesmen had debated the fate of Europe. Delighted with the speed with which Dawe worked and captivated by his dashing, Romantic style, Alexander then invited him to leave the suite of England's Duke of Kent and come to St. Petersburg, where he bestowed upon him a studio that surpassed that of every other painter in Russia. Acclaimed by the Emperor and court, Dawe asked several times the fee of Russian artists for his portraits, and he added even more to his income by selling large numbers of engravings of his portraits to publishers in Russia and Europe.

Working at a frenzied pace, Dawe painted more than eighty portraits for the 1812 Gallery during his first year in Russia's capital. Aloof and disdainful of the people around him, he nonetheless became the toast of St. Petersburg society and was flooded with requests to paint the lords and ladies who flocked to his studio uninvited. When he began to fall behind in his work for the Emperor's gallery, Dawe hired two Russian assistants to paint the lower-ranking generals, whose portraits would stand in the less visible top two rows. The least fortunate was the serf painter Aleksandr Poliakov, who received (in addition to the sixty rubles Dawe paid his master every year) nothing beyond housing, food, and clothing, all of which cost less than his paintings earned for the Englishman in a single week. Dawe, therefore, carried a fortune with him when he left Russia at the beginning of 1829. When he died later that year in London at the age of forty-eight, he left an estate valued at nearly a million rubles, the equivalent of a hundred thousand pounds sterling. Never had the Russians paid so generously for art. Less than two decades earlier, it had cost only four times the sum Dawe collected in Russia to build the entire Kazan Cathedral.[58]

Hung in Rossi's stunning 1812 Gallery, Dawe's dashing, Byronesque portraits heralded the arrival of Russia's Romantic age. Here in one huge hall hung more than three hundred personifications of the Romantic yearning for heroic exploits that now led the men and women who had lived through the Napoleonic wars to teach their sons and daughters to regard Russia as superior to the Western nations to which their ancestors had paid homage. Russians must now stand apart and create a national history and artistic experience that was as distinctive as the true faith their ancestors had preserved from ancient times. "We have a different climate from the West," one of them wrote. "[We have] a different outlook, a different cast of mind, different beliefs . . . [and] a different history. Everything is different."[59] The Romantics who shaped Russia's artistic experiences in the 1820s and 1830s thus considered their nation unique. "What state compares with it," one of Karamzin's successors asked. "How many states can equal its twentieth, its fiftieth part?"[60] Full-blown, the Romantic vision that Dawe had captured in his portraits focused upon Russia's messianic mission in Europe and in Asia. Set in a world apart, with palaces, cathedrals, government buildings, and monuments all cast in heroic proportions not seen in the West since the days of Rome, the men and women of this Romantic generation believed that their Russian Tsar must rule an empire in which the arts, politics, and vision of the future all would be thoroughly Russian.

# RUSSIA'S ROMANTIC AGE

*BETWEEN 1780 AND 1820,* the French Revolution and the rise and fall of Napoleon had stirred the cauldron of national feelings all across Europe. In Spain, the Netherlands, and Bohemia—and in the German lands east of the Rhine—men and women in the days after Napoleon's defeat began to take new pride in their national past and revered those artistic and cultural monuments that set them apart. All through Italy, Central Europe, and the Balkans, the separatist feelings that would one day destroy the empire of the Habsburgs were taking hold. Further south, the Greeks dreamed of liberation from their Ottoman masters, while the South Slavs began to speak of winning autonomy or independence. Patriots in the lands that had once been Poland paid tribute to the historical forces that divided them from the Russians and searched for ways to restore the kingdom that the monarchs of Prussia, Austria, and Russia so recently had divided among themselves. Beyond the frontiers of Eastern Europe, the Russians were discovering the past from which Peter the Great had separated them at the same time as they spread the trappings of their empire across seven million square miles of Eurasia to Alaska and the shores of northern California.

Whether in the East or West, poets and philosophers spoke of national language, national character, and national ways of life, and measured artistic accomplishments in terms of how well they expressed the *Volksgeist,* or national spirit, of their people. The belief that the experience of every nation is unique and that each person's feelings and intuitions matter more than reason took shape in Russia, too, as people began to cherish those artistic and cultural influences that set them apart from Europe. Not the ideas and culture of France, Germany, or En-

gland, but beliefs that had been molded by Russian religion, history, and national consciousness now took pride of place among men and women who believed that autocracy, the form of government that had come down to them from Ivan the Great, held the key to their nation's future.

As the Russians followed the rest of Europe in turning away from the French fashions, manners, and culture that had dominated their lives since the days of Louis XIV, rationality yielded to tender moods and soft impressions. Feeling that the certainties which had ruled the Age of Enlightenment were no longer enough, men and women began to seek true freedom and self-fulfillment in the inner life of the spirit and to look inward to escape from the material world that pressed upon them. "A poet has two lives, two worlds," the Russian writer Nikolai Karamzin explained to a friend. "If he is bored in the physical world, then he escapes into the land of his imagination."[1] Whether in the intimate circle of Wordsworth and Coleridge in England's fog-drenched Lake Country, the more solemn gatherings that assembled around Goethe and Schiller in Weimar, or the Romantic literary salons of Moscow and St. Petersburg, men and women shared the belief that sensibility had become the true mark of nobility, and that in the inner recesses of the human spirit a truth could be found that surpassed anything rational argument could produce. In the world of letters, prose yielded to poetry, while in painting, misty landscapes populated by half-seen figures took the place of portraits to proclaim the birth of a full-blown Romantic movement all across the continent.

Between about 1820 and 1850, the Russian forms of Romanticism found their fullest expression in the ideology of Official Nationality, which underlay the political system of the Emperor Nicholas I, the passionate poetry of Aleksandr Pushkin, and the writings and paintings of a score of others who shared his belief that the special qualities of the Russian Empire defined its greatness. The cosmopolitan confidence that had allowed men and women of culture and education to feel equally at home in Paris, London, Vienna, and St. Petersburg disappeared, and a complex blend of nationalistic passions that set intuition above logic took its place. Official Nationality and Romanticism now obliged the Russians to discard Catherine the Great's dictum that their empire was a part of Europe, and for the first time since Peter the Great they began to take pride in the ways their nation stood apart. Customs and traditions that were uniquely Russian became a virtue. Visions of an empire that would be Russian in spirit replaced earlier hopes that the remnants of Muscovite Russia could be made over in the image of Europe.

In paving the way for this new outlook, Nikolai Karamzin found the sentimentalist beginnings of Russian Romanticism in the poetry of England and Germany. Rescued from the oblivion of Russia's provinces by the opportunity to study in Moscow, he spent his adolescent years reading England's present-day poets and Germany's Romantic writers before setting out on a grand tour just two months before the Revolution broke out in 1789.[2] As he meandered through Europe, Karamzin shared his musings with Germany's philosophers, marveled at

the Swiss Alps, and tried to ignore the turmoil that held all of France in its grip. While others flocked to see the Revolution, he put off going to Paris for ten months, and when he finally reached the city he found the theater more interesting than the National Assembly. Paris filled his soul with "lively impressions" that he could not explain even to himself, but the Revolution seemed to him "a gaping tomb for virtue." Relieved to board a packet boat for Dover, Karamzin cast into the English Channel the tricolor cockade he had worn for prudence's sake and greeted England as "a land of beauty." The wan, shy freshness of England's women stirred his sensibilities to their depths. "If you have not been in England," he exclaimed to Russia's artists in the letters that described his journey, "then your brushes have never portrayed perfect beauty."[3]

Karamzin returned to Moscow in 1790 to become one of Russia's leading writers and publishers. At every opportunity, he urged his readers to broaden their vision of the future by looking to their past, at the same time as he reminded them of the larger artistic world of which their experiences had made them a part. Full of heavy sighs and tender laments, his *Letters of a Russian Traveler* in the early 1790s introduced a generation of young Russians to the new fashions in European literature, and his poetry showed them how to distill what was elevated and beautiful from the mundane and profane. As Russia's best-selling work of fiction until that time, his *Poor Liza* reaffirmed the belief that feeling ought to stand higher than reason, and that tears which stemmed from helplessness against the forces of Fate could uplift a person's spirit. By blending these melancholic musings with the more modern "salon style" of language that Karamzin defended against a legion of literary conservatives for the better part of twenty years, his disciples brought Russia's Romantic Age into being.

Among Karamzin's literary disciples, Vasilii Zhukovskii became the first and best-known of Russia's early Romantic poets. The illegitimate son of a Russian nobleman and a beautiful Turkish captive, Zhukovskii was endowed with finely wrought features and a gentle personality that caused many of his friends to remember him as "maidenlike."[4] Winsomely fearful of any hint of conflict or confrontation—and dedicated to wandering through graveyards at night—he entered into manhood in an aura of lost love and tragedy that brought him directly into the world of Goethe and Thomas Gray. He lost his dearest friend at the age of twenty, and endured the pain of falling hopelessly in love with a girl he could never marry because her mother was his own half-sister. As if in anticipation of these events, Zhukovskii had written at the age of fourteen that "life . . . is an abyss of tears and sufferings."[5] Melancholic introspection, which he called "incomprehensible enchantment which lends inexplicable charms to suffering,"[6] shaped much of what he wrote. Over thirty when he began to teach Russian to the future wife of the Emperor Nicholas I, he spent a quarter of a century as a tutor to Russia's grand dukes before retiring at the age of fifty-eight to wed the twenty-one-year-old daughter of one of his closest friends. Known to his contemporaries as the greatest poet of the Alexandrine era, Zhukovskii would be best

remembered by later generations as the mentor of Aleksandr Pushkin, the greatest of Russia's Romantic poets.[7]

More than half of Zhukovskii's verses consisted of translations and he won acclaim for his renderings of Romantic literary monuments even before his own poetry brought him fame. At nineteen, he translated Gray's "Elegy Written in a Country Churchyard" and then went on to render the poetic visions of Schiller, Goethe, and Byron into Russian with a freedom and creativity that few translators ever matched. Certain that "the beautiful rarely passes from one language to another without losing some of its perfection," he insisted that every translator must either "find in his own imagination such beauties as may serve as a substitute" or else "produce something of his own [that is] equally beautiful."[8] The great nineteenth-century critic Vissarion Belinskii called him "our country's Columbus, who discovered for [Russia] German and English literature."[9] When Pushkin's more masterly creations displaced Zhukovskii's poetry as the Russians' favorites, his translations lived on in the generations of educated men and women who learned them by heart, and it would be his translation of Schiller that Dmitrii Karamazov would declaim in Dostoevskii's last great novel.[10] Even today, a critic recently concluded, "Zhukovskii's rendering of the *Odyssey* . . . remains unsurpassed."[11]

In 1813, Zhukovskii's *Bard in the Camp of the Russian Warriors* won him fame as a poet in his own right, but it survived the ravages of changing times and tastes far less well than his contemporaries might have expected. For Russians who had stood shoulder to shoulder against Napoleon at Borodino, the poem's passionate patriotism struck a sympathetic chord that won praise from even the Emperor. But the stylization of war—the arming of Russia's "warriors" with bows, arrows, spears, and swords in the age of Napoleon—struck later readers as absurd, even though they were willing to tolerate the flowing tunics in which the sculptor Martos clad his statues of Minin and Pozharskii just three years afterward. In his later poems, Zhukovskii spoke of "the mysterious threshold of life," of "the greatness of submissive quietness," and of "hills clothed in the last beauty of half-faded Nature" as he probed the meanings of good, evil, love, hate, fate, sorrow, hope, and death. Using poetry to shift grief from the present into the past and future, he saw death as a way to create perfection out of love. "With what joy I will die!" he once exclaimed.[12] Death became for him "the longed for fatherland, the promised shelter for wanderers of the earth."[13] In death, friends could be closer than they could ever be in life. Death could make the friendships of this world truly sublime in the next.

Abstract, elevated, and designed to stir higher feelings, this Romantic view of death appealed to Zhukovskii and his friends as the 1810s shaded into the 1820s, for it deepened friendship and freed sufferers from earthly cares. "The thought of death . . . neither horrifies nor aggrieves me," one of them confessed. "It is sweet to die."[14] The resignation that came with their acceptance of death led such men to accept the present and believe that Russia's greater glory could be

best ensured by strengthening the existing order. Convinced that the strength Russia needed to confront the rapidly changing world of the nineteenth century lay in the person of their sovereign, they and hundreds like them dedicated their pens and brushes in years to come to glorifying him and the nation he represented. "Honor, freedom, greatness, glory, peace, fatherland, altar, everything, everything," Zhukovskii wrote, "has fused in one divine word: Tsar."[15] People such as these sought freedom in the quiet depths of a poet's soul, not in the turmoil of everyday life. In the world of politics and human conflict, the Emperor would reign supreme over men and women who served him and Russia with their bodies while they contemplated love and beauty in their hearts.

Yet Romanticism had another current that cast heroes not as men consumed by tragic resignation but as noble foes of tyrants in the manner of Schiller's *William Tell*. Once described as "the poet of people who . . . are condemned to dream about liberty but never to live it," Schiller had sought freedom in his native Germany in communion with beauty—"in the development of a beautiful soul"[16]—while revolution raged in France. His plays struck a responsive chord among younger Russians who shared Zhukovskii's tender compassion for others but led more active, decisive lives as officers in the imperial army. They too reconciled life with death, but they sought in death more than the means to experience friendship on a loftier, more exalted plane. Death for a higher good—for God, country, liberty, or glory—stirred their hearts in ways that Zhukovskii's visions of the abstract sweetness of life's final moments never could. "We shall die!" one of them once exclaimed. "But oh, how gloriously we shall die!"[17]

In a land in which more than eight out of every ten people were serfs, Russia's Romantic revolutionaries came to see their Emperor as the one person able to bestow freedom upon all the Russians. At one time, they had believed that Alexander I shared their dedication to liberty, but when they had discovered that he did not, several hundred of them had joined in a tragic, Schilleresque plot to liberate the Russians from autocracy. Leading several battalions of the St. Petersburg garrison to the Senate Square on the morning of December 14, 1825, they had hoped to overthrow Russia's newly proclaimed Emperor Nicholas I and bestow a constitution upon the Russians. But the Emperor had met their call for freedom with grapeshot, and by nightfall they had been driven from the square in headlong retreat. Hanged as traitors or exiled to Siberia, these so-called "Decembrists" seemed destined to leave the earth without a trace. Yet their example stirred the dreams of generations to come. "The heritage we received," one Russian revolutionary later wrote, "was an awakened feeling of human dignity, a striving for independence, [and] a hatred for slavery."[18] Beyond that, the Decembrists' poetry urged their countrymen to think of the time when the struggle for freedom would triumph in Russia. "For a mortal this exploit is perilous," one of them wrote. "But it is the straight path to immortality."[19]

While Zhukovskii and his friends remained indifferent to worldly affairs, the Decembrists saw politics as the key to freedom. Awakened to Russia's past by Karamzin's *History*, these young poets and officers based their visions of glory

and emancipation upon the Russia they knew and the West they had seen when they had pursued Napoleon's armies across Europe. Astounded by how free and prosperous Europeans seemed by comparison with their sullen, poor, and frightened countrymen, they vowed that Russia's backwardness must be overcome and that only liberation from aristocratic masters and government officials could lift its people to the level of prosperity that Europeans enjoyed. "I came to see the aristocracy as a wall standing between the Monarch and the People," one of them confessed, "[and I concluded that] the states which had not had revolutions continued to be deprived."[20] Dedicating their lives and fortunes to bringing the freedom they had found in Europe to their homeland, these men had therefore dared to challenge the massive strength of the government that Peter the Great and his successors had built. "Even if we fail," the revolutionary-poet Kondratii Ryleev declared, "our failure will serve as a lesson for others."[21]

As the heart and soul of the Decembrists, Ryleev spoke for the few who led and the many who followed in their footsteps. He had joined the army as a nineteen-year-old ensign in the artillery just in time to take part in Russia's triumph over Napoleon in 1814, and as he looked over his shoulder at Russia from Europe he saw a patriotic and loyal nation overwhelmed by tyranny. "I saw Russia enslaved," he wrote. "With her head bowed, her chains rattling, she prayed for her Tsar."[22] Freedom became Ryleev's passion and liberty the goddess to whom he gave his heart. "I know that death awaits those who are the first to fight the despot," he confessed, "yet self-sacrifice is the price of freedom."[23] Convinced that art must bow to political struggle, he left the army and took a position in the Russian-America Company that had its central offices in St. Petersburg so that he could be near to others who shared his beliefs. "I am not a poet!" he exclaimed as he and his friends debated how to free the Russians. "I am a citizen!"[24]

With the fires of revolution flashing in his deep-set almond eyes, Ryleev enlisted poetry in the cause of freedom. From Karamzin's newly published *History*, he drew tales of heroes who had fought for Russia against oppressors, and he shaped his accounts of their deeds to suit his poetic and political fantasies. As Glinka would do in his *Life for the Tsar*, Ryleev idealized Ivan Susanin, the peasant patriot who had led Russia's Polish conquerors to their deaths in the depths of a wintry forest. He wrote, too, of the Cossack chieftain Ermak, who had conquered Siberia for Russia, and of Prince Oleg the Wise, who had hung Russia's shield in triumph on the gates of Byzantium. Yet he also remembered the men and women who had stood against the Tsar in the name of justice as they had understood it: Natalia Dolgorukova, who had followed her husband into Siberian exile, and Artamon Matveev, the friend and counselor of Tsar Aleksei Mikhailovich, who was sent to a monastery prison by his enemies.[25] As champions of freedom in Ukraine, Bogdan Khmelnitskii and Mazeppa had their places in the cycle of poems that Ryleev called *Dumy* (meaning thoughts or meditations in Russian, and a popular song or ballad in Ukrainian), and so did Andrei Kurbskii, the prince who had turned against the tyranny of Ivan the Terrible.[26] Ryleev's longest poem,

*Voinarovskii,* eulogized a Ukrainian hero exiled to the wastes of Siberia. "Always grim and wild is the sullen nature of these lands," he wrote. "The angry river roars, foul weather often rages, and the clouds are often dark."[27] A year later, most of his friends would enter that fearsome realm of ice, snow, and blizzards as punishment for trying to overthrow the Tsar. For Ryleev, Fate had other plans.

After crushing the revolt that Ryleev and his friends had led against him on December 14, 1825, the Emperor Nicholas I had them rounded up and brought before him. Like the Romantic heroes of whom they had read in the writings of Byron and Schiller, the young men stood proudly before their inquisitor, confessed their guilt, and spoke openly of Russia's oppression. In his turn, the Emperor sent a hundred of them to Siberia and condemned Ryleev and four of his comrades to death. At three o'clock in the morning of July 13, 1826, the five men were led onto the square of the Peter and Paul Fortress, the golden spire of its cathedral splitting the already bright summer sky. Dressed in white execution robes of the same type that Dostoevskii himself would don when he faced the firing squad from which he received a last-minute reprieve twenty-three years later, Ryleev and his friends mounted the scaffold, kissed the cross, and were hanged. The priest who witnessed the executions swore that Ryleev had remained silent to the very end.[28]

Although Ryleev had written passionately of patriots' struggles against tyrants, his poems were not the ones that the Decembrists carried closest to their hearts. As they searched the papers of the men their Emperor had accused of treason, Russia's high officials found handwritten copies of poems that condemned tyranny and cheered freedom in tones more ringing than any that Ryleev's words could convey. Endowing the plainest, most common words with a beauty and power beyond that which any Russian had yet created, these verses described how the people's wrath could make tyrants tremble and asked when "the beautiful dawn of freedom" would rise above Russia.[29] The Emperor's inquisitioners soon discovered that these verses belonged to the pen of Aleksandr Pushkin, the "proud singer of freedom" (as he once called himself), whose poetry so touched his readers' souls that he came to be regarded as the greatest poet Russia has ever known.

A "preserver of the past and a prophet of the future,"[30] as some have called him, Pushkin defined the nature of Russian Romanticism and shaped the language in which the Russians have written ever since. Dostoevskii, Tolstoi, Chekhov, and Gorkii all called him their teacher, and except for perhaps Goethe in Germany no modern European poet ever surpassed the beauty and quality of his work. Well versed in the life of Russia and Europe—and equally at ease in both—he wrote of many times and places, setting his poetry in the medieval and modern ages in both his homeland and the West. His genius for choosing just the right word and using it in just the right way still endows his poetry with a brilliance that never seems to fade. "A poem by Pushkin creates the impression that what he says could never be said otherwise," a critic once insisted. "No other words," he added, "could ever assume a similar function."[31]

From beginning to end, Pushkin's life was more adventurous, turbulent, and contradictory than any he portrayed in his writings. Nicknamed the Cricket by his friends because of the energy with which he threw himself into the churning life of St. Petersburg's upper classes, Pushkin gambled wildly and drank incessantly during days and nights that were punctuated by visits to elegant salons and seamy brothels. He seemed determined to burn the candle at both ends and to enjoy every minute. "The champagne," he wrote from St. Petersburg to a friend, "is magnificent, [and] the actresses likewise. The one gets drunk and the others get fucked, amen, amen. That's how it should be."[32] High-born ladies, noble maidens, widows down on their luck, governesses, tradesmen's daughters, servants, and prostitutes all received Pushkin's attentions, and the illnesses that inevitably followed in no way deterred him. He endured several bouts of venereal disease during his debut into the world of St. Petersburg, but he treated them all with mercury and continued on his way. Efforts by well-meaning friends to shield him from such difficulties too often came to naught or produced unexpected complications. "Pushkin is very sick," one of them wrote during the summer of 1819. "He has caught a cold while waiting at the door of a certain [prostitute] who kept him out in the rain rather than infect him with her disease. What a struggle," he added in French, "between generosity, love, and dissipation!"[33]

There seemed to be no way to curb the Cricket's passions. In a world in which young men eagerly sought the baptism of fire that would mark them as men, he was known for the shortness of his temper and the lack of provocation needed to bring forth a challenge. He drank with friends, fought at dawn, made up before the gunsmoke died away, and then went on to fight again. He spoke too rashly too often, and disdained any thought of restraint. "Sometimes my life was like an epigram," he concluded as he took stock at the age of twenty-six, "but in general it was an elegy."[34]

Immoderate in the way he lived, Pushkin was no more restrained in the words he let flow from his pen as he cursed the tyranny of Russia's masters and lamented the wretched lives its masses led. His "Ode to Liberty" spoke of killing tyrants, and his "Fairy Tales" (cast in the form of a Christmas carol) told how the Christ Child wept with joy when he heard that Russia's Emperor was planning to grant freedom to his people. His "Village" told of "maidens come to flower to satisfy the whims of unfeeling scoundrels," and described savage masters who had no feeling for the serfs they worked to exhaustion.[35] "One could scarcely find a literate ensign in the army who did not know [Pushkin's verses] by heart," one of the Decembrists remembered. "Pushkin was the voice of his generation, a truly national poet the likes of which Russia had never seen before."[36]

Just after he turned twenty-one, and with a friend still lamenting that he was destined to be remembered only for "his small poems and his big escapades,"[37] Pushkin finished *Ruslan and Liudmila*, the narrative poem that would win him the title of Russia's greatest poet. Conservative critics were appalled by the erotic descriptions the poem contained, and literary purists took equal offense at the

vulgarity that made it seem as if "a dirty, ragged peasant had barged into a smart drawing-room."[38] Yet, when Pushkin read the poem's six cantos to acquaintances who had gathered to celebrate its completion, Zhukovskii was so ecstatic that he inscribed a portrait "To the victorious pupil from the vanquished master on that most solemn day on which he finished his poem *Ruslan and Liudmila*" and presented it to his one-time protégé.[39] With his friends all proclaiming that he had written a brilliantly original piece in language closer to colloquial Russian than anything his predecessors had ever created, Pushkin grew bored with the polishing and revisions his verses still required. "I have a craving for distant places," he wrote less than a month later. "Petersburg is stifling."[40]

Much sooner than he had intended, Pushkin got his wish. Sick of the poet's biting epigrams and caustic verses, Alexander I sentenced him to exile, and it took all of Zhukovskii's and Karamzin's combined influence to persuade the angry Emperor to send him to southern Russia instead of Siberia. For the next six years, Pushkin lived in the mountains of the Caucasus, on the shores of the Black Sea, and in the borderlands of Bessarabia, until the summer of 1824, when the Governor General of South Russia sent him to Mikhailovskoe, his parents' estate in Pskov province, where he remained until the fall of 1826. Wherever he settled, he pursued women, complained of boredom, and wrote poetry, all the while begging his defenders in the capital to intercede with the Emperor so that he could return to St. Petersburg.

Separated from the friends with whom he had discussed poetry and politics, Pushkin lived even more dissolutely in the South than he had in the capital. In the Bessarabian town of Kishinev, he pursued Greek and Moldavian women, none of whom provided more than passing relief from his larger worries about politics and money. With the officers of the Second Army among whom he lived, he discussed politics and fought duels, one of which took place as he stood eating a capful of cherries while his opponent fired at him. After being transferred to Russia's bustling Black Sea port of Odessa in 1824, Pushkin found more serious attachments, including the wives of a rich Dalmatian merchant and the Governor General. At times he feared he would die from an aneurysm (actually a varicose vein) in his leg. On other occasions, he claimed to be on the verge of suicide. He spent too freely on drink, lost too much at cards, and was perpetually in debt. Only poetry saved him. It occupied his mind, and the sale of his books began to bring in money to pay his debts.[41]

Throughout his years of exile, brilliant scenery, warm southern sun, the company of exotic women, and loneliness for his friends all stirred Pushkin into a frenzy of creativity that produced an avalanche of poetry. Anxious to keep his subject always before his eyes, he littered his manuscripts with sketches that told of his innermost thoughts, and friends, enemies, places he remembered, and women he had loved all appeared in the margins of his manuscripts to remind him of the brilliant portraits he wanted to paint in words.[42] Between 1820 and 1826, he wrote *The Captive of the Caucasus*, *The Fountain of Bakhchissarai*, *The Robber Brothers*, *The Gypsies*, and more than a score of lesser poems under the

influence of Byron, whose work he particularly admired. Still, he remained un-satisfied. He later called *The Captive of the Caucasus* an "unsuccessful experi-ment with character" over which he and his friends "had quite a few laughs," and dismissed *The Fountain of Bakhchissarai* as being "as ridiculous as melo-drama" and "an echo of the reading of Byron, whom I was mad about [at the time]."[43] Although kinder in his remarks about *The Gypsies* and *The Robber Brothers*, he was not entirely pleased with them either. He continued to search for other forms and models, none of which yet served his purposes as well as he wished.[44]

In looking for new models, Pushkin turned from Byron to Shakespeare and Karamzin, whose works helped to shape *Boris Godunov*, the great historical tragedy to which he devoted much of his time at Mikhailovskoe. Yet, despite his hope that *Boris* might become Russia's *Macbeth*, the play proved to be one of his least enduring. Some of its critics thought that *Boris* ought to have been a Ro-mantic narrative poem, and Nicholas I even suggested that it be rewritten as a novel in the manner of Sir Walter Scott. Certainly Pushkin had no intention of following that kind of advice, but the Emperor's remarks showed that he and the poet had at last come to terms, even though neither ever found the arrangement very pleasant.

Pushkin's accommodation with the Emperor Nicholas I had its beginnings in the aftermath of the Decembrist revolt, which had taken the life of Ryleev and the freedom of so many of his comrades. As word of the arrests of the conspira-tors reached Mikhailovskoe at the beginning of 1826, Pushkin grew fearful that his friendship with them might cause the new Emperor to send him to a more re-mote part of Russia, and he begged Zhukovskii and Karamzin to plead his cause so that he could return to the capital. Although respected in court circles, neither succeeded at first. "It's true that you have not been involved in anything," Zhukovskii wrote a few months later, "but your verses have been found in the papers of each of the conspirators, [and] that," he concluded, "is not a good way to make friends with the government."[45] Almost nine months after the Decem-brists had been arrested, Nicholas I decided to deal with Pushkin in his own pe-culiar way by ordering him to ride immediately to Moscow from Mikhailovskoe and "present himself at once to the general of the day at the staff headquarters of his imperial majesty" the moment he arrived.[46]

Pushkin reached Moscow on the rainy morning of September 8, 1826, the day before Nicholas's coronation. Unshaven, weary, feeling somewhat ill after travel-ing five hundred miles in four days, and with the mud of the road still filling the creases of his clothes and boots, he was taken immediately to see the Emperor to hear the terms under which he would be set free from exile. In age, the two men were only three years apart, but a chasm of disagreements separated the poet of freedom from the Tsar who believed that the arts could have no higher purpose than to glorify him and the land he ruled. "*I* will be your censor," Nicholas sup-posedly replied when Pushkin complained about how difficult it was to work under the censor's restraints. Then the poet heard the words that would haunt

him for the rest of his life. "Here is the new Pushkin," the Emperor told the lords and ladies of Russia's court. "Let us forget about the old Pushkin."[47] For Pushkin, the Emperor's words meant that he must endure the ultimate oppression of having to hear his Emperor-censor explain how he ought to reshape his poetry, even as he struggled to complete *Eugene Onegin*, which he had begun during his days of exile in Kishinev.

Pushkin began *Eugene Onegin* on the evening of May 9, 1823, and finished it during the summer of 1831 at Boldino, an estate he had inherited in the province of Nizhnii-Novgorod. He had worked on it during his exile days in Odessa and during the silent boredom of his two years at Mikhailovskoe. For more than eight years, he had woven boredom, passion, rejected love, and a score of other feelings into a brilliant tapestry that portrayed an aristocratic society that had passed beyond its Golden Age and moved into the first stages of decline. *Onegin* became a chronicle of the times, just as its hero Onegin portrayed all the artificiality and failings of the society in which he lived. Pushkin called it "a novel in verse."[48] Others saw in it "a theory of human life,"[49] and a richly colored portrait of Russian society during the first quarter of the nineteenth century.

Bored, melancholy, aloof, self-centered, and shallow, Onegin stands at the very center of Pushkin's poem to deny real love and destroy true friendship. By contrast, the heroine Tatiana portrays an honesty that is rare in any age, impulsively offering her love to a man who cares little for truth and wallows in insincerity. Shallow and bored, Onegin continues his aimless existence as the years go by, while Tatiana rises to rule the world of high society as the wife of an important prince and general. Only then does Onegin begin to love her, but she rejects his pleadings with the unforgettable lament (carried over into Chaikovskii's famous opera) that "happiness was once so possible, so very near."[50] The moment endured through the ages, but readers of the early 1830s were disappointed that Pushkin had not supplied the conventional happy love-story ending to his poem, and their reaction showed that he no longer spoke for a generation as he had in earlier times. As one later critic explained, *Onegin* "was too original, too much the distillation of one man's thought to be either successful with the public or understood [at the time]."[51] That would be even more true of *The Bronze Horseman*, Pushkin's last and greatest work.

Even before Pushkin had finished *Eugene Onegin*, his life had shifted onto a dramatic new course when, at the beginning of 1831, he married Natalia Goncharova, a seventeen-year-old beauty whose hand he had sought for two tumultuous years. "I have known many beautiful women in my time," one of the men who admired her confessed, "but I have never seen one blessed with such classical perfection of face and figure. She was tall, with a fabulously thin waist and a beautifully developed bosom and shoulders," he continued. "Her small head swayed gracefully on her slender neck like a lily on its stem, and I have never seen such a beautiful and perfect profile. What a complexion, what eyes, what teeth, what ears! She was a real beauty, and even the most dazzling women faded the moment she appeared."[52] Often thought to be as insensitive as she was beau-

tiful, Natalia had only a limited understanding of her husband's art. The man who once had written that nature had bestowed upon women "a sparse intelligence and a most peevish sensitivity"[53] now found himself married to one of the most peevish women of all.

Marriage became another chain that bound Pushkin to a court he was coming to despise, for Nicholas I had become infatuated with Natalia the moment he met her, and his Empress predicted that she would be the hit of the coming social season. Yet, even as Pushkin chafed at the restraints of court life and complained of its costs, a flood of new works poured from his pen. During 1831 alone he finished *Eugene Onegin*, finally won the Emperor's permission to publish *Boris Godunov*, and wrote a score of lesser works. That same summer, he met Nikolai Gogol, an aspiring young writer of no particular accomplishment, who was destined to help lead the Russians from Romanticism to Realism. Captivated by Gogol's ability "to divine a man's character and display him as if he were alive," Pushkin urged him to write. "How can you possibly fail to write a big work?" he used to ask. "It's simply scandalous."[54] From his conversations with this man whom he would remember as an "astounding and perhaps unique phenomenon of the Russian spirit," Gogol concluded that Pushkin embodied "what the Russians may become two hundred years hence." From the discussions the two men had about art and life, he drew the ideas around which he would shape the plots of *Dead Souls* and *The Inspector General*, his two greatest works.[55]

While Pushkin urged Gogol to consider the foibles of petty provincial tyrants, his own thoughts turned to the sovereign whose relentless spirit still separated modern-day Russians and their past. Two years after his marriage, Pushkin finished *The Bronze Horseman*, a brilliant poem that transformed Russia's greatest Emperor into a Romantic abstraction that towered above mortal men in his power to command nature and control the elements. Here, in just more than five hundred lines of verse, the poet told of the rise of modern Russia, of the Emperor who brought it into being, and of the mark he had left upon the lives of his people. St. Petersburg became "the city of Peter's creation," and Peter himself "the idol astride a steed of bronze," who "stood with mighty thoughts elate . . . with outstretched arm above the Neva raging."[56] In images that have never faded with time, almost every word in the poem left a mark. Yet its visions were contradictory, for Pushkin's Peter created a beautiful city even as he ruined the lives of his subjects. Offended by some of the poem's lines and puzzled by others, Nicholas I postponed its publication so long as Pushkin lived. After the poet's death he permitted Zhukovskii to publish a "softened" version, but the Russians had to wait another three-quarters of a century before anyone dared to publish the original text.

Driven to write almost as much by the excesses of his wife as by his urge to create, Pushkin stayed at his desk throughout the mid-1830s. Deeply in debt to private creditors, shopkeepers, and even the Emperor, he could not leave the capital, where the attentions that the French adventurer Georges D'Anthes showered upon his wife drove him to the brink of madness. St. Petersburg

seethed with whispers and insinuations as high society and the court took the side of the younger, more dashing D'Anthes. When an anonymous letter informed Pushkin that he had been elected as deputy to the Grand Master of the Most Serene Order of Cuckolds, the poet could stand no more and challenged D'Anthes to a duel. Mortally wounded by the Frenchman's ball, he died two days later on January 29, 1837, surrounded by friends and attended by a physician that the Emperor himself had sent. Few who bade Pushkin farewell in the hours before his death could have failed to recall the lines with which he had greeted the death of the young poet Lenskii half a decade before in *Eugene Onegin*: "He is no more," the poem exclaimed. "The altar flame has now been quenched!"[57]

The dashing, passionate poet who had pursued women, cards, duels, and fate from St. Petersburg to Russia's South and back never had to face the crisis of turning bald, or becoming paunchy and infirm, for death spared Pushkin the supreme indignity of becoming a middle-aged Byronic Romantic. Yet, in the brief sixteen years that separated *Ruslan and Liudmila* from his killing by D'Anthes, Pushkin's poems, stories, and plays had changed Russia's literary landscape forever. In a generation, Russian letters had moved to the forefront of the modern literary world, and Pushkin alone had been responsible. Each of the literary giants who followed him openly acknowledged their debt, and all drew upon the heritage he bequeathed when D'Anthes's pistol ball took his life. Ivan Turgenev called Pushkin "my idol, my teacher [and] my unapproachable model." For Tolstoi, he stood as "a master of beauty" and a "father." Dostoevskii once insisted that, "if Pushkin had not existed, there would have been no talented writers to follow him." Even as Russian letters entered their Silver Age and moved toward their rendezvous with the Bolshevik Revolution, change, progress, and even startling innovation still had to take Pushkin's work into account. "Till now, our literature has not outlived Pushkin," the great symbolist poet Valerii Briusov wrote at the beginning of the twentieth century. Whenever Russian literature tried to move in a new direction, he added, it still encountered "landmarks put down by Pushkin to indicate that he knew and saw the path."[58]

These were high praises indeed, but none matched the passion and the pain that flowed from the pen of a young lieutenant in the Imperial Hussar Guards in the days after Pushkin's passing. At the age of twenty-three, Mikhail Lermontov spoke out bravely against "the greedy crowd that stands behind the sovereign's throne," whom Russia's artistic world blamed for the pressures that had driven Pushkin to challenge D'Anthes. Enraged at the loss of his hero, Lermontov cursed "those executioners of Freedom, Genius, and Fame, who hide behind the shelter of the Law," and reminded them that the day would come when they would stand in "God's Own high court," unable to atone for "the righteous poet's blood" that they had let be spilled.[59] For his poem "The Death of a Poet," Lermontov was expelled from the Guards and sent to fight in Russia's wars against the natives of the Caucasus. As he left for the faraway mountains

of the South, the literary world of St. Petersburg proclaimed him Pushkin's successor.

If Pushkin represented the passionate, heroic elements of Russia's Romantic Age, Lermontov spoke to its bitter, darker side. Like Pushkin, he lived a more adventurous life than any he portrayed in his poems or novels, and like him, too, he struggled to break the chains with which the Emperor's government sought to bind the minds of its subjects. Yet Lermontov did not share Pushkin's taste for life, and a dark compulsion drove him ever nearer to destruction. "There was something sinister and tragic about Lermontov," one of his St. Petersburg acquaintances remembered. "Grim and evil forces, premeditated contempt, and passion lurked in his tanned face and large, dark eyes. His fixed, heavy gaze was strangely at odds with his childlike, protruding lips. . . . It was impossible," he concluded, "not to sense the power within this man."[60]

While Pushkin paid homage to the kaleidoscope of human experience, Lermontov focused on discord, conflict, and evil. Born in 1814, the year in which Russia's armies defeated Napoleon and marched into Paris, he wrote more than three hundred poems, three plays, and a short novel by the time he turned seventeen, yet he had no clear sense of himself as a poet and spoke of trying to forget "this nonsense about freedom, and infinity, and poetry."[61] As a junior officer in St. Petersburg, he lived a lonely and dissolute life until his "Death of a Poet" catapulted him to fame. Sent to the Caucasus by his angry Emperor, he returned to the capital two years later only to be exiled again for fighting a duel with the French ambassador's son. When a brief visit to St. Petersburg during the winter season of 1841 got him into still more trouble, Lermontov returned to exile, proclaiming: "Farewell, unwashed Russia, land of slaves [and] slavemasters."[62] Two months later, he was dead at the age of twenty-seven, killed, like Pushkin, in a duel he had sought as an antidote to the desperation he felt at the social and political constraints that had closed around him. "As soon as a man of genius appears among the Russians," one of his admirers wrote bitterly, "the low-browed scions of triviality persecute him to death."[63]

Starting in 1837, Lermontov had become a mature poet almost overnight. In the wilds of the Caucasus, he wrote of loneliness, the emptiness of life, and of isolation from the world and the universe. He became one of the first Russian writers to deal with the darker sides of human nature and saw little reconciliation in the world around him. Lermontov wrote "Prayer" and "Flower of Palestine" while he maintained his "proud enmity against God," and lamented that his generation had neither goals nor identity. Not with Zhukovskii's longing, but matter of factly and with little sentiment, he often spoke of death, exalted the "wonderful ecstasy of rebellion,"[64] struggled with the problems of suffering, cruelty, and warped human values, searched for happiness, and "longed for wonder." "I loved all the enchantments of the world," he once wrote, "but not the world in which I lived."[65]

Written before Lermontov turned twenty-six, the epic poems "Mtsyri" and

"Demon" won him fame that rivaled Pushkin's. Taking its name from the Georgian word for a novice monk, the first tells how a youth fled from his monastery to seek freedom in the wilderness only to find, as he lay dying from exhaustion and thirst, that his wanderings had led him back to the very walls from which he had struggled to escape. A kaleidoscope of moods set against an exotic tapestry formed by the mountain scenery of the Caucasus, "Mtsyri" has been called "the most sustained piece of poetic rhetoric in [the] Russian [language]."[66] Certainly it is a masterpiece, perhaps even more so than "The Demon," on which Lermontov labored at odd times and places for more than a decade. In some ways more complex than "Mtsyri," "The Demon" explored the problems of free will, good, evil, and predestination for the first time in Russian literature, as Lucifer (the demon) grows bored with his evil ways and seeks reconciliation with God only to fail and become, once again, "full of mortal poison and endless hate."[67] Of all Lermontov's verse, "The Demon" became the most popular, even though its full text did not appear until fifteen years after his death in an edition published in the West.[68] By that time, poetry had had its day and the novel, in which Lermontov also excelled, had replaced it as the most popular form of letters in Russia.

Acclaimed as a poet when poetry in Russia had fallen on hard times, Lermontov won fame for his fiction, even though he completed only one novel. Set in the Caucasus like "The Demon" and "Mtsyri," his *Hero of Our Time* tells the story of Pechorin, a dashing officer who has grown bored with life because he has tasted everything it has to offer. Neither God nor the Devil can move Pechorin's heart. Nothing delights or dismays him, and he finds no higher purpose to which he can be true. Disillusioned, cynical, supremely fatalistic, and without principles, he ruins friends and foes, disdains the love of the women who give themselves to him, and squanders all his immense energy on trifles. "What is the purpose of my life?" he asks himself on the eve of one of his many duels. "Why was I born? I must have had some higher calling," he continues, "because I feel some immense force within my soul. But I have never understood what that was, and I have let myself be attracted by empty and evil passions. From this crucible, I emerged hard and cold like iron, but I lost forever the ardor of noble strivings."[69] With a few modifications, such lines might have been spoken in later times by Stavrogin, the hero who hanged himself in Dostoevskii's *Possessed* because he had attempted everything, tasted everything, and had nothing left to live for, but Pechorin's lament also represented Lermontov's condemnation of the world around him. *A Hero of Our Time*, he explained not long before his death, was a portrait, "not of a single person . . . [but] a portrait compounded of the vices of our whole generation in their full development."[70]

In poetry, Lermontov had followed the trails blazed by Pushkin, but in prose he marked the path that soon would lead others into the Age of Realism. Close behind him came Nikolai Gogol, the young friend of Pushkin's last years, who, as one critic explained, made ugliness "laughable [so that] it may not be terrifying."[71] Perhaps best described as a "Romantic realist," who blended Romantic

metaphors with vernacular dialogue, Gogol saw a world filled with the human vices that Lermontov had portrayed in *A Hero of Our Time*, but chose to present them in caricatures shaped by his own contorted vision of humankind. A pathologically warped personality rendered him incapable of responding to emotions as others did, twisted his vision of human experience, and drove him so close to the brink of madness that critics still debate the source and meaning of his genius. While the writings of such realists as Turgenev and Tolstoi painted life with the near-crystal clarity of images reflected from the mirrorlike surface of a pond, the pond in which Gogol saw the world always looked as if a large stone had just been thrown into it, the waves and ripples lengthening, shortening, and contorting the images that were reflected back at the viewer. Distortion was the key component in Gogol's vision. For him, nothing was ever precisely what it seemed to be. Nor could it ever be what others thought it was.

Like the great eighteenth-century painters Borovikovskii and Levitskii, Gogol was born into a family of Cossack squires who owned a small estate in present-day Ukraine. "He was a trembling mouse of a boy, with dirty hands and greasy locks, and pus trickling out of his ear," Vladimir Nabokov once wrote. "His schoolmates," he added, "avoided touching the books he had been using."[72] Shunned at school, Gogol was doted on by parents who coddled him and eventually supported his effort to escape from the mediocrity of the provinces to a life in Russia's capital. "Fate is driving me off to Petersburg," the young man wrote to an uncle as he set out full of great expectations at the age of nineteen. Confessing that "it would be terrible to live and leave no mark of my existence behind,"[73] he dreamed of becoming a statesman, an acclaimed actor, or a brilliant poet. When he failed to become any of the three, he announced that he was fleeing to America, only to change his mind a few hundred miles away in Lübeck and return. Back in St. Petersburg, Gogol found a modest position in a government office and began to write the humorous, ironic stories that would make him famous. At first, these helped him to escape from the boredom and bitterness he felt at being trapped in the depths of St. Petersburg's civil service but they soon became his instruments for settling scores with the world around him and for supporting the principles that underlay the society and artistic experience that the Romanovs had created.

Unable to enter the aristocratic world in which Pushkin and Lermontov had moved so easily, Gogol protested loudly against the realm of petty bureaucrats into which fate had cast him. A collection of stories called *Arabesques* marked his first revenge against the system that tormented him, and he used it to portray Russia's capital as a city in which "the smug, the vulgar, and the callous are here to stay," while "the pure of heart are crushed by the unbearable discrepancy between their dreams and 'revolting' reality."[74] Here for the first time was the seamy side of St. Petersburg, which such aristocratic writers as Pushkin and Lermontov had avoided and which Dostoevskii was soon to portray so brilliantly in the pages of *Crime and Punishment*. But more than the trials of the city's lesser folk shaped Gogol's vision, for he also saw those flitting forms and surreal shapes

that would not be seen again in Russian literature until Andrei Belyi's *St. Petersburg* appeared on the eve of World War I. Gogol saw Russia's capital as a city in which "the devil himself lights the street lamps only in order to show that everything is not really as it seems." Everything seemed to have been turned upside down in this strange and foreign city, in which faceless officials shaped the fates of millions. "How strangely our fate plays with us," Gogol mused in one of his *Arabesques* tales. "I try not to take any notice of the things I encounter. Everything's an illusion. Everything's a dream!"[75] Yet the fault was not St. Petersburg's, nor even the Emperor's, and Gogol blamed the failings of the world around him on those many men and women whose mean and petty natures so often worked against the vision of their rulers.

When he turned to describe Russia more generally in the play he called *The Inspector General*, Gogol continued to criticize the failure of his countrymen to measure up to the standards set by their sovereign. The theme of the play—in which corrupt small-town officials mistake a traveler down on his luck for an Inspector General traveling in disguise—may have been suggested to Gogol by Pushkin, who once was mistaken for a police official during his travels through central Russia, but the brilliant satire in which the play portrays the greed and corruption that moves an entire community is entirely Gogol's own. The result is "poetry in action," Nabokov once wrote, "true poetry . . . that provokes—not laughter and not tears—but a radiant smile of perfect satisfaction."[76] First read at one of Zhukovskii's literary evenings about a year before Pushkin was killed, *The Inspector General* impressed everyone with its brilliance at the same time as it terrified the censors. Only after Zhukovskii arranged for the play to be read at court and secured the Emperor Nicholas's personal approval could it be performed in public.

Although many critics greeted *The Inspector General* as a brilliant critique of the corruption and greed that festered in Russia's provinces, Gogol's play also can be (and was) seen as a justification for the secret police system that the Romanovs had created to keep their subjects from straying from the path of virtue. Certainly that was the Emperor's view when he gave permission for it to be performed, and the best estimates are that that was what Gogol intended for the play to mean. As he had in his *Arabesques* on St. Petersburg, Gogol faulted not the Emperor, but the men and women who had failed him. "In *The Inspector General*," he once explained, "I decided to gather into one heap everything bad in Russia . . . and laugh at it all at one stroke."[77] He intended that the vulgar and shallow Khlestakov around whom the play turned should stand for everyman. "It is so hard not to become Khlestakov, even if but once," he wrote. "A sleek officer in the Guards, a statesman, or even we sinful writers all turn into Khlestakovs now and then."[78]

Seeing a universal meaning in his play, Gogol therefore found that the shoe made for him by critics who applauded *The Inspector General* as a radical satire about the failings of the Romanovs' Russia fit poorly indeed and he fled abroad to escape their acclaim. "I am going abroad to shake off the anguish which my

countrymen inflict upon me," he wrote to a friend. "The prophet can have no fame at home."[79] Except for two brief visits to his homeland, he remained in the West for the next twelve years, struggling against the demons of self-doubt that threatened his sanity as he tried to write the novel which, although never finished, would become the greatest monument to his genius.

*Dead Souls.* The censors demanded that Gogol change its title because "the soul is immortal [and therefore] there can be no such thing as a 'dead soul,' "[80] but this masterpiece that tormented its author for the last fifteen years of his life remains to this day one of the most vibrant pieces of prose ever written in Russian. Centered upon the misadventures of Pavel Ivanovich Chichikov, the novel tells of an enterprising swindler who sets out to cheat the authorities by using a quirk in the law that treats dead serfs as if they were alive until the next official census and therefore makes them usable as collateral for loans from the government. To carry out his scheme, Chichikov travels through central Russia, buying up "dead souls" and revealing in the process the foibles of all humankind. Greed, corruption, meanness, and vicious selfishness all find their universal expressions in Gogol's cast of characters, and it is the rare reader who does not catch a glimpse of himself somewhere among the grimacing portraits that fill the novel's pages. "If men are what they are, then some grave error must have been committed in their creation," Gogol confessed at one point. "Can it be possible," he asked in wonderment, "that mortals were really created in the image of God?"[81] To his dismay, critics again hailed the work he had returned to Russia to publish as a radical critique of national life. Overwhelmed, he fled back to Rome.

Gogol conceived of the edition of *Dead Souls* that he published in 1842 as only the first part of a Russian *Divine Comedy*, but he never completed more than a rough draft of part of its second volume. Plagued by his tormented vision of the world, he struggled to explain what he had intended for his work to mean in a brief volume entitled *Selected Passages from Correspondence with Friends.* "This book is needed, badly needed," he wrote. "Everything will become clear, and misunderstandings will be promptly dispelled."[82] Emphatically, and more clearly than ever before, he explained that true virtue lay in a *Domostroi*-like patriarchal society, which subjected serfs to masters, wives to husbands, and Russians to their emperor. "Why is it necessary for one of us to be above everything and, even, above the law?" he asked. "[Because] you need a superior mercy to soften the law," he replied, "and this can only come to us in the form of absolute monarchy. A state without an absolute monarch," he concluded, "is an automaton. . . . A state without an absolute ruler is like an orchestra without a conductor."[83]

As he put the finishing touches on what was destined to be his last book, Gogol hoped that *Selected Passages* ("my first sensible book" as he wrote to one friend) would wipe away all the misunderstandings that had surrounded his great works.[84] Instead, the critics who had praised his earlier writings condemned it as a betrayal of the progressive cause and a bizarre consequence of its author's growing obsession with religion. Confused and frightened, Gogol drew

back in horror. "Oh, Lord," he exclaimed at one point, "how empty and terrify-ing Your world has grown!"[85] In fact, his critics and his countrymen generally missed a vital point, for by using satire to comment upon the forms that the foibles of humankind assumed in Russia Gogol may have been offering them a means to criticize and improve conditions in their homeland short of the revolu-tionary violence on which some of them were preparing to embark. It was neces-sary to love Russia in spite of her flaws, he once explained, for "without loving Russia you cannot love your brethren, and without loving your brethren you will not be aflame with the love of God, and without being aflame with the love of God you shall not be saved."[86]

Laughter, he insisted, was the key—"not that sort of laughter that stems from temporary irritability, nor from a bilious, morbid disposition of one's char-acter . . . but laughter that comes from the better side of human nature."[87] In the 1760s, Catherine the Great had attempted to enlist that sort of satire to support her efforts to enlighten the Russians. Three-quarters of a century later, Gogol may have worked toward the same end, but on a more sophisticated level[88] that the Russians did not begin to understand until much later. "There is perhaps no other work in the Russian language," a commentator remarked a few years be-fore the Bolshevik Revolution, "that is so wholeheartedly, so totally permeated with the spirit of civic concern—right down to the tiniest shades of meaning in its words and thoughts—than *Selected Passages from Correspondence with Friends*."[89]

The Romantic visions that Gogol, Lermontov, Pushkin, and Zhukovskii brought to life in their poetry and novels found other expressions in paintings that emphasized the unique qualities of their subjects rather than continued the classical forms favored by Levitskii and Borovikovskii. Especially Orest Kipren-skii, who ushered in Russia's Romantic Age in art by painting his country's dash-ing young soldiers before they rode off to fight Napoleon, portrayed men whose peculiar characteristics set them apart from all others, and in that tradition the heroic likenesses with which Dawe and his assistants filled the Gallery of 1812 showed Romantic portraiture at its height. Yet, as in the poetry of Karamzin and Zhukovskii, the Romantic glorification of the individual that marked the paintings of Kiprenskii and Dawe only pointed the way to more sophisticated expressions of the same qualities of life and spirit. In the 1820s and 1830s, the landscapes and paintings on religious and mythological themes in which Briullov, Venetsianov, Ivanov, and Fedotov struggled to match the spiritual regeneration that Pushkin was achieving in poetry carried them far ahead of Kiprenskii and made them the most famous practitioners of Romantic art in Russia.

Although born and educated in the eighteenth century, Orest Kiprenskii was among the first of Russia's painters to break with the classical styles of Levitskii and Borovikovskii. Far more handsome than Pushkin or Lermontov, Kiprenskii had been blessed by nature with wide-set eyes, high-arching eyebrows, a straight, well-formed nose, and masses of swirling dark hair that made him a living model

of the Romantic portraits he was destined to paint. The illegitimate son of a nobleman, Kiprenskii grew up as a serf in his father's household, where his master recognized his talent and hurried to develop it. At the age of six, the young serf, therefore, found himself in St. Petersburg's Academy of Fine Arts, where he spent the next fifteen years being steeped in the "dead ideas and patterns"[90] that had become part of the rigid scholastic tradition that the Academy had adopted during the reign of Catherine the Great.

After Kiprenskii won the Academy's gold medal in 1805, the turmoil of the Napoleonic wars kept him from continuing his studies in Paris and Rome. With all of Russia awash in patriotism, the armies of Alexander I prepared to meet the French, and Kiprenskii became the chronicler of that generation of daring youths who set out to find glory on the battlefields that lined the road from Moscow to Paris. Junior officers still in their teens, who had already won the Cross of St. George for valor, colonels and generals who wore the epaulets of imperial aides-de-camp, and the wistful, beautiful women who awaited their return all found places on Kiprenskii's canvases. As the fighting moved west and then died away, he painted the brilliant young Sergei Uvarov, who became president of the Academy of Sciences at the age of thirty-one, and in the same year his portrait of Zhukovskii captured to perfection the "maidenlike" features of Pushkin's mentor. Kiprenskii painted Pushkin the year after Nicholas I freed him from exile, and painted himself again and again as living testimony to the supremacy of the individual in Romantic art.

More than any of his predecessors, Kiprenskii worshiped color, and filled his backgrounds with grays and the ominously shaded greens of gathering storm clouds. While Levitskii and Borovikovskii had concentrated on perfecting the form of their paintings, Kiprenskii gave his portraits greater life and deeper meaning by centering them on his subjects' eyes, the Romantic gateway to the mind and soul. The results, one observer explained, "conveyed the feeling of fresh air bursting through an open window and carrying sounds from afar that make the soul rejoice or even tremble at the approach of something new."[91] Each had an inner tension that the work of Russia's eighteenth-century painters had never known, and that in turn made Kiprenskii's paintings unique in eighteenth and early-nineteenth-century Russian art.

Much of this brilliance faded after Kiprenskii moved to Rome in 1825, for the force of Rome's continuing infatuation with classical art convinced him to abandon his passion for what he now called "frivolous color" in order to search for "more dignified subjects" than the portraits he had painted with such brilliance.[92] Typical of a frustrated Romantic, sickness, love affairs that came to naught, and an inability to find the means of artistic expression he sought in the Eternal City made Kiprenskii's last decade one of the least productive of his life. When he died in 1836, Russian Romantic art had begun to move away from portraits to the forms of genre painting that had become so much a part of Romanticism in the West.[93]

A serf like Kiprenskii, Vasilii Tropinin helped to bridge the gap that divided the two one-time servants from the masters of genre painting, who would dominate Russia's art world during the reign of Nicholas I. For several years, Tropinin's master allowed him to study at St. Petersburg's Academy of Fine Arts as an auditor but then took him away to one of his Ukrainian estates, where the thirty-year-old aspiring artist served as valet, confidant, and painter of family portraits. During the early 1820s, his master set him to work on a Moscow townhouse to replace the one that the armies of Napoleon had destroyed in 1812, and only after that was finished in 1823 was Tropinin released from bondage. At the age of forty-seven, the artist became a free man.[94]

In over two thousand paintings produced between his liberation and his death thirty-four years later, Tropinin painted a collective portrait of Moscow's people. Street vendors, flower girls, lace makers, bricklayers, and hackney drivers, not to mention artisans, merchants, and aristocrats, all came to life on his canvases, which if not executed with the uniform brilliance of Kiprenskii's portraits nonetheless showed the vibrant life of a city that was rising from the ashes to which Napoleon's armies had consigned it. Painted not long after the Emperor Nicholas I freed Pushkin from exile, Tropinin's portrait of the poet projected a calm and gentleness that were completely absent from Kiprenskii's more restless, guarded work, and he generally sought to portray life's peaceful, idyllic side, not the turbulent troughs and peaks of human experience. Tropinin's hero, one observer concluded, "was not a warrior in 'the battle of life' but a true homebody."[95]

Candid, homely, and unique for that reason, Tropinin's paintings displayed a breadth of understanding not yet seen in Russia. Aged men and women, overdressed merchants' wives, children, servants, and seamstresses—there seemed no end to what caught his eye in Moscow's streets, and he left no corner of the city's life unrecorded. High and low, rich and poor, the brilliant, commonplace, beautiful, and ugly all fascinated him as an artist, and each found a place on his canvases. In the same way that Gogol captured the cacophony of St. Petersburg life in his *Arabesques*, so Tropinin in the 1830s and 1840s recorded Moscow's more provincial diversity. Never before had any Russian painted such variety—and never had one left such a full portrait of daily life on canvas.[96]

Both Gogol's *Arabesques'* prose portraits and Tropinin's paintings illustrated urban life and city people. Although no author would portray Russia's peasants in prose until Ivan Turgenev wrote his *Hunter's Sketches* at the end of the 1840s, the laboring men and women who made up more than eight-tenths of all the Russians found their chronicler on canvas a quarter of a century earlier in the person of Aleksei Venetsianov, the son of a tradesman who sold flowers, shrubs, and berry bushes near Moscow's Taganskie Gates. Where or how Venetsianov received his first instruction in painting still remains a mystery, for he did not study at the tradition-bound Academy of Fine Arts in St. Petersburg as did most of his contemporaries. He lived in Moscow until he turned twenty-three. Then, in 1802, he went to St. Petersburg and studied for nearly a decade with Borovikovskii, who

had also learned his art outside the Academy and had escaped the rigid formal training that its teachers continued to impose.

Working in Borovikovskii's shadow, Venetsianov painted the young men who marched off to fight Napoleon, but like Kiprenskii he made his subjects' eyes the center of his portraits rather than painting the social types for which his teacher had become famous. Struggling to discover how to transfer the inner force and meaning of the human spirit to canvas, he turned away from Borovikovskii's style of "painting in the grand manner" and insisted instead that an artist must paint "from the world that surrounds him." How to portray the true essence of Russia and what it meant to be Russian remained at the center of his artistic quest until 1818, when he began to experiment with painting peasant life. In the simple earthy qualities of Russia's peasants Venetsianov found what he had been seeking, and he set out to portray it in the lyrical fashion that became so typical of his work. To portray peasants sleeping, waking, plowing, reaping, threshing, spinning, caring for children, and tending their animals became his passion. Uninhibited by the rigid classical precepts that still ruled the Academy, he thought only of color, composition, and the wonderful northern light that flooded the farms and fields of his country estate. For the first time, Russia's peasants truly came to life, not as idealized images but as real people whose faces showed tenderness, longing, and sadness, and whose hands, with stained and broken fingernails, showed the marks of the heavy work that ruled their lives.[97]

Until 1836, when Karl Briullov returned to Russia surrounded by the glitter of the fame he had won in the West, Venetsianov's majestic spirit and love of nature drew students to him. Then the aging artist saw his best students drawn away to work with the first of Russia's painters to have won a wide following in Europe. Twenty years younger than Venetsianov and indisputably more talented, Briullov was to propel Russian painting into the arena in which the artists of the West won their success. From that moment on, Russia's painters would have to measure their work against the best that Europeans could produce and win acclaim from the same audiences that were watching the rise of some of the greatest artists the Western world had ever seen.

Raised in St. Petersburg by French émigré parents who had come to Russia by way of Germany, Karl Briullov was born into a family of artists in the last year of the eighteenth century. Determined that his sons should continue the family tradition, his father enrolled all five of them in the Academy of Fine Arts and demanded that they study even harder at home than they did in school. In the case of Karl, this meant developing a brilliant talent very early in life, with the result that he stood head and shoulders above his schoolmates and easily won the gold medal that entitled him to study in the West at the Academy's expense. As his tradition-bound masters insisted, he concentrated upon allegorical and classical themes, and his painting entitled "Narcissus" won such praise that one of his teachers, the father of the famed painter Aleksandr Ivanov, spent his own money to buy it not long before the Academy's prize student set out for Rome at the age of twenty-four.[98]

During his first seven years in Rome, Briullov did nothing to distinguish himself from the horde of artists who painted sunny Italian scenes and stylized, sentimentalized portraits. Then, a visit to the ruins of Pompei and a performance of Giovanni Pacini's opera *Il ultimo giorno di Pompei* set him to work on "The Last Day of Pompei," which catapulted him to fame. As the first painting in the history of Russian art to have as its subject not a key figure but a group whose identities were entirely unknown, Briullov's huge canvas won praise from critics as a true masterpiece, and for a while every knowledgeable foreigner who visited Rome went to see it. Entranced by the artist's portrayal of the volcano's victims as a knot of intertwined human bodies seeking refuge from heaven-sent destruction, Sir Walter Scott pronounced it an epic, not a painting. In Paris, Briullov's "Last Day" won the French Academy's gold medal for 1834.[99] When it reached St. Petersburg that August, Gogol called it "a radiant resurrection of art" and "one of the most brilliant phenomena of the nineteenth century."[100]

Too arrogant to admit his limitations and too vain to try to repair them, Briullov became a victim of his countrymen's acclaim. In an effort to surpass his "Last Day" and memorialize the heroic story of Russia's past, he painted "The Siege of Pskov by the Polish King Stefan Batory in 1581," but he never managed to recapture the grandeur and drama that had marked his earlier work. So immense that it was never finished, this new painting marked the advent of a blatantly nationalistic current in Russian art that would survive to the end of the Romanov dynasty. As a part of the national artistic experience that was destined to stand forever apart from the best of nineteenth-century Russia's art, "The Siege of Pskov" all too clearly proclaimed Briullov's limits as an artist, although his reputation survived far beyond his death more than fifteen years later.

Unable to repeat the feat that had catapulted him to greatness, Briullov turned to portraits, which still stand as the best work he produced after returning to Russia. His portrayal of the aging Zhukovskii, his dashing rendition of General Vasilii Perovskii, and his sensitive vision of the young playwright Nestor Kukolnik all won him praise from critics, who cheered his "deep understanding of the human heart."[101] At the same time, his Romantic renderings of Russia's rich and famous won him new acclaim. Yet, even as he worked, Briullov's failure to surpass the "Last Day" led him to see his life as being "like a candle that is burning at both ends while being held in the middle by a pair of red hot tongs."[102] A wasted, intense, and dissatisfied self-portrait painted in the spring of 1848 showed his disdain for the fame that the Russians had heaped upon him and revealed the torment that seared his soul. A year later, he left Russia for the island of Madeira off the western coast of Morocco and then moved on to spend the last years of his life in Rome, the scene of his greatest triumph and warmest memories.

Even as Briullov basked in the Russians' acclaim, the deeply religious Aleksandr Ivanov set out to surpass him by painting the perfect rendition of Christ. A close friend of Gogol, and the artist upon whom that tormented writer pinned his last hopes for Russia's artistic deliverance, Ivanov was the son of Briullov's

teacher at the Academy of Fine Arts and had studied there for a decade before he went to Rome. Touched by the spirit of youthful revolt, he had criticized the Academy as "a survival of the past century," and had announced his departure with the withering remark that "a Russian artist cannot remain in a city such as Petersburg, which has no character."[103] Certain that a new golden age that would proclaim the greatness of Russian art to all the world was about to dawn, Ivanov set out for the Eternal City that had inspired artists since before the time of Christ in the hopes of winning a place at its very center.

In Rome, Ivanov copied individual figures from the work of Michelangelo, paid particular attention to the paintings in which Raphael had portrayed crowds being swept up in waves of spiritual inspiration, and studied the nude human form in the city's public baths. In search of a truly decisive event around which he could shape a work of art with deeper meaning and greater truth than any Russian had yet created, he read, thought, and prayed for the better part of a decade until he settled upon that pivotal moment when John the Baptist and his followers had first seen Christ.

Until he finished it in 1857, "Christ's First Appearance to the People" remained Ivanov's abiding passion and deepest torment. He visited Rome's synagogues to study the facial structures of Jews, sat in courtrooms to observe the despair on the faces of condemned criminals, and searched through museums of classical sculpture to deepen his understanding of the facial types that had been common at the time of Christ. His search for natural beauty took him into the countryside (where he painted landscapes that anticipated the French Impressionists and are now regarded as some of his finest work), and he made a brief journey to the Near East and Jerusalem to see the land in which Christ had walked and preached. To be worthy to paint Christ, he came to believe that he must truly be like Christ.[104] That conclusion brought him anguish, exaltation, and a vision of a new temple to "the golden age of all humanity" that would rise in Moscow and help Russia's artists "lift men up and away from worry and grief to the finest moments of life."[105]

From the Bible, Ivanov drew the spiritual comfort that strengthened his belief in Christ's divinity at the same time as his reading of David Strauss's famed *Life* tormented him with doubts that Christ might have been no more than human. Slowly, the same dark forces that were driving his friend Gogol to the brink of madness took hold of Ivanov, too, and led him to that same messianic patriotism that would later impel Dostoevskii to proclaim that "the outlet for the anguish of Europe [lay] in the all-human and all-uniting Russian soul."[106] Convinced that only Russia and the Russian Tsar could lead humankind to spiritual renovation, Ivanov came to see the artist as "the priest of the future of humanity," who would become superfluous once humankind came to enjoy the "eternal peace" that the Russians would one day bestow upon it. A visit by the Emperor Nicholas I to his studio in Rome in 1845 drove him into a final frenzy of chauvinism and led him to dream of a new Russian academy that would pay tribute to that vision. "The Messiah whom the Jews await and in whose second coming Christians believe,"

he proclaimed, "is the Russian Tsar." In his mind, Nicholas I had become Christ in His second coming.[107]

Yet Ivanov had no more success in realizing his vision than did Gogol, for classicism, romanticism, and realism could not coexist on a single canvas. Aside from portraits and misty landscapes, the Romantic vision had its limits, and the tradition-bound forces that continued to hold the Academy of Fine Arts in the rigid classical mold into which Catherine the Great had cast it made those limits even more difficult to transcend. Perhaps nothing underscored that point more emphatically than the paintings produced by Pavel Fedotov, the first important Russian painter to be born after the Napoleonic wars and the one who first began to place his nation's art within reach of a larger audience.

Even more than Tropinin, Pavel Fedotov captured the pathos and pretension of the world in which he lived. Born in the outskirts of Moscow in 1815, he grew up among the petty clerks and lesser tradesmen who flocked to the city as it began to rise from the ashes of Napoleon's occupation, and he knew at first hand the hard realities that life presented for men and women to whom fate had not been kind. As one of the numerous children produced by his parents' several marriages, Fedotov endured poverty tempered by the rigid discipline that his retired army officer father imposed. He showed a talent for drawing in school, but with none of the encouragement that had paved the way for Briullov and Ivanov to study at the Academy of Fine Arts he embarked upon a military career that took him away from his native Moscow to St. Petersburg at the age of eighteen. Eleven years later he retired to devote the last eight years of his life to art. Soon, the madness that tormented Gogol and Ivanov seized him too, and held him fast in a psychiatric clinic until death released him from it in 1852.[108]

As a junior officer in the Imperial Guards, Fedotov found his inspiration in barracks life, the paintings he viewed at odd moments of leisure at St. Petersburg's Hermitage, and the painful scenes of daily life that he encountered in the back streets of Russia's capital. Like Tropinin in Moscow, he had a talent for coming across those small incidents and tiny tragedies that personified larger social and personal problems, and his satirical sketches portrayed the foibles of Russian life in much the same manner as Gogol had done in prose. There was something reminiscent of Hogarth in his method, especially in the sepia drawings he produced in the mid-1840s. Yet while Hogarth had emphasized the grotesque, Fedotov captured the tragic, the pathetic, the painful, and the wicked and revealed the meanness of life around him in ways that the work of his English predecessor never did.

In his drawings of the mid-1840s, Fedotov took his viewers into the lodgings of down-at-the-heels aristocrats, petty shopkeepers, and struggling painters. Moving decisively into the untried arena of realist art, he illustrated the greed that drove men to steal from their wives and portrayed the desperation that flowed from having staked all on a single card and lost. He painted aristocrats who shared squalid lodgings with well-trimmed poodles and ate coarse rye bread at richly veneered tables while they read advertisements for costly oysters. One

of his paintings showed a petty official on the morning after he had received his first decoration, his tattered bathrobe draped to resemble a toga and his pose mimicking a Roman senator. Showing an impoverished middle-aged aristocrat in quest of the hand of a rich merchant's daughter, his painting of "The Major's Proposal of Marriage" showed the dilemma that faced many impoverished Russian nobles who sought to rescue themselves from ruin by marrying into families who stood far beneath them on the social scale. In oils, in drawings, and in watercolors, Fedotov's art blended vanity, hypocrisy, deception, and greed to portray a world in which virtue, truth, and beauty had all but lost any hope of finding a place.[109]

Gogol's writings had described a world too improbably perverse to be real, but Fedotov's paintings showed the realities of daily life in an unvarnished form that reflected the social and political dilemmas that the Russians soon would face on a massive scale. As the first stirrings of the Industrial Revolution reached the suburbs of Moscow and St. Petersburg, the reality of modern life began to overpower the ideal visions that Romanticism had created. Poetry and blast furnaces refused to mix, and the passion with which Russia's Romantics had exalted love, beauty, and friendship could not be applied to spinning jennies and speeding locomotives. Tender feelings had to give way to the practicalities of technology and science, and thoughtful men and women now had to ask—in hard, practical terms—how they could reconcile modern-day progress with a way of life that required nearly eight out of every ten of their countrymen to live in bondage. And, as had already happened in England and France, a way had to be found to engage them in a national debate about the dilemmas of modern life, even as Russia's sovereign demanded that his censors remain vigilant so as to spare his nation the political consequences that had followed such discussions in the West.

As Russia faced defeat in the Crimean War, the sons and daughters of the men and women who had embraced the Romantic visions of Pushkin, Lermontov, and Briullov began to pride themselves on being emancipated from the illusions that had led their fathers and mothers to portray a brighter, better world in which higher impulses might one day shape the feelings that ruled their lives. Young Russians now began to speak of freedom for serfs and women, and the letter and spirit of the law, not the exalted feelings that had once lifted their parents into the inner world of the spirit, became the true measure of their liberation. Starting around 1850, novelists began to write about how it felt to live like a serf, what it meant to be poor, and what it was like to be a victim of bureaucratic tyranny, while artists portrayed the defining moments of Russia's history and struggled to capture the pain and passion of daily life. As the Russians' artistic experience turned to focus on life as it really was, not as painters and poets hoped it might one day become, a host of new writers ushered in an age of literary brilliance that surpassed anything Russian letters had ever seen. In Russia between 1850 and 1900, the novel came into its own. So did opera, theater, and the ballet.

There seemed to be no end to the amazing literary and artistic creations that

the Russians could produce. Just as Andrei Rublev and Dionysii had elevated Russian icon painting to heights that challenged the greatest of Byzantium's masters in the fifteenth century, so in the second half of the nineteenth century would the novels of Dostoevskii and Tolstoi take their places in the literary pantheon of modern Europe. *War and Peace*, *Anna Karenina*, *Crime and Punishment*, and *The Brothers Karamazov* all appeared in less than twenty years, and so did the operas of Musorgskii, Chaikovskii, Borodin, and Rimskii-Korsakov, the unforgettably realistic canvases of the peasant painter Ilia Repin, and the twilight dramas of Anton Chekhov. Yet these stood only at the apex of an artistic pyramid that overflowed with dozens of talented men and women whose creations brought Russia international acclaim. During its age of realism, Russia enjoyed such an abundance of talent that artists, writers, and composers whose work would have won acclaim in any other time or place received only passing attention.

# THE RISE
# OF
# REALISM

❦

DURING THE SECOND HALF of the nineteenth century, the ability to portray life as it really was, not as it might—or ought to—be made Russia's painters, writers, and composers the equal of any in Europe. In Paris, Rome, and Munich, Russian painters competed for the same gold medals and faced the same sharp-tongued critics as did the artists of the West, while in the capitals of Europe, Chaikovskii conducted symphonic orchestras in performing his latest works before audiences who measured them against the best that Europe had to offer. By 1880, it had become a matter of course for educated men and women to discuss Russian novels (now translated into French, English, and German almost as soon as they appeared) in salons all across the continent. Europeans knew the works of Turgenev, Dostoevskii, and Tolstoi every bit as well as the Russians knew the writings of Flaubert, de Maupassant, and Zola. The wrenching emotions of Ilia Repin's paintings, the raw native power of Musorgskii's *Boris Godunov*, and the fading twilight atmosphere of Chekhov's plays all touched the lives of thoughtful Europeans just as certainly as the writings of Europe's Romantics had shaped the ideas of the Russians half a century earlier. Probably no European thinker in 1900 had more followers than Lev Tolstoi, whose death at an out-of-the-way rail-road station in central Russia ten years later became a world media event that stood on a par with the assassination of Abraham Lincoln and the passing of Queen Victoria.

Yet, as the products of Russian art were winning fame in Europe, their creators were becoming more centered on Russia than ever before. During Russia's Romantic era, Pushkin had written of Mozart and Salieri, and Briullov had

painted "The Last Day of Pompei," but after Ivan Turgenev published his *Spring Freshets* in 1872, no major nineteenth-century Russian writer wrote a novel about Europe again. Russia's recent past and present were the exclusive focus for the writings of Tolstoi, Dostoevskii, and Chekhov, just as its more distant history provided the inspiration for Borodin's *Prince Igor*, Musorgskii's *Khovanshchina*, and the vast historical canvases of Vasilii Surikov. Shades of Russia's past and present blended together in the paintings of Ilia Repin. Rimskii-Korsakov found inspiration in the fairy-tale world of Russia's peasants, and even if Chaikovskii shaped some of his ballets around European themes, the operas that truly defined his genius—*Eugene Onegin* and *Queen of Spades*—were purely Russian. The age of realism thus brought Russian art, music, and literature into the very center of the European experience at the same time as it placed Russia at the center of its artists' work. After more than a hundred years of struggling to make their art more "European," Russian writers, painters, and composers finally realized how important it was to be "Russian."

Ironically, the beginning and end of this era, during which Russia's artistic experience reached out to touch so much of the world, was marked by military defeats that cut away the underpinnings of Russia's international political prestige. At the beginning of the age of realism, the Treaty of Paris that ended the Crimean War in 1856 signaled the Russian Empire's first military defeat in nearly 150 years. Then, as realism gave way to the symbolism and decadence of the avant-garde, Russia acknowledged its armies' defeat at the hands of the Japanese in the Far East. Yet, even as these defeats challenged Russia's status as a Great Power, they unleashed floods of creativity that added vivid new dimensions to the Russian artistic experience. Combined with the Revolution of 1905, defeat in the Russo-Japanese War marked the emergence of an avant-garde that transformed the art not only of Russia but of all Europe. In much the same way, Russia's Crimean defeat began a period of searching and self-examination that yielded the landmarks of realist art by which Russia's artistic experience is still best known in the West. The art of Repin, Dostoevskii, Tolstoi, Turgenev, and scores of others all flowed directly from the dilemmas that the defeat of 1856 obliged the Russians to confront in realist terms, and the work of each one of them owed a great deal to the new values and aspirations that that confrontation set free.

For the better part of a century before its armies lost the Crimean War, the visions of glory and empire that Catherine and her successors had drawn from ancient Rome had defined Russia's mission, given it strength, and justified the burdens that its lords and peasants had shared in pursuit of national greatness. Russia had grown powerful, but as the nineteenth century had approached its midpoint it had started to turn inward for fear of losing the qualities that had made it strong. Instead of challenging his subjects to become more European as Peter the Great had done, Nicholas I now demanded that they become more Russian. While Peter had measured success in terms of progress, Nicholas I and his ministers insisted in the 1830s and 1840s that the key to Russia's future lay in

the conservative Romantic teachings of Orthodoxy, autocracy, and nationality, all of which demanded that progress should be slow and that the forces of the past ought to rule the present and shape the future.

While the Russians had turned inward toward the values that had shaped their past, the Europeans had reached out with greater energy than ever before. The new creative forces that the French and Industrial revolutions had set free had transformed the first half of the nineteenth century into a time of remarkable innovation in the West, during which technology, science, and a new belief in the rights of man had begun to transform the ways in which people lived and rulers governed. The steam engine increased a hundredfold the amount of work a pair of hands could accomplish in a single day, and the railroad and telegraph altered the dimensions of time and space in ways few people had dared to imagine in earlier times. Between 1800 and 1850, the Western world had grown smaller, and the prospects for individual human activity much greater. To the poet Zhukovskii, who observed it from the stagnating imperial grandeur of Nicholas I's St. Petersburg, the rapidly changing West seemed like "an onrushing train" that swept everything from its path as it roared ahead.[1]

Fearful of where these new forces might lead, the Emperor Nicholas had used censorship and political repression to slow their advance. By doing so he had rendered the most articulate and educated people in his Empire mute at the very moment when new ideas were laying the groundwork for a new time of greatness in the West. Then, like the thoughtful men and women who responded to repression and censorship by seeking fulfillment within their hearts and minds, Nicholas had turned inward, too, and had relied on loyal officials to tell him what he wanted to hear rather than take the opinions of free and public-spirited citizens into account. In that way, he had cut himself off from the very source of new ideas that the rulers of Europe were enlisting to advance the cause of progress. After the revolutions of 1848 had swept through the cities of Europe, Nicholas had tightened the bonds of censorship until even the most innocent discussions of public affairs led to tragic consequences. No one knew that better than the young novelist Fedor Dostoevskii, who in 1849 had to endure the horrors of mock execution before being condemned to a term of hard labor in Siberia for having been present at a gathering in which several casual acquaintances had discussed the implications of progress for Russia.

Half a decade later, the unexpected victory of the European allies in the Crimean War had forced Nicholas's son, the young Emperor Alexander II, to reassess his nation's relation to the great powers of the world and ask how the stain of defeat could be wiped away. To avoid being driven back into Asia, Russia had to follow the path of the West, but no one knew just how to proceed or what aspects of the nineteenth-century European experience would best fit its needs. Prepared to cast aside the fetters of their past, the Russians had not yet asked what the West's new freedoms meant in the context of their history and experience. Nor did they know to whom and what those freedoms ought to apply. The centuries-old precepts of the *Domostroi* still underlay the view that husbands

were responsible for their wives and children, masters were responsible for their serfs, and the sovereign was responsible before God for them all. If those principles were swept away by the flood tides of progress, who would take responsibility for the millions of peasants and women who would be set free from husbands and masters? And what role should men and women play in the society and politics of modern-day life?

First and foremost, the Russians had to decide what place an autocrat had in their future. As Russia freed its serfs, created new institutions of self-government, and made all its citizens equally subject to the law during the Great Reform Era of the 1860s, many men and women continued to believe that the best hope for modernization and progress lay in the hands of the Tsar himself. At the same time, others thought that their nation ought to explore the political principles that flowed from the new visions to which Europe's revolutionaries had dedicated themselves since the Revolutions of 1848. As at no other time in their history, Russians needed to debate the merits of evolution and revolution, balance autocracy against democracy, and decide how far they should follow the path of Europe before finding one of their own. Yet, because censorship always stood in the way, words that could not be spoken in public had to be put into the mouths of men and women whose fictional existence set them apart. Literature and art became powerful tools for social and political change, which advocates of progress would use to challenge Russia's rulers until the end of the Soviet era. Nowhere else in Europe did fiction become such a force for progress. Nor, in other countries, did it relate so directly to so many lives.

Fiction owed its preeminent role in defining Russia's political and social debate to the preachings of one daring man who burst upon the Moscow literary scene at the end of 1834 with a series of "Literary Reveries," announcing that Russia had no literature and concluding that its civilization remained an enigma. Like the Romantics about whom he wrote, Vissarion Belinskii took refuge for a time in the inner realm of the spirit, but by 1840 he had decided that artists must become the consciences of their society and that critics must judge their work only according to the success with which they fulfilled that task. Called "furious Vissarion" because of the passion with which he wrote, he demanded that Russia's writers abandon the comfortable shelters that Romanticism provided and take responsibility for their nation's future. Russia's salvation, he wrote in an angry letter to Gogol in the summer of 1847, lay "not in mysticism, nor asceticism, nor pietism, but in the successes of civilization, enlightenment, and humanity," and writers therefore had no choice but to become their nation's "leaders, defenders, and saviors."[2] By the time he died of tuberculosis at the age of thirty-seven in 1847, Belinskii had set down the principles that would define the meaning and content of Russian literature for half a century. As Russia's first great literary critic, he had established a tradition that others would follow until the collapse of the Soviet regime.

In terms of his education and experience, Belinskii represented a new breed of intellectual who helped to reshape Russia's artistic experience as the nine-

teenth century moved toward its midpoint. The son of an obscure country doctor, he had grown up during the years after the Napoleonic wars in the deadening backwater of Russia's provinces, and the chance to enter Moscow University in 1829 had seemed to him a priceless opportunity to escape from a life of oblivion. At the university, he had joined a number of young men who rejected the cultural and political values of the established authorities, and he looked to the West for guidance at the same time as he insisted that the Russians must find the key to their future in the "Herculean strength" of their national spirit.[3] As he demanded that writers confront the dilemmas that Russia faced, Belinskii demanded that literature and art be judged according to the social or political message it set forth, and he drew the attention of Russia's readers to a new generation of writers who wrote about the lives and problems of real people. The urgency with which he recommended that his readers pay attention to Dostoevskii's and Turgenev's early work helped to bring both writers into the national spotlight. Not until Vladimir Stasov called upon them to pay homage to the paintings of Repin and the music of Musorgskii and Rimskii-Korsakov in the 1870s would any single figure do more to focus the Russians' attention on the masterpieces that were taking shape in their midst.

Just a few months before he died, Belinskii drew his readers' attention to the first installments of *A Common Story*, which a thirty-five-year-old civil servant had published in *The Contemporary*, a literary journal that was already famous for printing some of the great works of Zhukovskii, Pushkin, and Gogol. From it, he extracted an urgent summons for Russia to confront the reality of everyday life and for its writers to break away from the exalted realm of the heart and spirit. The time had come, he said, for writers who saw life as it really was to take command of Russian letters. "Who of us has not dreamed, harbored illusions, and grasped at straws in his youth?" Belinskii asked. "Who has not been disappointed in such dreams . . . and paid for them with burnings of the heart, anguish, and apathy [only to] laugh heartily at them later on? Healthy natures only benefit from this practical logic of life and experience," he concluded, "[but] Romantics perish from it." In keeping with Belinskii's ideal of what art ought to accomplish, the author of *A Common Story* had painted a portrait of life as it really was and had walked away without comment to let his readers draw their own conclusions. "[The author] is an artist, but nothing more," Belinskii concluded. "He has neither love nor hate for the persons he has created."[4]

Among Russia's novelists, Ivan Goncharov thus became the first to insist that Romanticism must give way to literary styles and subjects that reflected real life. A lifelong bureaucrat, he seemed an unlikely candidate for greatness, but his writings mapped a path that would soon be trod by such giants as Turgenev, Tolstoi, and Dostoevskii. "Stout, impassive, and pensive, with rather somnolent eyes," according to one description,[5] he at first seemed little more than an uncomplicated composite of a provincial squire and a successful civil servant whose aspirations and desires were limited to those that could most easily be fulfilled. Yet there was a more vibrant side to Goncharov's nature that conflicted with the

one that helped him bear the drudgery of life in the Russian civil service for the better part of three decades. In this other world where men did not "bend beneath the burden of constant thoughts about duty, labor, and obligations,"[6] Goncharov gave free rein to his imagination and wrote the novels that earned him a place among the leading writers of nineteenth-century Russia.

When millions of Russian peasants stood at the threshold of liberation in 1859, Goncharov published *Oblomov*, a novel that told the story of a provincial gentleman who, after failing to make his way in government service, had retired to spend the next decade lying on a sofa, where he dreamed great dreams that could never be brought to life. "He knew the delight of lofty thoughts [and] he was not a stranger to human sorrows," Goncharov wrote in describing Ilia Oblomov. "Sometimes . . . thoughts were kindled in him, sweeping through his mind like waves of the sea, developing into intentions and strivings, and setting his blood on fire. . . . The striving was on the point of passing into action . . . and then, Oh God! what wonders, what beneficent results would have followed from so lofty an effort. . . . But the morning fled by, the day was drawing to its close, and with it Oblomov's exhausted energies sought rest. . . . Slowly and thoughtfully he would turn over on his back and, fixing sad eyes on the window, mournfully watch the magnificent colors as the sun sank out of sight behind a tall house. How many times he had watched the sun set in this way!"[7]

Here, one critic exclaimed, was "the sign of the times"[8] in which the Russians lived, for the spirit of Oblomov had given birth within their hearts and souls to a malaise that condemned the Russians to live to no purpose, dream of everything, accomplish nothing, and drown the reality of the world around them in Romantic strivings that came to naught. This Oblomovism bedeviled Russia at every turn. It condemned its people to tsars who dreamed of great deeds but never acted, noble overlords who dreamed of progress but stuck to the tried and true, and government officials who dreamed of bureaucratic efficiency while they created a morass of red tape. To move ahead, Russia had to break free. Deeds would have to replace dreams, and realists who lived in the practical, everyday world would have to take the place of poets who let their pens be ruled by Romantic visions.

To speak of the everyday world in those days meant to speak particularly of peasants, for nearly eight out of every ten people in mid-nineteenth-century Russia tilled the soil or had some close connection to it. But educated Russians knew nothing of peasant life, for an immense chasm kept masters and serfs apart. Untouched by the huge cultural changes that had come since the days of Peter the Great, Russia's peasants continued to live in the old world of their ancestors and to shape their lives according to superstition and tradition. What dreams and hopes ruled the lives of the huge, shadowy mass of men and women who grew Russia's grain, fought its wars, and served its lords and ladies in ways too numerous to count were unknown to literate Russians until Ivan Turgenev published *A Hunter's Sketches* about the deep, daily agony of peasant life.

The son of a dashing cavalry officer who had married a despotic heiress in the

hope of recouping his fortunes, Turgenev grew up surrounded by the victims of his mother's tyranny. Long before he left home for the university, he had seen the flesh torn from the backs of serfs by lead-weighted whips and had watched parents parted from their children and sold to new masters. At the universities of Moscow and St. Petersburg, he met Zhukovskii, Pushkin, and Gogol, went on to study for several years at the University of Berlin, and then, following the example of Goncharov, tried to make a career in the civil service. Yet, while Goncharov had little choice but to make his peace with the deadening routines that ruled Russia's government, Turgenev could afford not to. Knowing that he stood to inherit a fortune (sooner, it turned out, rather than later), he gave up on government service and divided his time between living in the country, traveling abroad, and writing. His first efforts won polite smiles but nothing more. His romantic poems bordered on being maudlin, and his plays—written half a century before Stanislavskii developed the method that made such "slice of life" dramas a success—earned little more than passing shrugs. Measured against Gogol's *Inspector General* and Aleksandr Ostrovskii's early plays, Turgenev's first efforts took a poor and distant third place. Only when Belinskii urged him to write about the daily life of Russia's serfs did Turgenev produce the first of the twenty-one short stories that would catapult him to first place among Russia's writers when he published them together under the title of *A Hunter's Sketches* in 1852.[9]

Turgenev's sudden fame came at a moment when Russia's literary and artistic world was falling on hard times. Late in the winter of 1852, Gogol died in Moscow. Then Briullov died in Rome, and Goncharov set out on the three-year journey that would take him to Japan and back. Dostoevskii was completing his third year of hard labor in Siberia's Omsk Prison, while far away to the south young Lev Tolstoi was fighting the tribesmen of the Caucasus as a subaltern in his Emperor's field artillery. Belinskii had died four years before and no other critic had yet matched his passion and sense of purpose. Crushed by censorship, Russian letters were adrift. Turgenev complained that repression had become "its own type of plague for educated society,"[10] while another of his friends confessed that apathy had reached such a peak that it had become "impossible to recognize the people I knew just two years ago."[11]

Midway through this year of malaise, Turgenev's *Hunter's Sketches* awakened the Russians with a jolt. For "ridiculing the landowners, presenting them in a light derogatory to their honor, and in general propagating opinions detrimental to the respect due to the nobility from the other classes,"[12] the Emperor sent Turgenev into exile on one of his estates in Central Russia at the same time as Russia's liberals acclaimed him as a greater writer than either Gogol or Goncharov.

In contrast to Harriet Beecher Stowe's *Uncle Tom's Cabin*, which had appeared half a world away in New York City just four months earlier, Turgenev's condemnation of human servitude was more subtly presented and relied upon the wretched plight of the serfs themselves to make the case that Mrs. Stowe had pleaded in such strident tones. Never did he condemn serfdom, for that was neither his style nor in keeping with the spirit of the times. Instead, his

brilliantly drawn portraits revealed the intensely human qualities of serf life and left no doubt that serfs were as touched by love and tormented by tragedy as any who bought and sold them. It was difficult to come away from Turgenev's *Hunter's Sketches* without feeling that nothing separated these unfortunate victims from their masters and mistresses except for the vagaries of fate and the laws of the Russian Empire.

Summoning forth odors of new-mown hay, mushroom-filled woodlands, and peat fires at the edge of an endless steppe, *A Hunter's Sketches* had no plot. Its twenty-one stories were tied together only by the person of a nobleman, who with gun, dog, and companion wandered the lands of central Russia, where the forests of the North shaded into the grasslands of the South. Each tale recounted one of the hunter's experiences as he met women whose lives had been ruined by forced marriages, families who had fallen victim to the meanness of bailiffs, and men who had changed occupations a dozen times to satisfy the whims of new masters. Every encounter revealed some quality of heart and mind that serfs shared with their owners—a love of music, pain felt at parting from home and family, and a capacity for deep, wrenching sadness. At the same time, Turgenev showed how the thoughtless tyranny of masters often destroyed serfs' lives. All in all, the book comprised "a portfolio of pastels and etchings"[13] designed to portray but never to comment upon a world in which men and women of privilege could crush others with a whisper, a nod, or the mere blinking of an eye.

Having challenged the morality of serfdom, Turgenev turned in the late 1850s to the question of how women might be liberated from the patriarchal constraints that bound them to husbands, fathers, and brothers. Turgenev once explained that *On the Eve* was "based on idea that we must have *consciously* heroic natures in order to move forward,"[14] and he used the novel to present a brilliant and compelling portrait of a woman of high ideals and powerful will who turns her back on Russia to follow the young Bulgarian freedom fighter to whom she has given her heart. The novel makes it clear that men worthy of such a woman have yet to be born in Russia, for the ones who pay her court are without exception pedantic, self-centered little Hamlets "groping in subterranean darkness" and hopelessly ineffective. "We still have no real men among us, no matter where you look," one of her rejected Russian suitors laments. "When will our time come?" he asks. "When will real men be born among us?"[15] Yet the principles that ruled Russian life—tradition, fear of change, and power wielded from above for the purpose of crushing those who stood beneath—all barred the way. Turgenev's heroine made that clear in describing Egor Kurnatovskii, the man her parents hoped she would marry because he personified all the qualities that commanded respect in Russia of 1853. "There is something like iron in him, something empty and dull at the same time," she explained. "He certainly seems self-assured, hardworking, and capable of sacrifice . . . but he's a great despot, too. How terrible it would be to fall into his hands!"[16]

Some seventeen years later, Tolstoi fleshed out Turgenev's portrayal of Kurnatovskii in the person of Aleksei Karenin, the cold, unbending husband of the

heroine in *Anna Karenina*. Yet Turgenev's more sketchily drawn portrait may have served a more important purpose, for it challenged the precepts upon which the Romanovs had built Russia at the very moment when the nation's defeat in the Crimean War called those principles into question. During the years that separated *On the Eve* from *Anna Karenina*, the Russians searched for new principles, and their visions of the future differed as dramatically as the precepts they embraced.

Although they approached it from different directions, nearly all of the men and women who favored progress in Russia shared the conviction that the laws determining human behavior could be discerned in the same way that scientists were discovering the natural laws that governed the physical world. As science became the new deity to which such Russians paid homage when the nineteenth century entered its second half, scientific thought, scientific principles, and scientific precision became just as much a part of their lives as Romantic visions of beauty, love, and friendship had been in the days of Pushkin and Briullov.[17] Dispassionately, and with the care of a scientist working at a dissecting table, Turgenev examined this new faith in *Fathers and Sons*, the unforgettable novel that he published in 1862, when he and all Russians were struggling to come to grips with the Emancipation Acts that had freed twenty-two million serfs the year before.

Evgenii Bazarov, the central character in *Fathers and Sons*, personified the passion for science that gripped so many young Russians in those days. A university student and the son of a poor provincial doctor, Bazarov believes that science alone holds the key to the future and that all tender feelings stand squarely in the way of progress. Art, literature, and music are of no use because they have no practical purpose. "Raphael's not worth a copper farthing," he says. "A decent chemist is twenty times more useful than any poet." People who share his view, Bazarov announces proudly, are nihilists who "bow to no authority [and] accept nothing on faith." Reason, science, and practical considerations alone must guide them, and there can be no place in their hearts for sentiment. Such men and women will take nothing with them from the past into the future because, as Bazarov explains, there is "not a single institution in our present day family or civic life that does not demand complete and unqualified repudiation." Yet he offers no positive vision, and his sense of the future remains clouded to the end. "Negation," he concludes, "is the most useful thing at the present time and therefore we deny everything." Detached, calculating, and cold, Bazarov shrugs off the passionate protests of his questioners in order to "go on dissecting frogs"[18] until his nihilism destroys him. In the end, he dies a senseless early death from septicemia that he contracts during an autopsy because his father has forgotten to keep on hand the caustic he needed to cauterize the cut made when his own scalpel slips.

Painted with all the brilliance of which Turgenev was capable, Bazarov's portrait sparked a bitter debate among the Russians. Was he a true reflection of the younger generation? Had Turgenev portrayed the nihilists too darkly? Or had he

made them too attractive? Many radicals rejected what they thought must be a caricature of their beliefs, but conservatives angrily accused Turgenev of "crawling at Bazarov's feet" and seeking favor with Russia's radicals.[19] Turgenev himself had mixed emotions about his hero, and confessed that he felt "an involuntary attraction" to Bazarov at the same time as he claimed that one of the "fathers" who had spoken against Bazarov was a self-portrait.[20]

Only a handful of Russians took Bazarov at face value and saw in him a reflection of a new generation of "thinking realists" who might one day plot Russia's course. "He recognizes no governing social force, no moral law, no sanctioning principle outside himself," the radical critic and publicist Dmitrii Pisarev wrote proudly. "If Bazarovism is a sickness then it is a sickness of the age in which we live."[21] Although few dared to agree with Pisarev, none could deny that, once created, Bazarov never could be erased from the Russians' consciousness. The issues raised by *Fathers and Sons*—nihilism, a negation of art, history, and culture, and the belief that Russia must find an entirely new system of values—had to be squarely faced even though Turgenev's novel offered no conclusions and indicated no course for Russia to follow.

*Fathers and Sons* raised the most burning issues of the times, but Turgenev's own dispassionate view of Bazarov frustrated those critics who wanted Russia's authors to take a stand. Some insisted that Turgenev "never uttered a sincere word or had a sincere feeling,"[22] and one of Russia's leading radicals even scornfully compared him to "[Gogol's] Khlestakov: educated, clever, [and] superficial."[23] Yet it was precisely his genius for standing apart that made Turgenev the most brilliant literary portraitist Russia had yet seen. "His strength is in his sketches and details,"[24] one of his friends remarked not long before *Fathers and Sons* appeared, and that indeed proved to be as true of *A Hunter's Sketches* as of such later novels as *Smoke, Spring Freshets*, and *Virgin Soil*.

Each of Turgenev's novels (there were three before *Fathers and Sons* and three afterward) was carefully measured and exquisitely balanced—never too long, too boisterous, or too mercurial—and that drew Europeans to him even more than Russians. Able to count Flaubert, Henry James, and de Maupassant among his close friends, Turgenev was easily the most European of Russia's writers and the one whose works gave Europeans the surest sense of understanding the complex and fascinating land to their east. "No man has been so much the incarnation of a whole race as Turgenev," one French critic remarked just after spinal cancer had taken the author's life in 1883. "Generations of ancestors, lost, speechless, in the sleep of centuries, have come to life and found utterance through him."[25]

Turgenev probably would have quarreled with that description, for he saw himself (as he explained to a friend in 1856) mainly as "one of the writers of an interregnum . . . between Gogol and [some] future great [literary] leader."[26] At the beginning of Russia's Great Reform Era, it was not yet certain who that leader (or leaders) might be, although most educated Russians knew that a young artillery officer by the name of Lev Tolstoi, and Fedor Dostoevskii, who had just recently returned from a term of hard labor in Siberia, were the two writers most

likely to win that honor. In Siberia, Dostoevskii had found God and vowed to serve Him, while Tolstoi spent the half decade after he returned from the carnage of the Crimean War indulging his tastes for cards and women in Moscow and St. Petersburg. In those days—and for nearly two more decades to come—Tolstoi would accept Russia as it was, but would go on to spend the last thirty years of his life as a mortal foe of everything Russia's rulers stood for. Dostoevskii would dedicate the rest of his life to defending Russia's rulers and government in an attempt to atone for the youthful political transgressions that had sent him to Siberia. Both men dedicated their lives to agonizing quests for truth and the meaning of life. And, as they struggled to come to grips with the questions that underlay all human experience, they produced novels that rivaled the greatest to be found anywhere in Europe.

Of the anguished lives that Fedor Mikhailovich Dostoevskii chronicled in his novels, none was more tormented and chaotic than his own. Born the son of an army doctor in 1821, he endured a lonely childhood and lonelier adolescence before fate turned him loose in the real world. Dostoevskii spent his late teens in St. Petersburg's School for Military Engineers, at which he was trained for a career he abandoned within a year. At twenty-eight, he was sentenced to death for his part in the revolutionary circle of Mikhail Butashevich-Petrashevskii, and suffered the horror of a mock execution followed by five years at hard labor in the infamous Siberian "House of the Dead," Omsk Prison. After that came the torments of epilepsy, the trauma of a failed marriage to a woman he had tried to save, and the anguish of a failed love affair with a woman who abandoned him for younger, more docile lovers. As he struggled to win acclaim as a writer, Dostoevskii's addiction to roulette drew him from his desk to the gambling table, where his passion for challenging fate continually overwhelmed his reason and common sense. Forty-five when he wrote *Crime and Punishment*, the novel that catapulted him to the pinnacle of greatness, he continued to struggle with debts, gambling fever, and illness for the rest of his life. If Dostoevskii ever knew happiness and contentment, it was only during the few years before he died from a pulmonary hemorrhage at the age of fifty-nine.

Dostoevskii's compelling literary creations painted a canvas of Russian life that dwarfed all others in its breadth and complexity. His novels took readers into Russia's worst slums, the bureaucratic warrens through which uncaring clerks moved the affairs of the empire, and the vast, empty Siberian wastes that swallowed exiles by the thousands. He described the gnawing pain of prison, the hopelessness of poverty, and the grim, uncaring ways of Russia's provinces. Palaces of the rich, hovels of the poor, fetid prisons, and ascetic monks' cells all had a place in his novels, and so did the squalid corners in which pawnbrokers, thieves, and whores plied their seamy trades. Dostoevskii tried to understand what caused men and women to kill, cheat, and steal, and he explored the paths that led them to saintliness and madness. He wanted to know what led poor folk to squander their pitiful wages on drink and risk the savings of a lifetime on the luck of a single draw. Why would one man curse his son for piety, while another

drove his daughter to sell her body so that he could steal her pitiful earnings? Why did men try to live in society when they wished to break free from its bonds and why did others turn away from the world around them when they wished to be a part of it? Was man a creature of God or a servant of Satan? Was it enough to live like Christ—or did God even care?[27]

Scribes and statesmen, lords and beggars, *grandes dames* and prostitutes, convicts, jailers, thieves, and victims—the whole legion of "the insulted and the injured"—not to mention soldiers, writers, nihilists, women of high purpose, men of low repute, and the seething tide of humanity that ebbed and flowed across the Russian Empire all formed a part of Dostoevskii's vast and varied portrait of the human condition. Harsh, painful, raucous, and cruel, life in his novels stood a world apart from the noble tranquillity that Tolstoi portrayed in *War and Peace* and *Anna Karenina*. Never could he write with Tolstoi's majestic sweep, nor could he stand aside and comment upon life as Turgenev so often did. Always Dostoevskii stood at the center of his novels, tearing open the flesh of human experience and sticking his readers' noses into the throbbing nerves and muscles of the wounds he had opened. Breaking free from a literary tradition of elegant prose and calm, measured objectivity, he became Russia's first apocalyptic writer. "The end of the century," he once warned, "will be marked by a calamity, the likes of which has never yet occurred."[28]

More than any other Russian writer, Dostoevskii searched for the meaning of life in the vast arena of human experience. The dilemmas of good and evil, the split between human and divine law, and the alienation between man and God in the increasingly materialistic and technological society that had found its ultimate expression in the bourgeoisie of France and the entrepreneurs of England all seemed to him the creative and destructive sides of a single universal coin. In the cultural and artistic realm, he saw this duality in the split personality of Russian culture, in which a Europeanized elite had imposed Western laws, institutions, and moral precepts upon Russia's masses to produce a far more divisive *raskol* (the Russian word for schism) than the eternal generational division between "fathers" and "sons" that Turgenev had described with such force. That Russia's upper classes arranged their lives according to the individualistic precepts that had reigned in Europe since the Middle Ages while the masses continued to follow the communal practices of Old Muscovy represented only one part of that schism. In Dostoevskii's view, science and superstition, innovation and tradition, progress and stagnation, enlightenment and ignorance—all juxtaposed and in perpetual conflict—formed an unresolvable duality that had split Russian culture since the days of Peter the Great.

Once he had seen Europe for himself during a trip to Germany, France, and England in the summer of 1862, Dostoevskii believed even more firmly that the passion with which Russia's writers and artists had embraced the West had led them to forsake their national roots and become perversely European. "Now the masses consider us to be entirely foreign," he wrote in *Winter Notes on Summer Impressions*, which he published in 1863. "They don't understand a single word

we speak, not a single book we write, not even the way we think—but this is considered progress nonetheless." The chasm that had first opened between educated Russians and the masses in the time of Peter the Great had become immense, yet the intelligentsia persisted in its self-proclaimed mission to transform Russians into Europeans. "How self-assured we are in our civilizing mission!" Dostoevskii exclaimed. "The soul has become a *tabula rasa,* an empty honeycomb, out of which you can mold in an instant a real person, a universal being, a homuncule—you only have to apply the fruits of European civilization and read two or three books and you've got the job done!"[29]

Convinced that Russians must find their future within themselves because they had a unique historic mission to fulfill, Dostoevskii saw danger and destruction in the West. In place of the ideals of liberty, equality, and fraternity, he saw in France a society in which "the personal principle, the principle of individuality, intensified self-preservation, self-assertion, and self-definition within the bounds of one's ego" proclaimed the pursuit of "money as the highest virtue and human obligation." England seemed even worse. "You look at these hundreds of thousands, these millions of people, obediently flowing here from all over the globe," Dostoevskii wrote after he visited the Crystal Palace at the second London World's Fair in 1862, "[and you see] some kind of Babylon, some prophesy of the Apocalypse being fulfilled before your very eyes." All over London, he saw not the much-vaunted splendor of Victorian civilization but "the same dogged, unhearing, never-ending struggle, a struggle to the death between the general Western principle of individuality and the need to somehow live together, to in some way establish a society and organize an anthill." He saw nothing creative. "Turning into an anthill," he concluded, was necessary just so that people ruled by individualism would "not eat each other up."[30]

Turning away from the West, Dostoevskii sought salvation in the unique Russian principle of "brotherly communality," the "voluntary, totally conscious sacrifice of oneself in the interests of all made under no sort of compulsion," which he called "a sign of the highest development of the personality." Therein, he wrote, lay the makings of Russia's greatest contributions to human civilization. "Brotherly communality must be in the nature of a people in the sense that it was born within them or has been assimilated as a way of life throughout the ages," he explained. This form of union, "[in which] nobody is deprived of anything on your behalf," Dostoevskii believed was destined to become Russia's answer to the teeming capitalist and socialist "anthills" of the West. Only this, he concluded, could become an alternative to the war of all against all toward which he believed that the experience of the West was leading.[31]

*Winter Notes on Summer Impressions* brought Dostoevskii to the threshold of the era during which he would write the monumental works that raised him from national fame to international immortality, yet perhaps not even one of them could have been written had he not paved the way with a disquieting and compelling short book in which he identified the facets of human experience he would explore in the masterpieces that filled the last fourteen years of his life.

Entitled *Notes from Underground*, this disturbing tale of alienated and degraded human existence did not receive even one review or notice in any of the famed "thick journals" that shaped Russian opinion during the 1860s and 1870s, yet no other work in the nineteenth century ever explored the darker sides of human nature with greater thoroughness or sensitivity. Since it was first published in 1864, the disciples of Nietzsche, Freud, and Sartre all have embraced it as their own, and so have the creators of such modern artistic movements as Surrealism and Expressionism. "Like Hamlet, Don Quixote, Don Juan, and Faust," a critic concluded not long ago, "[Dostoevskii's] underground man has entered into the very warp and woof of modern culture."[32]

Sick, malevolent, unattractive—and "feeling a sort of secret, abnormal, despicable enjoyment in returning home to my corner on some revolting Petersburg night and knowing full well that I had again done something disgusting that day"[33]—the underground man lived a nasty, despicable life of the very sort (so claimed the liberals and revolutionaries whose teachings Dostoevskii so despised) that stood at odds with human nature. Yet by showing that his underground man was perfectly willing to wallow in those very depths of degradation from which social reformers thought humankind so urgently wanted to escape, Dostoevskii showed that men and women would choose to work against their best interests just to prove they had the freedom to do so. In the process of pointing that out, he raised the cosmic questions that he would pursue in the four great masterpieces that lay ahead. Was free will a blessing or a curse? What fate awaited heroes who sought a guiding force within themselves rather than turning toward God? Was it possible for people to defy the laws of God and nature in the name of higher truths that they alone perceived? What *was* the purpose and meaning of life? And how could men and women live the sorts of lives that would permit them to attain salvation, whatever that "salvation" might consist of?

Dostoevskii turned to explore these questions after a decade of personal sufferings that would have destroyed a lesser man. "My stomach is ruined," he had written after he left Omsk Prison at the beginning of 1854. "As a result of my bad nerves I have become epileptic. And I have rheumatism in my legs."[34] Starved for human warmth, he soon fell in love with Maria Isaeva, a sensitive woman he married in order to save her from the ravages of life as a widow on the Siberian frontier. The religious fervor he had brought with him from prison into the free world led him to nurse his wife through the final stages of the tuberculosis that claimed her life in 1865 even though their love had long since died and a burning passion for the younger Apollinaria Suslova had already seized him. "A great egoist," and possessed of a "colossal self-love," in Dostoevskii's words, Suslova burdened his soul at the same time that she ruled his heart. *"Why does she torment me?"* he once asked. "I wish that I did not love her . . . [but] I love her still." One of Suslova's later husbands called her "a Flagellant's Mother of God." She was, he explained, *"by the style of her soul,* completely Russian."[35]

While he struggled to curb the gambling fever that tormented him for the rest

of his life, Dostoevskii pursued Suslova across Europe. As gambling debts he could not pay, a dying wife he no longer loved, and a dying romance with a mistress who delighted in telling him of her new lovers deepened his sufferings, he faced the death of his favorite brother, Mikhail, and the failure of their joint effort to publish a literary journal. Everywhere he turned, life seemed to be coming apart. "I've suddenly been left alone and things have become simply terrible for me," he wrote to a friend. "My whole life has broken in two. . . . There's nothing left to live for. Everything around me has turned cold and empty."[36]

Dostoevskii owed money to everyone and could borrow from no one. Swearing that "I'd gladly go back to penal servitude in Siberia for any number of years just to have my debts paid and feel free once again," he agreed in the summer of 1865 to write a novel for a literary speculator by November 1, 1866, in return for an advance of three thousand rubles. If the novel was finished on time, the speculator would have the right to publish it or sell it to whomever he saw fit, but if Dostoevskii failed to meet the November deadline, then the rights to his future works would be forfeit. "Now I'm beginning to write under the whip again," he complained. "Working out of necessity, just for money, simply crushes and torments me."[37]

That fall, he fled to Europe—to Suslova and the roulette wheels that enticed and betrayed him. In Wiesbaden, he gambled away every pfennig and could not pay his hotel bill. Then, miserable and hungry, he experienced a euphoria of nervous exaltation that brought him not to the novel he had promised to write on short notice but to *Crime and Punishment*. "This is the psychological account of a crime," he explained. "Expelled from the university, living in utter poverty, and having come under the influence of some of those strange, 'incomplete' ideas, which go floating through the air," he went on, "a young man of lower class origins . . . has resolved to escape from his nasty situation at a single stroke. He has decided to kill an old woman . . . who lends money out at interest . . . and rob her of everything she has in order to bring happiness to his mother, who is living in the provinces, save his sister, . . . finish his studies, go abroad, and then become honorable, upright, and steadfast in fulfilling his 'debt to society,' so as to 'make amends for his crime.' "[38]

Such crimes, Dostoevskii insisted, almost always left clues that led to the perpetrator's arrest, but in this case the young man had succeeded in leaving no trace. Then the "whole psychological process of the crime unfolds." Although nothing links the murderer to the crime and no one suspects him, Dostoevskii continued, "unexpected and unforeseen feelings torment his heart. Divine and earthly law both claim their due, and it ends up that he is *compelled* to turn himself in . . . so that, even if he should perish in penal servitude, he will be reunited with humanity."[39] In this way, Dostoevskii summarized in less than two pages the tale of Rodion Raskolnikov, who was destined in the course of *Crime and Punishment* to test the fearsome theory that a person "obviously made not of flesh but of bronze" could, by virtue of his intelligence, broader vision, and superhuman will, "march over corpses and wade through blood if his ideas require him to do

so."[40] Dostoevskii had been turning this idea over in his mind ever since he had first encountered men who showed contempt for everything outside of themselves during the terrible years he had spent in the Omsk House of the Dead.[41] Only men such as they had been able to bear the psychological torment of relinquishing all control over their daily lives. Impervious to physical and psychological pain, and completely self-absorbed, they had become living embodiments of the axiom that whatever cannot destroy a man will make him stronger.

As one of Dostoevskii's friends remarked, Raskolnikov represented "nihilism carried to its extreme."[42] He had something in common with Turgenev's nihilistic Bazarov, but the contrast between his beliefs and his manner was even more sharply drawn. He was "remarkably good looking, with beautiful dark eyes, dark hair, and a slender, well-built figure that was taller than average," yet his "soul was so full of bitter scorn that, despite frequent flashes of adolescent self-consciousness, he had no shame at appearing in rags in public."[43] While Bazarov thought that men and women who devoted themselves to science would eventually improve the world in which they lived, Raskolnikov believed that, throughout history, a few select "men of bronze" had reshaped human experience by transcending the laws of nature and morality for a higher purpose known only to themselves. Anxious to stand among them, he had rejected society and gone to live "underground," where he murdered a parasitic old pawnbroker to prove that he stood among the elect who dared to change the course of history. Yet it proved to be far easier to kill than to bear the psychological burden of having done so, and Dostoevskii devoted far more of his novel to studying Raskolnikov's inability to remain apart from society than to describing his rejection of it. From the moment Raskolnikov felt "suddenly drawn to people" on its seventh page, *Crime and Punishment* became more a study of the forces that drove him to rejoin society than of the ideas that separated him from it.[44]

*Crime and Punishment* thus became Dostoevskii's first major test of the nihilist ideas that had seized the imaginations of Russia's youth. "I understood that power is given only to him who dares to stoop and take it," Raskolnikov explains at one point. "I wanted to have that courage. . . . I wanted to dare!" Yet wanting and daring were not enough. To prove his belief that he stood among history's men of bronze, Raskolnikov had to act. "I had to find out—and find out as quickly as possible," he continues, "whether I was a louse like everyone else or a real man. Could I cross beyond the barriers? Did I dare to take power? Was I merely a trembling creature or did I possess the *right* to act?" The manner in which earlier heroes had shaped destiny had shown him the way. "I wanted to be like Napoleon," he explains, "and so I committed murder."[45] When he realizes that he cannot be a man of bronze, Raskolnikov confesses his crime and seeks repentance, redemption, and resurrection through the agony of penal servitude in Siberia. Despite the great pain and suffering he and his loved ones must bear, he finds that no cost is too great to regain his place in human society. "He did not know that this new life would not be his for nothing, that it would cost him dearly, and [that redemption would] have to be bought at the price of great fu-

ture struggles," Dostoevskii told his readers. "But here begins a new tale," he concluded, "the tale of the gradual renewal of a man, the tale of his gradual regeneration and his gradual transition from one world to another."[46]

If Dostoevskii's personal and artistic torments had helped him to find the way from suffering to redemption, they had not liberated him from the tyranny of creditors. To be freed from the speculator to whom he had promised a novel by November 1, Dostoevskii set *Crime and Punishment* aside in the fall of 1866 and began to dictate *The Gambler* to Anna Snitkina, the twenty-year-old stenographer he would marry a year later. Anna became his guardian angel, soothed his soul, and nursed him through his bouts with epilepsy, gambling fever, and self-doubt. With her help and encouragement, he wrote *The Gambler* in twenty-six days and delivered it a day ahead of schedule.[47] It was, critics still agree, one of his best works, in which he described in just over a hundred pages the "hell of roulette," in which his passion held him fast. "With what trembling, what faintness of heart, I hear the croupier's cry," he wrote toward the end of the novel. "With what greed I gaze at the table on which are strewn louis d'or, friedrichs d'or, and thalers—at the little pillars of gold when they are scattered by the croupier's rake into small heaps that glow like fire, or at the yard-high columns of silver that are stacked around the wheel. While approaching the casino, I almost go into convulsions as soon as I hear the clink of coins being poured out, even though I am still two rooms away."[48] Never would Dostoevskii escape from his compulsion to challenge fate, risk everything on one spin of the wheel, and feel the terror of losing every last kopek seize his throat and settle deep into the pit of his stomach. Was it hopeless despair or the highest transport of pleasure? "Man sometimes loves suffering with an extraordinary passion," he had written in *Notes from Underground*. "I think that man will on no account ever renounce suffering."[49]

During the winter after he delivered *The Gambler*, Dostoevskii finished *Crime and Punishment* and married Anna Snitkina. In the spring, he took his new wife to Dresden, where he lost all of her dowry at the roulette tables in less than a month. After that, he pawned his watch and lost. Then he pawned her last brooch and earrings and lost again. He pawned her wedding ring, and lost that, too. In desperation, he begged five hundred rubles from his publisher, and went to the casino at Baden-Baden, where he lost every pfennig. After he pawned his fur coat and lost, he pawned and lost Anna's coat also. No matter how often he swore to give it all up, the spinning wheels and clinking coins drew him back. "Ania, my dear, I am worse than a beast!" he wrote from Saxon-les-Bains, where he had gone to try his luck on his own. "I have lost absolutely everything, everything!" Six weeks later, he tried again with the same results. "Angel, my dear, my precious," he wrote on November 18, 1867, "I have lost everything, everything, everything!" Then, he saw a ray of hope. "Now for the novel," he told Anna. "The novel will help us."[50]

Unable to find a clear sense of direction, Dostoevskii had been struggling to write *The Idiot* the whole time he had been fighting to break free from the

roulette tables of Germany and Switzerland. Only after he had thrown everything he had written away toward the end of 1867—"thrown it all to hell," as he told a friend—had the theme of the novel emerged. Almost against his will and in opposition to everything he had intended, he faced squarely for the first time the question of determining what would happen if a person who lived like Christ were set adrift in Russia of the late 1860s. Lamenting that it could be "by and large only an introduction,"[51] he wrote the entire first part of *The Idiot* around that theme in less than a month, but then his vision slipped out of focus. He struggled with the second part of the novel until midsummer, and worked on the third part until well into the fall. "I'm terribly unhappy," he wrote to a friend as the fourth and last part of *The Idiot* still loomed before him. "My soul is unwell . . . and I'm beginning to loathe my novel."[52] Then, as the October rains began to fall on the north Italian hills outside the apartment that Anna had rented for them in Milan, Dostoevskii's vision cleared in a moment of intense inspiration. "Never in my entire literary life have I had a poetic thought that is richer and better than the one which has now become clear to me in my more thorough plan of the fourth part [of *The Idiot*]," he wrote.[53] By the end of January 1869, he had produced a *tour de force,* in which murder, grief, and loneliness destroyed any hope that the novel's main character, Prince Lev Myshkin—so reminiscent of the holy fools the Russians had revered in olden times—could ever find a place in the modern world.

As he emerged from Dostoevskii's tormented thoughts, the "idiot" Myshkin was openhearted, trusting, and completely honest. His pure and simple Christianity was a reflection of Dostoevskii's own, and his face, with its large eyes, hollow cheeks, and wispy beard, called forth memories of an icon such as Feofan Grek might have painted five hundred years earlier. "The whole notion of God's joy in man," Myshkin once explained, "is like the happiness a father finds in his child." That, he concluded, "is the most true and fundamental idea of Christ!"[54] Yet his Christlike goodness failed in the real world just as utterly as had Raskolnikov's nihilism. Like Raskolnikov, Myshkin became a pariah—an idiot—not because he had broken society's laws but because his genuine goodness set him apart from the greed-driven men and women around him. Incarcerated in a Swiss asylum for the insane with no chance of redemption, he faced an even more absolute rejection by society than had Raskolnikov.[55]

What course remained if Russia could follow the path neither of Myshkin nor of Raskolnikov? Dostoevskii had tried to escape the oppression he felt in Russia by living in Europe, yet he longed to renew his contact with the land whose essence filled his heart and soul. "Life here has become very hard for me," he wrote from Milan just before he began the last part of *The Idiot.* "There's nothing here that's Russian. There's no Russian air, no Russian people."[56] Convinced that Europe was not for Russians, Dostoevskii sought to regain his native roots by turning to the Russian people—the *narod*—who had lived apart from Europe. Certain that something deep within the Russians would combine with their love for their Russian God to create a powerful force in the future, Dostoevskii con-

cluded *The Idiot* with a warning, almost as if he were speaking to all those rulers who had followed Peter the Great in making Russia a part of Europe. "Enough of this being carried away," he exclaimed at the very end. "All of this—this life abroad, this Europe of yours—all of it is pure fantasy, and all of us who have crossed over that boundary are just a fantasy too. Remember my words!" he concluded. "You'll see for yourself!"[57]

Yet, if Europe was a fantasy, was Russia the reality? Clearly, Dostoevskii thought so, but the tangle of opposites that Russian life juxtaposed seemed almost too overwhelming to unravel. Even in a single area of human experience— sometimes in a single person—profanity mixed with devotion, violence with meekness, selfishness with generosity, and torment with exaltation to create a multitude of dualities that defied explanation. The fate of Myshkin and the murder of the woman he loved in *The Idiot* forced Dostoevskii to confront the questions of why God permitted evil to exist and why man was so attracted to it. How could the goodness of human experience be extracted in such a world? And wherein lay the way to redemption? In Russia, nihilism was turning onto a more violent path and there were fears that a secret conspiracy had been formed to spread political terror all across the empire. As a sense of mission seized Dostoevskii, he began to plan a new novel in the spring of 1870. "Even if it turns out to be a [political] pamphlet, I will speak out nonetheless," he wrote. "It is necessary to write with whip in hand," he went on. "These nihilists and westernizers require a real thrashing."[58] Nihilism needed to be measured against the teachings of Christ and condemned. "This is precisely the theme of my [new] novel," he wrote to a friend that fall. "It is called *The Devils*."[59]

To condemn nihilism, Dostoevskii had to know if a man of bronze, who negated everything outside himself, could create a better world. *Crime and Punishment* had failed to answer that question because Raskolnikov had not been a man of bronze after all and had needed to seek redemption in the society from which he had hoped to stand apart. It therefore still remained to be seen what a *real* man of bronze could accomplish if he remained true to himself and steadfast in his purpose. Could such a man succeed where Raskolnikov had failed? That question lay at the very heart of *The Devils*. To each of the "devils"—the novel's lesser heroes—the answer brought destruction as they stole, lied, cheated, and killed in the name of the revolutionary trinity of fraternity, equality, and freedom they sought to achieve. Only slavery could produce the absolute equality of which Dostoevskii's "devils" dreamed, and absolute freedom could be proved only by freely chosen self-annihilation. But even slavery and suicide could not reveal the full consequences of trying to rise above the laws of God and man in the name of another truth. Dostoevskii therefore placed at the center of his novel Nikolai Stavrogin, the "devils'" own progenitor, who embodied all the attributes that each of them represented singly.[60] "Everything is contained in Stavrogin's character," he wrote as he finished the outline for the novel. *"Stavrogin is everything!"*[61]

Brooding, malevolent, and dark, Dostoevskii's Stavrogin embodies the sum

total of all the dualities that his creator saw in Russian life. Handsome and surrounded by women, he cannot love, and personifies evil in its coldest, most passionless form. Representing "reason without faith: cold intellect born in aristocratic boredom, nurtured during a scientific expedition to Iceland, confirmed by study in a German university, and brought by way of St. Petersburg to the Russian people,"[62] he thinks great thoughts but cannot act. Although his name bears within it the Greek word for the cross, he cannot embrace God, for the power of his intellect negates all belief. He is, one critic concluded, the man-god "by comparison with whom Nietzsche's superman seems only a shadow."[63]

A true man of bronze, Stavrogin succeeds where Raskolnikov had failed, but he can never reconcile the opposites that attract him with equal force. "I still am capable of wanting to do something decent, and I experience pleasure from that fact," he confesses. "But the next moment, I want to do something wicked, and I derive pleasure from that too. Now, as always . . . my desires are far, far too weak to direct me. You can cross a river on a log," he concludes, "but not on a splinter." Having experienced joy, sadness, virtue, sin, love, hate, pain, and pleasure, Stavrogin negates them all so thoroughly that he cannot even join the circle of nihilists that his ideas have brought into being. "I looked at them with hatred bred of envy for their hopes," he confesses, "but I could not be one of their comrades because I shared nothing with them." With nothing left to live for, Stavrogin kills himself. At the end of the novel, his mother finds him in the attic, where he has hanged himself with a carefully soaped silken cord. "Blame no one," he has written on a scrap of paper that lies nearby. "I did it myself." There is no chance for redemption, not even a glimmer of hope in Stavrogin's coldly rational self-destruction. "At the autopsy," the novel concludes, "our doctors absolutely and insistently rejected any verdict of insanity."[64]

When Dostoevskii finished *The Devils* in the fall of 1872, he had just turned fifty-one and had fewer than nine years left to live. Now that they had returned to Russia, Anna began to bring order to their personal lives, and although the wolf still came to their door too often, they no longer faced the moments of desperation that his gambling had brought upon them in the West. Still, creditors demanding payment for debts connected with the failed journals that Dostoevskii and his brother had published a decade before pursued them, and it was only Anna's determined resourcefulness that kept them at bay until she collected enough from publishing separate editions of her husband's novels to pay them. Always, there was need—creditors, whining relatives, and the roulette dens into which he still fell from time to time—that kept Dostoevskii at his desk in one cramped and gloomy St. Petersburg apartment after another. Even in the last year of his life, one of Russia's greatest living authors still enjoyed very few luxuries. "Could one call this wretched corner room in a tiny wing, where one of the most inspired and profound writers of our time lived and worked, a study?" a young writer who visited Dostoevskii not long before his death asked himself. But work there he did—and find moments of happiness too. "Nowhere is a person's character expressed so vividly as in the life he lives in his own family circle,"

Anna wrote in reminiscences that revealed how Dostoevskii rocked his children, chose her dresses, and decorated the family Christmas tree.[65] Still contentious and intense, with his epileptic seizures coming more frequently, the tormented writer was at last beginning to find peace, and even a measure of leisure.

During these more quiet years, Dostoevskii turned once again to the question that *The Devils* had left unanswered. If neither a man of bronze nor a man who lived like Christ could create a better world, even for himself, then how should people live? To provide an answer, he drew from every corner of his experience—all the pain, suffering, and struggles with nagging doubts that could be extracted from half a century of inner torment—to write the greatest and most complex of all his novels, *The Brothers Karamazov*. Here, in an attempt to perceive where the Russians were heading and how they would get there, he set down his final words on the cursed questions that had plagued his countrymen for so long. Wherein lay the key to Russia's future? To what purpose did Russia and the Russians continue to suffer? And could the Russians because of—or in spite of—this suffering find salvation? "I believe," Dostoevskii had written after he and Anna had returned from Europe, "that the chief, most basic spiritual need of the Russian people is the need to suffer, perpetual and unquenchable, everywhere and in everything."[66] In *The Brothers Karamazov*, he would explore the full dimensions of that suffering in a final effort to discover its true meaning. "In my head and heart," he wrote to a friend at the end of 1877, "I have a novel that is asking to express itself."[67] To do so, he would have to follow his life back to the long-ago days when he had borne the torments of penal servitude in the Omsk House of the Dead.

Very soon after he had entered Omsk Prison in the spring of 1850, Dostoevskii had met retired Second-Lieutenant Ilinskii, formerly of the Tobolsk Infantry Battalion, who had been sentenced to twenty years of penal servitude for killing his father. Something about Ilinskii had held his attention, and when Dostoevskii wrote of life in prison the former lieutenant was one of the first men he mentioned. As Dostoevskii reported in the first chapter of *Notes from the House of the Dead* (published in serial form during 1861 and 1862), Ilinskii had fought with his father over money and had killed him to get his inheritance. That account had been sworn to by a regiment of witnesses, and the lieutenant had been sent to Siberia even though he claimed to be innocent. Eight months after the first installment of his *Notes* appeared, Dostoevskii returned to Ilinskii in one of its later chapters. "Not long ago," he wrote, "the publisher of *Notes from the House of the Dead* received word from Siberia that the criminal [Ilinskii] was, in fact, in the right all along, that he had suffered ten years of penal servitude for nothing, and has now been officially declared innocent by the court."

As Dostoevskii planned his new novel, he remembered the "full depths of the tragedy" of a "life ruined while still in its youth" that the Ilinskii episode had represented. Despite some important differences, parts of the story of the wrongly condemned lieutenant would become the central melodrama around which he would shape *The Brothers Karamazov*.[68] Although innocent, Dmitrii

Karamazov would be convicted of killing his father and condemned to seek redemption in the Siberian wilderness, where he would be saved from his sins as a prodigal son through humility born of suffering. "God will save Russia," Dostoevskii promised. "God will save His people, for Russia is great in her humility."[69]

A synthesis of Dostoevskii's most cherished thoughts, *The Brothers Karamazov* is built upon a kaleidoscopic array of opposites. One brother is visited by God, another by the devil. One sets rational brilliance above faith and sees no hope in Russia's future, while another places faith before all earthly things and sees in Russia the key to human history. Among the men and women who move through the novel's seven hundred pages, moral degenerates stand in contrast to saints, monasteries to dens of iniquity, greed to generosity, and atheism to deep Christian piety. Men and women of virtue counterbalance creatures of lust, learning offsets superstition, and Russia stands in contrast to Europe. Grovelers gain self-respect, wise men go mad, and madonnas bear false witness. There are people who live only for the present, past, or future, and those who place intuition before certainty. From one perspective, the novel is confined to a provincial town and the region around it; from another, it encompasses the whole span of Russia's experience.

Of all the opposites Dostoevskii juxtaposes in *The Brothers Karamazov*, none are more contradictory and complex than those that seethe within the heart and mind of the principal hero, Dmitrii Karamazov. Sensual and unrestrained, inclined to vice and perpetually in need of money to support it, Dmitrii at first seems in no way different from the hundreds of daring junior officers who led Russia's nineteenth-century battalions into battle. Yet Dmitrii turns out to be no simple scoundrel, for this rough, seemingly uneducated army officer declaims Schiller's *Ode to Joy* (in Zhukovskii's translation) and gives great thought to the meaning of beauty. "Beauty is a dreadful and terrible thing!" he exclaims at one point. "I cannot bear the thought that a man of lofty mind and heart begins with the ideal of the Madonna and ends with the ideal of Sodom. . . . Is there beauty in Sodom?" he asks. "For the huge mass of humankind, the answer is 'yes,' believe me. The dreadful thing," he concludes, "is that beauty is at one and the same time mysterious and terrible. Here, the devil struggles with God and the human heart is their battlefield." In the words of the public prosecutor at his trial, Dmitrii is "a marvelous mingling of good and evil, a lover of learning and Schiller who at the same time brawls in taverns." This man who stands accused of killing his father "seems to represent Russia as she is," he concludes, "the very scent and sound of our Mother Russia." Like Russia, Dmitrii is ready and willing to suffer. "Now I seem to have such strength," he exclaims as his trial approaches, "that I think I could fight against anything, any suffering, only to be able to say and to repeat to myself every moment, 'I am.' "[70]

If Dostoevskii created Dmitrii to stand for Russia "as she is," he chose Ivan, the second brother, to stand for the "Europeanism" that had shaped Russian art and life since the time of Peter the Great. A man of bronze like Stavrogin, Ivan is "one of those modern young men with a brilliant education and a powerful intel-

lect, who believes in nothing."[71] Yet, unlike Stavrogin, Ivan's purpose is not to test a hypothesis but to present a conclusion, for his "Europeanism" destroys him in the end. Like Prince Myshkin, who was also a product of Russia's "Europeanism," Ivan goes mad, unable to live in the real Russian world that surrounds him. Together, they represent Dostoevskii's belief that the efforts of Russia's rulers to adopt European thought and science are incompatible with the true nature of Russia and the Russians.[72] Russia, Dostoevskii insisted, must build its future on the values that lay in every Russian's heart. "Is it not clear that the Russian people bear within themselves the organic embryo of an idea which differs from any idea in the world?" he asked just a few weeks before he died. "Our history *cannot be like the history of other European peoples*," he concluded. "Even less can it be a slavish copy of it."[73]

In the person of Alësha, the youngest Karamazov, Dostoevskii sketched the alternative to Ivan's "Europeanism" and Dmitrii's rough "Russianness." Alësha is endowed with some of the Christlike qualities of Prince Myshkin, but he is different, too. "He loved people and seemed throughout his life to trust them completely," Dostoevskii explained, "but no one ever thought of him as being simple-minded or naïve." Myshkin had failed to come to grips with the real world and had found refuge in a Swiss asylum for the insane, while Alësha cannot live apart from it. He is "perhaps the only person in the world whom you might suddenly leave alone and penniless in the center of an unfamiliar city of a million inhabitants," Dostoevskii wrote, "[who would] come to no harm and would not die of cold and hunger because he would be fed and sheltered at once." Unlike Myshkin, whose features recalled an ancient icon, Alësha is "red-cheeked, clear-eyed, and brimming with good health." More than that, Dostoevskii adds, he is "more of a realist than anyone," standing for "the principles of the people," not as they are—for Dmitrii fulfilled that role—but as they might one day become.[74] "To be a true Russian means to become brother to all men," Dostoevskii explained a few months after the last installment of *The Brothers Karamazov* was published. That was his final answer to the quest upon which he had embarked when, in the rashness of his youth, he had vowed to devote himself "to the solution of the mystery of man."[75] Perhaps for that reason, he allowed himself a rare joyful moment of hope in the final lines of his last novel: "And forever thus, hand in hand, for all our lives! Hurrah for [Alësha] Karamazov!"[76]

Even before Dostoevskii had finished *The Brothers Karamazov*, his fame had soared to new heights as readers found in its first installments a new vision of Russia's future. His crowning moment came at the beginning of June 1880, when he spoke to the Society of Lovers of Russian Literature during the celebrations that accompanied the unveiling of Moscow's famed monument to Pushkin. Turgenev had come from Paris especially for the occasion and many feared that the event would become a confrontation between Turgenev's belief that Russia ought to draw even closer to Europe and Dostoevskii's faith that the Russians' future lay within themselves. Yet Dostoevskii had a grander purpose in mind

than settling scores or winning arguments. That spring, he had set the final chapters of *The Brothers Karamazov* aside for several weeks to polish a speech that pleaded for all Russians to be reconciled as a first step in shaping a universal union of humankind. The intelligentsia must merge with the masses, he insisted. Only then could the "historical suffering Russian" be cured of his malady. "To be a real Russian," he told a breathless Moscow audience on June 8, 1880, "means to become the brother of everyone, to become *All-Man*. . . . It means finding an outlet for the anguish of Europe in the All-Human and All-Uniting Russian soul." Russia, he concluded, must lead the way toward a higher stage of civilization, in which the contradictions and conflicts so evident in Ivan Karamazov's character would be resolved by creating a "concert of all nations in the Gospel of Christ."[77]

"The moment he finished speaking," one of his listeners later wrote, "the audience gave Dostoevskii—an ovation is not the right word—they went into ecstasies of idolization."[78] The Omsk House of the Dead in which he had wasted the best years of his youth now seemed very far away, yet the suffering he had endured there continued to shape the words he spoke. "When I proclaimed the *world-wide union* of humankind, the hall was in hysterics," he wrote to his wife that evening. "Strangers in the audience wept, sobbed, and embraced each other, and *swore to each other that they would be better, and that they would love, not hate in the future.*" The mayor of Moscow, whose brother would one day donate the Tretiakov Gallery and all its treasures to the city, thanked Dostoevskii on behalf of everyone. Then came the incident that Dostoevskii treasured most of all. "A crowd of women (more than a hundred)," he told Anna, "thronged onto the platform carrying a huge laurel wreath almost five feet in diameter that bore the inscription 'in the name of the Russian women, about whom you have said so much that is good.' . . . It was worth waiting for," he confessed. "There were pledges for the future, pledges for *everything,* even if I were to die."[79]

Just less than eight months later, on the evening of January 28, 1881, the brittle, emphysema-damaged blood vessels in Dostoevskii's lungs gave way in a pulmonary hemorrhage that took his life. "You know, Ania," he told his wife that morning, "I have just realized clearly that I am going to die today." When she protested that the doctors had said he would recover, he asked for the copy of the New Testament that he had kept with him throughout his terrible years in Omsk Prison. "Do not restrain me, for so it is fitting that we fulfill all righteousness" were the first words he saw when he opened it at random. "You hear," Anna remembered his saying, " 'do not restrain me.' This means that I am going to die." He called their children and asked her to read the parable of the prodigal son aloud to them all. "Never forget what you have just heard," he told them. "I love you very much, but my love is nothing in comparison with the Lord's infinite love for all men."[80] A few hours later, he died. Thirty thousand people attended the funeral, which had been arranged by the Director General of the Holy Synod that ruled Russia's Church. Fifteen choirs took part in the proces-

sion. Those who believed in Russia's greatness hailed him as a prophet, and critics acclaimed the depth of his psychological insights. Yet Dostoevskii saw himself as something less—and more—at the same time. "I am only a realist in the highest meaning of the word," he wrote not long before his death. "I depict all the depths of the human soul."[81]

Dostoevskii, a critic once wrote, had been obliged to sin his way to God, while Count Lev Nikolaevich Tolstoi, his rival for the title of Russia's greatest writer, "had to reason his way to Him."[82] Both men searched for God, sought to discern the shape of Russia's future, and turned to its masses when their faith in their nation's Europeanized culture failed them. Yet few men could have been more different. Dostoevskii lived his early life on the seamy side of Moscow, where his physician father eked out a living in the city's charity hospital, while Tolstoi, born into a comfortably well-off noble family, never knew the torments of debts and creditors that Dostoevskii endured all his life. Both men were acutely conscious of death throughout their lives, but although he lived for nearly a quarter of a century longer, Tolstoi never became resigned to it in the way Dostoevskii did. "I am tumbling, tumbling downhill to death," he wrote when he was not yet thirty-five. "I do not want death; I want and love immortality."[83]

Death shaped some of Tolstoi's earliest memories. Born on August 28, 1828, at Iasnaia Poliana (Serene Glade), the family estate that lay about a hundred miles south of Moscow in the ancient province of Tula, Tolstoi lost his mother as a toddler of two and his father and grandmother before he reached the age of nine. Given over to the care of a favorite aunt, who died not long after his thirteenth birthday, Tolstoi lived his entire childhood never knowing which of the precious figures in his life death would take from him next. For him life seemed to be a process of being deprived of love by death. "I feel alone and want love" was a feeling he confided to his diary more than once. "I'd like to make myself small and cling to mother as I imagine her to myself," he confessed at the age of seventy-eight. "All this is insane, but it is all true." Feeling deprived of love, Tolstoi felt eternally alone and unwanted. "I have no friends," he concluded in the year of his marriage. "I am alone." He doubted others, mistrusted them, kept his distance, and broke friendships when they became too close, but he doubted himself even more. "I am ugly, awkward, slovenly, and socially inept," he wrote at the age of twenty-six. "I am petulant, boring to others, immodest, intolerant, and bashful. . . . I am intemperate, indecisive, inconstant, stupidly vain, and fervent, like all people without character." He preferred isolation. "A person is strong only when he is alone," he decided at the age of sixty-three. "Good," he added, "is done only by each single person separately."[84]

Just after his sixteenth birthday, Tolstoi entered the University of Kazan to prepare for a career in Russia's Foreign Service. At the end of his first term, he switched to the study of law. Then, when he received title to Iasnaia Poliana eighteen months later, he left the university altogether and went home to try his

hand at being an enlightened master. When the serfs did not respond in the way he had hoped, he gave up and went to Moscow. Then he moved to St. Petersburg and promptly lost some of his smaller estates at cards. In the spring of 1849, he toyed with the idea of becoming a cadet in the Imperial Horse Guards. By the middle of May, he had begun to talk about entering St. Petersburg University, but fled instead to Iasnaia Poliana two weeks later. That fall, he tried his hand as a civil servant in the provincial capital of Tula, but was back on his estate before summer began in 1850. That winter, he tried Moscow again, spoke of reentering the university, taking up a career in government service, or getting married, but he only spent more time at brothels, gambling dens, and gypsy taverns.

The charms of peasant girls, gypsy singers, women of the street, and a few ladies of high society all drew Tolstoi on as the 1850s began. Now going on twenty-three, he still had no sense of direction. That spring, he set out for the South to fight as a subaltern in the war Russia's armies had been waging against the natives of its Caucasus territories for the better part of forty years. Ever since the Russians had claimed those untamed mountain lands that divided the Black Sea from the Caspian at the beginning of the nineteenth century, their wild Moslem tribesmen had waged a series of holy wars to stay free. Now it became Tolstoi's fate to fight against them in the name of progress and Holy Russia. Yet he had no greater sense of mission in the Caucasus than he had anywhere else. As he reached his mid-twenties, he was still searching to discover what his life's work would be.[85]

While he drifted, an inner sense told Tolstoi that his life would not be wasted. "There is something within me that compels me to believe that I was born to be different from other men," he wrote in the spring of 1852. "Is it," he asked, "that I, in some manner, really do stand on a higher plane than ordinary people?"[86] By then, he had begun to write the first parts of his novel *Childhood*, which would appear in *The Contemporary* later that year. Afraid of how it might be received by critics, he signed it with only his initials and then watched in delight while enthusiastic reviewers wondered who the mysterious "L.N.T." might be. In the faraway mountain battlefields of the Caucasus, he learned that Dostoevskii had sent a letter from Siberia to ask who had written *Childhood*, and that Turgenev had asked the same question from the estate to which he had been exiled for publishing *A Hunter's Sketches*. Then, just as the sweet smell of success convinced Tolstoi he should leave the army for a literary career, the Crimean War broke out. Now obliged to fight against England, France, and Turkey all at once, the Tsar decreed that no officer could retire until the fighting had ended.

As the Crimean War dragged on, Tolstoi made an entry in his diary that would rule his life for many years. "Be what you are," he told himself sternly. "By ability—be a writer; by birth—an aristocrat."[87] In the winter of 1855, he returned to St. Petersburg to reveal that he was the "L.N.T." whose tales of army life in the Caucasus and the Crimea continued to win acclaim. Nikolai Nekrasov, the famous poet who edited *The Contemporary*, welcomed him with open arms, and so did a dozen others in the world of Russian literature. "You cannot picture

to yourself what a dear and remarkable man he is," Turgenev wrote to a friend after Tolstoi had stayed with him for a fortnight. "Although I have nicknamed him the 'troglodyte' because of his savage ardor and buffalolike obstinacy, I have grown to love him with a strange feeling that is almost parental."[88]

Within a few months, Tolstoi's obstinate arrogance had turned his new friends against him, and he set out for Paris in the spring of 1856 in hopes of finding the sense of purpose that continued to elude him. Unable to do so, he moved on to Switzerland and then returned home to "a gray, dewy, glorious Russian morning with birch trees" at the beginning of August.[89] For a time, he wandered to Moscow, St. Petersburg, and Iasnaia Poliana—and then back to Moscow and St. Petersburg again. He read Balzac and Dumas, Goethe and Stendhal, Proudhon and de Maistre, *Adam Bede* and the Gospels. He set up a school to teach the serf children on his estate to read, write, and do sums, feuded a great deal, and watched his literary reputation fade. Growing tired of his school and bored with his life, he decided to get married, but none of the women he met in the drawing rooms of Russia's capitals pleased him. "Too much of a hothouse plant," he wrote of one woman who tried to win his affection. "She is occupied with the preparation of moral sweetmeats and I have to do with soil and manure."[90] "I don't dare marry Liza," he wrote of another. "How beautifully unhappy she would be if she were my wife!"[91]

In September 1862, the thirty-four-year-old Tolstoi proposed to Sofiia Behrs, a lively, sentimental, dark-haired, slender girl of eighteen. Thanks to the influence of his highly placed relatives at court, he wed her two weeks later in the Kremlin's Church of the Nativity of the Virgin, which had been the private chapel of Russia's tsarinas in the days of Ivan the Terrible. That very night, the couple set out for Iasnaia Poliana, to which Tolstoi would bind their lives for the next forty-eight years. Sonia, as she was known to her family and friends, would bear thirteen children during the first quarter-century of their marriage and would remain faithful throughout the moral crises and intellectual perambulations that filled her husband's life. Always, she would be tormented by memories of the "dreadful" chronicle of sexual misadventures that she had found in the diaries Tolstoi had given to her to read before their wedding. "I don't think I ever recovered from the shock of reading the diaries when I was engaged to him," she recalled almost thirty years later. "I can still remember the agonizing pangs of jealousy, the horror of that first appalling experience of male depravity."[92]

At Iasnaia Poliana, Tolstoi gave up trying to teach the children of his peasants, closed down his school, and returned to literature. Apprehensive and full of apologies, he sent off the novel he called *The Cossacks* toward the end of 1862, and was delighted when critics greeted his account of the free-living, free-loving frontier fighters among whom he had lived in the Caucasus with unqualified admiration. Almost overnight, the fame that had faded during his three years of silence came surging back, and he began to search for a grander theme around which to shape a much larger novel. He thought first of those revolutionary

comrades of Ryleev and Pushkin, who had recently been allowed to return from thirty-five years of exile in Siberia. But, although Siberia provided a fearsome and romantic setting, the dreams and sufferings of a scant hundred men offered too small a framework to contain his vision. Looking further back to the events that inspired these young men to dream of freedom, Tolstoi came to Russia's Great Patriotic War of 1812 and found in the vast panorama of events that had ebbed and flowed across Napoleonic Europe a canvas large enough for any artist. That year Russia was in the midst of celebrating the fifty-year anniversary of Napoleon's retreat, and the drama of those events was writ large for all to see. Seventeen years later, Chaikovskii would recall the same heroic events in his *1812 Overture*, and in the midst of the screaming air-raid sirens and flashing searchlights of World War II Moscow, Prokofiev would begin an opera upon which he bestowed the same title. Yet neither of these works could equal the power and scope of Tolstoi's earlier work. The *War and Peace* that flowed from his pen encompassed the range of human experience so entirely that no other modern Russian work has ever matched it.

More than half a million men fighting in the heat of summer and the dead of winter across the million square miles that separated Paris from Moscow offered Tolstoi room to explore the meaning of human history in all its complexities. Here he could probe the depths of love, patriotism, and hate, and pose those cosmic questions that only the greatest of artists dared to confront. What was the meaning of good? Of evil? Of life? And of death? What forces shaped human experience? And could those forces be found within the mind of man or did they lie beyond his control?[93] "Lëvochka . . . is bursting with ideas," Sonia wrote in her diary, "but when will he ever write them all down?"[94] By late summer, he had begun to do so. "I write and meditate as never before," he told his favorite aunt. "Now I am an author with all my soul."[95]

Unlike Dostoevskii, whose whining relatives and compulsive gambling drove him from novel to novel to pay his debts, Tolstoi had the luxury of working at a leisurely pace. As he struggled to record the comings and goings of 559 characters across more than eighteen hundred printed pages, his search for the precise combinations of people and events that he needed to illustrate his broader message obliged him to rewrite the chapters of *War and Peace* again and again. "To consider and reconsider everything that can happen to all the people in my prospective work is an immense task," he wrote at the end of 1863. "To think through the millions of possible combinations in order to select only 1/100,000 of them is terribly difficult."[96] In March 1865, he spoke of making his book into a "psychological novel about Alexander and Napoleon, and the baseness, madness, and contradictions of the people surrounding them."[97] Then he began to see as Russia's saviors the peasants who had risen against Napoleon's armies after the invaders had defiled Holy Moscow. Eventually, he made the lives and reactions of Russia's nobles the novel's main focus, but allowed the true meaning of life to be perceived only by the peasant Platon Karataev. Tolstoi then revealed Karataev's knowledge through the experiences of those very lords and ladies

whose daily lives would never have intersected with a peasant's had it not been for the war that engulfed them all.

The title *War and Peace* came only four years after Tolstoi had begun to write, and only after the first parts of the novel had already been published as *The Year 1805* (the year when Russia's first war with Napoleon began) to a flood of unenthusiastic reviews. "I didn't like Tolstoi's *1805* very much," one of his friends wrote after reading its initial chapters. "It's boring." Turgenev shared that same unflattering opinion, but stated his objection even more emphatically. *The Year 1805*, he concluded, was "positively bad, boring, and unfortunate."[98] Another of Tolstoi's friends found it "amazing for its perception of countless small details, for its portrait of the times, and still more for the fact that nothing comes from all of it."[99] But when brought together in the last two-thirds of *War and Peace*, the details and portraits blossomed into a chronicle that plumbed the very depths of human experience. Although it confronted questions that were no less profound, Dostoevskii's recently published *Crime and Punishment* and *The Idiot* had focused more narrowly on the present. Now Tolstoi, by setting his novel into the dramatic framework of events that had happened more than half a century earlier, had created both a stunning tapestry and a context from which his readers could view it.

When they appeared in 1868 and 1869, the last five volumes of *War and Peace* amazed the critics who had dismissed its beginnings so arrogantly. "With the appearance of *War and Peace*," Turgenev exclaimed, "Tolstoi has taken first place among all our contemporary writers." The critic and thinker Nikolai Strakhov added that the novel presented "a complete picture of everything in which people find their happiness and greatness, their grief and humiliation,"[100] for it asked if the actions of men and women could really shape the fates of peoples and nations, or whether forces beyond the control and comprehension of the human mind ruled the universe. Was it possible, Tolstoi's novel asked, to understand the past, and by doing so to gain insight into the future? Or were there other forces that determined the destinies of battles and nations no matter what such heroes as Napoleon, Talleyrand, or the Emperor Alexander might think or do? For Tolstoi, one critic explained, "there *was* a God who operates as a kind of puppetmaster in *War and Peace*."[101] And that fact determined the fate of Napoleon's grand designs, his generals' grand strategies, and the destinies of hundreds of thousands of men and women who lived unaware of the forces that shaped their lives.[102]

Wherever he turned after he finished *War and Peace*, Tolstoi's search to discover the forces that shaped human destiny brought him face to face with death. The confrontation began in the late hours of a night he spent far from home early in the fall of 1869. "Suddenly," he wrote to Sonia, "I felt despair, fear, and terror such as I have never known."[103] As he embellished his recollection of this terrible moment in his "Memoirs of a Madman" some twelve years later, Tolstoi remembered being driven from his room by an unknown force that left him asking: "Why have I come here? Where am I going? What am I afraid of?" There was

silence, he wrote—and then came the answer: " 'Me,' the voice of death replied. 'Me. I am here.' "[104]

Before 1874 reached its end, Tolstoi and his wife saw two of their children die in infancy and mourned the deaths of favorite aunts, nieces, and friends. Death seemed to be the only certainty in life and the one illness that family happiness could never cure. "Why does a child live and die?" Tolstoi asked. "There is only one explanation," he concluded. "It is better off."[105] That belief seemed to be shared by Anna Pirogova, the cast-off mistress of a neighbor, who threw herself beneath a train in a town not far from Iasnaia Poliana. After he had gone to see her body and learn the details of her suicide, Tolstoi began *Anna Karenina*, the novel in which the heroine's death (as with the real-life Anna) came beneath the wheels of a train passing through an out-of-the-way provincial railway station.

Although he had relegated it to a secondary place in *War and Peace*, Tolstoi put the question of sexual morality at the very center of *Anna Karenina*. To illustrate that point, he chose the common theme of a woman married to a man she had never loved, who has to decide whether to reject the hero who has captured her heart or accept his embraces and be banished from the world in which she lives. Pushkin had resolved that question in *Eugene Onegin* by having Tatiana confess her love for Onegin but remain faithful to her husband. Now Tolstoi allowed Anna to abandon her husband, run away with her adored Vronskii, and bear his child despite the scorn of St. Petersburg's high society. Anna gives up wealth, security, high position, and even her young son to her passion for Vronskii, and that, Tolstoi explains, leads her to ruin. To emphasize that whatever goes against the laws of God will be punished by God, he began his novel with the biblical epigraph: "Vengeance is mine; I will repay." Anna's transgressions cost her Vronskii's love, and at the novel's end her life.

Yet Anna's readiness to set love before everything posed problems that Tolstoi found difficult to resolve, despite the divine injunction with which he began his book. Because he found her obsession with love unsettling and even repulsive, he at first tried to make Anna coarse, foolish, and undeserving of sympathy. But the broader question of morality that he sought to confront could not be resolved simply by describing the thoughtless acts of a stupid, selfish woman, and Tolstoi had to recast his heroine as a warm, sincere, beautiful, generous, and openhearted person, who became petty, dishonest, selfish, and mean-spirited as the force of physical passion began to rule her life. Only after that transformation had been accomplished could he begin to explore the dilemmas that her descent into ruin had posed.[106]

To underscore the destructive force of illicit love, Tolstoi counterposed to the story of Anna and Vronskii that of Konstantin Lëvin, a noble landowner who loves the land and country life, and the Princess Kitty, a carefree Moscow debutante who marries him to share his idyll in the countryside. Lëvin and Kitty bring children into the world, help their fellow beings, and watch the fields yield their bounty as they seek to become at one with the land and the people. From beginning to end, the contrast is sharp and the meaning clear: Anna's sins bring her a

gruesome death, while Kitty's virtue is rewarded by a life filled with family happiness. But the fact that death eventually would come to Lëvin and Kitty, too, forced Tolstoi to ask if there was any meaning in life that death would not obliterate. That was the cursed question for which he had no answer when he wrote the last lines of *Anna Karenina*, yet it was the one that tormented him most during the thirty-two years he had yet to live. For, if nothing survived beyond death, what was the point of living at all? When all was said and done, did it not make more sense to accept the inevitable as Anna had done and destroy oneself without waiting for death to come of its own accord?

To answer this question, Tolstoi read the great philosophers of East and West, the teachings of the Christian fathers, and the writings of men who promised to reveal the truth that others had failed to find. One by one he rejected them all, and then went on to denounce the society of which he had been a part, the great novels he had written, and the Russian Orthodox Church in which he had once contemplated becoming a monk. Turning to his inner self, he explored what lay behind his thoughts, feelings, and sins, and preached the virtues of frugality and hard labor. "Our main misfortune lies in the fact that we consume more than we produce," he explained. "To produce more than we consume can never be harmful. This is the supreme law."[107]

Insisting that he knew for certain "that copulation is an abomination,"[108] Tolstoi now began to preach a life of sexual denial. When he could not control his own passions, he blamed his wife and made her the object of his disgust with himself. "Cohabitation with a woman alien in spirit, that is, with her, is really vile," he confided to his diary. "It is hopeless," he concluded. "She'll be a millstone around my neck until I die."[109] He took to working in the fields, making shoes, and dressing like the peasants from whom he hoped to draw the inspiration he could find nowhere else. Money, he said, was evil, and poverty the way in which a righteous man ought to walk. As he began to seek the kingdom of God on earth, his diatribes against sin, sex, and society became all but impossible to bear. "Family life becomes complicated," the long-suffering Sonia wrote as the 1880s neared their end. "My own moral strength diminishes."[110] During the years that carried them into the new century, the conflicts between Tolstoi and his wife deepened. "He is systematically destroying me by driving me out of his life," Sonia complained a few years later. "It is unbearably painful."[111] At times, Tolstoi's torments drove her to the brink of madness, and there were moments when she seemed to have fallen into the abyss. "I stagger from corner to corner and weep like an insane person," she wrote to her sister. "Can one live long with such suffering? Life seems suddenly to have ended."[112]

As his family happiness broke apart and his preachings tapped the wellsprings of religious populism that flowed beneath the hard-packed foundations of Russian Orthodoxy in the 1880s, Tolstoi began to paint wrenching portraits of the misery brought to Russia's masses by the Industrial Revolution and to lament the lack of charity among the men and women whose fortunes had been built upon the backs of the poor. "The masses are hungry because we are too well fed," he

wrote. "All our palaces, theaters, and museums, all these things, all this wealth—all are produced by the same starving masses."[113] Even though he had no patience with liberals' hopes for constitutional government or revolutionaries' dreams of political violence, his pleas to feed the hungry, clothe the poor, shun the established Church, and live according to Christ's Sermon on the Mount drew such people to him, and that stirred the concern of high officials and censors. Tolstoi's strident warning that Russia's Church and government opposed the law of God deepened the tension. Only his immense public stature at home and abroad restrained the authorities from acting against him, but, as the 1880s shaded into the 1890s, no one knew how long Russia's high churchmen and statesmen could be held in check.

While the world looked on throughout the 1890s, Tolstoi worked on *Resurrection*, the last of his novels and the first to enter the Dostoevskiian realm of thieves, whores, revolutionaries, and Siberian exiles. Here readers found long convoys of sick and exhausted prisoners stumbling across the Siberian wilderness to seek the moral regeneration that Dostoevskii had promised Raskolnikov and Dmitrii Karamazov. No longer did Tolstoi concentrate on the comfortable lives of the upper classes or idealize the world of the peasants. Now, in what Russian intellectuals saw as one of the greatest exposés of modern literature,[114] he emphasized the depths of the gulf that divided the upper classes from the oppressed masses. Tolstoi, as one critic wrote, had become "a prophet in search of his crown of thorns."[115] Sensing the stirrings of a titanic confrontation between prophet and Emperor, readers everywhere waited for the first installments of the novel to appear in the Petersburg magazine *Niva* in 1899, and European publishers paid exorbitant fees to have the text telegraphed to them for immediate translation. "May God grant that there will be still more and more!" one of Tolstoi's friends wrote when the first chapters appeared. "Not only people here, but I think throughout all of Russia . . . wait solely for that day, Friday morning, when the bell rings and the boy brings the latest *Niva*."[116] What people read had been changed by the censor in nearly five hundred places, leaving scarcely one chapter in five unscathed. Still, *Resurrection* remained an intensely powerful work—and one that stirred bitter feelings among the men who led the government and Church it criticized.

On February 24, 1901, the Holy Synod, which had governed the Russian Orthodox Church since the days of Peter the Great, ordered an edict to be posted in every church in the Empire. "God has permitted a new false teacher to appear [in the person of] Count Lev Tolstoi," the document began. Among his many sins, it explained, Tolstoi had tried to destroy the true faith in the minds and hearts of the faithful. He had preached the overthrow of Orthodox dogmas, denied the Holy Trinity, and questioned the virginity of Mary. He had rejected all the sacraments and derided the Holy Eucharist. Therefore, the document concluded, "the Church does not beckon him as its member and cannot so reckon him until he repents and resumes his communion with her."[117] In St. Petersburg, Ilia Repin's famous portrait of the barefoot "Tolstoi at Prayer" became a national

icon and the focus of large demonstrations as the telegraph flashed the news around the world. Most of all, as repressive acts of Church and State so often do, Tolstoi's excommunication enlarged the forum from which he spoke. The eyes of the world were on Russia, and the seventy-two-year-old author of *Resurrection* had every intention of rising to the occasion.

Tolstoi cast his reply as a direct profession of faith stated in brilliantly simple language. "I believe in God," he began. "I believe that the true well-being of man lies in fulfilling the will of God, that His will is that we should love one another, and as a consequence should do to others as we would have others do to us. . . . I believe that the meaning of the life of every person is to be found only in the increase of the love that is within him and that this increase of love . . . helps more than anything else to establish the Kingdom of God on earth." Insisting that he could follow no other course, Tolstoi used the word of God as preached by Christ Himself to condemn the established Church. "I can as little change [my beliefs] as I can change my body," he wrote. "I can no more return to that from which I have just escaped with such suffering than a flying bird can re-enter the shell of the egg from which it has come."[118]

Tolstoi challenged the morality of Russia's government, Church, and society at a time when circumstances made opposition particularly difficult. Much as his grandfather Nicholas I had done before him, the Emperor Alexander III had crushed dissent throughout his reign at the same time as he had encouraged the narrowest kind of chauvinism and racial prejudice in an effort to deepen his subjects' pride in being Russian. Between the beginning of his reign in 1881 and its end in 1894, Russian anti-Semitism had become so virulent that it had endangered the loans Russia's government sought abroad. All this reflected deeper concern with public order and national pride than ever before, and as Russia's Industrial Revolution got under way, every precaution had been taken to make certain that the wealth it created could not be used to establish new centers of political power.

Yet, as prisoners had flowed into Siberia's mines and prisons by the tens of thousands, the Russians' willingness to tolerate repression began to show its limits. By the early 1900s, the peasants in Russia's countryside were becoming restless, and factory workers were beginning to take to the streets. During 1904 and 1905, Russia's unpopular war with Japan in the Far East had caused new waves of discontent to spill into its towns and cities, and when that discontent turned into revolution in the fall of 1905, it seemed for a moment that Russia's Emperor might be overthrown. Then, almost at the last minute, Nicholas II had regained his grip, but only by promising his people a constitution and a parliament. The Russians therefore entered upon their last decade of peace before the First World War with greater opportunities for civic involvement and the freest press that they would know at any time before the fall of the Soviet regime eighty-five years later.

None of this tempered the wrath of Iasnaia Poliana's aging prophet. Autocracy, he had written in the year after his excommunication, had "outlived its

time."[119] He continued to urge passive resistance to all authority and lamented the executions and sentences of penal servitude with which the government crushed the last stirrings of the Revolution of 1905. Manipulating the domestic and foreign press with a virtuosity that he had learned from long years of experience, Tolstoi published an article not long before he turned eighty that invited the authorities to "tighten the well-soaped noose around my aged throat" as they were doing to peasants and workers all across Russia, and watched with satisfaction as thousands of letters and telegrams poured in to Iasnaia Poliana from around the world to applaud his courage.[120]

Yet, if he could manipulate public opinion, Tolstoi could not so easily set aside the conflicts in his personal life, and while he thundered against the government, the tension between him and the woman who had shared his trials and torments for nearly half a century deepened. At the center of their dispute lay the rights to the life's work that Tolstoi threatened to bestow upon his disciples and which Sonia demanded for their children and grandchildren. "They value me only in rubles here and say that I'm ruining the family," Tolstoi complained to an old peasant friend in the fall of 1910. "I will," he concluded firmly, "go away."[121] He had set out on the road a number of times before only to have his feelings of duty to his wife and family bring him back, but this time, he vowed, would be different. "Maybe I am wrong," he wrote in his diary on the morning he turned his back on Iasnaia Poliana for the last time, "but it seems that I have saved myself."[122] At last he was on the road, traveling with his physician in a third-class railway car filled with peasants and workers. "Do not think that I went away because I do not love you," he wrote to Sonia from the monastery inn at which he spent his first two nights away from home. "I love and pity you from the bottom of my soul, but I cannot do otherwise than what I am doing. . . . For me, life with you is simply unthinkable."[123]

All across the world, newspaper headlines trumpeted the news of Tolstoi's flight. Upon learning his whereabouts, his youngest daughter rushed to join him, while his wife sent the police to search for them both. Then, as pilgrim, daughter, and physician resumed their journey, Tolstoi began to feel the first signs of a chill that caused him to shiver and sweat as it turned into a high fever. At Astapovo, a little town not quite 120 miles away from Iasnaia Poliana, his companions took him into the stationmaster's house and summoned the local doctor for a second opinion while he tried to rest. Could he resume his journey in a day or two? Tolstoi wanted to know. Fearful that the fever would develop into pneumonia, the killer of so many sick and elderly in the days before penicillin, the doctor told him firmly that it would be at least two weeks before he could travel again. For the time being, the old man refused to see his wife, but friends fearing that he might soon be taken from them summoned her anyway. When Sonia and several of her children reached Astapovo in the private railway car they had rented for the journey, Tolstoi had begun to drift in and out of consciousness, and on the morning of Sunday, November 7, 1910, his breathing stopped. "A quarter to

six," one of the doctors announced as the last signs of life departed. Then Tolstoi's friend and disciple Dr. Makovitskii closed his eyes. "The expression on his face," one of his sons remembered, "was entirely peaceful."[124]

"Tolstoi is dead!" flashed around a world made smaller by scientific marvels that had been unknown when he was born. The man who had hoped to become a prophet had searched diligently and relentlessly for the truth, sparing no one and yielding to no earthly force in his quest. Yet from the beginning there had been an element of irony in the anguished odyssey to which he had dedicated his heart, life, and soul. In the end, Tolstoi the master had done little more than try to become Tolstoi the peasant, who warred against towns, civilization, science, technological progress, and all the trappings of modern life that Russia's country folk rejected as instruments of Satan. "His quest for truth and wisdom," a critic concluded some time ago, "amounted to no more than a trip around Iasnaia Poliana. After having duly admired its proprietors, he ended by idealizing its servants."[125] Still, the truths Tolstoi found in his lifelong journey proved to be even more profound than those Dostoevskii had uttered in the speech he had given in Pushkin's memory thirty years before. On the eve of his own death, Dostoevskii had begged Russians to become the brothers of everyone as a first step in creating a "concert of nations in the Gospel of Christ." Tolstoi had extended Dostoevskii's message to the whole of humankind through all of time. "The most important thing in life," he concluded, "is for man to unite with man . . . to feel the mysterious gladness of a communion which, reaching beyond the grave, unites us with all men of the past who have been moved by the same feelings and with all men of the future who will yet be touched by them."[126]

The sworn enemy of all earthly authority and a bitter critic of the artistic experience that had evolved from the secular revolution of Peter the Great, Tolstoi shared with the more conservative Dostoevskii a common faith in Russia's masses as the source of the values they cherished most. But they were not alone in summoning their countrymen to close the chasm between upper and lower classes that the upheavals of Peter's time had opened. Between 1855 and 1905, many Russians turned away from the sparkling Europeanized gems that illuminated their nation's artistic experience to seek new inspiration in the lives of the common folk. Among those who took that path, the peasant painter Ilia Repin led the way in urging artists to join with the masses in the name of the people. "Come to . . . the peasants . . . [and] your eyes will be fascinated," he urged Russia's artists. "You will see for yourself . . . how our Russian reality . . . will begin to glitter right before your very eyes [and] how its poetic truth will draw you in to the very core of your being."[127]

Repin's summons reflected the revolutionary views of a group of brilliant young artists, who at the beginning of the 1860s had responded to the credo that Belinskii had set forth twenty years earlier by urging artists to portray life with all its flaws and failings. Although Belinskii had been the first to set down the precepts that shaped their vision, these rebels found their spiritual godfather in

Nikolai Chernyshevskii, a radical critic and publicist who in 1855 had proclaimed that life must reign supreme over art. The time had come, Chernyshevskii had said, for artists to abandon themes drawn from the Bible, mythology, and classical history, and turn to the everyday world that touched them on every side. "Beauty is life," he exclaimed. "Reality is not only more animated, but also is more perfect than imagination."[128]

In responding to Chernyshevskii's injunction that life must rule art and not the other way around, all thirteen of the young artists who had been chosen to compete in the annual contest for the Large Gold Medal at the Imperial Academy of Fine Arts in the summer of 1863 asked to choose their own subjects rather than accept an assignment from their teachers, and when their examiners refused, they left the Academy and struck out on their own.[129] With the raw passion of Dostoevskii and the descriptive brilliance of Tolstoi, they began to set down on canvas a world of prisons, poverty, back alleys, and rural hovels that stood very far from the gentle country scenes of Venetsianov or the well-controlled classical elegance of Briullov and Ivanov. The pain of exile, the anguish of loneliness, and the torment of facing execution all figured in their paintings, and as their work gave beauty a new meaning, reality replaced Romantic myths as the focus of Russian art.

For guidance in their daily lives, these young rebels turned to *What Is to Be Done?*, the novel that Chernyshevskii had published earlier that year to portray how liberated men and women might build a new society. Although rightly described as "maladroit and in places laughable" in terms of its artistic merit, this clumsily written book was hailed all across the empire as the gospel that could lead Russia's youth to a better future.[130] "No novel of Turgenev and no writings of Tolstoi or any other writer," one revolutionary remembered some years later, "ever had such a wide and deep influence upon Russian society." Some called *What Is to Be Done?* the "gospel of Russian radicalism," while others even equated its author with St. Paul and Jesus Christ.[131] Following its precepts, the young artist Ivan Kramskoi and his rebel followers organized an artists' cooperative, in which each contributed a portion of his earnings to help his comrades. By the time they transformed their cooperative into the Association of Traveling Art Exhibits, from which they took the name of *Peredvizhniki* seven years later, the young men who had dared to turn their backs on the Academy had begun to lay the foundation for Russia's first national school of modern painting.[132]

In their struggle to establish a school of painting that portrayed Russian life as it really was, the Peredvizhniki won the support of Pavel Tretiakov, one of the first Moscow merchant princes to patronize the arts, who spent almost a million rubles on Peredvizhnik paintings between their first exhibition in 1871 and his death twenty-seven years later. Portraits by Ivan Kramskoi, Vasilii Serov, and Vasilii Perov, religious paintings by Nikolai Ge, monumental historical canvases by Vasilii Surikov, and the brilliant, anguished paintings of Ilia Repin all hung in the gallery Tretiakov built as a gift to the city of Moscow. Surikov's gripping portrayal of Boiarina Feodosiia Morozova being hauled away in chains dominated

an entire room, while Repin's unforgettable painting of Ivan the Terrible cradling in his arms the head of the son he had killed in a fit of rage held sway in another. Tretiakov spent almost two hundred thousand rubles to buy most of the major works of Vasilii Vereshchagin. "A man of sensitivity and genius living through the horror of human carnage,"[133] as Tretiakov once said, Vereshchagin highlighted the brutality of war as no other Russian painter had ever done. By the time he presented it to Moscow, Tretiakov's gallery held the largest collection of Peredvizhnik canvases anywhere.[134] Later, it would become a repository of artistic treasures, in which the Soviets enshrined many of the masterpieces they confiscated from art collectors who had been less civic-minded than its founder.

If Tretiakov's patronage helped the Peredvizhniki to survive the poverty of their early years, Ivan Kramskoi, who claimed that "the ideal artist serves truth by way of beauty,"[135] provided the vision and leadership that inspired them in their mission to transform Russian painting. Although many of the Peredvizhniki painted scenes from Russian daily life, Kramskoi's strength lay in the portraits he painted of Shishkin, Ge, Vereshchagin, Perov, Repin, and Miasoedov, the scientist Mendeleev, the Peredvizhnik patron Tretiakov, the philosopher Vladimir Solovev, the writers Nekrasov, Saltykov-Shchedrin, Goncharov, Dostoevskii, and Tolstoi, and more than four hundred others. Some of his portraits of peasants, woodsmen, and shepherds were particularly notable for the clarity of the human types they portrayed, and his rendition in 1883 of a haughty aristocratic "Unknown Lady" dressed in fur and velvet and seated in an elegant carriage remains one of the most striking of all.[136] Kramskoi's portraits captured beauty, disdain, intellectual brilliance, literary and musical genius, and dozens of other human feelings and achievements, but he longed to show those inner forces that perpetually drove men and women to break free from life's certainties to explore higher spiritual realms. How, he asked at the beginning of the 1870s, could one paint faith, belief, and the search for truth? To find the answer, he set his portraits aside for the better part of five years.

Vowing to capture the painful search for moral truth on canvas, Kramskoi turned his thoughts to painting Christ in the tradition of Ivanov's "Christ's First Appearance to the People." Yet his portrayal of Christ seated alone amidst a barren, rocky landscape seemed too human and too deeply introspective to stand above the men and women he had come to save. Convinced that he had painted only "an image of the sorrows of humanity which are known to us all,"[137] Kramskoi knew that he had not yet reconciled the contradictions of belief with the faith in science that was coming to rule the world in which he lived. Could man's belief in God survive the assault of human science on divine mysteries? Could realism in art preserve people's faith even as the cold-eyed rationality of science disproved some of their most cherished beliefs? When "Christ in the Wilderness" failed to resolve those questions, the task Kramskoi had taken up fell to Nikolai Ge, who vowed to find the answer by depicting the passion and torment of Christ.

The winner of the Academy's Large Gold Medal and stipend for European

study in 1857, Ge spent the next twelve years in Europe (except for a brief visit to St. Petersburg for the triumphant showing of his "Last Supper"), and returned home less than a year before Kramskoi and his rebels formed their Association of Traveling Art Exhibits in 1870. Immediately he joined their ranks and dedicated himself to creating a series of historical paintings that focused on some of the high and tragic moments in Russia's history. Liberals hailed Ge's huge canvas of Peter the Great interrogating the son who had opposed his secular revolution as an expression of the fears that plagued them all as Emperor Alexander III's new wave of reaction threatened to overwhelm Russia's recent steps toward liberation.[138] Others found similar meanings in his painting of Catherine the Great at the bier of the Empress Elizabeth, but neither canvas even hinted at the genius that Ge's later work would reveal. The drama of Russia's history failed to permeate his paintings. Although viewers might find in them lessons for the present, they offered few hints of the glory that Russians of the 1870s hoped to find in their past.

For the rest of the 1870s, Ge painted portraits, yet this new enterprise brought him no greater sense of achievement than had his attempts to paint the defining moments of Russia's history. Stripped of any larger messages or historical meaning, his work seemed somehow clumsy, its lighting too naïve and its composition too awkward. By the end of the decade, he had sunk into a spiritual crisis that drove him to Ukraine, where for the better part of three years he painted nothing at all. With no clear idea of the direction in which he wanted his work to go, he continued to grope for inspiration until a brief essay that Tolstoi wrote about the poor people of Moscow revealed to him the vision from which he would extract some of the greatest paintings of Christ in the history of Christian art.[139] At that moment, in 1882, Ge found the challenge that was destined to catapult him to greatness.

Tolstoi's simple statement that "our lack of love for the humblest among us is the reason for their wretched condition" seared Ge's heart.[140] He became Tolstoi's disciple, and as his new teacher's writings began to reshape his view of God and man he turned once again to the theme of Christ that he had taken up after meeting Ivanov during his student days in Rome. In 1863, Ivanov's influence had inspired him to paint "The Last Supper," in which he had depicted a contemplative, saddened Jesus surrounded by fearful disciples as the traitor Judas departed from their midst. Unlike Da Vinci's painting of the same name, Ge's painting had no grand vision, but the human emotions it depicted in Christ and his disciples challenged the Byzantine and Baroque traditions that had shaped the image of Christ in East and West for so long. For the first time in Russia—and a full decade before Kramskoi produced his "Christ in the Wilderness"—Christ had been painted as a man, not as God.[141]

Twenty years after Ge had painted Christ and his frightened disciples, Tolstoi's teachings led him to a deeper understanding of the inner passions that Ivanov and Kramskoi had failed to portray. He now depicted a harried, haggard Christ facing a smirking, self-satisfied Pontius Pilate, who in response to his

prisoner's statement that he had been sent into the world as a witness for truth had posed the cynical question "What *is* truth?" In leaving the question mark out of his title, Ge made it clear that such powerful, worldly men as the Roman Governor understood truth only as it suited their purpose and that they recognized no absolute truth at all. Pilate and Christ—the mouthpiece of Caesar and the Son of God—stood at opposite poles in the world of man, and nothing in the painting even hinted at a resolution of the starkly stated conflict between the two. Tolstoi called the painting "an epoch in the history of Christian art." When the Church authorities ordered it removed from the exhibition in which Ge hung it in 1890, the master of Iasnaia Poliana convinced Tretiakov to buy it for his private collection and begged George Kennan, whose articles in *Century Magazine* were stirring sympathy for Siberia's exiles all across the Western world, for help in arranging to have it shown in America.[142]

Because Ge's new vision had shown only Christ's torment, not his passion, it had left unanswered the question of what impact the terrifying sentence of death by crucifixion had made upon the mind of the spurned Messiah, whom God had sent into the world. Ge sought to find an answer in his paintings of "Christ at Golgotha" and two versions of "The Crucifixion," which set the Son of Man against a barren lunar landscape to highlight the sheer terror and agony with which he faced death. In "Golgotha," which he finished in 1892, Ge painted Christ clutching his head in horror, certain of the torment that awaited him and knowing that he could not escape it. Later that same year, his first "Crucifixion" showed Christ at the moment of death, rigid in agony, the crown of thorns having been torn from his head by his death throes, while the dying robber who witnessed his last moments looked on in anguish. In a second "Crucifixion" two years later, Ge replaced the robber's anguish with outright horror as he witnessed Christ's suffering. "How could you have accomplished it!" Tolstoi whispered in awe when the painter first showed him the canvas.[143] Ge was "one of the greatest artists, not just of Russia but of the whole world," he wrote to Tretiakov. "People wanted an icon of Christ before which they could bow down," he went on, "but he gave them a Christ who was a living person." Such paintings would be eternal, Tolstoi insisted, for Ge had created an entirely new vision, in which Christ became the man who died, not the God who lived.[144]

Ge's realistic portrayal of Christ overwhelmed the skepticism of modern science, but his earlier efforts to paint great moments of history had lacked the realism to project a clear vision of Old Russia across the centuries. That task fell to Vasilii Surikov, an artist nearly twenty years younger than Ge, who joined the Association of Traveling Art Exhibits only after it had entered its second decade. A descendant of the Cossacks who had marched with the chieftain Ermak to launch Russia's conquest of Siberia at the beginning of the 1580s, Surikov had grown up in the new lands of his ancestors and had shared their love of freedom and thirst for glory. "I lived freely," he wrote in his recollections of the childhood he had spent in Siberia's untouched wilderness. "Everything was filled to the brim: the rivers with fish, the forests with game, and the land with gold."[145]

Arriving in St. Petersburg in 1869 at the age of twenty-one, Surikov saw the city's imperial founder as the singular, irresistible force that had pulled Russia out of her backwardness. As a student at the Academy of Fine Arts, he drew Peter leading his men against the Swedes and painted Falconet's great statue of "The Bronze Horseman" silhouetted against the moonlit sky and the Cathedral of St. Isaac as a monument to the Tsar's achievements. Yet he soon began to ask if Peter might have done more harm than good, and by the time he left the Academy in 1878, he had exchanged his heroic vision for one that looked to those glories of Old Russia that Peter's abrupt turn to the West had obscured. That very year, Surikov moved to Moscow, where the Kremlin walls, Red Square, and the ancient churches all stirred hidden memories, "like forgotten dreams," that drew him toward Russia's ancient days.[146] Fascinated by visions of the long-ago events that could never be erased from Russia's history, Surikov set out to paint Moscow's Red Square as no Russian ever had. He would portray it not as the revered spot on which tsars and saints had walked in ancient times, but as the place where Peter the Great had executed hundreds of the elite *streltsy* musketeers who had opposed his turn to Europe.

In 1881, Surikov's "Morning Comes on the Day of the Execution of the *Streltsy*" portrayed a crowd of stubborn, angry men awaiting death for opposing their Tsar's decision to turn away from their nation's past. Liberal critics condemned the painting for diverting attention from Russia's present troubles, but Muscovites proudly embraced it as a monument to the glories that Russia had known in olden times. To one side, a mounted Peter sat immobile, surrounded by the foreign advisers his subjects so despised, while St. Basil's Cathedral and the walls of the Kremlin rose in the background as reminders of the world he had vowed to destroy. Dawn had just lit the leaden sky and puddles from a late fall rain dotted the square. Bound or chained, the Tsar's rebellious musketeers held center stage as they shared their last moments on earth with grief-stricken wives and sobbing children. Everything about the painting was Russian—the light, the mud, the buildings, and the powerful Tsar surrounded by grieving subjects awaiting his command for the executions to begin. In his overture to *Khovanshchina*, Musorgskii had suggested a similar conjunction of natural forces just the year before. As Russians began to set aside the godlike vision of Peter the Great that had ruled their land for almost two centuries, others would follow Surikov's vision in the years ahead.[147]

While his predecessors had populated their historical canvases with only a handful of people, Surikov brought masses of them into focus. Condemned criminals, wives, children, priests, nobles, soldiers, tradesfolk, foreign officers, and a milling Muscovite crowd surged across his painting of the *streltsy* execution, and even more crowded into his next painting of "The Lady Morozova." Here on a single canvas viewers found all the elements of national life in Old Russia: dissident priests grieving for the noble woman who had led their opposition to the reforms that had split their Church, a holy fool sitting barefoot in the snow to offer a blessing in the style of Morozova's Old Believers, and the iron-

willed prisoner herself, who would bear whippings, brandings, and death by starvation with the same triumphant defiance with which she raised her hand to give one final forbidden Old Believer blessing as she was being taken to prison.[148] In vain did liberal critics exclaim that "we cannot be concerned anymore by those issues that agitated this poor fanatic woman two hundred years ago because nowadays we face broader and deeper problems."[149] Most Russians closed their ears and let their hearts be warmed by the feelings of national pride that Surikov's masterpiece stirred within them. The Old Russia that surrounded Morozova lay far enough in the past to be remembered fondly. Russia had held the key to the salvation of humankind in those days, when it had believed itself to be the only vessel of pure Orthodoxy left on earth.

In addition to visions of faraway days of long ago, Surikov's canvases captured defining moments in Russia's history. Just two years after painting "Morning Comes on the Day of the Execution of the *Streltsy*," he portrayed the fall of Peter the Great's closest comrade in his painting of "Menshikov in Berezovo." Menshikov had supported everything that Peter had set out to accomplish and had risen from poverty to the highest ranks in the Russian land. Yet, after his master's death, his transgressions against Old Russia had brought him to exile in Siberia's Far North. Unshaven and ill, Surikov's Menshikov sat huddled with his three children in a cold Siberian hut, the only ray of hope in the entire painting coming from the Old Russian icons that glowed warmly in a distant corner. A dozen years later (1895), the land of Surikov's childhood appeared again in his painting "Ermak's Conquest of Siberia," in which he portrayed the first battle between Russians and Siberians in 1582. That these later paintings no longer stirred the wellsprings of patriotism that had poured from Surikov's earlier work showed that even the icons of realism could have failings that overwhelmed their strengths. In a broader sense, the emotional flatness of Surikov's last canvases underscored the limits of Chernyshevskii's dictum that art must become "a textbook of life." Stripped of emotion and inner meaning, canvases painted only to inform and instruct never transcended the gulf that separated the mundane reality of the everyday world from the brighter vision that only true genius had the power to project.

The painter whose genius elevated realism to heights that no other Peredvizhnik achieved came from more humble origins than any of his comrades. The second child of a peasant settler in Ukraine, Ilia Repin spent his childhood in want while his father served in the army and his mother worked as a seamstress among folk who had scarcely more means than the servants they employed. Often left with no more than a crust of bread, Repin might never have escaped the depths of poverty had the local icon painters not recognized his talent and taught him their trade. For several years, he worked with them until his paintings earned enough to pay his way to St. Petersburg, where, in the halcyon days of liberation that followed the Emancipation Acts of 1861, he entered the Academy of Fine Arts at the beginning of 1864.[150]

Repin won the Academy's Small Silver Medal before he had been there a year.

Two years later, he received the Large Silver Medal, and four years after that, in 1871, the coveted Large Gold Medal for a painting entitled "The Resurrection of Jairus's Daughter." At the same time, he won the friendship of Vladimir Stasov, an influential critic who had begun to urge a group of composers known as "the Mighty Handful" to compose national Russian music. Just as Stasov in those days saw Modest Musorgskii as the genius who could create true Russian music, so he regarded Repin as the artist whose work promised to create a national school of painting.[151] Repin, Stasov announced joyfully, had "become totally absorbed in the very depths of the lives, interests, and crushing burdens of the masses,"[152] and the masses would create the foundation for his greatness.

Stasov's urgings that gallery goers pay attention to "Mr. Repin's marvelous work"[153] stemmed from his delight at a painting that had catapulted the young artist to the forefront of Russia's realist painters. When Repin had first seen men pulling barges along the Neva River in the outskirts of St. Petersburg in the summer of 1868, he had been appalled at the idea of human beings being used for tasks assigned to beasts of burden in Europe and America. Vowing to paint Russia's barge-haulers in all their wretchedness, he had spent two summers watching them at work along the great Volga River highway, where he had probed the depths of their misery. At first, the superstitious men had been elusive, fearful of losing their souls if they allowed themselves to be painted. But Repin eventually had sketched dozens of them as they struggled to pull their heavy barges upstream against the powerful current of the "Mother of Russian rivers." That experience had led him to see Russia's barge-haulers as personifications of the folk wisdom and eternal resilience of the masses, who bore the burdens fate had placed upon them with the fortitude of men who suffered for a higher cause.[154] "[He] was a man who inspired great respect," Repin wrote of one of the haulers who posed for his sketches. "He resembled a saint undergoing an ordeal."[155]

Repin painted his first version of "The Volga Barge-Haulers" in time for it to win first prize at the 1871 exhibit of Peredvizhnik canvases. The haulers' arms hung limp, their heads bent, with faces mirroring the pain and exhaustion that deadened their lives. They dressed in tatters, and like all of Russia's lower classes in summer wore slippers woven from linden-tree bark to cover their rag-bound feet. At first glance, Repin's haulers projected such intense dejection that the artist seemed to have erased all hope from their lives. But one in their midst remained defiant, with back straight, head erect, hands clenched around the harness as if to fling it aside, and eyes gazing beyond the present to a better future. Even Dostoevskii, who dismissed most Peredvizhnik art as a crude assault upon the conscience of civic-minded Russians, confessed that Repin's painting had touched his heart. The last of Repin's haulers, "a wretched little peasant, trudging along apart from the rest, his face not even visible [and] . . . his poor, drooping head . . . bent beneath the weight of perpetual misfortune," had held his attention most of all. "This haulers' 'gang,' " he promised his readers, "will return in your dreams. You will still remember it fifteen years from now."[156]

At the age of twenty-seven, Repin had created the populist icon against which

Russian realist art would be measured for almost a century. After that, his brush produced a steady flow of moving paintings, but he would never again explore the masses' suffering as deeply as he had in "The Volga Barge-Haulers." Seeking to connect the people of Russia to their past, Repin turned to Church festivals and the collective portrait they presented of holiday life in rural Russia. His painting of "The Procession of the Cross in Kursk Province" showed rich, poor, young, old, priests, merchants, government clerks, policemen, and scores of peasants all crowded together, their noses already crimson with drink, and their minds already clouded with the sensations that shaped holiday celebrations. Well-fed women clad in brocades and gaudy jewelry, local dignitaries with large stomachs emblazoned with small medals, schoolboys and their teachers, monks, soldiers, and policemen with raised whips all heightened the contrast between the tawdry trappings of rural prosperity and the wretched poverty of peasant Russia. As if the cross had no meaning aside from being the signal for a holiday celebration, few of the marchers gazed at it. To the poor, the halt, and the sick, Repin offered no succor from the Church. As in "The Volga Barge-Haulers," the only ray of hope gleamed from the eyes of a single youth, this time crippled and limping at the procession's edge, who held his head high as he stared firmly at the future.[157]

But what did the future hold? For men and women in search of opportunity and social justice, the 1880s were a disorienting time of economic progress, deepening poverty, and political repression, which convinced the sons and daughters of those men and women who had championed the cause of gradual progress in the 1860s that only a revolution could bring the benefits of the modern age to all Russians. Some of these young men and women risked their freedom to smuggle propaganda leaflets into Russia from the West, while others took the even greater risk of printing them in larger quantities on underground presses in Moscow, St. Petersburg, and Kiev. Almost without exception, their efforts condemned them to long terms in remote Siberian prisons and penal colonies, in which many died or contracted illnesses that shortened their lives.

Repin dedicated some of his most moving canvases to the tragic fate of those Russians who ended their days on the gallows or in Siberia. He painted "The Arrest of a Propagandist" as a tribute to the young men and women who had spread revolutionary leaflets among Russia's ever-passive peasants, and as he watched their comrades turn from propaganda to violence he went on to portray a condemned terrorist disdainfully refusing a priest's offer of confession before his execution. He dedicated another canvas to a "Secret Meeting" among revolutionaries, and still another to prisoners being transported to Siberia. Yet Repin's most moving commentary on the revolutionary movement portrayed neither crimes nor punishments, but the moment when an exile returned to his family after years of suffering and loneliness in Siberia. In this single painting, he captured the tragedy of young lives wasted at hard labor at the same time as he reminded his viewers that the agony of exile did not begin and end with the revolutionaries themselves.

Shown at the Twelfth Traveling Exhibition of Peredvizhnik Art in 1884, Repin's

"They Did Not Expect Him" portrayed a gaunt exile entering his family's sitting room after being freed by the amnesty that had celebrated Alexander III's coronation the previous year. Perhaps suggesting the symbol of the crucified Christ, Repin's subject stood at the center of two intersecting beams of light, from which a man who had all but forgotten the world he had left behind faced his startled family. Too deadened by suffering to express joy, but still too much among the living to remain unmoved, the exile's frightened features betrayed such torment that shaken viewers debated their meaning for weeks afterward.[158] "Do we witness the end of one tragedy or the start of a new one?" one critic asked.[159] No one could say, but everyone had an opinion. Repin had created another populist icon—this time portraying the tragic human cost of Russia's Siberian exile system.

Yet the sufferings of revolutionary exiles were not the only moments of pain Repin portrayed as he rose to rule the world of Russian art. In the early 1880s, he painted "Ivan the Terrible and His Son Ivan, 16 November 1581," which was to capture the torment of the Tsar who had killed his son in a fit of rage. Anguish at the immensity of his crime, utter hopelessness at the realization that he had condemned his dynasty to extinction, and sheer terror in knowing that he would soon have to account to God for killing a fellow being twisted the aged Tsar's features beyond recognition as he held the lifeless body of his son in his arms. Never before had the Russians seen the blood, tragedy, and torment of their nation's history compressed into a single moment, and thousands stood in line to view Repin's canvas when the Thirteenth Traveling Exhibition of Peredvizhnik Art opened at St. Petersburg's Iusupov Palace at the beginning of 1885. "Women fainted when they saw it," one observer wrote as he recalled the vividness of the blood that poured from the Tsarevich's wound in Repin's painting. "High strung people," he added, even "lost their appetites."[160] Because Russia's laws forbade anyone from writing about tsaricide, censors refused publishers permission to print copies of Repin's painting, and when Pavel Tretiakov bought it they warned him not to hang it in his gallery.[161] Ten years later, the prohibition against printing "Ivan the Terrible and His Son Ivan" still remained in force. It was not the function of the press, a censor informed the editor of the popular magazine *Niva* in 1895, "to spread the idea that a tsar had taken the law into his own hands and shown a bestial lack of restraint."[162]

Yet populist icons and paintings of defining moments in Russia's history did not satisfy Repin's passion to paint. Even as he worked on the huge canvases that won him recognition as Russia's greatest realist artist, he painted likenesses of the rich, famous, poor, and insignificant to create a veritable portrait gallery of the faces that filled Russia's fields and cities. Statesmen, women of high society, priests, tradesmen, peasants, old people, and children all held Repin's attention as he painted the merchant patrons of the Peredvizhniki, the founder of modern Russian medicine, Nikolai Pirogov, the great scientists Dmitirii Mendeleev and Ivan Pavlov, the critic Vladimir Stasov, and even the Procurator General of the Holy Synod, whose complaints had drawn the censors' attention to "Ivan the Terrible and His Son Ivan." Beginning in the 1880s, Repin painted Tolstoi walking behind a plow, working in

the fields, writing at his desk, and resting in the woods. Most of Russia's living painters, writers, and composers, some of its most beautiful women, and a few of its most powerful men all sat for him at one time or another, but his most memorable portrait was of his friend Modest Musorgskii, the tormented, besotted genius who shared his passion for the masses and composed some of Russia's greatest operas.[163]

No portrait ever captured the tragedy of self-destroyed genius with greater brilliance than Repin's. Sickened by long weeks of boozing, Musorgskii lay at death's door in a ward for chronic alcoholics, "dreaming," as Repin remembered some years later, "of making up for" having been kept sober for the better part of a month.[164] Fearful that time was short, Repin worked quickly, using all of his talent to portray the tangled hair, the bulbous nose, the unkempt beard, and the stubborn, angry self-disdain that had brought his friend to the verge of madness and death. While he painted, the two men talked of old times, undoubtedly recalling the common vision of portraying Russia's masses—the *narod*—they had shared for most of their adult lives. "I see them when I sleep," Musorgskii had once confessed in earlier, happier times. "I think of them when I eat, and when I drink their image haunts me in all its reality, huge, unvarnished, and without any tinsel!"[165] That vision had underlain *Boris Godunov*, which the tormented composer had finished in the mid-1870s, and it was also woven deeply into the fabric of *Khovanshchina*, the second opera he was destined never to complete. Neither of the two friends knew, as Repin filled in all but the final details of the portrait on the fateful Ides of March 1881, how soon death would part them.

When Repin put away his brushes on the afternoon of March 15, 1881, he had every intention of returning to his friend's hospital room for one final sitting a day or two later. A few hours after that, Musorgskii managed to bribe a hospital attendant to bring him a bottle of cognac, and the next day, just a week after his forty-second birthday, he died after drinking it all. Thus death severed the ties that had bound together the wretchedly poor peasant whose talent had made him rich and the once-wealthy nobleman who had been driven to poverty and madness by the torments of a genius that had turned inward to destroy itself. Yet, by that time, the dedication to the *narod* that had bound the two friends together had reached far beyond them to touch every area of Russia's artistic experience. The life of the *narod* was destined to loom largest of all in Russian music, where composers of unparalleled brilliance wove folk-music motifs into operas and symphonies that dazzled their countrymen and the entire Western world. Between 1860 and 1900, five composers known as "the Mighty Handful" in St. Petersburg joined with the fragile, morbid Chaikovskii in Moscow to transform the world of Russian music into a brilliant kaleidoscope of shifting sights and sounds that created an era of orchestral and operatic brilliance that would never be surpassed in Russia's history.

## The Mighty Handful and Chaikovskii

⟨✦⟩

*EVER SINCE THE EMPRESS ANNA* had invited the Neapolitan composer Francesco Araja and his entire opera company to her court in 1732, opera and ballet had held special places in the hearts of the Russians. Araja had composed more than a dozen Italian comic operas for the theaters of Anna and Elizabeth, and Giovanni Paesiello and Giuseppi Sarti had written many more for Catherine the Great. Not until well into the second half of Catherine's reign had the first Russian composers appeared on the scene, and only Vasilii Paskevich had managed (after being trained in Italy) to win a place of prominence in the ranks of the Empress's favored Italians when he had set to music Kniazhnin's *Misfortune from a Coach*. With the single exception of Mikhail Glinka's *Life for the Tsar* in 1836, the first half of the nineteenth century had left the Italians' monopoly undisturbed. As the century passed its midpoint, Russian music had continued to reflect the tastes and teachings of Europeans.

Because their country had no conservatories, almost no competent teachers, and virtually no books on music theory, Russia's handful of partly self-taught native composers still looked to the West for inspiration as the Crimean War came to an end, and their music remained largely European in form and content.[1] Glinka, after all, had studied in Germany and Italy, where he had known Donizetti and Bellini, and his famed *Life for the Tsar* was in fact composed in the Italian style with a thin overlay of Russian ornamentation. Russian audiences therefore continued to believe that the works of Mozart, Bach, Beethoven, and the masters of Italian opera should be as welcome in St. Petersburg and Moscow as in Vienna, Paris, Berlin, or Rome. They still were "accustomed to thinking,"

Rimskii-Korsakov wrote in his recollections of those days, "that a musician ought to be a foreigner, that anyone who played an instrument was supposed to be a German, and that singers were supposed to be Italian."[2]

The wave of liberation that set free the serfs and brought a new sense of national pride to life in painting and literature in the early 1860s saw Russia's leading musicians and patrons draw still closer to the West. Certain that the education he had received in Berlin from the great Siegfried Dehn represented the final word in how a musician ought to be trained, the St. Petersburg pianist child prodigy Anton Rubinstein founded Russia's first conservatory in 1862 in order to make certain that the musicians and composers who followed him would maintain Russia's strong ties to Europe. Working closely with the Tsar's aunt, the Württemberg-born Grand Duchess Elena Pavlovna, Rubinstein staffed the St. Petersburg Conservatory with teachers from the West (at the time there were no Russians able to teach composition on any advanced level, anyway), and set out to train young musicians according to the rigid precepts that reigned in Germany. Believing that "passions are not national and therefore there can be no national opera," he dismissed all attempts to compose the sort of "barbaric" national music advocated by a handful of poorly trained Russians as being inevitably "doomed to failure."[3] Because the composition and performance of music must reach beyond geographical boundaries, he argued, operas could be "Russian"—or "German," "French," or "Italian," for that matter—only in their settings and libretti.[4]

Rubinstein rose to rule Russia's world of music over the objections of a handful of lesser-known men who dreamed of challenging the cosmopolitan compositions he favored. As followers of Glinka, all of them drew their inspiration from a deeply held belief that the ancient music of Russia's Church and the popular songs of its masses must be elevated into the realm of fine art to create music that would instill in audiences everywhere a sense of Russia's meaning and Russian patriotism. They rejected Mozart and Haydn as too naïve and old-fashioned, condemned Bach for being too frigid and mechanical, and disdained Beethoven (except for his Ninth Symphony) as too insignificant. Their idols in the West—Berlioz in France and Wagner in Germany—were composers who shared similar dreams, and all of them thought that whatever was uniquely Russian, German, or French could be expressed more vividly in music than in literature or painting.[5]

Led by Milii Balakirev, a twenty-five-year-old disciple of Glinka, who believed that genius and insight could take the place of those fundamentals that Rubinstein saw as the cornerstone of every composer's training, the men who hoped to create truly Russian symphonic and operatic music organized St. Petersburg's Free Music School in the same year that Rubinstein founded his conservatory. They opened its doors to anyone who wanted to compose, and they insisted that intuition, enthusiasm, and a love for the music of old Russia counted for more than training and discipline. That the melodies with which they worked were at odds with the rules of harmony that reigned in Germany was of no consequence to them. Like Glinka and Balakirev, they worked to shape ancient popular

materials into modern symphonic forms, and when critics rejected their work as crude, inconsequential, and downright boring, they continued on their chosen path with scarcely a second thought.

While Rubinstein celebrated the success of his conservatory in St. Petersburg by founding one in Moscow just four years later, the dynamic and arrogant Milii Balakirev worked to assemble a "Mighty Handful" of young men who shared his passion for Russian music. By blending popular melodies collected during summers spent wandering through far-flung villages with a new vision of how music ought to express the spirit and meaning of Russia, these men created operas that would enthrall Europeans at the same time as they proclaimed that the Russians had become their equals. Here at last was music about Russia that could have come only from Russia. While the operas of Mozart could be set in Spain, Italy, Germany, or even a Turkish seraglio, those of Musorgskii, Borodin, and Rimskii-Korsakov could only have true meaning in the context of Russia's past and present.

"Young, with marvelous, lively, fiery eyes, with a wonderful beard, [and] decisive, authoritative, and direct in what he said," according to the memoirs that Rimskii-Korsakov wrote many years later, Balakirev had grown up in the Volga River trading center of Nizhnii-Novgorod that had been an eastern frontier outpost in the days when the Russians had labored beneath the Tatar yoke. From the fearsome horsemen who once had ruled his land, Balakirev had inherited slightly Oriental features that added to the exotic image with which he charmed his protégés, and he used that power to win over would-be composers to the cause of blending centuries-old folk melodies into huge tapestries of national passion. Endowed with a prodigious talent that he never learned to express in his own compositions, he had a genius for sensing what was needed to perfect the compositions of others, and he imposed his views with a confidence that no other composer of his generation ever matched. Finding the talented eccentrics who made up his Mighty Handful in military barracks, schools of medicine, and aboard His Imperial Majesty's ships-of-the-line, Balakirev convinced them all to set their chosen careers aside and dedicate their lives to creating the great symphonies, ballets, and operas that would define Russia's national music. "The spell of his personality was tremendous," Rimskii-Korsakov remembered. "He was obeyed absolutely."[6]

Destined to become its leading spokesman and defender, the military engineer César Cui entered Balakirev's circle in the mid-1850s. Next came Modest Musorgskii, a dashing lieutenant in the Preobrazhenskii Imperial Guards, who charmed hostesses all over the capital with his piano performances and elegant manners. After Musorgskii came Nikolai Rimskii-Korsakov, the seventeen-year-old naval cadet who had allowed music to become his life's ruling passion without knowing very much about it. Then Aleksandr Borodin, who had taken degrees in medicine and chemistry and had begun to teach at the Medical-Surgical Academy, joined the Mighty Handful in 1862. Few of them had much formal training in musical theory or composition and none had yet turned thirty,

but their common love for their nation's past and their passion for the melodies of its common folk made it possible for them to transform Russian music in less than a quarter of a century.

Balakirev urged his followers to embrace a freer, fresher method, which relied more on intuition than on textbook knowledge of harmony and counterpoint. He convinced Musorgskii to give up his career in the Imperial Guards and dedicate his life to music, induced Rimskii-Korsakov to abandon the navy, and persuaded Borodin to share his devotion to chemistry with his genius for composition. Although all of them surpassed him in vision and insight, Balakirev always remained the master who had inspired them to create compositions more brilliant than his own. "From the very beginning, I was conscious of your superiority, [and] no matter how enraged I became with myself or with you, I had to agree with the truth," Musorgskii wrote to him two or three years after their first meeting. "I owe you a great deal," he concluded. "You knew just how to rouse me from my stupor."[7]

The first of the young composers whom Balakirev drew into his circle, César Cui became a general in the Imperial Corps of Engineers, a music critic for one of St. Petersburg's largest newspapers, and one of nineteenth-century Russia's most prolific composers. He wrote ten operas, thirty choruses, three string quartets, and over two hundred songs in the course of his life—more, in fact, than any other of Balakirev's Mighty Handful. Yet it was the tragedy of Cui's life and work that his creations remained consistently mediocre. Not one of his operas enjoyed lasting success, and virtually none of his music is remembered now. His fame thus rests not on his compositions but on the role he played as an influential critic, who believed that "after Beethoven, Schumann, Liszt, and Berlioz" symphonic art had "reached perfection and that no means could be new enough to carry it farther and give it greater freedom." Cui, therefore, urged Russia's young nationalist composers to concentrate on the opera as the musical art form that remained "in a very imperfect, transitional state" and therefore offered the greatest opportunities for truly innovative work. The "ideal of the new Russian school" in opera, he explained, must to be to achieve "pregnant, specific characterization, not only of each character, but also of the period and atmosphere of the drama and of every single point in it. All these principles," he wrote, "are very similar to Wagner's, but Wagner's way of carrying them out is in many respects deplorable."[8]

While Balakirev and Cui had given lessons to stave off the ravages of poverty before they rose to positions of influence, Modest Petrovich Musorgskii enjoyed more than enough wealth as a young man to spare him from such burdens. Born into a well-to-do noble family that owned hundreds of serfs and more than 27,000 acres in the ancient northwest province of Pskov, Musorgskii grew up under the watchful eye of a peasant nanny whose artful stories brought to life a fairy-tale world populated by the witches, elves, sprites, and spirits who lurked in the forests and fields in which Russia's common folk spent their lives. Visions of giants and trolls kept young Modest awake at night, but they also bound him for

life to the spirit and music of Old Russia.[9] By the time he had reached the age of ten, Musorgski had already absorbed the essence of that mysterious world of superstition and myth that had shaped the lives of Russia's masses since the ancient days, when their ancestors had worshiped pagan gods and Christianity had not yet come to their land.

Not long after his tenth birthday, Musorgskii left the primeval groves of his family estate to study in St. Petersburg, where, for the better part of a decade, he traded the traditions of Old Russia for the modern world that Peter and Catherine the Great had brought into being. By the time he received his commission in the famed Preobrazhenskii Guards, he had become an accomplished pianist and could claim to be well versed in Italian opera. He had a passion to compose, but no sense of how to set about it until he met Balakirev and the influential critic Vladimir Stasov in the spring of 1857. Then, he later wrote, "my musical life began."[10] In response to the enthusiastic urgings of his new friends, he came to understand that he could not serve the Tsar and the gods of harmony at the same time, but it took him nearly a year to decide which one to choose. When he finally chose Balakirev's despotism over the tyranny of the parade ground, the decision set him apart from everything that had given his life focus and plunged him into a world of uncertainty in which he would never find an entirely solid footing.

During 1858, Musorgskii resigned his commission, suffered a nervous breakdown, and dedicated his life to music. The next summer, he went to Moscow, where its sights and sounds kindled the passion for Old Russia that dominated the rest of his life. He loved everything about the city—the "delightful Red Gate," the "wonderful Kremlin," the tomb of Dmitrii Donskoi, and the way in which Red Square called to mind the turmoil of Russia's past. He felt the presence of Ivan the Terrible, heard the uncertain steps of his adviser and successor Boris Godunov, and envisioned a procession of great lords marching in the long robes and fur hats that had marked them as men of wealth and power in the long-ago days of Moscow's greatness. "I feel close to everything Russian," he wrote to Balakirev. "I am really beginning to love it."[11] That summer, Musorgskii found in Moscow the visions of Old Russia that he would bring to life in *Boris Godunov* and *Khovanshchina*, the two masterpieces that celebrated the music of the people in ways that Russia's operagoers had never before envisioned. From a world long since past, he would revive the Golden Age of Holy Moscow to give new meaning and substance to Russia's present.

Yet the days of *Boris Godunov* and *Khovanshchina* remained far in the future. As his elder brother's failure to come to grips with the new world that was taking shape in Russia all but destroyed what was left of the family fortune, Musorgskii was obliged to give up his life as a well-to-do gentleman and enter Russia's civil service. Hoping to create a new and higher form of art by blending philosophy, religion, art, and politics, he and several friends organized a commune according to the model that Chernyshevskii had set down just a few months before in *What Is to Be Done?* and they continued their experiment until the death of the would-

be composer's mother drove him into the first of his many bouts with alco-
holism.[12] Obliged to leave the commune in the fall of 1865, Musorgskii took
refuge in his brother's apartment, where a more regular, disciplined life brought
him back to his studies of composition and the music of Russia's masses. As had
happened to Tolstoi just four years earlier, friends urged him to get married. In
reply, he told Glinka's sister that if she "ever happened to read in the
newspaper" that he had shot or hanged himself, she "might be sure that it had
been on the eve of his wedding-day."[13]

Whether visiting Moscow, struggling to set his family affairs in order, living
with his friends, or battling the ravages of wine and cognac, Musorgskii centered
his artistic life in the circle of Balakirev, Cui, Rimskii-Korsakov, Borodin, and the
critic Stasov, several of whom doubted that he would ever bring his talents well
enough into focus to create the music of which his genius seemed capable.
"Everything about him is sluggish and insipid," Stasov wrote to Balakirev in dis-
gust in 1863. "He is, I think, a complete *idiot* . . . and, were he not under your
supervision . . . he would soon go to hell."[14] Balakirev hurried to agree. Yet, even
as doubts tormented his mentors, Musorgskii drew new encouragement from
Borodin and Rimskii-Korsakov, who became his closest friends at the very
moment when the Mighty Handful decided to concentrate on opera as the
form best able to express the true nationality of Russian music. In their company,
he found the inspiration that led him to compose his first and greatest work.

The year 1868 saw Musorgskii and his friends throw themselves into the
world of opera with unrestrained passion. Balakirev was hard at work on *The
Fire Bird*, which he was destined never to finish, and Cui was about to complete
*William Ratcliffe*, the opera that was fated for oblivion despite the great hopes he
and his friends harbored for its success. Borodin had just begun *Prince Igor*, Dar-
gomyzhskii was trying to finish the ill-starred *Stone Guest*, and Rimskii-Korsakov
had just started to compose *The Maid of Pskov*. For more than half of the year,
Musorgskii struggled to set Gogol's comedy *The Marriage* to music, but gave it
up that fall to begin *Boris Godunov*, the masterpiece that would be performed at
the Imperial Mariinskii Opera just a few weeks before his thirty-fifth birthday.
The next several years would be the most productive of his life, and his hopes
soared as he worked. He strived, he said, to make his characters "speak on the
stage as living people really speak," and make his music "an artistic reproduction
of human speech in all its finest shades."[15] Originality and spontaneity had to
come before all else. "One has to be oneself," he wrote to Rimskii-Korsakov.
"This is the hardest task of all—that is, it happens very seldom—but it can be
done."[16]

Reshaped by Musorgskii's genius, one of Pushkin's least memorable creations
became one of the greatest works of art ever to come out of Russia. Equal in
every way to Dostoevskii's *Brothers Karamazov*, Tolstoi's *War and Peace*, and Re-
pin's *Volga Barge-Haulers*, Musorgskii's *Boris Godunov* told a dark and painful
tale of Old Russia laid waste by foreign armies and shattered by domestic strife,
while the people's Tsar struggled to bring order out of the chaos that his own

ambition had sown. Against a brilliant backdrop of medieval splendor, Musorg-
skii juxtaposed the sufferings that had shaped Russia's history, the tragedies that
had darkened its past, and the melancholy that still clouded its present. Most of
all, in everything and everywhere, the Russian masses—"huge, unvarnished, and
without any tinsel,"[17] as he once described them to Repin—held center stage. "I
regard the people as a great personality, animated by a unified idea," he wrote in
the dedication to *Boris Godunov*. "This is my task," he concluded. "I have tried
to resolve it in opera."[18]

Yet success did not come all at once. When the Mariinskii Opera rejected the
first version of *Boris Godunov* as being too somber, unconventional, and "mod-
ern," Musorgskii added a third "Polish" act to satisfy objections by the opera
committee that it did not have a significant female part, transposed the scenes of
the final act, resubmitted it, and waited for the better part of a year to hear that it
had been rejected again. Its radical innovations repelled and fascinated even his
friends, and none more than Rimskii-Korsakov, who later confessed that "I
hated *Boris*, and yet I worshipped it."[19] Only because some of the Mariinskii's
leading performers demanded it did the theater's director override the critics
and agree to stage the opera.[20] Although condemned by most critics after its first
performance in January 1874 as "a cacophony in five acts and seven scenes" that
suffered from "indiscriminating, self-satisfied, hurried methods of composition,"
*Boris Godunov* transformed opera and its audience in Russia.[21]

Musorgskii's *Boris Godunov* played to cheering audiences, and its success set
a precedent that would help his comrades overcome their European rivals. The
popularity of Italian opera that had dominated Russia's eighteenth century had
continued well into the nineteenth, and St. Petersburg's Grand Theater still per-
formed only works by Italians even as late as 1874. Only at the Imperial Mariin-
skii Theater had operas by Russian composers appeared, but audiences had
showed little appreciation for either the music or its performers, who often sang
to half-empty halls. St. Petersburg's high society had thought it so unfashionable
to be seen at Russian operas, in fact, that only seven had been produced during
the entire decade and a half before *Boris Godunov*. Although it soon became
popular with younger aristocrats and students who made it a point of flaunting
their disdain for the tastes of their elders, even Rimskii-Korsakov's *Maid of Pskov*
had stirred up a good deal of criticism after its premiere in 1873. All in all, Rus-
sian operas received mixed receptions at best in the 1860s and early 1870s. In
similar fashion, Musorgskii's *Boris Godunov* also irritated St. Petersburg's critics,
but the city's audiences loved it.

Thanks in part to the enthusiastic efforts of Stasov, who promised that *Boris*
would be a "great triumph,"[22] the Mariinskii Theater was sold out four days be-
fore its first performance even though the tickets cost three times the regular
price. For Russians caught up in the wave of deepening nationalist feeling that
was sweeping over their land, the opera became a living expression of a history,
in which the men and women who had borne the burdens of Russian life for so
many centuries helped to shape their nation's course. Here the *narod* was no

longer the vocal backdrop that glorified the opera's heroes (as it had been in Glinka's *Life for the Tsar*). Instead, Musorgskii's masses bowed down to authority, rose up against it, prayed before it, and cursed it. In all their power and pathos, the *narod* had at last become both the victim of Russia's history and its court of last resort.[23]

Although it seemed that *Boris*'s popular acclaim only stirred its critics to more bitter condemnations, Musorgskii was too deeply immersed in his work to dwell upon their complaints for very long. That summer, Stasov organized an exhibition of paintings by the artist and architect Viktor Hartmann, and Musorgskii seized upon it as a chance to pay tribute to the dear friend whose unexpected death had caused him such pain the year before. Complaining joyfully to Stasov that "my scribbling can hardly keep pace" with the "sounds and ideas [that] float in the air,"[24] he completed the piano suite *Pictures at an Exhibition* in less than a month. The most important of his instrumental compositions after *A Night on Bald Mountain*, Musorgskii's *Pictures* was in no way the equal of *Boris Godunov*, nor could it rival the work into which he flung himself the moment it was finished. He had begun to dream of bringing the world of Old Russia to life on the stage in a way that no living Russian had ever seen. He intended to do so by means of a vehicle whose dramatic complexity even he could not fully imagine.

Musorgskii was particularly drawn to the *Khovanshchina*, a series of rebellions among the Kremlin's elite palace guards that had occurred when the storm clouds of religious, political, and cultural conflict had spread a black pall over Russia during the days when Peter the Great's half-sister Sofiia had ruled as regent.[25] Taking its name from Prince Ivan Khovanskii, the popular commander of the palace guards, who had dedicated himself to defending Russia's old ways, the *Khovanshchina* symbolized a clash between progress and stagnation, in which Musorgskii saw a way to capture "the finest traits in man's nature and the mass of humanity in general." Once called a "philosopher among musicians," he now had to become a master psychologist to study those "elusive [human] traits that no one has ever touched." To do so required profound insight, colossal daring, and a reckless willingness to probe the past in the hope of giving deeper meaning to the present.[26]

Rather than rely on the sort of unified plot that had shaped operas until that time, Musorgskii chose to follow Tolstoi's practice of creating a tapestry of dramatic episodes that would produce a panorama of epic proportions when viewed together. Yet, with no play or text to guide him, he kept flitting from one scene to the next without developing a clear vision or even writing down the music after he had worked it out in his head. Unable to bring into proper focus the events that formed its setting, he left *Khovanshchina* unfinished when he died in 1881, and even after Rimskii-Korsakov edited and orchestrated it four years later it never conveyed the full sense of historical drama that its composer had envisioned. Yet, for all its shortcomings, the opera formed the second of the supporting pillars upon which Musorgskii had erected his edifice of Russian national

music. Like *Boris Godunov, Khovanshchina* conveyed, as one critic wrote, "the very essence of the [Russian] people, its forces, its sense of the starkness of life, the inevitability of suffering, [and] its Asiatic fatalism."[27] Here from Old Russia at its best and worst, Musorgskii sought to extract the inner substance of the masses to which he, Repin, Dostoevskii, and Tolstoi all paid humble, self-indulgent tribute.

The masses had vices as well as virtues, and it became Musorgskii's fate to share them. "It was absolutely incredible how this well-bred [former] Guards officer, with his beautiful, worldly manners . . . [would] sell his furniture and elegant clothes and begin to hang around cheap taverns the moment Vladimir Vasilevich [Stasov] left him alone," his friend Ilia Repin remembered. "It is hard to count the number of times," Repin added, "when, after returning from abroad, Stasov would track him down in some cellar hang-out [and find him] nearly in rags."[28] From the mid-1870s on, no amount of effort by friends and well-wishers could slow Musorgskii's plunge to ruin, and when he collapsed at the beginning of 1881, his friends placed him in the hospital, where Repin painted his portrait just before he died on March 16. Two days later, he was laid to rest not far from the grave of Dostoevskii at the Aleksandr Nevskii Monastery. "He was everybody's friend and his own enemy," one of his friends concluded sadly. "The coolness and gentleness with which he bore the burden of his distress and difficulties were remarkable."[29]

While Musorgskii created the brilliant masterpieces that brought the masses to the forefront of Russia's opera, his serious and more conscientious friend Nikolai Rimskii-Korsakov concentrated on bringing to the musical stage the fairy-tale visions that shaped the world of Russia's common folk. Born in the landlocked province of Novgorod to a family of seafaring aristocrats in 1844, Rimskii-Korsakov left his childhood home at the age of ten to follow his ancestors' footsteps. For the better part of two decades, he held to his chosen course, graduating from the Imperial Corps of Naval Cadets, sailing to England, America, Brazil, and France, and serving in shore assignments in St. Petersburg until he resigned his commission in 1873. After that, he served the navy for another decade as its civilian Inspector of Naval Bands, a post created especially for him by Russia's Minister of Marine. Yet Rimskii-Korsakov never gave his heart and soul to the navy as his ancestors had done. From the moment he came to St. Petersburg in the summer of 1856, music ruled his life, even on distant seas and in faraway ports. On several occasions, he tried to turn away from its seductive beckonings, yet it always drew him back, never releasing him from its grip and always demanding from him the dedication of heart and mind that his ancestors had reserved for the service of Russia's sovereigns. Not long after he turned twenty-nine, Rimskii-Korsakov finally heeded the summons of his true love and traded his naval epaulets for a conductor's baton and a composer's pen. After Chaikovskii died in 1893, Russians embraced Rimskii-Korsakov as their nation's premier composer until his own death in the summer of 1908.

Like Musorgskii, Rimskii-Korsakov entered the musical world of St. Peters-

burg through Balakirev's salon, where he first appeared at the end of 1861. "From our very first meeting, Balakirev produced an enormous impression on me," he remembered many years later. "A brilliant pianist who played everything from memory, he held bold opinions, embraced new ideas, and, last but not least, had a gift for composition, which I already revered."[30] Balakirev saw in this shy, adoring naval cadet a disciple who could be molded into a composer of Russian national music, and he urged him to plunge ahead with his Symphony in E-Flat Minor, despite the fact that he knew almost nothing about the fundamentals of composition and instrumentation. When the symphony was finished in the fall of 1865, Cui hailed it as "the first symphony ever written by a Russian," even though Anton Rubinstein (whom Cui considered a Jew rather than a Russian) had written his Symphony in F Major fifteen years earlier.[31] Like Musorgskii and Borodin, Rimskii-Korsakov had fallen victim to Balakirev's confident assurances that raw talent and genius were enough for any composer so long as he followed his mentor's forcefully expressed opinions. "Whatever would be unfinished or clumsy in this early creative work of his student-friends, [Balakirev] himself would finish," Rimskii-Korsakov later explained. Balakirev believed, he added, that "one must begin to compose from the very outset, to create and learn through one's own creative work."[32]

For half a decade after he finished his Symphony in E-Flat Minor, Rimskii-Korsakov's experience seemed to proclaim the brilliance of Balakirev's method. Still relying on inspiration and instinct, he wrote two more symphonies and finished *The Maid of Pskov*, his first—and, eventually, highly successful—opera, which came to be known outside Russia as *Ivan the Terrible*. When the censors required him to change the opera's portrayal of medieval Pskov from an independent-minded republic into a city that had risen in rebellion against the righteous authority of Moscow's Ivan the Terrible, that new emphasis seized the hearts of Russia's youth just as the most radical among them set in motion the revolutionary movement that would bring down the Romanovs half a century later. In a burst of enthusiasm not seen since the premiere of Glinka's *Life for the Tsar*, St. Petersburg's audiences called Rimskii-Korsakov back to the stage to acknowledge their applause a dozen times when the opera was first performed on New Year's Day, 1873. As they cheered his work with pure delight, it seemed for a time that perhaps he, and not Cui or even Balakirev, might inherit Glinka's mantle.

In the midst of this whirl of creativity and success, the new head of St. Petersburg's Conservatory offered Rimskii-Korsakov an appointment as Professor of Practical Composition and Instrumentation. Delighted with this unexpected chance to live entirely in the world of music, the composer now had to face the fact that he knew very little about the art form that had brought him fame. "Had I ever studied [music] at all [before that]," he later confessed, "it would have been obvious to me that I could not—and had no right to—accept the appointment that was offered me.... I had no idea of how to harmonize a chorale decently," he continued. "Not only had I not written even one counterpoint in my entire life, but I had scarcely any notion of how a fugue was structured...

As to the conductor's art," he concluded, "having never conducted an orchestra nor even rehearsed a single choral piece, I, of course, had no conception of it at all."[33]

For the better part of a year after he began to teach at the Conservatory in the fall of 1871, Rimskii-Korsakov kept just a step or two ahead of his students while he studied harmony, counterpoint, and instrumentation. "By the time they had learned enough to begin to see through me," he later wrote, "I had really taught myself something" and was able to stand with the best professors the Conservatory had to offer. In the process he discovered the flaws in the compositions that had brought him fame, and he hurried to rewrite them at the same time as he focused his relentless pursuit of perfection on the unfinished works of several recently deceased friends. He edited Glinka's *Life for the Tsar* and *Ruslan and Liudmila*, and also finished the parts of *Prince Igor* that Borodin had left undone. But the greatest burden he shouldered was the task of extracting a complete version of *Khovanshchina* from the jumble of scrambled papers that Musorgskii had left at his death. Only by seeking better balance and smoothing out his friend's sometimes "impossible" original forms, at the cost of moderating some of their raw brilliance, could he create an opera out of the material that Musorgskii had found so overwhelming. The result left critics unhappy, but it brought to an end the struggle to impose order upon the sprawling mass of unconnected manuscripts that had defied Musorgskii's best efforts for the better part of a decade.[34]

His studies at the Conservatory, his decade as Inspector of Naval Bands, and his task of editing, completing, and orchestrating the works that Musorgskii, Borodin, and Glinka had left unfinished all sharpened Rimskii-Korsakov's sense of technical perfection. His friends worried that he had become a pedant; Musorgskii even went so far as to claim that his friend's preoccupation with theory and technique had made him a "traitor" to the cause of progress. Balakirev complained about his "spiritual flabbiness."[35] Yet beneath Rimskii-Korsakov's academic shell a fertile imagination yearned to create a world of fantasy, and his deeper knowledge of the technique and context of his art now made that possible. As the 1870s shaded into the 1880s, *May Night*, and the magical, sparkling *Snow Maiden* showed his genius for transporting operagoers into the realms of fantasy, fairy tale, and folklore. For the first time, they brought to life the world that popular imagination had created in an effort to explain those supernatural phenomena that shaped the lives of Russia's masses.

Rimskii-Korsakov's world of magic and mystery arose from the wealth of Russian folklore which, like Musorgskii, he had absorbed as a child. Here, heroic warrior princes, cruel tsars, lonely mermaids, lovely snow maidens, beautiful swan queens, powerful kings of the sea, mischievous river sprites, sorcerers, devils, witches, and wizards all thronged together in an amazing intermingling of historical fact, legend, and supernatural forces to create an enchanted realm that enthralled audiences all around the globe. Here was the fantastic world of the brothers Grimm and Alice's Wonderland all rolled into one and seasoned with visions of exotic Oriental bazaars, fearsome Mongol horsemen, and the songs of

ancient Slavic bards. Oceans churned, storms thundered, the sun sparkled in wintry forests, and in the new warmth of spring nightingales sang and golden fish leaped from crystal streams.[36] Half a century after Pushkin and Gogol had first brought this magical domain to life in the realm of high culture, Rimskii-Korsakov gave it musical substance. "He invented the perfect music for such a fantastic world," one critic wrote. It was "music insubstantial when it matched with unreal things, deliciously lyrical when it touched reality, in both cases colored from the most superb palette a musician has ever held."[37]

Based on a play that Aleksandr Ostrovskii had written just a few years before, *The Snow Maiden* displayed Rimskii-Korsakov's talent for bringing magical, fairy-tale realms to life. "My warm feelings towards ancient Russian customs and pagan pantheism . . . now burst into flame," he wrote of the time when he first laid out the rough sketches of his opera. "Colors and shadings corresponding to the various aspects of the subject," he continued, "began to take shape, dimly at first, but then more and more clearly later on."[38] With a thick book of notes in hand, he moved his family from St. Petersburg to the ancient village of Stelëvo to spend the summer of 1880 in the bosom of old peasant Russia, when "everything seemed to be in peculiar harmony" with his "pantheistic mood." "A thick, twisted knot or stump overgrown with moss seemed to me to be the Wood Sprite or his dwelling," he remembered. "The forest of Volchinets became the forbidden forest [of Ostrovskii's tale], the bare summit of Mount Kopytets became Iarilo's mountain, and the thrice-heard echo from our balcony, the voices of wood sprites or other demons. . . . We reigned supreme," he wrote with longing for those magical long-ago days. "There was not a neighbor anywhere."[39]

So far removed, yet less than a day's journey from St. Petersburg, Rimskii-Korsakov hearkened "to the voices of folk art and nature" and finished his opera in less than eleven weeks.[40] By that time, the hot, thundery summer was coming to an end; he took his family back to the city, where he orchestrated the entire 606-page score by the end of the following March. When *The Snow Maiden* was performed at the Imperial Mariinskii Opera ten months later, critics complained of its "lack of dramatic action and the poverty of melodic inventiveness," which, they said, was evident in the composer's "predilection for borrowing folk-tunes."[41] The composer was inclined to give their words little weight. "I now felt," he wrote, "like a fully mature musician and operatic composer, who was finally able to stand on his own two feet."[42]

Despite the *The Snow Maiden*'s popular success, the rest of the 1880s proved to be one of the least productive periods in Rimskii-Korsakov's life so far as original compositions were concerned. He spent much of the decade working on the unfinished manuscripts left by Musorgskii and Borodin, and it was only toward its very end that he returned seriously to his own work. Then, during the eighteen years after 1889, he wrote a dozen operas and sketches for two more. Using stories by Gogol and Pushkin as his guides, he blended myth, satire, and fantasy to stunning effect in *May Night, Mlada, Christmas Eve, Sadko, The Tsar's Bride, The Tale of Tsar Saltan*, and half a dozen other works that all won favor with

Russia's audiences, even if critics treated them harshly on occasion. The land of a beautiful Swan Princess, a kingdom beneath Novgorod's Lake Ilmen, a long-ago mythical land on the shores of the Baltic, and the Invisible City of Kitezh in the sky all carried Russians into realms of fairy-tale enchantment such as no other composer had ever created. As they turned toward a new century destined to bring war, revolution, and the obliteration of those traditional landmarks upon which they had taken their bearings for so long, the Russians found Rimskii-Korsakov's frivolous evocations of fantasy all the more appealing as a shelter in which to escape the hard reality that pressed upon them from all sides.

When none of these new creations repeated *The Snow Maiden*'s success, Rimskii-Korsakov began to fear that his talent had faded. Several of the operas he wrote at the turn of the century received harsh criticism, and his *Legend of the Invisible City of Kitezh* only partly restored his reputation's tarnished luster. When his efforts to begin a new opera came to naught after revolution swept Russia in 1905, he began to ask himself "whether it might not be time to draw the curtain" on his career as a composer. Yet he could not end his life in music without making one final effort, which in 1907 yielded the brilliant *Golden Cockerel* that transported Russia's operagoers into a mythical Eastern land ruled by the aged, pleasure-loving Tsar Dodon. Fearful that invading armies would disturb his rest (he ruled while lying on his side with hands folded), Dodon promised a eunuch astrologer anything he might desire in return for a golden cockerel that would crow at the first sign of danger. When the astrologer asked for the beautiful young Queen Shemakha, for whom the Tsar himself had a passion, Dodon struck him dead, only to be killed by the cockerel in return. Here satire combined with fantasy, and voluptuous, shimmering scenes blended with vivid human characters to become Rimskii-Korsakov's farewell to the land and people he had served as a composer for nearly fifty years.

Rimskii-Korsakov's death in 1908 came twenty-one years after that of his close friend Aleksandr Borodin, the chemist-composer whose greatest opera he helped to orchestrate at the end of the 1880s. The illegitimate son of a prince, whose family traced its lineage back to the Tatars of the northern Caucasus,[43] Borodin had been the last to take his place among the Mighty Handful, and unlike Rimskii-Korsakov and Musorgskii he never set his original calling aside. A renowned professor of chemistry at the Imperial Academy of Medicine, he called himself a "Sunday composer," and was well known for once having said that he could write music "only when I am too unwell to give my lectures [in chemistry]."[44] Yet he was in fact as devoted to music as to science, and he pursued both with equal passion. "When I came to visit, I often found him working in the laboratory that adjoined his apartment," Rimskii-Korsakov remembered. "He would go with me to his apartment," he continued, "where we would play or discuss music until he would suddenly jump up and run back to the laboratory to make certain that something had not burned out or boiled over. Then he would come back and we would proceed with the music or our interrupted conversation."[45]

Absentminded and generous to a fault, Borodin lived amidst a sea of disorder brought on by his wife's readiness to offer shelter to all living things and his own inability to refuse anyone a favor. Begging relatives, impecunious friends, do-gooders seeking support for their favorite charities, and students in quest of a sympathetic ear all crowded into Borodin's apartment, which was filled with an assortment of stray cats that his wife habitually collected from alleys and nearby doorways. Anyone could appear at any hour and drag him away from a dinner that he would have forgotten to eat had it not been put in front of him. Details of daily life simply did not concern him, yet it was precisely the time required to sat-isfy the requests of acquaintances and friends for favors, and the hours con-sumed by meetings at the Academy of Medicine that sapped his energy and left him with too little time to work on either of the endeavors to which he had given his heart. When he died at the beginning of 1887, Borodin's one great opera, *Prince Igor*, remained unfinished even though he had been working on it for al-most twenty years.

Borodin wrote his first composition—a polka—at the age of nine in 1842. Not long afterward, he chose the course of study that would make him a doctor of medicine and chemistry before he turned twenty-five, but he continued to com-pose songs and piano pieces, several of which reflected his passion for the new national music with which Glinka had just enthralled the Russians. He went on to study chemistry and music in Europe, where he spent the better part of three years in Heidelberg, Paris, and Pisa before returning to his new position as a pro-fessor at the Imperial Academy of Medicine in the fall of 1862. A month or so later, a friend arranged his first fateful meeting with Balakirev. "It seems that I was the first to tell him what his real calling was—composition," Balakirev later wrote. "Until our meeting," he added, "he had thought of himself only as a dilet-tante."[46] Dedicated to creating authentic, national Russian music, Borodin—like Cui, Musorgskii, and Rimskii-Korsakov before him—soon became part of Bal-akirev's inner circle.

As had happened with Musorgskii and Rimskii-Korsakov, Balakirev's enthusi-asm spurred Borodin to greater efforts. He finished his First Symphony in the fall of 1866 and wrote *The Valiant Knights*, a parody of European grand opera, just a year later. Then, like the rest of the Mighty Handful, he began an opera, choosing as his subject the ill-fated campaign that Prince Igor had waged against the nomadic horsemen who had ridden out of Asia in the spring of 1185. The topic had much in common with the work that such Peredvizhnik painters as Surikov were soon to produce, and it fitted well with the revived interest in his-tory that the era of Great Reforms had stirred. Larger than life and boldly con-ceived, *Prince Igor* offered Borodin the perfect vehicle to develop his talents as he set out to tell the tale of the prince's terrible defeat at the hands of invaders from the steppe, his days of captivity among them, and the daring escape that re-turned him to his wife and kingdom.[47] "Bold outlines only are necessary," he wrote as he planned the dramatic tapestries that would form its libretto.[48] Then, in seeking to revive a defining moment in Russia's ancient past and strengthen

the ties that bound the Russians to it, Borodin created some of the most beautiful music ever written in Russia.

Borodin's habit of setting *Prince Igor* aside in favor of his scientific studies condemned his friends to eighteen years of never-ending vexation. After five years of reading Russia's ancient chronicles and working to shape a libretto that he never managed to finish, Borodin wrote the opera's first number—the "Polovtsian March"—at the end of 1874, and then went on to compose the "Princess Iaroslavna's Lament" a few months later. The "Polovtsian Dances" and the First Act's Chorus came into being at the end of the following summer, but then work in his laboratory and at the Academy of Medicine halted all progress. When a bout of influenza kept him at home during the Christmas holidays of 1875, Borodin wrote the opera's "Chorus of Praise," which Cui described as "superlative" and which Stasov called "a work of genius" when it was first sung at a concert in St. Petersburg that spring. Yet, if the praise pleased Borodin, it seemed to depress him, too. "I am a composer in search of anonymity," he wrote to a friend. "Now . . . everybody knows that I am writing an opera. There's no getting around it," he concluded. "Like it or not, now I shall have to finish it."[49]

Then Borodin did nothing more on *Prince Igor* until one day in the fall of 1876, when a flood in the Moscow River forced him to postpone his return to St. Petersburg. That afternoon, his wife remembered, "he sat down at the piano, and Iaroslavna's Arioso, 'How dreary is everything around me,' poured forth in its entirety."[50] In odd moments during the fall and winter, Borodin wrote the duet that Iaroslavna and Igor sang in the Fourth Act. He did nothing more until the fall and winter of 1877, when he composed the cavatina that Igor's son Prince Vladimir was to sing in the Second Act and the duet between Vladimir and the daughter of the Polovtsian khan. At the end of the next summer, he composed some of the music for Act One, but he did not write the Prologue until the fall of 1883. Problems with his wife's health, whining relatives, and a host of other distractions continued to pull him away. By the spring of 1885, the work had dragged on for so long that Rimskii-Korsakov offered to help him with the piano arrangements and orchestration.

Almost two years later, the opera still remained unfinished. Then, on the evening of February 15, 1887, Borodin died at a fancy-dress ball, when an aneurysm burst in one of the arteries that led from his heart.[51] When Rimskii-Korsakov and Aleksandr Glazunov completed the opera that Borodin had left unfinished, *Prince Igor* became one of the greatest works of modern Russian music and the first of the great Russian national operas that would earn international acclaim. Among the Mighty Handful, no one else had yet created music of such consistently high quality. "No musician," a critic later wrote of Borodin's comparative handful of works, "has ever claimed immortality with so slender an offering. Yet," he concluded, "if there be, indeed, immortalities in music, his claim is incontestable."[52]

While the dynamic, unorthodoxly trained Mighty Handful struggled to create

in St. Petersburg national Russian operas that would claim a place among the masterpieces of the modern world, the fragile and morbidly introspective Petr Ilich Chaikovskii worked toward the same end in Moscow. A passionate nationalist who had managed to win Rubinstein's favor as a student at St. Petersburg's Conservatory, Chaikovskii was thoroughly European in his training while remaining Russian to the core. "I passionately love Russians, the Russian language, the Russian mind, the Russian style of beauty, and Russian customs," he once confessed. "I am a Russian in the fullest sense of the word."[53] Chaikovskii, Igor Stravinskii added, "drew unconsciously from the true, popular sources of our race" perhaps more than any other Russian composer.[54] In his passion for his native land, he created the music that symbolized Russia to the world's audiences for all time to come.

Chaikovskii believed that music came from hard work, not raw inspiration. "One must always *work* rather than wait for inspiration," he insisted. "If one waited for the *mood* to strike without going half way to meet it," he added, "one would very easily become *lazy* and *apathetic.*"[55] As the composer of eleven operas, three ballets, six symphonies, and nearly a hundred other works, Chaikovskii could never be accused of sloth. Yet, if he stood out as one of the most industrious of his contemporaries, his music also became some of the most misunderstood. After sweeping Europeans and Russians off their feet in the 1880s and 1890s, his creations came to be dismissed as frivolous, overly emotional, and trite by critics who favored the avant-garde of the early twentieth century. "It is customary not to criticize Chaikovskii's music but to sniff at it," a leading commentator wrote on the eve of the Second World War. "To confess a liking for it in these days," he concluded sadly, "is almost equivalent to an admission of bad taste."[56] Only more recently have critics come to appreciate the full virtuosity and power of Chaikovskii's compositions. "The Finale alone," two of his biographers wrote of his Sixth—and last—Symphony, "was so original that musicians were to ponder it for years to come. It cannot be improved upon," they concluded. "It is unique."[57]

Born four years before Rimskii-Korsakov in the out-of-the-way Russian mining town of Votkinsk, Chaikovskii set out to become a government official until three years of service as a junior clerk in the Imperial Ministry of Justice convinced him to follow his heart and join the first class of students in Anton Rubinstein's newly founded Conservatory. For something more than three years, he bore the sting of his mentor's caustic tongue, and then, as he prepared to graduate, found that Rubinstein had recommended him for a position at his brother's new conservatory in Moscow. At the beginning of 1866, the twenty-five-year-old Chaikovskii left St. Petersburg to become a professor of harmony in the most Russian of all Russian cities.

In Moscow, the sensitive Chaikovskii reconciled his European training with the Russian patriotism that lay so close to his heart. When they met for the first time in 1868, he accepted Balakirev's generous offerings of help and friendship, yet he took pains to keep a distance from the man who had insinuated himself so

deeply into the lives of Musorgskii, Rimskii-Korsakov, and Borodin. "For some reason, I just cannot get into full sympathy with him," he confessed to a friend. "His company would weigh upon me like a heavy yoke if I lived in the same city as he."[58] Nor did Chaikovskii take to heart all of the advice that Balakirev thrust upon him. Balakirev had found the conclusion of *Romeo and Juliet* too harsh and continued to complain about it even after it had been revised. "The ending is not bad, but what is the point of the unexpected sharp chords in the very last bars?" he asked in a letter at the beginning of 1871. "This goes against the sense of drama," he warned, "and lacks grace at the same time."[59] Yet here Chaikovskii's genius had moved well beyond Balakirev's more limited vision. "Their succession of fierce tonic chords harshly recalls that fatal feud on which these young lives have been broken," Chaikovskii's preeminent biographer wrote of the bars that ended *Romeo and Juliet*. "Through them," he explained, "Chaikovskii drove home the fatalism of a musical masterpiece, which is likely to remain unsurpassed as an expression of young and tragic love."[60]

When it was first performed in 1870, critics cheered *Romeo and Juliet* as Chaikovskii's first true masterpiece, but his work did not regain that level of brilliance until 1877, the year in which he suffered the most devastating crises of his life. The year began badly, when grotesque mismanagement by the Bolshoi Theater in Moscow turned *Swan Lake* from a brilliant innovation, in which Chaikovskii had given the world its first ballet music of true symphonic proportions, into a dismal failure. But the personal disaster that awaited Chaikovskii later that year exceeded even the pain that followed his ballet's ill-starred debut.[61] Not long after the *Swan Lake* debacle, he wed an unbalanced young woman he barely knew in a desperate attempt to deny his homosexuality. Married in the middle of July, he fled in unconcealed horror at the beginning of October, after wading into the icy Moscow River in the middle of the night in the hope of contracting pneumonia and ending his life. Only after his brother spirited him away to Switzerland and arranged for him never to see his wife again did Chaikovskii begin to recover from the nervous collapse that had so overwhelmed him.[62]

During these months of psychological torment, Chaikovskii's personal fortunes suddenly improved, for just a few months after her fled from marriage, he established a relationship with Nadezhda von Meck, a wealthy widow who preferred to admire him only from afar. Determined to avoid physical intimacy at all costs, Chaikovskii and the woman who was to become his benefactress for the next thirteen years communicated only through letters that allowed each to see the other as a fantasy figure entirely untainted by reality. For Madame von Meck, the intimate confidences that poured from Chaikovskii's letters allowed her to derive intense emotional satisfaction from his music. In return, she bestowed upon him the independent income he needed, and her readiness to share wealth and passion at a distance proved to be his salvation. In the coming year and a half, two great new creations blotted out the catastrophes of 1877 and elevated Chaikovskii to the pinnacle of artistic achievement that he would occupy until his death.

Throughout the terrible crises of 1877, Chaikovskii had found refuge in his work on *Eugene Onegin* and his Fourth Symphony in F Minor. He had begun his opera midway between the *Swan Lake* debacle and his ill-fated venture into marriage, had sketched out nearly two-thirds of it during the summer, and had finished the rest in Switzerland and Italy while recovering from his nervous breakdown. As he would in his last great opera, *The Queen of Spades*, he shaped his libretto from a work by Pushkin, this time the "novel in verse" in which the poet had portrayed the failings of the Europeanized culture that had dominated Russia during the years after Napoleon's defeat. Romantic in the manner of Byron, cynical, aloof, and so absorbed in his own worldliness that he destroyed his one true chance for happiness, Onegin had stood at the center of Pushkin's portrait of an aristocratic society that had passed beyond its Golden Age into an era of decline. Now Chaikovskii thrust Tatiana, the woman whose love Onegin had spurned and then desired, into the opera's center. "I am in love with Tatiana," he confessed to his brother,[63] and that love—idealized and insulated from reality in the same manner as his growing intimacy with Madame von Meck—kindled the flame that illuminated the entire opera.

Chaikovskii filled his opera with tender melodies and touching "lyric scenes"[64] that elevated his heroine's love for Onegin to a higher plane. Intimate and finely wrought, the music called forth haunting visions of a bygone age, of faded memories brought suddenly to life, which stirred the remembrance of loves lost or long forgotten. From Chaikovskii's intimate vision, *Eugene Onegin* emerged as an opera of moods into which the composer wove all the musical forms of Romance to explore the emotional lives of his heroes. "If ever music was written with sincere passion, and with true love for the subject and the main character alone," he confided to a friend, "then that is the music for Onegin. I trembled with inexpressible delight when I wrote it," he confessed. "If those who hear it will experience even the smallest part of what I felt when I was writing this opera—then I will be truly pleased indeed and can ask for nothing more."[65]

Could such idealized love be portrayed by the leading singers of the Mariinskii and Bolshoi operas, who attained the pinnacle of success only after they had passed thirty and turned toward forty? Thoughts of middle-aged Tatianas and balding Onegins tormented Chaikovskii when he contemplated his opera's Romantic duets and dreamy, caressing music. "Where shall I find a Tatiana as Pushkin envisioned her and as I have tried to portray her in my music?" he asked. "Where shall I find that artist who can even approach the ideal of Onegin?" To Madame von Meck he complained that "Pushkin's charming picture will be falsified by veteran actors and actresses who will, without any shame whatsoever, play . . . the parts of sixteen-year-old maidens and beardless youths!"[66] Once again the Romantic vision and the ravages of middle age threatened to clash in the perennial dilemma from which Byron and Pushkin had been spared by their early deaths. *Onegin* required a small, intimate theater and singers who were handsome, beautiful, and young—a combination that directors still rarely achieve.

If *Onegin* summoned forth what Chaikovskii once called "the agony and the perfect bliss of love,"[67] his Fourth Symphony in F Minor centered upon the power and meaning of Fate. "This is that inexorable force, which bars the impulse to happiness from attaining its goal, [and] which jealously makes certain that peace and happiness shall never be complete or serene," he wrote to Madame von Meck. Fate, he added, was an awesome force. "[It] hangs above your head like the sword of Damocles and . . . can never be overcome. You can only reconcile yourself to it," he concluded, "and yearn fruitlessly."[68] Because he wrote much of his Fourth Symphony while struggling to regain his emotional equilibrium after fleeing from his marriage, it became, as one of his biographers wrote, "a true piece of emotional autobiography."[69] It flowed from the heart and soul of a man shattered by the realization that he could never establish the human bonds that society regarded as normal, but who remained hopeful that, even if his way of life would never yield heirs in the traditional sense, his music might create an even greater legacy.

Thanks to the generosity of Madame von Meck, Chaikovskii resigned his post at the Moscow Conservatory in the fall of 1878 and lived the rest of his life in Europe, Moscow, and the Russian countryside. Except for concert tours that took him abroad, he spent most of the years after 1885 in three modest country villas in the vicinity of Klin, a town of seven thousand people that sat astride the railroad, where he could live in solitude within an easy two-hour journey by train to Moscow.[70] After the turmoil of Russia's old capital, the first of Chaikovskii's rural retreats seemed to be a dream come true. Called Maidanovo, it stood atop a bank overlooking a small river, and it was there that the composer sought the isolation he needed to create some of his greatest works. "How wonderful . . . this freedom is!!!" he wrote to Madame von Meck, after she agreed to pay the thousand rubles' annual rent. "What a delight it is to be in my own home! What bliss to know that no one will come and bother my work, interfere with my reading, or interrupt my walks! Now I understand," he concluded, "that my dream of spending the rest of my days in the Russian countryside is not a passing fancy, but a fundamental part of my being."[71] First at Maidanovo, then at Frolovskoe, and finally at a small villa in the outskirts of Klin itself, Chaikovskii found the peace he had craved for so long. There, in less than eight years, he wrote *The Queen of Spades*, *Sleeping Beauty*, two ballets, and two symphonies, including his last and greatest—the Sixth Symphony.

Ensconced amidst the birches and rolling hills of the Russian countryside, Chaikovskii lived in isolation while he worked, and joined the company of friends when he felt the need for companionship. The mornings during which he composed were precious, and the early afternoons, when he took the walks on which he created the melodies he later worked into his compositions, more treasured still. He shared them with no one. "P. I. Chaikovskii," a small engraved metal plate attached to his doorway read. "Guests received on Mondays and Thursdays from three o'clock in the afternoon until five. Otherwise, not at home."[72] Only in the evenings did he allow friends to enter his life, when he

dined with his house guests and shared with them his thoughts and the wine that flowed so freely at his table. "For me, a man harassed with nerves, it is simply impossible to live without the poison of alcohol," he confided to his diary a little more than a year after he settled at Maidanovo. "Every evening," he confessed, "I am drunk, and cannot live otherwise."[73]

Chaikovskii's confession made it clear that there were dark clouds, even at Maidanovo. He found it painful to conduct his own works in public and suffered perpetual torment from the politics that ruled the world of music at home and abroad. Each and every one of the problems his brothers, sisters, nieces, nephews, and friends faced over the years intruded upon his contentment, and a flood of letters in 1886 reminded him that his estranged wife still remained in the shadows of his life. "[She] now proposes that I should experience with her the supreme delights of life," he wrote to his brother that summer. "Of course, she can't force me to live with her and there is no danger in her attempts at reconciliation—but all the same, it is incredibly painful."[74] At the end of the summer, he agreed to pay his wife an allowance through his publisher on the condition that there be no further contact between them. Then he returned to his work and to the solitude punctuated by visits from the friends whose company he so much enjoyed.

After returning to Russia from a tour of Europe in the spring of 1888, Chaikovskii moved from Maidanovo to the tiny village of Frolovskoe just a few miles away, where the crowds of summer visitors did not venture and where peace was easier to find. That summer, he finished his Fifth Symphony, and then left on another European tour that took him to Paris, London, Geneva, and half a dozen German cities during the late winter and early spring. He carried with him a sketch for a new ballet that the Director of the Imperial Theaters wanted to have based on the fairy tale of *Sleeping Beauty* and staged in the style of Louis XIV, "with melodies written in the spirit of Lully, Bach, and Rameau."[75] Chaikovskii had responded with enthusiasm. "It suits me perfectly," he exclaimed after reading the proposed scenario. "I am absolutely carried away with it."[76] This time, he would work with Marius Petipa, Russia's newly discovered genius of choreography, who would make the ballet's performance as brilliant as that of *Swan Lake* had been lackluster. "I think that the music for this ballet will be one of my best works," he confided to Madame von Meck at the end of July. "The subject is so poetic, so musically rewarding," he added, "that I have been completely caught up in writing it."[77]

Finished a month later, Chaikovskii's *Sleeping Beauty* was performed at the Imperial Mariinskii Theater at the very end of 1889. Although the ballet had its critics, some of whom lamented that its subject had been taken from a foreign tale, others acclaimed it as "a triumph of that art in which music, dance, and painting are combined."[78] But it was one of Chaikovskii's close friends who made the most telling point of all. Chaikovskii, he wrote, had become the most Russian of all Russian composers. "The internal structure of the music," and above all "the foundation of the element of melody," he concluded, were

fundamentally and "undoubtedly" Russian.[79] Although cast in a foreign setting, the music of Russia's villages shone through to project a feeling of Russianness that overcame the alien elements of time and place. One could shut one's eyes, imagine a Russian prince and princess, and be brought back to the time of Louis XIV only when one repoened one's eyes and looked again at the stage.

Even as the newspapers of St. Petersburg debated the merits of *Sleeping Beauty*, Chaikovskii's thoughts had already shifted elsewhere. "I very much want to work," he wrote to Madame von Meck as the new year approached. "If it turns out that I can find some little corner abroad I think that I shall cope with my task very well."[80] He found his "little corner" in Florence, the center of the Italian Renaissance, in which he began to compose the most purely Russian work he had written since *Eugene Onegin*. Never had the music come so quickly and never had he been more satisfied with the result. Within six weeks, he had sketched all of *The Queen of Spades* and become identified so closely with its unheroic hero that he wept as he composed his death scene at the opera's end. "I pitied Hermann so much that I suddenly burst into tears," he confessed to his brother. "I think that this warm and animated relationship with the opera's hero has had a good influence on the music."[81] Planned to be the grand attraction of St. Petersburg's 1890 opera season, the fate of Chaikovskii's new opera seemed certain. "Unless I am terribly mistaken," he confided not long after he finished, "*The Queen of Spades* will be my masterpiece."[82]

As one of Pushkin's finest prose works, *The Queen of Spades* has been described as "a masterpiece of concentration . . . as tense as a compressed spring," in which each carefully chosen detail highlights the finely chiseled lines of the poet's characters.[83] As he had done in *Eugene Onegin*, Chaikovskii added new dimensions to Pushkin's vision that made *The Queen of Spades* the most powerful and disturbing of his operas. Cynical greed, tragic love, love overwhelmed by obsession, macabre reminiscences, and outright madness crowded its scenes with emotions so tangled and intense that even Chaikovskii did not always resolve or even fully understand them. As a work of art, *The Queen of Spades* marked the conclusion of much that the composer had tried to accomplish at the same time as it showed (in the words of his leading biographer) "his increasing preoccupation with emotions bordering on hysteria, and . . . a darkening of his orchestral palette." *The Queen of Spades* seemed to hold the key to the future. In it, "the clouded, tormented world" of Chaikovskii's Sixth Symphony could be "distinctly foreheard."[84]

Chaikovskii returned to Russia in the spring of 1890 intending to enjoy the wooded paths of Frolovskoe, only to find, as he wrote to a friend, that "*all the woods, literally all,* have been cut down, and . . . there is *nowhere* to go for a walk!"[85] Briefly, he returned to Maidanovo, but found it "very gloomy" and "more and more objectionable." Finally, in the spring of 1892, he moved to the nearby outskirts of Klin, where there was "a wonderful view," and a "peaceful, quiet place" to work. "I feel much more at home here," he wrote to one of his brothers. "There are lots of walks, and living on the main road is very convenient

because I can go for walks even in the rain without drowning in mud." Happy to have left "rotten old Maidanovo,"[86] Chaikovskii set to work only to be dealt another crushing blow by a now lost letter from Madame von Meck, which evidently announced that she no longer could provide the allowance that she had paid with such generosity for the past thirteen years. "I was disagreeably struck and surprised [for] she had written so many times that I was guaranteed this subsidy to my dying breath," he told his publisher. "Now I shall have to live quite differently, on a different scale [and] . . . I am very, very, very hurt." Although his royalties from *The Queen of Spades* soon more than replaced the money that his patron could no longer send, Chaikovskii continued to see cruelty in her act. "My pride is wounded," he confessed. "My confidence in her unbounded readiness to support me materially and bear every kind of sacrifice for me has been deceived."[87]

Plagued by feelings of abandonment and the fear that he was "played out and . . . dried up," Chaikovskii returned to Klin from a triumphal concert tour in Europe and the Black Sea port of Odessa in February 1893.[88] "What I need is to believe in myself again," he wrote to his brother. "My faith has been greatly undermined [and] it seems to me my role is over."[89] He had already destroyed the symphony he had begun the previous autumn after concluding that it had "nothing remotely interesting or attractive about it," and he now set to work on something entirely new. "Whilst I was on my travels I had an idea for . . . a program symphony, but the program will be left as an enigma," he explained to a nephew to whom he often confided his innermost thoughts. "This program is so intensely personal," he continued, "that as I was mentally composing it on my travels I frequently wept copiously."[90] As soon as he reached Klin in the middle of February, the new symphony gushed forth. "The work went so fast and furious that I had the first movement completely ready in less than four days," he wrote just a week after his return. "The remaining movements are already clearly outlined in my head," he went on. "You can't imagine what bliss I feel, being convinced that my time is not yet passed and I can still work." The new symphony, he promised, would have "much formal innovation" and a finale that would "not be a noisy Allegro but, on the contrary, a long drawn out Adagio."[91] In less than two months it was all finished except for the orchestrations. Sufficiently grief-laden to earn the title *Pathétique*, this Sixth Symphony was to become a work of unmatched expressive richness.

Before Chaikovskii began to score his new work, another concert tour drew him away. "Is it not indeed strange that I voluntarily submit myself to these torments?" he asked his nephew not long after he had left Klin. "Not only do I suffer from a misery which cannot be put into words (there is a passage in my new symphony which does, I think, express it well)," he added, "but I also suffer from a hatred of other people."[92] As soon as he returned to Klin in the summer, he finished scoring what he had composed several months before. "I definitely consider it the best and especially *the most sincere* of all my works," he wrote. "I love it as I have never loved any of my other musical progeny."[93] By the end of

August, the scoring was done. "I have honestly never in my life," he wrote to his publisher, "felt so pleased with myself, so proud, so happy in the knowledge that I really have written something good."[94]

The symphony in which Chaikovskii took such delight began in a mood of deep pathos, rose to a moment of shattering violence at the end of its third movement, and then slowly and inexorably descended into the dark, subterranean realm whence it had come. It marked the composer's moment of absolute mastery, in which "the method, the form, [and] the ethos were as personal as the musical invention and the expressive experience which shaped its structure."[95] Of the power of Fate and the triumph of Death there could be no doubt, and death was much on Chaikovskii's mind as he scored its final bars. "They are burying my old friend and colleague," he lamented. "So many of my old friends are dying."[96] Yet Chaikovskii's brother thought that it was at precisely this point that death had "become less terrible, mysterious, and frightening" for the man who had formerly been driven to despair by the passing of even a single friend or colleague. "You felt now," he wrote, "that he would not travel several hundred kilometers, as formerly he had done . . . just to see a friend before the eternal parting."[97]

While Chaikovskii contemplated Fate, life, the future, and Death during the spring and summer of 1893, the pain and prejudice of late imperial Russia began to close more tightly around him. In mid-October, he conducted the premiere of his Sixth Symphony in the Assembly Hall of the Nobility in St. Petersburg. Nine days later, on October 25, he was dead. Although it was said that he died from cholera, it now seems certain that Chaikovskii poisoned himself, probably in complying with a sentence handed down by a court of honor that his former schoolmates had convened when a high-ranking official threatened to expose his homosexuality to the Emperor, stain the honor of their school, and create the very sort of scandal that the composer feared most.[98] Three days later, he was buried near Musorgskii and Borodin at the Aleksandr Nevskii Monastery after a huge state funeral that Alexander III himself had ordered. "We have many dukes and barons," the Emperor reportedly said as he watched the tens of thousands bid farewell to Russia's great composer, "but only one Chaikovskii."[99]

Now, only Cui, Balakirev, and Rimskii-Korsakov remained of the men who had vowed to express the true meaning of Russia in music. Thanks to those who had died, Russian national music had come into its own, and the songs of the people had been elevated into the high realm of the fine arts. Chaikovskii had spoken in the name of the people. So had Glinka, Musorgskii, Borodin, and, of course, Rimskii-Korsakov. Yet others also spoke the people's name—and with similiar force and passion. In painting and literature, too, the decades that followed the Emancipation of the serfs saw a rising passion for Russia's masses that drew them into the very center of the world of art. As painters, writers, and composers all spoke in the name of the people, they broadened their nation's artistic experience beyond all imagining.

# ART IN THE
# NAME OF
# THE PEOPLE

❦

*DURING THE LAST THIRD* of the nineteenth century, the number of men and women who took part in the Russian artistic experience grew more rapidly than at any time since the art of writing had come to ancient Kiev. By the tens of thousands, Russians were learning to read in those days, and as the population of the empire's cities quadrupled between 1850 and 1900, so did the audiences for painting and music. With the provision that it be kept open to the city's residents, Pavel Tretiakov presented the gallery in which he housed his collection of nearly two thousand great Russian paintings to the city of Moscow in 1892, and not long afterward the merchant magnate Sergei Shchukin began to admit the public to his superb private collection of modern European paintings on Sunday mornings. At the beginning of the new century, there were three museums in St. Petersburg that displayed spectacular collections of paintings to public view, and there were well over a dozen theaters at which men and women with the price of a single admission could enjoy plays, ballets, operas, and concerts. Every provincial capital had its theater. Even in far away Siberia, public subscriptions from the civic-minded citizens of Irkutsk built an opera house at a cost of two hundred thousand rubles at a time when the city had neither paved streets nor sidewalks.

Russia's growing audience for art, literature, and music was in part a product of its people's liberation. When Turgenev had published his *Hunter's Sketches* in 1852, fewer than one Russian in five had been free. Twenty-two million men, women, and children had lived as serfs of the empire's aristocrats in those days, and nearly twenty-eight million more had worked on lands owned by the

imperial treasury and the royal family. Unfree men and women had tilled Russia's soil, fed its people, created its wealth, and fought its wars, but they had had no power over their lives or the world in which they lived. Then, starting with Emperor Alexander II's Emancipation Proclamation in 1861 and continuing through the 1860s and 1870s, these millions had gradually become free. Russia in the last third of the nineteenth century thus became a country of newly freed masses that had to be integrated into the fabric of a society in which only a comparative handful had been able to enjoy the benefits that life had offered in earlier times.

Some believed that these newly liberated masses had the potential to enrich Russian life by bringing an untapped reservoir of raw new talent to industry, science, and the arts. During the first half of the nineteenth century, businesses built by the Morozovs, Riabushinskiis, and Alekseevs had enabled their serf founders to buy their freedom at prices that soared into the tens of thousands of rubles, and such giants as Voronikhin, Kiprenskii, and Tropinin were only the most prominent examples of once-enserfed men and women who had enlivened the cultural life of Russia's cities and provinces. But many of the lords and ladies whose family histories bore scars from the fearsome "peasant wars" of the seventeenth and eighteenth centuries feared that the *narod* might once again unleash the raw power that had ravaged the Russian countryside in earlier times. Did the promise shown by a comparative few justify leaving the rest free to pursue their destinies in any way they saw fit? Or was it necessary to establish new institutions that would limit the freedom of newly emancipated serfs to live and move as freely as they wished?

Many defenders of the old order preferred not to face such questions about the role of the people in shaping Russia's future. Yet how those questions were answered held the key to the way in which Russia's economic and political life would develop in the century ahead, just as the form in which artists, writers, and composers elevated the people's art, songs, and oft-told tales into the realm of the fine arts would determine the shape and content of the nation's artistic experience for a long time to come. If Russia's artistic experience was to become truly national, a way had to be found to bring the sights, sounds, and words that Russia's masses cherished directly into its mainstream by elevating the arts of the people into the realm of the fine arts.

Russia thus approached the end of the nineteenth century as a land of unresolved and growing contradictions, in which a rising new order that required the masses to make it whole stood at odds with a declining old order in which lords and ladies who had once been the focus of the people's labors struggled to come to grips with a dynamic, modern way of life. At a time when money made in railroads, trade, and manufacturing made it possible for men and women who had once been poor to live comfortable, even affluent lives, there were fortunes to be made in the world of art as well. Ilia Repin's rise from rags to riches represented an early example of a lower-class artist who had escaped from poverty, and Maksim

Gorkii would soon become another. In late-nineteenth-century Russia, it became possible for the first time for men and women to live by their pens and brushes, and that single fact helped to further enrich the nation's artistic experience.

New representations of the contradictions that tore at the fabric of Russian life flourished in Russia's world of art as the century drew to a close. Anton Chekhov's short stories and plays presented the confrontation between old and new as a central fact of turn-of-the-century life, while Maksim Gorkii's novels highlighted the struggle of newly freed men and women to escape society's lower depths. In a symbolic sense, the raw power portrayed in Gorkii's novels struggled to push aside the twilight world of Anton Chekhov's plays, but the confrontation was more complex and disorienting than any rivalry between old and new had been in earlier times. Under the impact of the Emancipation, the Industrial Revolution, and a new rivalry with the West, the values that had held Russian society together were breaking apart, yet nothing immediately appeared to take their place.

For a time, Russia's thinkers, writers, and painters turned away from God to the certainties of science, only to find that the material world lacked the spiritual comfort that their abandoned belief had provided. As they searched for new directions, Russians struggled to find new values. Some responded by holding on to the past, while others sought to sweep aside all old landmarks so as to move into the future with the greatest possible speed. Either course set people adrift. Among some of the upper classes after 1900, a desire to live only in the present and burn the candle at both ends became a way of compensating for a future that seemed too uncertain to contemplate, while a growing sense of frustration at not being able to share in the wealth that their labor produced led the lower classes to anchor their vision of the future in revolutionary propaganda.

This struggle to find new directions formed Russia's writers, painters, and composers into an avant-garde whose sense of the future was clouded with apocalyptic images. It was no accident that apocalyptic literature was more plentiful in Russia than anywhere else in Europe on the eve of World War I, or that Promethean visions pervaded the controversial, modern music of Skriabin and Stravinskii. As Russia moved through the Revolution of 1905 toward the outbreak of the First World War in 1914, the clear images that had dominated the paintings of Repin and shaped the novels of Dostoevskii and Tolstoi turned dark and murky. In 1870, Dostoevskii's St. Petersburg had been a city of striking, sharply defined, never-ending contrasts, while the St. Petersburg of Andrei Belyi in 1912 overflowed with shifting, fog-sodden specters that had neither definition nor clear direction.

Russia's rulers, statesmen, and artists all had to take into account that the struggle of the newly freed *narod* to come to grips with the modern world underlay the ominous images that darkened Russian life. A way had to be found to bridge the chasm that the secular revolution had opened between the upper classes and the masses 150 years earlier, and that required understanding how

the people lived, what they aspired to accomplish, and to whom they would give their loyalty. Thousands of Russian artists, writers, composers, doctors, and observers of society therefore went to tens of thousands of villages between 1850 and 1900, and what they discovered gave their view of the masses a solid factual base for the first time. That in turn led to dramatic changes in the way in which they presented the people in painting, literature, and music.

As newly trained teachers, midwives, doctors, and agronomists made their way into the countryside to meet the needs of people who had never had medical treatment or seen a printed page, their observations spurred the men and women who shaped Russia's artistic experience to replace the images of the gentle, Arcadian world that the upper classes had created in earlier times with accounts of the suffering that the masses continued to endure. Certain that fact had to take the place of the Romantic images that had described the peasants in earlier times, the poet Nikolai Nekrasov spoke his first eloquent words about the dull agonies that reigned in Russia's villages more than a decade before Repin painted his "Volga Barge-Haulers." "O how bitterly I sobbed / When I stood / On the banks of my native river, / And, for the first time called it / The river of bondage and anguish!" the young poet wrote of the childhood he had spent near the Volga River.[1] For him, the river's barge-haulers stood as monuments to the suffering that condemned generation after generation of Russia's common people to the grave at forty and offered no hope for a better life.

Born into a family of provincial nobles who had settled on the upper Volga River in the province of Iaroslav, Nekrasov grew up among household servants, his father's unwilling serf mistresses, and the children of the peasant village that stood near the family manor. A contemporary of Turgenev and Tolstoi, he knew all too well the pain of the system on which his family depended for its wealth, but unlike them he broke with tradition and followed a different path. Without a kopek to his name, he went to St. Petersburg at the age of seventeen, lived among the poorest of the poor, and kept himself alive by doing odd jobs in the city's slums.[2] For the better part of three years, he struggled to bring his dream of becoming a writer into focus as he labored to survive among St. Petersburg's ragged throngs. His first pamphlet of poetry, called *Dreams and Sounds,* sold not a single copy when it appeared in 1840, but his belief in himself remained firm.[3] "I vowed to myself," he wrote, "that I would not die in a garret, that I would win through, and become successful at any cost."[4]

The next year, Nekrasov's fortunes changed. He met Ivan Panaev, a rich nobleman, writer, and publisher, who introduced him to Belinskii, the impassioned literary critic whose essays had set Russian literature upon the course it would follow for half a century. To make his way among the elegant aristocratic writers into whose company his new acquaintances brought him, Nekrasov published a series of successful literary almanacs, containing essays by writers whose talents stood several rungs below Gogol's, but whose satirical comments about the dark corners of life in Russia's capital found a ready audience. In 1847, Panaev invited Nekrasov to join him in editing *The Contemporary*, the progres-

sive literary journal he had purchased the year before and that Pushkin had founded just before his death.[5]

Panaev had just convinced Belinskii to leave the better-known *Notes of the Fatherland* and write only for his journal, and the two men soon used Belinskii's popularity to draw some of Russia's leading young authors to *The Contemporary*'s pages. During his first decade as its editor, Nekrasov published Tolstoi's *Childhood* and Turgenev's *Hunter's Sketches*, not to mention the essays of Belinskii and his successor Nikolai Chernyshevskii. As Russia moved into the era of Great Reforms, *The Contemporary* pointed the way with essays that championed the emancipation of the serfs, the liberation of women, and the opening of the Russian press to debates about questions of broad national importance. By 1857, its circulation had tripled to six thousand, and it had more than twice as many subscribers as any of its competitors.

Nekrasov's reputation grew along with that of *The Contemporary*, and so did his passion for old wine and young women. On the verge of becoming well-to-do, he won the heart of Panaev's wife Avdotiia, who became his confidante, friend, assistant, inspiration, and lover until well into the 1860s. Avdotiia Panaeva inspired the best of Nekrasov's love lyrics and served as the hostess of a literary salon in which the greatest writers of the day met every week. "If the roof of her living-room had collapsed on one of her Monday evenings," a critic remarked some years later, "Russian literature would have perished."[6] In part at Panaeva's urging, Nekrasov used his poems to chronicle the masses' suffering. The people's fate, the burden of their labor, and the weight of their despair all stirred his anger, and he wrote with deep, abiding grief of those men and women whose lives reflected the melancholy of the Russian landscape. Distinctly operatic, and needing to be sung instead of spoken, his poems recalled the soaring melodies of the people's minstrels, whose voices called forth memories of misery deeply buried and long endured. "A true, passionate Russian soul sounded and breathed in it," Turgenev once wrote in describing the voice of such a singer. "It seized you by the very heart, seized it right by its Russian cords."[7]

Nekrasov responded to Alexander II's liberation of Russia's serfs and state peasants by asking, "Are they happy?" For the next sixteen years, he struggled to answer that question by exploring the lives of the masses whose labor shaped the well-being of "wretched, abundant, powerful, downtrodden Mother Russia."[8] "Children Weeping" spoke of the pain and suffering that child labor inflicted on Russia's lower classes, and beckoned readers to remember "the golden days of childhood when everything is bright." Such days were not for the common people, Nekrasov wrote. In the mills, where the iron wheels never ceased to turn, the labor of children went on day and night. "Even if one dies, the cursed wheel still turns," he lamented. "Even if one dies—it hums, and hums, and hums!"[9]

Although more picturesque, life in the countryside was scarcely better than in Russia's factories. Nekrasov began his poem about "Peasant Children" with a description of the charms of rural life, but quickly shifted its focus to a six-year-old boy hauling firewood on a bitter winter day. His longer and more finely

wrought "Red-Nose Frost" showed the tragedy of life in the village, when a grief-stricken young woman froze to death in the forest, where she had gone to gather firewood after burying her husband. He used "The Railroad" to transform the nineteenth century's greatest symbol of progress into an instrument of oppression by speaking not of the dramatic material changes that the railroad promised to bring, but of the masses of corpses upon which its iron rails had been laid. Always "a merciless tsar, whose name is hunger" drove the masses to risk their lives for a crust of daily bread as they moved earth and struggled to lay track under inhuman conditions. For Russia's well-to-do, the railroad promised comfort and convenience, but for the *narod* it offered nothing but suffering and death.[10]

In 1863, Nekrasov began a poetic encyclopedia of rural life in Russia that occupied him until his death fourteen years later. Cast as a folk tale that described the wanderings of seven peasants who set out to discover if one happy person could be found anywhere in the Tsar's domains, "Who Can Be Happy in Russia?" has been called "an epic of the Russian peasant,"[11] for it blends folk songs, proverbs, and poignant observations into a rich portrait of rural life during the decade in which educated men and women first began to pay homage to the people. From one end of Russia to the other, Nekrasov's seven peasants carried their search, asking priests, merchants, tavern keepers, landowners, high officials, and great lords if any of them was truly happy, while the chronicle of their wanderings revealed the poverty, grinding labor, hunger, and deadly boredom that formed the fabric of life in the Russian countryside. Everywhere, Nekrasov's peasants found that the rich persecuted the poor, while the powerful crushed the weak and the cruel overwhelmed the gentle. Had emancipation made the people happy? And had it made their lives better? For the masses, everything went on as before, and only a fatalism born from centuries of grief and want enabled them to bear the burdens of their lives. There seemed to be little cause for joy in the world of rural Russia, but Nekrasov saw hope in the people themselves, despite their failings and ignorance. "The strength of the people / Is a force that is mighty," he wrote at the end of his chronicle, "A conscience that is clear, / A truth that is vital."[12]

Combined with a belief that Russia's civic salvation must be found in its villages, Nekrasov's poetic chronicle of the people's misery turned the attention of thoughtful Russians to the countryside. Yet a vast cultural chasm separated such people from the superstitious, ignorant, suspicious masses of whom they yearned to be a part, for the values of the intelligentsia remained European while those of the peasants continued to be unrelentingly Old Russian. To cross from one world to the other proved to be all but impossible, as Turgenev made clear in *Smoke*, a novel that examined how thinking men and women hoped to remake Russia. "If I were a painter, I should paint the following scene," Turgenev's spokesman told his listeners. "An educated man comes upon a peasant and bows low before him. 'Cure me, I beg you, dear little peasant, little father,' he says. 'I am perishing from disease.' Then the peasant in his turn bows low before the educated man:

'Teach me, O little father, master,' he says. 'I am perishing from ignorance.' Well, of course," Turgenev's character concluded, "neither one gets anywhere at all."[13] As Dostoevskii pointed out a decade later, the people continued to be whatever their admirers, apologists, or critics wanted them to be. "We all, lovers of the people, regard them as a theory and it seems that none of us really likes them as they actually are, but only as each of us has imagined them," he wrote in his *Diary of a Writer* in 1876. "Should the Russian people at some future time turn out to be not what we imagined," he concluded, "we all, despite our love of them, would immediately renounce them without regret."[14]

Whether they went to serve the people, imagine their virtues, or lead them to a better life, educated Russians discovered in the countryside the harsh truth that the people were as coarse and rude as the lives they lived. "For the first time in my life, I found myself face to face with village life," one young woman wrote. "I was lonely, weak, and helpless in that peasant sea," she confessed. "Until that point, I had never seen the true ugliness of peasant life at first hand."[15] How could the brutality of living on the precipice of survival be reconciled with the dreams that educated men and women cherished of becoming at one with the people? All too many of them discovered that the reality of life among the masses stood at odds with their utopian visions, for as one of the men who sought salvation in the countryside but found only heartache explained, "every peasant, if circumstances permit, will, in the most exemplary fashion, exploit every other."[16]

Yet, in the people's art, the people's music, and the people's literary traditions the real and ideal could be reconciled in a more limited sense. Elevated into the artistic stratosphere by Musorgskii's and Rimskii-Korsakov's operas, Tolstoi's later novels, Repin's paintings, and the more modest creations of the many men and women who worked in their shadow, folk motifs added rich new dimensions to Russia's artistic experience. At the same time, by drawing upon the modern world within which the creators of Russia's fine arts worked, the people slowly began to broaden the dimensions of their own experience by learning to read and write so as to enter the larger community of which the written word could make them a part. By the late 1880s, one out of every eight of the twenty-four million copies of books being printed in Russia each year was written specifically for adult lower-class readers.[17] Although the majority of Russians still could not read, the number who could was growing.

These new qualities of the people's experience were particularly evident in the aspirations to success that touched Russia's masses during the 1880s and 1890s. Success had not been among the serfs' concerns in the days when noble lords had owned their lives and labor, for their common response to their masters' overwhelming power had been to venture little so as to have less to lose if fate took an unkind turn. With the opening of new opportunities in the Russian countryside after the Emancipation of 1861, visions of success entered into the lives of the people for the first time, in the form of stories told in popular fiction—the Russian counterparts to America's "penny dreadfuls" and "dime novels" of the same era. As in America, wealth, education, power, and the ability to

rise above the world into which a man or woman had been born defined success, and the writers of such "kopek tales" shaped scores of plots around those themes.[18] In most cases, success came to enterprising peasants and workers in the blossoming world of business, where fortunes could be made as the Industrial Revolution took hold. Yet, for a few among the people, the arts offered the means to enter a world of prosperity such as their parents had never dreamed of. That route had led Ilia Repin to fame and fortune. Later in the century, it became the pathway to success for Maksim Gorkii, the ragpicker, river-boat scullion, and cobbler's apprentice who rose to become the most brilliant realist writer of Russia's industrial age.[19]

Gorkii began life in the throbbing Volga River trading center of Nizhnii-Novgorod as the son of a carpenter and the grandson (on his father's side) of a barge-hauler. His family name was Peshkov, and he took the name of Gorkii—meaning "bitter" in Russian—as his pen name when he published his first story at the age of twenty-three. An orphan not long after he turned ten, Gorkii set out to make his way among the lower depths of life in the river towns and seaports of Russia's South. For almost a decade, he worked as a painter of cheap icons, a baker's helper, a stevedore, and an apprentice in a dozen menial trades, while he rubbed shoulders with thieves, gamblers, murderers, cruel bosses, and gentle simpletons. As he made his way through a world in which greed, violence, and never-ending struggle for survival marked every day of life, his passion for books and learning raised him up, even though he got less than a year of formal schooling along the way. By the time he turned twenty, Gorkii had found work in a law office in his hometown, but he soon gave it up to tramp again along the riverbanks and country roads of Ukraine, the Crimea, and the Caucasus.

Gorkii celebrated his twenty-third birthday in Tiflis, the capital of Georgia, in the company of several revolutionaries with whom he had made common cause. These were men who had spoken in the name of the people during the 1870s, and one had even attempted to carry out the "will of the people" by plotting to kill high officials. After several years of penal servitude, they had been allowed to leave Siberia on the condition that they settle far from St. Petersburg or Moscow. It was to the one among them who locked him into a room and insisted that he write down a story he had told that Gorkii owed the beginning of his literary career. By the time he turned thirty in 1898, Gorkii's *Sketches and Stories* were among the best-selling fiction in Russia, and he became, almost overnight, a celebrity risen from the lower depths. Everywhere "one could see his picture—on postal cards, cigarette- and candy-boxes, and in endless cartoons," a commentator explained. "Gorkii's costume—a Russian blouse and high boots—became the vogue," he continued, "[and] in various cities there even appeared pseudo-Gorkiis, who posed as the original and tried to make use of his popularity."[20]

As the twentieth century opened, Gorkii turned from short stories to the theater. By that time, he had become a friend of Anton Chekhov, the greatest Russian playwright of the day, and his first attempt to write for the stage owed a great

deal in structure, style, and character to the dramas that had won Chekhov fame. He called his second play *Among the Dregs* (often translated as *The Lower Depths*), and with it became Chekhov's rival. The avant-garde Moscow Art Theater seized upon his work, and its directors—Konstantin Stanislavskii and the same Nemirovich-Danchenko who had reported in such detail on the coronation of Nicholas and Aleksandra—greeted it with unconcealed delight. "Here was the brilliance of fireworks," Nemirovich later wrote. Gorkii's work, he said, had become "a new tocsin to the joys of life."[21] "Gorkii is a destroyer, who must destroy all that deserves destruction," Chekhov remarked. "Therein lies his strength and his calling."[22]

First performed at the end of 1902, *Among the Dregs* brought the lower classes to the forefront of Russia's artistic experience, and forced men and women who had for so long lived in the rarefied stratosphere of the fine arts to confront the stench of poverty. Set in a *trushchoba*—a flophouse that shelters beggars, thieves, and people down on their luck—the play centers on the hopeless world of crime, brutality, and hate that infected the slums of Russia's cities. On its most obvious level, *Among the Dregs* is about life among people condemned by fate to live at the very bottom of society's pyramid, where their comings and goings are little noted and less remembered. These "creatures that once were people," as Gorkii said,[23] can escape their miserable lives only in dreams and fantasies. Some have fallen far. Others have never risen high enough to fall, but they exhibit all those human feelings and failings that more fortunate men and women forget they possess. Hopelessness reigns among them all as they live only for today in cellars and crumbling corners and think little of tomorrow. Some hold to fleeting moments remembered from pasts otherwise forgotten, while others have forgotten everything but the cares of the moment. Yet there was more to Gorkii's play than a poignant reminder that each of Russia's cities had a netherworld of which respectable men and women remained (or tried to remain) ignorant. *Among the Dregs* speaks also of good, evil, truth, and falsehood, and how those forces shape the fate of humankind.[24] "What is truth?" the character who speaks for Gorkii asks. "Lies are the religion of slaves and bosses," he exclaims. "Truth is the God of a free human being!"[25]

Despite the misery in which its characters live, *Among the Dregs* strikes a spark of hope. "Only man exists, and all else is the product of his hands and brain," Gorkii's mouthpiece explains toward the play's end. "M-a-n! It's truly splendid! The word has a proud ring to it!" he continues. "One must respect man, not pity him, or demean him." Even among the dregs, Gorkii continues, men and women have a sense of worth that hunger, want, and loneliness cannot destroy. "I've always despised people whose main goal in life is to feel satisfied," Gorkii's spokesman concludes. "Man is above that!"[26] When they heard these words audiences cheered. "There were endless curtain calls," Stanislavskii later wrote of the play's premiere. "It was funny to see [Gorkii] appear for the first time on stage . . . not knowing that he was supposed to bow to the audience and take the cigarette out of his mouth. . . . 'By God, fellows, this is success, honest,'

Gorkii seemed to be saying to himself. 'They are clapping, and how! They are yelling! Just think of it!' "[27] When published in St. Petersburg a few weeks later, forty thousand copies of Gorkii's play sold out in two weeks. Thirty thousand more were sold before the year came to an end.[28]

While Russians cheered Gorkii's play, those very lower depths of which he had written were beginning to churn, and the social and economic tensions that had shaped his characters' lives grew more threatening and intense. On Bloody Sunday, January 9, 1905, soldiers from the St. Petersburg garrison killed or wounded more than five thousand peaceful demonstrators in a roar of gunfire that changed Russia for all time. Gorkii saw how the workers of St. Petersburg marched toward the square in front of the Winter Palace that day. "The crowd reminded one of the ocean's dark billows," he wrote. "The gray faces of the people were like the turbid, foamy crests of the waves."[29] In an instant these gray, surging forms turned away from the Tsar and sought relief from their misery elsewhere. Throughout the year, other outbreaks of violence burst across Russia, culminating in October in a nationwide general strike that won a promise of constitutional government, followed by an armed uprising of Moscow's workers at the beginning of December. A new era had dawned. The people's representatives had begun to seek a voice.

The Revolution of 1905 drove Russia's writers, artists, and composers into a frenzy of creative searching and experimentation. No one could tell where the aftermath of revolution would lead, but everyone sensed that the world in which they had lived could never be the same again. With censorship all but gone, Acmeism, Primitivism, Rayonism, Futurism, Cubism, Cubo-Futurism, and Constructivism all surged to the fore in less than a decade, and the sense of impending Apocalypse that had first seized Russia's writers at the dawn of the century grew more intense. The Symbolist poet Valerii Briusov began to speak of titanic struggles, marching Huns, and "days of fire and blood" that would carry Russia's poets into the vortex of the upheaval.[30] Others turned to politics, convinced that they could no longer remain apart from the struggle that lay ahead. That applied to Gorkii most of all. Driven into exile by his open support for Lenin's Bolsheviks, he spent the better part of a year in the United States, and then settled in Capri, until a general amnesty given by Nicholas II to celebrate the Romanovs' three-hundredth anniversary in 1913 allowed him to come home.

In the United States, which he condemned as a nation in which gold "surrounds man with its web, deafens him, sucks his blood and marrow, [and] devours his muscles and nerves,"[31] Gorkii wrote the first part of *Mother*, the novel that was to stand as his affirmation of the revolutionary creed to which he had now dedicated his life. As a work of art, *Mother* stands among the crudest things that Gorkii ever wrote, yet despite its starkly drawn characters and simplistic plot, it touched the hearts and minds of millions. Translated into dozens of languages (it first appeared in English, not Russian), it embodied the myth of the revolutionary spirit, and it gave "to all those who wanted to believe in something, something to believe in."[32] In Russia's artistic experience, it stands as the first

work of Socialist Realism, written a full quarter-century before the doctrine was officially promulgated. Once again, the idealized image of a mother had become a binding force in Russian art, just as it had in the long-ago days when the princes of Suzdalia had ruled Russia's Northeast. Then Russia's icon painters had portrayed the Mother of God in forms that radiated the warmth, mercy, and tender human kindness that medieval men and women needed to ease the hardness of life on the frontier between Europe and Asia. Now Gorkii created a literary icon to the Mother of Revolution to whom Russia's masses would turn to ease the burdens of their still wretched, painful lives.

*Mother* tells the story of a widow who, because of her love for her son, follows his revolutionary path and eventually comes to see why he and his comrades stand ready to sacrifice their lives and freedom in the hope of building a brave new world of economic opportunity and social justice. When her son is arrested, she joins the revolutionary movement to carry on his work, and stands firm against the awesome power of the Tsar's soldiers and police to spread propaganda among Russia's workers. At the end of the novel, she too is arrested and beaten by the police, as she cries out that "even oceans of blood cannot drown out the truth." By using force against the apostles of revolutionary truth, *Mother* warns at the end, the men who serve as the Tsar's instruments "can only make us hate you all the more."[33]

Before he wrote *Mother*—even before the Revolution of 1905, in fact—Gorkii began to contemplate a novel that explored the process that had brought capitalism and capitalists into being in Russia.[34] He discussed his idea with Tolstoi in 1902 and with Lenin almost a decade later, but he did not seriously begin to write *The Artamonovs* until the terrible days of World War I, when he was struggling to save Russia's young writers and artists from being consumed by the flames of conflict.[35] For a few months in 1916, he worked in earnest to write the family chronicle of a former serf and his descendants who rose to wealth and power, but then he set it aside when revolution surged across Russia the following year. Only after the Bolsheviks had triumphed did he take up *The Artamonovs* again, partly to describe the forces against which the Bolsheviks had fought, and partly to chronicle a phenomenon he thought was important.

Published in 1925, Gorkii's *Artamonovs* tells the story of three generations of Russian entrepreneurs, beginning with a newly freed serf who builds a huge linen mill and ending with his grandson who takes up the revolutionary cause. Father, son, and grandson all stand in conflict, each representing a particular link in the sociological chain that binds them all. None fully comprehends the forces that the family's success has set in motion, even as their world crumbles around them. After the Revolution, the most powerful of the Artamonovs spends his last days in what had once been the small garden house of his mansion, asking why his life had "been so terribly messed up [and] so filled with deceit." In the end, old Artamonov blames his wife, who in a time of hunger offers him the only scraps of food she has been able to find. "Eat," she says, as she offers him a salted cucumber and a soggy bit of bread. "Eat. Don't be angry." Powerless to change the

course of history, the fallen prince of industry is overcome with bitter fury. "I won't have it," he says in a rage at the novel's end. "Get out."[36]

Gorkii's Artamonov chronicle skirted the edge of a phenomenon that shaped Russia's industrial revolution and its artistic experience at the same time. As in the United States, men who won great wealth and power in the arenas of trade and industry sought to atone for their success through generous deeds and noble works, and a handful of Moscow businessmen, therefore, began to support the arts on a scale not seen since the passing of the great noble patrons who had flourished under Catherine the Great. The first among these merchant princes was Pavel Tretiakov, the patron of the Peredvizhniki, who, starting in 1865, built an immense collection of Russian art that included paintings by all of his country's major artists and many minor ones. "Though it may well be a mistake, I buy everything that I think is necessary to create a full portrait of our painting," he confessed to Tolstoi at one point. "I sometimes buy a hundred unnecessary things," he added, "just to make certain that I do not let the one necessary one slip through my hands."[37]

By the beginning of the new century, other magnates had begun to patronize the arts in different ways, but Tretiakov's only rival in the 1870s and 1880s was his wife's uncle, Savva Mamontov, a prince of Russia's railroad builders, who spent money on painting, theater, and music on a massive scale. Like the first of the Artamonovs, Savva Mamontov's father had built his fortune with ruthless daring, and his son shaped that fortune into an empire. Born twenty years before the Emancipation, Savva came to manhood on the eve of Russia's greatest age of opportunity, and he spared no energy in throwing railroads across the huge, empty expanses of his homeland to add to his wealth. Allowing no obstacles to stand in the way of his dreams, he cajoled rivals too powerful to be swept aside, and bullied the rest. As painted by the tormented artist Mikhail Vrubel at the end of the century, he seemed every inch a magnate, his huge chair resembling a throne, and his manner far more imperious than that of the weak Emperor who ruled Russia at the time. Without doubt, one commentator wrote, Mamontov was "an uncompromising, unregenerate capitalist in the mold of his American counterpart and contemporary J. P. Morgan,"[38] yet his field of vision was broader and his passions even stronger.

At the age of twenty-four, Savva Mamontov married Elizaveta Sapozhnikova, the seventeen-year-old daughter of a textile magnate whose fortune rivaled his own. Quiet, pious, and plain, Elizaveta was a woman of indomitable spirit, and like her impatient husband she had strong passions. The two shared an interest in art, music, literature, and the beauties of the Russian countryside, but a love for the people belonged especially to her. Five years after their marriage, the two joined their love for the arts and the masses at Abramtsevo, an estate within sight of the ancient Trinity Monastery that St. Sergei of Radonezh had founded during Moscow's early days, and just two miles from the railroad that formed the basis of the Mamontov fortune.

Forty miles from Moscow, Abramtsevo encompassed nearly eight hun-

dred acres of meadowlands and forests. A small river flowed near its rambling eighteenth-century manor house, and beyond it the cupolas of the Trinity Monastery could be seen in the distance. Turgenev had visited there often in the days when it had been owned by Sergei Aksakov (whose autobiographical trilogy, *The Family Chronicle*, had been one of the first to extol the joys of provincial life) and Gogol had read aloud in its drawing room the chapters from the never-finished second volume of *Dead Souls* that he would one day destroy. Savva and Elizaveta Mamontova first set eyes on Abramtsevo at the end of March 1870, when "the smell of spring was in the air" and their hopes for the future were high. They bought it the next day and set about making the house larger, more modern, and more comfortable. "Life suddenly seemed filled with pleasant and happy concerns," Savva wrote that summer. "There is no more delightful and amusing task in life," he added, "than to set one's nest in order."[39]

Over the next several years, the nest took on a very different form from anything that Savva or his wife had imagined that first spring, as they drew into their circle a number of young painters who dreamed of blending on a scale as grand as Russia itself the elite and popular cultures that had divided the Russians since the days of Peter the Great. Starting with Vasilii Polenov, a young realist Russian painter they had met on their first visit to Rome, and Mark Antokolskii, whose statue of Ivan the Terrible had just won him the title of academician at the age of twenty-eight, the Mamontovs invited young artists to spend their summers at Abramtsevo and paint whatever suited their inspiration. To remind them of their shared belief that true art must be indisputably Russian, they built for their guests' use a large studio in the style of the famed wooden architecture of Russia's North, with carvings and decorations that resembled those that had adorned the Kolomenskoe Palace two hundred years earlier.[40] "I see a whole new world for myself in the future," Mamontov told Polenov and Antokolskii when they arrived, and he vowed to support them in creating art that would aid and educate Russia's masses.[41]

Over the next decade, Ilia Repin, the brothers Viktor and Apollinarii Vasnetsov, Valentin Serov, Surikov, the landscape painter Isak Levitan, and the Symbolists' precursor Mikhail Vrubel all enjoyed the Mamontovs' hospitality. During one of their first summers together at Abramtsevo, they designed and decorated a tiny chapel that called to mind the perfection of the twelfth-century churches in Novgorod and Pskov. Like a tiny artifact excavated intact from the ruins of past, the church boasted an iconostasis by Polenov and an icon of Christ painted by Repin. Viktor Vasnetsov designed its mosaic floor in the form of a single spreading flower, and Mamontov himself, as a talented amateur sculptor, who had studied under Antokolskii's direction, produced many of the carvings.[42] The overall effect was brilliant, and it stirred new interest in the restoration and reconstruction of the ancient churches and icons that had long since fallen into ruin all around Moscow. "How much this church has added to Abramtsevo," Elizaveta Mamontova exclaimed after it was done. "How joyously the ardent and devout masses came to offer up their prayers."[43]

Even more than Repin and Surikov, the Vasnetsovs and Serov were tied to Abramtsevo and the circle's vision of the masses and Old Russia. Apollinarii Vasnetsov dedicated most of his life to painting images of log houses leaning against the Kremlin's walls, the cluttered markets of Red Square, and scores of other scenes from Old Moscow that helped Russians relate their past to their present, while his brother Viktor painted the struggles that had shaped Russia's history in ancient times. In 1878, Viktor Vasnetsov portrayed an Old Slavic *bogatyr*—one of the giant folk heroes who had fought for Russia in ancient times—at a crossroads, where the skull of a man and a horse showed where a knight's journey had ended in days gone by. Then, two years later, just before he helped to build the Abramtsevo church, he painted the field on which the army of Prince Igor had met its end. Birds of prey gathered around the bodies of Old Russia's fallen warriors to remind viewers of the tragedy from which Borodin had shaped Princess Iaroslvana's lament for his opera half a decade before. Yet Vasnetsov painted early Russia's defenders in the peaceful repose of fallen heroes, not as tormented victims of war's carnage in the way that his contemporary Vasilii Vereshchagin was portraying the men who fell in Russia's battles in Central Asia.[44] In further contrast to Vereshchagin, Vasnetsov showed not death's terror but its majesty, and the historical distance that separated Prince Igor's battlefield from the present helped to deepen the sense of glory that surrounded it.

Most of Viktor Vasnetsov's work breathed a sense of melancholy that anchored it in the past and kept it apart from the present. No other living thing appears in the painting of Ivan the Terrible that he finished in 1897, and the look of anger that so often scarred the fearsome Tsar's countenance is muted by an undertone of saddened isolation. In some of his early sketches, Vasnetsov envisioned Ivan seated, seemingly deep in thought, but his final version portrays him standing on the stairs to his royal audience chamber, holding the iron-tipped staff with which he was destined to kill his son. No more lonely, lonesome pose could be imagined, as Vasnetsov's Tsar stands burdened by his robes of office on the dark, empty stairway by which his fearful subjects enter into his presence. More powerful than any man or woman in Russia, Ivan could find nowhere the love and true human companionship that the poorest of his subjects enjoyed in their humble peasant cottages. No other Russian painter ever portrayed more vividly the burdens with which autocratic power weighed down its bearers.

With less melancholy and a stronger sense of optimism, Vasnetsov completed his painting of "The Three Bogatyrs" the year after he finished his portrait of Ivan the Terrible. Here three ancient Russian heroes sit astride their steeds in the midst of an open plain, heavily armed and armored as they stare into the distance with their weapons at the ready. Together, these huge warriors await the call to ride in defense of their faith and the land of Rus, and their manner makes it clear that they are heroes of the people, not the servants of any royal master. Ready to defend the people's cause, these three giants expressed in full measure the power of the people and the spirit of Abramtsevo. Every artist who worked at Abramtsevo shared this sense of being at one with the masses and their past. It stood at

the very core of the Slavic revival that radiated outward from Abramtsevo to en-
compass all the new evocations of Russia's past that lit the darkening twilight of
Imperial Russia during the quarter-century before the First World War.[45]

Probably no other Russian artist bore the imprint of Abramtsevo more deeply
than Valentin Serov, whose portraits captured the spirit of turn-of-the-century
Russia in much the same way that Repin's had chronicled the three decades that
had passed before. The son of a well-known composer who had died young,
Serov had first visited Abramtsevo as a child of ten in 1875, when his mother had
been among the Mamontovs' first summer guests. After that, he spent several of
his childhood and adolescent summers on the estate, where Elizaveta Mamon-
tova became a second mother and Repin and Mamontov second fathers. During
Serov's painful student years at St. Petersburg's Academy of Fine Arts, when his
teachers rated his paintings no better than average, Abramtsevo became for him
a refuge, where he continued to work with Repin and Viktor Vasnetsov on paint-
ings that used the estate's picturesque landscapes bathed in the bright summer
sun of the Moscow countryside to capture all of nature's freshness.[46]

Nowhere were Serov's feelings for Abramtsevo and the Mamontovs more evi-
dent than in his "Girl with Peaches," a portrait of the Mamontovs' twelve-year-
old daughter, Vera, whom he painted just a year or two after he turned twenty.
Serov portrayed Vera Mamontova seated at a table, staring directly at the viewer,
with a peach in her hands and others spread out before her. Combined with the
luminous sunlight that streams across the painting, the way in which the ripe,
luscious early-summer peaches mirror the girl's natural freshness reminds one of
Renoir, even though Serov had not yet discovered the paintings of France's Im-
pressionists. It was easily Serov's first masterpiece, but only one of many to come.

Like Repin in an earlier age, Serov captured Russia's worlds of art, politics,
and high society as no other artist of his generation did. A dozen well-known
painters all came alive beneath Serov's brush, as did the Mamontovs, the Tretia-
kovs, and a parade of beautiful women. The graying Princess Zinaida Iusupova,
her skin still translucent and fresh; the haughty Princess Orlova; the prima
ballerina Anna Pavlovna; and her rival Ida Rubinstein (whose nude portrait radi-
ated tormented passions in a way that no artist of the era ever equaled) all filled
Serov's canvases, as did grand dukes, grand duchesses, debutantes, and *grandes
dames*. Serov's portrait of Felix Iusupov at the age of fifteen was unmatched in
the cold aloofness that he imparted to the Prince, who, at the age of twenty-nine,
would kill the man of the people Grigorii Rasputin in the name of Russia's sal-
vation, and no portrait of any Russian ruler ever vied with his rendering of
Emperor Nicholas II in terms of its sensitivity to mood and temperament. At a
time when the form of Russian art was in the throes of revolutionary charge, few
artists managed to preserve so thoroughly the fundamental human qualities of
the men and women they painted.[47]

In 1889, Serov introduced Mamontov to his close friend Mikhail Vrubel, who
has been seen as a Russian Van Gogh by some and as a Russian Cézanne by oth-
ers.[48] Intensely personal in all that he did, and passionately dedicated to art for

the sake of art alone, Vrubel was among the first of Russia's painters to see form, line, texture, and color as meaningful in themselves rather than as mere "instruments for the communication of meaning" in the realistic sense.[49] Unlike Serov, Vrubel saw nature as a tangled interplay of lines and forms that could be shifted and changed in endless combinations. As the precursor of Russia's turn-of-the-century Symbolists, he struggled to discover how the lines and forms of the world around him could be best combined, and he explored the sharp and striking harmonies of Oriental glass and Persian carpets, the mosaics of the Cathedral of San Marco in Venice, and the problems of perspective that divided medieval Byzantine art from that of the West, as he searched for new visions. Eventually, Vrubel's search drove him to madness and death in an asylum, where "he reduced himself to utter exhaustion," one of his friends wrote, "because he had concluded that God would give him emerald eyes if only he could remain standing for seventeen days."[50]

Some two decades before his tormented death, Vrubel's meeting with Mamontov changed his life. From the moment he abandoned his studies at the Academy of Fine Arts, his dream of soaring beyond the rigid limits that realism imposed had cost him the commissions upon which artists depended, and Mamontov's unexpected patronage gave him the leisure to paint as he wished for the first time. Yet, even with Mamontov's support, Vrubel still could not escape from the no-man's-land that separated the realism of Repin from the Symbolism to which Russia had not yet given birth, for the critics who judged his paintings remained firmly dedicated to the course that Repin had set. "All you see is . . . ugliness, ugliness, ugliness," the critic Stasov once wrote of Vrubel's work. "From beginning to end there is nothing here but utter madness, anti-artfulness, and repulsiveness."[51]

Nor was Stasov alone in that opinion. When Vrubel painted two panels for the Northern Pavilion at the All-Russian Exhibition of 1896, the Exhibition's Artistic Committee rejected them out of hand, and even Mamontov's decision to build a special pavilion to exhibit them did little to improve their reception.[52] Dismayed, Vrubel continued to test his vision by repainting a series of revolutionary watercolors that he had created to illustrate a jubilee edition of Lermontov's *Demon*. His "Dance of Tamara" at first had showed the tormented demon, brooding and melancholy, in the depths of Georgia's mountains, watching while the beautiful Princess Tamara and her bridegroom danced on a rich Oriental carpet. Soon that vision became more abstract to reflect the despair that the artist felt as contemporary taste continued to reject his bold lines and brilliant splashes of color for being too far removed from reality. As the demon became more broken and the vision of Tamara's beauty faded, Vrubel's anguish flowed into sets that he designed for several of Rimskii-Korsakov's operas and into a series of panels that he completed at the dawn of the new century to portray Faust and Mephistopheles.[53]

All of the artists who lived and worked in the Abramtsevo Circle found new outlets for their genius in the sets that their patron commissioned them to paint

for his theater. During the mid-1870s, Mamontov's passion for plays and operas led him to stage a series of performances in his Moscow townhouse and at Abramtsevo, and in 1885 the Private Opera that evolved from those efforts announced its first regular season. In keeping with its creator's natural excesses, Mamontov's theater staged no fewer than twenty-three European and Russian operas in its first season, but Rimskii-Korsakov's *Snow Maiden*, for which Viktor Vasnetsov painted the sets with all the virtuosity that only a true artist could bring to the stage, held pride of place. "I was delighted, not by the singers, nor the music, nor the arias and choruses . . . but by the sets," one critic wrote. "It was all so poetic, so deeply moving and exciting, [that] I was positively hypnotized and on the verge of weeping from the wondrously joyful feeling that swept over me."[54]

Never had art and theater been blended with such dazzling effect, and Mamontov was by no means willing to let the moment pass silently into history. During the months that followed the performance of the *Snow Maiden*, he urged Vasnetsov to create sets for Dargomyzhskii's *Rusalka*, and convinced Isak Levitan, modern Russia's greatest painter of landscapes, to do the same for Glinka's *Life for the Tsar*.[55] Twenty years later, Mamontov's revolutionary practice of commissioning sets from Russia's greatest artists rather than leaving them to hack set painters led Diagilev to turn to Lev Bakst and Nikolai Rerikh for the brilliant backdrops with which the Ballets Russes dazzled the West when it came to Paris. Loyal to the creed that art was "a form of mystical experience, a means through which eternal beauty could be expressed,"[56] Vrubel's spiritual heirs Lev Bakst and Nikolai Rerikh proceeded to create sets that suggested "dreadful deeds of lust and cruelty"[57] that would raise ballet to an entirely new plane.

As the 1870s shaded into the 1880s, Mamontov looked for new ways to blend Russia's past and present, while his wife sought to bring the art of the masses into the world of fine art. With the help of Vera Polenova, a long-time student of Russian peasant art, Elizaveta Mamontova founded several workshops at Abramtsevo in which local peasants produced the crafts of their ancestors in stylized modern form. Working throughout the year, they created utensils and small pieces of furniture decorated with folk motifs that had been adapted by Vasnetsov and Vrubel to reflect the fashionable style of Art Nouveau, and then sold them to the Mamontovs' friends and acquaintances. By 1889, the fame of these folk masterpieces had reached St. Petersburg, and the wife of the Grand Marshal of the Imperial Court descended upon Abramtsevo to order thirty small carved mirror frames as gifts for the debutantes who would dance at her winter ball. Caught up in a perpetual quest for anything that could set a new trend, St. Petersburg's bored courtiers flooded the Abramtsevo workshops with so many orders that Mamontova and Polenova decided to open a shop in Moscow that would cater to the new enthusiasm for folk crafts that was spreading among Russia's upper classes. Typical of the passion with which they blended folk and fine art, Mamontova and Polenova commissioned Vrubel to decorate their shop and

design its cases and cabinets to present the people's crafts to the upper classes in elevated and elegant form.[58]

The Mamontovs and the other merchant magnates of Moscow were not alone in providing the patronage and sense of common purpose that broadened Russia's artistic experience as the end of the century drew near. At her palace on St. Petersburg's fashionable English Quay, and on her estate in the province of Smolensk, the Princess Mariia Tenisheva provided gathering places for writers, artists, and composers that clearly rivaled Abramtsevo as the twilight of the old order settled upon Imperial Russia. More than a quarter-century younger than Mamontov, Tenisheva entered Russia's world of art at the end of the nineteenth century as an apostle of Repin's realism, but she soon allowed the theatrical designer and producer Alexander Benois and his friend Sergei Diagilev to draw her so far into the art and literature of the avant-garde that she became known as the "mother of Russian decadence."[59] At their urging, the young princess joined Mamontov in subsidizing *The World of Art*, the journal of art and literature which in Diagilev's words spoke to a "generation thirsting for beauty" all across Russia and Europe, but even that was not enough to satisfy her passion for new art and new artists.[60]

An energetic patron and a devoted collector, the Princess Tenisheva attracted scores of young artists, musicians, and writers to the "conspiratorial apartment" in her palace in St. Petersburg. The young composer Aleksandr Skriabin and the violinist Leopold Auer often performed at her musical evenings along with a dozen lesser lights.[61] Apollinarii Vasnetsov, Serov, Isak Levitan, and virtually all of the avant-garde artists led by Lev Bakst and Nikolai Rerikh found a warm welcome in her palace, and there seemed almost no end to her enthusiasm for their work. Clearly, she saw herself as Mamontov's rival, yet the interest in the arts of the people that she shared with Elizaveta Mamontova drew them together at the same time. Like Mamontov's wife, Tenisheva became a passionate collector of peasant wood carvings, embroidery, and weaving, and assembled a collection of nearly ten thousand prized items in less than a decade.[62]

In 1893, the princess and her husband bought Talashkino, an estate near the West Russian city of Smolensk. Setting out to surpass Abramtsevo, the princess made Talashkino into a summer refuge for Russia's younger artists and writers as well as such Mamontov favorites as Vrubel, Korovin, and the *basso profundo* Fedor Chaliapin. In the style of Old Russia's Far North, she built cottages for her guests, workshops for the estate's peasants, a theater, a museum for her collection of folk art, several artists' studios, and a church with murals painted by Nikolai Rerikh and a dome gilded by Fabergé. Some of Russia's leading artists adapted the motifs of ancient folk art to modern use in her workshops, usually by integrating Art Nouveau elements into their patterns as they had already done at Abramtsevo. At one time, some two thousand peasant women from fifty different villages were associated with Talashkino's embroidery workshop, and hundreds more carved and painted benches, chests, and tables that were sold in

the shop that the princess opened on Stoleshnikov Lane in central Moscow. Talashkino flourished until World War I brought it to an end, after which the princess fled into exile in Paris.[63]

Like the Mamontovs, the Princess Tenisheva had dreamed of reconciling Russia's masses and elites through art, music, and education, even as the lengthening shadows cast by the empire's final years showed that time was running out for the world of privilege and patronage in which she lived. At the base of Russia's massive cultural and social pyramid, inertia and an acute shortage of money continued to slow the spread of the learning that the masses needed to enter the modern age. The numbers of schools had increased by more than ten times in the past half-century, and more than four million Russians were in school in 1900. But not even one lower-class person in three knew how to read and write, and even fewer had a sense of being part of a nation. In that, they stood far behind the people of Europe, where the masses had already entered the political arena and begun to share on a very large scale the trappings of culture that only a comparative handful had enjoyed half a century before.

Nonetheless, Russia of the 1890s and 1900s was very different from what it had been fifty years earlier. Change was in the wind and people were on the move, but many had little sense of where they were going or how they would deal with the huge array of choices that the modern world presented. Millions of Russia's newly free serfs had never walked on a paved street, let alone ridden on a train or lived in a city, where the massive scale of urban life all but overwhelmed people who had grown up in tiny hamlets. At the same time, those who had ruled Russia in days gone by had been obliged to make their peace with a world in which serfs no longer did their bidding, and where talent and energy promised to shape the future more certainly than high birth or the forces of tradition. Whether rich, poor, young, or old, Russians had to look at life from a new perspective as the new century began. For them all, change and uncertainty had become a way of life.

Would the shrinking dimensions of time and space bring the past closer, so that it could give meaning to the present and supply direction for the future? Or must the past once again be set aside as Peter the Great had done when he erased the values of Old Russia in order to make way for the dynamic new culture of Europe of which Russians could be a part? To the many Russians who sought to avoid those troubling questions as their more daring countrymen struggled to harness the forces of progress and modernity, a lengthening twilight seemed to cast its shadows across life and art. The fanciful settings of Rimskii-Korsakov's operas helped to express the sense of opulent melancholy that surrounded this fading world, and so did the ethereal grace of the ballerinas who performed Chaikovskii's fairy-tale ballets. Most of all, Anton Chekhov's portraits of the moody people whom the modern age was pushing into oblivion presented the ultimate contrast to the struggling masses of Gorkii's *Lower Depths*, and made it clear how fast the life of Imperial Russia was fading. Delicately balanced

and wistfully poignant, Chekhov's *Seagull*, *Three Sisters*, and *Cherry Orchard* reminded Russians for one final time of the treasures that would soon be forever lost. These stood among the last and best-remembered expressions of an Imperial twilight whose deepening shadows embraced the remnants of the old order and the beginnings of an avant-garde that would carry Russia to the brave new world of Bolshevism that lay beyond the turmoil of war and revolution.

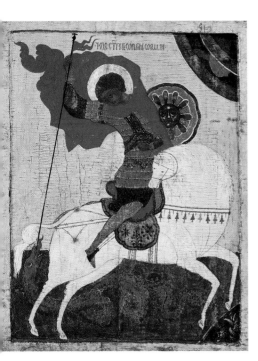

Icon of St. George and the Dragon (Novgorod School, XV century).

*Photo courtesy of Scala/Art Resource, New York.*

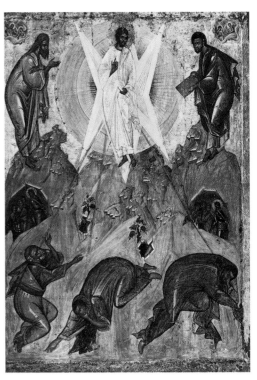

Icon of the Transfiguration.

*Photo courtesy of Scala/Art Resource, New York.*

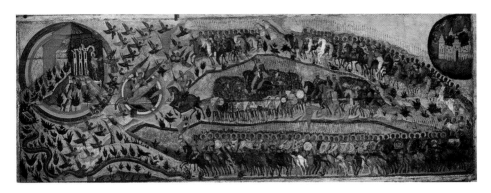

Painted in the 1550s to celebrate the storming of Kazan and the opening of Russia's advance into Siberia, "Icon of the Church Militant" reflects Ivan the Terrible's demand that art celebrate Russia's greatness in addition to the glory of God.

*Photo courtesy of Scala/Art Resource, New York.*

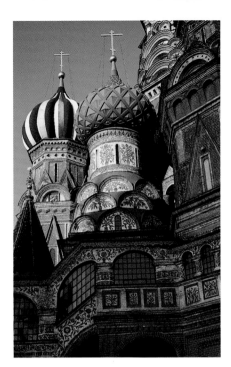

Blending the Russians' favorite decorative devices with a complex, overall Middle Eastern pattern, St. Basil's Cathedral illustrates the many influences that shaped Russian architecture in the middle of the sixteenth century.

*Photo courtesy of Jack Kollmann.*

A serf of the wealthy Sheremetiev family who rose to become a portrait painter at the Russian court, Ivan Petrovich Argunov (1727–1803) painted "A Portrait of Peasant Girl in Russian National Dress" (1784) in part as a tribute to his humble roots.

*Photo courtesy of Scala/Art Resource, New York.*

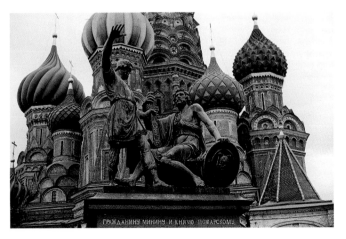

Commissioned in 1808 to commemorate the bicentennial of Russia's liberation from the Polish armies that had occupied Moscow in 1612, the monumental bronze statue to the national heroes Kuzma Minin and Prince Dmitrii Pozharskii that Ivan Petrovich Martos (1754–1835) completed in 1818 stands with striking grandeur against the background of St. Basil's Cathedral on Moscow's Red Square.

*Photo courtesy of Jack Kollmann.*

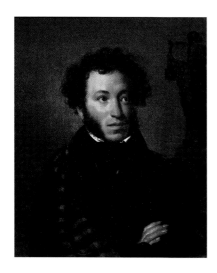

A living model of the Romantic portraits he was destined to paint, Orest Adamovich Kiprenskii (1782–1836) was the illegitimate son of a nobleman and was raised as a serf in his father's household. It is only fitting that as Russia's most dashing Romantic painter, he should have painted the portrait of Aleksandr Pushkin (1827), the greatest of Russia's Romantic poets.

*Photo courtesy of Scala/Art Resource, New York.*

Greeted by Sir Walter Scott as an epic, not a painting, when it was first exhibited in Rome in 1833, "The Last Day of Pompei" established Karl Pavlovich Briullov (1799–1852) as the first Russian painter to win wide acclaim in Europe.

*Photo courtesy of Scala/Art Resource, New York.*

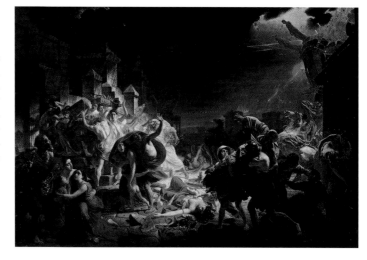

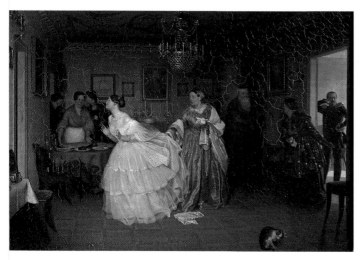

Particularly well-known for his ability to capture the pathos and meanness of daily life, Pavel Andreevich Fedotov (1815–1852) painted "The Marriage Proposal" (1848) to dramatize the dilemmas confronted by the daughters of wealthy merchants who received proposals from down-at-the-heels nobles trying to repair their family fortunes.

*Photo courtesy of Scala/Art Resource, New York.*

A friend of Sergei Diagilev and a traveling companion of Lev Bakst, Valentin Aleksandrovich Serov (1865–1911) painted Anna Pavlova in the ballet *Les Sylphides* (1909) to commemorate one of the highlights of the Ballets Russes' first season in Paris.

*Photo courtesy of Scala/Art Resource, New York.*

As the designer of some of the most stunning sets used by the Ballets Russes in its early years, Lev Bakst also created some of its most erotic and exotic costumes. Nizhinskii in *Scheherazade* (1910) is one of the most notable.

*Photo courtesy of Giraudon/Art Resource, New York.*

As one of the first Russian artists to move decisively away from realism, Natalia Sergeevna Goncharova (1881–1962) led the way in launching Russia's new "Primitivism" after the Revolution of 1905. "Bath of the Horses" (1911) dates from the height of Goncharova's Primitivist period.

*Photo courtesy of Scala/Art Resource, New York.*

Often homesick and sometimes too poor to buy canvases, Marc Zakharovich Chagall (1887–1985) spent several years living and working on the top floor of a cheap studio complex in Paris that was called La Ruche (the Beehive). Painted at the beginning of that period of his life, "The Green Donkey" (1911) portrays Chagall's memories of the world he had left behind in his native Russian town of Vitebsk.

No portrait captures the tragic beauty of the great twentieth-century Russian poet Anna Akhmatova with greater brilliance than that painted by the avant-garde artist Natan Isaevich Altman (1889–1970) in 1914.

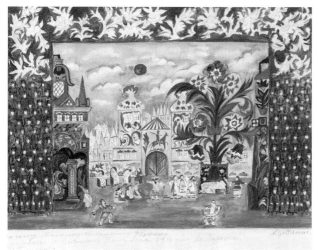

Fascinated by the brilliant colors and simple forms of peasant art, Natalia Goncharova spent an entire summer collecting dolls and toys in Russia's backwater villages before she produced the set design for Rimskii-Korsakov's *Le Coq d'Or* (1914).

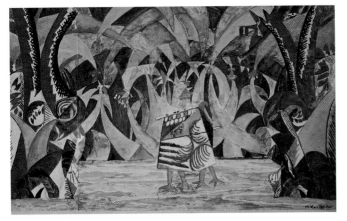

Although Mikhail Fedorovich Larionov (1881–1964) worked closely with Natalia Goncharova from the moment they met in 1900 until her death in 1962, his "Sketch of a Screen for Baba-Iaga" featured in Diagilev's production of *Les Contes Russes* in 1917, shows his ability to maintain artistic independence from the influence of the woman he loved.

*Photo courtesy of Scala/Art Resource, New York. 1998 Artists Rights Society (ARS), New York/ADAGP, Paris.*

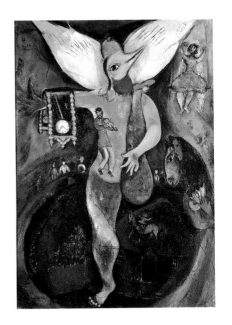

Painted in 1943 after Marc Chagall had fled to the New World, "The Juggler" recalls the artist's early life in Russia and also shows how the intensely colorful peasant art he had seen during an earlier visit to Mexico influenced his work.

*Photo courtesy of Giraudon/Art Resource, New York. © 1998 Artists Rights Society (ARS), New York/ADAGP, Paris.*

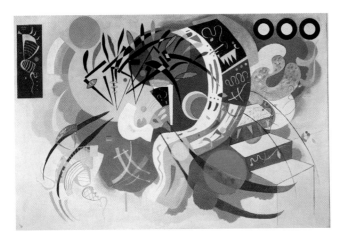

Painted in 1936, almost fifty years after he had first encountered the art of Russia's peasants during a summer spent in the Far North, "Dominant Curve" (1936) continues to show the passion for Russian folk motifs that moved Vasilii Vasilevich Kandinskii (1866–1944) throughout his life.

*Photo courtesy of the Solomon R. Guggenheim Foundation, New York. 1998 Artists Rights Society (ARS), New York/ADAGP, Paris.*

## IMPERIAL
## TWILIGHT

ᏋᏋᏋ

*BETWEEN 1850 AND THE EARLY 1900S,* the population of St. Petersburg tripled to a million and a half, and that of Moscow increased by more than four hundred percent. The number of people living in the throbbing Black Sea port of Odessa rose by a factor of six, and Kiev's population expanded by a factor of eight. Not even listed among the major cities in the Russian Empire in 1856, Ekaterinburg, Baku, and Kharkov all had populations of more than two hundred thousand by 1910, and in faraway Siberia, more than a dozen cities had more than fifty thousand dwellers by that time. Krasnoiarsk and Vladivostok both tripled during the twentieth century's first decade. The population of Chita increased by seven times to nearly a hundred thousand in the same period of time, and Kharbin, thanks to its location on the newly built Trans-Siberian Railroad, grew from a small trading village to a city of eighty thousand in barely ten years.[1] To those who stood ready to seize the moment, this new world offered opportunities that seemed without limit. Innovation and experimentation ruled their thoughts, and for men and women whose grandparents had been content with a future that had seemed certain to be no different from the present, risk-taking now became a way of life.

Yet, for every daring Russian who forged ahead at the beginning of the twentieth century, fifty others retreated into the lengthening shadows of the empire's twilight, where habit reigned supreme and life moved in a circular course that led from no place to nowhere. Afraid of what lay ahead, such men and women hoped to stay in the present, where a shield of monotonous banality cut them off from the future and limited their vision to the familiar, the tried, and the true. As

the chronicler of the bittersweet world in which such timid people lived, Anton Chekhov recreated the quiet, boring shelter that shielded modern life from everything that made it interesting and worthwhile. In hundreds of short stories and almost a dozen plays, this greatest of end-of-the-century writers captured the mood of mournful longing that assured Russia's timid victims of progress that their way of life would never change.

The grandson of a serf and the son of a tradesman who ran a small shop in the South Russian port of Taganrog, Chekhov grew up surrounded by meanness and deceit. In the days of its thriving grain trade, Taganrog had drawn Greeks, Italians, and Russians together in an atmosphere of reckless colonial prosperity that had seen men build fortunes with a speed that was matched only by the frequency with which they let them slip away. All that changed when railroads began to carry Russia's grain to other destinations, and, as Taganrog fell upon hard times, the fortunes of Chekhov's family declined with it. Obliged to flee his creditors one spring night in 1876, Chekhov's father left his oldest son alone to finish his studies at the Taganrog gymnasium and moved the rest of his family to a dark cellar room in a Moscow tenement. When he came to Moscow three years later, the nineteen-year-old Chekhov took his father's place as the main support of his mother, brother, and sisters at the same time as he struggled to build a life of his own.[2]

In Chekhov's Moscow, railroad stations crowded against ancient churches, and rich new townhouses arose just a stone's throw away from hovels. At every turn, there was something to be observed and commented upon, and all of it provided mountains of grist for the city's scores of newspapers and magazines. Do-gooders, soul-savers, and learned practitioners of the new science of observing society found in Moscow every shape and shading of the human condition, and Chekhov came to know them all as he haunted the city's cafés, cheap eating houses, parks, and streets. All the survivals of the old order and everything churned up by the new became raw material in Chekhov's hands, and he wove them all into one of the richest literary tapestries of Russia ever created. Beggars, aristocrats, bureaucrats, peasants, merchants, soldiers, whores, *grandes dames*, and all the rest of the ever-changing social kaleidoscope of Russia had their place in his creations. Taken together, these became the best-remembered portrait of Russia on the eve of the twentieth century ever painted.

In the fall of 1879, Chekhov registered as a medical student at the University of Moscow, but his first days left him with a sour remembrance that lasted for the rest of his life. "The dilapidated university buildings, the gloomy corridors, grimy walls, bad light, and the cheerless stairs, coat racks, and benches," he later wrote of his first impressions, "have undoubtedly played a key role in shaping the history of Russian pessimism."[3] Yet it was precisely within the university's walls that Chekhov began his friendship with the great turn-of-the-century painters Isak Levitan and Konstantin Korovin, and came to know Fedor Shekhtel, who was to design Moscow's Historical Museum, its Iaroslavl Railway Station, and the palatial residences of some of its richest merchants.[4] Together,

Chekhov and these other young men took the measure of Moscow in the 1880s, and then went on to shape Russia's artistic experience according to that vision.

To the grime and grind of his medical studies, Chekhov added poverty and the distractions of a crowded household that lived mainly on his meager earnings.[5] Yet it was precisely these frustrations that set the mood for many of the vignettes he wrote for Moscow's weeklies as he struggled to support his family while he studied medicine in the early 1880s. Published under the pseudonym of "Antosha Chekhonte," these brief burlesques revealed Chekhov's genius for extracting humor and pathos from life's daily trials. Making no judgments and avoiding all moralizing, he rejected Belinskii's credo that a writer must be the conscience of his time, and described instead his characters' happiness, suffering, generosity, greed, cruelty, and kindness in the matter-of-fact manner of an attending physician. Sex-starved old maids, cringing government clerks, absent-minded professors, complacent husbands, unfaithful wives, and scores upon scores of others all had a place in Chekhov's early work as he struggled to find the voice that would soon make him the premier chronicler of Russia's twilight years. "Literature is accepted as an art because it depicts life as it actually is," he once explained to a friend who had chided him for having written too often about the seamier sides of life. "The writer should be just as objective as the chemist," he went on. "He should ... acknowledge that manure piles play a highly respectable role in the landscape and that evil passions are every bit as much a part of life as good ones."[6]

Chekhov's passion to observe the human condition took him to street markets, slums, courtrooms, shops, public baths, drawing rooms of *grandes dames*, parlors of merchant wives, and anywhere else that people gathered, for he was as concerned with where his characters lived as he was with who they were. During his brief quarter-century literary career, he peered into life in cities, small villages, homes for incurables, insane asylums, the vast Eurasian steppe, the forests of Siberia, and even the penal colonies on the Pacific island of Sakhalin, all of which he described with such clinical precision that they could never be forgotten. "They were crude, dishonest, filthy, drunken, and they quarreled continually and did not live in harmony because they distrusted, feared, and did not respect one another," he once wrote in a brief paragraph about life among Russia's peasants. "But they were human beings," he added, "and they suffered and wept like anyone else. There was nothing in their lives for which one could not find some sort of justification."[7]

No matter where he placed them, Chekhov concentrated on ordinary people doing ordinary things. His characters cheat on their wives, betray their husbands, swindle their neighbors, deceive their friends, put on airs, fume over imagined insults, hatch petty plots against pettier enemies, drink to excess, tell lies they regret, and regret the lies they fail to tell. Whoever the subject and whatever the setting, the boredom of life among people too mired in the present to move into the future never ends, as Chekhov's characters pay each other the same empty compliments, tell the same stupid jokes, attend the same dull parties

with the same boring people, and make the same complaints. The drabness that tarnishes everything that is in any way bright, energetic, or exciting deadens all feelings, thoughts, hopes, and ideas. Men seduce women they do not love out of boredom. Women succumb out of boredom. People cheat, lie, steal, hurt each other, and play cruel jokes—again, out of boredom. "Our soul is a great empty space," Chekhov lamented in one of his letters. "We have no politics, we do not believe in revolution, we have no God, we have no fear of ghosts. . . . Staleness and dullness are our lot."[8]

During the late 1880s, Chekhov shifted the focus of his writing to the heavy pall of moodiness that hung over Russia. Antosha Chekhonte had laughed at drunks, fools blinded by arrogance, and bigots overcome by pride and prejudice, but the maturing Chekhov began to see the world as a place in which no one takes responsibility for anyone or anything, and where no one does, thinks, or says anything significant. In "Ward No. 6," a pivotal short story that he published just after Russia entered the 1890s, the only character with true human passions is confined to a ward for the insane that is overseen by a physician who takes no responsibility for his own failings or anyone else's. Dishonesty, this man claims, is nothing more than a minor consequence of the times in which he and his patients have been fated to live. "Were I to be born two hundred or so years from now," he concludes, "I would be an honest man."[9] Here, as in many of his later works, Chekhov places the future beyond the reach of a lifetime. "In two hundred, three hundred, or even a thousand years—the length of time doesn't really matter," a provincial artillery commander says in one of his last plays, "a new, happy life will appear."[10]

By the time "Ward No. 6" appeared in 1892, Chekhov had been out of medical school for eight years, had never formally practiced medicine, and had been acclaimed as the greatest teller of short stories that Russia had ever known. Russia's leading monthlies had begun to pay him handsomely for his writings, and collections of his stories had found a ready audience among men and women who wanted more lasting versions of his work. Yet an ominous cloud had already appeared on the horizon, and it gave Chekhov a sense that he had no time to waste. Toward the end of 1885, Chekhov the physician had noticed the first signs of tuberculosis in Chekhov the writer, and by 1892, the symptoms had become so much worse that he had been obliged to buy an estate outside of Moscow in order to have the fresh, clean air that his diseased lungs required. There Chekhov wrote some of his most memorable works, including his long memoir-exposé about *The Island of Sakhalin*, in which he described with relentless precision the brutal day-to-day lives of the men and women who had been sentenced to exile on that north Pacific island.

Renowned at home for short stories that touched every corner of Russian life (and which sold in such quantities that he had become comfortably well-to-do by the early 1890s), Chekhov became best known abroad for his plays. From the plays he wrote in his late teens through the scores of short stories and the great plays of the last few years of his life, he insisted that structure held the key to

every play's success. "The more compact and tighter a play is," he once explained, "the brighter and more expressive it will be."[11]

Built entirely on relationships between their characters, Chekhov's greatest plays have no substantial plots, no stirring climaxes, and are generally bereft of dramatic events. They are theater at its most unspectacular, yet they have the capacity to enthrall audiences by making them a part of the trivial happenings that mark every viewer's experience. A game of croquet, preparations for a trip, and an afternoon spent around the samovar in a garden, on a veranda, or in a sitting room provide the settings for some of Chekhov's greatest dramas, while such pivotal events as suicides, deaths in duels, failed love affairs, and the destruction of the famed cherry orchard all occur offstage. "It isn't dramatic," one of Chekhov's friends complained when he read *The Seagull* for the first time. "You make your character shoot himself behind the scenes and don't even give him a chance of making a speech before his death!"[12] Like Chekhov's short stories, *The Seagull* and its successors projected a mood of wistful longing. "It is the sort of life that is so accessible and close to us, that you sometimes forget that you're in a theater," one admirer wrote after *The Seagull*'s first performance in St. Petersburg. "You really feel," he added, "as though you could be a part of the conversation that is taking place in front of you."[13]

Written in 1895 and first performed in the fall of 1896, *The Seagull* stands as the first of the four great dramas that marked Chekhov's last years. He wrote the play under the influence of the revolutionary creations of Ibsen, Strindberg, Hauptmann, and Maeterlinck, all of which had been disdained by Tolstoi and were being ignored by such younger writers as Gorkii. Chekhov found genuine inspiration in these new plays, and they led him to write in a form entirely different from the models that Ostrovskii's clear-cut characters had imposed on Russia's stage for nearly half a century. Chekhov set upon the stage men and women who did not know their own minds and whose dialogues related only tangentially to complex inner feelings that they had not yet sorted out. In contrast to Ostrovskii's decisive dramas, nothing in *The Seagull* and its successors was in any way conclusive, and even the final curtain marked no defining moment in their characters' lives.

More than in any play before it, *The Seagull* raises cosmic questions about the nature of art and the meaning of creativity. Is creativity a gift or a curse? Does it liberate the person upon whom it has been bestowed, or is it a burden that condemns its bearer to a life of prodigious toil? "I no sooner finish one story, then for some reason I must write another, then a third, and after that a fourth," the hack novelist Trigorin laments during the play's second act. "I feel," he concludes, "that I am consuming my own life."[14] Yet Trigorin's creativity is, in fact, a sham. Although women infatuated with the thought of loving a great writer endow him with an aura of brilliance he can never hope to achieve, he does little more than collect apt phrases in his notebook and weave them into third-rate stories. Petty, mean-spirited, and self-centered, Trigorin proves to be no greater than the small-minded provincials he disdains, and that very fact emphasizes

Chekhov's certainty that humankind cannot be divided into major and minor characters. At the play's end, the suicide of the struggling writer Treplev seems no more tragic than the fate of the woman who fails to return his love and goes on loving Trigorin, who has already rejected her. The banality and boredom of daily life simply overwhelm them all.

In retrospect, the disappointments that *The Seagull*'s characters faced seem small compared to the feelings of failure that overwhelmed the play's creator when it opened at St. Petersburg's famed Aleksandrinskii Theater. In what one literary historian has described as "an unbelievably ill-advised move," Chekhov had allowed a well-known comic actress to turn *The Seagull*'s first performance into a popular benefit, and the play therefore opened before a lowbrow audience of admirers who had come see the kind of broad farce in which their heroine usually performed. Unprepared for Chekhov's subtly nuanced scenes, the audience booed, laughed, and hissed. Critics were heard to remark that Chekhov's seagull had, in fact, turned out to be nothing more than a dead duck, and few searched for any deeper meaning. The next morning, Chekhov fled on the first train out of St. Petersburg to his estate in the countryside south of Moscow. "The theater," he later remembered, "breathed malice and the air was full of hatred. I flew out of Petersburg," he told a friend, "like a bomb according to the law of physics."[15]

Chekhov had been too quick to flee and too impatient to hear acclaim. "The play is a complete, unanimous success, just as it ought to be, just as it had to be,"[16] the actress Vera Kommissarzhevskaia wrote after she had played the leading role before a more sophisticated audience the next evening. Others who went to the theater in search of more than comic entertainment shared Kommissarzhevskaia's view. "This is *life itself* on stage, with all its tragic alliances, eloquent callousness, and unspoken sufferings," the great jurist Anatolii Koni wrote a few days later. "It is the sort of life that is accessible to everyone but understood by almost no one in its cruel inner ironies.[17]

So long as *The Seagull* continued to be staged in the traditional manner, only the handful of men and women who shared Koni's sophisticated sensitivity could perceive its subtle meanings. Then, when Konstantin Stanislavskii and Vladimir Nemirovich-Danchenko revived the play at the newly organized Moscow Art Theater two years later, audiences suddenly saw the brilliance that Koni and Kommissarzhevskaia had sensed from the very first. Stanislavskii remembered the "gravelike silence" that fell upon the actors as they waited for the audience's response on that second opening night. The silence hung heavily, and then, Stanislavskii wrote, "there was a roar in the auditorium" as the audience rose to its feet and burst into cheers.[18] "At moments, it seemed that life itself was speaking from the stage," one viewer remembered. "We, onlookers, were already under the complete sway of the stage, of Chekhov, and of the Art Theater," another added after the play had ended. "New feelings, unfamiliar before in the theater, filled the soul, [and] a new rapture shook it."[19] At that moment, *The Seagull* and the Moscow Art Theater became one. "The Rubicon was crossed," a

critic wrote. "The [Moscow] Art Theater had irrevocably become Chekhov's theater."[20]

On the heels of *The Seagull*'s success came *Uncle Vania*, which Chekhov also set in the depths of the Russian countryside. Produced by the Moscow Art Theater just a year after *The Seagull*, it too is a drama of mournful moods, in which men and women fall victim to their illusions while they move through Imperial Russia's twilight years. Uncle Vania and his niece Sonia devote their lives to running the estate that supports Sonia's father, Professor Serebriakov, only to realize (when he comes for a visit with his beautiful young second wife) that he is a parasite who appreciates neither their suffering nor their sacrifice. Intertwined with the labors of Sonia and Vania throughout the play are a host of other loves and hatreds, all of which come to naught because love is never reciprocated and hatreds have no consequences. Bored with life and resigned to their fate, uncle and niece lack the will to do anything other than what they have always done. "We shall live through a long, long procession of days and longer evenings, and we shall patiently endure the trials fate sends us," Sonia tells Uncle Vania at the play's end. "When our time comes," she continues, "we shall die submissively, and there, beyond the grave, we shall say that we have suffered, that we have wept, that our lives were bitter, and God will take pity on us. Then, dear Uncle Vania," she concludes, "we shall look back on our present troubles with a feeling of tenderness, with a smile—and we shall rest."[21]

The boredom and inertia that condemned Sonia and Uncle Vania to thankless toil also shaped the lives of *The Three Sisters*, which the Moscow Art Theater first performed at the beginning of 1901. Like the characters in Chekhov's other plays, the three sisters, their family, and friends all live empty lives, in which the falsely important, falsely beautiful, and falsely clever blend with the obviously tawdry in a surging tide of vulgarity. Marooned in a provincial Russian city, they live to no purpose, and make no attempt to take command of their destinies. Each of the three sisters yearns to escape the provinces and return to the life she has known in Moscow, but none of them ever does so. All remain where fate deposited them twelve years earlier: one continues to be the schoolteacher she never wanted to be, another is trapped in a loveless marriage she cannot escape, and the third allows the inertia of provincial life to corrode the idealism that once had spurred her to dream of serving others. "Time will go by and we shall be gone forever," one of them sighs at the end. "People will forget what we looked like, what we sounded like, and how many of us there were." What was the point and where was the purpose of lives lived in such a way? "If only we knew," the last line of the play concludes. "If only we knew!"[22]

Perfectly conceived and flawlessly written, *The Three Sisters* was a product of one of the happiest and most difficult years of Chekhov's life. He knew that he had not long to live, for the tubercular hemorrhages that he had suffered for the past fifteen years were becoming more frequent and violent. Since he had so little time left, he wanted most of all to work, but his popularity brought friends, well-wishers, and hangers-on to his door wherever he sought refuge. "I am being

constantly interrupted—cruelly, nastily, meanly," he complained in one of his let-ters. "I have the play in my mind, it has taken shape and form, it begs to be put on paper, but the moment I touch the paper, the door opens and some swine comes crawling in."[23] Yet, as he struggled against sickness and interruptions, Chekhov unexpectedly found new joy, for he fell in love with Olga Knipper, an actress at the Moscow Art Theater, and that love became a passion as he worked on *The Three Sisters* during the summer and fall of 1900. The next May, the two began a marriage that gave deeper meaning to each other's work, even though the conflicts posed by her career and his health often kept them apart.

For almost a year, Chekhov reveled in his newfound happiness. Then, just as the Crimean winter was coming to an end in 1903, he sat down at his desk in Yalta, took up a stack of paper, and wrote *The Cherry Orchard* across its topmost sheet. After working for several days, he set the play aside and returned to it only when Olga joined him in the middle of July. Now so weakened by tuberculosis that he sometimes could write no more than half a page before stopping to rest, he made good progress during the two months she stayed with him and finished the play just a month after she returned to Moscow. A few weeks later, he went to Moscow to spend what was to be the last winter of his life in the city he loved most of all. He saw his old friends and celebrated New Year's Eve with the actors of the Moscow Art Theater. On his forty-fourth birthday seventeen days later, *The Cherry Orchard* had its first performance, and its opening night included a well-intended public celebration of his twenty-fifth literary anniversary. Chekhov found the event embarrassing, distasteful, and exhausting. His illness had ad-vanced into its final stage, but he complained only of wanting more time to work and continued to send lighthearted and irreverent letters to his wife and friends in a style reminiscent of the short stories he had written in days gone by. "You ask me what [the meaning of] life is," he wrote at one point. "It is like asking what a carrot is. A carrot is a carrot, and nothing more."[24]

To those who debated the meaning of Chekhov's new play that spring, the un-forgettable Madame Ranevskaia, whose estate and famed cherry orchard had to be sold for debts, represented a microcosm of an aristocracy that had failed to come to grips with the loss of its serfs, while the peasant trader Lopakhin, who bought the estate of his former masters and had its cherry orchard cut down to make room for summer cottages, personified the individualistic entrepreneurs who were taking its place.[25] Yet, if Chekhov's contemporaries agreed on what Ranevskaia and Lopakhin represented, they had different visions about how they ought to be portrayed. Lopakhin, Chekhov once wrote, "is a decent person in every sense and his behavior must be entirely proper, cultivated, and free of pet-tiness or clowning."[26] Ranevskaia, he added, must be presented as a woman who dresses "with great taste. She is intelligent, very kind, and absent-minded. . . . She feels deeply for everyone she meets [and] always has a smile on her face."[27] Ranevskaia cannot comprehend the new world that the Emancipation has brought into being. Nor can she understand the type of businessman that her former serf Lopakhin has become any more than he can comprehend how his

former mistress cannot take hold of her destiny once he offers her the chance to do so.

Chekhov's vision diverged from that of *The Cherry Orchard*'s directors and actors from the very start, for it was too tempting to portray Ranevskaia as self-centered and stupid, and Lopakhin as loud-mouthed, tight-fisted, and boorish. "Don't lose sight [of the fact] that Lopakhin was loved by Varia, a serious and religious girl. She wouldn't fall in love with a tight-fisted peasant," Chekhov warned. "Lopakhin shouldn't be played by someone who shouts," he added in a note to Nemirovich-Danchenko soon afterward. "He's rich, and rich people never shout."[28] But Chekhov was too ill to prevent the play's well-meaning director from presenting it as a tragedy.[29] "Stanislavskii has been the undoing of my play!" he lamented at one point. "Oh, well," he added with the resignation of a man who had little time left to live. "Never mind."[30]

Even without the delicate tenderness that Chekhov intended, the symbols that shaped *The Cherry Orchard* expressed far more than the failings and foibles of Lopakhin and Ranevskaia. Each of the cherry trees stands as a reminder of a dying past that has to be cut down to make way for the future, and the play is filled with other symbols that emphasize the breakdown of Imperial Russia's old order. Everywhere, things are being broken—a thermometer that registers unseasonable cold, a saucer, a billiard cue, and a string that snaps with "a fading and mournful" sound "coming from the sky" at the play's end.[31] Everywhere, the twilight of Imperial Russia seems to be fading fast, a reflection, perhaps, of Chekhov's own clear sense that his life was ending at a time when deepening social and political tensions were about to tear his homeland apart. Violent strikes, mutinies, and revolution all stood waiting in the wings when Chekhov wrote *The Cherry Orchard*. Their outbreak in 1905 would transform autocratic Russia into a nation ruled by a parliament and a constitution.

Razing the cherry orchard in the name of progress portends all of these tragic and painful events, yet the most striking symbol of Russia's waning twilight comes when the sound of the workmen's axes is heard at the end of Chekhov's play. Ranevskaia, her brother, daughters, friends, acquaintances, and servants all have left the manor house, locking its doors behind them. Then old Firs, the former serf who had cared for them all as children and served them as adults, shuffles onto the stage. "Locked," he mutters as he tries to turn a door handle. "They've gone away . . . and they forgot all about me. . . . Life," he sighs, "has just slipped by as if I'd never lived at all."[32]

Like the eighty-seven-year-old Firs's, Chekhov's life was about to slip away as Russia moved toward its rendezvous with revolution in 1905. He spent the month of May 1904 with Olga in Moscow, and the two then hurried to Baden-weiler in Germany—she in a last futile attempt to find him a cure and he, as he told a friend, "to die."[33] Chekhov thus ended his life in a German hotel during the early-morning hours of July 2, 1904, not long after his doctor ordered a bottle of champagne to ease his labored breathing. "He picked up the glass," Olga remembered, "turned to me, smiled his wonderful smile and said: 'It's been such

a long time since I've had champagne.' He drank it all to the last drop," she added, "[then] quietly lay on his left side and was soon silent forever."[34] Russian literature would never be the same again. As the Revolution of 1905 came and went, younger authors turned away from Chekhov's way of writing to styles that were more in keeping with the new times that Russia faced, but the theater of which he had been so much a part continued to flourish. Even as the moody Chekhovian world its performances had brought to light slipped away, the Moscow Art Theater continued to stand for innovation, progress, and a new artistic vision that would carry it into the brave new revolutionary world that lay beyond Imperial Russia's twilight.

The Moscow Art Theater, which breathed so much life and feeling into Chekhov's plays, had its beginnings in a marathon eighteen-hour meeting at the famed Slavianskii Bazar restaurant between the actor, director, and patron of the arts Konstantin Stanislavskii, and the novelist, playwright, and critic Vladimir Nemirovich-Danchenko. Finding the main dining room still crowded when they arrived for lunch at two o'clock on the afternoon of June 21, 1897, the two men engaged a private room, sat down to the first of many courses they would consume that day, and began to speak of the problems that concerned them both. "We vied with each other in the supply of poisoned arrows," Nemirovich later wrote in describing their "ruthless criticism" of the contemporary Russian theater. "The most remarkable thing about this conversation was that we did not once disagree," he went on. "Our programs either merged or complemented each other. Nowhere did they collide."[35]

Chain-smoking cigarettes, the two men talked through lunch, afternoon coffee, and dinner.

> "Take actor A," one said to the other. "Do you consider him talented?"
> "Yes, very."
> "Would you have him in the troupe?"
> "No."
> "Why?"
> "Because he has adapted himself to his career, his talents to the demands of the public, his character to the whims of his manager, and himself most of all to theatrical trash."
> "What about actress B?"
> "A very good actress, but not for us."
> "Why?"
> "She does not love art, but only herself in art."

And so their discussion continued as they searched for actors who set art above self and put ideals before profit. They spoke at length about "artistic ideals," the meaning of pure art, and what Stanislavskii called "artistic ethics."

"There are no small parts," they agreed, "only small actors. . . ."

"Anything that offends the creative life of the theater," one of them added, "is a crime."

"Tardiness, laziness, caprice, hysteria, bad character, failing to learn one's lines, the need to say something more than once," they agreed, "all these threaten equally what we want to accomplish."[36]

Late that night, when the room at the Slavianskii Bazar had become too thick with cigarette smoke for comfort, Stanislavskii suggested that they adjourn to his villa in the outskirts of Moscow. As they drove through the ancient pine woods, the early summer night cleared their heads, and before they parted the next morning they made one final agreement. "The literary veto belongs to Nemirovich-Danchenko," they decided, "[and] the artistic veto to Stanislavskii." Temperamental, sometimes arrogant, often in disagreement, the two men held to that principle for as long as they worked together. "One of us would only have to utter the magical word *veto*," Stanislavskii remembered many years later, "and the argument would end in mid-sentence."[37]

The greatest of nineteenth-century Russia's actors Mikhail Shchepkin once counseled Stanislavskii to "take examples from real life" if he wished to portray human experience as it really was.[38] Now his alliance with Nemirovich-Danchenko brought a new type of theater into being, based on that single simple principle. "We wanted real, artistic, scenic truth," Stanislavskii explained. "[We wanted] the truth of feeling and experience."[39] True to the convictions they had expressed at their first meeting at the Slavianskii Bazar, neither man permitted any actor of small talent to perform at the Moscow Art Theater, and whoever joined their company had to be a consummate artist. Because each performer was expected to bring a passion for perfection to every role, whether small or large, actors and actresses lived their characters on stage and off. "The creative process of living and experiencing a part is an *organic* one founded on the physical and spiritual laws governing the nature of man," Stanislavskii once wrote. "All the work we do on ourselves and our roles is aimed at preparing the ground for the inception and growth of living passions and for inspiration."[40]

No effort was spared to create the realism around which the founders of the Moscow Art Theater shaped their vision. For the first time in the history of the Russian theater, Stanislavskii and his friends paid serious attention to the details of what men and women had worn at particular moments in history, and they scoured Russia's ancient towns and villages for clothing and objects from bygone days. To recapture the atmosphere of Old Russia for one of their plays, Stanislavskii and several followers visited Russia's old Northeast, listened to the ancient bells, and even arranged to live for several days in a medieval palace so as to better understand the hidden forces that had molded life in olden times. "A breath of Russian antiquity suddenly seemed to touch us," Stanislavskii remembered of the night when one of their group wandered through their chambers

clad in monastic robes with only a candle to light his way. "It seemed," he added, "as if the ghost of Tsar Ivan the Terrible himself was making its way across the stone flags of the palace."[41]

Yet there was a great deal more to the theater's methods than realism and dedication to historical authenticity. "Our program was in the nature of a revolution," Stanislavskii later explained. "We protested against the old ways of acting, against theatricality, against false pathos, against declamation, against overacting, against the crude ways of production that had ruled the theater in the past, against stereotyped scenery, against the star system which spoiled the ensemble, [and] against the . . . farcical repertoire that dominated the theater in those days."[42] Transferred to the stage, this "revolution" struck many critics as a "theatrical miracle"[43] that had no equal anywhere in Russia. "The Moscow Art Theater became both the center of new aesthetic experiments and the symbol of liberal tendencies," one of them later wrote. "In this twofold aspect, it faithfully expressed the yearnings of the progressive intelligentsia with which it was justly identified."[44]

Aesthetic innovation and political liberalism led Stanislavskii and Nemirovich-Danchenko to stage plays never before seen in Russia. Those of Chekhov became the most famous, and the silhouette of the seagull that adorned the theater's announcements of the play's first performance soon became its symbol. But the Moscow Art Theater also turned to Ibsen and Hauptmann—the authors who had so influenced Chekhov's work—and then to Gorkii and Leonid Andreev, who became one of the most popular dramatists in Russia between the Revolution of 1905 and the beginning of World War I. Symbolism, realism, and impressionism all had their places in shaping the famed method that enabled Stanislavskii to bring to light that fragile inner life that could give greater substance to a playwright's words. "One of the most irresistible *lures* to our emotions lies in the *truth* and our *faith* in it," he once explained. "An actor need only believe in himself," he concluded, "and his soul will open up to receive all the inner objectives and emotions of his role."[45]

Closely related to Chekhov's gentle descriptions of nature, the muted, impressionistic landscapes of Isak Levitan reflected the twilight mood of turn-of-the-century Russia with the same poignancy that Stanislavskii's method had created in the performances of the Moscow Art Theater. Born in the same year as Chekhov and fated to live in even greater poverty during his teenage years, Levitan began to study art at Moscow's School of Painting, Sculpture, and Architecture as a homeless thirteen-year-old orphan. For six years, he slept in the school's classrooms or on cots offered by friends and relatives. Yet poverty in no way diminished his passion for the beauties of nature that he learned to appreciate from the two Peredvizhnik landscape painters who taught at the school. Sharing his teachers' belief that an artist must find his models beyond the studio in the open air, Levitan won his first prize at the age of fifteen. Before he turned twenty, the great collector Pavel Tretiakov bought his painting "An Autumn Day in Sokolniki Park."[46]

Not long after Tretiakov bought his first painting, Levitan left the Moscow School and plunged into Russia's world of art. These were the days when Ilia Repin was painting his "Procession of the Cross in Kursk Province," and when Surikov was at work on his huge renditions of "Morning Comes on the Day of the Execution of the *Streltsy*" and "The Lady Morozova." Like Serov and Vrubel, Levitan joined the Abramtsevo Circle in the mid-1880s and took part in Savva Mamontov's revolutionary new experiment in using great artists to design the backdrops for operatic productions. Backdrops now ceased to be mere decorative backgrounds and became instead integral parts of operatic productions that helped to shape an audience's perception of everything that occurred on stage.[47]

In contrast to Surikov's crowded canvases and the highly emotional works of Repin, Levitan's paintings of fields, forests, rivers, lakes, and country roads almost never show human figures. Like Chekhov's plays, his exquisite landscapes highlight deep-set moods, and these shift with the changing weather and passing seasons. Spring for Levitan is a time when bursting buds, newly thawed streams, and flowering shrubs radiate a feeling of optimism and hope. His summer paintings show barns, cottages, and fields drenched in the sun, while his autumn scenes project the fading brilliance that precedes the passive calm of winter. In such paintings, weather shapes the observer's feelings, and clouds, storms, surging waves, and wind-bent trees heighten the sense of nature's power. In some of Levitan's paintings, changing weather captures several moods at once, as when the sun begins to break through the clouds in "After the Rain" (1889), or when changing light casts complex shadows on "The Vladimir Road" (1892). In other paintings, the depth of the water, the brightness of the sun, or the intensity of the fog sets the mood. Taken together, Levitan's canvases reveal the soul of Russian nature—elusive, ever-changing, but always infinitely and indisputably Russian.[48]

Yet the richness of Levitan's collected paintings stems not from the wide variety of his experience, but from the many ways in which he interprets some of his best-loved themes. Water has a central place in his work, and he views it from perspectives that emphasize its grandeur, power, and tranquillity. Lakes, rivers, streams, and the sea all hold center stage on his canvases, and he projects feelings of peace, joy, gloom, and loneliness through them. Water stands at the center of each of his three largest works ("Deep Waters," "Eternal Rest," and "The Lake"), which he painted between 1892 and 1898, and the theme in every case highlights the significance of water in expressing the complexity of nature. Stormy, peaceful, deep, and complicated, lakes seem to fascinate Levitan, and he painted them again and again as he explored the lands of northern and central Russia. Yet rivers and streams have their place in his work too, and none more prominently than the Volga, that famed "mother of Russian rivers," which seized his imagination with immense force when he saw it for the first time. Repin had seen the Volga as the scene of dreadful human suffering, and Gorkii had sensed in it the throbbing pulse of modernity that drew humans into the misery of the lower depths at the same time as it offered a means for others to escape. By

contrast, Levitan sees in the Volga the true essence of Russia, and it becomes in his paintings the river highway that leads to the very depths of the Russian soul. "What can be more tragic," he wrote in exasperation to Chekhov from the Volga in the spring of 1887, "than to feel the infinite beauty of one's surroundings, be fully aware of their innermost secrets, see God in everything, and realize that you simply cannot fully express these powerful emotions?"[49]

Simplifying and stylizing its forms, Levitan set the details of nature aside and concentrated on light, color, and form, all of which he expressed with never-failing brilliance as his tragically short life drew to a close. Every brush stroke now captured a deeper meaning, and provided viewers with a sense of the universality of nature's beauties. No churning crowds, roaring locomotives, or scenes that tell of pain or suffering can be found among Levitan's canvases, nor does he show haughty aristocrats, self-satisfied merchants, or work-worn peasants breaking the sod of virgin soil. "Levitan's landscapes are closely connected with a whole sphere of Russian life," a critic wrote just a decade after his death in 1900. "They bring to mind thousands of remembrances about places, people, [and] events in our lives. Amidst these fields, forests, rivers, and summer sunsets," he concluded, "the life history of each one of us is played out."[50]

If Levitan's paintings captured the idyllic beauty of the moody, misty twilight world immortalized in Chekhov's plays, the fantasy world of the Imperial Mariinskii Ballet preserved the grace and charm of the bygone days that Russia's Industrial Revolution was consigning to history's pages. Although the ballet had first become a part of court life in the reign of the Empress Anna, it had come into its own only at the beginning of the nineteenth century, when the French dancer and ballet master Charles Didelot had come to St. Petersburg. Driven by his dream to surpass the ballet that had spurned him in Paris, Didelot had set in motion a revolution in Russia's ballet. His first sojourn in the land of the tsars had lasted for less than a decade, but he had returned for a second stay that stretched from 1817 to 1828, during which he produced an average of three new ballets every year. He was the first anywhere to stage ballets with dramatic content, for which he drew heavily upon the poetry of Pushkin, and he was a master of those special effects for which the opera and ballet in Russia became famous. Didelot raised Russian ballet to rival the best in Europe, and it was no accident that Maria Taglioni, the greatest of Italy's ballerinas, received such an enthusiastic welcome in Russia's capital in the year of his death.[51]

Thanks to the imperial ballet school over which Didelot had presided, the training of Russia's dancers surpassed that of all others, for the subsidy of some two million gold rubles that the Emperor bestowed upon it every year provided resources that no Western nation could match. Emperors, empresses, grand dukes, and grand duchesses sent delicacies from their own tables to the school's students, and they showered the best of its graduates with jewels and other marks of favor. All of Russian high society shared their passion. Ballerinas danced to packed theaters night after night and reveled in the shouts of "Bravo!"

with which audiences cheered their performances. From the West, Fanny Elssler and Carlotta Grisi joined Taglioni to vie with Russia's own Elena Andreanova in the 1840s, and the vehicle for their rivalry was *Giselle*, the Romantic jewel that Grisi's husband had choreographed especially for her from Théophile Gautier's tale about revenge wrought by the spirits of maidens betrayed by false love.[52] Each ballerina danced *Giselle* in her own way, but critics cheered Andreanova most of all for the brilliance with which she captured the Romance of pure poetry in her performances. On stage, they all agreed, she was absolutely "ravishing."[53]

The 1860s had seen the founding of the first conservatories in St. Petersburg and Moscow, the rise of realism in literature, and the revolt of Kramskoi and his Young Turks at the Imperial Academy of Fine Arts. In the person of Marius Petipa, ballet master and choreographer of the imperial ballet, innovation touched the ballet, too. Dashing and romantic, his mustache and beard always perfectly trimmed and immaculately groomed, Petipa balanced the "will of higher authority" and the "sated taste of Russia's theater-goers" with his own fertile imagination for forty-one years and created almost fifty ballets in addition to some three dozen dances for operas.[54] Working with a pleiad of brilliant artists, and supported by such geniuses as Chaikovskii, Glazunov, and the choreographer Lev Ivanov, he created a repertoire for the Russian ballet that indelibly marked the last third of the nineteenth century as "the Petipa era."[55]

Yet, as Petipa's regime entered its final years, the greatest years of the Russian ballet still lay ahead. At the Imperial Mariinskii Ballet, the first decade of the twentieth century saw the almost simultaneous appearance of three of the world's greatest ballerinas, beginning with Matilda Kshesinskaia, the daughter of Poland's "King of the Mazurka" and a Russian ballerina. Anna Pavlova, daughter of a laundress and a private in the Imperial Guards, came next in the parade of prima ballerinas who burst onto the Mariinskii's stage at the beginning of the new century, and finally Tamara Karsavina, daughter of one of the theater's leading dancers, completed the trio.[56] Then in 1907 came Vatslav Nizhinskii, the ballerinas' greatest male counterpart, whose fabled leaps carried him straight into the air and landed him like a feather during the brief decade before madness overwhelmed him at the age of twenty-nine. Together, these "children of Theater Street"—as aspiring dancers were called during their student days—lifted the Russian ballet into the stratosphere of artistic achievement. Passion for the ballet became so intense among the Russians that a performance of these dancers in another city would empty the front rows of the stalls at the Mariinskii Theater as the balletomanes of St. Petersburg followed them from one guest performance to another.[57]

Housed in colonnaded buildings that lined an entire side of the short Theater Street that Rossi had laid out behind the Aleksandrinskii Theater during the days of Nicholas I, the Ballet School of the Imperial Mariinskii Theater that produced these stunning ballerinas and *danseurs* had the appearance of a cloister. For the girls consigned to this secluded world, every moment of the day was planned,

and every act designed to improve their chances of becoming prima ballerinas. Ruled by the stern traditions of an earlier age, they wore long dresses of corn-flower blue serge, with tight bodices covered by a plain white fichu that crossed in the front, and black or white aprons. "Our winter coats were voluminous," Karsavina remembered some thirty years later. The black pelisse lined with red fox was called a "penguin" because of its short, winglike sleeves, and its billow-ing folds made its wearers all appear "not unlike a sugar loaf in shape." The boys who would one day support these aspiring ballerinas in *pas de deux* and punctu-ate their *fouettes* with soaring leaps, dressed in plain uniforms of black, blue, or gray depending upon the season and the occasion. So strict were the rules against communication between male and female students that pointed glances were reprimanded almost as sternly as words.[58]

With doctors, nurses, teachers, and chaperons in constant attendance, the forty-eight girls and forty-eight boys chosen between the ages of nine and eleven each year from among thousands of applicants were fussed over like the thoroughbreds they were. Food was plain but plentiful, housing spacious but spartan, and each student was allowed the traditional Russian steam bath on Fri-days. Except for Sundays, every morning was devoted to music practice and dancing lessons. After lunch and a brief walk in the school's inner courtyard, stu-dents turned to history, languages, and arithmetic, as well as manners and elocu-tion. Only in the evenings after prayers had been sung were they allowed to share private thoughts with one other. "We were brought up in almost convent-like seclusion," Karsavina explained. "It took on the color of romance every time a glimpse or a sound or a token from outside found its way into the precincts of our isolation."[59]

A collection of superb dancing masters transformed the school's adolescent ugly ducklings into graceful adult swans. Teachers from the West taught them grace and strength, while Russians helped them impart to their performances the unique emotional intensity that gave them all a uniquely national style. The best among them also studied privately with Enrico Cecchetti, the brilliant Italian *danseur* who had traded fame in the West for greater renown in Russia. In the enormous apartment in which he gave private lessons, Cecchetti molded the unique talents of Kshesinskaia, Karsavina, Pavlova, and Nizhinskii into his own special tribute to the world of dance.[60]

Born in 1872, Kshesinskaia was the oldest of the great prima ballerinas who adorned the stage of the Imperial Mariinskii Ballet at the dawn of the new cen-tury. At first, she studied under Lev Ivanov, with whom Petipa had worked to choreograph Chaikovskii's *Swan Lake*, and then moved on to work with Ekate-rina Vazem, the ballerina for whom Petipa had created some of his most memo-rable roles during the 1870s. A disciplined perfectionist, who could traverse the huge stage of Moscow's Bolshoi Theater in just three gazellelike leaps, Vazem had stopped dancing at the age of thirty-six to devote herself to teaching, and it was under her watchful eye that Kshesinskaia took the first steps toward perfect-ing the techniques that would carry her into the senior classes of Christian Jo-

hannson, the great Swedish master who taught the school's "class de perfection" into his late eighties. Johannson became Kshesinskaia's idol, "a poet, an artist, and an inspired creator," whose every movement, she remembered, "reflected a state of soul which he strived to pass on to us."[61] In large measure thanks to his efforts, Kshesinskaia was well on the way to success when she entered the corps of the Mariinskii Ballet in the summer of 1890.

Small and vivacious, Kshesinskaia had a coquettish smile that could turn wistful in an instant, and her sparkling, deep-set dark eyes set off the mass of dark ringlets that framed her face. She, therefore, seemed to have every chance of fulfilling the special command to "be the glory and the adornment of our ballet!" that the Emperor Alexander III had given her at her graduation, and it was in that spirit that she fell in love with Russia's Tsarevich, the future Nicholas II, at the dinner that followed her graduation performance.[62] He was not quite twenty-two, and his shy, charming ways captured her heart. "It was like a dream," she confessed in memoirs written three revolutions and two world wars later. "I fell in love with the Tsarevich on the spot! I can still see his magnificent eyes, [and] his tender, kind expression."[63]

Two years later, Kshesinskaia became Nicholas's mistress. After he wed the Empress Aleksandra, she became a close friend of his uncle, the Grand Duke Sergei Mikhailovich, who gave her a summer villa on the Gulf of Finland, and then, around 1900, the consort of the Tsar's cousin Grand Duke Andrei Vladimirovich. Yet the triumphs and tragedies that would bring her into the arms of Russia's grand dukes still lay in the future when Kshesinskaia gave her heart to the Tsarevich. "I did not sleep a wink the whole night," she remembered after their first meeting. "Fortune was giving me everything."[64] In the fall of 1892, she left her parents' home and rented "a charming little house" that the Tsarevich's great-uncle had built for another ballerina in earlier times. "With beating heart I awaited the Tsarevich's return," she remembered of the evenings they shared over the next several months. "I stood by the window waiting," she added, "for the regular gallop of his magnificent charger, which rang out from afar on the roadway."[65] Kshesinskaia saw in the Tsarevich the prince of her dreams. In the Romantic fantasy with which they surrounded themselves, Nicholas became the dashing knight he would never be in real life.

Carefully coached and trained by Cecchetti, Kshesinskaia began to dance in title roles to the raves of St. Petersburg's exacting critics before she turned twenty. Her debut was pronounced "a landmark in the history of our ballet," and her technical perfection was said to have "astonished the balletomanes" of Russia's capital. From Paris, *Le Monde Artiste* added an enthusiastic welcome to the European scene: "This young prima ballerina has everything on her side," it told its readers. "[She has] a charming physique, faultless technique, polished execution, and perfect lightness." After Kshesinskaia danced as Aurora in *The Sleeping Beauty* at the beginning of 1893, Chaikovskii hurried backstage to congratulate her and promise to compose a ballet for her alone. In years to come, she would be credited with having "opened the way for a complete conquest of

the stage by Russian ballerinas," and be proclaimed (in 1898) as "the best Russian dancer of our time." Hers, it was said, was a virtuosity "which makes one forget the art as one watches the artist."[66] By the turn of the century, she had won the affection of all of Europe. It was rumored that her power was so great that she played a key part in forcing Petipa's retirement a few years later.

Yet the secret to Kshesinskaia's success lay only partly in the favor of Russia's Emperor and grand dukes, for she possessed a singularity of purpose that enabled her to place art ahead of even the most basic human needs. "She trained for hours, ceased to receive and go out, went to bed at ten, weighed herself every morning, [and was] always ready to restrict further her already frugal diet," her protégé Tamara Karsavina wrote some years later of the life Kshesinskaia led during the ballet season. "One evening," she added, "I noticed a feverish glitter in her eyes. 'Oh!' she said, in answer to my inquiry, 'I have been simply dying for a drop of water the whole day, but I won't drink before dancing.' "[67] Kshesinskaia ruled the Mariinskii's stage for more than a decade. "Thanks to her complete control and the beautiful and pure style of her dancing and acting," *The Imperial Theaters Annual* concluded as she began her eighteenth season, she was "unrivaled in the contemporary Russian theater."[68]

Despite the *Annual*'s claim, Kshesinskaia had already been eclipsed by the greatest ballerina ever to dance on the Mariinskii's stage. Small, slender, and frail, Anna Pavlova was once thought too fragile for ballet, yet she came to rule the world of dance as no other prima ballerina has ever done. On tour in London and unable to return to Russia when World War I broke out, she became an exile after the Bolshevik Revolution, and in the thirteen years that remained before her early death she danced her way around the world. Critics competed to shower accolades upon her. "Her first steps . . . led us into a hitherto unknown world wherein the laws of gravity fled before her all-conquering power," one of them exclaimed. "[There were] moments when the very march of Time seemed to be stayed to allow the realization of an unearthly masterpiece."[69]

Kshesinskaia's protégé Karsavina remembered Pavlova as "the very spirit of romantic beauty in dancing," who conquered audiences by "her inimitable grace, her delicacy, [and] some indefinable fairy quality, something spiritual and exclusive to herself."[70] Others could only look upon her in wonder. "She became a princess in the remote kingdom of dreams, Phantasms, Sylphs, Dryads, Naiads and Fairies," one enthusiast wrote, "a princess born of magic dreams, of elegy and romance, of those ballads that express a whole epoch and have created a romantic style of their own."[71] After having taught all of Russia's turn-of-the-century prima ballerinas, the great Cecchetti claimed that he could teach her nothing. "Pavlova," he concluded, "has that which can be taught only by God."[72]

Pavlova remembered her days at the School of the Imperial Ballet as being akin to living in "a convent whence frivolity is banned and where merciless discipline reigns."[73] From the moment she began her studies at the age of ten until her death almost forty years later, the discipline of her art ruled her life. "Even after having reached perfection, a ballerina may never indulge in idleness if she

wishes to preserve what she has acquired," she once warned. "A true artist must devote herself wholly to her art."[74] The world of the dance thus became the axis upon which Pavlova's life turned, but it was one that shifted as the forms of ballet changed. Trained in the choreography of Petipa, she took up the innovations of Fokin and then went on to shape the dance on her own. "I borrow from the palette of choreography any color which happens to suit my fancy," she once confessed. "Art should not, and cannot remain immovable. Progressive evolution is its law."[75]

Pavlova won the title of prima ballerina at the Mariinskii Ballet six years after her debut in 1899. Just nineteen when she danced as Giselle for the first time, she mastered the role's demanding routines so superbly that critics called her performance "an absolutely exceptional and priceless artistic experience." When Kshesinskaia retired briefly from the stage to have a child a year later, Petipa chose Pavlova to dance in his favorite *Baiaderka*, and she instantly made its difficult Indian dances into a vehicle for stardom. "All the rest remains in the background and colorless," one critic exclaimed. "From the moment Pavlova touches it," another added, "everything in this most ephemeral of the arts becomes symbolic."[76] Over the next several years, Pavlova whirled through the dances of Greece, Poland, Egypt, and Spain, and endowed each with an originality not yet seen by the balletomanes of St. Petersburg. Then, as critics continued to acclaim her triumphs in classical ballet, she began to dance with Mikhail Fokin, the dazzling young *danseur* whose revolutionary choreography would soon provide her with a stunning new vehicle for self-expression in Diagilev's Ballets Russes.

In all of her performances with the Mariinskii Ballet, Pavlova displayed an originality that astonished audiences used to the rigid forms of classical ballet. Her Giselle was a rare work of art, instinctively conceived to portray the peaks and depths of human emotion by exploring the outer limits of love, grief, and madness without ever speaking a word or uttering a sound. "She is in absolute command of her own beauty, which is lit up with every flame that arises from her soul to burn bright with every one of her movements, with every flash of her inspiration," a critic wrote after one performance.[77] "It is all as simple as life and as beautiful as a fairy tale," another added. "It is a most lovely poem without words." Pavlova's portrayal of a peasant maiden driven to madness by her royal lover's betrayal held her audiences in thrall. "The secret of her wonderful achievement," one observer concluded, "lies . . . in the fusion of every element into one beautifully balanced whole."[78]

Pavlova breathed new life into *Giselle*, but she made the *Dying Swan* her own special treasure. Created by Fokin as a short choreographic poem from the music of Saint-Saëns, the *Dying Swan* became the signature of Pavlova's achievement. It was, a critic once wrote, "the mystic elegy of a fated ending translated into the soulful poetry of dramatized dance."[79] After she left Russia, Pavlova danced the *Dying Swan* on the stages of Berlin, Paris, and London, in Buenos Aires, Melbourne, and San Francisco, and in scores of cities in between. "There is something at once fascinating and agonizing in watching this pitiful ebbing of

life, which ever retreats before the conquering advance of death," one of Pavlova's first biographers explained. "The arms extend like wings and flutter feebly. . . . Suddenly one arm leaps upwards towards the sky in a supreme effort to escape from the invisible force that bears her down, but the figure falls help-lessly to the ground. . . . The arms close stiffly above her head and fall forward on the outstretched leg," he concluded. "Her head drops on her breast. Then all is still. The swan is dead."[80] Pavlova and the swan merged into one priceless cre-ation. She kept beautiful white swans on her estate on the edge of London, made them her pets, and had herself photographed with them on countless occasions. Then, in 1931, some twenty years after she had first danced the part, Pavlova lay at death's door, struck down by an attack of pleurisy just three weeks before her fiftieth birthday. "About midnight," her husband later wrote, "she opened her eyes and with difficulty raised her hands as though she wished to make the sign of the cross." Pavlova whispered to her maid: "Get my 'Swan' costume ready," and then, a few moments later, breathed her last.[81]

The audiences that applauded Pavlova and the other great turn-of-the-century prima ballerinas who danced across the stage of the Imperial Mariinskii Theater on the eve of the First World War blazed with gold and gems, for the era of the ballet's greatest brilliance coincided with that time in history when new technology, improved magnification, and relatively low labor and material costs made it possible to produce fabulous jewelry on a large scale. Newly unearthed deposits in Siberia, California, South Africa, and Alaska in the nineteenth cen-tury had expanded the world's supply of gold many times over, and the discovery of large quantities of precious stones in South Africa and Siberia had increased the quantity of fine gems at the same time. Using superbly ground lenses to mag-nify their work and newly developed electric tools to cut and shape their materi-als more precisely, the jewelers of the Western world created breathtaking treasures between 1880 and 1914. Among them, few became more renowned than Peter Karl Fabergé, the son of a minor goldsmith who sold his wares from a tiny basement shop on St. Petersburg's Bolshaia Morskaia Street, not more than ten minutes' walk from the Winter Palace.

Born in 1846 in St. Petersburg, but trained in his art in Dresden and Frank-furt, Karl Fabergé transformed his father's modest shop into one of the world's most brilliant centers of the goldsmith's art. The key to his success lay in superb workmanship, true originality, and the identification of his fabulous creations with the elegance and opulence of his adopted homeland. Russia's Emperor and Empress, some fifty grand dukes and grand duchesses, and scores of the lords and ladies who made up their courts all owned treasures that bore Fabergé's mark, and so did Kshesinskaia, Pavlova, Karsavina, and all their rivals. The roy-alty of Europe, the rich and famous in America, the King of Siam, maharajahs of India, and mandarins of China all bought pieces of Fabergé's work, each being a unique creation that spoke of its creator's genius.[82] Often inspired by the styles of eighteenth- and early-nineteenth-century France, but also indebted to the in-fluences of the Orient, Old Russia, and the contemporary designs of Art Nou-

veau, each and every one of Fabergé's creations remained exquisitely and unmistakably Russian.

Turn-of-the-century Russia had more than a dozen gold- and silversmiths whose work in gold, silver, and enamel rivaled Fabergé's, but none matched his reputation or his flair for fantasy. None did finer work in those exquisitely engraved designs highlighted with niello—a blackened, fired alloy of sulfur, silver, copper, and lead that had been a part of the Russian silversmith's art since the tenth century—than the Moscow workshops of Ivan Khlebnikov and Vasilii Semenov, whose snuff boxes, cigarette cases, and trays engraved with intricate leaf patterns and monuments of Old Russia called up memories of those long-ago days when Russia and the West had moved along different paths. Nor did Fabergé's workmanship in enamel ever surpass the brilliant goblets and duck-shaped serving dishes, or *kovshes,* created by the artists employed by Khlebnikov and his rival Pavel Ovchinnikov, whose exquisitely shaded enamels glowed in settings shaped from gilded silver and pure gold. Ovchinnikov's artists also excelled in imitating the textures of lesser things, as in a gilded silver basket chased to imitate woven grass covered by a silver napkin that Tsar Alexander II received when he visited the Russian exhibit at the Vienna Exhibition in 1873. No finer monuments to the silversmith's art could be found than these. Yet the hallmarks of Ovchinnikov and Khlebnikov never won the international renown so readily bestowed upon Fabergé, and collectors never acquired them with the same pride or passion.

Nor were Ovchinnikov and Khlebnikov alone in rivaling the quality of Fabergé's work in precious metals. The Grachëv Brothers, Fedor Rückert, and Mariia Semenova all excelled in enamels, while Grigorii Sbitnëv and Pavel Sazikov did exquisite work in silver. At one time or another, all of them created chalices, wedding crowns, crosses, and triptychs, whose intricacy and delicacy of design surpassed anything from Moscow's golden age.[83] Yet none of these ever rivaled Fabergé's fame either. The mark of Fabergé placed objects in a world all their own, and it was to the elegant building that Karl built at No. 24 Bolshaia Morskaia Street in 1899 that Russians and Europeans in search of the "best" always turned their steps.

What set Fabergé apart from goldsmiths and jewelers of similar talent was his genius for creating objects of pure fantasy and decadence to illuminate Imperial Russia's twilight. Lilies of the valley made of pearls and diamond flowers with leaves carved from nephrite rose from a basket filled with golden moss, figures of peasants carved from seamlessly fitted pieces of semiprecious stones, a frog carved of nephrite with rose diamond eyes set atop a column of moiré pink enamel, and a diamond-eyed baboon carved from agate all stood as monuments to the decadent excess that turn-of-the-century men and women of great means found so enchanting. In a similar vein, Fabergé's masters created dancing peasants with eyes cut from sapphires and bodies shaped from agate, jasper, chalcedony, and purpurine; captains of the Imperial Lancers wearing lapis-lazuli uniforms, obsidian boots, and agate cuffs; and on one occasion a life-sized mouse

carved from chalcedony, with ruby eyes, silver ears, and a diamond-studded tail.[84] Setting the finest gems in humble jasper, agate, or nephrite figures mirrored the countless contrasts between opulence and poverty, crudity and elegance, and frugality and prodigality that marked Russia in those days. This was a nation of endless spaces and infinite wealth, in which resources were so vast that carved stone pigs could be given diamond or ruby eyes, and agate chicks endowed with golden feet.

Employing more than seven hundred of the best artisans on the eve of the First World War, Fabergé's workshops produced masterpieces by the thousands, but each carried the aura of romance and mystery that made it worthy of bearing the Fabergé mark. There was something rare about the way in which each work was conceived, every one a product of Fabergé's belief that no artisan could be a cog in a wheel and that creativity was a private and personal process.[85] From the raw materials that Fabergé placed at their disposal, his artists shaped some of Russia's finest jewelry, yet they concentrated mainly upon the firm's famed objects of fantasy, which were limited only by the boundaries of their artistic imaginations. Exquisitely enameled miniature sedan chairs with rock-crystal windows, tiny tables of gold and malachite (one with a mother-of-pearl top shaded to resemble fine leather), a stamp dispenser cut from rock crystal and topped by a golden serpent with a large ruby head, miniature grand pianos of enamel and gold, and even a silver motorcar with ruby running lamps, all poured from the fertile minds of Fabergé's craftsmen. As a gift for Nicholas to present to Aleksandra on their tenth wedding anniversary in 1904, one of his artists created a golden pansy with exquisitely tinted enamel petals that opened at the touch of a hidden button to reveal miniatures of the imperial children.[86] There seemed to be no limit to what Fabergé's ingenious jewelers could create, and no end to the extravagance they were ready to employ.

Among the thousands of fantasy objects that his workshops produced, Fabergé's famed Easter eggs carried the goldsmith's and jeweler's arts to the greatest heights. As symbols of creation and new life, colored eggs had been exchanged among Christians at Easter for centuries, and Russians exchanged red eggs bearing the Cyrillic letters "XB" (for "*Khristos voskres,*" "Christ is risen") in the tens of millions. Colored eggs made of sugar, hollow eggs filled with bonbons, and glass or crystal eggs that held images of saints or flowers flooded the shops of the empire's towns and cities as pious Russians prepared to exchange gifts with wishes for life, health, and happiness. As an end to six weeks of Lenten fasting, a celebration of Christ's resurrection, and a recognition that new life was about to burst forth with the coming of spring, Easter marked the Russians' most festive holiday.

When Karl Fabergé took over his father's business in 1870, the practice of making Easter eggs from porcelain, precious metals, and gems already was nearly two centuries old, but he raised the art to new heights a little more than a decade later with the first of the fifty-seven eggs that he and his master craftsmen created for Russia's Emperor and Empress. Sometime in the summer or fall of 1883, the

Emperor Alexander III asked Fabergé to design a special Easter egg, and in keeping with the Russian tradition of giving gifts to loved ones at Easter he specified that it must contain a surprise that would be discovered only when his Empress opened the egg on Easter morning. Fabergé produced a simple golden egg covered with opaque white enamel that looked for all the world like an ordinary chicken's egg. But when the Empress opened it, she found a golden yolk within which a ruby-eyed hen with feathers sculpted from four shades of pure gold sat upon a nest of golden straw. Inside the hen nestled a tiny replica of the imperial crown, and within that an even smaller egg cut from a perfect ruby. Delighted, the Emperor instructed Fabergé to create a new egg every year. To his anxious query as to what the next year's surprise would be, he received only an enigmatic smile and Fabergé's calm assurance that "Your Majesty will be content."[87]

Every Easter until the Revolution of 1917, Fabergé appeared at the Winter Palace bearing a new treasure. In 1890, he brought an egg of strawberry-red enamel laced with delicate golden scrolls that opened to reveal a diamond-studded platinum basket filled with delicate wood anemones carved from milk-white chalcedony. The next year he delivered an egg carved from red-flecked green jasper set with diamonds, which contained a perfectly modeled gold-and-platinum replica of the ship in which the Tsarevich Nicholas had sailed to Japan the previous winter. Two years later, the egg was ruby-colored, with four pearl-bordered panels that opened to reveal tiny paintings of the imperial retreat in the Caucasus to which tuberculosis often confined the Empress's youngest son, the Grand Duke Georgii Aleksandrovich, whose portrait could be seen when she looked through the large diamonds set in the egg's top and bottom.

When Alexander III died at the age of forty-nine in 1894, his son and heir, Nicholas II, continued the tradition, ordering an egg for the Empress Aleksandra and another for his mother. Fabergé's first creation for Russia's young Empress in 1895 was again of red enamel, which opened to reveal a perfectly shaped yellow enamel rosebud that concealed a miniature imperial crown of diamonds and rubies. Two years after that, Fabergé concealed a replica of the imperial coronation coach made of gold, diamonds, rubies, and rock crystal, inside an egg of yellow enamel studded with black imperial eagles set with rose diamonds, at the same time as he fashioned for the Dowager Empress Mariia a rose-gold egg topped by a diamond-and-enamel pelican. The egg opened to reveal eight miniature paintings of the special schools for young ladies that the Empress's namesake had founded a hundred years before, all of which were still in existence.

During the twenty years that remained before revolution consumed the Romanovs, Fabergé created two new eggs every year, each designed to surpass the ones done the year before. In 1901, he created for the Empress Aleksandra a huge golden egg of dark green enamel, which contained a tiny gold replica of the first Trans-Siberian Express that moved when wound with a tiny golden key. To celebrate the bicentennial of St. Petersburg's founding two years later, he designed a much smaller egg of gold, diamonds, and rubies that contained a perfect golden miniature of Falconet's famed "Bronze Horseman." The next year, there

was an egg over a foot high that contained a representation of the interior of the Kremlin's Dormition Cathedral.

In 1909, the egg for the Empress was carved from pure rock crystal, mounted in gold, and filled with a replica of the imperial yacht on which Nicholas and Aleksandra cruised the waters of the Finnish Gulf during the famed white nights of the far northern summer. These were the days and weeks that Russia's Emperor and Empress treasured most of all as the tension of their empire's last days tightened its grip. There, away from prying eyes, they could be themselves, find joy in each other's company, and set their cares aside. When the Romanovs celebrated their three-hundredth anniversary on Russia's throne in 1913, Fabergé created an egg mounted with ivory miniature portraits of Russia's eighteen Romanov sovereigns. Inside, the egg held a simple globe of blued steel, one-half showing a map of the domains that the Romanovs had ruled in 1613, and the other showing the immense lands over which they reigned three hundred years later.

As the future darkened with the outbreak of the Great War in August 1914, Fabergé's eggs began to reflect the austerity that the war effort required. The two eggs he created for 1915 both centered on the Red Cross, the one for the Empress being made of white enamel and decorated with red crosses, while that for the Dowager Empress contained a screen of five portraits of the Empress and her four daughters in Red Cross uniforms. The next year, the Empress's egg of blued steel contained a steel easel with a painting of the Tsar and Tsarevich at the front, while the Dowager Empress's (also of blued steel) featured motifs connected with the Cross of St. George, the Russian counterpart to the Congressional Medal of Honor, the Victoria Cross, and the Croix de Guerre. What Fabergé had in mind for 1917 is still not known. His craftsmen completed the required eggs even as Russia's dynasty crumbled, but when Easter came Nicholas and Aleksandra were prisoners at Tsarskoe Selo and the Provisional Government refused to allow him to deliver the eggs he had created. Eighteen months later, Fabergé had become an exile, driven from his workshops by the Bolsheviks. Less than two years after that, he died, convinced, as he told his friends, that the life of an exile "is life no more."[88]

According to his son's best remembrance, Fabergé's Easter eggs had cost thirty thousand rubles apiece, at a time when a skilled metalworker in St. Petersburg's mills earned well under two rubles a day. Yet, for a brief, prodigal moment before war and revolution swept away the old order, the Russians could afford the price. As the most recent arrivals among the *nouveaux riches* of the Western world, the men and women who reaped the wealth of Russia's industrial revolution squandered fortunes with an abandon unmatched anywhere else in Europe, at the same time that the handful of aristocrats whose fortunes had survived the Emancipation of 1861 continued to spend with reckless unconcern. Fabergé produced Easter eggs for the wife of a Siberian tycoon that were nearly as fine as the ones he created for the Romanovs,[89] and the hundreds of men and women who purchased his tea services, table silver, clocks, boxes, cigarette cases, and

picture frames all had the means to spend a fortune for an exquisitely worked masterpiece made from gold, silver, gems, or semiprecious stone. Such objects all stood as the hallmark of an era, but they had few successors in the tormented, uncertain world that followed the First World War onto history's stage. With three of Europe's great empires destroyed, and some of the continent's greatest fortunes in ruins, the means to realize the vast horizons that had spread out before humankind during Europe's final days of peace diminished after 1918 under the combined impact of Fascism, Bolshevism, and economic catastrophe.

Although the era of fantasy and decadence that his art represented was fading fast as Fabergé shaped the last of his great creations on the eve of the Revolution of 1917, other forms of art held greater promise for the future. By then, Levitan's tranquil landscapes had long since given way to the tormented masterpieces of Vrubel and the more abstract works of a whole legion of modern painters. At the same time, the Moscow Art Theater had offset the quiet moods of Chekhov and Turgenev with the raw, grating realism of Gorkii and Andreev, and as Russia moved closer to the beginning of the First World War a handful of rebels from the Imperial Mariinskii Ballet had given birth to the brilliant avant-garde dances of Diagilev's Ballets Russes. In like measure, the realist prose of Dostoevskii and Tolstoi had yielded to the brillant verse of Russia's Silver Age Symbolists, which quickly had evolved into still more daring poetic visions. Driven by a "yearning for other worlds,"[90] and unable to find a key to the future in either the West or their nation's past, the artists and thinkers of Russia's Silver Age set out to create new art and new values. "We saw the glow of a new dawn," the young philosopher Nikolai Berdiaev remembered. "The end of the old age," he added, "seemed to coincide with a new era which would bring about a complete transfiguration of life."[91]

At the beginning of the twentieth century, the brilliance of the new creations of Russia's Silver Age proclaimed that, even as the sun was setting on the way of life that the secular revolution had brought into being two hundred years before, it was rising on a new world of unmatched artistic creativity, in which daring men and women who worked at the modern world's aesthetic frontiers had begun to challenge the hegemony of realism in every form of art. Certain only that the moody, misty vision portrayed in Chekhov's plays could not stand as the final chapter of Russia's experience, they moved resolutely into a brave new world, where between 1900 and 1914, they created a dazzling new kaleidoscope of artistic gems that would never be matched again. Calling themselves the "children of Russia's terrible years,"[92] the young poets, painters, and thinkers who watched the clouds of war and revolution gather searched for a new faith that would reconcile the force of science with the power of belief. As they awaited what the novelist-poet Andrei Belyi called "a leap across history,"[93] their vision of the future darkened and they proclaimed that the Antichrist would engulf humankind in a final struggle between good and evil. Then, like the white nights that bathed St. Petersburg in sunlight during the midnight hours of the summer solstice, the passage of time transformed the brilliance of their Silver Age into darkness at

noon, as if to fulfill their prophecy. In barely more than a quarter of a century after they had proclaimed the dawn of a new age, the rise of Stalinism would turn the vision of writers and artists into plodding images of hard-working proletarians who claimed to shape the course of all human civilization with their hands alone.

# THE BIRTH
# OF THE
# AVANT-GARDE

❦

SENSING THE EMPTINESS of a world ruled by the certainties of science, Dosto-evskii had struggled in the 1870s to find new paths to deeper faith by pleading for a worldwide spiritual union of humankind, and Tolstoi had spent the next thirty years trying to find God in the simple world of Russia's peasants. Yet nei-ther of these literary giants could provide spiritual comfort to men and women seeking God in the modern world. As the nineteenth century reached its end, Russia's thinkers and artists continued to struggle with the questions that had tormented Dostoevskii so many years before. How could an artist escape being overwhelmed by the dehumanizing forces that the Industrial Revolution had brought into being? Did death obliterate life's meaning, or did life have a pur-pose that reached beyond human experience? And could there be salvation in a world ruled by technology? To men and women who had dedicated their lives to art, it seemed that creative activity ought to lead to a higher, more spiritual realm in which they could escape the loneliness of the material world around them. Only then could they throw off the crushing anonymity of modern life and be at one with God.

At the turn of the century, it became the mission of Russia's Silver Age artists and poets to find a system of values that would help them answer these questions and chart a course into the future. At one time or another, nearly all of them fell under the influence of the ideas of Vladimir Soloviev, who, as the spiritual god-father of the Silver Age and the first Russian ever to develop a comprehensive philosophical system, became the patron saint of its avant-garde. A gentle ascetic who hoped to bring the seemingly contradictory realms of science and religion

into closer harmony in a "free theocracy" in which the Russian Tsar would reign as the ideal Christian prince, Soloviev saw humankind as a link between nature and God, and believed that his shining vision of a Beautiful Lady who symbolized divine wisdom and eternal womanhood held the key to human history.[1] Like Alësha Karamazov, for whom he is thought to have served as Dostoevskii's model, Soloviev had the soul of a monk but lived willingly in the real world. His writings about philosophy and art awakened a generation of writers and artists "thirsting for beauty," who had grown weary of Russia's long dedication to realism.[2]

Convinced that symbols were not illusions but higher forms of reality, and that the everyday world was only a pale, symbolic reflection of a higher, more vital realm, Soloviev urged poets to discover new harmonies and higher beauties. Following in his footsteps, Russia's avant-garde poets and painters saw music as the preeminent form of art, and assembled their creations into "sonatas" and "symphonies," which they exhibited at "auditions."[3] All the while, they shifted the focus and content of their work with such dizzying speed that evolutions of styles and visions that had taken decades to accomplish in the past took place in years or even months. Between 1905 and 1914, Kazimir Malevich moved from painting in the style of France's Impressionists to a Suprematist vision that portrayed a realm beyond earthly measure in the form of red, yellow, green, black, and orange squares and rectangles, while the Symbolist poets Andrei Belyi and Aleksandr Blok needed barely more than a year after the Revolution of 1905 to replace the shining visions of their early poems with apocalyptic images of "bog water and blood."[4]

Seeking new harmonies in realms that lay beyond the real world, Russia's Silver Age artists and writers found their voice in *Mir Iskusstva* (*The World of Art*), which, from the moment it appeared in 1898, became one of the first journals in Russia to concentrate exclusively on the arts. Convinced that art must encompass "every form of expression that raised humanity above mundane, utilitarian concerns,"[5] *The World of Art* dared its readers to move beyond the realism of Repin and the Peredvizhniki, and it set priorities that played a vital part in bringing Russia's avant-garde to life. Certain that "the artist . . . does not serve any idea or any society,"[6] the journal vowed to stand above all earthly things and to "reign arrogantly, enigmatically, and alone like an eagle on a snowy crag."[7] Devoted to paying homage only to beauty and the creative power of the human soul, it drew together editors and contributors who shared a love of art, but had no common intellectual loyalties. For that reason, they quickly split apart. By 1904, poets, painters, and writers whose work had made *The World of Art* unique in the annals of Russian life had created half a dozen newer journals that served the audiences that their daring efforts had brought into being.

As a broader force in shaping turn-of-the-century Russia's artistic experience, *The World of Art* had its beginnings in St. Petersburg among a group of former schoolmates who met several times a week. At first dominated by the painter Aleksandr Benois and the literary critic and thinker Dmitrii Filosofov, the group

soon added the young artists Lev Bakst and Nikolai Rerikh, as well as Filosofov's mercurial country cousin Sergei Diagilev, whose eclectic passion for collecting all manner of art and objects had already made him notorious among his friends.[8] Although, as Benois once said, Diagilev "painted no pictures, created no productions, ballets, or operas, [and] hardly ever appeared even as a critic on questions of art," he seethed with raw, explosive energy and was blessed with the organizational genius to use it well. "I am a man with a great quantity of logic, but with very few principles," Diagilev once explained to the stepmother with whom he often shared his innermost thoughts. "I think that I have no real gifts . . . [but] I think I have found my true vocation [in] being a Maecenas."[9] Almost immediately, he took the lead in giving form to his friends' common strivings to transform the arts. "I am looking at the future through a magnifying glass," Benois remembered his once exclaiming in a frenzy of enthusiasm. "I am planning a journal in which I mean to bring together the whole of our artistic life."[10]

"A raging lion," in the words of one of his friends, Diagilev possessed the will to become the heart and soul of *The World of Art*, and it was he who convinced Savva Mamontov and Princess Tenisheva to finance the journal during its first two years.[11] Levitan and Serov, Bakst and Rerikh, Vrubel and Konstantin Korovin all found common ground in its pages. So did the poets Gippius, Briusov, Belyi, and Balmont, and the writers Merezhkovskii, Rozanov, and Filosofov. All believed that art, as a product of an artist's reactions to what was seen and felt, embodied a mystical experience through which eternal beauty could be expressed, and all insisted that its sole purpose could be nothing more than pleasure. "Despite triumphant Americanism, railroads, telegraphs, telephones, [and] all this modern brutality and vulgarity," Benois said at one point, "the world still contains great charms, and most important is full of promise."[12] From that promise all of them hoped to extract a new vision that would preserve the unique character of Russia's arts and artists against the depersonalized way of life that the modern age had brought into being. For that reason, Diagilev wanted *The World of Art* to create a revolution among artists and their audience.

Believing that "one of the greatest merits of our times is to recognize individuality under every guise and at every epoch,"[13] the creators of *The World of Art* assembled at Diagilev's apartment every Tuesday and Sunday during the early part of 1898 to plan its first issues. There, amidst an eclectic collection of Max Liebermann's neo-Impressionist landscapes, signed photographs of well-known European artists, and casts of Renaissance bronzes, they sat around the huge sixteenth-century Italian table that their host had brought home from one his frequent European travels.[14] Always grumbling about the dangers of change but persistently failing to comprehend the importance of what she saw and heard, Diagilev's old peasant nanny Dunia tended the samovar while he and his friends proclaimed that the task of the coming century must be to "establish the first principles for Russian art, Russian architecture, Russian philosophy, Russian music, and Russian poetry."[15]

Art, architecture, philosophy, music, and poetry—*The World of Art* tried to

bring them all together into a harmonious whole in which they could intermingle in new and ever-changing patterns, for its editors believed that no single art form could capture the ethereal combination of eternal beauty and mystical experience that Russia's artists and poets were seeking. As they probed the unfamiliar realms into which the writings of Soloviev and the new doctrines of Symbolism and Decadence led them, some of Russia's greatest modern writers and poets joined forces to usher in the new century with a flood of brilliant essays and poetry. Zinaida Gippius, her husband Dmitrii Merezhkovskii, and the recently emerged leader of Moscow's modern poets Valerii Briusov led the way, while the spirit of the times drew them, like Soloviev, to seek the deeper meaning of the human sexual and artistic experiences. Soloviev had shaped his beliefs from the Gospel's assertion that "the Word was made flesh."[16] Now his followers struggled to demarcate the realms of the flesh and the spirit in order to discover how human and divine might become one.

While some of Russia's Silver Age writers concluded that Christianity had become a religion of death by denying the primacy of sex, the poet, critic, and novelist Dmitrii Merezhkovskii saw physical love as the manifestation of God's earthly presence. Ugly, introspective, and eccentric, yet paired by fate with the beautiful Zinaida Gippius,[17] he saw sex as "a forecast of the even greater pleasures in store for man after the Apocalypse," and argued that all physical love was a reflection of the love men and women had for Christ.[18] Merezhkovskii believed that sex made it possible for men and women to reach God and find salvation, but he warned that the act could make the flesh holy only so long as both partners remained conscious of Christ's presence. Purely physical love was damned. To confuse the "Virgin Mother with the Whore of Babylon," he once wrote, was the greatest of sins. To be holy, sex had to be inspired by spiritual love.[19]

If "holy sex" was the key to salvation, Merezhkovskii saw art as a way to link human and divine. For a model of the place that art ought to occupy in life and culture, he turned to ancient Greece, where on his first visit to the Acropolis he had found the synthesis that united good and evil, nature and man, and heaven and earth into a single perfect harmony.[20] "It seemed to me that all my past, the whole past of mankind, all twenty unhealthy, turbulent, and doleful centuries, remained . . . behind me," he wrote after he had seen the Parthenon. "Nothing disturbed any longer the harmony and eternal peace that reigned there."[21] The harmonious blending of human creation and nature that Merezhkovskii found on the high hill overlooking Athens seemed to have no counterpart in the modern world. For it to be restored, new gods had to be born, and a balance between paganism and Christianity had to be created.

To live between the death of the ancient gods and the birth of the new ones, Merezhkovskii claimed, was the modern tragedy that placed men and women between "two equally powerful but irreconcilable forces."[22] He explored this conflict at length in *Christ and Antichrist*, a trilogy of historical novels that presented

history as a struggle between paganism and Christianity, faith and knowledge, and the world of the flesh and the realm of spirit. All three of Merezhkovskii's heroes—Julian the Apostate, Leonardo da Vinci, and Peter the Great—stood beyond the limits of good and evil, and in his novels about them he struggled to reconcile art, God, and man. Yet Julian remained torn between Christ and Apollo, while Leonardo, as a man who was half Christian and half pagan, found it impossible to solve the "mysteries of the flesh" and find complete happiness.[23] Then, in the conflict between the ruthless reformer Peter the Great and his meek and pious son Alexis, Merezhkovskii showed that Christ and Antichrist had been at war throughout modern history. Convinced that "a new earth and a new sky" could be found only in the Apocalypse,[24] he and his friends awaited the collapse of civilization and the emergence of a harmonious new world as Russia turned toward the Armageddon of the First World War and the revolutions of 1917.

As a poet who was once described as standing "a full twenty-five heads higher than Merezhkovskii in the subtlety of her thoughts and feelings,"[25] Zinaida Gippius shared many of her husband's convictions, but altered their meaning in subtle, sometimes contradictory ways. Her flamboyant beauty, seductive costumes, and passionate courting of men led turn-of-the-century Russians to see her as a woman of scandalous notoriety, but her view of sex and love was far more complex than any that Merezhkovskii or Soloviev ever conceived. Some have called her a Petersburg Hedda Gabler and a Russian Messalina, while others have branded her a "witch" and a "white she-devil."[26] More recent studies have portrayed her as a psychologically and spiritually androgynous poet, who dedicated her life and art to combining the differences between masculine and feminine on a higher, more exalted plane than the everyday world in which most Russians lived. "Spiritually, I am more a man," she once confessed, but "physically, I am more a woman."[27]

Gippius struggled to unite the antipodes of male and female in her poetry, but she never integrated the other opposites that she encountered in life and art. To enter the realm of the spirit, she rejected the physical and carnal, praised God and ignored the devil, and then set good aside in order to speak of evil. "I have no courage to die or to live," she once wrote. "God is close to me, yet I cannot pray; I yearn for affection, yet I cannot love."[28] She struggled to shape a new religious consciousness around trinities that included life, love, and death, and God the Creator, Christ the Son, and Eternal Woman-Mother, the Holy Spirit. She spoke of a Third Testament that would proclaim the Kingdom of the Third Humanity, and she insisted that God wanted man to be free and strong.[29] "We are seeking new forms, a new death, and a new resurrection," she proclaimed in *The World of Art* as the new century opened.[30] To find them all, she sought to create the Kingdom of God on earth by fusing life and religion so as to create a higher form of freedom.

At the turn of the century, Gippius and Merezhkovskii established a salon called the *Dom Muruzi*, the House of Muruza, at which the city's leading writers,

painters, and critics gathered at least once a week until the Bolshevik Revolution. Here Gippius reigned supreme, the scent of her Tuberose-Lubain perfume hanging heavy upon the drawing room's red brick walls as she circulated among her guests. In those days, she dyed her long blond hair a flaming red, and often appeared in male attire or white dresses that fitted her like a second skin. Her sensuous mouth and glittering green eyes drew men to her, and the long holder through which she smoked her perfumed cigarettes became a wand with which she worked her charms. Living on a schedule that reversed the habits of ordinary mortals, she arose at three o'clock in the afternoon and went to bed at dawn, often having spent the entire evening and night lying on a settee, as Andrei Belyi remembered, with "her luxuriant red-gold tresses illuminated by the red flames in the fireplace."[31] Everything about her seemed at odds with the world that surged along the avenue outside the Dom Muruzi. At times a decadent lioness, at others an elegant hostess, and at still others a formidable poet, Gippius never ceased to be the axis upon which the world she ruled turned.

Dark and furtive, with sunken cheeks, an enlarged nose, and a shrunken body perpetually shrouded in a haze of cigar smoke, Merezhkovskii seemed the antithesis of his wife's brilliance as he shuffled back and forth through their apartment in his slippers, oblivious of whoever gathered around him. After he had greeted them with his ritual exclamation "We are yours, you are ours!"[32] visitors usually noted his presence only when he emerged from his study to issue a pronouncement in a loud voice, to which his wife would sometimes respond by exclaiming, "Dmitrii, you are out of order!"[33] Marred by its hosts' egocentricity and a kind of intellectual narcissism that some visitors eventually found distasteful, the Dom Muruzi overflowed with heady conversation among people drawn to abstractions. It was not, the thinker Nikolai Berdiaev remembered many years later, "a place where you would meet a real person."[34]

Among those who visited the Dom Muruzi at the beginning of the new century, the poet Valerii Briusov wrote of "voluptuous shadows,"[35] but shaped his words with his mind, not his heart. Gippius dismissed him as being "neither handsome nor the reverse," and whispered to several friends that he had begun to remind her of a chimpanzee before their first meeting was over. Yet others praised him as an artist whose poetic powers soared above mortal men, and Belyi considered him to be "the first among Russia's contemporary poets."[36] Briusov had been introduced to French Symbolist verse by Aleksandr Dobroliubov, a tormented young poet who lived in a windowless, black-walled, gray-ceilinged room, where he held forth on demonism and magic whenever his opium-clouded mind wandered from the modern French poetry to which he had given his heart and soul. "[Dobroliubov] was saturated with the very *spirit* of Decadence," Briusov later wrote, and although his friend insisted that it was necessary "to speak of the incomprehensible incomprehensibly," the man who was soon to lead Moscow's Decadents gained from him a clear vision of the new course Russian poetry ought to follow.[37] The Symbolism and Decadence of the West (the two terms were used interchangeably at the time) became the "guiding star in the

mist" that Briusov followed with all the faith of a navigator on a voyage into un-known seas. To flourish in Russia, Decadence needed only to find a leader, and Briusov intended to play that role.[38]

Just as Gippius kept the literati of St. Petersburg in check with her cruel tongue, capricious moods, and a sixth sense that allowed her to exploit others' weaknesses, so Briusov used flattery, insult, and sinister hints at the otherworldly powers he might possess to reign tyrannically over Moscow's poets.[39] To the young poet Andrei Belyi, he had the appearance of "madness buttoned up in a frock coat,"[40] and he wielded an authority over men and words that few dared to challenge. Yet Briusov's flirtation with the Dom Muruzi never produced the strong alliance of which his hosts had dreamed, for he never shared their passion for finding a new religion, just as Merezhkovskii never cared for his emphasis on artistic craftsmanship and literary technique. As the guiding spirits of the Dom Muruzi sought to join men's souls through faith, Briusov insisted that such unity could come only through art. "Here," he concluded, was the only source of "true unity among people."[41] From that perspective, he set out to conquer Moscow's world of art with such energy that a critic once dubbed him "Peter the Great in miniature."[42]

Toward the end of 1901, when the effort to reconcile the poets of Moscow and St. Petersburg was at its height, Briusov introduced Gippius and Merezhkovskii to Boris Bugaev, a young poet who had taken the *nom de plume* of Andrei Belyi so as not to embarrass his father, a renowned mathematician who shared his fellow academics' scorn for modern poetry. Still a student at Moscow University, Belyi had just come of age, discovered love, and scored his first poetic triumphs. Con-sumed by nervous energy that transformed him into a *perpetuum mobile,* he seemed to illuminate the room wherever he went, and his eyes, "not simply blue—but azure—enamel, the color of the very 'heavens,' with thick, marvelous eyelashes that shaded them like fans," as a friend remembered, seemed to open passages into the inner recesses of his soul.[43] Gippius insisted that the young poet "never walked . . . but danced." All his friends, another writer confessed, were "a little in love with him."[44]

Belyi believed that music held the key to understanding God, the universe, and the place that human beings held within it. For him, music alone tran-scended the limits of time, space, and place that barred the way to that higher plane from which the Beautiful Lady of Soloviev's vision sent forth her mystical summons.[45] Free from any taint of "phenomenal reality," the symphony stood as the high point of musical form in Belyi's understanding of the arts, and he there-fore made his literary debut with four "Symphonies" published between 1902 and 1908, which, one critic explained, represented a serious attempt to compre-hend the complexity of life in symphonic terms.[46] Not since Pushkin's *Ruslan and Liudmila* had Russia seen such daring literary innovations as Belyi drew from the works of Gogol, Nietzsche, and the Revelation of St. John to argue that dreams, symbols, and visions were true and accurate expressions of a higher or-der. "I did not have a clear idea of what a 'Symphony' in literature should be," he

confessed at one point. Only later could he explain that the form had evolved from "sequences of 'storyless' little themes based on 'cosmic' images" that had emerged from his thoughts and his improvisations on the piano.[47]

Ever since Soloviev had first warned of a new Mongol horde forming in the East, visions of the Apocalypse—a resounding clash between Good and Evil whose cleansing fires would sweep away the old world and give birth to a new order—had begun to spread through the writings of Russia's Symbolists. Deriving his pen name by combining that of Russia's "first called" saint with the word for "white," the color that symbolized the Apocalypse, Belyi foresaw a time when Soloviev's Eternal Woman-Mother—the Beautiful Lady "clothed in the Sun"— would "tear her soul in agony" at the Great Whore's triumph.[48] In the first issue of the Merezhkovskiis' *New Way*, he announced that the search for new gods and new religions, which marked the opening of the twentieth century in Russia, signaled the onset of the final struggle. Certain that "the storm is near [and] the waves are raging," he awaited a titanic confrontation between Christ and Antichrist.[49] Merezhkovskii responded by urging Belyi to "teach us" that which Gippius hastened to describe as "remarkable and new,"[50] and for the next several years, the poet remained under their spell. So did Aleksandr Blok, the greatest of all Russian Symbolist poets, and the friend and adversary with whom Belyi shared the paths first trod by Soloviev.

The son of a man who had been driven from home for abusing his wife, Aleksandr Blok grew up in the warm cocoon of his grandparents' household, where culture and civility were a way of life. His botanist grandfather was the Rector of St. Petersburg University, and his mother, a tiny woman whom he called by the affectionate nickname of Droplet, possessed a heart as large as her frame was small. Combined with the imagination and ingenuity he inherited from his mother, stories from his nanny, books from his grandfather's library, and summers spent on their country estate south of Moscow shaped Blok's childhood. Words and nature became his playthings just as surely as did the toys and games that figured so large in the lives of other boys. In the circle of his mother's family, he grew up precocious, but reserved and somewhat distant. Spontaneous expressions of love and tenderness were not in his nature. "Sasha lives by passions and by the spirit," his mother once explained. "Sentiments have always been alien to him."[51]

During the summer after he turned eighteen, Blok gave his soul to the writings of Soloviev and his heart to the daughter of the world-famous chemist Dmitrii Mendeleev. Soloviev's writings bore him away into the stratosphere of philosophical speculation, where beauty, eternity, and a quest for a new religion became one, but his courtship of the beautiful and strong-willed Liubov Mendeleeva drew him toward the more mundane realm of fleshly pleasures. "Her Titianesque and Old Russian beauty was further set off by the elegant way she dressed," a close friend wrote. "She looked best of all in white," he remembered, "but black also suited her very well, and so did bright red."[52] To sublimate his earthly passions to his spiritual odyssey, Blok began his *Verses About the*

*Beautiful Lady,* the volume of poetry that occupied him throughout a long and stormy courtship, which extended from the summer of their meeting in 1898 until their marriage in 1903. Inevitably, he confused his quest for Soloviev's Beautiful Lady with his courtship of Mendeleev's daughter. The result produced confusion, bitterness, and anguish that left Blok struggling to transform the lovely Liubov into a personification of his master's vision.

Yet Liubov refused to become an earthly incarnation of the Beautiful Lady to whom her suitor had given his soul, and she questioned the vision that had transformed her into a being bound more to ideas than to life. "You look on me as though I were some kind of abstract idea," she once wrote to Blok in anger. "Behind that fantastic fiction which exists only in your imagination you have failed to notice *me,* a live human being with a living soul." Convinced that she should have nothing more to do with the poet who spoke of endowing earthly love with a deeper meaning by consigning it to the realm of celestial chastity, Liubov broke off their relationship at the beginning of 1902. When she relented a few months later and agreed to announce their engagement at the end of the year, Blok called her "all my *youth,* my *living* hope, my *earthly* being," and saw the sunlight begin to glow more brightly around the Beautiful Lady of his poetry. "If you should go," he wrote, "I shall completely disappear from the face of the earth."[53] Without Liubov, he could not summon the vision that sustained his inspiration.

Still struggling to reconcile his earthly feelings for Liubov with his mystical vision, Blok called upon Gippius in the late afternoon of March 26, 1902, to request a ticket to one of Merezhkovskii's public lectures. Known in the world of art and literature only as the author of a handful of poems that had circulated in manuscript, he deferentially referred to Gippius as "Madame Merezhkovskaia" and spoke, she remembered, "precisely as if he were tearing himself away from some deep meditation." Soberly dressed and well-mannered, he did not strike her as handsome, but she was drawn to his face—"straight and motionless, [and] as calm as if it were made of wood or stone."[54] During their first conversation, she encouraged him to tell her of his poems, his dreams, and his quest for Soloviev's Beautiful Lady, while Merezhkovskii offered to guide his searchings for the meaning of art, love, and faith in exchange for his support for their efforts to create a new religion.

Dazzled by Merezhkovskii's book *Lev Tolstoi and Dostoevskii,* Blok reread both writers from an entirely new perspective that led him to ask if he ought not to "deny the purity of art and accept its inexorable transformation into religion."[55] Yet for the moment his natural reserve held him back from casting his lot with the young men and women who were destined to be remembered as Russia's "frenzied poets."[56] "Even when he was right there with you, he was somewhere else at the same time," Gippius once wrote. "Tragic" and "defenseless," Blok became her "lunar friend"—a cool and distant poet who could work spells upon those who stood in the light of his genius.[57]

Even more than to the preachings of Merezhkovskii and the charms of Gippius, Blok was drawn to the ideas of Andrei Belyi. At the beginning of 1903, the

two young men began a correspondence that would run to more than 250 letters over the next decade and allow each to touch the soul of the other. Although the two would not meet for another year, Blok poured out his feelings in letters to his newfound "brother" in Moscow, and he allowed only him to enter the inner recesses of his spiritual world. Only to Belyi could Blok exclaim (in the third letter the two exchanged) that "I embrace you. I kiss you. . . . I am with you. I love you."[58] He was beginning to be critical of the Merezhkovskiis' ideas and to find the atmosphere at their Dom Muruzi alien to his "inner 'spiritual' state."[59] Yet he could not tear himself away from their influence at that point any more than Belyi could.

While Blok struggled to find his way among the aesthetes of St. Petersburg, Belyi reveled in the excitement of artistic life in Moscow, four hundred miles to the south. He wrote verses for an anthology that Briusov's publishing house released during Easter week of 1903, warned that the Antichrist would one day appear in Christ's image, and discussed the "craft of the poet" with Briusov and his allies. Foreseeing a new age in which humankind would be regenerated through passionate love and divine mercy, he sought to live out his vision in the arms of Nina Petrovskaia, a writer of lesser talent, who sought to realize her own decadent vision of Decadence in the bed of one poet after another. "She seemed a little dumpy," he later wrote of his first impressions of the young woman, whose passions would torment him for several years, "but her huge, dark brown, sorrowful, marvelous eyes penetrated the depths of your soul."[60]

As one of her friends remembered, Nina Petrovskaia was one of those "modernistic girls—thin, wan, fragile, enigmatic, and languid—like the heroines of Maeterlinck," who haunted the fringes of Russian Symbolism at the beginning of the twentieth century.[61] Konstantin Balmont, a poet with whom Briusov had once "wandered drunk in the streets until eight in the morning and vowed eternal love," had been her first lover until she had tired of his arrogance and turned to younger, more sympathetic men for comfort.[62] When Nina turned away from the obsessions that had ruled her days with Balmont, Belyi vowed to become her "teacher for life," only to have her physical charms cloud his mystical vision.[63] When the fires of earthly passion consumed their heavenly love, Belyi fled, and Nina fell into the arms of Briusov, with whom she sank into a hysterical swamp of spiritualism, black magic, and morphine addiction. In the spring of 1905, she tried to shoot Belyi at a public lecture, but Briusov wrested the revolver from her hands just in time.[64] After that, Nina slipped out of sight. Hungry, alcoholic, and addicted to morphine, she killed herself in a cheap Paris hotel in 1928.

Throughout 1903 and 1904, Belyi's poetry reflected his joyous expectations and his personal traumas. He wrote of the "red-gold" sun, its "silver-burning arc," and its "brightness to the point of pain." He admired the "engoldening world," the "enrubied sky," the "purple air," "blue herds of sapphires," and the azure of the air and sky, and he had visions of a "magic king" and a princess who rode upon the "golden back of a dolphin." Then, when he sensed that his passionately sought harmony could never be found, his shining vision turned sour

and he began to see skies filled with warring giants and evil beasts. Lightning bolts split the fearsome clouds that once had seemed "like rubies," and a poet shrouded in apocalyptical white could be seen in an iron coffin. Open golden fields became enclosed caves in mountainsides, from which mad prophets, false messiahs, and a "wildly funny Christ-pretender" all came forth. Madness, impotence, exhaustion, and defeat became the themes of the poet who so recently had envisioned golden banquets and shining dreams. "They began," he concluded, "to drag me into a madhouse, driving me forward with kicks."[65]

While Belyi set aside his dream of ascending into higher worlds, Blok wed Liubov Mendeleeva. At first, the purity of their love contrasted sharply with the decadent quality of their friend's tragic submission to Nina Petrovskaia's earthly charms. For a year the young couple lived in what Liubov described as a "fine-strung tenderness" as Blok continued to insist that their love must remain above the profane touch of sex.[66] Then, as Liubov confessed in her memoirs, "with malice aforethought on my part, unpremeditatedly on his," the fires of earthly passion welded them together. "I have fallen, betrayed, and now I really am an 'artist,' " Blok confessed. "[I] live not from that which makes life full but from that which makes it black and terrible."[67]

While Liubov still remained his unsoiled bride-companion at the beginning of 1904, Blok took her to Moscow, where they both met Belyi for the first time. Until then, Belyi had imagined Blok to be remote, ethereal, and cold, but he found him instead to be worldly and handsome, with "faultless manners" that injected an aura of "*bon ton*" into everything he said and did. At first glance, the talkative, restless Belyi later confessed, Blok seemed to be a typical "man from St. Petersburg, not at all an intellectual, more of an 'aristocrat,' a realist and a skeptic," and the two men who were destined to be remembered as Russia's greatest Symbolists groped for things to say.[68] Then the awkwardness eased and they began to share the closeness that their year-long correspondence had created. "Blok is both unexpected happiness and sorrow," Belyi wrote soon afterward. "[He] is the crucial moment in my life, a variant on the theme of fate."[69]

During the two weeks Blok and Liubov spent in Moscow, they visited the Kremlin cathedrals, wandered through the grounds of the Virgins' Convent, where Soloviev had been laid to rest, and dined at the famed Slavianskii Bazar restaurant just off Red Square.[70] In the evenings, when Moscow's Symbolists gathered at each other's lodgings to declaim their verses in strident tones, Blok met Briusov, Balmont, and a score of others who had turned away from the realist path. Belyi remembered how Balmont read his poetry arrogantly during those meetings, while Briusov spoke more elegantly as he placed "each line on the table like a succession of well-presented courses at dinner." Blok's austere, straightforward way of reading verse contrasted oddly with them all, for among men and women who believed that music held the key to all the arts he added no flourishes or vocal emphasis to what he had written. Still, at the end of his visit, his hosts acclaimed him the "first poet in Russia," and pronounced his verses "superior even to Briusov," although his first book of poetry would not appear in

print until later that year.[71] "They looked on Blok, if not as Hamlet, then as Faust," Belyi remembered. "He left Moscow surrounded by an aura of love and high esteem."[72]

On January 26, 1904, the day after the Bloks returned to St. Petersburg, Japanese torpedo boats attacked the Tsar's Pacific Fleet while it lay at anchor in the roadstead at Russia's Far Eastern bastion at Port Arthur. Anxious for a "small victorious war" (as the Tsar's Minister of Internal Affairs said) to divert public attention from the unrest among Russia's factory workers, the government of Nicholas II took up arms against its Asian foes in a chauvinistic frenzy, believing—as Europeans invariably did in those days—that the white man's destiny was to triumph over the peoples of the Orient. Five thousand miles east of Moscow, some nine time zones and a quarter of a world away, the Tsar's soldiers thus became the first Europeans to be tested against the might of newly modernized Asia in a conflict that would destroy once and for all the myth of Asiatic inferiority. In less than eighteen months, the Russians lost two fleets, the fortress of Port Arthur, and the battle of Mukden. Not since the Mongol armies of Batu Khan had ridden against the West almost seven hundred years earlier had Europeans felt the danger from Asia so keenly.

As the armies of Japan moved from triumph to triumph, Belyi concluded that "the great mystic [Soloviev] was right," and that Japan's unexpected victories signaled the beginning of the end of the world as he knew it. Yet he did not see "the threatening specter of a Mongolian invasion arising in the East" as the greatest danger modern civilization faced, for he viewed the Russo-Japanese War as only a pale reflection of the more ominous shadow cast by the rising confrontation between cosmos and chaos in the universe. "It is only an external symbol in the struggle between universal spirit and world terror," he concluded as the war drew to an end, "only a symbol of the struggle of our souls with the chimeras and hydras of chaos."[73] The poets, artists, and writers of Moscow and St. Petersburg all felt the deepening tension between Russia, the West, and the East as they pondered the meaning of love, faith, and the impending Apocalypse while 1904 shaded into 1905. "The air bore the destructive currents of revolution, and they percolated through all the new literature," Blok's aunt wrote some years later. "Balmont, Briusov, [and] the Merezhkovskiis all said the same thing, as they summoned [society] to stage a protest against its calm and balanced way of life . . . [and] urged people to renounce happiness."[74]

While the Tsar's forces lost battle after battle in the Far East, the political situation in Russia turned sour. At the war's outbreak, thousands of students had gathered on St. Petersburg's Palace Square to cheer their Tsar and his generals before going on to join an even larger rally that marched along the Nevskii Prospekt to the rising strains of "God Save the Tsar!" "Generals and tramps marched side by side, students with banners, and ladies, their arms filled with shopping . . . [all were] united in one general feeling," a reporter for the weekly magazine *Niva* wrote.[75] Patriotism bound them together, but so did a deep racial hatred for the peoples of the East. Unable to vent their wrath upon the Japanese,

rampaging mobs of Russians turned against the Jews, just as they had at other times of stress and uncertainty in their recent history. Within a few months, demonstrations against the Japanese and assaults against the Jews had turned into mass protests against the government. Just seventeen days before the first anniversary of the war's beginning, the Russians had a foretaste of the revolution that would strike their empire with full force in October 1905.

On Bloody Sunday, January 9, 1905, jittery guards shot hundreds of the un-armed workers who had marched to the Winter Palace to plead with the Tsar to grant them a better life. That marked the beginning of a year during which the Tsar admitted defeat in the war with Japan, faced Russia's first nationwide gen-eral strike, and crushed a full-scale armed uprising of Moscow's factory workers. At the cost of granting a constitution, Nicholas II kept his throne, but his nation and people were forever changed, for the Revolution of 1905 curbed the arbi-trary power of Russia's ancient autocracy and opened the way for its people to shape their own political destinies in a newly elected national assembly called the Duma. Political campaigns, elections, and even modest criticism of government policies all became a part of Russia's domestic landscape, and as censorship fell by the wayside, novelists, poets, playwrights, painters, and composers brought into being more artistic and literary innovations than at any other time in their nation's history.

Perhaps most surprising, the reign of Merezhkovskii and Gippius as the ar-biters of Russian Symbolism began to wane. They and Blok had come to an intel-lectual and artistic parting of the ways at the beginning of 1905, when he had pronounced Gippius to be "a complete blank," and claimed to believe that "nothing at all" could be learned from her husband.[76] Belyi, on the other hand, had continued to visit the Dom Muruzi for the rest of the year, and for a time felt closer to Gippius than ever before. Yet, even though they had discussed tempta-tions of the flesh and the meaning of religion long into the night, he, too, had failed to find the guidance he sought. Gippius and Merezhkovskii now seemed too aloof from the mainstream of life Belyi hoped to enter, for like Blok, who had turned his gaze toward the things of the earth when his Beautiful Lady had fallen, Belyi now wanted to touch the rawness of life and feel its force.[77] Almost before the echoes of Bloody Sunday died away, the two men began to explore the side streets and back alleys of the city that Blok had made a part of his apoc-alyptic vision. Drawn to the misery of the real world and fascinated by its com-plexity, Blok would exclaim: "It's a rotten life, very sad indeed, and *they*—the Merezhkovskiis—don't even notice!"[78]

That year, the Beautiful Lady to whom Blok had written his first book of verse changed into a "Woman Arrayed in Purple and Scarlet," and Belyi's Lady Clothed in the Sun "tore her soul in agony, and gave up her pure body to cruci-fixion before the fixed gaze of thousands."[79] It was a time when Belyi felt "the earth tremble underfoot," and Blok remembered "everything whirling . . . into darkness."[80] In bitter conflict for Liubov Blok's love, each man challenged the other to a duel, and the fact that neither accepted the challenge in no way eased

their rancor.[81] Blok exclaimed that he had "slammed shut the oven doors to my own soul," and Belyi fled to Paris to put his life in perspective.[82] "Pallid, with a face as gray as ashes," he remembered some years later, "I stared at myself for two years and everything I saw was a farce."[83] Both men felt themselves adrift, and neither could give the other guidance to find the way to solid ground.

Nor were they alone. Briusov later called 1905 "a year of storms, a year of maelstroms," and he confessed that he felt himself "dying in one part of my soul and reviving again in another."[84] Convinced that he must erase the line that separated him from the real world, he threw himself headlong into the new society being shaped by "the fires and hammers of factories" that Russia's year of defeat and revolution had left in its wake. But Briusov, too, could not be certain if poetry and art could survive in Russia's new world of politics. Could they be shielded from the curse of philistine middle-class values (what the Russians called *meshchanstvo*) as capitalism strengthened its roots in the land of Ivan the Terrible and Peter the Great? Fearful that the art that had given his life meaning had begun to slip away in the turmoil of revolution, Briusov felt himself "slowly rolling downhill into an abyss" and feared that he "must fall to the bottom" before the rebirth that promised new life could take place.[85] The Apocalypse still remained in the future, but he was beginning to hear its approach with a clarity that his pen could not resist. "Where are you, you marching Huns?" he called out. "I hear your iron tread!"[86]

How such visions of the approaching Apocalypse would reshape the arts still remained unclear to Russia's avant-garde as 1905 drew to a close, and it remained for Sergei Diagilev, the daring arbiter of talent and good taste who was about to lead Russia's ballet in its conquest of Europe, to suggest where the future might lead.[87] On New Year's Eve, he raised his glass at a banquet given in his honor and offered an astounding toast to "a new and unknown culture, which will be created by us and which will also sweep us away."[88] In less than a quarter of a century, everything of which he spoke would come to pass, as new visions shaped by the apocalypticism of the aesthetes who followed Soloviev, the Prometheanism of artists and writers who believed that men and women could transform the world, and the hopes of a new generation of poets and artists dreaming of revolution all combined to give birth to a proletarian culture unlike any the world had ever seen.

The endless and bitter debates about politics, art, and life that had led Diagilev to foresee the destruction of Russia as its avant-garde knew it made the appearance of the new journal, *Zolotoe Runo (The Golden Fleece)*, all the more remarkable at the beginning of 1906. Claiming the support of the painters Benois, Vrubel, Bakst, Rerikh, Somov, and Serov—and with a literary section that listed Belyi, Blok, Briusov, Balmont, Gippius, Merezhkovskii, Leonid Andreev, Ivanov, and Nina Petrovskaia among its contributors—*The Golden Fleece* published the work of every leading writer of Russia's Silver Age at the same time as it featured the paintings of its best artists. Greeted as a worthy successor to *The World of Art* the moment it appeared in print, the journal's first issue fea-

tured the paintings of Mikhail Vrubel, whose pioneering belief that form, line, texture, and color had meaning in and of themselves had opened the way for the painters who now abandoned the representational for the abstract. Convinced that art must be allowed to "grow fully, going where it will," the editors of *The Golden Fleece* paid particular attention to the works of Gauguin and Van Gogh, and dedicated an entire issue to the art of Matisse at a time when such arbiters of public taste as Benois still dismissed his paintings as "incomprehensible."[89] At the same time, they acquainted Russians with the work of Natalia Goncharova and Mikhail Larionov, whose Primitivist paintings marked the avant-garde's first steps toward the Rayonism, Cubo-Futurism, Suprematism, and Constructivism that would flourish between the outbreak of World War I and the rise of Stalin.[90]

As Russia moved toward this still unknown brave new world, its avant-garde writers and artists sought to escape the uncertainty of the present by living outside of time and space in the "Tower" of Viacheslav Ivanov. A poet who shaped his guiding principles from Nietzsche's belief that a philosopher must be a physician of the arts, and a brilliant student of Roman antiquities who was once described as being "quite possibly the most urbane, cultured, and esoteric man in Europe and certainly in Russia," Ivanov had lived much of his life in the West and dreamed of a time when the arts would become the product of the entire human community.[91] When he had published his first book of verse at the age of forty in 1903, he had returned to Russia only long enough to bask briefly in the accolades showered upon him by his critics.[92] Then, as quickly as he had appeared, this newly acclaimed master poet had fled back to Switzerland.

In 1906, Ivanov returned to St. Petersburg with Lidia Zinoveva-Annibal, a writer and distant relative of Pushkin, whom he had married after divorcing his first wife some years before, and the couple rented a seventh-floor penthouse overlooking the Tauride Palace and gardens that Catherine the Great had built for her lover Prince Potemkin. There, amidst what Belyi once described as a place of "capriciously interlaced corridors, rooms, and doorless anterooms: square rooms, rhomboids, and sectors, where thick rugs swallowed up the sounds of footsteps," they created their Tower to which St. Petersburg's avant-garde flocked every Wednesday in search of the artistic meaning and direction that none of them could find. There, brilliant red-orange modern tapestries and ornate antique furniture upholstered in rich damasks and velvets created a sense of timelessness in which, Belyi said, "day became night and night became day. . . . You'd forget what country you were in and what time it was," he confessed. "You'd blink, and a month would have passed."[93]

In the Tower of "Viacheslav the Magnificent," the Wednesday gatherings flowed into Thursday and beyond as people discussed life, love, and God, and searched for ways to embrace the "greater reality" expressed by the poetic symbols and visions that reached beyond the real world in which they lived.[94] At times, some of them climbed onto the Tower's sloping roof to declaim poetry to the stars, and it was there, during one of St. Petersburg's magical white nights, that Blok read "The Stranger," which revealed the new identity of his fallen

Beautiful Lady. "In those days, we got drunk on verses as easily as on wine," the young critic and translator Kornei Chukovskii confessed as he recalled how Blok's poetry had affected them all "in the same way as the moon affects lunatics."[95] When the sun rose, Ivanov would order food to revive his guests, and the discussions would continue without missing a beat. "So it went, day after day," Belyi wrote. "One time I planned to stay at the 'Tower' for three days, and ended up living there for five weeks."[96]

The people who gathered at Ivanov's Tower harbored apocalyptic thoughts, spoke of apocalyptic events, and lived apocalyptic lives. Having just extricated himself from his tangled affair with Nina Petrovskaia, Belyi was now consumed by his destructive passion for Blok's wife and dedicated himself to convincing her to run away with him to Europe. Blok's own life was a seething mass of tensions that separated him from the wife he loved and drew him into the arms of women he did not, and Briusov was descending into a dark morass of spiritualism, black magic, and narcotics with the same Nina Petrovskaia from whom Belyi had just escaped. While Ivanov proclaimed that "anyone who does not love is dead," Belyi insisted that an "artist-phoenix" could overcome even death with love.[97] Painful, tormented, glorious, and all-consuming, love ruled life as Russia's avant-garde poets and painters sought to heighten their awareness of the "real" world of the spirit. "One needed only to fall in love," the young poet Vladislav Khodasevich explained as he looked back on those days a quarter of a century later, "to have all the necessary elements for one's first lyrics: Passion, Despair, Exaltation, Madness, Vice, Sin, and Hatred."[98]

Widely known but rarely discussed facts of love, homosexuality and lesbianism became new themes in the writings of Russia's avant-garde after 1905. In 1906, Mikhail Kuzmin, who had dropped in for a visit at Ivanov's Tower and stayed for several years, published *Wings*, a novel whose defense of pederasty outraged conservative critics but won praise from Belyi and Briusov as a "wonderful" monument to Russia's avant-garde culture.[99] Then Lidia Zinoveva-Annibal published *Thirty-three Abominations* about lesbian love and saw it branded by critics as pornography. Just a little more than a decade after Chaikovskii had taken his life to prevent his homosexuality from being publicly revealed, *Wings* obliged the Russians to admit that homosexuality was a longstanding fact of life among them, and *Thirty-three Abominations* liberated the discussion of lesbianism from the realm of gross titillation to which Russia's male writers had previously consigned it. A few months later, Zinoveva-Annibal's *Tragic Menagerie* added stories about a young girl's discovery of her body in puberty to her earlier discussion of female sexuality. Then she succumbed to scarlet fever, while her distraught husband, in a final desperate attempt to carry the present into the future, married her daughter from an earlier marriage.[100]

Outside the hermetic world of the avant-garde, the Russians' new fascination with sex degenerated into mindless debauchery, as people lived only for the present and shrugged off any concern for society, morality, or justice with the phrase "*tryn-trava*"—"What the hell; who gives a damn?"[101] Such men and women

found a handbook of *tryn-travizm* in *Sanin*, a brief novel in which the avant-garde writer Mikhail Artsybashev wrote that "conceptions of debauchery and purity are merely as withered leaves that cover fresh grass." Artsybashev's heroes urged Russians "to plunge into the stream of sexual enjoyment" and "enjoy absolute sexual liberty, allowing women, of course, to do the same." Determined to experience all sensations before fate severed life's fragile thread, *Sanin*'s men lived freely, but left the women with whom they shared their liberation trapped on the sure and certain path that led from the boudoir to the nursery. Despite Artsybashev's assurances that one of his heroines "had a right to take from life all that was interesting, pleasurable, and necessary to her," unwanted pregnancies and tragic abandonments left such female sexual pioneers to care for the by-products of their attempted liberation, even as self-gratification led their lovers to self-destruction rather than freedom. Three suicides—all of them men—filled the novel's last fifty pages. "What a vile thing man is!" the hero exclaimed at *Sanin*'s end. Having failed to find liberation in his dreams of sexual utopia, he turned his back on civilization and set off alone into the wildness of the Russian steppe.[102]

While Artsybashev envisioned a future in which men and women would be drawn to each other by "the sexual instinct and nothing else"[103] (an image that would be developed with greater sophistication by the dissident Soviet writer Evgenii Zamiatin in his futuristic novel *We*), Aleksandr Kuprin, the army officer turned singer, carpenter, newspaperman, and novelist, concentrated on the sexual here-and-now as portrayed in the lives and longings of prostitutes in a South Russian brothel. *Iama*, the novel that Kuprin published in two parts in 1909 and 1914, pandered to a reading public that reveled in tales of rape, incest, and sadism, but it also destroyed the long-standing official myth that frequent medical inspections and thorough government regulation assured the well-being of prostitutes and the clients they served. Based on a careful study of police reports and public-health records in the cities of Russia's South, Kuprin's tale told how life in what have been called "prison houses for sexual slaves"[104] drew Russia's prostitutes into "the pit" (the English meaning of *Iama*) of hopelessness and despair.

The writings of Artsybashev, Kuzmin, Zinoveva-Annibal, and Kuprin showed that high society, too, had its lower depths as Russia moved toward the outbreak of World War I. Moscow had its "Suicide Club," and there were reports in St. Petersburg of a Temple of Eros, in which men, women, and children engaged in sexual orgies.[105] Necrophilia enjoyed a new wave of popularity among Russia's decadent aristocrats, and the latest gossip often revolved around the transvestite adventures of one of the empire's greatest lords, Prince Feliks Iusupov. Responsibility, loyalty, respect, and a concern for right and wrong all seemed to be falling away, as violence replaced order, and sin seemed about to overwhelm virtue. Scandal, crimes of passion, and betrayals became commonplace among aristocrats, intellectuals, and revolutionaries alike. All of them, Blok told Gippius one day, had been condemned to be "the children of Russia's terrible years,"[106] and

nothing showed that more clearly than the "heroes" his countrymen chose to follow.

In the days of Pushkin, the noble sacrifice of the Decembrists, who had given up wealth, position, and success in a hopeless attempt to overthrow autocracy, had been the model upon which Russia's idealistic youth had patterned their lives. The next generation had followed the example of the radical publicist Nikolai Chernyshevskii, who like the Decembrists had languished in Siberia in the name of what he believed. After that, radical young Russians had looked to Vera Zasulich, who had risked her freedom to shoot the Governor General of St. Petersburg after he had tortured defenseless prisoners. Now as Russia moved across the brief span that separated the Revolution of 1905 from World War I, the man of the hour for the disciples of *tryn-travizm* appeared to be Evno Azef. The truest personification of evil of the age and a double agent, Azef was thought to have served and betrayed the causes of the revolutionaries and the secret police. Ready to serve any master and concerned to reap personal gain from the betrayal of those who had given him their trust, Azef emerged as a popular icon among those men and women who saw in his unscrupulous manipulations of people and events the elevation of *tryn-travizm* to the level of high art.[107]

While they explored at first hand the lower depths of human emotion in the world of *tryn-travizm*, the Russians seemed to be waiting for something that no one dared to identify or define. A sense of fearsome but delicious foreboding gave them the feeling of standing on the brink and not knowing whether to spring forward or draw back.[108] The Apocalypse seemed nearer than ever, but the time and shape of its appearance still remained a mystery. At one time or another, virtually every avant-garde writer tried to imagine how and when it would appear, but Belyi came closest to describing its form and substance in the pages of *The Silver Dove*, the novel he started to write at the beginning of 1909 while living in self-imposed exile among the peasants in the remote hamlet of Bobrovka.

Cut off from those influences of Europe that had shaped so much of Russia's artistic experience since the days of Peter and Catherine the Great and surrounded by a dark forest that stretched for miles in every direction, Belyi unearthed new truths about life among the common folk that set his country and its people apart from every other land on earth. Europe, he concluded, was a place of many books, while Russia remained a realm of "unspoken words." The widespread learning of one was incompatible with the raw inner life of the other, and they could only be reconciled on a higher, symbolic plane. "On the day when the West is grafted on to Russia," Belyi concluded, "a universal fire will engulf it. Everything that burns will be consumed, because only out of the ashes of death can the heavenly little soul, the Fire-bird, fly out."[109] Only in death and rebirth—in the same sort of miraculous transformation that enabled coarse, illiterate, brutal Russian peasants to create some of the most beautiful folk songs known in human experience—could Belyi imagine the apocalyptic confrontation between Russia, Europe, and Asia.

Belyi envisioned *The Silver Dove* as the first volume of *East or West?*, a never-

to-be-completed trilogy whose title posed once again the eternal Russian dilemma of being caught between Asia and Europe. Here Russia's peasants—ignorant, brutish, and primeval—stand in juxtaposition to its "civilized," Europeanized upper classes, as Belyi contrasts the primitive joys of life in the countryside with the more polished pleasures favored by Russia's urban elite. Raw, animal passion and romantic love, superstition and knowledge, and rural primitivism and urban sophistication make up a dramatic juxtaposition of opposites as Belyi blends asceticism, eroticism, and sadism with the dark secrets of peasant life to create an extraordinary allegory of tragedy and foresight.

*The Silver Dove* centers upon the experiences of Darialskii, a fictional Symbolist poet who is destined to be swallowed by the dark superstition of the Russian countryside, in which, a commentator once explained, "the spirit of [Russia's] poets and artists is extinguished by the black force of the earth and the forest."[110] Engaged to marry the gentle, beautiful Katia, whose noble thoughts stand far above his own, Darialskii rejects her exalted love for the grossly sensual passion of Matrëna, a pockmarked peasant woman who negates everything Russia's European experience stands for. Matrëna personifies the Great Whore's triumph over the Woman Clothed in the Sun. "The movement of her breasts, her thick legs with their white calves and the dirty bottoms of her feet, her large belly, and her receding, predatory forehead," Belyi wrote, "all bore the stamp of unbridled lust." Animalistic in her desire, Matrëna enslaves Darialskii with a primeval passion whose power no person of culture dares to imagine. "Now she had climbed upon him, embracing him and pressing her large breasts against him—a veritable grinning beast," Belyi wrote of their first encounter. Then, he concluded, "she was no longer a beast, and her large eyes, now filled with tears, ebbed into his soul."[111]

Bewitched by Matrëna's primeval desires and her "sea blue" eyes, in which a man could "drown until the Second Coming," Darialskii leaves Katia, forsakes poetry, abandons civilization, and returns to the warm bosom of the earth with which his ancestors had been at one in the long-ago days before they had followed Peter the Great in choosing West over East. Certain that the civilization of Europe holds no hope for Russia's future, Darialskii seeks new truths in the heart of peasant Russia. As he stands between "his cherished past and a new reality that was as voluptuous as a fairy-tale," Darialskii announces that he is "going to the East," where, as Belyi wrote, he imagined that "Russia was gathering its forces and preparing to burst forth anew."[112]

Personified in the body and lust of Matrëna, a vision of the "pastoral Apocalypse"[113] draws Darialskii into an unknown world in which "a wizard of the evil eye," the peasant carpenter Mitia Kudeiarov, reigns supreme over a mystical sect of men and woman who call themselves doves and commit dark and violent acts in the depths of the Russian forest. Yet, in his readiness to abandon the ways of the West for the promise of the East, Darialskii finds neither the cleansing fire of Armageddon nor the rebirth of the Apocalypse, but only "the noose and the pit"[114] that signify the death he must suffer for failing to impregnate Matrëna

with the new savior for whom Kudeiarov and his doves await. "Having flown from the Antichrist of the West," one critic remarked, "Darialskii fell into the hands of the Antichrist of the East." Once again, as in the disillusionments that followed Russia's defeat by Japan and the Revolution of 1905, "the incarnate spirit of the Harlot was victorious over the Woman Clothed in the Sun."[115]

The forces that drew Darialskii from the enlightenment of Russia's Europeanized cities into the depths of its peasant villages proved to be more potent and enduring than Belyi had imagined. "*The Silver Dove*," he later wrote, "fell short in many ways, but it was successful in pointing at a still-empty place—a place that was soon to be occupied by Rasputin."[116] To all but a handful of Russians, the fraudulent itinerant man of God who called himself Rasputin and found a place in the inner circle of the imperial family was unknown when *The Silver Dove* appeared in 1909, but Belyi was amazed a few years later to note the disturbing resemblance between Kudeiarov and the Romanovs' fake prophet, whose pronouncements—like Matrëna's unbridled lust—held forth a false promise of salvation. Belyi watched in morbid fascination as the "spirit of Rasputinism" moved from Russia's smallest villages to its greatest cities, and his vision of the Apocalypse moved with it. As he traveled to Europe and North Africa with the young wife he had married the year after he had finished *The Silver Dove*, nothing could lift the sense of impending doom that hovered above him. "Come back to Russia," Blok wrote urgently in the spring of 1911. "It may turn out that there is not much time left in which to know her as she is now!"[117]

When he returned to Russia that fall, Belyi began *Petersburg*, a novel of startling apocalyptic imagery that portrayed a more twisted and perverse world than anything he—or any other Russian writer—had envisioned before. After its intended publisher rejected it because of its "malice and scepticism" (and also, Belyi suspected, because it portrayed "absent-minded liberals" in a negative light),[118] Ivanov summoned Russia's greatest writers to his Tower and invited Belyi to read the novel aloud. "During those days when the poet read his *Petersburg*," Ivanov later wrote, "I was shaken by the strength of its inner meaning and the depth of its abundant insights."[119] The novel, he proclaimed, had brought Russian letters to the edge of a new artistic universe, and once his remarks became known, publishers outdid each other to secure the rights to it. But even after it appeared in serial form in 1913 and as a book three years later, Belyi remained dissatisfied. When war and revolution finally had run their course, he transformed *Petersburg* in 1922 in order to make it clear that he now saw revolution not as "an infernal mirage" but as "the truth of the genuine Golgotha."[120]

From beginning to end, *Petersburg* presented a grim vision of nightmares, distorted perspectives, and disembodied people clustered together at the brink of a cataclysm too terrifying to describe. "There will be a leap across history," Belyi wrote at the end of his second chapter, "[and] great will be the strife, the likes of which the world has never seen. Yellow hordes of Asiatics," he continued in describing the final confrontation he envisioned between East and West, "will stain the fields of Europe with oceans of blood." There would be thunder, earth-

quakes, and "all the people of the earth would rush forth from their dwelling places." Here was the Apocalypse in its grimmest form, centered not in Asia or the faraway fields and forests of the Russian countryside but in those hellish urban monuments of modern civilization that proclaimed the full impact of Europe upon Russia. As the largest and most perverse of Russia's dens of Satan, St. Petersburg seemed to Belyi certain to "go to pieces" in the turmoil that lay ahead.[121]

"Ashy and indistinct," its streets and the "blackish-grayish cubes" of its buildings barely visible through the "greenish murk" and "greenish-yellow fog" that hung over it, Belyi's St. Petersburg was peopled by specters.[122] It was a terrifying, nightmarish industrial city, "the final curse of man" (in the words of the writer Leonid Andreev) that drew unto itself people with "small, compressed, cubic souls."[123] Briusov already had warned of its dangers, and so had Blok. Now Belyi wrote of the "human swarm of many thousands that dragged itself to the many-chimneyed factories every morning" to trade a day of life for a handful of kopeks. His St. Petersburg was wet and cold and filled with germs that infected its inhabitants with the grippe and digestive complaints. It was, he wrote, a realm of "bodies, bodies, and more bodies, bent, partly bent, just slightly bent, and not bent at all," with faces "utterly permeated with smoke," tinged with green or yellow, and marked by "bluish veins," lumpy noses, and "little white warts" that belonged to people who were "not quite people and not quite shadows."[124] As Belyi fixed his attention on this "non-Russian capital" of the land that had stood between East and West for a millennium, he brought into question all that the city represented in Russia's political and artistic experience.[125] Yet, although he sensed the nearness of disaster, he still could not locate the Apocalypse precisely in time. He promised that the sun would one day "rise in radiance" over Russia, but his vision of the future remained tantalizingly—and persistently—out of focus.[126]

As the Apocalypse moved closer and Belyi's sense of the future darkened, the vision of Russia's avant-garde artists became more colorful and abstract. In part, this new movement owed its inspiration to the efforts of Sergei Shchukin, a rich merchant whose love for modern painting rivaled Tretiakov's earlier passion for the art of the Peredvizhniki and Old Russia. In one way or another, Goncharova, Larionov, David Burliuk, Vladimir Tatlin, Marc Chagall, Kazimir Malevich, Aleksandr Rodchenko, and a dozen other Russian modernists owed their introduction to the work of Europe's Post-Impressionists to the collection that Shchukin assembled between 1900 and 1914, as he succeeded in making the paintings of Matisse and Picasso better known in Moscow than in Paris.

A small man with jet-black Tatar eyes, a bristling goatee and mustache, and somewhat Oriental features, which were especially prominent in the sketch that Matisse did of him in 1912, Shchukin came from a family of sturdy Old Believers who had built a fortune in Russia's textile trade. As a child, he had been a sickly, pampered stutterer, to whom his impatient father was reluctant to cede any place in the business he had built. Yet time soon showed that it would be Sergei more

than any of his five brothers who would raise his family from the ranks of Moscow's well-to-do merchants to the pinnacle of Russia's entrepreneurial pyramid. Immoderate in his pursuit of profit in public, he lived frugally in private, using public cabs to spare the expense of maintaining a carriage, and dining on vegetable broth, new potatoes, and an Old Russian dessert made from yogurt, sugar, and nutmeg, while he served his guests the finest wines and cuisine his great wealth could buy.[127]

Shchukin lived only for business until he passed forty. Then, in 1897, he bought Claude Monet's *Argenteuil Lilacs* at the urging of a friend, and fell in love with everything it represented. As his new passion carried him from Monet, Manet, and Renoir to Pissaro, Degas, and beyond, he purchased an average of one major painting every month for the next eighteen years, and filled the Moscow palace that his father had bought from Russia's ancient Trubetskoi princes with the largest collection of Impressionist and Post-Impressionist art to be found anywhere in the empire. Said to have been the only man ever to have owned more Picassos than Picasso himself, Shchukin collected paintings with the same passion as some of his friends collected beautiful women, but he loved them even more and cared for them more kindly. He once acquired eleven Gauguins in a single afternoon, and bought more of Matisse's paintings than the artist's richest patrons in Europe could hope to acquire. He asked only that artists paint as they wished. When, after he purchased Matisse's "Harmony in Blue," the artist transformed it into a "Harmony in Red" by overpainting its cool blue tones in shades of glaring cherry, Shchukin hung it in his palace without protest. Even in Paris, no one bought the paintings of France's young artists with more urgency or greater dedication. "Living in a picture," Shchukin said after four of his family had died in less than three years, helped one to look beyond the present to find meaning in the future.[128]

Reminiscent of the reds, greens, blues, ochers, and whites that had been a hallmark of Novgorod's icon painters, the Post-Impressionists' brilliant primary colors drew Shchukin like a magnet. As he moved from the more muted paintings of Monet to the blazing colors of Cézanne and the brilliant reds, greens, oranges, and blues of Matisse, his passion for their art deepened and he filled room after room with paintings that now stand among the greatest masterpieces of the modern world. Mixing uninhibited, pliant Polynesian maidens with the extravagance of ornate carving, gilt chandeliers, and Oriental carpets, he hung sixteen Gauguins on the walls of his cavernous dining room in tiers that called to mind the iconostasis in an Old Russian church, and then emphasized the influences that had shaped the painters' work by placing three Renoirs and five Degases in the rooms nearby.

Along with the silvery paintings of Alfred Sisley, Shchukin placed most of his thirteen Monets in his gilded *salon des dances*, and complemented them with sixteen Derains, four Van Goghs, and eight Cézannes. Between 1905 and 1914, he bought thirty-seven of Matisse's early works and mixed them with more than fifty canvases from Picasso's blue and early Cubist periods. But these only marked the

early highlights of a collection that was destined to grow to include 221 major modern works.[129] When he opened his palace on Sunday mornings to share his treasures with Moscow's young artists, the men and women whose paintings soon would stand among the most revolutionary in Europe could see all at once Cézanne's "Flowers in a Vase," Degas's "Woman Combing Her Hair," Renoir's "Woman in Black," Matisse's "Joy of Life," "Game of Bowls," "Nasturtiums and the Dance," and his huge panels depicting "Dance" and "Music," along with Picasso's "The Old Jew and the Boy," "Nude with Drapery," "Three Women," and "The Farmer's Wife." "One may quarrel with Shchukin's collection—but with head bared," a critic once wrote, "for here is the repository of *labor, continuity,* and *culture.*"[130]

Enthralled by the exciting new impressions that radiated from Shchukin's palace walls, Moscow's young painters launched the revolution that was to echo across the years of war, revolution, and tragedy that stood between them and the beginnings of Stalin's Socialist Realism. The creations of Gauguin drew them toward Russia's own natives and left them yearning to share the spirit of the common people, which they hoped would enable them "to express contemporaneity—its living beauty—better and more vividly."[131] Yet, unlike Belyi, Blok, and Briusov, who cursed cities and their factories as the work of the Antichrist, Russia's young artists greeted them as expressions of nature's most modern forms, even as they looked to the simple life of the peasants for inspiration. "We can no longer be satisfied with a simple organic copy of Nature," one of them wrote. "We have grown used to seeing it around us altered and improved by the hand of man the creator, and we cannot but demand the same of Art." Such painters insisted that art must express the forms and sensations of colors but be free to change them as an artist's inner feelings dictated. "The Earth and Nature remain only a memory, like a fairy tale about something beautiful and long past," one of them wrote. "In the light of daytime sun darkened by houses, in the bright light of the electric suns of night, life presents itself to us as quite different, replete with different forms [that are] new to us."[132] To paint the world as one *felt* it to be, so as to capture the way its colors flowed and its forms changed, became the mission upon which Russia's avant-garde painters now embarked. Once they set out to do so, a critic once explained, "so much happened, so fast, in so many places, that it is difficult to piece it together so as to make a pattern of the whole."[133]

Along with the brothers David and Vladimir Burliuk, who had studied art in the turbulent Black Sea port of Odessa, where the influences of East and West clashed at every level of life, Natalia Goncharova and Mikhail Larionov led the way in launching Russia's new "Primitivism." After meeting as students at Moscow's College of Painting, Sculpture, and Architecture (they would live and work together until their deaths in Paris more than sixty years later), Larionov and Goncharova showed their early work at exhibitions sponsored by *The World of Art* and *The Golden Fleece*, but they soon decided to move beyond the West to newer visions that could be found only in the East. "I shook off the dust of the West," Goncharova would explain a few years later. "I turned away from the

West because for me personally it had dried up and because my sympathies lie with the East." Only in Russia and the East, she said, could one find the means for creating those new forms that could make art "all-embracing and universal."[134]

In searching for those native roots that could set them apart from the West, Russia's aspiring Primitivists looked to the art of the people—to cheap *lubok* woodcuts, embroidery, and crudely painted icons—for inspiration. Goncharova devoted an entire summer to collecting peasant dolls and toys, and from these long-ignored sources she and her friends drew the brilliant colors and simple forms that would mark their work.[135] For a time, they all lived on the hospitality of Andrei Shemshurin, an eccentric Moscow manufacturer of linseed oil and varnish, who had made it a standing rule that any painter, poet, or musician who could reach his reception room before its doors swung shut at precisely five-thirty every evening was welcome to dine "in the true Moscow manner."[136] Nourished by Shemshurin's dinners and their firmly held belief that art must be freed from the ivory tower to which society had consigned it, Goncharova and her friends worked to achieve the simplicity, purity of form, and native innocence that would reunite the fine arts in Russia with the art of the people.

For several years, Russia's budding Primitivists pursued their vision among avant-garde groups in Moscow, St. Petersburg, Odessa, and Kiev. Then, to the dismay of the city's many conservative critics, the "Knave of Diamonds" Exhibition brought them all together in Moscow at the beginning of 1911 to display their art and debate its meaning. Among the twenty or so who exhibited their work, Larionov and Goncharova stood out because of their larger reputations and their uncompromising dedication to the Primitivists' credo that was soon to split Russia's modernists apart, but what separated them from former friends remained as murky as their new beliefs. "I tried to establish a distinction between . . . [their] world views," one of their newly proclaimed adversaries remembered as he looked back on their split, "but even then I found more points of convergence than of divergence. . . . All this," he concluded sadly, "was too personal and lacking in any sound [aesthetic] principle."[137]

Indeed, what divided Larionov, Goncharova, and their friends from Vasilii Kandinskii, the already well-known Russian modernist living in Munich, remains particularly obscure. Kandinskii had visited Moscow just a few months before, and four of his paintings hung in the exhibition. He too had gone through a Primitivist phase, and perhaps even sooner than his Russian counterparts he had moved on to abstract painting because he sensed, as he later wrote, that "objects harmed my pictures."[138] Yet Larionov in those days used "Munich" as a curse, as when he condemned his friend David Burliuk for being a "decadent follower of Munich."[139] Although many of the Knave of Diamonds artists had a great deal in common with Kandinskii and the other artists who lived in Munich, the small points that divided them kept them decisively—and bitterly—apart.

Taking an entirely new name from an incident in which a group of French

painters reportedly tied a brush to a donkey's tail and won acclaim for the painting it produced, Larionov and Goncharova soon broke with the friends with whom they had organized the Knave of Diamonds exhibit and formed an alliance with the Cubo-Futurist Kazimir Malevich and Vladimir Tatlin, the future Constructivist, whose experience thus far had been limited to costume design. Completely at odds with anything seen in Moscow before, their first "Donkey's Tail" exhibition of some two hundred paintings caused a furor in the spring of 1912. Larionov's drawings of soldiers and prostitutes with obscene words scrawled across them enraged critics even more than the style in which all four artists painted, but there were also those who praised their blatant defiance of convention. "Everything fused into a crazy whirlwind of the fragmented solar spectrum, into a primal chaos of colors, which restored a barbaric acuity of vision and provided an inexhaustible source of forgotten pleasure to the human eye," the Futurist poet Benedikt Livshits explained in his memoirs. "The world," he concluded with a flourish, "had been revealed in a new way."[140]

When Goncharova and Larionov announced the advent of Rayonism a year later, their critics learned that the "Donkey's Tail" Primitivists had been moving in a new direction even as they had mounted the exhibition that had so outraged the critics. After stating that the key to perception lay "not [in] an object itself but . . . [in] the sum of rays [radiating] from it," Larionov explained that "Rayonism erases the barriers . . . between the picture's surface and Nature."[141] With color, line, the sensation of speed, and an awareness of motion as their chief concerns, he and Goncharova announced that art could no longer be ruled by form and substance, and that painting, shaped only by painters' perceptions of texture, must be seen outside of space and time. "We march hand in hand with our ordinary house painters," they exclaimed. "Long live the style of Rayonist painting that we have created—free from concrete forms."[142]

Freedom from concrete forms did not mean liberation from the material world in which Russia's modernists lived, for as Blok wrote, "human culture is being made . . . ever more machine-like, ever more resembling a vast laboratory."[143] Larionov and Goncharova saluted the "brilliant style of modern times" and proclaimed the "great epoch" in which they lived to be "one that has known no equal in the entire history of the world." Yet, even though they embraced "trolleys, cars, airplanes, trains, [and] grandiose steamships" as the most fascinating creations of their time,[144] they still had to discover how to combine these complex products of modernity with the simple Primitivist peasant style they espoused. A way had to be found in art to blend the crescendo of factories and modern life with the simple rhythms of peasant existence.

The inspiration for integrating the machines of the modern world with the still-primitive life of the people came from Kazimir Malevich, son of a foreman in a Kiev sugar factory and an ally of Goncharova and Larionov in the "Donkey's Tail." Already past thirty in 1912, and with little formal training in art, Malevich created Cubo-Futurism in Russia in less than a decade. Moving with great speed

away from the Impressionist style in which he had painted on the eve of the Revolution of 1905, he had become a thoroughgoing Primitivist by 1910, portraying the peasants in his scenes of country life without separate identities of face or form in a manner somewhat reminiscent of the figures seen in ancient icons. Within a year, he had begun to paint peasants with cylindrical, robotlike arms, legs, and bodies, which made them seem a part of the industrial world at the same time as his lavish use of metallic greens, blues, and bronzes set them apart from the real world of human experience. Here Malevich portrayed that realm beyond earthly measure to which Russia's Symbolist poets had for so long aspired to elevate their vision of the future, but he had no sooner done so than he transformed his cylindrical metallic figures into ovals, circles, rhombuses, triangles, rectangles, and squares. As if recalling Galileo's famous dictum that "nature speaks the language of mathematics and the letters of this language are circles, triangles, and other mathematical figures," Malevich now spoke in similar terms.[145] By 1913, he had reduced the three dimensions in his earlier work to the verge of two. Two years later he would announce that "each form is free and individual" because "each form is a world [of its own]."[146]

As a critic once wrote, Malevich's art now had become a "combination of incompatibles pregnant with tragedy and conflict: industrialization and the icon; eternity and modern times; the past, the present, and the sense of a future offering 'unheard-of changes.' "[147] From that point it was only a short step to the new Suprematist style—"the beginning of a new culture"—that he created the year after the First World War began.[148] Proclaiming that "color is that by which a painting lives" and that "Suprematism is the beginning of a new culture," Malevich urged all artists to "abandon subject and object if they wish to be pure painters." Now claiming that he had "untied the knots of wisdom and set free the consciousness of color," he showed his first Suprematist works, only to have a critic ask, "What's to be done with it all?"[149] As if in reply to such skeptics, Malevich maintained that painting had at last been purified of all outside contaminants. "Suprematism is the pure art of painting, whose independence cannot be reduced to a single color," he wrote that year. Black squares, red squares, and later red and black squares combined with blue, red, yellow, green, and orange rectangles held the key to the future. "The square," Malevich explained, "is not a subconscious form. It is the face of the new art . . . [and] the first step of pure creation in art." Now, he concluded, "our world of art has become new, nonobjective, and pure."[150]

Looked at in combination with the fog-sodden images of Belyi's *Petersburg*, the abstract paintings of Goncharova, Larionov, and Malevich showed that the boundary lines between the arts were dissolving. The beginnings of this phenomenon reached back at least to the 1880s, when Savva Mamontov had commissioned some of the artists at Abramtsevo to paint sets for his Private Opera, thereby merging the brilliance of Vasnetsov's, Levitan's, and Vrubel's art with the musical genius of Rimskii-Korsakov, Dargomyzhskii, and Glinka. Diagilev took

up Mamontov's experiment on an even grander scale, when he took some of Russia's greatest ballerinas to Paris in the spring of 1909. Combining the painting of Nikolai Rerikh, Aleksandr Benois, Konstantin Korovin, and Lev Bakst with the choreography of Mikhail Fokin, he blended the music of virtually every major Russian composer of the nineteenth century with the dancing of Pavlova, Karsavina, Ida Rubinstein, and Nizhinskii. "I had already presented Russian painting, Russian music, and Russian opera in Paris [in 1908]," he later wrote in explaining the daring manner in which he set out to blend the arts. "Ballet," he added, "contained in itself all these other activities."[151]

Diagilev then proceeded to use the ballet to blend kaleidoscopic combinations of sight, sound, and motion into intense musical pictures that left the stunned audiences of Paris breathless. Put off by painful memories of his difficulties with the management of the Paris Opera the previous year, he chose to present the premiere season of his Ballets Russes at the rundown Châtelet Theater, which a contemporary once described as "an old barrack . . . used to blood-and-thunder melodrama and orange-eating, villain-hissing audiences."[152] With more daring than his modest financial situation ought to have allowed, he refurbished the entire building, expanded the stage, installed new boxes, and as one of his contemporaries remembered, "made the foyers into gardens of flowers."[153] To create announcements and programs, Diagilev's French impresario, Gabriel Astruc, enlisted Jean Cocteau, a young Parisian poet, whose drawings emphasized that fading boundaries between the arts were not limited to Russia. Explaining that it was his principle "to look after the auditorium on . . . [opening night] as if it . . . [were] part of the scenery," Astruc then invited fifty-two of the most beautiful actresses in Paris to sit in the first row of the dress circle, taking "the greatest care," he later explained, "to alternate blondes and brunettes." Critics acclaimed the result as "Astruc's flowerbed," and Parisians have given the name "flowerbed" to the first row of the dress circle in their theaters ever since.[154]

Alternating between programs of ballet and opera, Diagilev presented Chaliapin, Karsavina, Nizhinskii, Pavlova, and Rubinstein in dazzling performances of selections from Rimskii-Korsakov's *Maid of Pskov*, Glinka's *Ruslan and Liudmila*, Borodin's *Prince Igor*, and *Les Sylphides*, a "romantic reverie" created by Fokin from the music of Chopin as orchestrated by Stravinskii and Glazunov. *Cleopatra* (a "choreographed drama" created by Fokin to highlight Rubinstein's great beauty and mask her lack of training as a ballerina) featured Pavlova, Karsavina, Nizhinskii, and Fokin himself, with the willowy and exotic Rubinstein, Benois later said, "[giving] herself up to an ecstasy of love before the eyes of the whole audience" as the Queen of the Nile.[155] On opening night, *Le Pavillon d'Armide* featured Pavlova, Fokin, and Nizhinskii dancing in a flurry of ermine tails, lace ruffles, and silk festoons against Benois's pink, green, and blue backdrop of eighteenth-century France.[156] Every performance revealed something new and uniquely Russian in choreography, music, and design to create an overall impression unlike

anything ever seen before in Russia or Europe. "Something akin to a miracle happened every night," Karsavina remembered. "The stage and audience trembled in a unison of emotion."[157]

The theatergoers and critics of Paris hailed Diagilev's ballet as the onset of a new era. "A new, marvelous, and totally unknown world was revealed," one of them wrote. "A sort of psychosis, a mass delirium, seemed to sweep over the spectators." By restoring the emotion and sense of anticipation that nearly a century of neglect had erased from the ballet in the West, Diagilev had created the inspired magic that people sought in the theater to compensate for never finding it in real life. "Some acclaimed it a miracle, others pure barbarism—but all without exception were deeply, profoundly moved by it," another viewer wrote. "All our ideas changed," an aging academician remembered thirty years later. "It was as though the scales had fallen from our eyes."[158]

The acclaim went on for six weeks. With leading male dancers conspicuously absent from their own ballet, the Parisians were enthralled by the virtuosity of the Russians and charmed when Nizhinskii replied to the question of whether it was difficult to stay aloft during his leaps by saying: "No! Not difficult. You have just to go up and then pause a little up there."[159] Parisians pronounced Nizhinskii a "genius, a triumphant god of the performance and the divinest of dancers." They acclaimed Karsavina's beauty as "perfect [and] incomparable," an expression of "poetry" that enabled her to create an exquisite union between "classical tradition and artistic revolution." Rubinstein was pronounced "too beautiful," while Pavlova was applauded for being "to the dance what Racine is to poetry, what Poussin is to painting, and what Gluck is to music." Critics agreed that the Ballets Russes marked the end of the ballet as "a mere setting" for the ballerina's art. "The supreme quality [of the Ballets Russes]," they concluded, "is that of seeming indivisible, of being one with the work it represents, even to the point of seeming to issue from the very music itself before melting back into the colors of the settings."[160] In little more than a month, Karsavina said, the dancing of Diagilev's company had brought the ballet back to Paris "like a gust of fresh wind" from the North.[161]

Almost as much as the virtuoso performances of its dancers, the sets and costumes of the Ballets Russes infatuated the audiences of Paris. For the first time in the history of the stage, wrote Sergei Lifar, the young *danseur* who rose through the Ballets Russes to become the ballet master of the Paris Opéra, sets and the costumes that went with them stood as works of art in their own right.[162] Benois, Rerikh, and Konstantin Korovin each claimed a share of the triumph, but it was Lev Bakst who soared above them all. Between 1909 and 1914, Bakst designed the scenery and costumes for twelve ballets, each and every one of which left its audiences breathless. It would be these sets, especially those that suggested "dreadful deeds of lust and cruelty" for *Scheherazade* in 1910, that shaped audiences' remembrance of the Ballets Russes forever after.[163]

As the son of a poor tradesman, Bakst had begun life with few comforts, the

disability of being Jewish in a society that despised Jews, and an ambition to excel. For something over a year, he had studied at the Imperial Academy of Fine Arts, but had been asked to leave after he had painted the Virgin weeping over Christ in what the authorities had considered to be an insulting and demeaning pose. Just after he had turned twenty-four in the spring of 1890, he met Benois, and through him Diagilev and *The World of Art* circle. Among them, he had changed quickly from what one critic remembered as a "badly dressed, really poor specimen" into "a dandy dressed like a new pin,"[164] and he played a major part in *The World of Art*, designing the eagle perched above a snowy crag that became its emblem and producing many of its illustrations. In pursuit of the fame that still eluded him, he painted Russia's leading writers, artists, and composers, and his portraits of Belyi, Balakirev, Gippius, and Diagilev proved to be the ones by which they now are best remembered. While passion and enthusiasm ruled the lives of his more affluent, better-connected friends, Bakst thought only of mastering his profession.[165]

Perhaps because Bakst shared none of the revolutionary artistic visions of such younger painters as Goncharova, Larionov, and Malevich, he stood among the leading Russian artists who continued to work in the style of Art Nouveau when Diagilev planned his artistic assault on Paris. "You will have to paint us a lovely *décor* [for the ballet *Cleopatra*]," Diagilev told him that winter. "There will be a huge temple on the banks of the Nile," Bakst promised. "Columns. A sultry day. The scent of the East, and a great many lovely women with beautiful bodies."[166] He did that and more. Drawing upon the influences of Aubrey Beardsley and Oscar Wilde, Bakst created a set flanked by huge columns and gigantic statues that fairly shimmered in the reflected rays of the desert sun when it appeared on the Châtelet stage the following spring.

Highlighted by accents of gold, silver, and ebony, shades of orange, pink, and red dominated Bakst's stage, all of them blending with the costumes to create an unforgettable impression of sex and violence in the East. The result was "a vitally interesting excursus into the realms of archaeological iconography," one critic wrote, "a break with all the old traditions, an overturning of all the old standards."[167] Even though Diagilev had refused to bring him to Paris for its opening, *Cleopatra*'s success guaranteed that Bakst would dominate set design at the Ballets Russes until the First World War, when Goncharova, Larionov, and Picasso began to transform its sets into monumental creations of modern art. By that time, Bakst had created more than enough successes, including *Scheherazade, Le Dieu Bleu, Daphnis et Chloë, L'Après-midi d'un Faune*, and Stravinskii's *Firebird*, to make certain that his place was indelibly inscribed in the history of Russian painting, ballet, and theater.[168]

Combined with the brilliance of its dancers, the genius of Bakst, Fokin, and Diagilev enabled the Ballets Russes to blend painting, dance, theater, and music as the boundaries between the arts continued to dissolve on the eve of the First World War. In literature, the search for a "language beyond the mind" by such

Futurist poets as Velemir Khlebnikov aspired to raise the arts above the plane of reason to a realm in which the contradictions of earthly experience could be reconciled through symbols. Wanting "to paint with words,"[169] Khlebnikov broke familiar phrases apart in much the same way as Goncharova, Larionov, Malevich, and Burliuk separated objects into abstract shapes and rays that could be recast into other forms. Together with the Futurist poet Vladimir Maiakovskii, Khlebnikov began to blend poetry and painting by mixing words and images in ways that offended their audiences and defied convention.

At the end of 1912, Maiakovskii and Khlebnikov joined David Burliuk in publishing a volume of poetry printed on gray-and-brown wrapping paper and bound in sackcloth. Called *A Slap in the Face of Public Taste*, it summoned readers to dump the giants of nineteenth-century literature overboard "from the ship of modernity" and exhorted them all to defy convention and liberate themselves from tradition by looking down upon the "insignificance" of Pushkin, Dostoevskii, and Tolstoi "from the height of skyscrapers."[170] Older and wiser by a decade, Burliuk in those days saw Maiakovskii as "a wild natural genius glowing with self-confidence," and he tried to educate him in the poetry of modern Europe. "He forced books on me, paced and talked constantly, [and] wouldn't let me out of his sight," Maiakovskii wrote a few years later. Burliuk also arranged for Maiakovskii's Futurist paintings to be shown alongside those of such renowned modernists as Larionov, Goncharova, and Malevich, for all of them still hoped to blend poetry and painting into a new Futurist language that would unite the arts. In an attempt to explain the chaotic aesthetic beliefs of Russian Futurism, which disdained virtually all past and present art, condemned the West for creating the forces that had dehumanized urban life, and summed up its feelings in Burliuk's memorable couplet "Poetry is a frazzled wench / And beauty sacrilegious trash,"[171] they spoke to uncomprehending audiences of puzzled provincial philistines who had no sense of what they meant. "Publishers wouldn't print us," Maiakovskii wrote in his recollections of those days. "The capitalist nose smelled dynamite in us."[172]

Maiakovskii and Burliuk launched a broader "fight for Futurism" in the middle of October 1913, when they and some friends appeared at one of Moscow's busiest intersections dressed in outlandish clothes and wearing wooden spoons and radishes in their buttonholes. Burliuk had painted a dog with a waving tail on one of his cheeks, while the poet Vasilii Kamenskii, one of Russia's first amateur fliers, had painted an airplane across his face. Together with the poet Benedikt Livshits they marched down the street four abreast, ignoring the police and the angry shouts of the crowds. A month or so later, they set out on a speaking tour that took them to seventeen different cities to confront (or, more often, affront) their critics. On some occasions, Kamenskii gave exhibitions of flying to attract larger audiences. At other times, Maiakovskii and Burliuk held their listeners' attention by suspending a grand piano above the stage, or by going through the motions of having a tea party while they ignored everyone seated before them.

Whether he lectured, recited poetry, or simply glowered at the people around him, Maiakovskii always wore the orange-yellow-and-black-striped blouse that became his trademark. With no more than an eighth-grade education, he argued the case for Futurism, using his six-foot frame, velvety bass voice, and masterful stage presence to win the respect of those intellectuals who had come to scoff.[173] He promised "a new life to come," and urged his listeners to seize control of language. Earlier generations of poets and writers, he told his listeners, never perceived the full potential of words. That gave them something in common with the ancient Egyptians, who had discovered how to produce electricity by stroking black cats but had never learned how to use it to make their everyday lives easier.[174]

Eventually, the Futurists, their allies, and their rivals all looked to music—that ultimate "language beyond the mind" and the antithesis of silence—to blend their artistic experiences. Blok talked of escaping from calendar time to "musical time," Kandinskii acclaimed music as the most comprehensive of the arts, and Burliuk's friends called his apartment the "Nest of Music." Others dreamed of the time when the "symphonic society" of the future would resolve all social conflicts.[175] As a man who could neither paint, write, nor perform, Diagilev had dared to combine the brilliance of Fokin's choreography with the virtuosity of Russia's greatest dancers and painters, but even he had been obliged to be satisfied with music that was far more traditional than any of the other artistic elements with which his Ballets Russes launched its assault on Paris. After having been so slow to liberate themselves from the constraints of European classicism, Russia's composers broke away even more slowly from the artistic constraints that Glinka and his descendants had imposed upon them. By 1900, those same conservatories that had been created to free Russia from the West half a century earlier had become the greatest obstacle to resolving what Igor Stravinskii once called the antagonism between "modernism and academicism."[176]

A tormented genius who died before he could shape his belief in the certainty of a "world cataclysm" into an apocalyptic musical mystery play that was to have had thousands of performers but no spectators, Aleksandr Skriabin broke the grip of the conservatory conservatives who wanted to hold Russian music to the course that Glinka and the Mighty Handful had set. The most revolutionary composer of his time, the diminutive, frail Skriabin grew up in the sort of tender setting that rarely gives birth to men of daring. Raised by a protective and strong-willed grandmother, a doting maiden aunt, and a grand-aunt who shared all the qualities of the other two, he was not allowed to walk Moscow's streets alone until after he turned fourteen, and his piano teacher, the famed Director of the Moscow Conservatory, Sergei Taneev, often escorted him home from his lessons. Spoiled at home, he was treated no differently when he entered the Moscow Cadet Corps, where he was excused from the rigorous parts of cadet training because he lived with an uncle who taught there. When he graduated from the Cadet Corps at the age of sixteen, the tiny Skriabin had yet to fire a shot, shoulder the eleven-pound Russian infantry rifle, or march in a parade. After that, he

went to the Moscow Conservatory, where he once again became so much the spoiled darling of his teachers and classmates that, by the time he finished his studies, his arrogance and conceit had become notorious. "Already at twenty," he remarked some years later, "[I was] firmly convinced that I should do something big."[177]

Despite his puny hands and weak fingers, Skriabin chose the piano as his instrument, adored the music of Chopin, and slept with sheets of it under his pillow. By the time he turned twenty-five, he had written nineteen mazurkas, scores of preludes and etudes, three waltzes, three nocturnes, and a polonaise, all of them in the Chopinesque style, but original nonetheless.[178] Still, his success remained in doubt until Mitrofan Beliaev, heir to Russia's largest timber fortune and another of its merchant Maecenases, gave him a monthly allowance and arranged a series of private performances at which he could play his new compositions for the elite of St. Petersburg's musical world. As patron, confidant, and head of the publishing house that printed Skriabin's compositions, Beliaev nursed his erratic and temperamental protégé to success. Before Beliaev died at the end of 1903, he even found him another patron, in the person of Margarita Morozova, whose family's large stake in Russia's textile industry made it possible for her to send her new protégé to Switzerland with his wife and mistress. On a steamer that plied the waters of Lake Geneva in the summer of 1904, Skriabin for the first time poured out his vision of a new gospel to Iurii Engel, the chance acquaintance who was destined to become his first biographer.[179]

Not yet quite thirty-three, Skriabin was already beginning to see himself as a savior of humankind. He had just finished his Third Symphony, *The Divine Poem*, which showed how the human spirit could become at one with the universe after freeing itself from the "delights of the sensual world."[180] Proclaiming that there had never yet been such music as his *Divine Poem*, Skriabin began to dream of creating a vast mystery play in which all of humankind eventually became part of the cast. "There will have to be a fusion of all the arts," he told Engel in explaining how his *Mysterium*'s music could unify the true, good, and beautiful in human experience.[181] "Art," he continued, "must unite with philosophy and religion in an indivisible whole to form a new gospel, which will replace the old Gospel we have outlived."[182] To his notebooks that summer, Skriabin made the ultimate statement of his belief in his genius. "I am come to tell you the secret of life, the secret of death, the secret of heaven and earth," he wrote. "I am the *author* of all experiences. I am the creator of the world."[183]

During the four years after he met Engel, Skriabin worked on a symphonic poem, which emerged in 1908 as a symphony of one movement accompanied by three hundred lines of verse. At first, he called it his "Orgiastic (meaning "orgasmic") Poem," but eventually changed its title to *Poem of Ecstasy*, which recounted the quest of the human spirit in a musical score that alternated between erotic languor and clamoring triumph. Skriabin shaped his new *Poem* around themes that symbolized longing, aspiration, and victory, and ended it with the triumphant cry "I am!" as the spirit ultimately surrendered to "the bliss of

love."[184] An excellent example "of innovation in its highest sense, expressing a new quality, alloying many traditional elements, and embodying the leading ideas of the time," as a critic later wrote, the entire symphony lasted less than half an hour.[185] One conductor fell on his knees, the first time he heard it, to exclaim: "It's genius, it's genius," but the much-respected Taneev reluctantly confessed that listening to it made him feel as if he "had been beaten with sticks."[186]

Most contemporaries recognized Skriabin's *Poem of Ecstasy* as an attempt to open a new path into an untamed wilderness.[187] Yet its revolutionary atonality and dissonance left them all unsure of its meaning. "I think Skriabin cannot be understood in our time," one of them confessed sadly. Audiences, he went on, "simply cannot *hear* the excellence of Skriabin's music."[188] Only Skriabin himself seemed able to comprehend the full meaning of what he had created. "Listening to his music, he froze his face strangely, closed his eyes, and displayed an almost physiological voluptuousness," a Moscow observer reported after attending a rehearsal of the *Poem of Ecstasy*. "In moments of tension in the music, he breathed heavily, gripping his chair with both hands. I never saw a composer," he confessed, "react so intensely."[189]

Skriabin began *Prometheus: The Poem of Fire* not long after he finished his *Poem of Ecstasy*. Following in the footsteps of Goethe, Shelley, Byron, Beethoven, and Karl Marx, all of whom had been drawn at one time or another to the myth of Prometheus, Skriabin saw this celestial rebel, who had brought fire and the arts to humankind, as an eternal embodiment of those colors and lights that soared beyond man's highest thoughts.[190] In homage to Prometheus, he shaped a symphony in which the Creative Principle arose from Chaos, ascended in a cosmic dance of atoms to the Dawn of Human Consciousness, and then, as Spirit, descended into Matter. As the first composer to dream about a new kind of fire in the form of harnessed electric current, Skriabin incorporated into his score notes that could be played by a special "light keyboard," which, at the time, existed only in his imagination. So as to create what he called "a contrapuntalism of all the different lines of art," he dreamed of flooding a concert hall with light and changing its colors in accordance with (sometimes in opposition to) his music.[191] Nothing like it had ever been conceived in the history of music. As a unique blending of the arts, he saw it as a new synthesis that might lift humankind to the level of the gods.

In a magisterial study of the composer's life and art, Skriabin's leading biographer once insisted that *Prometheus* was the greatest symphony his subject ever wrote. "Nothing," he said, "approaches its shimmering brilliancy and scintillant novelty. Its sheen is brittle as icicles, its heat blistering, and mixed in are soaring, surging themes . . . of almost naked exaltation." Here Skriabin had tried to synthesize all human artistic experience and to express the result in sound, color, and light. "It dazzled with its sparkling genius, its glimmering tongues of flame," he explained. "Every phrase is as remarkable as summer's first light on a spring day."[192] Yet many of the Muscovites who heard *Prometheus* for the first time in the spring of 1911 thought it the work of a madman. "It makes the air heavy and

irritates the nose," one critic complained. A second described it as "sick," and another dismissed it as "hopeless, chaotic noise" and "a burning example of anti-art innovation." Only a handful saw *Prometheus* as "a bridge between what *is* and what *will* be," a "daring event in the history of art," and a "step forward in the direction of . . . [bringing] all influences to bear on man's psyche in order to attain ecstasy."[193]

Daring, explosive, revolutionary, and brilliant, even *Prometheus* could not encompass the vision that took shape in Skriabin's mind as the smoke from a hundred forest fires, fanned by the hot summer winds of 1914, hung over Moscow. Acclaimed in London, Paris, Brussels, and Berlin, and cheered all across his homeland after a grand tour that the conductor Sergei Kusevitskii arranged, Skriabin had become famous. Universally respected as a master composer and pianist, he ended his wanderings through Europe and settled with his common-law wife Tatiana and their three children in Moscow, where their apartment became a mecca for the avant-garde from East and West. Isadora Duncan and Pablo Casals stayed with the Skriabins regularly on their visits to Russia. Merezhkovskii, Gippius, the young novelist and playwright Aleksei Tolstoi, and Viacheslav Ivanov, who had turned toward theosophy and the mysticism of the East, often visited from St. Petersburg, while such Muscovites as Belyi, Briusov, and Balmont shared evenings with the Skriabins as they moved their never-ending discussions about transcending human experience from their apartment to the Journalists' Café on Stoleshnikov Lane and back again. When the Great War finally broke out, they debated its meaning, with Skriabin seeing it as a much-needed "spiritual renewal for people . . . even though it destroyed them materially."[194]

Firmly under the influence of theosophy and the teachings of Madame Blavatskaia, who sought to link past and present through communion with the dead, Skriabin set to work on his *Mysterium* in earnest just before the Great War began. He made plans to visit India to find the perfect location for the temple in which his *Mysterium* would be performed, and he began to study Sanskrit in hopes of constructing from it the new language in which the text would be written. He spent the drought-stricken summer weeks of 1914 in the country beyond Moscow, planning and writing the "Prefatory Action" that was to form the beginning of his larger work. As he worked on the big, open, sun-flooded balcony of the country house he and Tatiana had rented for the summer, his vision burst all bounds, and he added colors, scents, and tastes to his score. He hoped to set his "Prefatory Action" against the background of the Himalayas, with their peaks, sunrises, sunsets, deserts, meadows, and forests all forming part of the decor. So that the musicians could learn to "play their instruments as if they felt the sensation of each sound, as if caressing each tone,"[195] he planned to establish a special school in England, and when ordinary score paper could not accommodate the massiveness of his "Prefatory Action," he pasted two sheets together so as to have seventy lines to use for scoring it rather than the usual thirty.

Focusing upon the creation of the universe as he shaped his "Prefatory Action," Skriabin blended ecstasy, dreams, angels, flames, clouds, waves, and death

in an outpouring of images that revealed no profound truths but created a dazzling amalgam of words and music that he hoped would give form and substance to that higher realm to which Russia's Symbolist poets continued to direct their vision. Yet, as in his earlier works, Skriabin could not find an ending, for he saw music as a continuum in which past and future merged and one composition flowed into the next. So it became with life, for just when his vision seemed about to come into focus, death struck in the form of a pimple on his upper lip that ballooned into streptococcus staphylococcus blood poisoning and bacteremia. As Moscow's best physicians marveled at the speed with which the pimple became a pustule, a carbuncle, and a furuncle, Skriabin's temperature soared to 106 degrees, and massive infection spread through his entire body. Early in the morning of April 14, 1915, he awakened, complained of the pain in his chest, and then screamed, "This is a catastrophe!" A few hours later, he was dead. At his funeral, the Kremlin choir sang a mass for the dead and tens of thousands of mourners followed his coffin to the same Novodevichii Convent in which Musorgskii had set the opening scene of *Boris Godunov*. "Our sun has gone out," one of his friends wrote. "Without warning, we, the satellites, are left suddenly with no planet."[196]

Although focused on cosmic questions, Skriabin's work on the "Prefatory Action" of his *Mysterium* had signaled his growing separation from humanity at large. The feelings of heroism, religious fervor, love of country, and deep human passion that shaped the works of other composers barely touched him in the final months of his life, when his vision had focused only on the abstraction of seeking the origins of creation.[197] Yet his passion to find new modes of musical expression was shared by others, not the least of whom began life in the shadow of that sprawling Oranienbaum Palace that Gottfried Schädel had designed for Peter the Great's favorite Menshikov in the days when Russia's new capital was a swamp and its elegant canals muddy tributaries of a muddier Neva River. There on the shores of the Finnish Gulf, where St. Petersburg's well-born and well-connected spent their summers, Igor Stravinskii was born on June 17, 1882. The son of the leading bass at the Mariinskii Opera and a woman of uncommon musical gifts, who shared their apartment with an uncle whose passion for music was rivaled only by his belief in progress and the modern way, Stravinskii went frequently to the theater, studied for a career in law, dabbled from time to time in studying composition and the piano, but did not decide to devote his life to music until he was well past twenty.[198]

As a university student, Stravinskii had studied law in the company of Rimskii-Korsakov's youngest son, and their close friendship soon brought him into the charmed circle of the composer's students. Stravinskii learned to orchestrate from the master himself, but his early work barely hinted at the amazing masterpieces that soon would follow. Then, not long after Stravinskii turned twenty-seven, Diagilev commissioned him to write the music for *The Firebird*, a ballet that was destined to stand second only to *Scheherazade* as the brightest gem of the Ballets Russes's second Paris season. Some of Diagilev's friends

thought it pure madness to rely on an untested composer, yet as in so many other instances, the impresario sensed brilliance in an unlikely place. While Stravinskii hammered on the piano to impose his sense of rhythm on a *corps du ballet* that thought his music odd at the very least, Diagilev looked on with unruffled confidence. "Mark him well," he told Karsavina as he motioned toward the irascible young composer. "He is a man on the eve of celebrity."[199]

A week after Stravinskii turned twenty-eight, Diagilev's prediction came true. With Karsavina dressed in the dazzling green-and-orange costume that Bakst had designed especially for the occasion, *The Firebird* made its first glorious flight across the Paris stage on June 25, 1910, to win fame for Stravinskii in an instant. While the audience at the Opéra applauded and cheered, Claude Debussy hurried to the stage to embrace Stravinskii, and a score of other stars of the Parisian culture firmament hastened to welcome the new meteor that had fallen into their midst. Hailed as a genius, Stravinskii for some years remained, as Debussy later wrote, "a young savage, who wears loud ties and kisses women's hands while stepping on their feet. When he grows older he'll be unbearable," the Frenchman Debussy concluded, "but at present, he's terrific."[200]

Eleven months later, Stravinskii finished *Petrushka*. A fantasy ballet about a victim of fate and circumstances whose ill-starred escapades dominated the puppet theaters that flourished during the Shrovetide carnival, the last festival before the beginning of Lent, Stravinskii brought to life a fairy-tale world of lusty coachmen, singing beggars, gay organ grinders, brightly dressed nursemaids, and lovely maidens all dancing to music that was as complex as their lives were simple. "In composing the music," he explained, "I had in my mind a distinct picture of this puppet, suddenly endowed with life, exasperating the patience of the orchestra with diabolical cascades of arpeggios. The orchestra," he continued, "retaliates with menacing trumpet blasts. The outcome is a terrific noise which reaches its climax and ends in the sorrowful and querulous collapse of the poor puppet."[201]

Here was a musical carnival unlike any that anyone had ever seen or heard. "Stravinskii used the different instruments in the score with a touch of genius," one critic exclaimed. "The flutes bubbled like the reeds in a fun-fair organ; trombones and tubas, released from their Wagnerian servitude, filled exciting new roles as circus clowns, [and] hurdy-gurdy tunes, churned out to the tinkling rhythm of triangles, infused a delicate flavor of irony into the music."[202] To dance the roles of Petrushka and the Ballerina as Fokin choreographed them required never-flagging virtuosity. As always, Nizhinskii and Karsavina, both of whom grasped the movements with uncanny insight despite the complexity of Stravinskii's music, proved more than equal to the challenge.

Asked by Diagilev to design the sets and costumes for *Petrushka*, Benois created a second masterpiece—a true labor of love—to go with Stravinskii's music. "Petrushka . . . had been my friend since childhood," the artist explained some years later. "I immediately had a feeling," he added, "that 'it was a duty I owed

to an old friend' to immortalize him on the real stage."[203] Benois set Stravinskii's ballet in the St. Petersburg of Nicholas I, a time thought by *The World of Art* group to have been a lost golden age of Russian values. This was the age of Pushkin and Gogol, and Benois filled his set with samovars, carousels, puppet shows, and characters that imparted a truly Gogolian flavor to life in Russia's capital. "What I remember about *Petrushka*," Karsavina later said of the frantic rehearsals that began "among the smells of stale scampi and stale carpet" in an old Roman restaurant, "is that it was utterly tempestuous." Struggling to come to grips with music that Benois thought too complex to choreograph in any case, Fokin was in a frenzy, while Stravinskii, impeccably dressed as always, tried to impart his shifting and subtle rhythms to the dancers by playing the score himself. "He had a woodpecker nose and it looked as if he were pecking the piano," Karsavina remembered. "[But] we were deeply impressed by his beautiful manners. He bowed to us, all of us in ragged clothes and dishevelled, and asked our permission to take his coat off."[204]

From *Petrushka*, Stravinskii moved to *The Rite of Spring*, based on an inspiration that had come to him full blown in a moment when all his thoughts had been concentrated on finishing *The Firebird*. "I saw in my imagination a solemn pagan rite," he later explained. "Sage elders, seated in a circle, watched a young girl dance herself to death . . . to propitiate the god of spring."[205] His imagination set the scene in pagan Russia, where the seasons had ruled people's lives and the fear of unknown forces had shaped their religion. Stravinskii shared his vision with Nikolai Rerikh, the artist whose sets for the Ballets Russes rivaled those of Bakst, only to set the idea aside for more than a year to finish *The Firebird* and *Petrushka*. Then he returned to his pagan vision, and buried himself in the remote Russian countryside in much the same way Belyi had done when writing *The Silver Dove*. He continued to work throughout the fall and winter of 1912 in Switzerland, and by early 1913, *The Rite of Spring* was ready to be presented to the balletomanes and high society of Paris as the highlight of the Ballets Russes's fifth season. Program notes promised to show youths and maidens worshiping the Earth, followed by a sacrifice to the pagan god of spring in which the Chosen Virgin would dance herself to death in order to assure the regeneration of the fields and forests at winter's end.

Nothing had prepared the men and women who came to the theater on the night of May 29, 1913, for the wailing violins, howling woodwinds, and frenetic, spasmodic dances that accompanied Stravinskii's revolutionary score. As the audience hissed and shouted its disapproval, the Austrian Ambassador burst into laughter, and someone shouted: "Shut up, you aristocratic bitches" to a group of elegant ladies who joined in the din.[206] Some fifty people stripped themselves naked to protest the audience's disrespect, which only grew louder as the ballet went on. Stravinskii was stunned. In the wings, Nizhinskii seethed, his rage about to boil over, while Diagilev made frantic signs for the conductor to continue. Then, when it was over, the impresario left the theater with Stravinskii,

Nizhinskii, and Jean Cocteau, with tears of anger and frustration running down his cheeks. That night, the four men drove through the Bois de Boulogne, realizing as they went that years must pass before audiences would appreciate the magnitude of what they had created. While they drove, the critics were writing their first reviews of the "epileptic fits" of dancing in *"The Massacre of Spring."*[207] Only one critic dared to speak kind words. "A secret power brings you back to every performance," he wrote a few weeks later. "At the third hearing you are bound to the music ... and forced to gallop, whether you will or not, over mountains and plains."[208]

More than Skriabin's revolutionary *Prometheus*—more, even, than his unfinished *Mysterium*—Stravinskii's *Rite of Spring* moved Russian music resolutely into the modern age. Ahead lay other revolutionary works, but none equaled the impact of the ballet with which he had celebrated the final days of peace before the guns of August plunged the Western world into bloodshed and chaos. "We were impatient of explanation, and deriving no immediate enjoyment from the music dismissed the stage action as of no moment," a commentator confessed in revealing his second thoughts a few years later. "In the *Rite of Spring*," he concluded, "Stravinskii gives us far more than we were then able or willing to appreciate."[209] Written at the height of World War I, such sentiments still stood at odds with the feelings of most audiences. "Who wrote this fiendish *Rite of Spring?*" an outraged theatergoer wrote to the *Boston Herald* after hearing its orchestral suite introduced to America in 1924. "What right had he to write this thing? / Against our helpless ears to fling / Its crash, clash, cling, clang, bing, bang, bing!"[210] Only when Walt Disney incorporated the music into his *Fantasia* more than a decade later did Stravinskii's creation finally gain wide acceptance, although its revolutionary dimensions remained undiluted. "Seventy years after its creation," two critics marveled not long ago, *"The Rite of Spring* is still so potent that it can give someone who is hearing it for the first time the feeling that his life is being turned topsy-turvy."[211]

While audiences jeered Stravinskii's *Rite of Spring* and Skriabin struggled to come to grips with the beginnings of his impossibly complex *Mysterium*, the armies of the Western world found that poets' dreamlike apocalyptic visions had nothing in common with the reality of modern warfare. "In war, guns and soldiers' faces lose color," the novelist and memoirist Ilia Ehrenburg wrote in trying to explain how the stark reality of modern battlefields diverged from the Symbolists' visions of Armageddon's cleansing fires. "Straight lines, planes, drawings like blueprints, an absence of anything arbitrary, of anything that is lovably irregular," he added, left "no room for dreams." Among men who faced monstrous artillery barrages, the hosing fire of machine guns, and the desolation of no-man's-land, visions of glory won for God and Country had no place. Modern war, Ehrenburg concluded as he reflected on the days he had spent in Paris reporting on the Western Front for Russian newspapers, had become "a well-equipped factory for the annihilation of mankind."[212]

Modern war perpetuated none of the Romantic visions that Dawes's paintings of Russia's heroes still projected in the 1812 Gallery of the Winter Palace, nor had it anything in common with the apocalyptic images that Belyi, Briusov, and Blok had drawn from the East. Chivalry, heroism, and the exaltation of testing one's strength and courage in combat all counted for little in a war in which men lived, made ready to kill, and prepared for death in trenches seven feet deep and three feet wide with only a slit of sky above their heads to assure them that they had not already passed into the world beyond the grave. Such modern-day warriors bore no resemblance to the stalwart heroes who had fought for God, Tsar, and Mother Russia in olden times any more than their counterparts on Europe's Western Front resembled the men who had fought for Napoleon's empire or for England's mastery of the world's seas. Now they all marched in dehumanized form—"grotesques with India-rubber faces, great dead-looking goggles, and long tubes from their mouths to the box respirators [that hung at their sides],"[213] an Englishman once said of those who fought and died in clouds of poison gas— to tend the modern killing machines that did their bidding. "The disgusting part of this war [is that] it's all so mechanical," a young German complained. "One might call it the trade of systematic manslaughter."[214]

Almost from the moment it began, the Great War changed the way in which the painters, writers, and composers of Russia's avant-garde looked at the future. For one thing, the "children of Russia's terrible years" were passing into middle age. Merezhkovskii and Ivanov both turned forty-eight the year the war began. Gippius was forty-seven, Briusov forty-one, and even Belyi and Blok—the *enfants terribles* of the group—were just a year away from thirty-five. In the material and cultural sense, the "terrible years" between the Revolution of 1905 and the first battles of 1914 had been unexpectedly kind, for they all now lived comfortably from the art that their pens and brushes produced. Compared to the terror and destruction into which the Western world plunged so thoughtlessly in 1914, the Symbolists' raging declarations of disenchantment suddenly became irrelevant, and their complaints seemed sourly out of place in a time when the instruments of modern combat could erase tens of thousands of lives in a single morning.

The reality of living in a world at war forced the men and women of Russia's avant-garde to think about life, death, and survival in real, unvarnished terms that made it harder for them to focus their vision on those higher realms toward which Symbolism had drawn their thoughts in days of peace. Forced to adjust their lives in unexpected and disruptive ways, they began to shift from East to West and back again as they struggled to reconcile unexpected patriotic feelings with the demands of life and art. The young painter Marc Chagall left Paris, where he was on the verge of becoming famous, and returned to Russia, where he was not, while the forty-eight-year-old Vasilii Kandinskii returned home to Moscow after having lived virtually all of his artistic life in Munich. Caught in the West at the war's outbreak, Pavlova, Diagilev, and the Ballets Russes all settled in

Switzerland, where they were soon joined by Goncharova and Larionov. So did Stravinskii. Cut off from Russia, first by war, and then by revolution and the rise of Bolshevism, none of them would ever see their homeland again.

The experiences of these and many other émigrés showed that ideology and politics had become determining factors in the lives of Russia's avant-garde as the war ran its course. Initially choosing to stand above the mundane things of the everyday world, its artists and writers had first been made aware of the power of these unforeseen forces by the Revolution of 1905. Now under the impact of world war, revolution, civil war, and Bolshevism, Russians had to live differently, and that hard and obvious fact obliged them to seek new visions of the future in order to give meaning to their art. Especially for novelists and poets, living abroad would change the audiences to whom they spoke and even (in the case of Vladimir Nabokov) the language in which they wrote. In terms of the motifs they used, the same applied to Stravinskii, Chagall, and Kandinskii, and a host of other slightly less renowned composers, conductors, writers, dancers, and painters. Yet living in Russia required major transformations, too. Very soon, the optimistic hopes that the promises of ideology had raised in 1917 were soured by repressions.

But first, foremost, and most striking of all was the war itself. Russia went to war in 1914 with almost none of the resources needed for victory. Unable to adjust to the demands of modern war and unsupported by the industrial and financial resources that victory required, Russia marched from defeat to disaster, almost from the moment her armies crossed the Prussian frontier. As reports of incompetent generals, lost opportunities, and shortages of rifles, bullets, shells, and cannon began to spread like a festering poisonous tide, the apocalyptic images that had given meaning to the life and art of the avant-garde became real in ways that none of their creators had ever imagined. The hard facts of men torn to bits, lives blown away, and dreams snuffed out in a single explosive instant made it all the more urgent to find new visions that could give clearer direction to the future. These in some way had to give meaning to the deaths and devastation that had become so much a part of everyday life.

Just as the theme of death had shaped so much of the avant-garde's poetry before the war, so the meaning of life became the focus of its art during the war years themselves. Art that had soared so high in search of realms beyond earthly measure now came back to earth, and its leading practitioners gloried in the promise of technology and the world it seemed certain to create. Unlike the "children of Russia's terrible years," who had extracted images of the Apocalypse from factories and urban life, these Futurists saw the machine and the city as the keys to life in the modern world, placed them at the center of their art, and saw themselves as apostles of a shining new age. Like their European counterparts— and especially the Italian Futurist Filippo Marinetti—they paid homage to the "aesthetics of the machine" and the promises of modernity. But, while Marinetti proclaimed that "war is the hygiene of the world, and all the past is a cemetery,"[215] many of Russia's Futurists spoke bitterly against the Great War and re-

jected all violence except that which came in the form of a revolution that promised to make a better world. "To an armless stump left over from the bloody banquet," the poet Vladimir Maiakovskii exclaimed as the fighting raged in 1916, "What the hell good is it?"[216]

For a brief moment in 1917, some of Russia's avant-garde thought their dreams of a brave new world had come true, yet visions based on the promises of ideology and revolution soon proved to be just as deceptive as the Symbolists' dreams for finding a higher, brighter realm. Those who in 1914 had sought a new vision to lead them through the Armageddon of the Great War found such bitter disappointment when they reached the officially declared paradise of Stalin's Russia less than twenty years later that Vladimir Maiakovskii, their leading spokesman and for a time the "official" poet of the Bolsheviks' experiment, killed himself rather than cross its threshold.

Some who shared Maiakovskii's disillusionment escaped into exile, and many fell into the living hell of the GULag archipelago,* which had begun to spread across all of Russia even before Stalin rose to power. Of the many dreams from which Russia's avant-garde writers and artists had derived such hope and comfort when they had faced the shattering years of war and revolution between 1914 and 1921, only the utopian vision of Socialist Realism remained. For those who did not share its unfounded assumptions about human nature or believe its extravagant promises about the future, the limits of that vision became painfully clear very quickly. At home and abroad, the art of Socialist Realism would always have its critics, and their criticism ultimately would merge into the artistic currents that flowed out of the Soviet era into the uncertain times that lay beyond.

---

*GULag is an acronym derived from the Russian Glavnoe Upravlenie Lagerei (Central Administration of Labor Camps).*

# SEEKING NEW VISIONS

୧୫୫୨ଚ

THE FIRST WORLD WAR forced Russia's artists, writers, and thinkers to seek new visions of life, the world, and the future. From the Symbolists they could derive no comfort, for those who had seen their friends die in the first flower of their manhood now knew that the Apocalypse—impersonal, brutal, and unrelenting—promised only a cold, gray, and certain death. Nor could men who had witnessed the relentless destruction wrought by the modern world's killing machines look to the cleansing fires of Armageddon in which they had seen such promise in the days before the war began. From the English Channel to the lands beyond the Urals, death, destruction, and a sense that the world would never be the same again overwhelmed them all. When, after less than a year of fighting, the Belgian Socialist poet Emile Verhaeren dedicated a poem "with regret, to the man I used to be,"[1] he expressed with bitter certainty a widespread feeling that the battles of 1914 had changed the world irrevocably, and that the steps human civilization had taken when it crossed the divide between war and peace in 1914 could never be retraced. It now became all the more urgent for artists and writers to come to grips with the realm they had entered if they hoped to glimpse what lay ahead.

In the Russia of 1914, poets whose visions had reached the heavens in earlier times no longer proclaimed their verses from Ivanov's Tower to the stars, but turned instead to declaim them to comrades gathered at the Stray Dog, a cellar cabaret that stank perpetually of sweating bodies, clogged toilets, and stale tobacco smoke.[2] Poets, actors, and painters all gathered at the Stray Dog when it opened around midnight. So did well-heeled enthusiasts who enjoyed lurking on

the fringes of the avant-garde. Called "pharmacists" by the cynical management, these would-be followers of the arts paid up to twenty-five rubles apiece (four times the price of a room with bath in the city's best hotel) to sit in the larger of the cabaret's two brightly painted narrow rooms and watch the poets and painters of the avant-garde read their poetry, debate its meaning, and sip their drinks. All the while, the war set new patterns for their life and art.[3]

Yet the Stray Dog had not been conceived as an attraction for philistines, and for a brief time it had been tenuously connected to a serious attempt by the visionary avant-garde director Vsevolod Meyerhold to experiment with cabaret theater in Russia. The son of a prosperous German vodka distiller, whose ancestors had settled in the Volga River province of Penza during the reign of Catherine the Great, Meyerhold had been among the founding actors of the Moscow Art Theater but had gone his own way when his grotesque style of acting collided with the muted naturalism of Stanislavskii and Nemirovich-Danchenko. Dismayed that the theater was the last of the arts to respond to Symbolism, he had launched some of Russia's first experiments with nonrepresentational staging, proclaiming as he did so that "it is time for the theater to stop imitating reality."[4] For several years, he sought to come to grips with the mystical abstractions of "new drama" by staging plays in the provincial playhouses of southern Russia and Ukraine. The limited means of his sponsors and the limited talents of his actors meant that his efforts made only very modest headway.

Meyerhold had hoped to return to Moscow to establish a "theater of fantasy conceived as a reaction against naturalism."[5] But backers could not be found and he remained in the provinces, where he had continued to impose his experiments with the "new drama" on baffled audiences. Setting aside traditional costumes and sets, he had tried to use music, movement, colors, and plasticity in the plays he staged to point up what was truly significant in the "unspoken dialogue of emotions." On one occasion, he had presented an entire performance in semi-darkness. On others, he had used stark lighting, sets painted in black and white, and stages stripped of everything superfluous to convey his message. To survive, he had interlarded so many traditional performances among his avant-garde productions that, in two seasons, he presented no fewer than 140 plays, in which he himself played forty-four major roles. Overwork had made him sick, and for several months in 1904 doctors thought he was suffering from the same disease that was killing his friend Chekhov. That fall, after having worn out his welcome in South Russia, he had moved his experimental company to Tiflis, where Georgian audiences proved to be only slightly more sympathetic than Ukrainian ones.[6]

In the spring of 1906, the great actress Vera Komissarzhevskaia had rescued Meyerhold from the provinces by hiring him to direct the theater that she and her brother owned in St. Petersburg. Insisting upon crossing the barrier of the footlights to establish more direct contact between actors and audience, Meyerhold had soon drawn more criticism for his methods of production and direction than Komissarzhevskaia was prepared to tolerate, and she sent him on his way after less than a year. Then, promising to limit his radical experiments in staging

and direction to small studios so that they would not interfere with his main work, he had become an actor and stage-director at the city's Imperial Theaters. At the urging of Mikhail Kuzmin, who had turned to the theater in the wake of the controversy that had exploded around his novel in praise of pederasty, Meyerhold had adopted the pseudonym "Doctor Dapertutto" when he forayed into experimental theater. When the House of Interludes that he and Kuzmin had established in 1911 failed after a single season, he had moved his experiments to the Stray Dog cabaret that his former associate Boris Pronin had opened on the edge of central St. Petersburg's Mikhaikiovskaia Square.[7]

As "a place where all the 'stray dogs' on the different roads of contemporary Russian art could come together and be welcome"[8] under the eyes of its well-heeled patrons, the Stray Dog left Meyerhold too little opportunity to test his ideas. In search of more congenial surroundings, he had parted ways with Pronin early in the spring of 1912 and created a new Fellowship of Actors, Writers, Musicians, and Artists in the seaside town of Terioki in nearby Finland, where over the next two years he had staged enough successful modern plays to open his own studio theater in St. Petersburg the month after the Great War began. In the meantime, Pronin had followed the example of Aristide Bruant in Paris by inviting the first of the "pharmacists" to the Stray Dog in return for outrageous admission fees. One week he featured Filippo Marinetti, the founder of Italian Futurism. On another occasion, it was Karsavina just returned from a triumphant tour of London. For a time, Pronin featured "musical Mondays," along with "extraordinary" Wednesdays and Saturdays. One night, he held a banquet in honor of the visiting actors of the Moscow Arts Theater.[9]

By the beginning of 1914, one of its habitués later wrote, the Stray Dog had become "the only islet in nocturnal Petersburg where the literary and artistic youth, without a cent to their name as a rule, felt at home."[10] Here some of Russia's Acmeists demanded that their countrymen stop looking at objects as symbols of a higher, mystical world and admit that "the rose has once more become beautiful in and of itself."[11] Scorning every form of passion and eloquence, such Futurists as Maiakovskii and the philologists Viktor Shklovskii and Boris Eikhenbaum at the same time insisted—on the basis of the poet Velemir Khlebnikov's exhortations to ignore the rules of grammar and syntax—that the time had come to create a new kind of poetry, written in "language beyond the mind." Those who were not killed in the Great War would carry their visions into the revolutions of 1917, but only a handful would survive to see the Soviet world that lay beyond.

To the Stray Dog in its heyday came the best and the brightest of Russia's avant-garde. On some winter evenings, Aleksei Tolstoi, the young writer who would make his peace with the Bolsheviks and win the Stalin prize for his huge novel about Russia's passage through the Great War and Revolution, would storm in, filling the entryway with his mammoth raccoon fur coat and beaver cap. To Tolstoi in those days everything seemed out of focus. "Coldly seething

and satiated," he wrote in his *Road to Calvary*, St. Petersburg had become a city "tormented by sleepless nights, deadening its misery with wine, gold, and love without love. With the feebly emotional and strained sounds of the tango as its funeral dirge," he said, "the city lived as if awaiting the fateful day of judgement."[12] The poet Benedikt Livshits remembered that on such nights Maiakovskii looked on from a corner, "half-lying in the position of a wounded gladiator on a Turkish drum," which he thumped whenever one of the Futurists appeared. Soon to win fame as a leading exponent of formalism, Viktor Shklovskii held forth about "the place of Futurism in the history of language," as he insisted that the chief task of Futurism must be "the resurrection of things, the return to man of the experience of the world."[13] Some predicted that "the Futurists will fail!"[14] Others thought they had blazed a trail into the future.

Among the poets who gathered at the Stray Dog during its early days, Anna Akhmatova attracted the most attention. "I have never seen a woman whose face and entire appearance, whose expressiveness, genuine unworldliness and inexplicable sudden appeal set her apart anywhere and among beautiful women everywhere," one of her friends remembered. Still in her early twenties and already acclaimed as the leading poet of her generation, Akhmatova was thought to be "more than beautiful."[15] She attracted people like a magnet, and her brief poems about happiness, love, and passion drew them to her even more urgently than her beauty. Most of all, she wrote of love in all its phases—of meeting and parting, of jealousy and remorse, of longing, and of passion shared at a lover's return. She saw love as beautiful and terrible at the same time, and her readers found in each of her poems an intimate confession. Her manner of reading her poems, a friend once said, "was in itself already poetry."[16] To some, she seemed to live her entire life as a poem.

Two months before she turned twenty-one, Akhmatova married Nikolai Gumilev, the creator of Acmeism, whose verses never quite equaled her own. Gumilev spent his life in search of adventure, poetic perfection, and beautiful women, and he dreamed of marrying a woman who could be at the same time "Eve—the wanton, babbling incoherently," and "Eve—the saint, with grief in her eyes."[17] At the Stray Dog, he made a habit of scrutinizing every woman who entered, and although Akhmatova remained the most important woman in his life for the better part of a decade, he pursued other women throughout their marriage. Yet Akhmatova found fidelity nearly as burdensome as did he. She had been married to Gumilev for little more than a year when she began an affair with the young Italian Jewish painter Amedeo Modigliani, who showed her what she called the "true Paris" at a time when neither of them had yet ascended into the artistic stratosphere in which both would spend most of their adult lives. "The spirit of art had not yet transformed [us]," Akhmatova remembered many years later. "Everything that had happened to us up until that point was the prehistory of our lives."[18]

Akhmatova returned to Russia from her affair with Modigliani to write the

poetry of love and passion that catapulted her to the pinnacle of Russia's world of art. "Over my shoulder Paris seemed to still blaze in a last sunset," she confessed,[19] and love now drew from her the verses that held the Stray Dog's audiences in breathless silence. Just before the Great War, she added religious motifs in her work, seeking solace in God's grace while adding new dimensions to her poetic and personal explorations of love. One critic in those days called her "half nun, half whore,"[20] and her poetry highlighted the opposites that she found in life and love. "We are all revellers, we are all whores," she intoned as the Stray Dog's patrons greeted the New Year in 1913. "How unhappy we are together!"[21] Yet the memories of those times would seem warm and beckoning in years to come. "Yes, I loved those noisy, crowded nights," she later wrote of the happy times when artists sought the meaning of life in the midst of peace and prosperity."[22] "We did not know [then]," she added, "that we lived on the eve of the first European war and the October Revolution."[23]

While Akhmatova reigned as Russia's poet of love, Vladimir Maiakovskii became its voice of outrage and rebellion. Just twenty-one when the Great War broke out, Maiakovskii was part of the avant-garde generation that formed a bridge between those who, like Gippius and Merezhkovskii, had devoted their art to art, and those Constructivists of the early Soviet era who would place their art at the service of politics.[24] The "Golgotha of auditoriums" Maiakovskii had shared with Burliuk and his fellow Futurists in the fall and winter of 1913 had signaled his declaration of war against the bourgeois society that had begun to take shape in Russia, and he cursed the capitalists' exploitation of humankind at the same time as he cheered the modern cities and factories that their wealth brought into being. For Maiakovskii, the city, the factory, and the machine all stood as vibrant new symbols of progress, and it was against these that he and his Futurist comrades measured the significance of Dostoevskii, Tolstoi, and the other giants of the nineteenth century.

Sooner than most of the avant-garde, Maiakovskii spoke out against the terror and brutality of war. Like most of Russia's poets and artists, he had greeted the outbreak of the Great War with a burst of patriotism, seeing, he later confessed, "only its decorative and noisy qualities."[25] He had tried to enlist, was rejected for being politically unreliable, and then devoted several months to writing patriotic verses and drawing propaganda posters to support the war effort. "A whole new cycle of ideas is invading the world," he wrote. "Only words that are like gunshots can express them."[26] When his patriotic feelings began to ebb, Maiakovskii started to spend his nights at the Stray Dog, looking on in stormy silence while its enterprising proprietor extorted huge admission fees from war profiteers who wanted to bask in the avant-garde's reflected glow. Then, one night in February 1915, Maiakovskii rose to confront the men and women who reaped profit from the sufferings of the millions who had gone to war. "*Vam!*"—"To you"—he roared at his unsuspecting listeners. "*Vam*, who live only from orgy to orgy, / Who have bathtubs and warm toilets! / Aren't you ashamed to read in the newspapers / About the presentations of the Crosses of St. George [for valor]?"

While his audience sat in stunned silence, he continued to lay down an angry barrage of what he once had called "words like gunshots." "*Vam,* who love only women and food," he concluded. "Why should I give my life?! / I'd rather serve pineapple water drinks / To the whores at the bar!"[27]

With a mere seventy-seven words compressed into sixteen brilliant lines, Maiakovskii had shattered the veneer of sleazy patriotism with which those who had sworn allegiance to Tsar and Country in the name of profit had surrounded themselves, and as men who had never heard a shot fired in anger cursed in outrage, the Stray Dog exploded. "He should go to the Front!" one elegantly dressed woman shouted. Disdainfully, some of the audience arose to inform Pronin that "after this hideous incident we would consider coming here [again] beneath our dignity." Knowing that if they left others would take their places, Pronin shrugged his shoulders, turned his back, and replied: "Good riddance."[28] After that, Maiakovskii's opposition to the war deepened quickly. When the authorities who had forbidden him to enlist in 1914 tried to draft him into the army in the spring of 1915, Gorkii, who as the world-famous chronicler of Russia's lower depths made it a point of honor to rescue men of talent from the war's carnage, arranged for him to be assigned to Petrograd's automobile school as an "experienced" draftsman.[29] There, Maiakovskii's duties left him free to meet with his friends at the Stray Dog and write a massive poetic indictment of everything related to the war.

Condemned by the censor before it could be published, Maiakovskii's poem, *Voina i Mir* (*War and the World*), bore the same title as Tolstoi's massive epic (Russians used the same word for "peace" and "world") but it boasted little of Tolstoi's artful sophistication. Interspersing lines of verse with bars of tango music (later remembered by some as the "funeral dirge" of Imperial Russia), Maiakovskii's poem attacked war and all it stood for as an outrage against everything human and decent. "Listen!" he exclaimed in its dedication. "Each person, / Even someone who is of no use, / Has the right to live. / You can't, / You simply cannot / Bury him alive / In trenches and dug-outs— / You murderers!" As he surveyed the world that had brought the war into being, the cities he once had cheered as symbols of progress turned into symbols of decadence. "Where the woodland once was," he now saw "a square with a hundred-housed Sodom. / Whorehouse after whorehouse / With six-story-high fauns darting in dances." Quickly, he replaced the tango with staccato drumbeats. "Stage Manager!" he shouted. "The hearse is ready! / Put more widows in the crowd! / There still aren't enough!" Again, Maiakovskii shifted the tempo, this time to the Orthodox Mass for the Dead: "Lay to rest, O Lord, my soul." Yet, for the angry poet, God's grace and national honor could never be proper payment for losing one's life or limbs. "No one ever asked / That victory be / Inscribed for our homeland," he concluded at the end of the poem's third part. "What the hell good is it?"

In contrast to the Symbolists' vision of cleansing and purifying fires, Maiakovskii portrayed Armageddon as a moment of raw horror in which pain overwhelmed glory and brutality obliterated poetic romance. Yet, while those

Symbolists who had enjoyed the easier times of Russia's "terrible years" had seen only Armageddon's approach, Maiakovskii saw more clearly that a new world must emerge from its carnage: "All around! / Laughter. / Flags / In a hundred colors," he wrote, "pass by. / Rising high. / By the thousands." In the future, he saw people, happiness, and the promise of freedom. "The free man, / About whom I shout," he exclaimed at the end, "will come! / Believe me! / Believe me!"[30]

Even though Maiakovskii saw a better world beyond Armageddon's horrors, the searing, savage reality of war overwhelmed any thought of revolution in that time and place. "Many of us felt that revolution was imminent," his friend Viktor Shklovskii later wrote, "but many of us thought that we were outside of space, that we had established our own kingdom of time."[31] As a sense of doom settled upon them all, Maiakovskii wrote of suicide, of ascending into heaven, returning to earth, and being condemned to an eternity of wandering in outer space because paradise could not be found in heaven or on earth."[32] Briusov in those days muttered that "Maiakovskii won't amount to much," but Maiakovskii made a joke of it and continued to look inward.[33] He seemed to be wondering if he could find the will to live before he found the strength to die.

A sense of not knowing what lay beyond the horizon and not caring overwhelmed Russia's artists and intellectuals as the Great War moved into its third year. "The time had come for a reckoning," one of them wrote. "[We were] dancing a 'last tango' on the rim of trenches filled with broken corpses."[34] Some remembered that the statesmen and politicians in the Duma walked around "like underfed flies," unable to confront the crisis that was about to overwhelm them.[35] Others shared Maiakovskii's thoughts of suicide. In a single morning, the Petrograd office of the secret police reported, "the daughter of a colonel, E. V. Kritskaia, aged thirty-three, [killed herself] by drinking liquid ammonia. At 8 A.M., a noble [man], Stanislav Iakovich, aged fifty-five, [took his life] by shooting himself in the head with a revolver. At 9 A.M., a staff-captain, P. Gehring, aged twenty-eight, [suffered death] by shooting himself in the right temple with a revolver. At 12 noon, a student of the Women's College, Gebeksmann, aged twenty-seven, [was] found dead by hanging herself."[36] Time seemed to be running out. "We stand before the unknown and unexpected," an observer wrote. "The gloom is thickening around us and we know not what lies two steps ahead."[37]

Beginning as a demonstration by Petrograd's female textile workers, the revolution that overthrew the Romanovs at the end of February 1917 caught everyone by surprise. Some feared it, and others embraced it. But most people simply kept struggling to avoid being overwhelmed by the problems of daily life in wartime. Maiakovskii's friends remembered that the poet wanted to "transform the streets" and see the Revolution swell to floodtide in an instant. "He enjoyed the Revolution physically," Viktor Shklovskii concluded. "He entered [it] as he would his own home."[38] In a more abstract way, so did the now middle-aged heroes of Russian Symbolism. Proclaiming that "Russia is free—but not yet puri-

fied," Gippius greeted the fall of the Romanovs as the beginning of a true religious transformation but warned that the future remained uncertain. "The first cry of a baby is always a joy," she wrote, "even though there is still a danger that both mother and child might die."[39] Merezhkovskii mirrored her delight but did not share her caution. Like so many of the middle-aged men and women who took up the reins of Russia's government in February and March 1917, they both continued to support the war that Maiakovskii, his friends, and Russia's workers and peasants all despised. "The war now ought to become a real war of liberation," Gippius confided to her diary. "Now, we will be defending *our* Russia."[40]

Both Gippius and Merezhkovskii drew the line at Bolshevism, whereas other Symbolists of their generation did not. Balmont and Briusov saw revolution as an aesthetic experience, and Briusov, the poet in whom, Belyi once wrote, "one sees Prince Hamlet," actually joined the Bolshevik Party within a year after Lenin seized power.[41] As an elitist who believed that democracy must lead either to utopia or mob rule, Briusov had given his allegiance to the Romanovs until the Revolution. He had supported the Provisional Government until it proved unable to control the masses, and then took the side of the Bolsheviks as the only "strong power" in Russia capable of defending art and poetry against the mob.[42] "In Communism," the poet Khodasevich later explained, "Briusov worshipped a new autocracy, which from his point of view was even better than the old one since the Kremlin was more accessible to him personally." Now, Khodasevich said, Briusov hoped to conquer the world of art "by a single barked order."[43]

While Briusov regarded revolution as an instrument for imposing his vision on literature by means of orders, regulations, and resolutions, Belyi saw in it a way to transform human experience and achieve true freedom. As an extension of the rebellion against form that had been taking place in the arts for more than a decade, the Revolution now seemed about to rekindle the spiritual fire of Prometheus, and the poet cheered its "fiery enthusiasm." Marina Tsvetaeva, whose verses would place her among the best of Russia's poets in the 1920s, remembered Belyi in those days "with people always clustered around [but] always free." Somehow, he seemed "old fashioned, elegant, refined, birdlike—a mixture of a teacher and a conjurer," a sort of "enticing" anachronism in the midst of all the sufferings that revolution and civil war had brought to Russia.[44]

No Symbolist dreamed greater dreams or suffered more bitter disillusionment during the Revolution than Blok. After spending the previous winter as an officer assigned to build fortifications in the Pinsk marshes of West Russia, Blok saw in the overthrow of the Romanovs a "miracle" that promised to begin life anew. Appointed to the Provisional Government's Extraordinary Investigatory Commission, which inquired into the acts of tsarist officials during the war, he found in the parade of men and women brought before him an "absorbing novel with a thousand characters and the most fantastic combinations." When "the flames of enmity, barbarity, Tatarism, anger, humiliation, oppression, [and] revenge" began to flare up all over Russia, he proclaimed that Russian culture must organize the "swelling music" of the Revolution into "ungovernable freedom." Convinced

that the Revolution's ultimate purpose was to "organize things so that everything should be new, so that our false, filthy, boring, hideous life should become a just, pure, merry, and beautiful life," he concluded that "the music of the intelligentsia is the same as the music of the Bolsheviks."[45]

Whatever its higher purpose, the Revolution displayed none of the beauty and purity that Blok expected. Russia was hungry, cold, and sick to the death of war. Soldiers were pouring back from the front, living by the laws of war among people desperately in search of peace. In Petrograd, they roamed the streets, barging through crowds that clogged the sidewalks, and forcing their way onto streetcars from which people hung by any available handhold. For too long, war had made life cheap. Now, too many gray-coated men with too many guns made violence a way of life back home as they killed for money, vodka, clothing, and a hundred other reasons. One day, a diplomat saw two soldiers shoot an old woman and take the two gnarled, worm-eaten green apples she had been trying to sell. Others killed out of boredom, or sometimes for no reason at all. "When you recall that all this is going on in a country where human life is ridiculously cheap," no less a defender of the proletariat than Gorkii wrote in those days, "you grow fearful for Russia."[46]

From the violence Gorkii so feared, Blok extracted a poetic icon of the Russian Revolution that he called *The Twelve*. In years to come, Orthodox Christians would condemn Blok's poem as a demonic vision, cardinals of the Roman Catholic Church would place it on the Vatican Index, and Soviet critics would warn against its "religious deviations."[47] Yet Prince Dmitrii Mirsky, whose writings on the history of Russian literature reigned for decades as the best in English, once confessed that he would be obliged to hesitate if asked to choose between Blok's revolutionary icon and all the rest of Russian literature put together.[48] "It is worth learning Russian to read it in the original," a leading Western critic added some years later. "Blok here invested every word with such resilience of meaning, sound, [and] associative significance, that one cannot hope to reproduce more than a fraction of the effect in translation."[49]

"Trembling inside" with the power of a vision that was rare even for great artists, Blok took up his pencil to begin *The Twelve* on January 8, 1918.[50] Like an icon painter of olden times, he sketched the background first, setting the scene amidst darkness, snow, cold, wind, and raw, ruthless violence. Then he added the details, allowing the images of twelve Red Guardsmen, a prostitute, and a cast of lesser characters that symbolized Russia's turmoil to emerge from the black-and-white of his background before receding into it once again. Just as Skriabin added color to his music, so Blok wove amongst his verbal images a series of complex rhythms that lifted his readers on a floodtide of sound unlike any yet seen in Russian poetry. Shouts, curses, the cadence of folk songs, and the rhythm of revolutionary anthems combined with a staccato of gunshots, roars of the wind, and the tramping of marching feet into a crescendo that suddenly fell away into a void of calm and peace. Angry words are exchanged, shots ring out, the prostitute falls

dead, and the men march on, moving with sovereign tread until they see, marching at their head and carrying the blood-red flag of revolution, the figure of Christ wearing upon his head a crown of white roses—the symbolic color of the Apocalypse. Russia lay in ruins, and the triumphant armies of Imperial Germany were marching on Petrograd, yet Blok sensed the stirrings of a new force that would strengthen Russia and transform it. "Forward, Forward / Working men and women," his poem urged its readers. "Keep in step with the Revolution!"[51]

The Bolsheviks published *The Twelve* on March 3, 1918, the very day when their representatives signed the Treaty of Brest-Litovsk that took Russia out of the First World War. Fearful that Germany's armies might begin to march again, Lenin moved the capital back to Moscow eight days later in order to get it out of their reach, and Russia's ancient city regained the political importance it had enjoyed in the days of Ivan the Great, Ivan the Terrible, and the first Romanovs. Seeking the new artistic Jerusalem that would sustain their vision of freedom and revolutionary art, Maiakovskii, young Boris Pasternak, and Ilia Ehrenburg, who had just returned from spending Russia's war years as a correspondent in Paris, all hurried to Moscow that spring, and so did the painters Malevich, Tatlin, Natan Altman, and their friend Aleksandr Rodchenko. In Moscow's Arbat (a combination of Paris's Left Bank and New York's Greenwich Village in those days), Belyi, Briusov, and Balmont now debated the meaning of revolution and art, and so did Marina Tsvetaeva, whose poetic passion was matched only by her desperation to rejoin a husband who was fighting for the White armies in South Russia. The one-time streetcar conductor Konstantin Paustovskii, whose portrayals of the agonies men and women suffered in wartime would one day win him the Lenin Prize, lived in Moscow then, and Aleksei Tolstoi, no longer a fixture of wartime life at Petrograd's Stray Dog, could now be seen in Moscow absorbing as if by osmosis the pulse of daily life that would shape his *Road to Calvary*. Never had the arts been more vibrant and never had Moscow been the center of so many hopes and passions.

On the stage, this feeling that art had no limits was heightened by the Bolsheviks' uncertainty about what role the theater might play in their society of the future. Certainly Lenin and his followers saw the potential that mass festivals could have in propagating their myths long before Socialist Realist writers began to refine and reinterpret the past, and some of the earliest theater in Bolshevik Russia had that purpose in mind. Mass spectacles that mythologized the Revolution allowed Russia's new rulers to transform their sudden and unexpected triumph in October 1917 into the culminating moment of a process reaching far back in time, and to therefore legitimize the birth of the Soviet State as an inevitable outcome of an inexorable process. In contrast to their predecessors, Bolshevik playwrights and directors wanted to involve the masses in the theater, seeing them as active participants who could bridge the abyss that had kept actor and spectator apart in earlier times. Yet they also feared that the masses might unleash the "spontaneity" that their dogma decreed must always be kept in check.[52] Until

the advent of Socialist Realism created the means to impose Party "conscious-ness" upon the exuberance of the masses, the Bolsheviks vacillated between free-dom and uniformity on the stage. In doing so, they created some of the most striking theatrical events ever to be staged in Russia.

As in literature, the goal of Bolshevik theater was to draw the masses into the world that the architects of Communism intended to create. It was to be "a the-ater of rapid action, major passions, rare contrasts, whole characters, powerful sufferings, and lofty ecstasy," the first People's Commissar of Enlightenment, Anatolii Lunacharskii, explained in the days before the Revolution, when he confided that "its woe will make one sob . . . [and] its joy will make one dance." Most of all, Lunacharskii went on, "Socialist theater" must "create a lofty Social-ist art, resurrect Shakespeare, Schiller, and many of the other past titans in order to link great art with the great lords of the future—the people."[53] Leading Bol-sheviks saw the stage as a political platform from which to enlighten the masses, and they hoped to accomplish that task by endowing the theater with the Party's spirit. By contrast, such great directors as Meyerhold and Evgenii Vakhtangov saw the theater as an instrument for reeducating masses and leaders alike. Until Stalin transformed the theater into an instrument of the Soviet State, the two views made it possible to combine Bolshevik visions of the world to come with the most avant-garde of sets and methods of direction.

While their country writhed in the agony of civil war, the Russians' passion for the theater exploded. "In this terrifying world made of frost, stale herrings, rags, typhoid fever, arrests, bread lines, and armed soldiers," Maiakovskii's friend Vik-tor Shklovskii wrote, "one first night followed the other and the theaters were jammed every evening." Undaunted by shortages of coal and electric current, he added, "Isadora Duncan danced by the light of torches brought on the stage while thousands of voices, hoarse from the cold, sang 'Bravely forward, Com-rades. Keep in step.' "[54] Musicians played in fur caps and fur coats, while makeup froze on actors' faces and their costumes turned stiff from the cold. "The interest in the theater resembled an epidemic," one critic wrote. "[As] this collective psychosis assumed striking proportions, creative inventiveness rose in a fountain-like jet."[55] Both Vakhtangov and Meyerhold flourished until cancer destroyed Vakhtangov in 1922. A decade later, the heavy weight of Stalin's Socialist Realism would grind Meyerhold into silence.

For a brief, unforgettable moment during the Civil War, Vakhtangov became one of the most talked-about directors in Russia. Born the son of a wealthy Ar-menian cigarette maker in 1883, he was educated at Moscow University and the Drama School of the Moscow Art Theater, where he sought to explore the depths of the unconscious by combining Stanislavskii's method with Meyer-hold's "theater of fantasy." Anxious to interpret reality in the spirit of his era, he turned to popular theater as the Revolution approached, insisting that "artists should go to the people's soul . . . [to] bring forth true beauty."[56] Yet, despite his political radicalism, Vakhtangov could never devote his soul to the Revolution entirely, for he remained an artist first, last, and always. "He believed," a com-

mentator once explained, "that for the imaginative craftsman of the theater, there were no artistic boundaries that could not be crossed without some benefit to the adventurer."[57]

The Russian Revolution plunged Vakhtangov into a frenzy of theatrical experiments that involved eight theaters at once. Convinced that the time had come for spectators to be transformed into actors, he set out to create a People's Theater that featured heroic productions with large-scale mass scenes.[58] Yet his most innovative work centered on the Habimah Studio, which featured Yiddish works translated into Hebrew. Strongly supported by the painter Natan Altman, whose portrait of the poet Akhmatova had won such acclaim just a few years before and who now designed Constructivist sets and costumes for the Habimah, Vakhtangov struggled to blend innovation with antiquity in a tiny studio, which stood at the opposite pole from the heroic scale he envisioned for the People's Theater. "Situated in a decayed quarter of Moscow in a dilapidated and rather crazy building," one visitor remembered, the gray canvas walls of the Habimah Studio enclosed an audience of 126 set in seven rows divided by an aisle that resembled "an entrance to circus seats."[59] There, after more than a year of rehearsals punctuated by several operations that Vakhtangov underwent for stomach cancer, the group produced *The Dybbuk*, a play revolving around the themes of power and money, which dealt with demonic possession, exorcism, and ancient Jewish law. In *The Dybbuk*, one of his colleagues later said, Vakhtangov took "all the humor of Jewish life and made of it an integrally, deeply moving, organic part of a mystery play" during that one brief moment when the development of a genuine Jewish theater actually seemed possible in Russia.[60]

Yet the tragic mysticism of *The Dybbuk* showed only one side of Vakhtangov's achievement during those optimistic days when he thought that Russia seemed to be "on the brink of something exciting and new, and, at the same time, uncertain and mysterious."[61] While his countrymen struggled against the scourges of famine, epidemics, cold, and war, Vakhtangov proclaimed that "we need a festival," and turned to Carlo Gozzi's tale about the beautiful but cruel Princess Turandot, who got rid of unwanted suitors by beheading them when they failed to solve the riddles she set as the price for her hand. Bypassing Schiller's more classical and somber version, Vakhtangov chose Gozzi's rendition because of its ties to folk tradition and the "theater of improvisation," and with it he set out to transform Moscow's freezing winter into a world of orange trees, warm breezes, and sunshine. "Let there be blue sky over the whole stage, over the entire auditorium," he decreed. "Scenery should be light and airy, bright colored and even transparent, like a balloon."[62] Everywhere, improvisation was to reign, even in the orchestra, where the music of mandolins, balalaikas, flutes, and cymbals was augmented by waltzes and polkas played on combs covered with waxed paper.

Having turned away from Stanislavskii's emphasis on pure realism by proclaiming that "the slice-of-life theater must die" and that "everyone capable of being a character actor ... must learn to express themselves grotesquely,"[63] Vakhtangov sought to create in *Turandot* a flight of romantic fantasy that turned

toward the methods of Meyerhold. Certain that "irony, and the smile provoked by the 'tragic' contents of the tale"[64] must be paramount, and knowing that his cancer soon would kill him, he set out to make the story of the cruel Chinese princess gay and charming as a farewell to the world of art he loved so much. When Vakhtangov died in the late spring of 1922, *Turandot* became the center-piece of an artistic legacy that showed, as one of his friends later wrote, how well the techniques of Stanislavskii, Nemirovich-Danchenko, and Meyerhold all could "be brought together, amalgamated, and metamorphosed into a new won-derful product without doing violence to any of them. Here, writ large, was the "imaginative realism" of which Vakhtangov had spoken with such passion dur-ing his last days on earth. "Each of his productions," the same friend concluded, "was a harmonious blend of the very beautiful, very deep, very light, very mathe-matically clever and humanly true."[65]

Vakhtangov once wrote that of all the directors in revolutionary Russia only "Meyerhold provided the roots for the theater of the future."[66] After dividing his time during the First World War between Petrograd's Imperial Theaters and his own cherished experimental enterprises, Meyerhold greeted the Revolution as the bearer of the artistic freedom that was to liberate artists and audiences from the fetters of tradition and stale repetition. Here, he said, was the chance to "lib-erate" the "silent, passionless parterre [of the theater] where people come for a rest," and bring in active, energetic audiences, whose enthusiasm could make them part of the production. Like Vakhtangov, Meyerhold toyed with popular theater and dreamed of binding audiences and actors together through shared participation. He gathered a small army of followers, and proposed to provide workers who wanted to produce plays with "a polytechnical education in the theater arts."[67] Even before the Bolsheviks seized power, he had become the the-ater's embodiment of the Revolution.

To celebrate the first anniversary of the Bolshevik Revolution in Petrograd, Meyerhold staged Maiakovskii's *Mystery-Bouffe*, Russia's first revolutionary play. Written as a parody of the tale of Noah's Ark in what Lenin (with some ap-proval) once called the style of "hooligan Communism,"[68] the play centered upon a handful of capitalists and proletarians who had survived the flood of world revolution. In Meyerhold's hands, it became what the People's Commissar of Enlightenment Lunacharskii called a "merry symbolic journey of the working class, which after the flood of the Revolution gradually rids itself of parasites on its way through hell and heaven to the Promised Land—which turns out to be our own sinful earth."[69] With sets designed by Malevich, *Mystery-Bouffe* com-bined Cubism with circus acrobatics to portray a revolutionary world in which hell was a red-and-green Gothic hall and the Promised Land resembled a huge modern machine. Malevich himself called the play's color scheme "nauseat-ing."[70] Yet, even though many critics condemned it, *Mystery-Bouffe* created a new dramatic style, which was to help shape popular theater throughout Russia for the rest of the twentieth century.

Not long after staging *Mystery-Bouffe*, Meyerhold went to a tuberculosis sani-
tarium in the Black Sea port town of Novorossiisk, where he was arrested by the
Whites for his Bolshevik sympathies and only narrowly escaped execution dur-
ing the weeks before the Reds retook the city. He returned to Moscow in the fall
of 1920, dressed like a true Bolshevik commissar in a leather coat, red scarf,
knee-high boots, and a worker's cap with a red star bearing a likeness of Lenin.
Proclaiming that "the time has come to make a revolution in the theater and to
reflect in each performance the struggle of the working class for emancipa-
tion,"[71] Meyerhold took command of the Theatrical Department in Lunacharskii's
Commissariat of Enlightenment and organized a massive program of theater work-
shops. While others insisted that organizing "a propagandist theater after a revolu-
tion is like [serving] mustard after a meal,"[72] he created some twenty thousand
rural dramatic circles with more than ten times that many amateur actors in half
a decade.[73] "Here is our program," he announced. "Plenty of light, plenty of
high spirits, plenty of grandeur, plenty of infectious enthusiasm, unlabored
creativity, the participation of the audience in the corporate creative act of the
performance."[74]

Anxious for the theater to reflect the Bolshevik vision of a society in which la-
bor would "no longer [be] regarded as a curse but as a joyful, vital necessity,"[75]
Meyerhold set out to portray the new Communist man and woman on stage. He
drew some of Russia's leading avant-garde artists into set design, using not only
the work of Malevich, but also that of "the mother of Constructivism on the
stage," Liubov Popova,[76] with whom he planned to stage a huge mass festival on
Khodynskoe Field to celebrate the Third Congress of the Communist Inter-
national in 1921. Designed to include more than two thousand soldiers, military
bands and choruses, tanks, airplanes, and exploding land mines, *The Struggle
and Victory of the Soviets* never took place, but its plans for projecting intersect-
ing beams of light from dirigibles hovering overhead helped to clarify the Con-
structivist images that Popova later incorporated into sets for other Meyerhold
productions that portrayed the world of the future in the image of machines and
ultra-modern structures.[77] In the meantime, Meyerhold worked to free the the-
ater from every traditional constraint. "The modern theater wants to move out
into the open air," he insisted. "We want our setting to be an iron pipe or the
open sea or something constructed by the new man."[78]

In those days, Moscow teemed with back-alley theaters, cellar cabarets, and
literary cafés, in which Russia's artists and poets tested their new freedom. Bear-
ing such names as Tenth Muse, Domino, Pittoresque, Red Cockerel, Music Box,
Three-Leaved Clover, Pegasus's Trough, The Forge, The Imagists' Café, and The
Poets' Café, these provided forums for Futurists, Cubists, Suprematists, Imag-
ists, Expressionists, Acmeists, Constructivists, Accidentists, Anarchists, and a
virtually untranslatable group called the *Nichevoki* (the Nothing-ists). All of
them cursed the past and hailed the future, shouting, roaring, and urgently
whispering in a cacophony of sounds and visions that left no literary avenue

unexplored. "At the Poets' Café, Ehrenburg wrote, "I often saw a Mauser [pistol] beside a plate of cakes on a table. There was talk of gun fights, rationing, and typhus."[79]

As poets and painters explored their new visions, even the recent past suddenly became very remote. Realizing that "time had made a great leap forward," Ehrenburg struggled to decide whether he should feel pity or reverence when he heard Viacheslav Ivanov read some of his "highly-polished sonnets," and others seemed amazed at how the plays of Chekhov, which had seemed so full of meaning on the eve of the Great War, suddenly seemed like relics from another age. Having passed into history even though he still had a third of his life left to live, the poet Georgii Chulkov "looked like a large, sickly bird" at the age of thirty-nine, while Konstantin Balmont, who was a decade older, now lived only in the past. An age seemed to have slipped away since that not so distant time when Balmont had reigned with the Merezhkovskiis over the world of Russian letters. Now he spent his days cursing the city's proletarians and lamenting the lost days of old. "Make way, you dogs!" he would roar as he struggled to find a place on Moscow's crowded streetcars. "Make way for the child of the sun!"[80]

Moscow's constantly recombining artistic currents all came together at the Poets' Café, which Burliuk, Maiakovskii, and Vasilii Kamenskii, the aviator-poet who had joined them in their "Golgotha of auditoriums," opened in an abandoned commercial laundry with funds supplied by the famed Moscow confectioner Dmitrii Filipov. A black door on which its name had been scrawled in irregular large red letters marked the back-alley entrance, and its walls featured many-legged horses' rumps, swollen female torsos, and large, detached eyes set off by red, green, and yellow stripes. Their belts bristling with pistols, daggers, and hand grenades, Red Army soldiers and sailors lounged in the rear, while painters, poets, and journalists clustered around gray cloth-covered tables to argue about the meaning of life and revolution. Some nights, the program featured the "King of Clowns," Vladimir Durov, opera singers with voices too powerful for the long, narrow room, popular singers whom the management had cajoled into performing without the accompaniment that gave their voices breadth and depth, and even the young composer Sergei Prokofiev playing his newest works. Once, the People's Commissar of Enlightenment, Anatolii Lunacharskii, lectured on the limits of Futurism and the greatness of Maiakovskii's talent. Sometimes, when Burliuk or Maiakovskii would proclaim the café to be "a stage for all," its patrons would organize poetry readings and debates about literature and art.[81]

Night after night, Maiakovskii shone as the Poets' Café's greatest attraction. Now openly applauded as the poet of the Bolshevik Revolution, he had exchanged his yellow-orange-and-black-striped tunic for a worker's cap and a large red scarf that he wore as his new badge of rank. His manner alternating between rudeness and charm, he promoted his poetry at every opportunity, often reading from *Man*, the satirical poem he had written during the last year of the war. *Man* was Maiakovskii's own meditation on himself and the future, and although it

spoke of suicide at several points, those who heard his readings had no inkling that he would one day shoot himself out of disillusionment with the Revolution that had failed. "Nothing would be gained . . . by listing mutual hurts, troubles, and insults," he wrote in the moments before he shot himself through the heart in 1930, when the Revolution's failures had touched everything, and death seemed the best way out. "The love boat," he said as he looked toward his final moments on earth, had been "wrecked by daily life."[82]

During the happier days of 1918, Maiakovskii almost always waited until the evening's end before taking the stage. Then, with a cigarette hanging from the corner of his mouth and his hands stuffed into his trouser pockets, he would call for attention. "You must be quiet," he would tell his listeners. "You must sit quietly. Like buttercups." Reading in a hushed voice, he held his audiences spellbound. "He hardly moved," one of his friends remembered. "It was almost as if he were having a conversation with himself."[83] Seeking to discover the meaning of the Revolution and gain a clearer sense of the future, the audience hung upon his words. Then, as spring moved toward summer in 1918, the Poets' Café closed and its habitués moved on to spend the summer in the provinces. But, before they set out, they left behind one final reminder that artists in a revolutionary society must be free to create new art.

To celebrate Moscow's first May Day holiday under Bolshevik rule in 1918, the Chairman of the Council of People's Commissars, Vladimir Ilich Lenin, had suggested that Russia's capital be decorated "in such a way as to give it an entirely different appearance from any other city in Europe."[84] Evidently he had in mind displaying passages from the writings of Marx and Engels on Moscow's largest buildings, but under the benevolent oversight of People's Commissar Lunacharskii the project quickly got out of hand. "Moscow was decorated with Futurist and Suprematist paintings," Ehrenburg remembered some years later. "Demented squares battled with rhomboids on the peeling façades of colonnaded Empire villas [and] faces with triangles for eyes popped up everywhere." Along the Kremlin wall, artists from the Poets' Café painted the trees in vivid shades of red, blue, violet, and crimson, while lorries draped with "nonobjective" paintings plied the streets in the city's center.[85]

Staring at a huge Cubist painting with a large fish eye in its center that looked down on the square in front of the church in which she and her friends planned to attend Good Friday services, an old woman concluded that Russia's new masters wanted them all "to worship the devil." Ehrenburg laughed when he heard her remark, but he remembered that his laughter "was not happy." What did such art mean to the tens of millions of men and women for whom the Revolution had been made? Did such paintings advance the cause of Communism? Or were they so far outside the mainstream of human experience that they had no meaning at all? Such art, Ehrenburg concluded in a newspaper article a few weeks later, had to be considered either as "mad ornaments on a house about to collapse or as the foundations of another kind of structure never yet seen even in creative dreams."[86]

While Ehrenburg pondered the meaning of Futurist painting, Russia's new leaders dismissed it out of hand. Condemning it as "decadent"—a term that would be used consistently by Bolshevik leaders to describe all forms of modern art for the next seventy years—Lenin ordered workmen to remove the paintings from the center of Moscow only to learn that no amount of scrubbing would dissolve the paint the artists had used. Almost a year later, the British biographer of Oscar Wilde, who had come to see the Bolsheviks' new world at first hand, pronounced the remnants of the May Day paintings "delightful," and noted that their primitive brilliance fit especially well with the atmosphere of Moscow at the time. "They seemed less like Futurist paintings than like some traditional survival linking new Moscow with the Middle Ages," he wrote.[87] His words could not have been better chosen. Over the next two decades, scores of other parallels would emphasize the ties between the Moscow of Stalin, "little father" of all Russians, and that of Ivan the Terrible, whom medieval Russians had regarded in the same manner.[88]

Not long after Moscow's Futurists challenged their new leaders' tolerance with their May Day decorations, their comrades in Petrograd began to publish *Iskusstvo kommuny* (*Art of the Commune*), a small weekly paper in which Natan Altman, Iurii Annenkov, Malevich, and Marc Chagall joined with Maiakovskii and half a dozen others to demand that art throw off every traditional constraint. "We need rough art, rough words, and rough deeds," Maiakovskii wrote. "Art ought to be . . . on the streets, in streetcars, in factories, in workshops, and in workers' apartments."[89] As if recalling the time when he had urged his listeners to dump Pushkin, Dostoevskii, and Tolstoi overboard "from the ship of modernity,"[90] he summoned "Futurists, drummers, and poets into the streets" to carry on the struggle.[91] "It's time for bullets to ricochet off museum walls," he wrote. "Only an explosion of the Revolution of the Spirit can get rid of the rags of old art."[92] Maiakovskii urged Russia's poets and painters to keep moving to the left. "Go to your left! Your left! Your left!" he shouted at his readers as he repeated the command used by drill sergeants all across the Western world. "Go to your left!"[93] By the time he returned to Moscow in the spring of 1919, he felt certain that Russia's Futurists must become the voice of its working masses.[94] In what some have called "a sophisticated parody of the ancient [Russian] folk epic"[95] in which Russia's champion of the downtrodden overcomes the powerful defender of world capitalism, Maiakovskii exclaimed: "150,000,000 speak with my lips."[96]

The Futurists' readiness to consign all of Russia's artistic experience to history's trashbin found few sympathizers in the world of art, and none at all among the nation's new Bolshevik masters. "I am painfully shocked," Lunacharskii complained after reading the first issues of *Art of the Commune*, "and [I] blush for Maiakovskii."[97] Trotskii dismissed Maiakovskii's poem *150,000,000* as "out of place" and "frivolous," and Lenin called it "double-dyed stupidity and pretentiousness" that was fit only "for libraries and eccentrics."[98] Russia's powerful Chairman of the Council of People's Commissars was beginning to lose patience

with his Commissar of Enlightenment's belief that "it is better to make a mistake by giving the people something which will never gain their sympathy than to hide a work under a bush that may bear fruit in the future."[99] Just as Ivan the Terrible had decreed that art must serve the state, so Lenin now demanded that art must serve the Revolution.

As Maiakovskii and his Futurist comrades struggled to find a niche for themselves and their art in the Bolsheviks' brave new world, the men and women with whom they had shared Russia's artistic experience in earlier times turned against the Revolution or were destroyed by it. By 1922, Chagall and Kandinskii both had rejected the Bolsheviks' political and moral absolutism and returned to the West, and so had scores of painters, poets, novelists, ballerinas, and movie makers. Even some who wished to remain had been driven out by a Bolshevik decree that exiled "counterrevolutionary elements from among the milieu of professors, doctors, agronomists, and literary figures," while others had died of hunger or disease during the Civil War.[100] Some had been executed for their views, beginning with Akhmatova's former husband, the poet Nikolai Gumilev, who was shot by the Cheka in 1921. Khlebnikov died late in June the following year, and Blok, wasted and disillusioned, followed him two months later. Of those great Petersburg poets who once had gathered at the Stray Dog, only Akhmatova remained unreconciled to the Bolsheviks' proletarian vision and still in Russia. "I am not with those who abandoned their land," she wrote. "To me the exile is to be eternally pitied."[101]

About Akhmatova Russia's new masters continued to disagree. Aleksandra Kollontai, the first Commissar of Public Welfare, hailed her poetry as "the entire novel of a woman's soul," but Maiakovskii dismissed her as an "insignificant, pathetic, and laughable anachronism," who had refused to "participate actively in the creation of [the Bolsheviks'] new kingdom."[102] The same Kornei Chukovskii who once had watched Blok declaim his poetry to the stars from Ivanov's Tower now explained that Akhmatova represented the best of prerevolutionary letters, while Maiakovskii, who disdained the past and ignored the present, looked only to the future. Both were necessary, Chukovskii argued, because neither could speak for Russia alone, but something must be done to reconcile the bitter antagonisms they represented. "In the future," he argued, the two greatest poets of Russia in 1922 "must exist only as a synthesis, otherwise each of them will inevitably perish."[103]

In very personal ways, the fates of Akhmatova, who died at the age of seventy-seven in 1966, and of Maiakovskii, who shot himself in a fit of suicidal disillusionment thirty-six years earlier, dramatized the Bolsheviks' impact on Russian art. After his suicide, Maiakovskii's reputation declined until his friends pleaded with Stalin to save him from neglect. Then, when Russia's all-powerful leader replied that "indifference to [Maiakovskii's] memory and his works is a crime," Soviet critics embraced him as the premier poet of Russia's Revolution. Statues of Maiakovskii appeared everywhere. Obsequious officials named metro stations,

streets, city squares, ships, and tractors after him and required schoolchildren to memorize his poems. He was "propagated compulsorily," Pasternak later remarked wryly, "like potatoes in the reign of Catherine the Great."[104]

While the dead Maiakovskii's image grew larger than life, the living Akhmatova faced only scorn, as a poet whose work teemed with "bourgeois decadence." Yet she always remained elegant and proud, never flinching or turning aside from the path she had chosen. When some of her poetry was praised in the Soviet press right after the Second World War, her friends thought that her days of suffering had ended. Then the Secretary of the Central Committee of the Leningrad Communist Party demanded that she be expelled from the Union of Soviet Writers. "How can we place the education of young people in her hands?" he asked in lamenting how her poetry failed to extol the new order. "What positive contribution can her work make to our young people?" In thousands of small ways, the answer to those harsh questions came quickly in the form of ration cards and money sent by friends and strangers. "She was destined to be as immortal as the Russian word," one of her admirers wrote after she died. Her poetry, he concluded, embodied "Russia in its most difficult tragic years of its one-thousand-year history."[105]

Inflating Maiakovskii's accomplishment and denying Akhmatova's brilliance were part of a vast Bolshevik effort to create an artistic experience that would define Communism, describe the utopia that their dogma placed just beyond the horizon, and win converts to their vision. Seeing in the cinema—the newest art form of the twentieth century—a means to communicate with the masses in ways that could not be diluted by other ideas and influences, Lenin and his followers seized upon it as a way to bridge the chasm that had always separated the Russian people from their rulers. Movies could let them speak directly to those six out of every ten Russians who still could not read and whose lives they intended to transform.

As a medium disdained by the rich and adored by the poor, movies had enjoyed immense popularity in Russia from the moment they appeared at the coronation festivities of Nicholas and Aleksandra in 1896. Movies created a miraculous world of dreams and romance that everyone could share, and they brought illiterates into a realm that previously had been within the reach only of people who knew how to read. By the time of the Revolution, Russian movie studios were producing nearly 500 films every year and showing them in nearly 1,500 movie houses, which yearly sold 150 million tickets—or one for every man, woman, and child in the entire empire.[106] In 1917, many urban Russians were probably more familiar with the faces of the movie stars Ivan Mozzhukhin and Vera Kholodnaia than with Nicholas and Aleksandra, and Mary Pickford, Douglas Fairbanks, and Charlie Chaplin may have been better known to them than the empire's leading generals and statesmen.

Gorkii saw a "kingdom of shadows"[107] in this realm over which these idols reigned supreme. Yet unlike shadows in the world of natural phenomena, the flitting images on the screen could be manipulated and controlled, and Lenin

recognized that fact more quickly than anyone in the West. Even if he did not actually say that "cinema is for us the most important of all the arts" as his Commissar for Enlightenment, Lunacharskii once claimed, there is no doubt that Lenin understood the cinema's potential for propaganda very clearly.[108] But so long as the Bolsheviks had to defend their Revolution against half a dozen White armies supported by armed forces sent by no fewer than fourteen foreign powers, acute shortages of capital and electricity kept them from exploiting movies' full potential as propaganda instruments. Only after the fighting stopped could Sergei Eisenstein and Vsevolod Pudovkin begin work on the first of the great Soviet films that would earn them undisputed places among the world's best film directors in barely more than five years.

In 1925, Eisenstein directed a film that proclaimed to the world that Russia's revolutionary passion and the infant Soviet cinema both must be taken seriously. "A typical boy from Riga,"[109] as he wrote in his autobiography, Eisenstein had volunteered for the Red Army in 1918 at the age of twenty, and he had used his training as a military engineer to help strengthen Petrograd's defenses. After two years of service, he had gone on to study for a career in the theater under his "second father," the great avant-garde director Vsevolod Meyerhold, who taught that "art should be based on scientific principles" and that "the entire creative act should be a conscious process."[110] Fascinated by Meyerhold's ideas but convinced that they could be better applied to the cinema than to the stage, Eisenstein shifted from the theater to film in 1923. A year later, he started to work on *Strike*, the fifth and only completed film in a seven-part epic that was planned to dramatize the suffering that Russia's revolutionaries endured during their long struggle to overthrow the Romanovs.

*Strike* proved to be more than a film about labor protest, for in it Eisenstein set aside what he called the "individualist conception" of the hero so as to illustrate more dramatically the concept of collectivity. "In my 'revolt against the theater,' he explained, "I did away with a very vital element of theater—the subject-story"—and set out to portray "the masses as hero" instead.[111] Once described as a film "full of cinematic metaphors and images of sight, sound, touch, smell, and taste,"[112] *Strike* flooded moviegoers with powerful sensations. It played more upon its viewers' hearts than their minds, and its final directive— "REMEMBER . . . PROLETARIANS!"—urged them not to forget the lives of torment from which the Revolution had set them free. "[*Strike*'s] method is closely analogous to that of a poem with which it is almost exactly contemporary—*The Waste Land*," a critic later wrote. "It operates through the [same] rhythmic relationship of scattered images . . . the juxtaposition of which startles and surprises."[113]

If *Strike* reminded Russia's proletarians of the abuses they had suffered in factories of tsarist Russia, Eisenstein's next film, *The Battleship Potemkin*, emphasized the brutality with which the government had put down protest in the days when capitalism had flourished. Now convinced that cinema offered the best outlet for his talents, Eisenstein set out to mark the twentieth anniversary of the Revolution of 1905 with a large cinematic creation that would portray the key

revolutionary events of that year. When bad weather upset his filming schedule later that summer, he decided to focus all his attention on a mutiny that had taken place in Odessa harbor aboard the Black Sea Fleet's *Battleship Potemkin*, and the result was a masterpiece, which, some thirty-two years later, was voted "the best film of all time" at the Brussels Exhibition of 1958.[114]

Instead of allowing separate impressions and events to take on broader meaning as he had done in *Strike*, Eisenstein let a detailed portrayal of a single dramatic episode epitomize the cruelty of military service in the old days, the brutality of the government toward its people, and the heroism of the people's response to oppression. His film opens with a group of sailors complaining about soup made of meat filled with maggots. When their protest swells into a mutiny, they join demonstrators and strikers on shore, setting the stage for the film's dramatic high point, in which innocent men, women, and children are killed by the Tsar's Cossacks on the famed Richelieu Steps that lead to the harbor from Odessa's center. Helpless to take revenge for the killing of their revolutionary comrades, the mutineers sail away, leaving the slaughter of the innocents on the great stone steps to highlight the brutality of tsarsim in one of the most dramatic moments in film history. Even though, in fact, the killings on the Richelieu Steps never took place and the *Potemkin*'s crew simply sailed to the neutral Rumanian port of Constanta and surrendered, Eisenstein's film leaves its audience with the sense that Russia's revolutionaries are moving on to new and greater triumphs. "*Potemkin* looks like a chronicle (or newsreel) of an event, but it functions as a drama," its creator later wrote. "The secret of this," he explained, "lies in the fact that the chronicle pace of the event is fitted to a severely tragic composition."[115]

By portraying the masses as the heroes of *Strike* and *The Battleship Potemkin* Eisenstein projected a powerful vision of proletarian solidarity, but neither film produced an individual, human icon of revolution. To create one, his rival Vsevolod Pudovkin made a film version of Gorkii's *Mother* in the same year as Eisenstein completed his *Battleship Potemkin*. The son of well-to-do peasants, Pudovkin left Moscow University before taking his final examinations in chemistry and joined the Russian artillery at the beginning of the First World War. Wounded and taken prisoner, he remained in Germany until the beginning of 1918, when he escaped and returned to Russia, where the uncertainties of war and revolution kept him adrift for the better part of two years. At the age of twenty-seven, he found work as an actor in several early Bolshevik propaganda films, only to discover that he had greater talent for creating scenarios than for acting, when he prepared a scenario for the devastatingly tragic film *Hunger* from documentary footage taken during the terrible famine in Russia's Volga River provinces. Then, scarcely three years after that, he started to work on *Mother*, the film that would make him famous.[116]

Unlike Eisenstein at that point, Pudovkin saw his characters as real people, not as ciphers or symbols. "I think," he later wrote, "that there was in me a strong instinctive attraction towards living man, whom I wanted to surround with the camera and inside whom I wanted to 'climb' in the same way that Eisen-

stein had climbed inside the battleship."[117] With two of Russia's most popular actors of the silent era, he used *Mother* to tell of a middle-aged woman's political awakening as she is torn between her drunken, brutal husband, who symbolizes the tyranny of the old order, and her son, a revolutionary who stands for the new world yet to come. As the film moves along, the mother's husband is killed and she is tricked into revealing her son's revolutionary activities. At his trial, she looks on while well-to-do observers look down their noses, the police sneer, and the judges glance at their watches in boredom. Then, when her son is condemned to penal servitude in Siberia, she perceives the "true nature" of the world around her and joins the revolutionary struggle. At the end of the film, she and her son are both killed by the brutal forces sworn to uphold the old regime.[118]

Released ten months after *The Battleship Potemkin*, *Mother* was immediately compared to it. Critics continued to acclaim what one of them called Eisenstein's "astonishing mastery in directing the mass and in the magnificent art of montage,"[119] but they also could not help but recognize that Pudovkin's film had conquered its viewers in intimate, personal ways that had created human characters with whom they could readily identify. At the same time as they stood for greater forces and principles—men and women defending the old order and adversaries seeking to overthrow it—Pudovkin's actors shaped viewers' emotions just as surely as Eisenstein's exquisite montages had done. Yet for Pudovkin actors alone were never enough. "The foundation of film art is *editing,*" he explained in words that sounded far more confident than directing one film entitled him to be. "The film is not *shot,*" he concluded. "[It] is *built,* built up from the separate strips of celluloid that are its raw material."[120] Editing was what made the sensations seem so immediate in his first great film. In no other way could the senses of smell, feeling, and sound have been so strongly communicated to the viewers who flocked to see it.[121]

Set in motion by *The Battleship Potemkin* and *Mother* in 1926, the rivalry between Eisenstein and Pudovkin inspired both directors to devote the next year to films that commemorated the tenth anniversary of the Bolshevik Revolution. Despite his preference for communicating with his audience through people, Pudovkin made a concession to Eisenstein's practice of using ciphers, stereotypes, and symbols to portray universal concepts by making the Revolution his plot and telling the story of *The End of St. Petersburg* through the eyes of a single unnamed peasant.[122] Like Chekhov, who once said that if a gun is shown during the first act of a play it must be fired at the end, Pudovkin proved his genius for matching richness of imagery with economy of means. "Everything that Pudovkin puts on the screen is like Chekhov's gun, except that Pudovkin can get more than a shot from a gun," one commentator wrote. To clarify his point, he drew viewers' attention to a glass of steaming tea that sat on a worker's table in the film that, because it was never tasted or drunk, at first seemed to violate Chekhov's rule. "But this same glass serves to measure time, by showing the steam coming from it as thinner and thinner," the critic explained. "This glass all

by itself on the empty table," he added by way of conclusion, "[also] indicates lack of food, poverty."[123] In its mass scenes, *The End of St. Petersburg* commented on the horrors of war, the greed of capitalism, and the meaning of revolution. Yet critics thought its Romanticism too elevated and its lyricism too abstract to reach proletarian audiences. Instead of abstract visions created by their nation's greatest directors, Soviet viewers preferred films with plots and characters with whom they could identify.

If Pudovkin's *End of St. Petersburg* portrayed the larger face of revolution at the expense of showing how it touched the lives of real people, Eisenstein's *October*, the film often shown in the West under the title *Ten Days That Shook the World*, painted revolution in even broader strokes. A fictional recreation of the revolutionary events of 1917 from the Bolshevik point of view, Eisenstein's portrayal has acquired the legitimacy of documentary footage over the years, for none of the actual events of the Revolution ever matched the power of his account. Never was there a moment during the February days of 1917 that equaled the drama of the film's beginning, when a crowd of workers pulls down a statue of the Emperor Alexander III. First the head falls. Then, the arms and legs, the orb, the scepter, and, finally, the throne. The fact that no such statue of Russia's reactionary emperor ever existed is of little consequence. Nor is it significant for understanding the film's message that the dramatic storming of the Winter Palace, for which Eisenstein assembled several thousand Leningrad workers, never took place. What emerges from *October* is a cinematic symbol of the Russian Revolution that rivals Blok's *The Twelve*. And, like Blok's great poem, Eisenstein's film spoke not to the masses but to an elite who knew Russia's history and the meaning of its symbols.[124]

Brilliantly realistic though it seemed, Eisenstein's film teemed with ciphers and symbols, many of them too sophisticated for any audience of workers and peasants. In part because of its intellectual metaphors and lack of any human-interest element with which common folk could identify, Soviet critics greeted *October* with obvious disappointment. Lenin's widow Nadezhda Krupskaia knew better. Although she took strong exception to the film's flat, iconographic portrayal of her husband and the too frequent (to her mind) appearances of Kerenskii, Krupskaia greeted *October* as a film of "great revolutionary and artistic importance" that depicted "the fundamental experiences" of Russia's workers and peasants with great power. "This art has a colossal future," she concluded. "The film *October* is a fragment of this art of the future."[125] Having set out to create an icon for the masses, Eisenstein had made one for the Bolsheviks instead. "It is ironic," a film historian once wrote, "that one of the supreme examples of cinematic myth-making should have caused its creator to be denounced for obscurantism by the very people whose ideology he was attempting to popularize."[126] Pudovkin put it more simply. "How I should like," he said not long after *October* was released in March 1928, "to make such a powerful failure."[127]

*October* marked a clear step on a road that would transform Russia's artistic experience during the Stalin era. Rather than view the world around them as a

realm of symbols that could be rearranged at will or reconciled on a higher plane, Russia's writers, painters, and filmmakers now began to see the experience of daily life as a reservoir of raw material that could be shaped to reflect clearer visions of what their leaders were trying to create. Because the Russians had not yet achieved Communism and because Communist values did not yet shape their daily lives, it became the task of Soviet artists to depict life as it ought to be according to Bolshevik precepts, not as it really was. The focus of life and art thus became the collective—the organized mass of men and women functioning according to Communist principles—that derived its strength from its ability to achieve those common tasks that no one could hope to undertake individually. Eisenstein had projected that view in *Strike*, in *The Battleship Potemkin*, and, most of all, in *October*, in which the masses had always been moving toward a better future. In coming decades, writers and painters would follow the same course. To convince the Russians that the meaning of life stretched beyond the life and limits of any single person, the men and women who shaped their artistic experience had to become, as the proletarian writer Iurii Olesha explained, "engineers of human material" who could reinforce their leaders' vision and lead others toward it.[128]

Soviet Russia's writers and artists, therefore, needed to create newer and brighter works that portrayed how life ought to be in the future. Yet, as the Bolsheviks celebrated the tenth anniversary of their victory with Eisenstein's and Pudovkin's revolutionary cinematic creations, the vision of the new Soviet paradise that had seemed so near in 1917 was beginning to slip out of focus. With Lenin dead and the long-promised collective world of equality, opportunity, and social justice slipping further into the future, Stalin and his followers needed to reassure themselves, reinforce their own belief, and convince nonbelievers of its truth. To men and women struggling to prove that the brave new world they had not yet created would one day surely exist, Socialist Realism held the magic key. For, even if the cherished vision did not yet come into being, in fact, it could be made to exist in novels, movies, and paintings that could reassure them all of its certain—and inevitable—appearance in the years to come.

CHAPTER XV

# THE UTOPIA
# OF SOCIALIST
# REALISM

❦

BETWEEN *1914* and Stalin's rise to power at the end of 1927, world war, civil strife, famine, and disease killed more than ten million Russians. A million fled into exile, and nearly that many more disappeared into the prisons and forced-labor camps of Siberia and Russia's Far North. During the quarter-century that followed, the human catastrophe of Stalin's effort to build Communism in a single lifetime combined with the devastation of the Second World War to claim the lives of well over forty million more. All told, the forty-two years between 1914 and 1956 cost the Russians and the people they ruled in their new Soviet Empire more than eight times the number of lives lost in the Nazi Holocaust. On average, more than a million died every year. Between 1918 and 1940, most of them perished at the hands of their own countrymen.

Yet heroism seemed as much a part of Russia's Bolshevik experience as did suffering, for there were tens of thousands of men and women who willingly sacrificed life, health, and comfort to give form to the vision of Lenin and Marx. Dedicated to defending the worth of every man, woman, and child, they had thrown themselves into the unequal struggle that pitted the Bolsheviks' untried armies against forces supported by the world's most powerful nations. Shunned by the world's great powers, they had used their backs and bodies in place of machines, raised steel mills in the midst of the wilderness, and harnessed the huge rivers of Eurasia to create the new sources of energy needed to transform their nation into an industrial colossus. They had rebuilt railroads, factories, and mines, and brought fallow fields under the plow to overcome the devastation wrought by seven years of war. Looking beyond the misery of the present, many

had given their lives for the dream of building a better future. One of Lenin's closest collaborators, Iakov Sverdlov, had died at thirty-three, and America's John Reed, who had gone to Russia to give his heart to the Revolution, had been buried in the Kremlin wall at the age of thirty-two. Neither the poet Aleksandr Blok nor Mikhail Frunze, who had led the Red Army to victory against the Whites on three different fronts, had lived to the age of forty-one, and Lenin himself had died four months before he would have turned fifty-four. By the end of the Bolsheviks' first decade in power, these and tens of thousands of others filled Russia's revolutionary pantheon. Meeting death in their twenties, thirties, and forties, they too had been part of Bolshevism's human cost.

The sacrifices of so many dedicated revolutionaries in the cause of building a brave new world helped to give the Bolshevik vision new substance. "We live and work in a country where feats of 'glory, honor, and heroism' are becoming facts so familiar that many of these are already no longer noted in the press," the sixty-six-year-old Maksim Gorkii wrote when, as dean of Soviet writers, he urged his colleagues to dedicate their pens to portraying the spiritual and social values that the Bolsheviks hoped to impose.[1] Stalin added that any such portrayal must be based on truth, at least to the extent that it reflected the vision the Bolsheviks sought to perpetuate. "An artist must above all portray life truthfully," he told Russia's writers and artists. "If he shows our life truthfully, on its way to socialism, that will be socialist art, that will be Socialist Realism."[2] Officially proclaimed in 1934 as the model that art and literature ought to follow, Socialist Realism was to provide the writers and artists of the Soviet Union with ready-made formulas for bringing the Bolshevik vision to life. Combining, as one high official said, "the most matter-of-fact everyday reality with the most heroic prospects," typical Socialist Realist novels told of modest and self-effacing heroes who arose from the masses to be shaped by the Party and the teachings of Lenin before striding forth to lead their comrades to a glorious future in which the moral precepts of Bolshevism triumphed over the forces of nature and human adversity.[3]

Not since the days of the secular revolution had the direction of Russia's arts and letters shifted so dramatically as it did between 1927 and 1934, and never had a change come with greater speed. For seven hundred years after Grand Prince Vladimir had brought Christianity to Kiev, Russia's arts had drawn heavily upon the Orthodox East, until, by the late fourteenth century, the Russians had surpassed their Byzantine teachers in the creation of religious art. Moscow had become the Third Rome, the last refuge of pure Orthodoxy in an impious world, and the center of art that reflected both the glory of God and the power of its Tsar. Then, starting with the Great Schism in the middle of the seventeenth century, the secular revolution had turned the Russians toward Europe, and the process of imitating, equaling, and surpassing their teachers had begun anew.

In contrast to those earlier times, when artists had worked anonymously as the instruments of God, the 250 years after the Schism of 1667 had seen the individual rise to unchallenged prominence as both subject and creator of the arts.

Not two-dimensional images of Christ, His saints, and the defenders of His Church, but three-dimensional portrayals of clearly indentifiable people and the world in which they lived now filled painters' canvases. Novels, verses, and plays that turned upon the lives of flesh-and-blood men and women replaced chronicles of deeds done for the glory of God and sagas of larger-than-life heroes. By the 1860s, the Russians had once again begun to challenge their teachers. Followed by Ilia Repin, Musorgskii, Rimskii-Korsakov, and Chaikovskii, Turgenev, Dostoevskii, and Tolstoi had set Russia firmly into the mainstream of the broader artistic experience of the modern world. For the first time, Russian literature was deemed worthy of translation on a large scale, and Russian painters and composers began to gain preeminence in exhibitions and concert halls all across Europe. In 1899, Europeans had waited breathlessly for the first chapters of Tolstoi's *Resurrection* to appear in literary journals all across the West because they had sensed that they would say something truly original and important. A decade later, the first triumphs of Diagilev's Ballets Russes had underscored the original and important place that Russian art had won in the cultural life of Europe.

The success of the Ballets Russes made it clear that, with the explosion of the arts that accompanied the birth of the avant-garde, the Russians had begun to surpass the Europeans who had served as their mentors for so long. Although problems of language and context had kept Western readers from fully appreciating the poetic brilliance of Belyi and Blok, not to mention Gippius, Balmont, and Briusov, there had been no such barriers to set them apart from the truly brilliant creations of Goncharova, Malevich, and Aleksandr Rodchenko in the 1910s and 1920s, or from the revolutionary compositions of Skriabin and Stravinskii. As the First World War came to an end, the Ballets Russes continued to leave audiences breathless throughout the West, while Europeans who came to see the Russian Revolution at first hand between 1918 and 1921 could not help but be amazed at the brave new world that seemed certain to envelop the arts. Pablo Casals and Isadora Duncan both were amazed at the artistic brilliance of revolutionary Moscow, and so was England's Arthur Ransome, the biographer of Oscar Wilde. Combined with the reappearance of Kandinskii and Chagall in Munich and Berlin a few years later, the first performances of Sergei Prokofiev's compositions in Chicago and Paris deepened Europeans' awareness that Russia's arts had embarked upon an even more daring path that was destined to play a leading part in shaping the artistic life of a world in search of new values to replace the ones that the First World War had swept away.

Then the excitement died away, the vision changed, and Socialist Realism set Russia's artistic experience on a different course. As in the days of the anonymous writers and painters who had flourished in Holy Moscow, a sense of collectivity began to pervade the arts, and the importance of the individual began to fade. Embarked upon a path no other society had ever tried at any time in human history, turbulent Bolshevik Russia began to evolve into the stern, monolithic, and all-powerful Soviet State that expected its writers and artists to serve it

with all the devotion that Ivan the Terrible had demanded of their medieval fore-bears. When the new vision of Soviet art and literature became too broad and complex for any one artist to embrace, brigades of painters and writers began to work together to portray these defining moments that had shaped their past and present. Tested in the crucibles of collectivization, industrialization, and world war, Socialist Realism overwhelmed all other ideas and principles. With Stalin and the Soviet State as its central focus, it came to stand larger than life and for all of Russia, just as the hero saints Aleksandr Nevskii and Dmitrii Donskoi had done in olden times.

Socialist Realism required its practitioners to describe the past in the way that Lenin's disciples thought it ought to be remembered and to impart a sense of reality to a future that had not yet come into being. Using massive canvases and monumental palaces of the people to add visual dimensions to the literary visions that Russia's Soviet novelists created, painters and architects portrayed Stalin's Russia as a nation in which scores of millions of men and women who were said to have languished under capitalism in earlier times would enjoy lives of pros-perity and opportunity. Optimistic in their message and grandiose in their di-mensions, the theater and the cinema brought this world to life most vividly of all. There Russia's masses experienced, if only for a few hours, the world that their leaders insisted lay just a few steps ahead.

From the Civil War and reconstruction of the 1920s to the massive industrial-ization of the 1930s to the triumph of the Red Armies in Berlin in 1945, Socialist Realism told Russia's story as the Bolsheviks wanted it remembered. Yet to tell it that way required its practitioners to overlook suffering and misery on a scale never before seen and to erase from their collective memory any thought of the millions who perished in the huge network of slave-labor camps that spread across the Soviet Union in the 1920s and 1930s. From beginning to end, the art of Socialist Realism was selective and optimistic. It overlooked massive failures, inflated small accomplishments, and gave substance to the unfounded claim that Stalin, the mean-spirited and tyrannical revolutionary from Georgia, possessed the insight and brilliance to give shape to Lenin's vision. Yet even the artists who struggled most diligently to fit their work into the ever-narrowing framework of Party dictates during the High Stalin Era usually fell into error somewhere along the way. From time to time, writers, artists, theater and film directors, and com-posers all confessed their "sins," begged the Party's forgiveness, and proclaimed that they felt "stronger, gayer, freer, and happier" as a result of having unbur-dened their hearts.[4] Many such penitents disappeared into the forced-labor camps of Siberia and the Far North in any case. Those who escaped that terrible fate continued to praise Stalin as their "dear, beloved friend and teacher" be-cause silence carried too great a risk.

Yet Socialist Realism contained more than a new "truth" that portrayed the world-that-ought-to-be as opposed to the world-that-really-was. Because the minions of Stalin's tyranny envisioned art as an instrument for creating a new breed of human beings, it also provided a means for instilling Bolshevik values in

the minds of simple men and women who had none of the sophistication boasted by those readers toward whom earlier generations of Russian writers had directed their best-remembered work. The great realists of prerevolutionary Russia had written for people who had the leisure to absorb novels that were bulky and complex, while the Symbolists of the early twentieth century had addressed an audience sophisticated enough to contemplate how symbols might be used to describe a higher realm of truth that stood above and beyond the reality of daily life. By contrast, novelists of the new Soviet era wrote for the millions of men and women whose leisure might be limited to those parts of the day when they rode streetcars to and from work, or for the newly literate peasants who saw printed pages only as sources of entertainment or instruction. Such men and women required books that could be read in fragments, with uncomplicated, straightforward plots in which they could become immersed in the space of a few moments. "Our workers . . . spend eight hours in the factory," Stalin once told a group of writers who had gathered at Gorkii's townhouse. "Where can they sit to read a long novel?"[5]

Soviet writers in search of popular themes with mass appeal during the 1920s looked first to the Civil War struggles that had paved the way for the Bolsheviks' victory and the triumph of the Soviet State. For Russia's new proletarians, such novels placed familiar events in well-remembered settings, while they provided writers with a way to come to grips with the violence they had seen on battlefields scattered from the forests of eastern Poland to the semiarid lands of Central Asia.[6] Just as Aleksandr Nevskii, Dmitrii Donskoi, and Ivan the Terrible all had marched beneath the banner of the Blessed Virgin in ancient times, so the new proletarian heroes of Socialist Realist fiction now fought beneath the red banners of Bolshevism, while they sang of proletarian strength and unity in the same way that their ancestors had sung of their devotion to Tsar, Russia, and the Holy Mother Church.

Gripped by visions of the new world that the Bolsheviks had sworn to create, Socialist Realist heroes died not for Tsar, God, or Mother Russia as their ancestors had in days gone by, but for the dream of a new nation in which the people reigned supreme. All of them claimed to speak in the name of the people, but it was the Party, as guardian of Russia's new moral, political, and ideological orthodoxy, that defined who the people were and what they ought to believe. In the hands of the Party, Socialist Realism thus became a force for shaping the minds, hearts, and expectations of an entire society. By the middle of the 1930s, it had become, in the words of one recent commentator, "a powerful mechanism by which the leaders and supporters of the Stalinist system enlarged the domain of their moral and intellectual claims,"[7] so that none of them could be challenged on any meaningful level.

Perhaps no one fit the image of the new Soviet hero in the 1920s better than Vasilii Chapaev, a son of wretchedly poor peasants from the Volga provinces of Central Russia, who saw in the battles between Reds and Whites a chance to vent

his hatred for the system that had held his forebears in bondage. Victor in a score of battles against the White armies in the Urals and Western Siberia, Chapaev had been killed in the fall of 1919 while attempting to escape from an ambush, and he—like that handful of larger-than-life peasants who had led the masses against their masters in earlier times—had become a legend overnight. His comrades had sworn an oath on his grave to honor his memory with greater victories, and Red Army cavalrymen sang of his exploits around lonely campfires from the grainfields of Ukraine to the dark forests of Siberia. Just two years after the Civil War ended, Dmitrii Furmanov, a young proletarian writer, who had grown up in the great Central Russian mill town of Ivanovo-Voznesensk, wrote a novel about Chapaev's exploits that became a socialist landmark almost a full decade before the first All-Union Congress of Soviet Writers made the principles of Socialist Realism its own.[8] When it appeared as a film in the fall of 1934, it became one of the strongest statements of the newly promulgated Socialist Realist principles that Stalin's artists would ever create.

Based on Furmanov's personal experiences while fighting with Chapaev's guerrillas, *Chapaev* highlighted the strengths and weaknesses of those peasant fighting men whose spontaneous hatred for their oppressors drove them to feats of reckless heroism. It applauded their readiness to fight against impossible odds, but it also warned that their raw traditional anarchism could endanger the very cause for which they so readily gave their lives. Again and again, *Chapaev* made clear in language newly literate readers could understand that personal hatreds shriveled to insignificance when compared to the grandeur of the cause the Bolsheviks served. By showing how Chapaev had met his death in a moment when he had forgotten to remember that the Party and the People had to stand above and beyond any man's or woman's thirst for glory or revenge, Furmanov made it clear that revolutionary "consciousness" could triumph where even the bravest of heroes could not. Like *Mother*, which Gorkii had written almost twenty years earlier, *Chapaev* embodied the myth of the revolutionary spirit that would transform the "evils" of capitalism into the "virtues" of socialism. To simple men and women, it offered the promise of victory against odds that no human force could overcome alone.

Much less a work of Socialist Realism but more sensitive in its portrayal of life during the Russian Civil War, a collection of short stories that bore the title *Red Cavalry* told of battles fought on the Polish front in the year after Chapaev's death. Its author was Isak Babel, a young Jew who had studied the Talmud in Odessa, lived in the Petrograd underworld, and found favor with Gorkii in the year before the Revolution. At the beginning of 1917, Babel had joined the army and served on the Rumanian front before returning to Petrograd to work for Gorkii's newspaper. Then, at the beginning of the Russo-Polish War in 1920, this gentle, unmilitary writer joined General Budennyi's legendary First Red Cavalry Division as a war correspondent and served in its ranks for several months before bad health sent him back to his native Odessa.[9]

Babel went to war in search of a story to tell and the language in which to tell it. According to his friend Ilia Ehrenburg, he "immediately felt at home and entered into other people's lives wherever he found himself," and he was "passionately in love with life [and] involved in it every minute."[10] Short and nearsighted, he looked more like a village schoolmaster than one of the dashing cavalrymen in whose company he rode, and his poor health did little to help him bear the rigors of life in the field. Yet, for most of the summer and fall of 1920, he persevered, gathering the impressions, anecdotes, and ideas that would provide the raw material for *Red Cavalry* the moment he left the war. He worked painstakingly and with precision, honing each phrase and paragraph to eliminate every word that did not ring true. At one point, Babel showed the young writer Konstantin Paustovskii a stack containing twenty-two drafts of a single story to support his claim that a writer's life centered mainly on drudgery and hard work.

"Twenty-two drafts!" Paustovskii recalled exclaiming in amazement.

"Yes, and I'm not even sure that the twenty-second one is ready to publish," Babel confessed. As if hoping to share with his friend the inner secrets of his writing, he went on to tell how he shaped his finely crafted stories from the rough kernels of anecdotes heard around cavalry campfires.

"First of all, I get rid of every superfluous word," he explained. "You need a sharp eye for that because language is very clever in the way it hides its rubbish, repetitions, synonyms, and outright nonsense, as if it's trying to outwit us at every turn."

Then, Babel went on, one had to make certain that each metaphor was precise and every image was clear.

Above all, sentences had to be short and direct. "Don't hesitate to use periods!" Paustovskii remembered him exclaiming. "Each sentence can have only one thought and one image, no more."[11] Babel believed that only by cutting descriptions to the bone could a writer hold the attention of his audience in the days when leisure to ponder what one read was so hard to come by. The key lay in action and movement, the very things upon which the Cossacks with whom Babel had ridden had built their entire history.

The Cossacks whose exploits filled Babel's pages were descended from brotherhoods of fugitive serfs who had settled on the lower reaches of Russia's great European rivers in the days when those lands had stood beyond the Tsar's domains. For centuries, they had traded with the Turks and Persians, robbed the riverboats that carried goods north for trade, and formed an irregular cavalry army that had fought for the Tsar on some occasions and against him on others. Ninety years before Babel, Gogol had told the tale of Taras Bulba, the wild Cossack chieftain who had fought the Poles in the long-ago days of the first Romanovs. A decade before that, Pushkin had written of Emelian Pugachev, the real-life Cossack chieftain who had led the largest revolt in Russia's history, and Tolstoi had portrayed the Cossack community in which he had lived while serving as a junior artillery officer in the Caucasus on the eve of the Crimean War. Now the mild-mannered Babel, whose Jewish ancestors had been the target of

Cossack brutality since the days of Bogdan Khmelnitskii in seventeenth-century Ukraine, showed them fighting in the name of a revolutionary cause they could not comprehend against the Poles they had hated for centuries.

Precisely the sort of spontaneous violence that Furmanov condemned stood at the center of Babel's stories, for his Cossacks lived and died by fighting. In pages that reek of blood, Babel describes their anti-Semitism, their closeness to nature, their cruelty, and their strength as he poses the troubling questions to which answers cannot be found. Why do the strong torment the weak? Why do they kill without even a second thought? Why do some men submit so readily, while others refuse to do so at any price? Yet was submission so cowardly after all? In the way an old Jew, in one of Babel's tales, begs his Polish tormentors to kill him out of sight of his daughter, submission to death takes on a heroic aura that places it at least on a par with the way in which Cossack fighting men ride to battle. And who are these men who kill without emotion and with no remorse? A Cossack, Babel answers, must be defined in "layers: worthlessness, daring, professionalism, revolutionary spirit, [and] bestial cruelty."[12] Everywhere, he juxtaposes jarring opposites, showing portraits of Lenin and Maimonides lying side by side, Communist pamphlets with their margins filled with scribbled Hebrew verses, Jews who have lost their faith and others who have kept it.[13] Babel, the critic Viktor Shklovskii once concluded in amazement, "speaks in the same tone of voice about the stars and about gonorrhea."[14]

Like Pushkin, Gogol, and Tolstoi before him, Babel wrote of the Cossacks from the perspective of an outsider, for Russia had yet to find its first great Cossack writer. Then, in 1927, just a year after *Red Cavalry* appeared in book form, a manuscript appeared at the office of Aleksandr Serafimovich, an editor working in the office of the magazine *October*, and with it came a request that he pass judgment on its literary merits. Without paragraphs, and awkwardly typed on a primitive typewriter as a single unbroken text, the jumbled stack of pages seemed less than promising.[15] Yet, as Serafimovich read through it, a host of characters—real, compelling, and vibrant—began to "tumble out of the pages [as he later said] in a living, gleaming, crowd, each with his own nose, his own wrinkles, his own eyes, and his own speech." The amazed Serafimovich had before him the manuscript of the first volume of *And Quiet Flows the Don*, now widely regarded as the greatest Russian novel ever written about life during the Great War and Revolution. It seemed to him as if "a young, yellow-billed eaglet . . . [had] suddenly spread out his huge wings." From the mountains of lifeless manuscripts acclaiming the joys of proletarian life that flowed into the offices of *October* every day, the skeptical editor had extracted a "literary masterpiece."[16]

Further investigation revealed that the author was only twenty-two and that his first published work had appeared just two years before. Like Serafimovich, he was a Cossack, better educated than most, but by no means from the Cossack aristocracy. Could such a work have been written by someone too young to have fought in the Civil War? And how could a youth just turned sixteen when the

Civil War ended have perceived so clearly its impact on the famed Don Cossacks who lived around him? Such questions tormented critics and hounded the author throughout his life, leading some (including Solzhenitsyn) to say that a Cossack officer, who had fought for the Whites and died of typhus in 1920, had written the manuscript even as the flames of war raged around him and that Sholokhov had merely copied it and submitted it as his own. Like so many accusations of plagiarism viewed at a distance, those surrounding the manuscript that Serafimovich found so compelling in the year of Stalin's rise to power can never be put entirely to rest. We therefore must remain content with the conclusions presented by a group of experts a decade ago that the accusations do "not seem to stand up to closer scrutiny," and that the man whom the world knows as Mikhail Sholokhov, winner of the Nobel Prize for literature and acclaimed as one of the most widely read Soviet writers, must "be considered the sole author [of *And Quiet Flows the Don*] until anything else has been proven."[17]

A huge portrait of Cossack life that stretched from the eve of World War I until the end of the Civil War, Sholokhov's *And Quiet Flows the Don* has been called "a Cossack *War and Peace*"[18] because of its vast scope, many characters, and the sensitivity with which it portrays the life of a society at war. Published in four volumes between 1928 and 1940, it went through a hundred printings and sold over five million copies by the time World War II broke out. Critics have envied its success, doubted its authorship, and criticized its language and composition, but have failed to praise the impartiality with which it portrays the dilemmas that old loyalties and new ideologies posed for the people whose love of freedom was once as legendary as their prowess in battle.

Like Tolstoi's *War and Peace*, *And Quiet Flows the Don* is a family chronicle cast in epic proportions. Set in the romantic lands along the Don River, it carries its readers into the ancient grasslands on which Prince Igor fought his campaign in the spring of 1185 and the riverbanks where Moscow's Dmitrii Donskoi led the Russians to their first victory over the Tatars nearly two hundred years later. Here, in the 165,000 square kilometers that form the great Don River basin, the grass grows taller than a man on horseback and stretches as far as the eye can see. In spring, Gogol once wrote, "an ocean of green and gold, sprinkled with millions of different flowers" spreads out to the horizon,[19] and it was from these lands, in which men and women lived free from want, servitude, and fear, that the Cossacks had gathered hordes of oppressed peasants into the formidable armies with which they had challenged the Tsar in olden times. The lands of the Don also had yielded the Cossack squadrons that had crushed the workers of Russia's cities when they had first risen against capitalism and autocracy. Here opposites seem destined to be juxtaposed as a matter of course, making Sholokhov's quiet Don flow through a land inflamed by war and revolution, in which the differences of opinion that have divided its men and women for centuries must be decided by internecine strife.

Like no other writer in Russia's history, Sholokhov brings his readers into the inner world of the Cossacks as they ride off to fight for Tsar and Motherland and

return to find their villages torn by revolution and civil strife. Just as Tolstoi did in *War and Peace*, Sholokhov relied on firsthand accounts—on military dispatches, newspapers, and private remembrances of eyewitnesses—to tell his tale, and there is an authenticity about *And Quiet Flows the Don* that no other novel of the 1920s manages to match. Yet, unlike Furmanov, Babel, or a dozen others who wrote of the heroism and brutality of the Reds in those days, Sholokhov tells his tale from the viewpoint of the Whites, showing their failings from an entirely different and more convincing point of view. *And Quiet Flows the Don* thus chronicles the fall of a proud people as they are overwhelmed by events they can neither comprehend nor control. In the vacuum that remains, the Bolshevik dream of collective unity quickly replaces the old vision of a brotherhood united by its love of Tsar, the Holy Faith, and the ancient Cossack way of life.

The ruin of the old way of life that Sholokhov portrayed in the Cossack lands touched all of Russia as the Civil War came to an end in 1921. In the countryside, the peasants had no boots or tools. In the cities, workers had no food, clothing, or fuel. In the great grainfields along the Volga, Russia faced its worst famine in a hundred years, while inflation spread hunger into the cities, where it cost a third of a worker's monthly wages to buy a pound of bread. "The salary of twenty of the most renowned professors," one visitor to Moscow noted, "equals—according to the present purchasing power of the ruble—the amount allowed by the old regime's budget to support a watchdog at a government institution."[20] Russians had to be fed and restored to health. Fields had to be brought back under cultivation. Mines had to be reopened, locomotives repaired, and ruined track relaid. Factories had to be rebuilt and every type of public service restored. All this had to be done while the Bolsheviks struggled to create the new institutions that would take the place of the old regime they had overthrown. Who could be trusted remained unclear, and what could be carried over from former times far from certain. Yet all of this had to be accomplished quickly. Otherwise, Russia seemed certain to collapse into chaos.

Midway through the 1920s, these massive tasks of reconstruction found their place in Soviet novels that followed the concerns of the masses away from the turmoil of the Civil War toward dreams of a better life. Among the best-known, Fedor Gladkov's saga of reconstruction set the real problems of real people into a framework of industrial romanticism that depicted hard work as an exciting adventure and the new society that the Bolsheviks hoped to base on science and technology as the way of the future. Gladkov's *Cement* charted the new role of the machine in proletarian life, and presented the factories that housed them as the saviors of the new world the Bolsheviks were striving to create. Like Maiakovskii, Malevich, and their comrades, he, too, did not see the machine as an instrument of Satan nor did he see it as a point of conflict in the ongoing struggle between the old ways of village life and the forces of modernity. Aided by resolute Communists who marshaled the power of the human spirit to build a better world, Gladkov's working-class heroes greeted the machine as the instrument that could liberate humankind from the hitherto unyielding forces of nature.[21]

Written in what a Bolshevik critic once called "a heroic monumental style that corresponds to our age,"[22] *Cement* tells how a handful of honest workers struggled to rebuild a half-wrecked cement factory in a large Black Sea port in the years immediately after the Civil War. They face sabotage by counter-revolutionaries, shortages caused by stupid officials, and the erosion of traditional family ties by new Communist ethics, not to mention the crude self-interest of revolutionaries gone wrong and the shortsightedness of well-intentioned proletarians. As the story of a man whom Gladkov patterns on the larger-than-life heroes of old Russian folk tales, *Cement* describes the new "labor front" to which all are summoned to repair the damage wrought by years of fighting and revolutionary turmoil. "Here on the labor front you have to have heroism too," the novel's hero insists when his comrades argue against his plan to bring the cement factory back into operation. "Heroism is doing the impossible."[23]

Yet heroic labor alone cannot create happiness for the men and women who struggle to bring the Bolshevik vision into being. Just as in the long-ago days when Peter the Great's secular revolutions had replaced Old Russian customs with modern European ones, Gladkov's heroes find that the meaning of home, family, personal priorities, and the relationships between men and women all will be different in the new world of Bolshevism. The real point of *Cement* is that no individual can be of much consequence when measured against the needs of the collective of which everyone must become a part. What was the point of even talking about personal wants, when there were so many urgent tasks to be done? The past was over and done with, and only the future counted. "We are building Socialism and our own proletarian culture," Gladkov has his hero exclaim at the end. "Onward to victory!"[24]

Larger-than-life heroes, whose "inexhaustible energy" and "surging nature" impelled them to serve the revolutionary cause until the last moment of their lives, had been a part of the Bolsheviks' rapidly growing mythology from the first days of the revolution, and they quickly shaped the new Soviet artistic and political experience.[25] By 1928, such descriptions were being applied to Stalin himself, as a man of steel who dedicated all of his energy to the cause of building Socialism. Stalin became the "hard as flint" hero whose energy, will, and unflinching determination promised to bring the Russians to Socialism and Communism just as quickly and surely as the legendary heroes of ancient folk tales had overcome the enemies of Old Russia. Yet even the greatest of heroes needed allies, and Stalin looked for men whose dedication would carry his will into every corner of Russia. True Stalinist heroes would have less individuality than the central characters of *Chapaev* and *Cement*, but their dedication to the Bolshevik cause would be even more unwavering and true. Such men and women would struggle to set new records of production while remaining unshakably dedicated to the Party and the Soviet State that it represented.

In 1932, the first of these new heroes strode resolutely forth from the pages of *How the Steel Was Tempered*, a novel by Nikolai Ostrovskii that set Russia's new

"Stalinist" political culture into a fictional framework in which the Party's leadership stands supreme and its undaunted Bolshevik spirit leads the way to progress. Although confined to a small corner of the big picture that no one but Stalin and the Party could ever hope to comprehend, Ostrovskii's hero sets an example of dedication and endurance, even after he loses his sight and contracts an incurable disease that leaves only his right hand free from paralysis. Humble in origins, poorly educated during the last days of the Romanovs, and devoted to the Bolshevik dream, he thinks only of the Party and the new world it is struggling to bring to life. Even when the Party demands that his wife spend the evenings she once had devoted to caring for him at meetings and extra work, he makes no complaint. Still hoping "to return to the ranks of the builders of the new life," he bears his pain in silence, and even finds joy in his loneliness. "Pride for his wife, who was turning into a true Bolshevik," Ostrovskii explains to his readers at the end, "made his sufferings easier to bear."[26]

Like *Cement, How the Steel Was Tempered* told the true story of its author's life and showed that there were still people who would let no obstacle stand in the way of remaking Russia in the Bolshevik image. Born in 1904, Nikolai Ostrovskii had come from a family of poor Ukrainian peasants who had struggled for decades against the harsh regime of their Polish landlords. Like Gorkii, he had had almost no formal education, for after less than two years of schooling he had been obliged to live on his own and make his way through a succession of odd jobs that had ended when he had lied about his age and joined the Red Army at the age of fifteen. Seriously wounded in 1920, he had lost part of his sight. Struck down by a crippling form of arthritis soon after he left the army, he found work as an electrician, joined the Party, and dedicated his heart and soul to the Bolsheviks' cause. At twenty-five he became completely blind. Two years after that, he contracted tuberculosis of the bone.[27]

Paralyzed except for his hands, Ostrovskii vowed to write a novel about the Civil War, and "return to the ranks of the fighters," no matter what the cost. Confined to a large communal apartment packed with people struggling to come to grips with the turmoil caused by Stalin's relentless efforts to drive Russia into the industrial age, he nonetheless worked to overcome his poor education and give literary form to his remembrances. "It was noisy and crowded," a friend reported after visiting him at home. "People banged against you in the corridor, babies squalled, and someone was typing in a distant corner, pecking away at the keys with the persistence of a woodpecker." Stubbornly, Ostrovskii worked through it all, holding his pen against a thick cardboard straight-edge that enabled him to put "unnaturally shaped letters" into "too-straight lines." When *How the Steel Was Tempered* appeared in serial form in the well-known *The Young Guard* magazine at the beginning of 1932, he was overjoyed. "I'm back in the ranks!" his friends remembered him saying. "I'm back in the ranks! Isn't life wonderful?"[28]

Crudely written, with unconvincing characters and a stereotyped plot, the

first installments of *How the Steel Was Tempered* received little attention. Then Ostrovskii's struggle against ignorance, misfortune, and disease caught the attention of Party publicists in search of simple heroes whose life stories could be used to instruct the masses. Overnight, his fame soared. The Party to which he had given his devotion sent him to the best doctors and moved him from his damp Moscow apartment to a warm villa in the sunny Crimea. Secretaries and stenographers appeared to help him finish a second volume, and Stalin decorated him with the coveted Order of Lenin. By the time Ostrovskii died in 1936, *How the Steel Was Tempered* had gone through sixty-two printings that had produced two million copies. By the time the Stalin era ended seventeen years later, the number of copies in print had more than tripled.[29]

In the person of his novel's hero, Ostrovskii set down the formula that Socialist Realist novels would follow for more than a decade. Like the folk heroes of ancient times, these dedicated servants of the people's cause held the power to overcome nature and circumstance in ways that ordinary folk could not. As "true Soviet" men and women, they reflected the strength and vision of Stalin himself, each being endowed with one small aspect of their leader's greatness that made it possible to achieve in one of life's smaller arenas lesser versions of the feats that only Stalin could accomplish on a national scale.[30] Able to conquer the obstacles of place and circumstance, they resembled such real-life Soviet heroes as Aleksei Stakhanov, who hewed fifteen times the daily quota of coal from a Ukrainian mine in 1935, and Valerii Chkalov, who set records for long-distance flight across the Arctic in 1936 to prove, as the newspapers of the time proclaimed, that "there are no fortresses that Bolsheviks cannot storm." As it did with Socialist Realist heroes created according to Ostrovskii's pattern, the Party used their achievements to inspire others to reflect Stalin's greatness as the all-knowing supreme leader of the world's first Soviet Socialist society.

Even as the Soviet Union grew stronger during the 1930s, the world beyond its borders turned more dangerous. In 1938 and 1939, Soviet armed forces came to blows with the Japanese along the Manchurian and Mongolian frontiers, while Hitler preached the destruction of Communism and demanded more "living space" for the German people in the East. Stunned by the speed of the Nazi assault when Germany's dictator hurled 175 divisions across Russia's western frontier on June 22, 1941, Russia's heroes of Socialist Labor left their fields and factories to defend their Socialist Motherland, while Soviet writers brought into being new champions whose Socialist valor could provide new courage for a nation on the brink of defeat. Unlike the Socialist Realist heroes of the 1920s and 1930s, the literary heroes of World War II had been born and raised in Soviet Russia, and their bravery in battle showed how well the Stalinist crucible had tempered them in body, mind, and spirit. In 1946, Aleksandr Fadeev's *Young Guard* memorialized them all, especially those young men and women of the Komsomol—the Communist Youth League—who had cut short their adolescence to fight for their Motherland and had given their lives "in the name of the cause" when they had barely begun to live.

Fadeev had grown up on Siberia's Pacific coast during the last days of Imperial Russia. Steeped in the world of high adventure that Jack London, Mayne Reid, and James Fenimore Cooper had portrayed in their novels, he had developed a taste for "firmly and stably built" books in which an "author's great humanist ideas" could have a lasting impact on "the spirit of the reader." At the age of seventeen, he had found in the writings of Lenin, Engels, and Marx the ideas that defined his mission when he joined the Bolshevik Party, but before he could turn his pen to the task of building Socialism, he was drafted into the Red Army. Fadeev spent most of the Civil War on Russia's eastern fronts fighting the White armies of Admiral Kolchak, the interventionist forces of Japan, and the marauding bandits that the renegade Cossack Ataman Grigorii Semenov led against Reds and Whites alike in the wilds east of Lake Baikal. When he returned to Moscow in 1921, his Civil War experiences in Siberia formed the basis for his first novel, *The Rout*.[31]

Unlike Furmanov and Ostrovskii, Fadeev endowed his heroes with complex lives and characters that harked back to the great realist writers of the nineteenth century, and he urged Soviet writers to turn back to Tolstoi as the "dialectician of the human psyche" who had showed the impact of environment, dreams, needs, and desires upon his characters' thoughts and deeds. Convinced that a political idea must lie at the center of every novel, he believed that literature must be judged by an author's ability to define politics in terms of individual human experience. To portray the "complex psychological reality" of the men and women who were working to build Bolshevism in Russia, Fadeev therefore called upon Russia's new writers to reveal the inner thoughts that impelled the relentlessly flowing "human streams" of the 1920s to act as they did.[32]

As a high official in the Union of Soviet Writers that replaced the Russian Association of Proletarian Writers in 1932, Fadeev spent most of the 1930s trying to write a huge novel about the Bolshevik Revolution's impact on a tribe of Siberian natives. Called *The Last of the Udegs*, the novel took its title from the much-loved *The Last of the Mohicans* of his youth, but he found it hard to describe how primitive people responded to progress, and harder still to sense their inner feelings about Bolshevism.[33] "One must possess greater artistic experience than I have to write a big novel with a complex idea such as I have planned," he confessed at one point. He had meant, he said a few years before his death, for his uncompleted *Last of the Udegs* to be a historical novel. Some thirty years after he began it, he concluded that it did not contain enough history to achieve that end.[34]

In 1941, the outbreak of the Second World War freed Fadeev from the burden of the book he had not been able to finish. Like many Soviet writers, he joined the Red Army, where he searched for new themes that could celebrate the heroism of his countrymen. His quest led him to the young men and women of the Komsomol, who had helped to form the backbone of Soviet resistance against the Germans, and he found in their collective heroism a sacrifice that "could melt stone." Gathering together reports about attacks that the Komsomol

had led behind the German lines, he blended interviews and firsthand observations to create a novel about how Communist youths drove back the Fascist invaders who had ravaged their land. In the readiness of its young heroes to give their lives for a higher cause, Fadeev's *Young Guard* showed that the Soviet system had produced a whole new generation of men and women who stood ready to die for their vision of the society in which the art and propaganda of the Stalin era had taught them to believe.[35]

Despite Fadeev's long-standing passion for *War and Peace*, *The Young Guard* painted history on a more limited, intimate scale. At the novel's center stood nearly a hundred young men and women from the small Ukrainian mining town of Krasnodon, who had formed an underground partisan organization the moment Nazi armies occupied their land. Like hundreds of other groups that operated in the territories occupied by the Germans, they organized raids, stole weapons, and killed collaborators. Yet very few of them possessed the charisma of Russia's Civil War heroes, and fewer still felt comfortable in the heroic aura with which public opinion enveloped them toward the war's end. "The Young Guards," Fadeev once said, "were . . . ordinary, simple Soviet young people."[36] Nothing in their appearance distinguished them from millions of others who had been born not long before Stalin's rise to power and reached adolescence just as the war began.

Fadeev's young heroes had lived their childhoods amidst the turmoil of the Five Year Plans that Stalin had launched in 1928 with the idea of modernizing Soviet industry and agriculture in the space of a single decade, and they had learned their moral values at the height of the Great Purges that had claimed hundreds of thousands of lives between 1934 and 1938. As the greatest of Soviet heroes, Stalin was their "little father," and they looked to him for guidance in shaping their lives and values. As the novel's epigraph proclaimed, they marched "to meet the rising sun, opening the way with bayonet and shell for working folk to rule the world."[37]

Conscious of their mission, and ready to set their personal wants aside in the name of the cause to which they had been called, they felt a kinship with those revolutionaries of an earlier era who had borne the torments of the Tsar's secret police, fought the Whites, and set aside their rifles to wield picks and shovels in the 1920s to build a better world. Idealism to them was second nature. Ignorant of the realities of Stalin's reign of terror, they believed that they could change the world. As a tribute to its heroes' willingness to give their lives in the name of Soviet "freedom," Fadeev's *Young Guard* won instant acclaim. As the recipient of the Stalin Prize First Class in 1946, it quickly became for the generation of the 1940s what *How the Steel Was Tempered* had been for their older brothers and sisters and what *Cement* had been for their parents.

Within the framework of Socialist Realism, *The Young Guard* sets forth the eternal conflict between the "consciousness" of discipline imposed by the Party and the "spontaneity" of heroic action as its hero organizes the Young Guard and forges his own iron character. Yet, in his enthusiasm to show the personali-

ties of his heroes, Fadeev said too little about how the Party had shaped their visions, and for that he was sternly criticized when the euphoria of victory subsided. Quickly, he corrected his "errors," and rewrote his novel in ways that made it even more stereotypical and impersonal. With a resolve worthy of his novel's young heroes, he expanded its original fifty-four chapters to sixty-four to describe how older Party officials and Red Army officers had served as the Young Guard's mentors. In that way, he created a succession from "father" to "son" within the framework of the "great family" of working-class heroes in which older, more "conscious" revolutionaries passed on the traditions of Bolshevism and Stalinist leadership to a younger generation struggling to subordinate its "spontaneous" enthusiasm to Party discipline.[38]

As with Socialist Realist novelists from Gladkov to Fadeev, the political conflicts revolving around the death of Lenin and the rise of Stalin had a profound impact on Russia's revolutionary theater. In 1928, Meyerhold had again joined forces with Maiakovskii to stage *The Bedbug*, a "fairy comedy" that parodied the vulgar trivialities that were coming to dominate Soviet life under the heavy hand of Stalin. With sets by the Constructivist painter Aleksandr Rodchenko and a musical score by the young Dmitrii Shostakovich, the play showed both men's deepening disillusionment with the dream to which they had so passionately given their hearts. "Maiakovskii is forcing us to examine not a world transformed, but the very same sickness that is afflicting society today," Meyerhold explained when critics debated whether the play's second act, set in the year 1979, presented an inspired technological vision of the future or a parody of present-day Socialism. "Maiakovskii's aim," he added, "is to show us that illnesses have deeply rooted causes and take a great deal of time and vast amount of energy to overcome."[39]

Disgusted by the tawdry "petty bourgeois" vulgarity that infested the core of Stalin's bureaucratized Bolshevism, Maiakovskii and Meyerhold soon enraged Party loyalists with *The Bathhouse*, a commentary about Soviet life that was even more bitingly satirical than *The Bedbug*. Portraying Party functionaries who had grown fat by betraying the Revolution, the play in Maiakovskii's words "simply wiped out the bureaucrats" by the brutal manner in which it stripped bare the failings of early Stalinist Russia.[40] To escape the storm of criticism that *The Bathhouse* provoked, Meyerhold took his theater on a long-awaited tour of Europe, but Maiakovskii, on April 14, 1930, placed a pistol against his heart and shot himself. With more friends among the intelligentsia falling by the wayside, and with his supporters in the inner circle of the Party being accused of Trotskyism and other ideological errors, Meyerhold found very few to defend him when critics took him to task for his "inimical attitude toward Socialist Realism" at the beginning of 1932.[41] Criticized as part of an "antidemocratic sortie of ideological enemies," the handful of theatrical successes he produced after that time only got him deeper into trouble. When *Pravda* complained in 1937 about the "false political and artistic policies [that] had led his theater to total disaster,"[42] Meyerhold replied that Socialist Realism had "nothing to do with art."[43] Then, a few

months after his critics sent him to prison in the summer of 1939, Soviet Russia's greatest theatrical director was shot as a "class alien" whose "emotional trash" had led to a "glorification of bourgeois mentality" in Stalin's Russia.[44]

The avant-garde brilliance of the early Soviet theater faded quickly, for the first decade of Socialist Realism produced no playwrights with talents to match Meyerhold's and Vakhtangov's. Such brilliant 1920s plays as *The Bedbug* and *The Bathhouse*, Mikhail Bulgakov's *Days of the Turbins*, and Iurii Olesha's *Conspiracy of Feelings* all came from writers whose main talents lay in novels or poetry. As the theater became the instrument for imposing the Party's monolithic views and values upon Russia's masses, even these found few successors.[45] With Stalinist critics demanding that the theater's main themes must "concern the class struggle of the working class against its exploiters, the civil war, socialist industrialization, the collectivization of agriculture, and the role of intellectuals in the revolution," stale bureaucratic absolutism displaced the brilliant traditions that had ruled the Russian stage ever since Stanislavskii had first joined forces with Nemirovich-Danchenko.[46] "What Bolshevism wanted," a commentator concluded in looking back at the 1930s, "was a theater that would merely illustrate the repeated slogans of the Communist Party on stage."[47]

Just as the rise of Stalin corroded the theater's brilliance, so it cut short the decade of innovation and experimentation that had marked the golden age of Russian cinema. To marshal the masses to support collectivization, industrial development, and the imposition of Socialist morality from above, the urgings and preferences that the Party had used to shape cinema in the 1920s became ideological dictates that required each and every film to reflect Stalin's vision. "We are struggling for great, full-blooded art, for an art of great social content," one Party critic explained as the flickering images from nearly thirty thousand projectors showed audiences in collective-farm meeting rooms, military barracks, small-town theaters, and big-city cinemas how Stalin's truest disciples met the challenges of natural disasters, saboteurs, and workers who thought only of themselves and not the collective.[48] Disappointment, sickness, even the discovery that loved ones had failed to remain true to "the cause" never turned such heroes away from the shining path that led to Russia's Socialist future. Yet this new heroic world of grandiose deeds accomplished in the name of Socialism could be preserved only through censorship and repression. Films could project Bolshevik "truthfulness and historical concreteness"[49] only so long as no other visions challenged their portrayal of the past and present.

In the world of cinema, the search for Socialist Realist heroes culminated in *Chapaev*, the adaptation of Furmanov's novel that became a milestone in the early history of Soviet sound film. As a striking example of the power of Stalinist art to create an artificial world in place of the real one, the film concentrated on how the precepts of Bolshevism had transformed Chapaev into a conscious revolutionary at the same time as it emphasized the role of the Party in Russia's revolutionary history.[50] Issued to celebrate the seventeenth anniversary of the

Bolshevik Revolution on November 7, 1934, *Chapaev* won Stalin's praises, attracted over fifty million viewers in its first five years, and has been called "the most popular Socialist Realist" film ever made.[51] In less than a year, it became the standard against which new films were measured. "Soviet power expects from you . . . new films which, like *Chapaev*, will glorify the grandeur of the historical exploits of the workers and peasants of the Soviet Union in their struggle for power,"[52] Stalin told a meeting of film directors and producers in 1935. To find the grandiose deeds and larger-than-life heroes he demanded, Russia's greatest filmmakers turned away from utopian portrayals of the present and future to the annals of their nation's past. That was especially true of Sergei Eisenstein, whose efforts to repeat the successes that had won him acclaim in the 1920s drew him into repeated clashes with the authorities throughout the first decade of the Stalin era.

After working on several films that the authorities refused to release, Eisenstein turned in 1937 to Prince Aleksandr Nevskii, the medieval Russian hero who, on April 5, 1242, had defeated the fearsome Teutonic Knights in the famous Battle on the Ice on the frozen waters of Lake Peipus. Nevskii's heroism supplied a theme that could combine the new chauvinism of the age with the gnawing fear of foreign agents that Stalinism sought to instill in every Russian heart. Thus transformed, Old Russian nationalism could remind viewers of the dangers that foreign invasion had posed throughout Russia's history, warn aggressors of the obstacles they faced, raise a new monument to the people in whose name Stalin ruled, and in the words of the Party bureaucrats who governed the world of Soviet cinema prepare "every man, woman, and child to meet any war . . . with a sense of optimism."[53]

Proclaiming that the film *Aleksandr Nevskii* would be "heroic in spirit, militant in content, and popular in its style,"[54] Eisenstein portrayed Russia's earliest popular hero as a leader who had welded the masses together to fight in the name of Russia and its people. Brilliantly portrayed by Nikolai Cherkasov, one of twentieth-century Russia's greatest actors, Nevskii summons his people to face the heavily armed Teutonic Knights, whose weapons represent thirteenth-century military technology at its finest. Against these armored human fighting machines, who have sworn to do God's will, Eisenstein's Nevskii leads simple men with simple weapons, confident that their devotion to God and the land that has given them birth will give them strength. As the forces of nature join with the Russians to drive the invaders to their deaths beneath the ice on which they have chosen to fight, Nevskii claims victory to show that Russia will always stand firm against every danger. Eisenstein's film thus became a monument to the Russians' resistance against foreign attack for a nation fearful of German invasion. In a broader, symbolic sense, it showed that Soviet science could transform nature in ways not yet seen in human history. Fought on the eve of a great spring thaw, the Battle on the Ice was filmed in the outskirts of Moscow during a summer heat wave in 1938 on ice made of asphalt, white sand, chalk, and salt.[55] As

the heavily armored Teutonic Knights slipped to their watery graves beneath the ice, the summer sun shone overhead, carefully obscured by filters that transformed its light into a wintry haze.

Heroism and patriotic fervor shaped *Aleksandr Nevskii*'s score as well as its plot. Drawn to Eisenstein's genius and enthralled by the possibilities of applying sound to film, Sergei Prokofiev keyed each of the twenty-one separate pieces of its score to the scenes as Eisenstein filmed them. "Prokofiev works like a clock [which] isn't fast and isn't slow," Eisenstein wrote some years later. "We [would] look at a new piece of film at night," he continued. "In the morning the new piece of music [would] be ready for it."[56] Caught up, as he said, in "the fascination of the subject, the richness of the images [and] Eisenstein's great artistry," Prokofiev tried to evoke the emotions of the past rather than use real compositions from the thirteenth century. "I thought that it would be best to write the music for the Teutons not as it actually sounded at the time of the Battle on the Ice but as we now imagine it," he wrote. "The Russian music," he added, "is [also] cast in a modern mold rather than in the style of seven hundred years ago."[57] Prokofiev's score thus became a musical echo of each defining moment in the drama. Together with Eisenstein's artistry, it created a film in which sound and image blended in perfect harmony to remind viewers of the dangers that the "Teutonic Knights" of modern times posed to Russia and the Russians.

Eisenstein's ongoing collaboration with Prokofiev and Cherkasov made his next film all the more brilliant. Begun just a few weeks before Hitler's armies stormed onto Russian soil in the summer of 1941, *Ivan the Terrible* presented Russia's fearsome Tsar not as a capricious madman but as an awe-inspiring prince who had defended the Russian land against enemies at home and from abroad. The obvious parallels between Ivan and Stalin made Eisenstein's task more exciting and dangerous, for the Tsar had to be portrayed in terms that corresponded both to the dictates of Russian history and the Socialist Realist model of a Bolshevik hero. Like Furmanov's Chapaev, Eisenstein's Ivan thus had to be presented as a "sorely tried leader, hemmed in by the demands of public policy and by personal privation [who] ... summons in himself and others the resources to accomplish the task he believes history has set for him."[58] As an ally of the people and the defender of Russia, Ivan the Terrible had to be portrayed as a sovereign whose hard and terrible cruelty was made necessary by the times in which he lived.

While the Red armies fought to turn back the forces of Nazi Germany, Eisenstein filmed *Ivan the Terrible* in Kazakhstan's Central Asian capital of Alma-Ata. Once again, Cherkasov played the leading role and Prokofiev composed the score, using folk songs, Russian Orthodox liturgy, and epic choral works to create the twenty-nine pieces needed for its first two parts. As he had in *Aleksandr Nevskii*, Prokofiev worked with unrelenting precision, noting down the number of seconds required for every piece of music after he had seen each of the film's sequences. By that time, he and Eisenstein had grown so familiar with each other's ideas that each understood, almost without speaking, the subtleties that

the other was trying to convey. "Give me something that sounds like a corkscrew scraping on glass," Eisenstein would say. "Here it should sound like a child being torn out of his mother's arms."[59] In response, Eisenstein later wrote, Prokofiev created a drama of "magnificent and flawless music, which in all its articulations and accents blended perfectly . . . with every subtle detail and nuance of the scenic sequence."[60]

Vowing to "conceal nothing [and] smooth over nothing in the history of the actions of Ivan the Terrible," Eisenstein set out to create a "fearful and wonderful, attracting and repelling" image of the Tsar whom Stalin saw as the greatest hero of Russia's history.[61] In the film's first part, he successfully negotiated the treacherous currents of Stalin's preferences and won the Stalin Prize First Class for his effort. Yet, just a few months later, the film's second part drew a flood of complaints from Party critics, who denounced Eisenstein for presenting Ivan as "weak and indecisive, somewhat like Hamlet," and for portraying his fearsome retinue as "a degenerate band rather like the Ku Klux Klan."[62] To some, the parallels between the film's chief characters and Stalin's retinue seemed distressingly clear. Completed in 1946, the second part of *Ivan the Terrible* would not be shown until 1958, a decade after Eisenstein's death.

To create art that could instruct the masses on a scale never before seen in Russia, Stalin spent immense sums to subsidize huge murals, gigantic frescoes, massive friezes, and colossal mosaics, each and every one of which proclaimed that life was becoming gayer and better with every year that Russia lived under his leadership. "One can say that Socialist Realism is Rembrandt, Rubens, and Repin put to serve the working class," one of its leading exponents explained in 1933.[63] "Soon it will become clear to all," another added in the language so typical of Stalin's lackeys, that "whoever is not a realist is complete shit."[64] Such art was to be admired from afar as the product of an all-powerful patron who dictated its content for the benefit of the tens of millions of men and women in whose name he ruled. The masses were its only audience, but they could never possess or consume it.

Even more than for murals, frescoes, and mosaics displayed in prominent public places, the Soviet masses were the audience for the monumental buildings with which the Bolsheviks proclaimed their superiority over nature and the societies of the modern world. Like the writers, painters, and film directors who had embraced Russia's Revolution in 1917, Bolshevik architects disdained their imperial past and sought to work with new concepts and materials. Only in that way could they design those massive subterranean People's Palaces through which Moscow subway trains carried millions of workers every day, and the gigantic factories and mills that armies of strong-backed proletarians raised up out of steel, brick, and concrete to become the new cathedrals of Bolshevism in the midst of the wilderness.

Yet, before they could begin, Russia had to recover from the devastation that had left them nothing with which to build. Between 1914 and 1921, the output of Russia's heavy industry had shrunk by almost 90 percent. Its iron production

had fallen to what it had been in the days of Catherine the Great, and its textile industry had produced less than it had during the last days of serfdom. By 1921, Russia's mills yielded less than one-sixtieth of the steel they had in 1914 and copper production had stopped altogether. Without new rails to replace those destroyed by the fighting and with no spare parts to repair locomotives, railroads had fallen apart. Mills in the winter of 1919–1920 had only a tenth of the fuel they needed, and there was almost no electric power. Only two percent of the axes, shovels, picks, and scythes produced in 1914 were being turned out in 1920. As the Civil War came to an end, the surging industries that had raised Russia to fifth place among all the world's nations on the eve of the First World War had fallen silent.[65] "Such a decline in the productive forces . . . of an enormous society of a hundred million," a Soviet economist later wrote, "is unprecedented in human history."[66] Until this catastrophic decline was reversed, Russia's revolutionary architects could do little more than dream on paper. Only when new supplies of brick, cement, and wood became available, one architect explained, would it become possible for the Soviet State to "utilize architecture as a powerful means for organizing the psychology of the masses."[67]

Russia's revolutionary architectural dreams began at the height of the Civil War with Vladimir Tatlin's Constructivist plans for a Monument to the Third International in 1919. According to his friend Nikolai Punin, the avant-garde critic who became Akhmatova's lover a few years later, Tatlin set out to plan a monument that would be "built according to completely new architectural principles, from completely new architectural forms."[68] Seen by its creator as a way of "uniting purely artistic forms with utilitarian intentions," Tatlin's Monument took the form of a soaring, four-hundred-meter-high spiral of cast iron that was to straddle the Neva River in the center of Petrograd.[69] To celebrate the dynamism of the revolutionary society that was taking shape in Russia, steel cables were to suspend a cube, a pyramid, and a cylinder within the upturned spiral, each being made of glass and steel and designed to revolve at speeds regulated by whether the agencies they housed met once a day, once a month, or once a year. Maiakovskii cheered Tatlin's tower as "the first monument without a beard" and the "first object of [the] October [Revolution]."[70] Others criticized its impracticality. "Either build functional houses and bridges, or create pure art, not both," one critic wrote. "Don't confuse one with the other."[71]

Like the society it was designed to commemorate, Tatlin's Monument to the Third International never advanced beyond drawings, models, and dreams. As a Constructivist painter who sought to integrate the reality of art and the reality of life, its designer remained so indifferent to the practical construction problems his tower posed that he simply dismissed critics' worries with the lofty assurance that "modern technology fully allows for the possibility of constructing such a building."[72] Yet his spiraling tower was only one of many dreams that young architects committed to paper during the terrible days when little could be built because there was nothing on hand with which to build. The shortages of building materials and funds that confined architects to their drawing boards during

those hard and trying years sharpened their visions of the future, even as their new leaders conceived ever grander utopian plans for transforming the world in which they lived.[73]

In 1923, the visions of politicians and architects came together in a nationwide competition to design a Palace of Labor that would celebrate the newly proclaimed Union of Soviet Socialist Republics. "Many say of us that we are erasing from the face of the earth all the palaces of bankers, landlords, and tsars with the speed of lightning," one high official said at the time. "Let us erect in their places ... a new palace of workers and laboring peasants ... [that will] show friend and foe alike that we 'semi-Asiatics' ... are capable of ornamenting the sinful earth with monuments that our enemies cannot even dream of." Russia's leaders wanted the palace to convince workers all around the world that the future belonged to the revolutionary cause. On an even greater scale than the Monument to the Third International, the Palace of Labor was to create "an emblem of the forthcoming triumph of Communism" everywhere.[74]

To create a "magic palace" in which all the "worker and peasant artistry" of the Soviet nation would be brought together, the forty-seven architects who entered the competition piled together huge façades, towering entryways, soaring towers, and massive blocks of offices. Yet the Palace of Labor would never be built and the site prepared for its even more grandiose successor, a Palace of Soviets conceived in the 1930s, became a huge heated outdoor swimming pool in the late 1950s. Soviet architects simply lacked the experience to build on such a scale, and their preoccupations with the "expressiveness of forms" soon gave way to "a new respect for sober practicality," especially when Lenin's death at the beginning of 1924 ended the most idealistic phase of the Revolution.[75] For the next few years, the practical problems posed by mass construction and mass transportation took precedence over dreams and visions as Russia embarked upon the massive recovery needed to restore its shattered economic life.

Before they began to seek practical solutions to practical problems, Soviet Russia's visionary builders had one more opportunity to translate the dreams of the Revolution's early days into the reality of stone, steel, and glass. The massive outpouring of popular grief that followed Lenin's death on January 21, 1924, set in motion the "sanctification" of the Revolution's guiding genius in much the same way as memories of miracle-working saints had been revered in earlier times. As the self-proclaimed guardian of Lenin's legacy, Stalin assembled all of his relics—books, memorabilia, and personal papers—in a newly founded Lenin Institute, dedicated to elaborating the fallen leader's words and interpreting his beliefs. But the huge crowds from all over the Soviet Union that converged on Moscow to say farewell to the much-loved "little father" of the Revolution made it clear that an institution dedicated to preserving Lenin's words would not be enough. The need to build some public repository of Lenin's relics at which men and women of all walks of life and from all nations could pay their respects turned Bolshevik thoughts once more to the massive and spectacular once again.

In keeping with the visions that had been set down in the plans for Tatlin's

tower, the Palace of Labor, and half a dozen other never-to-be-built monuments during the early years of the Bolshevik era, several architects proposed monumental memorials to Lenin that included replanning several square miles of central Moscow and building a memorial structure that would house the general staff of world revolution, a school of Leninism, and the Executive Committee of the Comintern.[76] Practical considerations dictated by the limited means of a nation just emerging from political and economic chaos soon put an end to such costly dreams, and the Central Committee of the Communist Party decided to build a more appropriate monument to honor the man whose modest way of life had always signaled his dedication to the cause of revolution.

When Aleksei Shchusev, builder of churches and railroad stations before the Revolution and the mentor of several young architects whose visionary projects had found favor during the early days of Bolshevik power, received the commission to design a mausoleum for Lenin, he chose as his model an ancient Persian stepped pyramid to be set on the edge of Red Square near the Kremlin's walls. In place of the temples of the living God that had ruled the lives of Russia's faithful before the Revolution, Shchusev (and his "disciple" Konstantin Melnikov, who designed Lenin's sarcophagus inside the mausoleum) now created a temple of the living man, the builder of a new revolutionary world, whose deeds, his followers hoped, would gain him immortality. The polished red and black granite Lenin Mausoleum became a monument "To the Living Ilich," the patron saint of Bolshevism, who was, as propagandists would say in years to come, "more living than the living."[77]

Building a temple of the living man in place of temples of the living God marked the first of the Bolsheviks' many efforts to create symbols that would win the masses to their cause in the post-Lenin era. In a sense, modern, Stalinist Moscow was to bring all these together to form a Socialist city that was to stand at the center of a millennial artistic vision, which portrayed a promised land more bountiful and affluent than anything ever seen or imagined. Rich crops in a land notorious for its famines, bounteous sunlight in a region known for its long, dark winters, and frolicking children whose parents had spent their childhood years toiling in Russia's fields and factories all found places in Socialist Realist paintings that portrayed harvest festivals on collective farms and moments of leisure created by the technology that Soviet science had brought into being.

In hymns and songs, Russia's workers greeted Stalin as the sun who, "like the morning, rises above the world." The sun, they said, "shines for us on earth in a different way now—knowing that it has visited Stalin in the Kremlin."[78] Canvases, murals, frescoes, and statues showing Stalin as the friend and heir of Lenin, as leader, teacher, and comrade of all Russians, as the fount of ideas and wisdom, and as the force that inspired each and every Russian to greater achievements in the name of the Party all flowed from the brushes and chisels of Soviet artists in the 1930s. Painters hoping to win favor portrayed Stalin at Party Congresses, at the opening of factories, foundries, canals, and hydroelectric dams, in

the company of Lenin, and in meetings with common men, women, and children to show how even a single moment spent in the great leader's presence could change the course of a human life.

The Second World War transformed artists' visions of Stalin from teacher and friend of the people to all-powerful defender of the Soviet Union. As the Supreme commander upon whose shoulders rested the fate of Russia and all the Russians, his image grew from larger-than-life to monumental, and when victory came in 1945, its dimensions stretched beyond the limits of human experience. "Everything . . . takes place under the fixed stare of the plaster, bronze, drawn, or embroidered eye of Stalin," America's John Steinbeck wrote when he visited the Soviet Union not long after the war's end. "He is everywhere. He sees everything."[79] On canvas, in stone and concrete, and in every other artistic medium, Stalin towered above the Russians. "Artists no longer portrayed the man, as it were, but the idea of the man," a critic explained. "As flesh and blood, he might have ceased to exist. Stalin had become a bundle of concepts, the embodiment of all virtue, a divinity."[80] Beams of light shone upon him as he gazed upon the ocean from the deck of a Soviet cruiser or surveyed the fertile vastness of Russia's fields. Apart and alone, Stalin had become teacher, leader, and deity all rolled into one in the same way as artists and writers in earlier times had glorified Peter the Great, Ivan the Terrible, and Old Russia's hero-princes. Just as Feofan Prokopovich had called Peter the Great "Samson . . . at whom the whole world marvelled" for having accomplished deeds "unheard of in history,"[81] and in the same way that Vasnetsov had portrayed Ivan the Terrible as fearsome, aloof, and alone, so the artists of the 1940s painted Stalin as being apart from and above all ordinary mortals.

None worked more diligently to capture Stalin's larger-than-life image than Aleksandr Gerasimov, whose paintings became synonymous with the cult of Stalin after the end of the Second World War. The son of serfs from the black-soil province of Tambov, Gerasimov had helped his father in the horse and cattle trade, and was past thirty before he graduated from art school. After a decade of struggling to make his way in the new world of Bolshevism, he had struck up a friendship with People's Commissar of Defense Kliment Voroshilov, who arranged for him to paint a portrait of Stalin presiding over the Sixteenth Party Congress in 1933. Soon, as a critic later wrote, "canvases devoted to Stalin began to gush from his studio."[82] Gerasimov painted "Stalin and Voroshilov in the Kremlin," "Stalin and Gorkii Strolling on the Banks of the Moscow River," "Stalin and Voroshilov on the Volga," "Stalin at the Telegraph," and half a dozen other images before the Second World War was six months old. In 1942, his "Hymn to October" summoned Russians to arms against the Germans. After that, he painted a huge canvas of the Teheran Conference, and in the years after the war depicted such earlier high points of Stalin's regime as the opening of the Moscow Metro in 1935, and the "Great Oath" that Stalin had sworn to defend the ideals of Lenin. In the mid-1950s, he fell upon hard times. Gerasimov's

greatest tragedy was to live a full decade beyond Stalin's death and suffer the disdain that critics inevitably heaped upon him the moment the most powerful of all Russian patrons had passed from the scene.[83]

Just as artists' visions of Stalin shifted, so did the way in which they portrayed Russian life. The moment the Party took command of art in 1932, special committees began to commission paintings and sculptures of heroes of labor, heroes of the nation's defense, and heroes in the struggle for peace and progress to instruct the masses in the gospel of a Socialist future. As a first step in merging art and the Bolshevik vision of reality into a single monolithic whole, Party critics declared war on those modernist influences that had helped to shape the work of Malevich, Chagall, Tatlin, Rodchenko, and a score of others during the decade after the Bolsheviks' victory. The campaign against such "formalism" swung into high gear in 1936, with an attack against Shostakovich for writing "leftist confusion instead of music for people" in his opera *Lady Macbeth of the Mtsensk District*, and then went on to attack those remnants of the avant-garde who continued to work in the Soviet Union. Securely settled in the West, Chagall and Kandinskii both escaped, and Malevich died in time to receive full honors as the leading Suprematist of the age. But Tatlin and Rodchenko were not so fortunate, and each found misery and bitterness in the Revolution he once had embraced. Rodchenko's melancholy, grotesque paintings of circus clowns showed the sadness of an artist forced to turn away from his art in the 1930s and 1940s. Tatlin spent his last years trying to flee from the present into the past by painting in an Impressionist manner that dated from an era before he had been born.

Stereotyped, and focused within ever-narrowing limits, the art of Socialist Realism depicted a world that had never been and never was to be. Paintings that portrayed the new power of industry and the joys of life on collective farms shared pride of place with heroic Red Army soldiers, stalwart border guards, and workers who sat in the places of old-time aristocrats in the boxes of the Bolshoi Theater. The Second World War brought forth massive paintings of battles against Fascist foes and huge portrayals of Old Russian heroes bound closely to the present. The pain of defeat, the nobility of dying for Stalin and Russia, and the joys of victory all found expressions on canvas, and so did the blessings of peace and the new heroism of rebuilding the Socialist vision that the war had shattered. Romantic, sentimental, heroic, and often maudlin, the huge paintings of Russia's Socialist Realist masters stripped the people's art of all individuality and made it a formulaic embodiment of Communist virtue, especially after brigades of painters began to work in tandem to recreate moments in Stalin's past as symbols of Russia's history. Yet even the cult of Stalin could not obliterate all traces of the brilliance that had marked the golden age of Russian painting between 1870 and 1930. While such artists as Konstantin Iuon and Kuzma Petrov-Vodkin set their brushes aside for much of the 1930s and 1940s, Aleksandr Deineka continued throughout the Stalin era to create works that retained precisely those touches of individuality that Socialist Realism was trying to erase.

Born in the last year of the nineteenth century, Deineka grew up in the

provinces during the last moments of Imperial Russia's twilight, and he proclaimed his loyalty to the Bolshevik Revolution by leaving art school to join the Red Army. "Who is not thrilled by what is happening?" he wrote as the Bolsheviks drove back the Whites in the late summer of 1919. "Who can remain indifferent?" [84] During the Civil War, he decorated Bolshevik propaganda trains and worked with Maiakovskii to design the famed Russian Telegraph Agency "Windows of Satire" posters that urged Russia's toiling millions to take up arms in the name of the cause. By the time he turned twenty-five, his genius for capturing the essence of revolution in a few quickly scrawled lines had made him one of Soviet Russia's best-known caricaturists.

Convinced that "art and revolution had found a common language" and fascinated by the sense of perspective he found in Old Russian icons, Deineka tried to adapt their artists' methods to modern forms in order to portray Russia's new proletarian world in the mid-1920s.[85] Grouping his figures in the manner of Moscow's ancient masters and mixing planes with what he called "sharply accentuated three-dimensional" figures, he worked on a monumental scale, using confident, light strokes to emphasize his belief that an artist's brush ought never to touch any part of a painting more than twice.[86] Then, blending his vision of a new world with his interest in the techniques of Old Russia's artists, he painted "The Defense of Petrograd," in which he divided a large canvas into horizontal segments that told of the workers' determination to defend their Revolution at all costs. "I painted 'The Defence of Petrograd' in two weeks," he remembered many years later, "but the road to those two weeks was very long indeed."[87]

During the 1930s, Deineka turned away from images of proletarian revolution to paint the rural scenes he remembered from his childhood in Kursk. Convinced that "nature is beautiful and art should be the same," he set aside the ascetic, somber shades he had used during Russia's first revolutionary decade in favor of colors that depicted the brightness of the world he hoped Socialism would bring into being. Set against the backdrop of rivers, trees, and fields as they enjoyed moments of respite from the labors of building a new society, the figures in his paintings depicted the new breed of muscular and handsome men and broad-hipped, big-boned, broad-shouldered women destined to be created by Socialism. "One can close one's eyes to the succession of generations and hold on to the traditional," Deineka once wrote, "but isn't it better to absorb the new life and draw images from that?"[88] In the very year the Party took control of art, he painted his famous portrait of "A Mother," which portrayed a nude New Soviet woman holding her child. A monumental portrayal of human dignity and moral strength, Deineka's painting came to be called "The Madonna of the Twentieth Century," a pearl that shone amidst the proletarian muck with which the purveyors of Stalinism worked so diligently to coat the art and artists of Russia.

The opening of the Moscow Metro in 1935 inspired Deineka to create his second monumental work of the decade in the form of ten mosaic ceiling panels for the station on Maiakovskii Square. Designed to show "a day in the Land of the Soviets,"[89] his mosaics focused on the themes of sport, aviation, agriculture, and

industry to glorify the fruits of the Soviet people's labor. Set in brightly lit ceilings deep beneath Moscow's streets, his panels portrayed airplanes soaring through space, machines harvesting grain from immense fields, and factory chimneys spouting flame from furnaces that forged the steel that would build the proletarian world of the future. Vibrant blues, reds, greens, and yellows flooded the station with color and transformed it into a subterranean palace through which flowed those millions of everyday Socialist heroes who had dedicated their labor to building the world that Deineka envisioned would one day flourish around them all.[90]

In 1941, war shifted Deineka's attention to portraits of Russia's defense, and for the next four years his brushes showed once-peaceful fields filled with tank traps, children playing beneath barrage balloons, and villages ravaged by invaders. In a monumental canvas measuring more than six by thirteen feet, he portrayed sailors of the Red Navy fighting to the death to defend the Crimean bastion of Sevastopol against Hitler's legions. "The sailors defended Sevastopol to the last boundary of the city, to the last drop of their blood," Deineka wrote as he recalled how the bitterness of war had overlain the warm memories he had carried away from his paintings of Russia's countryside almost a decade earlier. "[I wanted] to paint this picture," he explained. "[I wanted it to be] full of the superhuman efforts of the battle."[91] Then, as the defeats of 1941 and 1942 turned into the triumphs of 1943 and 1944, Deineka sketched the trauma and tragedy that he found in the Red Army's wake. "I saw a pilot who had been shot down lying in the snow . . . like a dead bird," he remembered. "Then, through . . . the snow that lashed the face and ripped the cape from one's shoulders sped a tank with soldiers who were covered with oil and soot, with faces purple from the cold and with snow-covered brows and lashes. The baroque riot of man and nature," he concluded, "was pure Michelangelo. On the roadside, human hands with white nails and loose scraps of skin stuck up out of the snow."[92]

As one of the first Soviet artists to reach Berlin, Deineka painted the devastation of the fallen Fascist citadel to show the terrible price that Germany had paid for Hitler's folly. As in the 1920s, when he had painted the Bolsheviks' efforts to build a new world on the ruins of tsarism, he used dark, cold tones to portray the sinister forces that had been overcome, but he now used watercolors to deepen the sense of drama that hung over the city's shattered buildings. Nothing emphasized the loneliness of the defeated city more emphatically than Deineka's watercolor of the desolate "Berliner Ring," in which a lone figure made its way along an empty street toward a single toppled lamp post. Gutted buildings and a single chimney, all starkly silhouetted against a leaden north European sky, completed the picture of a once-proud city that Allied power had brought to its knees.[93]

In portraying the impact of the fighting at home, Deineka extracted new hope from the challenges that the war's end brought to the Russians. Combining the drama that had marked his work in the 1920s with the brightness that had colored his vision in the 1930s, he portrayed a nation in the grip of a frenzy to raise new buildings from the ruins of the old. Punctuated by Stalinesque skyscrapers,

the Moscow skyline now showed a brighter world emerging from the devastation the war had wrought. Then, when Stalin's final reign of terror began to darken that vision, Deineka turned to landscapes, fairy tales, visions of people and times long past, and bronze figures that still portrayed the new breed of men and women to whom he had once believed Socialism could give birth. Only after Stalin's death did his work come alive again, but never with its earlier drama and vision, for the Stalin era had taken a toll from which he never fully recovered. As a conclusion to a biography that encompassed a full half-century of the Soviet artistic experience, Deineka's last major work—a marble frieze formed from the crests of the fifteen Soviet republics for the foyer of the Kremlin's new Palace of Congresses—showed an artist who at last had fallen victim to the depersonalized formulas of Socialist Realism at their worst.[94]

If the optimistic vision that had given birth to Socialist Realism degenerated into formulaic paintings and novels stripped of every hint of individuality, it yielded a style of architecture that was equally sterile and devoid of feeling. Bolshevik visionaries had planned for projects of great size and complexity as the first Five Year Plan got under way, but Stalinist taste soon forced them to abandon the spare, clean utilitarianism that had characterized the Constructivist architecture of the 1920s in favor of huge façades with monumental ornamentations to celebrate the achievements of a society that claimed new triumphs at every turn. All across Siberia, huge mills, factories, and apartment houses marked the rise of new cities on virgin lands, while in European Russia older cities spilled into suburbs that once had held summer cottages and country estates. To create barriers against the urban sprawl that had stained the cities of the West with so many slum dwellings, Russia's urban planners set aside space for massive public facilities and parks. Yet resources and dreams almost never coincided, nor did the preferences of those paragons of lower-class taste who had risen to rule Russia. "Nothing pleases them so much as the gleam of marble columns under high ceilings [and] glittering chandeliers," Frank Lloyd Wright wrote after his visit to Moscow at the end of the 1920s.[95] Multistoried monoliths ornamented with columns, marble, and crystal housed Russia's new Communist elite at work and at rest, and separated them from the masses who continued to live in spartan facilities with no running water and the minimal amounts of living space allotted by Party planners.

The new palaces for Russia's elite reached the final height of bombast just after the Second World War, when Soviet planners built seven huge buildings at crucial points around Moscow. Designed as office complexes, apartment houses, hotels, and the central building of Russia's largest university, these blended decorative details from early twentieth-century Manhattan skyscrapers with motifs from sixteenth- and seventeenth-century Old Russian structures to create a "totalitarian style" of architecture which, in the words of one expert, melded "utopian notions of Communism with the unparalleled elitism of the late Stalinist period."[96] Huge, minimally functional, and built to dominate the Moscow skyline as monuments to the massive power of Stalin, these all combined "wasted

space and elaborate decoration" into "isolated points of opulence in a country wracked by destruction and deprivation."[97]

To mask the wretched condition in which Russia's urban masses lived before and after the war, Stalinist planners created grandiose public buildings, sprawling "parks of culture," and subterranean palaces to house the Metro stations through which millions of Muscovites flowed each day. Each more than three hundred feet in length and inspired by the architectural heritages of East and West, these Metro stations combined domed and vaulted ceilings with soaring arches, huge colonnades, and massive chandeliers of crystal and bronze. Delivered by fast-moving escalators into realms of subterranean splendor in which, a hundred feet below Moscow's streets, spacious trains waited to speed them on their way, Moscow's newly transplanted peasants became lords of a realm that none of their forebears had imagined. In no other capital of Europe or America did the masses enjoy the overdone opulence of such "people's palaces" or ride with such speed and comfort. Here, with palaces created for individuals in the millions while millions of individuals languished in cramped rooms with communal kitchens and primitive toilets, was Dostoevskii's vision of the Crystal Palace's hordes of people "obediently flowing ... from all over the globe,"[98] moved underground to become the ultimate Socialist utopia.

Yet some did not need the contrast between subterranean palaces and crumbling cold-water flats to show them that the Stalinist vision of utopia had poison at its heart. Almost from the moment that Stalin and his disciples first proclaimed it in art and literature, the Socialist Realist utopia came under attack by men and women whose artistic vision stood at odds with their own. Quietly from within Russia and more stridently from Russia Abroad—a new "country" created by refugees and émigrés who had fled their homeland—writers, composers, and painters set forth a vision of a world in which individuals remained the masters of their fates. By shifting the source of creative activity from the heart, mind, and soul to those rigid and oppressive decrees that flowed from the bureaucratic institutions of a tyrannical, abusive state, the Bolshevik utopia seemed to such people to be nothing less than a wholesale perversion of the entire human artistic experience.

# ÉMIGRÉS
# AGAINST
# UTOPIA

BETWEEN 1918 AND 1921, Russia's Civil War let loose a flood of refugees. Sometimes in the company of loved ones but more often without the families and friends who had given meaning to their lives, soldiers who had fought the Red Armies in Siberia made their way into Manchuria and China, while those who had survived the battles against the Bolsheviks in Russia's South crossed the Black Sea to Constantinople and the Balkans. Others, who had fought the Reds in the southern coastlands of the Baltic, in Ukraine, and in the western lands of Poland, converged on the cities of Central and Western Europe, and a handful more made their way to Latin America, Australia, Canada, and the United States. Tattered, destitute, and marooned in foreign lands, few had any vision of what lay ahead. The only certainty in their lives was that they could not return to Russia so long as the Bolsheviks remained in power.

Numbering nearly a million,[1] these refugees included some of Russia's greatest writers, painters, dancers, and composers. The composer Igor Stravinskii, the modernist painters Mikhail Larionov and Natalia Goncharova, and the ballerina Anna Pavlova all had remained in Western Europe when World War I had broken out, and the number who had followed them had increased with every month that passed after October 1917. Bitter at what the "beast people" had done to their land and way of life, Zinaida Gippius and Dmitrii Merezhkovskii had left Petrograd at the end of 1919, claiming that they saw only "a nocturnal void filled with black, clotting blood" that promised "civil war without end and without limit" in Russia's future.[2] Yet for neither Merezhkovskii nor Gippius did exile signal escape or retreat. Both saw its purpose as being to prepare the way

for the final confrontation that must inevitably come to pass between the "great religious truth" and the "great religious lie." "We are not in exile," Merezhkovskii proclaimed when they reached Paris a few months later. "We are on a mission."[3]

The dancers Karsavina and Kschessinskaia, the painters Marc Chagall and Vasilii Kandinskii, the composers Sergei Rachmaninov and Aleksandr Glazunov, and scores of novelists and poets quickly followed Gippius and Merezhkovskii to the West, and so, after testing briefly the rigors of life among the Bolsheviks, did the greatest of bassos profundo Fedor Chaliapin and the poets Viacheslav Ivanov, Konstantin Balmont, and Vladislav Khodasevich. The novelists Gorkii, Ehrenburg, and Aleksei Tolstoi, all of whom would return to live in Stalin's Russia, spent part of the 1920s in the West, as did Ivan Bunin and Aleksei Remizov, who would not. Together with fallen politicians, scholars, and scientists, many of whom were among a large group of non-Communist intellectuals expelled from the Soviet Union in 1922, these formed the artistic and intellectual underpinnings of Russia Abroad, an ephemeral "country" with far-flung "provinces" in the cities of Harbin, Belgrade, Prague, Munich, Berlin, Paris, London, New York, and San Francisco. Bound together by shared suffering, these men and women hoped to keep the timeless truths and the thousand-year heritage of Russia's artistic experience from being tainted by Bolshevik values and the moral absolutism of Socialist Realism. First with Berlin as their "capital" and later in Prague and Paris, the writers, painters, and intellectuals of Russia Abroad would seek to perpetuate the artistic dynamism that had made the culture of their Silver Age and its avant-garde one of the most vibrant in Europe.[4]

Whether they painted, wrote, or composed, émigré artists enjoyed greater freedom in the West than they had ever known at home. Yet the constraints of poverty, the quest for stability, and their struggles to find new audiences amidst the turmoil of exile bound many of them too rigidly to the past and clouded their sense of the future. For those with audiences confined within Russia Abroad, exile remained painful and difficult, for their native language created a barrier to integrating into the culture of the West that could almost never be surmounted. The number of readers in Russia Abroad was never large enough to support its writers, and émigrés from the 1920s and 1930s counted themselves fortunate if any of their books enjoyed sales of a few thousand. Scores of writers and poets thus endured shadow lives as taxi drivers, waiters, and hotel clerks, while they struggled to remain faithful to the artistic visions they thought had been displaced by the Revolution. Even a writer as brilliant as Vladimir Nabokov had to support himself by giving private lessons so long as he wrote in Russian.

Émigrés whose brushes and musical scores spoke a universal language unconstrained by the printed words of a national vocabulary found an even larger arena in which to work than any they had known at home. The painters Kandinskii and Chagall, and the composers Stravinskii, Glazunov, and Rachmaninov saw their creations hung in the best museums and performed in the greatest concert halls of the Western world. Sergei Kusevitskii won rapid acclaim as conductor of the Boston Symphony Orchestra, while Anna Pavlova, Sergei Lifar, and

George Balanchine ruled the ballets of Europe and America as their leading dancers and choreographers. Being obliged to remain in the West had far less impact on their art. Only for those émigrés who worked with words did the shrinking of Russia Abroad that came with the Great Depression and the Second World War mean the end of the artistic brilliance that had illuminated the Silver Age in which they had played such a vibrant part.

After having already lived in the Western world of art before his disillusionment with the Bolshevik Revolution drove him out of Russia, Vasilii Kandinskii was among the handful of émigrés who made the transition from East to West with particular ease. Born in 1866 among the brightly colored churches of Old Moscow, Kandinskii had grown up in the kaleidoscopic turmoil of Odessa, and then had returned to the city of his birth to study law at its university. In keeping with the spirit of the times, he had combined his studies with an interest in Russia's peasants, and he soon won support from the Imperial Ethnographic Society to study the survivals of pre-Christian beliefs and legal practices among the Zyrians who lived in the Far Northern forests on the western edge of Siberia. There he would study their way of life at first hand, and seek to understand what such universal concepts as good, evil, and justice meant to them. In the process, he would also explore their ideas about beauty and develop a sense of their feelings about art.

The summer of 1889 thus found the twenty-three-year-old Kandinskii making his way by riverboat and cart "through unending forests, between brightly hued hills,"[5] where in the "wonderhouses" of exquisite carvings and brightly colored interiors of the region's people he found such a wealth of symbols and colors that he felt as if he had "become part of a painting."[6] For six weeks, he wandered through a strange world of vibrant color in which wood goblins, little demons, and river sprites ruled a spirit world that determined the course of birth, life, and death. That fall, he returned to Moscow and his studies, but he would never forget what he had seen, nor would he ever cease trying to transfer the magic of the Zyrian shamans' symbols to canvas. Still overwhelmed by the color-filled impressions of that northern summer when he was offered a professorship of law at the University of Dorpat eight years later, Kandinskii decided to leave Russia and study art in Munich.[7]

Even as a child, color had been Kandinskii's passion, and some of his first memories (dating from the age of three) were of the "light juicy green, white, carmine red, black, and yellow ochre" colors of the toys and objects around him. A decade later, he had acquired his first box of paints, and he had found its colors to be "exultant, solemn, brooding, dreamy, self-absorbed, [and] deeply serious, with roguish exuberance."[8] With time, his fascination only deepened, and he added to it a powerful sense of light. "It seems to me that the living soul of colors emits a musical sound when the inflexible will of the artist's brush snatches part of their life away [and] sometimes I hear the colors whispering as they mix," he once confessed. "It is like a mysterious experience surprisingly occurring during the magical experiments of an alchemist."[9]

Arriving in Munich at the age of thirty, Kandinskii found himself in a world in which "everyone painted—or wrote poems, or made music, or took up dancing," and the city became for him "a spiritual island."[10] For more than a century, Bavaria's rulers had worked to make their capital an "Athens on the Isar," and it was home to Ibsen, Thomas Mann, the poets Rainer Maria Rilke and Hugo von Hofmannsthal, the caricaturist Ernst Neumann, and the composer and conductor Richard Strauss. Teeming with some twenty thousand artists and students, Munich combined immense resources with the promise of great opportunities, and its vibrant arts-and-crafts movement—the so-called *Jugendstil* that Thomas Mann once described as a "guileless cult of line, of decoration, of form, of sensuousness"[11]—reflected what Kandinskii had seen and felt among the Zyrians of the Russian North. In 1898, some two years after arriving in Germany, he failed the entrance examination at the Munich Academy, but that in no way lessened his dedication to art. He began to work in oil that same year, and in much the same way as Malevich's a decade later, his work moved from the representational to the abstract very quickly. His earliest paintings called to mind the soft light of Turner and the shading of Rembrandt, but within a year or two his landscapes had started to reflect a brighter, Post-Impressionist style. Soon he began to paint, as he later said, more and more "without object," using the colors and symbols he had found in the depths of the northern forests to define his place among the artists with whom he worked.[12] By the summer of 1904, Kandinskii was certain that he had found the way to "a beautiful, new method of painting with infinite possibilities for development," and that his discovery had made it possible for him to break "new ground only dreamed of periodically by some masters."[13]

Convinced that art "serves the spirit through freedom" and that it was therefore "the path to the experience of the soul," Kandinskii continued to live and mature as an artist in Munich until war broke out in 1914.[14] He submerged himself in the city's vibrance, studied with its masters, and rose to become one of the leading figures in its avant-garde. At the same time, he managed to carve out a place for himself and his work in Russia, for he kept up a lengthy correspondence with friends in Moscow and St. Petersburg, exhibited his paintings at avant-garde exhibitions, published Russian editions of his writings, and visited Moscow on several occasions. In Germany, he was best known for his paintings, but the Russians paid more attention to his ideas. In Russia, the small volume he published, *On the Spiritual in Art*, in 1912 made him famous overnight. Kandinskii now stated flatly that every work of art had to be considered a "spiritually breathing subject that also leads a real material life." Certain that there was "neither a single beauty or a single truth," he now argued that there were "as many of each as there are souls in the world."[15]

With critics all across the continent struggling to come to grips with the meaning of his art and writings, Kandinskii explained that "emotional vibration" held the key to creating and understanding art, that "paint and line constitute the essential, eternal, invariable language of painting," and that painting was "the combination of colored tones determined by inner necessity."[16] He predicted that art

would develop in the directions of "pure abstraction" (which would require the "fully abstract, wholly emancipated use of color in 'geometric' form") and "pure realism" (which would rely upon "more real uses of color").[17] In everything, color was so much the key that his biography, as a critic once wrote, became "a succession of revelations that color presented."[18] "He writes of art . . . in its relation to the universe and the soul of man," one of his contemporaries explained. "He writes . . . as an artist to whom form and color are as much the vital and integral parts of the cosmic organization as they are his means of expression."[19]

When he and the Bavarian painter Franz Marc published the first of their famed *Der Blaue Reiter* (*Blue Rider*) yearbooks in 1912, Kandinskii had come to see the eternal struggle between good and evil as being expressed in the conflict between abstractionism and materialism in art. "Our epoch is a time of tragic collision between matter and spirit and of the downfall of the purely material world-view," he had written the previous year. "For many, many people it is a time of terrible, inescapable vacuum, a time of enormous questions. But for a few people," he concluded, "it is a time of presentiment, or of precognition of the path to Truth."[20] This certainty drew Kandinskii away from "forms of corporeal origin" toward pure abstraction. "I more or less dissolved . . . the objects," he wrote in explaining his art at the time, "so that they could not all be recognized at once and so that their psychic sounds could be experienced one after the other by the observer."[21]

As a German resident with a Russian passport, Kandinskii was driven back to his homeland in the summer of 1914 when the First World War broke out. Feeling that he had been "torn out of a dream,"[22] and with friends, audience, and a woman he loved all behind him in Germany, he struggled to find his footing in the land he had left behind eighteen years earlier. His years in Germany had left him feeling "Russian yet un-Russian,"[23] and he turned again to the Far Northern experiences of his youth with a series of autobiographical "bagatelles" that depicted the inner torment his return had stirred. He drew upon the motifs of folklore and the northern forests, and began to fill his paintings with dragon-prowed ships, river sprites, firebirds, and the primitive pictographs of the Zyrians and their Siberian neighbors. As these helped him to see Russia in a new way, he gathered impressions which, he confessed, "shattered me to the depths of my soul [and] raised me to ecstasy."

Kandinskii's new vision showed him "pink, lilac, yellow, white, blue, pistachio-green, flaming red houses, churches . . . the Kremlin wall, and over it, towering over everything, like a shout of triumph, like an uninhabited hallelujah, the white, long, elegant, serious stroke of the Ivan Velikii bell tower." With the inspiration that had deserted him when he left Germany restored, he again began to think in grander terms. "I would like to make a great landscape of Moscow—to take the elements apart and reunite them in a picture," he wrote. "It must be like an orchestra," he added. "I sense the general idea, but the general form is not yet precise."[24] Now past fifty, he married a woman more than two decades younger, and their wedding trip took them to Finland at the very moment when the Tsar

was overthrown. The year 1917 thus set Kandinskii and his homeland on a new course. Both were seeking freedom, yet neither would find it where they expected it to be.[25]

Swept up in the artistic ferment that accompanied the Revolution of October 1917, Kandinskii joined the Commissariat for Enlightenment that the Bolsheviks established to spread literacy, culture, and Bolshevik ideas throughout Russia. He helped to found an Academy of Aesthetics and taught at several government art workshops, yet, by 1921, the moral and political absolutism of the new order had soured his hopes and he decided to return to Germany. When his friend Paul Klee found him a position in the Bauhaus—the "guild of craftsmen without class distinction" that Walter Gropius had founded in Weimar in 1919 to free humankind from becoming enslaved to machines[26]—he began to rethink his ideas on art and culture. "I expect," he wrote in 1924, "a further powerful, entirely new inner development, a deep penetration liberated from all external purposes into the human spirit."[27] An inner sense warned him that his dream had to be pursued outside his homeland, but his belief that Germany would lead the way in helping him to realize his mystical vision took no account of the forces that runaway inflation and the Great Depression were about to unleash. Even when Hitler's Nazis closed the Bauhaus in 1933 and Kandinskii moved to Paris, he still maintained that he was "not leaving Germany for good."[28]

Destined to spend the last ten years of his life in Paris, Kandinskii worked to create a "great synthesis" that would make clear the meaning of his life's work. In the course of exploring other "possible worlds"[29] in another realm of existence, he returned to his remembrances of that summer now half a century past when he had first seen the Zyrian "wonderhouses" of the Russian North. Insisting that the term "abstract" must not be taken literally, he drew again upon the designs and pictographic symbols displayed in the accouterments and implements of the shamans who still ruled the lives of the primitive peoples from whom he had drawn some of his earliest inspiration.[30] And as the Germans marched into Paris, he looked across Eurasia to assemble the pictographs of Siberia's shamans into new compositions that portrayed a growing concern for realms that stretched beyond the reach of the human mind.[31] During the last year of his life (1944), he painted "Ribbon with Squares," "The Green Bond," and "Tempered Elan," all of which evoked visions of Siberian dwellings, funeral rites, and incantations that expressed his fervent hope for triumph and rebirth. Kandinskii had found comfort in exile, but only because he had carried with him the native symbols that bound him forever to the experiences of his youth and the land of his birth.

While upper-middle-class Russian and Baltic German origins had made it possible for Kandinskii to live out his final days in a city ruled by Germans, an ebullient Jewish heritage forced his countryman and fellow exile Marc Chagall to flee to America. Born in Vitebsk, a town of fifty thousand residents on the Russo-Polish border, Chagall had grown up just beyond the threshold of the modern age in a world of twisted rooftops, crooked fences, and backyard gardens with

squawking chickens, gawking children, and prowling cats that promenaded on rooftops. Around him, a flock of Jews—about half of the town's residents—formed a milling throng that prayed morning and night, went to the synagogue on Friday evenings, observed the Sabbath on Saturdays, and labored long and hard on Sundays. Like the Zyrians Kandinskii had discovered in the Far North, the Jews of Vitebsk lived by superstition, praised God and nature, feared Christians and the evil eye, and paid attention to the messages that a thousand signs and portents sent their way. The heritage of hard labor, pain, pity, and sadness that stemmed from living in a land that had tormented its Jews for centuries thus lay at the root of Chagall's art. "Had I not been a Jew (with the meaning that I attach to this word)," he once said, "I would never have been a painter, or entirely a different one."[32]

Starting at the age of nineteen in 1906, Chagall began to study art at the school of the Jewish painter Jehuda Pen in Vitebsk. He then moved to St. Petersburg, where Lev Bakst taught him how to improve his technique and sharpen his focus. When Bakst went to work with Diagilev's Ballets Russes in Paris in 1910, Chagall followed, only to discover that his former teacher's warning "not to count on him" had been in earnest. Alone and with nothing to pay his way, the young artist struggled to survive in a city whose customs and language he barely knew. "Only the great distance that separated Paris from my native town," he remembered, "prevented me from returning to it immediately or at least after a week or a month." Then, as he drew comfort from the works of such "friends long vanished" as Delacroix, Watteau, and Rembrandt, the city's artistic brilliance drove away his fears.[33] The intensity of color seen in the streets, the cafés, and the marketplaces overwhelmed him, but he remembered most of all the city's unique form of light—"that amazing light that signifies liberty"—which showed him a different world. He saw it everywhere, but most of all in the "work of the people one meets in the street." Just as color was to be the ruling principle for Kandinskii, so color combined with light—and liberty—were to shape the world that Chagall portrayed on canvas.[34]

After a few months, Chagall moved into an artistic Noah's Ark called "La Ruche"—the beehive—that was home to struggling painters of a dozen nationalities. There, when he could not afford new canvases, he bought old pictures and painted over them, and on one occasion even painted over a friend's rendering of "dreadful Swiss mountains" when he needed a canvas and had no money to buy even a used one. At other times, he painted on table napkins, bedsheets, and pieces of his nightshirt. He concentrated on the rhythms and themes he had brought with him from the East until several friends arranged for him to have a large exhibition in Berlin in the spring of 1914.[35] Then, after telling one of them that "German girls are quite extraordinarily not pretty," Chagall boarded a train for Russia.[36] He planned to stay for only a few weeks, but war and revolution kept him there for eight years.

In Russia, Chagall went to Vitebsk and married his childhood sweetheart.

"She seemed to float over my canvases for a long time, guiding my art," he later said. "I had only to open my bedroom window, and blue air, love and flowers entered with her."[37] That summer, he painted all the crooked, disjointed forms of life that passed his Vitebsk window, and as he painted "The Preacher of Slutsk," "The Rabbi of Vitebsk," "The Old Man Reading," "The Man with the Torah," "A Jew over Vitebsk," and a score of others, he set forth a Jew's vision of the world that was unlike that of any other artist in Russia. When he and his wife moved to Petrograd that fall, the war entered his art with a rush in the form of soldiers with faces set in robotlike masks or as staggering figures in a world gone mad. Then, the Revolution swept him up and lifted him toward its crest with promises of freedom and a new age. Eight months later, the Bolsheviks named him Commissar of Art for his native Vitebsk province and urged him to establish there an Academy of Art.[38]

As a provincial commissar, Chagall "dreamed of making ordinary houses into museums and the average citizen into a creator" by bringing art onto the street and into people's lives. To his school, he brought Malevich. Then he invited El Lissitskii, an architect whom the Revolution had transformed into the leader of a movement to revive Jewish art. Soon, quarrels with these men whose Suprematist beliefs threatened to overwhelm Chagall's sense of freedom drove him from Vitebsk to Moscow, where he and his family found the city starving and destitute. Struggling to feed and shelter his family, he worked briefly with Vakhtangov at the Habimah Studio, and then went on to teach art at two orphans' colonies, where he found a brief moment of pleasure in the Revolution. "I loved them," he wrote of the scores of children who crowded around him. "Their eyes would not, or could not, smile [but] . . . they flung themselves at colors like wild beasts at meat." Still, the urge to escape the deadening bureaucracy that was coming to rule revolutionary art soon extinguished Chagall's last hopes for the Revolution. Proclaiming that "neither Imperial Russia nor the Russia of the Soviets needs me," he fled to Berlin in the summer of 1922 in the hope that "perhaps Europe will love me and . . . my Russia."[39]

After a year in Berlin, Chagall took his family to Paris, where the famed art dealer and publisher Ambroise Vollard invited him to illustrate Gogol's *Dead Souls* with 107 etchings. In Gogol's pages, Chagall found the Russia of his childhood, in which misery and despair thrived alongside elation and magnificence. Here were the personifications of greed, lust, sordidness, absurdity, and rascality—the true face of philistine vulgarity—all writ larger than life into a true human comedy that combined greatness of soul with meanness of spirit. For no one had ever sensed more clearly than Gogol how petty greed, sly stupidity, and impudent craftiness all came together in Russia's provincial towns, and no one knew better than Chagall how to capture that inner meaning with a few dramatic strokes of an etcher's steel needle on a polished copper surface.

The *Dead Souls* etchings consumed most of Chagall's energy for the better part of five years. "Marc sits there like a cobbler, hammering away at his copperplates, an upright craftsman of God," a friend wrote at one point. "For every

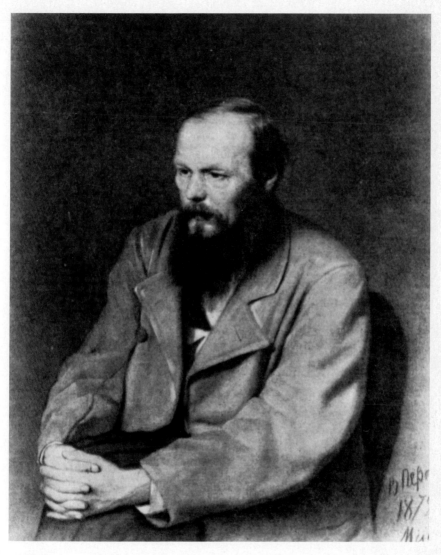

Vasilii Grigorevich Perov (1833–1882) painted this portrait of Fedor Mikhailovich Dostoevskii not long after the author finished writing in 1872 *The Devils,* a novel that condemned the radicalism with which Perov, as one of the first artists to be concerned with the troublesome social and political questions that plagued nineteenth-century Russians, generally sympathized.

*From: D. N. Ovsianniko-Kulikovskii, ed.,* Istoriia russkoi literatury XIX veke (*Moscow, 1910*), Vol. 4.

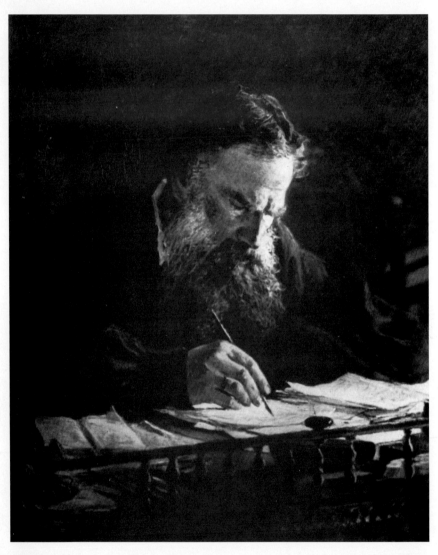

Painted by his devoted follower Nikolai Nikolaevich Ge (1831–1894), this portrait of Lev Nikolaevich Tolstoi (1828–1910) shows the author of *War and Peace* and *Anna Karenina* when he had set aside literature in order to search for the purpose of human existence and the meaning of death.

*From: D. N. Ovsianniko-Kulikovskii, ed.,* Istoriia russkoi literatury XIX veke (*Moscow, 1911*), *Vol. 5.*

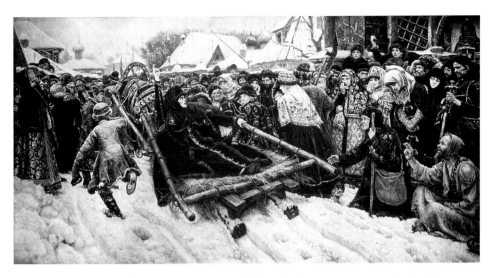

Dedicated to portraying the defining moments of Old Russia's history on an epic scale, Vasilii Ivanovich Surikov (1848–1916) painted "The Lady Morozova" in 1887 to dramatize the religious schism that had split Russia so irreparably in the mid-seventeenth century.

*Photo courtesy of Scala/Art Resource, New York.*

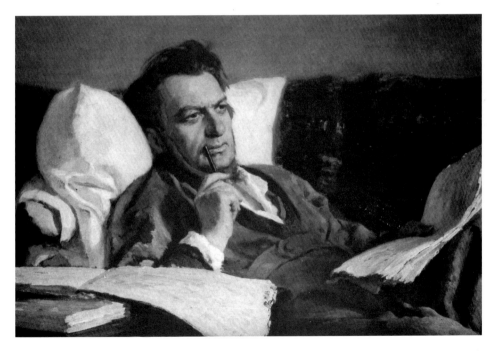

Painted a full forty-five years after the event, this 1887 portrait of Mikhail Ivanovich Glinka (1804–1857) shows how Ilia Repin thought Russia's first great composer might have looked while planning the score for his opera *Ruslan and Liudmila* in the early 1840s.

*From:* Istoriia Rossii v XIX veke (*Moscow, 1907–1911*), *Vol. 3.*

The strain of balancing his prodigious talents as a chemist and composer with the many petty demands of daily life seems particularly evident in this portrait of Aleksandr Porfirevich Borodin (1900), even though Ilia Efimovich Repin (1844–1930) painted it a number of years after the composer's death.

*From:* Istoriia Rossii v XIX veke (*Moscow, 1907–1911*), *Vol.6.*

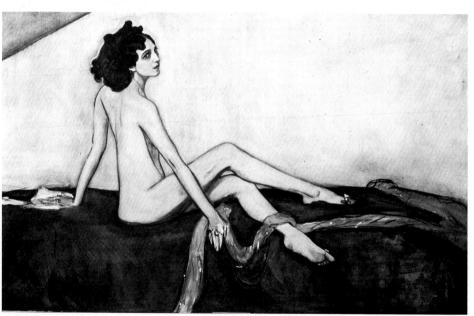

A notorious painting that won its creator both criticism and acclaim, Valentin Aleksandrovich Serov's nude portrait of Ida Rubinstein (1910) was a tribute to one of the most popular ballerinas to appear in the Ballets Russes' second Paris season.

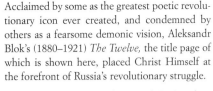

# АЛЕКСАНДРЪ БЛОКЪ
# ДВѢНАДЦАТЬ

*рисунки*
**Ю.АННЕНКОВА**

«АЛКОНОСТЪ»
ПЕТЕРБУРГЪ
1918

Acclaimed by some as the greatest poetic revolutionary icon ever created, and condemned by others as a fearsome demonic vision, Aleksandr Blok's (1880–1921) *The Twelve,* the title page of which is shown here, placed Christ Himself at the forefront of Russia's revolutionary struggle.

*From: Aleksandr Blok,* Dvenadtsat', risunki Iu. Annenkova *(St. Petersburg, 1918).*

By the time this photograph was taken in the early 1900s, the novelist and playwright Maksim Gorkii (Aleksei Maksimovich Peshkov, 1868–1936) had become Russia's leading chronicler of life among the lower classes from which he had risen.

*From:* Istoriia Rossii v XIX veke *(Moscow, 1907–1911),* Vol. 5.

By using Cubist techniques to dramatic effect in black-and-white images, the graphic artist Iurii Pavlovich Annenkov (1889–1974) created a series of illustrations in 1918 that gave Aleksandr Blok's *The Twelve* added meaning in a world turned upside down by war and revolution.

*From: Aleksandr Blok,* Dvenadtsat', risunki Iu. Annenkova *(St. Petersburg, 1918).*

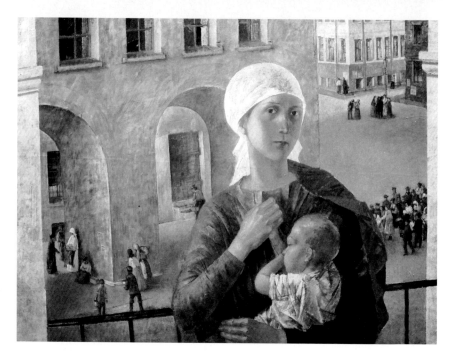

Painted by Kuzma Sergeevich Petrov-Vodkin (1878–1939) during the last months of the Russian civil war, "Petersburg, 1918" (1920) carried the theme of the Madonna and Child firmly into the Soviet era and was popularly known as "Our Lady of Petersburg."

*Photo courtesy of Scala/Art Resource, New York.*

Not long before he left Soviet Russia to spend the rest of his life in the West, the artist Leonid Osipovich Pasternak (1861–1945) sketched this likeness of his son, the famed poet Boris Pasternak.

*Photo courtesy of Corbis-Bettmann.*

Painted in 1928, "The Defense of Petrograd" shows at its best the form and style that Aleksandr Aleksandrovich Deineka (1899–1969) would use to create a series of heroic, patriotic paintings during World War II.

*Photo courtesy of Scala/Art Resource, New York.*

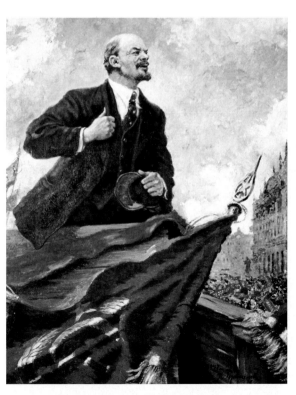

A friend of Commissar of Defense Kliment Voroshilov, Aleksandr Mikhailovich Gerasimov (1881–1963) won fame by capturing the defining moments of Soviet history on canvas. Although "Lenin at the Tribune" (1930) is now one of his best-known works, he devoted much more energy to painting Stalin in the larger-than-life poses that became synonymous with the Cult of Stalin during and immediately after World War II.

*Photo courtesy of Scala/Art Resource, New York.*

This 1978 photograph portrays Aleksandr Solzhenitsyn, the postwar Soviet Union's leading dissident author, some four years after he had been driven into exile and not long before he delivered his famous commencement speech at Harvard University.

*Photo courtesy of UPI/Corbis-Bettmann.*

picture [there is] a different technique, a different philosophy, a different out-
look. . . . How does he do it?" he wondered. "All the time Marc laughs . . . and
groans his daily 'I am so unhappy! I want to die!' "[40] The result proved to be a
magnificent portrayal of provincial Russian life and an enduring portrait of the
human condition by an artist whose inner sense of the foibles of humanity gave
him special insight into their meaning.[41]

As an artist who was finding that he had more in common with the place into
which fate had cast him than with the émigrés in Russia Abroad, Chagall drew
closer to the light and landscape of France. Wanting to create, as he told a friend,
"an art of the earth, not merely an art of the head," he painted the seacoasts of
Brittany and Normandy, often using his window to frame the scenes as he had
done in Vitebsk.[42] In the mid-1920s, he painted peasants, villages, and animals,
emphasizing the connections between man and nature and the closeness be-
tween humankind and the animal kingdom. To some of the people in his *Dead
Souls* engravings he therefore gave certain animal-like qualities, just as Gogol had
done, and he endowed some of his animals with vaguely human attributes in
their poses and facial expressions. "Art is in some way a mission," he explained.
"Art is first of all a state of the soul."[43]

From his etchings of *Dead Souls*, Chagall turned to the *Fables* of La Fontaine,
to which he brought his love of nature and his sympathy for animals. From those,
he went on to illustrate the Bible, a task that obliged him to recall his childhood
at the same time as it drove him to explore half a dozen new frontiers. For Cha-
gall, the Bible was the living history of his ancestors and the source of his roots.
As a child he had seen in the royal purple wine of Passover "the Ghetto marked
out for the Jewish people and the burning heat of the Arabian desert, crossed
with so much suffering,"[44] and in the Bible's stories of kings, patriarchs, and
prophets, he found a world that blended into his own. While Old Russia's great
icon painters had created from the Bible's heroes objects of eternal veneration,
Chagall saw the same figures as being almost as real as the family he remembered
gathering around him during the High Holy Days of his Vitebsk childhood. The
inner poetry of the Old Testament stirred his soul, yet, just as the barriers of time
and space had come to separate him from the lost world of Vitebsk, so they
divided him from the realm of the Bible. "I did not see the Bible, I dreamed it,"
he once said of the months during 1930 when he and Vollard were discussing a
commission for him to create etchings for a special edition.[45] To move from
dream to reality required him to shift his vision of the Old Testament's heroes
from the Vitebsk surroundings of his childhood to their "real" historical settings
in Egypt and Palestine. In that way, he hoped to give true substance to the
images he wanted to create.

To see at first hand the landscape, light, and faces of the land of the Old Tes-
tament, Chagall took his wife and daughter to Palestine and Egypt in the spring
of 1931. He visited Alexandria and Cairo, Tel Aviv and Jerusalem, where he
painted the interiors of synagogues, the beasts of the field, and the rocky, gray-
green hills into which half a score of ancient towns and cities nestled. As he

painted "Rachel's Tomb," "The Gate of Loving Kindness," "The Road to Sodom," and "The Wailing Wall," the impressions overwhelmed him. Visiting the Holy Land, he later said, left the most vivid impression of any experience in his life, and he drew from it a new sense of closeness to the world of his ancestors. It reminded him with new force how God had chosen the people of Israel and what that combined blessing and burden had meant since the long-ago days of the patriarchs and prophets. "In the East, I found the Bible and part of my own being," he explained after he had brought his family back to Paris. "The air of the land of Israel makes men wise."[46]

That summer and fall, Chagall finished twenty of what would become a set of 105 plates, but he found them lacking in human depth. As he struggled to capture the sense of the world as it had existed before modern civilization, he went to Holland to examine the Biblical paintings of Rembrandt, to Spain to see the religious oils of Goya, and to Italy to study the painting of the Renaissance. Not permitted to return to Vitebsk during Stalin's purges, he visited the Jewish communities of nearby Poland to refresh his memories of the elders who had ruled the world he had known as a child. Slowly, his vision took shape, although he would not complete the last of his etchings until 1956. He showed Joseph and his brothers, Jacob being blessed by Isaac, the flight from Egypt, the parting of the Red Sea, and Moses receiving the Ten Commandments, and then went on to portray Joshua in all his glory, Samson and Delilah, David and Goliath, and David and Bathsheba. As he worked with his steel needle and copper plates, the figure of Solomon took shape. So did Elijah, Saul, Ezekiel, and Jeremiah, and a score more of those ancients to whom the icon painters of Old Russia had given such a different meaning and focus. Looking back in time through the vital prism formed by Christ's life and death, artists such as Feofan Grek and Andrei Rublev had set the heroes of the Old Testament above and apart from the real world. For Chagall, they formed a part of the chain that bound him to his past. As ancestors, they endowed his present with deeper meaning.

Perhaps most striking of all was Chagall's vision of the angels who had appeared to Abraham and Sarah, for it captured with amazing economy of line and form the same intensity that Rublev's more complex masterpiece had projected five hundred years earlier. Like Rublev, Chagall placed the messengers of God at the center, yet while the master artist of Holy Moscow had created in his three angels a beauty beyond earthly existence Chagall's determination to contrast their youth and vigor with the frailty of the ancient couple through whom the miracle of the Annunciation would be completed moved the entire experience into this world from the next.[47] The same was true of his renditions of Moses, the prophets, and the patriarchs, all of whom had been placed by the icon painters of Old Russia in a realm beyond the world of the flesh. For him, they all remained first and foremost Jews, set firmly in the world of suffering and struggle into which God had placed them. They resembled nothing yet seen in Russia's artistic experience. Their surroundings fixed them in time, yet the depths of their pain and the power of their passion made them universal monuments to the hu-

man experience. Chagall now saw in the story of the Jews' journey from bondage to the Promised Land the Bible's fundamental thread. Unlike those Old Russian artists who set their painting in the realm of God, he focused his art upon man, that unique being, a critic once explained, "whom God looked upon [and] with whom God spoke."[48]

Long before Chagall completed his etchings for the Bible, the Jewish heritage that lay at the core of his fame forced him to set his success aside, as friends urged him to flee the lengthening reach of Hitler's anti-Semitic hatred. As the armies of Nazi Germany marched into Paris, he and his family settled into the quiet of village life in Gordes near the southern French port of Marseilles, still unconvinced of the danger they faced and unwilling to tear up the roots they had so recently set down. While others, including the brilliant émigré writer Vladimir Nabokov, frantically struggled to arrange the invitations from American institutions that would secure visas to the United States, Chagall put off confronting the reality of a Nazi-dominated Europe. "Are there trees and cows in America too?" he asked coyly when the American Consul General in Marseilles begged him to take advantage of the Museum of Modern Art's invitation to come to New York. Not wanting to become "somewhat like a man without a country,"[49] he settled deeper into his obscure retreat, hoping that he could find security for himself, his daughter, and his wife in an out-of-the-way village set apart from the centers of artistic life.

When the Vichy authorities detained him during a brief visit to Marseilles in the spring of 1941, Chagall finally saw the danger and turned his back on the continent on which his art had held him above national distinctions for a quarter-century. "A wall rises up between me and mine," he wrote sadly, "a mountain covered with graves and grass."[50] En route to the "Babylon" of New York and the thrill of the vast, violent, raw beauty of the huge American continent, he did not expect to see Europe again. Then, in 1948, the Jewish roots that had forced him to leave France drew him back to a Europe cleansed of the Nazi plague. There, Chagall was destined to dedicate the rest of his life to those avenues of exploration that the vision he had brought from the Jewish quarter of Vitebsk continued to mark out.

While the Western world cheered the creations of Kandinskii and Chagall, émigré poets and novelists faced a sadder fate. Banned in the Soviet Union for their anti-Bolshevik views, the poetic creations of Gippius and Marina Tsvetaeva, not to mention the brilliant fiction of Ivan Bunin, Aleksei Remizov, and scores of others, touched only that scant handful of dedicated followers in Russia Abroad who read them in the pages of such émigré literary journals as *The Contemporary Annals* of Paris, *The Will of Russia* from Prague, and half a dozen Russian-language newspapers that published poetry, fiction, and literary criticism in addition to reports on the news. Together, writers, publishers, and readers struggled to blend the rich culture of Russia's past with their own experience in ways that could create a sense of identity and give greater meaning to their lives. Yet in doing so they set themselves further apart from the artistic world around them.

Although they lavished acclaim on Russian émigré painting and music, few Western critics tried to integrate the poetry and fiction of Russia Abroad into the fabric of the Western artistic experience. Condemned as bourgeois trash in the Soviet Union, émigré literature continued to be seen in the West as an expression of views that fit poorly with the sentiments of those progressive-minded readers and critics who looked upon Stalin's experiment as a brave step into the future.

Not even the Nobel Prize that Ivan Bunin won in 1933 changed the hostile indifference with which many leading Western critics viewed the literary creations of Russia Abroad, for the uncritical sympathy with which so many of them cheered the Soviet experiment made émigré literature all the more suspect. Especially during the 1930s, when such literary giants as Theodore Dreiser, George Bernard Shaw, Romain Rolland, and André Gide applauded the humanity of the Soviet system despite its purges and swelling archipelago of slave-labor camps, any Russian writer who remained apart from the mainstream of Soviet culture faced deep hostility as "a reactionary exploiter from the past and an obstacle to human progress in the present."[51] In England, some literary journals made it a policy not to publish work by Russian émigrés, and it seems surprising now to remember that, in 1943, a number of prominent American intellectuals sent an angry letter of protest when the Book-of-the-Month Club chose the translation of a novel by the émigré Mark Aldanov as one of its selections.[52] Unable to find an audience outside the confines of Russia Abroad, many émigré writers lived in poverty and sacrificed even the most ordinary of creature comforts in the name of the artistic experience in which they all believed.

Foreign critics' readiness to applaud the humanity of the Soviet experiment despite mounting evidence of its brutality was only one of the dilemmas that confronted the residents of Russia Abroad in the years when Stalin was rising to power. When the first scattered conflicts between Reds and Whites had flamed into civil war in 1918, a number of key émigrés had welcomed the expeditionary forces sent by Germany, France, England, the United States, and Japan as instruments for destroying the Bolsheviks quickly. But as the fighting had dragged on into 1919 and 1920, some of them began to ask if they ought not to make peace with their enemies for the sake of restoring the well-being of the country they loved. Were Lenin and his allies as evil as they once had believed? Or did the brutality of their methods, when combined with their vision of a society based on equality and social justice, merely reflect the dual nature of those Russian people whom Gorkii once had called "hideously cruel and, at the same time, incomprehensibly kind-hearted"?[53] In any case, was it worth adding to the devastation that Russia had already suffered to defend their personal political convictions? As Lenin and his lieutenants replaced their exhortations for the proletariat to launch new "fierce assaults" against the remnants of the old order with calmer calls for evolution, gradualism, and reform, some of the homesick citizens of Russia Abroad started to think of returning to the homeland they so longed to see.

Led by the philosopher Nikolai Berdiaev and the liberal politician and histo-

rian Pavel Miliukov, a number of émigrés began to see the Bolshevik Revolution as the beginning of a new "Eurasian" era in world history, in which Russia would sever the ties that had bound her to the West since the days of Peter the Great and become a new bridge between the complex and contradictory cultures of Europe and Asia.[54] Such men thought of Bolshevism as an illness from which Russia could be expected to recover, but some of the politicians who had served with them in the Russian Provisional Government between March and October 1917 went so far as to claim that the time had come to "change signposts" and accept the Bolshevik regime for what it was. The "unbending arguments of life," these fallen politicians now argued, demanded that the citizens of Russia Abroad come to terms with the Bolsheviks' new order because reconciliation seemed to promise a future in which they could once again be at one with their country and its people.[55]

Later to win the Stalin Prize for *The Road to Calvary*, a massive novel about life in Russia during the war and revolution that he began in exile and finished in Moscow as Hitler's armies approached in 1941, Aleksei Tolstoi was one of the most prominent of the artistic émigrés to "change signposts" in the early 1920s. Convinced that "blood-stained phantoms, all trembling in vileness and lust" were leading his homeland to ruin, he had fled from Russia in 1918 to spend most of the Civil War years in Paris, where his bearlike figure became a common sight in the émigré cafés of Montparnasse. Yet, like so many artists whose hearts and souls belonged to Russia, Tolstoi found it painful to live away from his native soil. As he watched Russia become "menacing and strong" while Europe seemed to fall deeper into decay, pride in the Bolsheviks' newfound strength stirred his patriotism and convinced him that Western civilization was nearing its end. Certain that the "slumbering charioteer of history had suddenly begun to whip up the horses," and that Bolshevik Russia was about to lead humankind to a new and better society, he moved back to Moscow in 1923 to become a living monument to the magnetic power with which the Russian land and the Russian soul could draw its artists home. Even though life in his homeland proved to be "very much unpleasant, even foul" by comparison to the one to which he had grown accustomed in the West, Tolstoi felt certain that changing signposts was the only course a true Russian ought to follow.[56]

Yet even patriotism and a longing for the land they once had known could not induce most émigrés to follow Tolstoi's example. For those who remained in the West, what Vladimir Nabokov once called an "animal aching yearn for the still fresh reek of Russia"[57] continued to mark their novels and poetry just as surely as the precepts of Socialist Realism shaped the writings of those who had stayed at home. Of no one was that more true than Marina Tsvetaeva, who claimed to live outside of place and time while she reigned as the greatest of the poets who made their home in Russia Abroad.[58]

Born in 1892 to an overbearing mother and a distant, indifferent father, Tsvetaeva had come into the world just as Russia's greatest famine of the nineteenth century was ending and the Silver Age was taking shape. In the manner of Anna

Akhmatova, the only Russian woman poet whose genius ever rivaled her own, she devoted her life to her art and barely noticed the suffering that choice forced her to bear. Acclaimed as "inherently talented and inherently original,"[59] she published her first volume of poetry when she was just seventeen. Two more volumes followed before she turned twenty. All three marked hers as a voice that had to be heard, and the men and women who listened discovered a message that rivaled the beauty and insight of the best creations of Briusov, Belyi, and Blok.

Married at the beginning of 1912 to a weak and morbidly sensitive man, Tsvetaeva sought solace in passionate love affairs with the poets Sofiia Parnok and Osip Mandelshtam while her star rose among the avant-garde. Unlike Akhmatova, whose universe centered on St. Petersburg, she found her inspiration in Moscow, and it was from that city in 1922 that she set out on the wanderings that carried her through the "provinces" of Russia Abroad for the better part of twenty years.[60] "A living soul in a hangman's noose," she settled in Paris, but visited Berlin and lived for a while in Prague.[61] Then she joined a wave of several thousand émigrés who returned to Russia on the eve of the Second World War, only to see her sister, husband, and daughter all disappear into the GULag. "To live my life out is to chew bitter wormwood to the end," she wrote as her fate became a plaything of heartless Stalinist bureaucrats.[62] Despondent, alone, with no place to live and no place to publish her poetry, Tsvetaeva hanged herself in a hut in a tiny Tatar village on the edge of Siberia as the summer of 1941 neared its end.

Between 1910 and 1941, a critic once said, Tsvetaeva poured forth "a mighty Niagara of passion, pain, metaphor, and music."[63] While her husband fought on the side of the White armies in the South, she endured the terrible Moscow winters of 1919 and 1920, when starving people traded jewels for flour and fallen aristocrats exchanged rare antiquities for potatoes. "Timid and incongruous, in a man's mouse-colored sweater [and] feeling like a mouse,"[64] she worked for a time in Stalin's Commissariat of Nationalities, until her assignment to collect information about the defeats of the White armies in which her husband fought became too painful. By late summer 1919, she had become an aristocratic-bourgeois mongrel marooned without work in proletarian Moscow, with no ration card, no vouchers for fuel, and crowded with her two children into the small garret room of the comfortable apartment that she and her family had once had all to themselves.

Never concealing her hatred for Russia's new rulers, Tsvetaeva watched her two-year-old daughter die of hunger and nursed her older child through a bout of malaria while the regime's brutality deepened. "Do you remember the insulting demands, the taunting questions?" one of her friends asked in later years. "Do you remember the terror of hearing a doorbell ring, the repulsive searches, the offensiveness of the 'comradely' treatment?"[65] As friends shared their scant rations and helped her to turn to advantage the quirks of the system she could

never comprehend, the mendacity and ugliness of life drained Tsvetaeva's strength and deepened her fears. "I have no future, no will power," she confided as she counted up her losses. "I'm afraid of everything."[66] Still, she survived. "I no longer hold anything dear except for the maintenance of my rib-cage [and] I am indifferent to books," she confessed. "Whatever I need, I shall write myself!"[67]

Sick and emotionally adrift, Tsvetaeva recorded her innermost thoughts in neat, round, schoolgirl letters in the small notebooks that had come her way from the American YMCA.[68] "It's *years* that I have been alone (in a highly populated wasteland)," she wrote to her sister. Yet, combined with a longing to escape from the Bolsheviks, loneliness opened the floodgates of her genius. During her five years in Bolshevik Moscow, Tsvetaeva wrote *The Swans' Encampment*, *On a Red Steed*, *Mileposts II*, *Omens of the Earth*, and *Craft*, in addition to her first epic poem, *Tsar-Maiden*, and six plays that transported audiences back into the times of Casanova, the French Revolution, and Pushkin. She wrote of homosexual and lesbian love, of loneliness, of separation, and of youth, old age, and death. She addressed admiring verses to Maiakovskii, Blok, and Akhmatova, mocked Briusov in a bitter poem, spoke of her admiration for the Whites, and cursed the brutality of their enemies.

Tsvetaeva's praises for the White armies at public poetry readings led Ilia Ehrenburg to describe her as "guileless, obstinate, and sincere,"[69] and her refusal to come to terms with the Soviet regime made her friends continually fear for her safety. Then, in 1921, she received word that her husband had survived the Whites' last battles and escaped into exile in Prague. Elated, she applied for a visa, shrugged off a warning that "one day, you'll be sorry for leaving," packed up her things, and waited.[70] She set out the following spring, with her surviving daughter, an amber necklace, a red coffeepot, a new blue bowl, and several volumes of the poetry she had not yet managed to publish. Not one of her friends came to the station to see her off. "We left Moscow unnoticed," her precocious eight-year-old daughter later wrote, "as if we had shrunk to nothing."[71]

Four days later Tsvetaeva and her daughter reached Berlin. At that time the capital of Russia Abroad, Berlin boasted more than a hundred Russian publishing houses, a daily Russian newspaper, and a hundred thousand Russian residents, among whom, Nabokov remembered, writers and artists lived "in material indigence and intellectual luxury, among perfectly unimportant strangers, spectral Germans and Frenchmen in whose more or less illusory cities we, émigrés, happened to dwell."[72] Between 1921 and 1924, these Russians published a flood of books and periodicals that supplied all of Russia Abroad. The postwar mark was so low in comparison to other currencies that anything published in Germany seemed cheap everywhere else, and the émigré daily that Nabokov's father edited featured advertisements for hundreds of Russian émigré books every week and was sold in 369 cities and 34 countries. At different times during these years, virtually every Russian writer of note spent at least a few weeks in Berlin.

Gorkii, Maiakovskii, Aleksei Tolstoi, and young Boris Pasternak all could be found in Berlin's cafés during those turbulent times, and so could Nabokov, his friend Mark Aldanov, and their ofttime enemy Georgii Adamovich.[73]

For many of Berlin's émigrés, raw poverty overshadowed the luxury of ideas. "Berlin was a kind of caravansary where all those who shuttled between Moscow and the West met," Chagall recalled some years later. "In the cellar restaurants on the Motzstrasse one saw more generals and colonels than in a garrison town in tsarist Russia—except that in Berlin they worked as cooks or dishwashers." The city's Bavarian quarter seemed to hold "almost as many samovars and countesses who practiced theosophy or adored [Lev] Tolstoi as there used to be in Moscow," and all of them catered to men and women who sought to extract a glimmer of hope from hunger and poverty. Men of old faith and people of new vision had a place in this world, too. "Never in my life," Chagall once remembered, "have I seen so many miracleworking rabbis as in Berlin in 1922, but also never so many Constructivists as at the tables outside the Romanic Café where the great poetess Else Laskere-Schüler wandered from one table to another like a dethroned queen or a prophetess."[74]

Like so many other newly embarked wanderers, Tsvetaeva found friends she had known in Moscow the moment she arrived in Berlin. Later to become one of Stalin's favorites, Ilia Ehrenburg moved to Berlin in 1922 and so did Belyi, who had just been abandoned by his wife. Once prominent in St. Petersburg's avant-garde circles and later to become a leading Soviet philologist and literary critic, Viktor Shklovskii was testing the waters of émigré life in Berlin, along with the brilliant modernist poet Vladislav Khodasevich, the peerless linguist-to-be Roman Jakobson, young Vladimir Nabokov, and a score of others.[75] All of them cheered Tsvetaeva's genius, and in Berlin's émigré cafés, publishing houses, and literary journals she became a celebrity overnight.

For the next two months, Tsvetaeva's life centered on the literary café Pragerdiehle and Abram Vishniak, the young proprietor of the publishing house Helikon, who had agreed to publish her poetry. During those exciting weeks, Ehrenburg delivered her first letter from Boris Pasternak, who had just discovered her poetry while still in Moscow. "I was struck down, as if by a stranger, by a wave of tears which forced its way to my throat and finally broke through," Pasternak wrote after he had read her *Mileposts II*. "You are not a child, my dear, golden, incomparable poet," he concluded. "I hope you understand what that means in our times."[76] In reply, Tsvetaeva recalled previous encounters at which Pasternak had been unattentive, perplexed, "even doleful." "I know little of your poetry," she confessed. "I once heard you at a public reading [and] you kept forgetting everything." Yet Pasternak—far away, reachable only by correspondence, and growing more isolated by reason of the political forces at work in the newly proclaimed Soviet Union—was about to become such an important influence in Tsvetaeva's life that one critic would conclude that "probably everything she created in the Twenties and early Thirties was in some sense inspired by or directed towards Pasternak alone." More than a decade would pass before

the two poets met again. Prophetically, Tsvetaeva had promised Pasternak at the beginning of their correspondence that she was destined to "walk milliards of verses before we meet."[77]

Berlin, Tsvetaeva told Pasternak in her reply to his first letter, was truly "fine," but it was Prague that became the haven in which she took up the work she had set aside when she fled from Moscow.[78] She lived much of the next three years in the small villages that nestled against the city's suburbs, trying to encourage her husband, who was studying Byzantine art with exiled Russian masters at the university, and struggling to define her own place in the diaspora of which she had become a part. For a time she drew closer to other literary émigrés and entered into several love affairs, only to return to the solitary life of caring for her husband and daughter, smoking strong cigarettes, and sipping even stronger coffee while she shaped her thoughts into poetry. To Pasternak she wrote that she had become "a young woman in old dresses," a "goat, whose throat they are constantly slitting but never slitting quite enough."[79] In her loneliness, she wrote *Poem of the Hill*, which reeked with misery and bitterness, followed by *Poem of the End*, which had been called "one of the great psychological poems in the Russian language."[80] As autobiographical confessions of a love Tsvetaeva had set aside for reasons that were not entirely of her own making, each poem probed the passions that had driven her to impart romantic qualities to men who had proved to be less in reality than she imagined them to be. Her writing expressed intense pain, yet in her mention of the vulgar people among whom fate had cast her, her poems marked only the beginning of a new and urgent theme she would pursue in the months that lay ahead.[81]

After the birth of her son at the beginning of 1925, Tsvetaeva wrote an elegant satire that decried the perils of self-indulgence and parodied the Bolsheviks' new political and social order in a paean to the freedom of spirit and imagination that could be found beyond the limits of everyday society.[82] She then moved to Paris, where she, her husband, and two children lived in a single room in an out-of-the-way working-class suburb. In this "new Mecca and new Babylon," which, as Berlin's successor as the capital of Russia Abroad, condemned so many wandering émigrés to the torment of not being a part of the world around them, Tsvetaeva first felt the full weight of the poverty she had ignored in Prague.[83] "I go nowhere because I have nothing to wear and no money with which to buy anything," she confided. "I cannot show myself because there is no silk dress, no stockings, no patent leather shoes, which is the local uniform."[84] When one of her friends sent her an elegant black dress as a gift, she immediately soared into the city's artistic firmament, and her first poetry reading became a triumph of cheering, applauding listeners. After five years of loneliness in Bolshevik Moscow and four years of wandering, it seemed that Tsvetaeva had found her place. That summer, she spent a month at the seaside resort of St. Gilles before moving to the suburb of Meudon, just fifteen minutes away from Paris by train, where she found a house in which she, her husband, and her children had to share the kitchen with just one other family.

In less than a year, Tsvetaeva's triumph soured, in part because of her husband's new passion for political movements sympathetic to the Soviet Union, but also because of her efforts to defend such Soviet poets as Maiakovskii and Pasternak. Berated, extolled, criticized, and acclaimed, she struggled to comprehend the shifting sands of public opinion among her fellow countrymen, and lamented at every turn that such poets as Maiakovskii and Pasternak continued to be judged according to their politics, not their art. "She worked and wrote and gathered firewood and fed scraps to her family," a friend remembered. "She washed, laundered, [and] sewed with . . . the very same fingers . . . [that] wielded a pen or a pencil over paper on the kitchen table."[85] For a time, the letters she received from Pasternak and the dying German poet Rainer Maria Rilke brought forth a crescendo of new poetry, but Maiakovskii's suicide, followed by the deaths of several friends and one-time lovers, deadened her spirit. She responded to Maiakovskii's death with a cycle of seven brilliant poems, but said little after that. "I write almost no poems," she told a friend in 1933. "No one, anywhere . . . will publish [them]. . . . Emigration has made a prose writer out of me."[86]

By the mid-1930s, the shallow political schemes of Tsvetaeva's husband had come full circle. Once a monarchist, he had begun to work secretly as a Bolshevik agent, and his new infatuation with the Soviet Union soon induced him to return. Now snubbed by émigrés who thought she shared her husband's new loyalties, Tsvetaeva found it increasingly difficult to stay in the West. "Do you know of a good fortune teller?" she asked one of her few remaining friends as she tried to decide what to do. "It seems that I can't manage without a fortune teller."[87] "I fly on irrepressibly, with a feeling of homesickness and final farewell," she wrote of a dream she had at the end of April 1938. Now forty-six and convinced that life had become "unstoppable, unchangeable [and] fatal," she returned to Moscow two months later. Before she could get her bearings the NKVD arrested her daughter and her husband.[88]

Unable to find a place in which she could stay for more than a few weeks or months, Tsvetaeva became a victim of a system that thought people dispensable and artists interchangeable. "I am left, twenty-four hours a day, alone with my thoughts (sober, with no illusions), and feelings (insane, quasi-insane, prophetic)," she told a friend. "How will it end? . . . When will it stop? . . . I am slowly being whittled away," she concluded, "a little like that flock that leaves scraps of fleece on every fence."[89] Evacuated to Elaburga on the edge of Siberia after Hitler's attack in June 1941, Tsvetaeva could not even find work as a dishwasher in a canteen that was being built for officially approved writers in a nearby town. Now consumed by loneliness more intense than anything she had known during the years when she had wandered in Russia Abroad, she took her life. "My problem," she had confessed some months before, "is that I have nothing external; all heart and fate."[90]

Although many remained poor, not all residents of Russia Abroad suffered

the loneliness and harsh words that Tsvetaeva endured. In Paris, Zinaida Gippius and Merezhkovskii had simply returned in 1918 to the apartment they had lived in before the Great War began and proceeded to gather together such old friends as Bunin, Balmont, Nikolai Berdiaev, and Georgii Ivanov at Sunday soirées that dictated tastes and friendships just as imperiously as the Dom Muruzi had done in earlier times. Now nearly sixty, Gippius looked a decade younger, while her husband, who had been born four years earlier than she, looked considerably more than half a decade older. The two spent their summers in the South of France or at a retreat high in the Alps, and they continued to define people in terms of whether they were "interested in what is interesting." Prominent among those people who, Nabokov once said, made it a point to imitate in foreign cities "the remote, almost legendary, almost Sumerian mirages of St. Petersburg and Moscow, 1900–1916,"[91] Gippius and Merezhkovskii preferred to live in the past, claiming to be confused by the present and baffled by the future. "I understand nothing," Gippius used to insist. "I am trying to understand, but I cannot."[92]

Gippius worried that Russia Abroad provided too few outlets for poetry and novels at a time when the attractions of Paris threatened to draw her protégés away from the culture and history of their past. "You know that there is no place to publish your work [right now]," she would say. "Yet you may hope for a better future." She urged them all to master the shades and tones of their native language even though they lived apart from their homeland. "What is important is to preserve one's bright spirits, patience, and the desire to give all one can to the continuity of the Russian cultural tradition," she repeated again and again. "Culture is an inner value, a string made from many threads, which extend from everywhere, from all aspects of *life*."[93]

Among those who attended Gippius's Sunday gatherings, Ivan Bunin stood most prominently of all among those who struggled to preserve the cultural traditions of the land they had left behind. A distant descendant of the great Romantic poet Zhukovskii, Bunin wrote in the straightforward tradition of classical Russian realism, and his literary career, which spanned sixty-six years, was evenly divided between his native land and Russia Abroad. Born in the heart of old Muscovy in 1870, the same year as Lenin, Bunin wrote of the "boundless oceans of cornfields"[94] that gave Russia its wealth and strength. Throughout his life he wrote poetry, which Nabokov claimed to prefer to his prose. Yet it was his novels that made him famous, and it was for them that he won the Nobel Prize in 1933. In recognition of his effort to provide "an unvarnished picture of the Russian character and the Russian soul, with its bewildering complexity and chiaroscuro, from which an underlying note of tragedy is hardly ever absent," the Nobel Prize committee commended him as a "painter of the vast and rich beauty of the Russian land," who had "thoroughly explored the soul of vanished Russia."[95]

After having drunk (as he explained in an autobiographical note) "the cup of indescribable suffering and vain hope to the very dregs,"[96] Bunin had turned his

back on the Bolsheviks' Russia and moved to France at the beginning of 1920. Already well known in the West as the author of *The Gentleman from San Francisco*, which recalled Tolstoi's *Death of Ivan Ilyich* in its treatment of the attitudes of humankind toward death, he was better known in Russia for *The Village*, a novel that stripped away the idealistic and idealized trappings with which so many Russian writers had ornamented their descriptions of rural life. Bunin's village was a savage place inhabited by savage people who had only themselves to blame for the brutal, sterile lives they led, and as he and his common-law wife boarded the ship that carried them into exile, it seemed that the savage people had all of Russia in their grip. "No one can understand what the Russian Revolution degenerated into who did not witness it with his own eyes," Bunin wrote some years later. "It was an utterly intolerable spectacle for anybody who still nurtured the belief that man is created in God's image."[97] In Paris, he turned from Russia's Bolshevik present to those comforting memories that fifty years of life had engraved on his memory. "I constantly have the feeling that the last bond between myself and the world around me is rotting and breaking apart," he wrote in *The Eternal Spring* in 1923. "I am going back into the Elysium of the past."[98]

Because Bunin was already known in the West as the equal of Gorkii, Tolstoi, and Turgenev, France's presidents and prime ministers opened their doors to him in ways that allowed him and his wife to live at a level of comfort that most émigrés could never imagine. To whoever appeared at his door, Bunin preached his gospel defending Russian culture against the depredations of the philistines who ruled his homeland, and insisted that they all shared a mission "not to accept Lenin's cities [and] Lenin's commandments."[99] Younger writers spoke of his "enchanting, old-fashioned primitiveness," and he reminded others of "a man who had fallen out of time."[100] "He is frantically, bitterly antirevolutionary, antidemocratic, antipopulist, almost antihuman, a pessimist to the marrow of his bones," Romain Rolland confided to a friend. "But what a genius-artist he is! And how he gives witness to the rebirth of Russian literature!"[101]

In 1924, Bunin bought a crumbling villa overlooking the medieval town of Grasse, some seventeen miles from Nice. There, among the cracked walls, peeling wallpaper, and ragged furnishings of his "monastery of muses,"[102] he found spiritual contentment by offering food and solace to a host of émigrés who struggled to keep alive memories of the lost world they had left behind. Settled among guests who lived in the past, Bunin began to write *The Life of Arsenev*, which would occupy him intermittently from 1927 until 1952. Here, in what a critic once called "the simplest and, at the same time, the most profound picture [of love, life, and death] that art can provide,"[103] he revealed his life's story by telling of the wanderings through the twilight of Imperial Russia of a young poet in search of a credo to define his art. At the very least, the book presented an enduring portrait of the world the Revolution had swept away. In a larger, more meaningful sense, *The Life of Arsenev* showed how life had shaped the art of one of twentieth-century Russia's greatest writers. As a eulogy to the wonder and

beauty of human experience, Bunin's masterpiece showed above all how memory and art made it possible to transcend death.

To prevent the culture to which the citizens of Russia Abroad had dedicated their lives from turning stagnant, the story of their journeys from their strife-torn homeland and their lives in the West needed to be told. Yet Bunin, the Merezhkovskiis, and their contemporaries longed too intensely for the world they had left behind to see the pathos and promise of the present, and the sons and daughters born to them in exile knew the culture of Imperial Russia's twilight years only at second hand. It therefore fell to Vladimir Nabokov, perhaps the only émigré artist to have come of age in Russia but grown to maturity in the West, to capture the inner life of Russia Abroad in stories and novels set in the capitals of Western Europe. By his own admission, "the loneliest and most arrogant" of the young writers that Russia Abroad produced, Nabokov set the past into the present to create what a critic once called "windows opening onto a contiguous world."[104] Taken together, his writings of the 1920s and 1930s showed the triumph and tragedy of the men and women who had vowed to devote all that remained of their lives to the bittersweet task of preserving what they thought most precious of the culture that had given them birth.

Born in the last year of the nineteenth century, Nabokov belonged to a family that had served Russia and its tsars in high offices for centuries. His grandfather had been a famous Minister of Justice, and his father a Gentleman of the Chamber at court, a professor at the Imperial School of Jurisprudence, and, beginning in 1906, an influential leader of Russia's newly founded Constitutional Democratic Party. Several of his aunts had served Russia's empresses as ladies-in-waiting, and there were persistent rumors that his grandmother had been the mistress of either Emperor Alexander II or his younger brother, the progressive-minded Grand Duke Konstantin Nikolaevich. With magnificent country estates, large fortunes, palatial townhouses in St. Petersburg, and a score of handsome and beautiful relatives, the Nabokovs stood near the apex of the society that the Revolution of 1917 tore apart. Yet they were far more progressive than their wealth would suggest. Nabokov's father served three months in prison for having protested the Tsar's dismissal of the First Russian National Assembly in 1906, and he continued to urge Russia's Emperor to draw closer to his people and grant them a voice in shaping the nation's destiny. When his words fell on deaf ears, he faced the destruction of his world bravely. In 1922, he was killed in Berlin while trying to disarm a Russian Fascist who had attempted to assassinate the man who had served as Russia's first Foreign Minister after the Romanovs had been overthrown.[105]

In keeping with their progressive views, the Nabokovs sent their children to St. Petersburg's liberal Tenishev School to broaden their contact with the world around them. Founded at the beginning of the new century by the prince whose wife was widely known for converting her estate at Talashkino into a center for the arts that rivaled the Mamontovs' refuge at Abramtsevo, the Tenishev School boasted the best teachers in the city. There, Nabokov heard Blok read his poetry,

met such literary figures as Aleksei Tolstoi and the critic Kornei Chukovskii, and launched his own literary career in the form of two volumes of poetry that appeared before he turned seventeen. By that time, revolution had Russia in its grip and was driving the Nabokovs toward exile. Before 1917 ended, all of them fled to the Whites' stronghold in the Crimea, where they spent the next year hoping the Bolsheviks would be driven from power but fearing that they would not. When the Red Army reached the Crimea in the spring of 1919, the Nabokovs boarded a dirty Greek vessel laden with dried fruit and vermin to sail to Constantinople and exile.[106] They had brought with them no valuables beyond several handfuls of jewels swept up as an afterthought from a dressing table as they left Petrograd. Behind them lay a fortune in land, homes, material goods, securities, and bank deposits, including twenty million rubles (the equivalent of nearly ten million dollars) and an estate of two thousand acres that young Nabokov had inherited from his uncle just a year before.[107]

While most of the older writers who settled in Russia Abroad had studied at the universities of St. Petersburg and Moscow, Nabokov spent his university years at Cambridge. By the time he graduated in 1922, he had already begun to publish his work in *Rul'* (*The Rudder*), a newspaper for Russia's émigrés that his father had founded in Berlin a few months before his death. In those days, Nabokov wrote mainly poetry and plays under the pen name of Vladimir Sirin, which he had taken from the name of a bird of paradise in Russian folklore. Then he turned to the short stories that made him famous. Readers, enthralled by "Sirin's" sad portraits of émigrés living only in the past while their wistful, sorrowful heirs-to-be struggled to confront the present, called him their "new Turgenev," but his "realism" proved to be far more complex than anything Turgenev had ever conceived.[108] Convinced that "you can get nearer and nearer, so to speak, to reality . . . but you can never get near enough because reality is an infinite succession of steps, levels of perception, [and] false bottoms," this arrogant young émigré, who boasted that he had never once set foot in the library during all his years at Cambridge, had already begun to sense how complex the inner depths of reality really could be.[109]

Because it was ever-changing, capable of shifting direction at any time, and so complex that any analysis of human thought and emotion could reach only into its lower and middle ranges, Nabokov insisted that human consciousness was the "only real thing in the world."[110] This led him to believe that a higher plane of consciousness might be perceived if humankind could combine imagination with the senses in some truly superhuman (or extra-human) way. During the course of his life, he would hint in a dozen novels that language might in some way transcend the obstacles of time, space, and limited human knowledge that barred the way to those unknown worlds that lay beyond. "Nabokov lets an opaque world become suddenly translucent . . . [so we can] discover for ourselves how much more valuable this inexhaustible world of ours might look from somewhere beyond human time," a biographer once explained. Yet his novels' frail characters could never find a way to cross the barriers that life and their own experiences

erected. Unable to reach what lay beyond, they remained prisoners of their own experience, destined to be forever constrained by their limited views and narrow imaginations.[111]

After graduating from Cambridge, Nabokov spent a time of "blue evenings . . . light-headedness, poverty, [and] love" in Berlin.[112] He had four affairs in less than a year and a half, met Khodasevich and Bunin, and—during a brief visit to his mother and sisters in Prague—took a "lyrical stroll" through the Bohemian hills with the recently arrived Tsvetaeva. Friends remembered him from those days as a dapper young man about town, whom fate had cast into the midst of émigrés perpetually in search of literary heroes, but they also spoke of his passion for his art in a world often dedicated to pleasure.[113] For almost two years, Nabokov balanced his devotion to art and the carefree joys of bachelor life with aplomb. Then, at a charity ball in the spring of 1923, he encountered a young woman in a black wolf's mask who moved him so profoundly that he would celebrate the night of their meeting for the next half-century.[114]

The daughter of a Jewish timber merchant from St. Petersburg, who had lost his fortune in the Revolution and was in the process of building another in inflation-ridden postwar Germany, Vera Evseevna Slonim had loved the violet mosaics of the Nabokovs' pink granite mansion in St. Petersburg when she had walked past them as a child. She had gone to dancing classes with one of Nabokov's closest childhood friends, and had even spent the summers of 1916 and 1917 at a country house not far from his. Brilliant, beautiful, and passionately in love with literature, this blonde young woman of twenty-one, who spoke excellent German, perfect Russian, and fluent English, was to become Nabokov's muse, business agent, research assistant, legal counsel, chauffeur, and wife. By the time they married two years later, her father had lost his wealth again, and Nabokov later said that they had gone to Berlin's city hall to be wed with no assets in the world beyond the fee they paid to the magistrate.[115]

For the newlywed Nabokovs, life in Russia Abroad meant a succession of rented rooms and borrowed furniture. When he was not tutoring the children of wealthy Germans in English and French or struggling against the insomnia that plagued him all his life, Nabokov worked on *Mary*, his first novel, while his wife took a variety of jobs to help them escape the poverty that pressed upon them from every side. During that year and the next, Nabokov often ate his evening meals with the families of the children he tutored, while Vera sought refuge with her parents from time to time. Meanwhile the throbbing life that drew them and their friends to Berlin's Russian cabarets continued to remind Nabokov that émigré life had its peaks and depressions, even as its participants struggled to survive the crises that life in Russia Abroad heaped upon them.

Published in 1926—the same year as Hemingway's first novel, *The Sun Also Rises*—Nabokov's *Mary* set out to explore the relationships that bound together a group of homeless men and women in one of the cheap boardinghouses that sheltered so many of Russia Abroad's finest citizens. With a cast of characters diverse enough to include an aging émigré poet with no audience left to write for,

two homosexual dancers whose art transcended the limits of language, and a list-
less man on the verge of middle age who remembers with perfect clarity the time
and place of his first love in Russia, the novel enabled émigrés to relive a past that
many of them had idealized to abstraction in the few short years of their exile.
Berlin's leading émigré salon greeted *Mary* with unconcealed enthusiasm, and
*The Rudder* called it a new page in the history of Russian literature. As a theme
that Nabokov would explore again, the novel used the present to reach the past
in a manner not unlike the way in which devout icon painters of olden times had
used their art to create windows through which the soul might glimpse the king-
dom of God. To escape the limits of space and time in a world where thought
and feeling confined human experience to the past and present, Nabokov now
tried to hint at what might lie beyond the limited realm that the mind and senses
could perceive.

While the Bolsheviks celebrated the tenth anniversary of their revolution in
1927, Nabokov retreated into the creative solitude of life with his wife and his
writing desk. Around him, Berlin's émigré community was starting to shrink, as
inflation tore at the fabric of life all across Germany and drove the center of Rus-
sia Abroad toward Paris. Nabokov saw the price of a single issue of *The Rudder*
soar from ten thousand marks to two hundred billion in the course of eight short
months, and although runaway inflation worked to the advantage of those émi-
grés whose income came in francs, pounds, and dollars, it added an element of
uncertainty to their daily lives that soon took a painful toll. Happy for the solid
certainty he found in Vera's company, Nabokov now lived, he told his mother, "a
mole-like existence."[116] He had decided to set his second novel in Germany and
fill it with German characters, even though, as he later explained, he "spoke no
German [and] had no German friends." In creating a setting that kept him apart
from his characters and their feelings, he found "the lack of any emotional in-
volvement, and the fairytale freedom inherent in an unknown milieu" liberating.
"I might have staged *King, Queen, Knave* in Rumania or in Holland," he once re-
marked. "Familiarity with the map and weather of Berlin settled my choice."[117]

To move as far from *Mary* as possible, Nabokov set *King, Queen, Knave*
among people who had few memories, no interest in the past, and lived only in
the present. In its sleazy bourgeois German heroine, who plots to drown her hus-
band but is killed by pneumonia before she can carry out her plan, Nabokov
makes his first serious attempt to portray that philistine vulgarity (wonderfully
conveyed by the single Russian word *poshlost*) which sets conformity above indi-
viduality and inflates triteness into a sanctioning principle. Germany, he was to
explain two decades later, had always seemed to Russians a country where
*poshlost* had become "one of the essential parts of the national spirit, habits, tra-
ditions, and general atmosphere." Because *poshlost* encompassed "not only the
obviously trashy, but also the falsely important, the falsely beautiful, the falsely
clever, [and] the falsely attractive," it enabled Nabokov to "define what being
human means by showing people making themselves less than human."[118]

When published in the fall of 1928, *King, Queen, Knave* gave Nabokov and

Vera their first moment of economic security since their marriage. They spent the spring of 1929 in the Pyrenees, where he indulged his passion for collecting butterflies for the first time in a decade, while he set to work on *The Defense*, the likes of which, Vera promised his mother, "Russian literature has not seen."[119] Here, in what critics greeted as his first real masterpiece, Nabokov probed the meaning of consciousness with true brilliance as his hero, Luzhin, grows up to see only danger in the beauty and security that surround him. Nabokov allows Luzhin to escape his fear of the real world by retreating into the realm of chess, where his genius creates an atmosphere that seems safe and secure until his passion for a game revered by Russian intellectuals conflicts with his love for his fiancée and pushes him beyond the brink of madness. For a moment, Luzhin recovers and enters the world of real human joys and feelings. Then, unable to shield himself from the imagined dangers that threaten him from every side, he makes the move against which there can be no defense and commits suicide by throwing himself out of a bathroom window onto the courtyard below. "The whole chasm was seen to divide into dark and pale squares," Nabokov wrote in describing Luzhin's fall into the future. "At the instant when icy air gushed into his mouth, he saw exactly what kind of eternity was obligingly and inexorably spread out before him."[120]

In October 1929, the first chapters of *The Defense* appeared in the fortieth issue of *Sovremennye Zapiski* (*Contemporary Annals*), published in Paris and universally regarded as the greatest of the Russian émigré literary periodicals. "I sat down to read these chapters and read them twice," the writer Nina Berberova remembered many years later. "A tremendous, mature, sophisticated modern writer lay before me, a great Russian writer who, like a phoenix, had arisen from the flames and ashes of revolution and exile. From that day forward," she concluded, "our existence acquired a meaning. My entire generation had been vindicated."[121] Then Bunin sounded the sharpest—and truest—note of all by exclaiming that "this [thirty-year-old] kid has snatched up a gun and done away with the whole older generation, myself included!"[122]

While other émigré critics struggled to determine whether Luzhin was painfully derivative or the equal of Pierre in Tolstoi's *War and Peace*, the Nabokovs faced the Great Depression and the rise of Nazism.[123] Burying himself in work, Nabokov started to translate *Hamlet*, began a study of Dostoevskii, and wrote *The Eye*, *Glory*, and *Camera Obscura* (to appear in English as *Laughter in the Dark*), all in less than two years. In 1931, *The Rudder* folded, the Kurfürstendamm cafés shut their doors, and the pulse of Russian Berlin grew weaker and more erratic. The emigration's center shifted even more decisively to Paris, and as *Contemporary Annals* and the daily *Poslednye novosti* (*Latest News*) published more of his work, Nabokov moved toward it, too. Yet there was little hope of finding work in Paris in those days, and the Nabokovs hesitated to abandon the "almost idyllic retreat" that they shared with Vera's cousin in one of Berlin's quiet corners. Trying to set aside the apprehensions that the rise of Nazism was stirring among Europe's intellectuals, Nabokov settled down to write *Despair*, a

novel about a Berlin chocolate manufacturer who attempts to commit the perfect crime by killing a roadside tramp whose features mirror his own. Enthralled by the perfection of his plan, Nabokov's hero becomes the victim of his own bloated sense of self and loses all awareness of the line that separates reality from the world of art.

As a story of doubles, *Despair* calls to mind *The Double* that Dostoevskii had written almost ninety years earlier, but Nabokov brings none of Dostoevskii's fascination with the criminal mind to his novel, nor does he portray crime as a means to redemption as Dostoevskii so often did. Focused on crime as a form of art, and the criminal as a creative genius who kills for the sheer delight of watching the perfection of his plan unfold, the novel concludes with its hero's realization that he is in every sense a fool.[124] "I fell to doubting everything . . . and I understood that what little of life still lay before me would be solely devoted to a futile struggle against that doubt," Nabokov's mad chocolate maker writes at the end. "I smiled the smile of the condemned," he concludes, "and with a blunt pencil that screamed with pain wrote swiftly and boldly on the first page of my work: 'Despair'; no need to look for a better title."[125]

As Hitler's Nazis tightened their grip in 1933, the Nabokovs lived more from hand to mouth than ever before. A visit to Paris in the fall of 1932 had shown that the city boasted an enthusiastic Russian audience for Nabokov's books, but that it offered few chances to earn a living. Still fearful that émigré novels would only stir up criticism from native practitioners of drawing-room Bolshevism, publishers across the Channel continued to resist the urgings of even the most influential critics to translate Nabokov into English, thus limiting the market for his work to the shrinking ranks of perpetually indigent émigrés. Poorer than they had ever been, the Nabokovs struggled to change direction. "Never been in such a wretched situation before," Nabokov wrote to his ailing mother at the beginning of 1934. "We'll get out of it, of course," he assured her. "But when?"[126]

That spring and summer, Vera gave birth to their son Dmitrii, a British publisher finally bought the English translation rights to *Camera Obscura* and *Despair*, and Nabokov finished a brilliant inquiry into the relationship between consciousness and reality to which he gave the title *Invitation to a Beheading*. Reverberating with echoes of Kafka, Gogol, and Evgenyi Zamiatin, whose futuristic novel *We* had yet to be published in Russia, Nabokov's *Invitation* described the nineteen days that separated the execution of the novel's hero from the reading of his death sentence. Written during ten weeks of frenzied inspiration, it was, he later said, "a violin in a void,"[127] which a critic once wrote, "turned all of perceived reality into a trivial cartoon."[128]

The tale of a man of substance condemned to death by the superficial beings among whom fate has cast him, Nabokov's "cartoon" was far from simple and much too complex to be reduced to any single point. As the story of Cincinnatus C., whose readiness to wonder at the world has caused him to be sentenced to death for the crime of "gnostical turpitude," *Invitation to a Beheading* is a comic nightmare that ends when its hero is beheaded. Although critics have pointed

out the parallels between the ersatz camaraderie of Cincinnatus's jailer and the intense perversity with which Nazis welcomed Jews to their death camps with brass bands and morally uplifting slogans, Nabokov's vision applies to every time and any society.[129] *Invitation* suggests that, "if consciousness is the medium through which reality comes into being, [then] the sudden and final obliteration of consciousness . . . is the supreme affirmation . . . of the principle of ir-reality."[130] Liberated from the oppressive world of those banal assumptions that impose conformity upon everyone around him, Cincinnatus seems about to at-tain a more meaningful state of being after his beheading. Once again, Nabokov suggests that there may be a deeper, more meaningful reality somewhere beyond death, but that it can be apprehended only if one can in some way reach beyond the limits of the human mind.

Yet *Invitation to a Beheading* did nothing to liberate Nabokov and his wife from the deadly "*poshlost*-ean" coils of life in Hitler's Germany, nor did it ease their deepening poverty. As the rising wave of Nazi anti-Semitism convinced them that they had little time left, Nabokov and his family left Germany in the spring of 1937 to begin the odyssey that led them by way of Prague, the south of France, and Paris to New York late in the spring of 1940. In the midst of their travels, he finished *The Gift*, which had tormented him ever since he had written its first sections in 1933. Destined to be his greatest—and last—novel in Russian, he used it to say farewell to Berlin and the émigré world in which he and Vera had lived for most of their adult lives. After that, he set his native language aside. Between 1940 and his death in 1977, Nabokov would create such brilliant liter-ary masterpieces as *The Real Life of Sebastian Knight*, *Bend Sinister*, *Pnin*, *Lolita*, and *Pale Fire* to win acclaim as one of the best English-language writers of the quarter-century after World War II.

Sharply focused on the consciousness of its central character, Fyodor, *The Gift* rolls together a portrait of a young artist, an imaginary journey into the depths of central Asia, the story of Russia Abroad, an ardently told love story, a tribute to Russia's literary heritage, and a biography of the radical mid-nineteenth-century literary critic Nikolai Chernyshevskii. "Its heroine," Nabokov once said, "is Rus-sian literature,"[131] and there is never any doubt that Russian literature plays a vi-tal role in shaping the life and art of the novel's hero. Filled with untied loose ends, false starts, and unexpected connections that reflect the imperfections of the world in which Fyodor lives, *The Gift* becomes a revealing chronicle of how an artist comes into being, yet it does all these things at a pace that, a critic once wrote, resembles "a river serenely picking up its already subdued tributaries."[132] In all its majesty, *The Gift* became a tribute to the revered literary heritage Nabokov was about to exchange for another and a monument to the woman he loved but had briefly strayed from the year before. Like Fyodor's love in *The Gift*, so Nabokov's love for Vera would overcome the loneliness of his new exile as they moved toward the safe harbor of comfort, prosperity, and success in the years that lay ahead.

At the distance of more than fifty years, *The Gift* has been called "the greatest

Russian novel of this century,"[133] yet the arrival of its fourth chapter at the editorial office of *Contemporary Annals* in the summer of 1937 stirred a frenzy of controversy. Although long respected for being willing to publish materials that conflicted with their views, the exiled revolutionaries who edited the journal found *The Gift*'s portrait of Chernyshevskii so offensive that they refused to publish it. In vain, Nabokov protested that *Contemporary Annals* should not exercise the same kind of ideological censorship that made the Soviet literary scene so repugnant to them all. But, when the editors stood firm and insisted that they could not publish such a negative portrayal of the man they considered to be one of Russia's greatest revolutionary heroes, he had to resign himself to seeing his novel appear without its longest chapter. With the French authorities still refusing him and Vera work permits, Nabokov had no choice but to accept a decision about his novel that he found repugnant. *The Gift* would not appear in its entirety until 1952.

The next year, 1939, the Nabokovs' situation got even worse. As Germany occupied Czechoslovakia and Austria and unleashed its armies against Poland and Norway, Nabokov searched frantically for an exit from Europe before the onrushing Nazi tide overwhelmed them all. For a year, his pleas to friends in England and America seemed to fall on deaf ears, until the beginning of 1940, when a friend arranged for him to teach a summer course in Russian literature at Stanford University. Tolstoi's daughter Alexandra, the émigré Harvard historian Michael Karpovich, and Sergei Kusevitskii, the Russian émigré conductor of the Boston Symphony Orchestra, added their help in obtaining American visas. By the time the Nabokovs had raised the sum needed for their passage from benefit readings and donations from a score of friends in Paris, including several wealthy Jews, Hitler's armies had smashed their way through France's northeastern defenses and begun their march on Paris. Once again, as in the Crimea twenty-one years earlier, Nabokov escaped just in time. When German bombs destroyed his Paris apartment three weeks later, he, Vera, and their son were already well on their way to being safely settled in Karpovich's summer house in West Brattleboro, Vermont, the last "capital" of Russia Abroad anywhere in the world.

In America as in Europe, the Second World War wiped away the cultural identity of Russia Abroad in the sense that its leading creators died, were killed, or entered more resolutely into the artistic experience of the foreign lands into which their emigration from Russia had carried them. Certainly that was true of Nabokov, for whom arrival in Vermont marked the beginning of a second life as an acclaimed English-language novelist. The same could be said of Kusevitskii's long success with the Boston Symphony Orchestra and of Chagall and Stravinskii, whose reputations after the war lifted them into the stratosphere of international acclaim. Certainly these and many other émigré opponents of the Stalinist utopian vision enjoyed a level of freedom in developing their art that their Soviet counterparts could never imagine in their wildest dreams.

Yet there were those in the Soviet Union who found the Bolshevik vision seriously flawed and dared to criticize it even at the cost of their lives and freedom.

Subtly, but with quantities of persistence and courage that few in the West could imagine, utopia's critics within the Soviet Union struggled to turn their nation's artists away from the ever-narrowing focus that Stalin's cultural bureaucrats sought to impose upon them. Won at immense cost in artistic and human suffering, the fruits of their struggle helped to open the way for the gradual blending of those émigré and Soviet achievements that would eventually reunite the artistic experience that the Bolshevik experiment had torn apart.

<div style="border: solid">

# UTOPIA'S
# OPPONENTS
# AT HOME

</div>

꒰჻꒱

*WHILE ÉMIGRÉ PAINTERS,* composers, and writers enjoyed more freedom in the West than their ancestors had ever known, their countrymen in the Soviet Union were being crushed by the brutality with which the Bolsheviks imposed their regime and rushed to catch up with the West. Proclaiming that it was still "fifty or a hundred years behind the advanced countries," Stalin demanded that the Soviet Union close the gap in a decade by marshaling its colossal resources to reap all the advantages that centralized planning could produce.[1] If the "socialist reconstruction" of agriculture and industry were to wipe out backwardness in a generation and catapult the Soviet Union into the forefront of the world's modern nations, every person, Stalin said, would have to work at "a genuine Bolshevik tempo." Every thought of the more moderate evolutionary course that had drawn homesick émigrés back to Russia in the days of Lenin's New Economic Policy had to be forgotten, and anyone who would not accept the overriding imperatives of the Five Year Plans had to be eradicated. Under Stalin's heavy hand, the age of the machine that Maiakovskii, Malevich, and the Constructivists had greeted as the harbinger of a brave new world in the 1920s became the rigidly regimented Soviet society of the 1930s, which relied on terror, destruction, and death to create the conformity that its vision of the future required.

Between 1927 and 1941, Stalin's efforts to collectivize agriculture, modernize industry, and remove every hint of opposition from the ranks of the Bolshevik (soon to be renamed Communist) Party claimed millions of victims. The Great Purges of the mid-1930s eradicated most of the men and women who had worked with Lenin, hundreds of thousands of Party faithful, and hordes of peo-

ple who wanted nothing more than to live their lives as they saw fit. Two-thirds of the Red Army's marshals, eight out of every ten of its army commanders, and nearly a third of the entire membership of the Soviet Writers' Union all disappeared into the dark vastness of the GULag archipelago in less than a decade.[2] Then the Second World War took the lives of twenty-nine million soldiers and many more civilians. Of the losses in lives ruined, children not born, and dreams shattered there could be no count, for Russia had not known such devastation since the days of Batu Khan's Mongols. For a time, it seemed impossible that the nation could survive. Then, as it had always done, Russia gained new strength from adversity. By 1945, Nazi Germany lay in ruins, and the Red Army imposed a triumphant peace upon Eastern Europe.

During the dark and terrible years that separated Stalin's rise in 1927 from his death in 1953, terror and suffering touched Russia's writers, painters, and composers just as certainly as it did everyone else, for the architects of Stalinism demanded even greater loyalty and conformity from the "architects of men's souls" than they did from everyday proletarians. The Acmeist poet Nikolai Gumilev became the first casualty when he was shot by the secret police in 1921, and thousands of others followed him to starvation and death in prisons and forced-labor camps during the next half-century. Artistic achievements that would have won acclaim in any other country had to be kept hidden in Russia lest images shaped from words, paint, or music bring the wrath of the Soviet artistic bureaucracy down upon their creators.

Thousands of unsung heroes, therefore, took great personal risks to preserve some of Stalinist Russia's greatest literary treasures by hiding manuscripts and memorizing contraband poems. One of them was Anna Akhmatova, the brilliant poet who endured the torment of seeing loved ones go to their deaths while she remained free. Another was Nadezhda Mandelshtam, wife of one of the greatest lyric poets of modern times, who shared her husband's suffering, and then, after his death, dedicated the rest of her life to preserving his poetry and his memory. Through the darkest days of the Stalin era, this steel-willed woman served as a living archive that kept her husband's greatest works safe in her mind and heart. Then, in her old age, she told the story of her life in two volumes of memoirs that stand as monuments to the appalling degradation that the Soviet regime inflicted upon all who resisted the Socialist Realist vision it sought to impose upon the artistic experience of an entire nation.[3]

Now remembered among connoisseurs of Russian poetry as "the supreme verbal artist of this century,"[4] Osip Mandelshtam was born in Warsaw and raised in St. Petersburg, where he grew up at odds with the Jewish heritage he would later reclaim. "The chaos of Judaism showed through all the chinks of our stone-clad Petersburg apartment," he wrote in recollections that he assembled at the age of thirty-four. "[This was] the unknown womb world whence I had issued, which I feared, about which I made vague conjectures and [from which I] fled." Disdaining "the spiky [Hebrew] script of the unread books of Genesis" and "the strange, cheerless holidays, grating upon the ear with their harsh names: Rosh

Hashana and Yom Kippur," young Mandelshtam preferred instead the vigorous festivals that Christian Russians celebrated with "decorated eggs, Christmas trees, [and] steel skates from Finland."[5] He defined his cultural heritage as purely Russian. Instinctively, he turned away from everything Jewish.

As the eldest son of an upper-middle-class leather merchant who was prepared to cater to his son's dreams, Mandelshtam went to Paris at the age of sixteen to become a poet. Among those other Russians who frequented the cafés on the city's Left Bank in the days before World War I, he at first seemed lost and lonely, but he spoke passionately about poetry and sympathized with the idea of revolution.[6] His friends called him "a homeless bird," but there was nothing birdlike or fragile about the poetry he began to write when he returned home to become a student at the University of St. Petersburg in 1911.[7]

After seeing Mandelshtam at Ivanov's Tower, Akhmatova, who was just two years older, remembered him as "a thin boy, with a lily-of-the-valley in his buttonhole and long eyelashes."[8] Then, he compiled *The Stone*, a thin volume of twenty-three poems spread across thirty-three pages, which he published at the age of twenty-two. Lifted on a wave of critical acclaim that crested with the critic Nikolai Punin's remark that its author was "magnificent—grand—like a fugue,"[9] *The Stone* raised Mandelshtam to prominence in an avant-garde replete with first-rate poets. "Not since Pushkin," a reviewer exclaimed, "have we encountered such intent, such powerful vision, or such perfection in definition."[10] There was depth to Mandelshtam's poetry and a timelessness about his dedication to language and history that surprised acquaintances who thought him fearful and uncertain. "He was two weeks older than I," Ehrenburg remembered many years later, "[but] listening to his poems, I felt that he was many years the older and the wiser."[11]

In 1916, an expanded edition of *The Stone* proclaimed Mandelshtam's full coming of age as a poet at the same time as his short-lived love affair with Marina Tsvetaeva overcame his self-doubts and loneliness.[12] Yet the events of 1917 quickly plunged him into a new sea of uncertainties as he struggled to discover the meaning of the Revolution and define his place within it. From Moscow, he moved to Kiev, and then to the Caucasus, always seeking to derive a sense of time and place from life in the streets around him. "He made up poetry," Ehrenburg wrote, "not at his desk but in the streets of Moscow and Leningrad, in the steppe, in the mountains of the Crimea, in Georgia, and Armenia."[13]

For a time, Mandelshtam worked in Lunacharskii's Commissariat of Public Enlightenment. After fleeing again to the South, where the Whites put him in prison, he reappeared in Petrograd to share the trials and triumphs of the Civil War's hardest days, with Belyi, Khodasevich, Viktor Shklovskii, Evgenii Zamiatin, and a score of other writers who had taken shelter in the House of Arts that Gorkii had established in one of the city's most elegant mansions. Years later, Shklovskii remembered how "Mandelshtam [had] foraged in the house like a sheep and wandered through the rooms like Homer" to satisfy his craving for

sweets and his hunger for attention.[14] Blok thought that Mandelshtam's poetry in those days arose "out of . . . extremely original dreams, which lie wholly within the realm of art," and others who heard him read in public were amazed at how art transformed him. "Never have I seen a human face so transformed by inspiration and self-forgetfulness," one of his listeners remembered. "Mandelshtam's homely, insignificant face . . . [became] the face of a seer and prophet."[15]

At the end of the Civil War, Mandelshtam married Nadezhda Khazina, an avant-garde painter from Kiev, whose brilliant and touching memoirs would later tell the world of the torments that the Bolsheviks inflicted on any artist who disputed their vision. Supposedly the only Jew among the many women Mandelshtam loved—and the only one for whom his love did not prove transient—Khazina was the one to whom he addressed his poem "Return to the Incestuous Womb" soon after their first meeting in 1919. Convinced that "all marriages between Jews are incestuous" because "all Jews are related by blood," Mandelshtam used the poem to confront the Jewish past that his relationship with his future wife no longer allowed him to ignore.[16] Powerful and unsettling in its vision, "Return to the Incestuous Womb" marked a defining moment as the poet moved toward marriage with a woman to whom he would often be unfaithful but would never cease to love.

Within a year after marrying Khazina in 1922, Mandelshtam's revolutionary ardor began to cool. Like so many artists whose lives turned sour when they turned away from the Bolsheviks, his decline began imperceptibly, marked at first by only the slightest of shifts in his relationships to the increasingly monolithic Soviet literary world. In the beginning, it seemed to be only a matter of favors he found more difficult to arrange and editors who no longer sought his advice as often as they had before. Then, in 1926, several Soviet publishers rejected his autobiographical *Noise of Time*, and their interest in his earlier poetry began to dry up. Friends who could no longer print his work urged him to take up translation, a sure sign that the authorities thought his writings too much in conflict with the image they wanted the literature of their new society to present.[17]

The year 1928 saw a brief reprieve in Mandelshtam's deepening silence as Russia's state publishing house suddenly issued three volumes containing his poems, literary and autobiographical essays, and a novella. Then, as Stalin tightened his grip on Russia's writers and artists, one of the poet's few remaining friends in high places arranged to take him out of the Kremlin's line of vision by sending him on a trip to Armenia that lasted for the better part of two years. But distance did nothing to moderate Mandelshtam's festering anger. Seething with outrage and raw hatred, he dismissed Stalin's call for fiction to become national in form and socialist in content as "stupid and illiterate."[18] Wanting "to spit in the face of every writer who first obtains permission and then writes," Mandelshtam scorned the whole "race of professional writers" as "prostitutes."[19] As he did so, he seized the native roots he had pushed aside in the past, embraced "the

honorable title of Jew," and took new comfort from the Jewish past he had despised for so long. Now embarked on the terrible last decade of his life, Mandelshtam began to speak proudly of having his "blood burdened with the heritage of sheep breeders, partriarchs, and kings."[20] Jewishness now defined his poetic self-image as "a wilful disrupter of cultural orthodoxies" and bound him in his own mind to "the Jewish poets of Alexandria and Spain."[21]

After the Leningrad Writers' Union denied him and his wife housing and work, Mandelshtam greeted his fortieth birthday on January 15, 1931, with the bitter realization that he had reached an impasse from which there might be no escape. Life in Leningrad seemed to him "like sleeping in a grave," and he dreamed of traveling to a "station where no one would ever find us."[22] That spring, he took Khazina back to Moscow, where the Writers' Union arranged for them to have three small rooms in a crumbling wing of an old mansion. Then, while his wife worked in a newspaper office, Mandelshtam began to write his *Journey to Armenia*, the last work he would ever publish. Barely able to contain his fury at the petty insults the authorities heaped upon him during the next several years, he wrote of having "given up the cup at the elders' feast along with happiness and honor" while the "wolfhound of our times flings itself on my back."[23] Then, in 1933, he wrote a raging condemnation of Stalin, the "Kremlin mountaineer," the "murderer and peasant killer," whose "thick fingers moved like fattened grubs,"and for whom "each death is a sweet-tasting berry."[24] To think such thoughts in Russia was dangerous. To write them down was foolhardy, even if one believed, as Khazina later insisted, that "you can't escape your fate and better not try."[25]

On the night of May 13, 1934, Mandelshtam's intemperate poem brought the secret police to his apartment, and after weeks of interrogation he was sentenced to exile in one of those remote corners of Russia's Far North into which the Kremlin's rulers had sent their enemies since the days of Ivan the Terrible. Then Stalin interceded. Perhaps because of the intervention of Nikolai Bukharin, a high Soviet official who loved Mandelshtam's poetry, or perhaps because of the uproar the poet's arrest had caused among other writers, the "Kremlin mountaineer" ordered the Mandelshtams to be transferred to Voronezh, a provincial capital near the Don River that was better supplied and much farther south. There they lived for three years, destitute and dependent upon money sent by friends, while the poet continued to suffer from the severe heart trouble that filled his mind with visions of his approaching end. "It's stifling," he wrote, "and yet I am dying to live."[26] In vain, he penned an ode to Stalin in the hope of being spared further torment when his sentence of exile came to an end in the spring of 1937. Then, in a torrent of bitter poems, he regretted his moment of weakness. "If they dare to cage me like an animal, / and fling my food on the floor, / I won't be quiet or choke off the anguish," he raged. "I shall write."[27]

In the summer of 1937, the Mandelshtams returned to Moscow, where they languished in a no-man's-land of civic nonbeing until the police came again to ar-

rest the poet the following spring. This time, when the frail Mandelshtam was sentenced to five years' hard labor for "counterrevolutionary activities," Stalin made no effort to intervene, and like so many of his unfortunate countrymen the poet entered the bowels of the GULag archipelago that fall. Caged in one of the thousands of stinking, unventilated freight cars that brought prisoners to the unheated Vladivostok transit barracks through which they would be funneled into the gold mines of the frozen Kolyma wastelands, Mandelshtam spent the monthlong journey in such fear of being poisoned that he refused to eat even the soup ration that all prisoners received. As always, poetry became his solace and prisoners later remembered how he read the sonnets of Petrarch by the campfire around which the men who could find no room in the barracks spent the arctic nights.[28] In Vladivostok, Mandelshtam died of heart failure just three weeks short of his forty-seventh birthday. Among the thousands of human monuments to the abuses that the men and women of Stalin's Russia had to bear in order to remain true to their art, he was among the most tragic, for he had been obliged to endure all the torment that the system could impose before death finally cut short his sufferings.

Moderated by pure chance as in the days of the Romanovs, the whims of rulers and high officials condemned some artists and intellectuals to exile and imprisonment while others received lesser punishments for graver offenses. Dostoevskii had been sentenced to penal servitude in Siberia merely for being present when a group of casual acquaintances had discussed revolution in an abstract way, while Tolstoi had suffered no greater punishment than excommunication from a Church in which he no longer believed for denying the very foundations upon which the Romanovs' state had come to rest. In Soviet times, the same combination of tyranny and caprice put the poet Nikolai Gumilev before a firing squad and sent Mandelshtam to die in Siberia, while it condemned Evgenii Zamiatin, the novelist who embraced eternal rebellion, to nothing worse than European exile. Yet Zamiatin's published portrait of a dehumanized new world shaped by technology and dedicated to the greatest good of the greatest number did more than challenge the Bolsheviks' claim to having found the secret of building a just society. It also supplied the foundations for *Brave New World* and *1984*, in which Aldous Huxley and George Orwell parodied the dreams that Lenin and Stalin both held so dear. Most properly read as something other than a condemnation of Fascism or Communism, the novel *We* that Zamiatin published first in English in 1924 provided the kernel from which just such criticism of the Soviet system could most easily be derived.

A heretic who challenged the orthodoxy of the Bolshevik vision at its very source, Evgenii Zamiatin grew up lonely, introspective, and stubbornly individualistic amidst the torpor of Russia's provinces. As a student at St. Petersburg's Polytechnic Institute, he became a Bolshevik on the eve of the Revolution of 1905 and spent several months in tsarist prisons as punishment for his new beliefs. But Zamiatin had joined the Bolsheviks only because his nature craved

what he liked to call "the path of greatest resistance," and he soon set his radical sympathies aside to follow a career in shipbuilding that eventually sent him to England, where he supervised building the icebreakers that kept Russia's northern sea route open to Allied shipping during the First World War. When his short stories began to command attention as works of "a master with very distinctive characteristics and with a lively and brilliant talent,"[29] as one critic wrote, he decided to devote his life to literature even as his talent for designing ships opened wide the doors to success as a naval engineer.

Zamiatin returned to Petrograd in the fall of 1917 to find Russia moving resolutely toward the Bolshevik Revolution. Now believing that only never-ending revolution could guarantee the progress of humankind, he resisted the Bolsheviks' dogmatic demand for orthodoxy by insisting that "all truths are erroneous" precisely because "today's truths become errors tomorrow."[30] Believing that the essence of the true revolutionary was not Lenin but those ancient Scythian "spiritual revolutionaries" who had swept across the Russian steppes half a millennium before Christ,[31] he found it increasingly difficult to publish his work. In the fall of 1922, the Soviet authorities included him among the nearly two hundred intellectuals and scientists they sentenced to permanent deportation, but influential friends had his sentence revoked.[32] He replied by denouncing every form of absolutism and acclaiming "heresy" as the main stimulus for his vision of eternal revolution. "The world lives only through its heretics, through those who reject the seemingly unshakeable and infallible today," he wrote. "Only the heretics discover new horizons in science, in art, in social life. Only the heretics ... are the eternal ferment of life and ensure life's unending movement forward."[33]

To free the Russians from the threat of conformity, Zamiatin looked for new heresies to "explode the crust of dogma and all the most solid stone structures that have been raised on it."[34] When Soviet censors and literary bureaucrats condemned his "archbourgeois opposition to the working class that is building socialism" after his novel *We* was published abroad without his permission,[35] he resigned from the Leningrad Writers' Union in 1929 and asked Stalin to send him into foreign exile. He had no desire, he stated flatly, to remain in a country that denied avant-garde writers the means to practice their art, and Stalin, whose minions were soon to declare with pride that "our Soviet literature is not afraid of being called tendentious because it *is* tendentious" let him go.[36] In 1931, Zamiatin therefore left Russia forever to spend the last six years of his life in Berlin, Prague, and Paris.

Called "the most perceptive of the twentieth-century negative utopias,"[37] Zamiatin's *We* describes a civilization based entirely on reason, in which the city and the machine have triumphed over the countryside and a benevolent state directs every human action. In the Single State, people's names have become numbers, individualism has been so thoroughly erased that people speak only of "we," and the mechanisms of the government are so precisely tuned that no po-

litical acts are ever required. Because the citizens of the Single State have set aside their forebears' choice of "freedom without happiness" in favor of "happiness without freedom," paradise has been restored. "Again, we are simplehearted and innocent like Adam and Eve, [with] no more of that muddle about good and evil," the poet R-13 explains. In its efforts to guard the "unfreedom" of its people, he concludes, the Single State has become "majestic, beautiful, noble, exalted, and pure as crystal."[38]

Protected by the Guardians, a security force clad in blue[39]—the cool color of rationality, and also of the uniforms and insignia worn by the secret police in tsarist and Soviet times—Zamiatin's Single State is ruled by an iron-willed, loving Benefactor, who is worshiped for having freed his people from the burdens of free will and feared because he possesses the power to atomize any transgressor in an instant. Yet neither the Benefactor nor the Guardians can eradicate those remnants of human feelings that lie beneath the supreme rationality of all beings in the Single State. As these revolutionary seeds germinate and take root, they spread even into the mind of D-503, the narrator Zamiatin identifies as one of the leading mathematicians of the twenty-ninth century, and cause him to fall in love, discover the desperation of passion, and suffer the anguish of loneliness and self-doubt.

Telling himself that "all of it is doomed" when he is swept up in a new revolution that seeks to destroy the Single State, D-503 fears that "the greatest and most rational civilization in all history is coming apart" and that chaos is about to overwhelm reason. Assuring his readers that "reason must prevail," Zamiatin restores D-503 to "sanity" by an operation which removes the center of fantasy from his brain and makes him capable of perfect happiness within the shrunken Single State that survives the revolution. Yet he never makes clear whether "revolutions [like numbers] are infinite,"[40] or if the shrunken Single State can end revolution for all time. Either way, Zamiatin had rightly sensed the dangers that underlay the experiment upon which the Bolsheviks had embarked. Well before his death in 1937, the utopia of Socialist Realism had become too fragile to stand against such forms of fantasy even as its creators struggled to further mold and manipulate reality.

Others who shared Zamiatin's cynical disdain for the perversities of ideology and power escaped the terrible fate of Mandelshtam and Gumilev only by writing for posterity, and that was especially true of Mikhail Bulgakov, who won fame more than a quarter-century after his death for a novel whose complex brilliance raised it above every other piece of fiction produced in Stalin's Russia. Born in Kiev and educated as a physician before the Revolution, Bulgakov was known among his friends for his splendid wit and the "magnificent contempt" with which he, as "a literary patrician in times that were moved by a proletarian ethos," disdained the vulgarity of Soviet life.[41] By the time he died from sclerosis of the kidneys at the age of forty-eight, he had published only five stories, a modest novel, and three plays, only one which had been allowed to run for more than

a few performances. Condemned to silence because of his satiric portrayals of the Bolshevik vision, he seemed to most Soviet readers no more than a minor literary figure, whose "creative path," as the *Soviet Literary Encyclopedia* warned in the early 1930s, was that of "a class-enemy of Soviet reality." Only in 1966, when the novel to which he had devoted the thirteen years before his death in 1940 was published in Russia, did that opinion change. Even in its expurgated, officially approved version, *The Master and Margarita* catapulted Bulgakov into the ranks of the most insightful novelists of the twentieth century.

Bulgakov had grown up in Kiev surrounded by traditionalist intellectuals who found pleasure in books, ideas, and good music. As the cradle from which the arts and literature of Russia had sprung nearly a thousand years before, Kiev had flourished when St. Petersburg had been a swamp and Moscow a tiny frontier village, yet few twentieth-century Russians regarded it as central to the artistic experience to which it had given birth. Bulgakov, therefore, saw it as one of his life's most important literary tasks to present Kiev as one of the great cities that shaped the cultural experience of Europe.[42] Radiant in its setting among the hills that rise above the Dnepr River, this "Jerusalem of Russia"[43] became the setting for *The White Guard*, a novel in which he explored the tragedy of one family's disintegration as the forces of revolution and civil war swirled in ever-changing patterns around Kiev as their vortex. Just as Sholokhov would do a few years later, Bulgakov viewed the Civil War through the eyes of the Whites, but in contrast to Sholokhov's Cossacks, whose traditional loyalties made them unquestioning enemies of the Reds, his heroes, the Turbins, opposed Bolshevism because it violated the values they held closest to their hearts. When they finally accepted the Bolsheviks' rule, it was not because they had discovered some new and deeper truth, but simply because all the alternatives seemed even more terrifying. As all the beliefs around which the Turbins had shaped their lives dissolved into myths, only Bolshevism seemed to offer the stability that could restore life's normal patterns.

*The White Guard* stirred remarkably little furor when its first parts appeared in 1925. Bulgakov transformed it into *Days of the Turbins* for the Moscow Art Theater within a year, and its first performance at the beginning of October 1926 set in motion what one critic called "the biggest theatrical event of the decade."[44] While some immediately condemned the play as "counterrevolutionary" and others shouted, "Thanks for the truth!"[45] the official critics, who had been overruled by People's Commissar of Enlightenment Lunacharskii in their recommendation that *Days of the Turbins* not be performed at all, turned upon it in fury. In Bulgakov's play, they wrote, "wretched, insignificant, elementary, colorless, and petty" men and women spoke words "so vulgar, pallid, and boring," as to make one ask why the play had ever been performed.[46] Others described its heroes as "exceptionally vulgar," "stupid," and "definitely socially defective."[47] Yet if critics condemned the play as perverse "Bulgakovism" that stirred sympathy for Bolshevism's foes, Russian theatergoers thronged to see it. "These were not playgoers but palmers, and their pilgrimage was to see a stirring miracle in a land of

terror and 'class hatred,' " one commentator explained. "One could make a pilgrimage to this presentation," he concluded, "for it was filled with the miracle of Christian forgiveness [and] called for extending one's hand to the defeated enemy of yesterday."[48]

As happened so often in the world of Soviet art, popular success brought Bulgakov public disgrace. Over the next two years, the authorities condemned his *White Guard* as a counterrevolutionary attempt to "represent great tragic events in terms of a farce,"[49] closed down his two other plays, and at the beginning of 1929 banned *Days of the Turbins* from the Moscow Art Theater. Yet, in seeking to anticipate Stalin's will, Moscow's literary bureaucrats had done away with a play their leader had seen no fewer than fifteen times, because he thought that the Turbins' decision to eventually lay down their arms demonstrated that, in the end, "the Bolsheviks must be invincible." Revived at Stalin's request at the beginning of 1932, *Days of the Turbins* drew throngs until its sets were destroyed by German bombs in 1941, but since Stalin did not extend his favor to the rest of Bulgakov's work, his other plays continued to languish.[50]

Between 1928 and his death in 1940, Bulgakov wrote several plays that Moscow's directors refused to stage and a biography of Molière that the editors of the popular "Lives of Famous People" series refused to print. With no one willing to publish short stories or novels that bore his name, he earned his living by writing librettos and film scripts while he continued to work in secret on the novel that would one day lift him into Russia's literary stratosphere. Combining massive research about the history of early Christianity, a careful study of what Pasternak once called that "flea-market of borrowed gods and conquered peoples" that was life in ancient Rome,[51] and a broad acquaintance with human nature, satanism, and the world of the supernatural, Bulgakov struggled to create the amalgam of thought and image that would produce the treasure he envisioned, even as Stalin's purges swirled around him. He wrote eight different versions of *The Master and Margarita* before he was satisfied. Despite having lost his sight, he was still making corrections at the time of his death.

Centered on a four-day span during which the Devil and his entourage visit Moscow to wreak havoc among its legions of moral cripples, hack writers, and time-serving bureaucrats, Bulgakov's *Master and Margarita* evoked an almost endless array of intuitive responses. Its chief targets were those banal mediocrities who ruled Soviet literature and discouraged literary talent in the name of building a better world, and in the process of exposing their vulgarity the novel stripped away the virtuous veneer that overlay the self-serving triviality of Soviet artistic life. On a deeper level, Bulgakov took his readers into the even more fearsome realm of speculating about what actually determined human destiny. Repeatedly, his Satan encountered men and women in Moscow who insisted that they had the power to shape their own lives, even though they could not guarantee that they would not awaken in prison, or for that matter awaken at all.

Yet the novel's message was by no means fatalistic, naïve, or morose, for Bulgakov saw in the human spirit a fundamental optimism that transcended even

the terrors of Soviet life in the 1930s. Combined with the experiences of the Master (a persecuted writer who has written an unpublished novel about Pontius Pilate and Christ and is driven into an asylum) and Margarita (the only other living soul who knows he has written it), the experiences of Pilate and Christ in Jerusalem almost two thousand years earlier made very clear its author's firm conviction that everything would turn out all right in this world or the next. In Bulgakov's anti-Bolshevik vision, the Master, Margarita, Pilate, and Christ all found what they sought because they recognized that certain moral absolutes did not change with time, even under the impact of tyrants and revolutions.[52]

Combined with the vagaries of the bureaucratic tyranny that ruled the arts in Stalin's Russia, timely concessions, careful management, and outright good luck made it possible for a rare handful of brilliant artists to enjoy moments of acclaim and still preserve a limited measure of inner freedom. At times that was true of the composer Sergei Prokofiev, who was born just three weeks before Bulgakov in a small Ukrainian farming village that lay in the midst of lands once roamed by Russia's Scythian and Mongol conquerors. Blessed, as one of his teachers remembered, with "absolute pitch, a superb memory, remarkable harmonic sense, and a rich artistic imagination," Prokofiev had a musical vision that demanded expression in ways that no one seemed able to teach.[53] "I wanted to compose operas with marches, storms at sea, and terrifying scenes," he explained when he looked back on his student days at the St. Petersburg Conservatory, "but they tied me hand and foot . . . with all sorts of boring, tedious exercises."[54]

Immersed in his own creative fantasies, Prokofiev lived through the revolutionary events of 1905 almost without noticing. He found inspiration in the works of such frequently criticized modernists as Henri Roussel, Skriabin, and Stravinskii, but it was not until he played his own *Diabolic Suggestions* at his first public performance in 1908 that he saw how polarized the reactions to his music were destined to become. "Something like this can be witnessed only once in a lifetime," the fifteen-year-old aspiring painter and poet Maiakovskii wrote after he heard the performance. "One sees and feels that the master has gone insane in a super-ecstasy, as if he were going into mortal combat and as if this attack can never again be repeated."[55] Yet if Prokofiev's avant-garde music thrilled young Russian modernists, it outraged conservatives. Some of his audiences left in the midst of his performances, and others made unflattering comparisons between his compositions and the howling of cats.[56] As Russia approached the Great War, the leading conductors and orchestras of Moscow and St. Petersburg continued to refuse to play his music. Few claimed to understand it, but almost all of them disliked it.

During the war years, Prokofiev wrote his Classical Symphony and a handful of concertos, sonatas, and symphonic suites, all of which only deepened the controversy over modernism. When he conducted his *Scythian Suite* at a concert in 1916, his former teacher Glazunov left the auditorium before the end, and one of the cellists confided that he had been "willing to submit to this inferno" only because he had a wife and three children to support.[57] The following year, only

Gorkii's plea for the War Ministry to remember that "we are not so rich that we can afford to sole our soldiers' boots with nails of gold"[58] spared the young composer from being drafted into the army by Kerenskii's revolutionary government. Then, unable to find his bearings in the proletarian world of the Bolshevik Revolution, Prokofiev left Russia by way of Siberia, Japan, and the western United States for Chicago, where he finished his first opera, *The Love for Three Oranges*, and arranged for its premiere at the end of 1921.

After being cheered in Chicago, *The Love for Three Oranges* received such scathing criticism in New York that Prokofiev fled to Europe, where as Hemingway remembered many years later Paris offered a "moveable feast" of painting, fiction, poetry, and music to audiences perpetually in search of the new and unexpected. Here, Diagilev and Stravinskii ruled the Ballets Russes, while Schoenberg, Hindemith, Roussel, Kusevitskii, and Villa-Lobos took their turns at the Opéra. Now, the very qualities in Prokofiev's music that had disturbed critics in prerevolutionary Russia and postwar America stirred excitement and made his very first concert in the city a triumph. "A whole avalanche of ideas flows through my mind," he exclaimed as he read the reviews. "I do not need a comb but a large rake to sort out what will be useful."[59]

But sorting out what was useful proved to be Prokofiev's most daunting task, especially after the audiences and critics who had cheered his first concert unanimously disapproved of his Second Symphony. For a time, he found comfort in the cheering Soviet audiences to which he played in Moscow, Leningrad, Kiev, and Odessa when he visited Russia at the beginning of 1927, but he was not yet ready to entrust his life and freedom to the whims of the bureaucrats who were rising to rule his homeland's artistic establishment. That spring, he returned to the West a full two months before *The Love for Three Oranges* had its first performance at Moscow's Bolshoi Theater in order to preside at the premiere of his ballet *The Steel Trot (Le Pas d'acier)*, at Diagilev's Ballets Russes. In ways that Stravinskii, Kusevitskii, and Rachmaninov would never know, the daring of the Soviet vision enticed him even as the bureaucrats who ruled its artistic establishment repelled him.

Conceived as a tribute to the Bolsheviks' accomplishments in building a new and modern Russia, the music, choreography, and sets of *The Steel Trot* portrayed a nation hammering its steel into "a vast mechanism [in which] man is only one working part." Offended by scenes that portrayed children selling cigarettes while a fallen countess in a tattered gown traded jewels for food, Jean Cocteau complained that Prokofiev's new ballet had turned "something as great as the Russian Revolution into a cotillion-like spectacle," but others saw it as "a new and powerful form of art," in which the dancers resembled "living cam-shafts [with] . . . something beautiful—like a human smile—superimposed on their implacable metallurgical precision."[60] In London, critics who had not liked Prokofiev's earlier work cheered his "Bolshevik ballet" as a better expression of "the state of mind of contemporary Russia than all endeavors [of authors and orators] put together."[61] But such acclaim only posed troublesome new

dilemmas for an artist who was struggling to discover whether the true source of his inspiration lay in Russia or the West. Sympathy for what the Bolsheviks were trying to achieve continued to pull Prokofiev toward his native land, but public enthusiasm for his *Steel Trot* held him in Europe. Unable to decide whether to turn east or west as the 1920s drew to a close, the uncertain composer buried himself in his work to produce a flood of brilliant new creations that left audiences breathless.

During a three-week period that divided late April from mid-May in 1929, Prokofiev saw the premieres of his Third Symphony, his ballet *The Prodigal Son*, and the opera he had based on Dostoevskii's novel *The Gambler*. At the same time, he struggled to come to grips with the troubling new impressions that friends from Moscow brought with them to Paris. From Maiakovskii and Meyerhold he heard more details of how the sinister power of Russia's cultural bureaucrats was beginning to quench the revolutionary fires that had illuminated the arts after 1917, and everyone seemed to sense that the rise of Stalin would shape their national artistic experience in fearsome ways that they dared not imagine. It was clear, too, that life in Russia could never offer such luxuries as the fourteenth-century hilltop chateau that Prokofiev and his wife rented that summer. Yet the forces that drew the troubled composer back to Russia seemed to be gaining strength nonetheless. In the summer of 1929, the death of Diagilev in Venice cut one of the strongest ties that still held Prokofiev in the West, while the renewed hostility of some of Europe's leading critics deepened his sense of restlessness. Unable to maintain warm relations with his mercurial rival and fellow émigré Igor Stravinskii, and completely at odds with Diagilev's heir apparent George Balanchine, Prokofiev turned toward Russia, even as the strident self-righteousness of Stalin's state seemed almost certain to push him away.

Between 1930 and 1933, Prokofiev completed two triumphant tours of America, wrote several concertos and a ballet, and finished his Fourth Symphony. By the spring of 1933, he had decided to return to Moscow because "foreign air does not suit my inspiration, because I'm Russian, and that is to say the least suited of men to be an exile." Feeling cut off from his sources of inspiration, he needed, like his friend Aleksei Tolstoi, the homeland he had never been able to find in the West. "I've got to live myself back into the atmosphere of my native soil," he explained. "I've got to hear the Russian language echoing in my ears [and] I've got to talk to people who are my own flesh and blood."[62]

Angered when his ballet *On the Dnepr* failed to win the enthusiastic reception he expected in Paris, Prokofiev claimed to be all the more enthralled by "the enormous thirst the Russians now have for music."[63] Only one among a number of first-rate composers in Paris, he towered above all rivals in Moscow, where audiences seemed to cry out for new art even as the satiated French felt free to disdain it. In 1935, Prokofiev, therefore, gave up his Paris apartment and moved to Moscow. "I have two sons who speak French like Russians and Russian like Frenchmen," he confided to the friend who would become one of his best biographers. "I want them to speak at least their own language properly."[64]

In the Soviet Union, Prokofiev wrote the score for *Lieutenant Kizhe*, an early Soviet sound film that satirized the stupidity of royalty. Seeking to create different musical themes, rhythms, and orchestrations for each of the film's major episodes, he composed sixteen different pieces along the lines of a ballet score, and later blended them into the five-part *Lieutenant Kizhe Suite*, which became one of the best-known pieces he ever wrote. No longer obliged to curry the favor of impresarios, conductors, and wealthy patrons to have his works performed, Prokofiev now had his pick of the many commissions that the government-financed Soviet world of art had to offer. When he and his wife celebrated the New Year with their friends at the Moscow Art Theater in 1936, the future seemed so promising that he left Moscow for a brief concert tour of Europe "without particular enthusiasm" two weeks later.[65] He appeared not to notice that his travels between East and West were not possible for others, nor did he seem to understand that the careers of his friends Meyerhold and Eisenstein had begun to fall upon harder times. Then, as the winter of 1936 drew to an end, he learned in a single crushing moment that the artistic freedom he had taken for granted in the West could never be his in Soviet Russia. From that time forward, neither his life nor that of his young colleague Dmitrii Shostakovich would ever be the same.

Born in the aftermath of the Revolution of 1905 and educated under Bolshevik tutelage, Dmitrii Shostakovich had conceived in his early twenties a grand vision of "a Soviet *Ring of the Nibelungs*" that would be "the first operatic tetralogy about women."[66] Based on a novel by the nineteenth-century writer Nikolai Leskov, *Lady Macbeth of the Mtsensk District* became its first part and premiered to rave reviews in 1934. Built around the story of a merchant's wife whose insatiable passion for her peasant lover drives her to kill her husband, her father-in-law, and her cousin, Shostakovich's opera highlighted the excruciating boredom of life in nineteenth-century Russia's provinces and underlined the oppression its women perpetually suffered. Critics called it "an expression of the great creative urge that characterizes our musical front," and proclaimed that only under the conditions of life in Soviet Russia could such work ever have been written.[67] When exported to the United States in late 1935, *Lady Macbeth* played to sold-out houses in Cleveland, Philadelphia, and New York, where the line for standing-room-only tickets stretched for a block and a half in the midst of a driving snowstorm. As Shostakovich was greeted on both sides of the Atlantic as a composer of immense promise before he turned thirty, greatness seemed to be firmly within his grasp as the year drew to an end.[68]

Then, on January 28, 1936, a bolt of lightning struck. In an unsigned editorial entitled "Confusion Instead of Music," *Pravda* condemned Shostakovich's *Lady Macbeth* as a "confused stream of sound" filled with "quacks, grunts, and growls" that were designed to "[carry] into the theater and into music the most negative features of 'Meyerholdism' infinitely multiplied." In doing so, the anonymous reviewer concluded, Shostakovich had "ignored the demand of Soviet culture that all coarseness and wildness be abolished from every corner of

Soviet life."[69] A week later, a second editorial condemned *Limpid Stream*, the new ballet in which Shostakovich described the joys of collective farm life, as "music without character" that did nothing more than depict "painted peasants on the lid of a candy-box." Taken together, the two editorials turned Soviet music on its head. In what had suddenly become a very uncertain world, composers and critics struggled to find their bearings.[70]

Obviously written with the approval of Stalin, who had walked out of a performance of *Lady Macbeth* two days before, the *Pravda* editorials sent an icy chill through the veins of every Russian composer at the same time as they threw the nation's critics into a frenzy of maneuvering to explain away their recent enthusiasm for Shostakovich's work. During the "creative discussions" that raged for three days at secret meetings of the Composers' Union in Moscow and Leningrad, only one man dared to call Shostakovich "the greatest genius amongst composers of this epoch,"[71] while scores hastened to speak in support of *Pravda*'s views. Accused of "formalism," which was defined in those days as "the sacrifice of the ideological and emotional content of a musical composition to the search for new tricks in the realm of . . . rhythm, timbre, [and] harmonic combinations,"[72] Shostakovich saw his opera removed from the repertoire of the theaters that had performed it to cheering audiences just a few weeks before. At the same time, Stalin's attack against "formalism, leftist deformations, and distortions" spread to the theater, painting, literature, and the cinema in a campaign that soon led to Mandelshtam's death in the GULag, Meyerhold's execution, and the imprisonment of scores of writers, painters, performers, and builders who were found guilty of "formalistic eccentricities."[73]

Many of the men and women who shaped the Soviet world of art struggled to escape the pall of fear that had fallen upon them by promising to become more attuned to the life of the masses, but Shostakovich vowed to continue writing music "even if they chop my hands off . . . [and] I have to hold the pen in my teeth."[74] Refusing to lower his music to the masses' lowest common denominator, Prokofiev joined him, remarking in disgust that "in our country, everything that is not understood at first hearing is condemned as 'formalistic.' "[75]

For reasons that still are not clear, both composers were allowed to continue their work, and Shostakovich saw his Fifth Symphony premiered at the Leningrad Philharmonic less than two years after the editorials against him had appeared in *Pravda*. Yet the impact of Stalin's terrible attack could never be erased from the composer's memory. Shostakovich set aside forever his dream of creating a "Soviet *Ring of the Nibelungs*," and never wrote another opera. Nor would any other Soviet composer take up his plan to create an operatic framework that would bring to life the Bolshevik vision of women set free by revolution. Instead, the terror that Stalin had inflicted upon the world of Soviet music produced such ugly creations as Ivan Dzerzhinskii's operatic version of *And Quiet Flows the Don*, which for being "closer to the soil" won the Stalin Prize not long after Shostakovich's ordeal began.[76]

Just a few weeks after *Pravda* published its editorials against Shostakovich, the "Lady Macbeth Affair" spilled onto Prokofiev when the mediocre twenty-three-year-old composer Tikhon Khrennikov denounced him for having injected the poison of "formalism" into the very heart of Russia's young composers' work. Reluctant to retrace his steps to Paris and renounce the Soviet citizenship he had just accepted, Prokofiev retreated into the carefree childhood world of nature and imagination, and finished the entire score for *Peter and the Wolf* in time for his forty-fifth birthday on April 23, 1936. Cheered by its reception, he hurried to compose a musical score for a film version of *The Queen of Spades* and to write incidental music for Pushkin's *Boris Godunov* and *Evgenii Onegin* only to have them all rejected by the Stalinist establishment as inappropriate for Soviet audiences. Then Prokofiev's *Cantata for the Twentieth Anniversary of [the] October [Revolution]* suffered the same fate, and it was not until he completed his score for Eisenstein's film *Aleksandr Nevskii* that he finally regained the good graces of his critics.

Anxious to adjust his musical vision to the realities of Soviet artistic life and knowing that "to write an opera on a Soviet subject is not a simple problem,"[77] Prokofiev chose Kataev's novel *I Am a Son of the Working People* as the basis of the opera he began to compose at the end of 1938. Like all other popular novelists of the 1930s and 1940s, Kataev had followed the precepts of Socialist Realism faithfully to show how Bolshevik virtue triumphed over adversity when Semen Kotko, a Ukrainian peasant hero, fought against the Whites and their German allies during the Russian Civil War. Yet, unlike so many other works of the period, Kataev's book rose above the formulaic models that had shaped it, and Prokofiev found in its pages the "live, flesh-and-blood human beings with human passions, love, hatred, joy, and sorrow arising naturally out of our new conditions of life" that he sought.[78]

Knowing that Stalin preferred operas with sentimental, highly politicized, easily remembered tunes, Prokofiev nonetheless demanded that Soviet masses and their leaders rise to the level of his music. To continued criticisms that his compositions were too abstract and lacked melodies, he replied that audiences' capacity to hear music changed over time, and that his melodies were no more out of tune with the times than Beethoven's and Wagner's had been.[79] In reply, the mediocrities who ruled Soviet musical life greeted *Semen Kotko* with only the most grudging praise and hurried to compare it unfavorably with mediocre works that portrayed the joyful "reality" of Soviet life more convincingly. It was necessary for opera to be more "democratic," they insisted. To the disgust of Prokofiev and such virtuosos as the young Sviatoslav Richter, who called the new opera "an event of major magnitude,"[80] Soviet critics again pointed to the maudlin creations of Tikhon Khrennikov as the compositions most deserving of praise.

By the beginning of 1940, the world for which Prokofiev had forsaken Paris and the West had begun to seem very drab. At about that time, he and his

Spanish-born, New York–raised first wife Carolina Codina went their separate ways, and he soon began to live with Myra Mendelson, a young Jewish woman exactly half his age, who was the niece of Stalin's Commissar of Heavy Industry, Lazar Kaganovich. Announcing that "today one must work [because] work is the only thing, the only salvation,"[81] the composer started to compose the ballet *Cinderella* and an opera to which he gave the title *Betrothal in a Monastery*. Then, on June 22, 1941, the armies of Nazi Germany stormed into Russia and the focus of Prokofiev's inspiration changed entirely. While Shostakovich wrote the massive first movement of his Seventh (Leningrad) Symphony as he and his family huddled in one of the city's bomb shelters,[82] Prokofiev turned to Tolstoi's triumphant saga of victory over Russia's invaders in 1812 and drew from it an opera that was to remind the Russians of their glories when other conquerors had entered their land.

As searchlights cut through the Moscow night sky above him, Prokofiev composed the first movements of the opera he would call *War and Peace*. When he and Myra were evacuated to Alma-Ata, more than two thousand miles east of Moscow, he continued to work on the opera even as he wrote the score for Eisenstein's *Ivan the Terrible*. By the time they returned to Moscow two years later, he had in hand a self-consciously Russian, loosely connected collection of eleven "scenes," to which he would later add two more, all of them keyed to a libretto that the young woman who was to share the rest of his life had extracted from Tolstoi's own words and sources. Judging it to be the most important of all his works, he looked forward to having *War and Peace* performed soon after the war's end. Cheered once again by audiences for the deeply patriotic feelings his compositions had stirred during the war, he had every reason to expect *War and Peace* to be a success.

While Russia's armies recovered from the Nazi onslaught and began their march to Berlin, Prokofiev's music flooded Moscow's concert halls. The month of December 1943 saw the successful premieres of several new works, and the next two years saw more successes still. In honor of his fifty-fifth birthday in 1946, three of his piano concertos were performed by one artist in a single evening concert, but the premiere of *War and Peace* kept being postponed. Insisting that "bad, disharmonious music undoubtedly has a bad effect on man's psycho-physiological activity," Andrei Zhdanov, the Politburo member who spoke for Stalin in matters of ideology and culture, accused Prokofiev at the beginning of 1948 of creating "false, ugly, idealistic music" that was "unwanted by the people of the Soviet Union."[83] To the delight of the artistic mediocrities who had gathered to hear his speech, Zhdanov insisted that Prokofiev was not alone. Others, too, must repent of their sins and pay the price for having violated the sacred canons of Socialist Realism.

As the timeservers of the Soviet musical world raised a chorus of denunciations to accompany Zhdanov's vicious charges, it appeared to Prokofiev that "everyone seemed to go mad."[84] At the head of the list of offensive works that could no longer be performed in the Soviet Union, the Composers' Union

bureaucrats placed the Sixth Symphony, which had won him the exalted title of People's Artist of the U.S.S.R. just two years earlier. Then came his Sixth, Seventh, and Eighth sonatas, his arrangements of folk songs, all the ballets he had written in the West, and his Third and Fourth symphonies. Severely weakened by the malignant high blood pressure that would soon claim his life, the composer never confronted his accusers and they let him remain free once they had toppled him from the apex of the Soviet music world. Sick in body and spirit, he died on the same day as Stalin in 1953.

The thaw that followed Stalin's death allowed Prokofiev to be recognized once again in the Soviet Union as one of the greatest twentieth-century Russian composers, but there could be no doubt that the brutality of the regime under which he had so blithely chosen to spend the last two decades of his life had taken a terrible toll. The sterile artistic reality that the Bolsheviks' utopian vision had created eventually had crushed Prokofiev's spirit, for like every other artist in Stalin's Russia he had been obliged to concede that the dictates of those supremely vulgar philistines who ruled the world of Soviet art must shape every form of artistic inspiration. Only in that way could the all-powerful Party bring its deadening vision of the people's art truly into focus.

Among the artists who struggled to tolerate the sterility of the Soviet artistic vision and remain true to the ideas and feelings that moved them, the writer Boris Pasternak may have been one of the most successful.[85] A Jew born in Moscow at a time when most Jews were being driven from the city by the anti-Semitic policies of the Emperor Alexander III, Pasternak drew no inner sustenance from the faith that supported Mandelshtam and Chagall in times of crisis, and he viewed the world mainly from the perspective of the artistic influences that shaped his life. As one of the creators of Russian Impressionism and a prominent portrait painter, his father, Leonid, taught at the Moscow School of Painting, Sculpture, and Architecture, while his mother, Rosa Kaufman, played the piano with a brilliance that won her a place on the faculty of the conservatory at the age of twenty. A prodigy whose early adolescent renderings of Beethoven had captured the heart of Anton Rubinstein, she had played to thunderous applause in Vienna just after she turned sixteen, yet she abandoned her career to care for her husband and children without a second thought. "You have sacrificed your genius to me and the family," Pasternak's father once told her late in life. "Of us two," he added, with the honesty that set him apart from so many of his contemporaries, "you are the greater artist."[86]

Because his parents both lived for art and surrounded themselves with its creators, Pasternak spent his childhood at the very center of an artistic world that included Skriabin, Chaliapin, Nikolai Ge, Repin, Lev Tolstoi, and the German poet Rainer Maria Rilke. Raised to believe that his enemies would be powerless against him so long as he remained true to his art,[87] Pasternak learned from his parents that the key to any medium lay in mastering its fundamental techniques. Certain that art "always meditates on death and thus always creates life," he concluded that "man does not live in nature but in history," and that "all great art

tries to convey an integral vision of the world." He saw history (in the words of Dr. Zhivago) as "the centuries of systematic explorations of the riddle of death with a view to overcoming death," and believed that art, as a creator of life, could play a fundamental part in its triumph. Convinced that "form is nothing but recorded movement," he set out to reproduce the "whirling world as it was rushing headlong." At every step of Pasternak's artistic odyssey, his father, "a Colossus . . . large and wide as the world," loomed before him. "Before this image," he confessed when his father was seventy-two and he was forty-four, "I am still a nonentity and in every respect still a boy."[88]

Destined to win fame as a poet and a novelist, Pasternak first pursued his fascination with "recorded movement" in the realm of music. Enthralled by his mother's home performances and fascinated by the music of Skriabin, whom he later called "a personified festival and triumph of Russian culture,"[89] he studied piano and composition for six years before deciding that his abilities were too limited to give shape to his visions as a composer. At Skriabin's urging he turned to philosophy, which in the late spring of 1912 took him to Marburg and the university at which Russia's first Renaissance man, Lomonosov, had studied almost two hundred years before. Conscious of walking in Lomonosov's footsteps from the moment he arrived, Pasternak studied logic, ethics, and aesthetics with the university's leading scholars until love intervened in the person of a young woman who had come from Moscow to visit him. He asked her to marry him, and her refusal showed him a "fresh laconicism of life" that convinced him to exchange philosophy for poetry.[90] "Every love is a crossing over into a new faith," he explained some years later. By summer's end he had come to "the end of philosophy, that is, the end of whatever thought I had entertained about it."[91] He returned to Russia that fall to prepare for his university examinations—and to become a poet, mainly under the influence of Rilke, whose poetry he had already begun to translate.

In the summer of 1913, Pasternak started to write poetry, "not as a rare exception, but often and continuously, just as one paints or composes music." A few months later, he published his first book of poems, "entitled, with stupid pretentiousness," he later said, *A Twin in the Storm Clouds*.[92] His "large eyes, puffy lips, a proud dreamy look, a tall stature, a harmonious gait, and a beautiful and resonant voice," the avant-garde painter Iurii Annenkov remembered, gave him a magnetism that strangers found so hard to resist that "on the streets . . . passers-by—in particular women—would instinctively stare at him."[93] He was often seen in the company of the poets Balmont, Ivanov, and Khlebnikov, and in May 1914 he debated Maiakovskii at Moscow's famed Café Grek. Rejected for military service because of a childhood injury that had left one leg shorter than the other, he spent part of the war years in the Ural Mountains, where he processed exemptions from military service for peasants who worked in a chemical plant. Deeply involved with Futurism, he could never share Maiakovskii's passion for the brave new world that machines promised to create, nor did he

have much sympathy for Khlebnikov's nostalgia for the distant past. Pasternak spoke with his own voice, freely associating images, which through his own internal logic took on a special form that was uniquely his.[94]

Between the revolutions of February and October 1917, Pasternak wrote most of *My Sister, Life*, the volume of verse that would establish him as one of Russia's leading poets. That summer, he "wrote down," as he told a friend some forty years later, "only what by the character of language or by the turn of the phrase seemed to escape from me entirely of its own accord, involuntary and indivisible, unexpectedly and beyond dispute."[95] It was the only time in his life, he confided to Mandelshtam's widow long after they both had reached middle age, when his poetry had poured forth of its own volition.[96] Then, while the hunger, cold, and turmoil of the Civil War swirled around him during the years that followed, his poems took on a life of their own at Moscow's *cafés chantants,* where men and women gathered to share their art during the days when food was scarce, life's other necessities hard to come by, and the future uncertain. Tsvetaeva later called this Pasternak's time of "subterranean fame," as admirers passed dog-eared copies of his poems from hand to hand because shortages of paper had delayed their publication.[97] When *My Sister, My Life* finally appeared in spring in 1922, it seemed to Mandelshtam that "such a new and mature harmony [had not] sounded in Russian poetry" in nearly a hundred years. His wife called Pasternak's work "a book of knowledge about the world," while Tsvetaeva, who had just emigrated to Berlin, thought that it seemed like "a downpour of light."[98]

In the midst of his newfound fame, Pasternak married a beautiful young Petrograd painter and moved to Berlin, where his parents had settled the year before among the scores of writers and painters who were debating whether to return to Russia or stay in the West. Along with Chagall, Kandinskii, Nabokov, and many others who decided that the freedom of thought and expression offered by the West more than compensated for the miseries of émigré life, his parents chose to remain. Yet Pasternak, whose antipathy to politics enabled him to compress the soul-wrenching turmoil of war and revolution into the single autobiographical phrase, which noted that "six years passed," saw the West differently. "Deceived by nothing, deceiving no one, with a hand stretched out to the times as for alms," he later wrote, "Germany was starving and freezing."[99] Combined with the émigrés' political and artistic squabbles, poverty depressed him, while the rapid recovery that Lenin's New Economic Policy brought to Russia seemed to promise new excitement. With Moscow now boasting more than two hundred private publishing houses, and Petrograd nearly a hundred more, the reams of poetry that had been written during the Revolution and Civil War suddenly blossomed in print, and it seemed that a new golden age of literature was about to begin.[100] As "a happy man [who] will never be embittered," one of his friends wrote, Pasternak went back to Russia in the spring of 1923, feeling that "the propulsion of history" had left him no choice.[101]

For a time, the visions that had drawn Pasternak back to Moscow shone brightly, but by the middle of 1925 danger signs began to appear. As Russia's artists and writers grappled with the dilemmas posed by Soviet life, the First All-Union Conference of Proletarian Writers issued a blanket condemnation of all works "directed against the proletarian revolution," and the Central Committee of the Communist Party demanded that its members "work out proper forms understandable to the millions."[102] By the time the Bolsheviks celebrated the tenth anniversary of their revolution, scorn for intellectuals as purveyors of empty dreams and boring rhetoric filled the air, making it more urgent than ever for writers to become "proletarian" in manner and outlook.

While Eisenstein and Pudovkin greeted the Revolution's tenth anniversary with the films *Ten Days That Shook the World* and *The End of St. Petersburg,* Pasternak celebrated it with *The Year 1905,* which contained episodic poetic cameos of the upheavals that had created the backdrop for the more stirring events of 1917. In *The Year 1905,* the victims of the "Bloody Sunday" massacre, the terrorist who killed the reactionary Grand Duke Sergei Aleksandrovich, the students, peasants, and workers of Moscow, and most of all the leader of the *Potemkin* mutineers, Lieutenant Shmidt, all appeared larger than life as they sacrificed themselves to dreams of a brighter future. Especially in his rendering of Lieutenant Shmidt, Pasternak combined moral purity and lofty idealism with character traits that tied him both to the mournful people of Chekhov's fading world and to Shakespeare's Hamlet. In the process, he found those same qualities—the very ones which, a quarter-century later, would form the essence of Doctor Zhivago—in himself.[103]

*The Year 1905* transformed Pasternak into a literary mentor for Russia's Bolshevik "sons" and "daughters" in the same way that Gorkii continued to stand as the model for their "mothers" and "fathers." Maiakovskii greeted the poem as an example of how verse ought to be written, and *Pravda* reviewed it with undisguised enthusiasm at the same time as Tsvetaeva and the émigré critic Prince Dmitrii Sviatopolk-Mirskii acclaimed it as one of the highest achievements of European culture. In Moscow, the editor of *Novyi Mir* (*New World*), the literary journal that would publish some of Soviet Russia's best literary creations, claimed that Pasternak's new poetry surpassed even Maiakovskii's in technical brilliance and depth.[104] Pasternak would later call the few years that spanned Stalin's rise to power his own "second birth," in which a "reconciliation with reality" enabled him to come firmly to grips with the world around him. "[I am] at work on three connected works," he wrote at the age of thirty-nine in 1929. "I worry about my ability to meet publishers' schedules."[105]

By 1932, Pasternak had finished *Spektorskii* (a "novel in verse" in the tradition of Pushkin's *Eugene Onegin*) and *Safe Conduct* ("a philosophical thing of autobiographical content"),[106] and then had gone on to celebrate their completion by publishing *Second Birth,* a volume of poetry that he had written during the year after Maiakovskii's suicide. During those years, he fell briefly but passionately in love by mail with Tsvetaeva, for whom he decided not to leave his

wife, only to divorce his wife to marry the wife of a friend a year or two later. His "second birth" thus stirred the depths of his creativity, while his deep personal turmoil led friends to worry that he might follow Maiakovskii's terrible example as he struggled to overcome the guilt he felt at leaving his wife and son while celebrating the joy of his new love. "I fear for Boris," Tsvetaeva wrote to a friend in Prague in the spring of 1931. "Boris *is incapable of a happy* love. For him to love means to be tortured." Offended in part by the appearance of Pasternak's new wife in his poetry, but also angry that his "reconciliation with reality" had led him to portray that "faraway [realm] of socialism" as being "close at hand," Akhmatova was much less kind. *Second Birth*, she wrote nastily, was "the poetry of a bridegroom beside himself . . . [as] he makes excuses to one woman and runs to the other with a flower for her corsage."[107]

Neither his new love nor the "reconciliation with reality" that heralded Pasternak's "second birth" could carry him through the 1930s without decisive changes in his life and art. Even though it stood very far from the dreams he had embraced in 1917, he seemed entirely prepared to accept the reality of Soviet Russia. But he could not accept the depersonalization of the human spirit that Stalin and his lieutenants demanded, nor could he defend a system that left millions of starving peasants to beg for bread in Ukraine and the lands along the Volga. "How would you want me to write about the desolation?" he asked when *Pravda*'s editors suggested that he describe what he had seen on a visit to construction sites, where tens of thousands of hungry peasants labored for a crust of bread while the Party faithful ate sumptuous meals in separate dining rooms.[108] Because the gap between the Stalinist vision and reality had become too large for any moral person to embrace, Pasternak insisted that every artist had to determine how to respond to the contradictions it posed.

While Mandelshtam spoke out against the forces he despised at the cost of his freedom, Pasternak retreated into silence. "Time and circumstances are most indulgent toward me," he wrote to a friend as Stalin's bureaucratic colossus tightened its grip. "My reclusive and difficult way of life," he added, "protects me from unpleasant occurrences."[109] When Nikolai Bukharin called for artistic experimentation unfettered by official decrees, in the name of the Central Committee late in the summer of 1934, Pasternak hoped that the time of repression might have passed. "I have become a part of my times and the state, and its interests are my own," he wrote to his father that Christmas, even as the ground began to shift again beneath his feet. Mandelshtam and his wife had been banished to faraway Voronezh, Akhmatova's husband and son both were in prison, and Bukharin's new claim that the year 1935 had been blessed by the "flowering of socialist humanism" seemed entirely divorced from reality. Pasternak felt "a sensation of the end without any visible approach of death" settle upon his heart and soul. In this "time of absolutely unbearable shame and grief," as he later called it, he let his pen fall silent.[110]

Except for two small collections of wartime poetry, Pasternak published nothing but translations between 1934 and 1957. Here, his genius ranged far and

wide, from the German poets Goethe, Schiller, von Kleist, and Rilke, to the Polish Romantic Juliusz Słowacki and the Hungarian Sandor Petöfi. He translated the French Symbolist poetry of Paul Verlaine, the poems of the Czech Surrealist Vitezslav Nezval, and the writings of the Ukrainian Taras Shevchenko, not to mention those of nearly a dozen contemporary Georgians, even though he knew not a single word of their language. From English, he gave new Russian form to the verse of Ben Jonson, Byron, Shelly, and Keats, and his translations of Shakespeare helped to create what some critics have called the "Soviet Shakespeare." Seeing it "not [as] a drama of characterlessness, but a drama of duty and self-denial,"[111] he rendered *Hamlet* into colloquial twentieth-century Russian and imbued Shakespeare's Danish prince with features that he himself shared with his entire generation. In Shakespeare's tragedies and sonnets, Rilke's poetry, and Goethe's *Faust*, Pasternak gave vent to the poetic brilliance he no longer could put into verses of his own. The most important thing for any poet, he now claimed, was to "remain faithful to the springs of poetry in the name of our great love for our country."[112]

Throughout the terrible purge years, Pasternak remained aloof from the politics that condemned artists to silence, prison, or death, while coming to the aid of the victims and their families when he had the means to do so. He gave money to the Mandelshtams when they were banished, and comforted the poet's widow when word of his death arrived. He helped to support the families of others, refused to sign the joint letters that Party hacks drafted against André Gide and Marshal Tukhachevskii, and at various times defended the art of Akhmatova, Babel, and a dozen more when others spoke out against them. "The lives of people are disposed of by the government not by private individuals," he remarked sadly. "I did not give them life; I can't be their judge."[113] As his efforts condemned him to disgrace, presses stopped reprinting his works. Yet, for reasons that have never been explained, Pasternak remained free, even as the Great Purges destroyed Mandelshtam, Meyerhold, and Boris Pilniak, the Germano-Jewish-Russo-Tatar writer whose novels *The Naked Year* and *Mahogany* portrayed the Revolution as a "rebirth of some ancient Slavic quality in the Russian soul," in which romantic, idealistic Communists lived through a moment of "cleansing fire" that had no sequel in Soviet history.[114]

After the purges came the Second World War, which laid waste to almost 2,000 towns, 70,000 villages, 6 million buildings, 84,000 schools, 31,000 factories, and nearly 100,000 collective farms, while it destroyed machinery, livestock, railroads, and roads totaling in value perhaps as much as a quarter of the Soviet Union's entire wealth.[115] Until Hitler's forces were crushed, Stalin eased his grip, deemphasized Party loyalty and ideological orthodoxy, and allowed more freedom of artistic expression than at any time since he had come to power. Patriotism became the true measure of human worth, and men and women could once again differ in their visions of the future, until 1946, when Andrei Zhdanov, the Leningrad Party chief who had emerged as Stalin's *de facto* commissar of culture,

launched a new wave of denunciations to impose ideological orthodoxy on the writers and artists who had spoken too freely.

Any thought of drawing closer to the West, Zhdanov stated flatly, had to be abandoned, all digressions from the Socialist Realist path punished, and every attempt to portray non-Communists in sympathetic terms condemned. Within months of receiving the Stalin Prize for Part One of *Ivan the Terrible*, Eisenstein was told that Part Two could not be released because it portrayed a Russian ruler in terms "something like Hamlet."[116] Then, proclaiming that "our art is not a museum of historical weapons, but an arsenal meant for war," Zhdanov condemned Akhmatova for being "devoid of principles and ideas," and engineered her expulsion from the Writers' Union, along with the brilliant master of satire Mikhail Zoshchenko.[117] Taking the position that "the most important element in music was a melody that could be hummed," he denounced all music that did not fit that mold.[118] For being "carried away by confused, neurotic combinations which transform music into . . . a chaotic conglomeration of sounds" that reflected the decadent "spirit of American and European music," he once again condemned Prokofiev and Shostakovich to silence.[119] Warning his listeners that Pasternak "has always been selected by our enemies to be counterposed to us," one of Zhdanov's minions now claimed that the man who had once rivaled Maiakovskii for the title of the greatest Soviet poet had "spent his entire life in our poetry as a swine beneath an oak tree."[120] Pasternak's poetry, another Party loyalist chimed, was "the most blatant example of rotten decadence."[121]

While Zhdanov's literary bureaucrats continued their campaign to root out the "rootless cosmopolitans," Stalin died, and the Russians began to challenge those dogmas that had held their art in check for so long. One brave young woman wrote that the time had come for lovers in Soviet films to start whispering romantic sweet nothings instead of discussing production quotas, bulldozers, and tractors, and the poet Olga Berggolts, who had lived through the entire siege of Leningrad, bravely argued that without true "lyrical" heroes, Russian art and literature were being deprived of "humanity" itself.[122] Within three years, what had begun as timid whispers became a clarion call for new directions, and writers seeking to return genuine emotions and feelings to their proper places in the realm of human experience asked to be freed from the stereotyped formulas that exalted the collective over the individual. Novelists and poets started to criticize abuses in high places and to lament the corrupt qualities of mind and spirit that had flourished in Stalin's time. A way had to be found, they now insisted, to restore true Communist values and humanize a system that had become dehumanized by the abuse of power by faceless bureaucrats.

Published less than a year after Stalin's death, Ilia Ehrenburg's *The Thaw* made all these points and more. Born, like Pasternak, into a Russian Jewish family that had broken away from its roots and faith, Ehrenburg had spent much of the time between 1909 and the end of the First World War in France, where he had served as a reporter for a number of Russian and Soviet newspapers. In

1922, his *Extraordinary Adventures of Julio Jurenito and His Disciples* had earned him praise for its scathing attacks on bourgeois culture, and he had later written equally critical essays about the "conquest" of Europe by American capitalism. As *Pravda*'s correspondent in Spain during 1936 and 1937, he had filed vivid descriptions of Fascist atrocities during the Spanish Civil War, and his reports during the Second World War had attacked the Germans with unprecedented fury.

After the war, he had returned to Russia and proved himself marvelously adept at navigating the treacherous political shoals in which so many writers lost their bearings. During Stalin's last years, he sat on the committee that awarded the Stalin Prizes, represented the Soviet Union at writers' conferences all around the world, and played a major role in literary politics. Then at Stalin's death he shifted his position with consummate skill and published *The Thaw* to highlight the flaws of the system he had chosen to serve. A critic later remembered how the book "seemed [to be] a miraculous occurrence which . . . revealed Soviet life in its real colors and contours."[123] By attacking the caprice, dogmatism, and deadening monotony of the establishment that had ruled Russia's arts for thirty years, Ehrenburg became the first public champion of individualism and liberalization in the post-Stalin era.

Despite its condemnation by the Russian literary establishment as a "negative" and "formalistic" attempt to "revise the basic principles of Soviet literature and throw its ideological content and truthfulness into doubt,"[124] *The Thaw* signaled a brief loosening of the iron grip in which Soviet authorities had held the arts. Two years later, Khrushchev delivered his now-famous secret speech in which he denounced Stalin as a bloodthirsty, irrational tyrant, and some of the men who had helped to create the Stalinist literary establishment hurried to follow his lead by calling for more room for individualism and personal creativity. As men and women who had fallen silent for so long suddenly found their voices, Pasternak spoke loudest among them. Reaching past the Stalin era to the events that had brought the Bolsheviks to power, he demanded that Russians rethink the meaning of the Revolution that had given birth to the world in which they now found themselves.

While the critics who so despised his poetry thought they had tormented him into silence, Pasternak had been working on "a spiritual history of the Russian revolution" that bore the title *Doctor Zhivago*.[125] Although critics have searched for the novel's roots in much of what he wrote during the 1930s, Pasternak set down its main lines during the year after the Second World War ended, and just before he met the young woman who would become his main source of spiritual and emotional solace during the last fifteen years of his life. A provincial schoolteacher's daughter, who had come to Moscow to work at the editorial offices of *Novyi Mir*, Olga Ivinskaia equated Pasternak's poetry with "talking to God,"[126] and defined her life's mission as being to help him create all the literary beauty of which he was capable. Her love inspired him, and from it he drew his vision of Lara, the woman with whom Dr. Zhivago discovered love's greatest

miracles. "I love you truly," Pasternak wrote in a book he gave Ivinskaia in the spring of 1947. "This inscription," he added a few years later, "is eternal and valid forever."[127]

Unlike Zamiatin, who had set *We* in an imaginary future, or Bulgakov, who had chosen to place part of *The Master and Margarita* in the far-distant past, Pasternak set *Doctor Zhivago* within the time span and experience of his own life. Out of them, he created what Tolstoi once had called an "endless labyrinth of linkings,"[128] of shadows "crossed by destiny," as Zhivago would say in one of his poems,[129] in which true love happened because the earth, sky, trees, and clouds all willed it.[130] For Pasternak and the woman he loved, *Doctor Zhivago* became a "settlement of accounts" with the system that had tormented them both. It became his way of "getting even" for the "outrageously dark and unjust life" that the Bolshevik vision had imposed upon them and so many others who were close to their hearts.[131]

Written on a panoramic scale similar to that of *War and Peace*, *Doctor Zhivago* tells the story of Iurii Zhivago, an idealistic young physician who lives through the tumultuous events that swept across Russia between 1905 and 1929. As it follows Iurii's path through war, revolution, and reconstruction, the novel offers none of the vast historical sweep that made *War and Peace* so famous, nor does it display the mass of historical information that Solzhenitsyn would later assemble in *August 1914*. Virtually no real historical characters appear in its pages, and little is said about the thoughts that moved the great men of the time. *Doctor Zhivago* looks only at the impact of events on the private lives of its characters, none of whom stands even close to the forefront of history. Shaped by what Pasternak called "the frank arbitrariness of coincidences," the novel lacks the precise realism that made the works of Tolstoi and Chekhov ring so true. Yet its view that history is shaped by the unsystematic and self-centered actions of countless little people attending to their private wants and needs has much in common with Tolstoi's. "With the help of time and memory," Pasternak says near the beginning of his novel, history had been "made by man to answer the challenge of death."[132]

Like the Hamlet Pasternak so loved, Zhivago meets every crisis with hesitation and doubt, and lets the actions of others shape the course of his life. Coincidences and chance encounters bring him to love, send him to war, put him in danger, and save him from death. "His life in historical terms is a failure," a critic once wrote. "He has had two families but has taken care of neither, and the woman he loved he surrendered to a scoundrel who could save her life." Still, even if his life seems to be of little consequence, there is more to Zhivago than meets the eye. At his death, he leaves a slim volume of poetry, which shows for all time that "the life he created in art was a priceless treasure bequeathed to all men."[133]

Politics, not art, made the publication of *Doctor Zhivago* in 1957 the most significant Soviet literary event between the appearances of Zamiatin's *We* in 1927

and Solzhenitsyn's *GULag Archipelago* in 1973. Pasternak had originally intended for his novel to appear in *Novyi Mir*, but when the political backlash following the Hungarian uprising in the fall of 1956 forced its editors to cancel publication, he allowed the Russian edition to appear first in Italy. Presented as a victim of crude Soviet censorship, the book's fame soared in the West, and critics greeted its translation as "one of the great events in man's literary and moral history" (America's Edmund Wilson);[134] "perhaps the most important novel of our age" (France's Nobel laureate François Mauriac); and "a masterpiece of world literature" (*Il Lavoro*, one of Italy's Communist newspapers).[135] Within two years, *Doctor Zhivago* had been translated into twenty-five languages. By the beginning of 1959, more than half a million copies had been sold in France and England alone.[136]

In Russia, the timeservers who ruled the realm of literature saw each new accolade as an outrage. Then, when the Swedish Academy of Literature and Philosophy announced in the fall of 1958 that it had awarded the Nobel Prize for Literature to Pasternak, the Soviet press exploded. Incensed that "an artistically poverty-stricken and malicious work . . . full of hatred for socialism" should have been chosen for an honor that had been denied to such Soviet literary icons as Sholokhov, Moscow's widely read *Literary Gazette* denounced the Academy's decision as being "penetrated with lies and hypocrisy." *Doctor Zhivago*, it claimed, was nothing more than "the life story of a malicious philistine, an enemy of the Revolution," who had betrayed his country and its people. "In his novel Pasternak openly hates the Russian people," the editorial concluded. "*Doctor Zhivago* is a concentrated, condensed slander on Soviet partisans, on the Red Army, and on the great creation of the builders of a new life on Soviet soil." The next day, *Pravda* condemned Pasternak for having taken "the barren road of anti-realism" and dismissed Zhivago as an "infuriated moral freak" who had found fame as the main character in a piece of "low-grade reactionary hackwork molded into the form of a literary composition." The Union of Soviet Writers hurried to expel Pasternak for having allowed himself to become "a tool of bourgeois propaganda, a profitable object for the speculation of those circles who organize the cold war [and] endeavor to slander all progressive and revolutionary movements." *Doctor Zhivago*, the Union's leaders concluded, was shaped around an idea that was "false and paltry [and] fished out of a decadent heap."[137]

A few days after his expulsion from the Writers' Union, Pasternak renounced the Nobel Prize. "In view of the meaning given to this honor in the community to which I belong," he cabled the Swedish Academy, "I should abstain from the undeserved prize that has been awarded to me."[138] He now felt that he had no choice but to return to the silence that had helped him survive the repressions of the 1930s and 1940s. "I am like a beast in a trap," he wrote in a bitter poem that appeared in the *London Daily Mail* just before he fell silent. "There is no way out for me."[139] In vain did foreign writers, some of whom had sympathized with Communism's cause in the past, send appeals to Pasternak's persecutors. In reply, Sholokhov, who so recently had condemned Russia's literary bureaucrats for

trying to shape Russian literature by decrees, called *Doctor Zhivago* a "shapeless novel" written by a "poet of old maids." If the novel had been published in Russia, Sholokhov argued, its readers would have given Pasternak a beating.[140]

Statements such as Sholokhov's only underlined the brutal absurdity of the whole sorry business, from which the Soviet literary establishment found it impossible to retreat. There is a story that, about six months before Pasternak died in the spring of 1960, Khrushchev was told by Aleksei Adzhubei, the son-in-law who edited the newspaper *Izvestiia*, that there was "nothing fundamentally wrong" with *Doctor Zhivago* and that it would quite easily have been published in the Soviet Union had three or four hundred words been omitted.[141] Nonetheless, it remained a crime throughout the 1960s to read the book, and a number of people paid for doing so by spending several years in labor camps.[142] Even when some of Pasternak's poems were republished later in the decade, those that formed the final chapter of *Doctor Zhivago* remained forbidden. Yet word of Pasternak's novel continued to spread, and Ivinskaia tells how "more than a thousand young people" gathered one autumn night in 1971 to hear a reading of the Zhivago poems in the woods near a village outside of Moscow.[143] Even though more and more Russians read it in foreign editions, *Doctor Zhivago* would not be published in Russia until well after Gorbachev's *perestroika* had taken hold.

In the meantime, what became known as the Pasternak Affair focused world opinion on the meaning and quality of the Russian artistic experience at the same time as it undercut the Russians' long-standing claims that Socialist Realism and Soviet life had raised art to a higher level. Concerned mainly to bestow privilege and material comfort on artistic mediocrities in return for absolute loyalty, the Soviet artistic establishment had reached a point where it could tolerate no digressions from the long-stereotyped models according to which it insisted that all arts must be shaped. Catapulted into the arena of world opinion, where they could not control information by the same means they had used in Russia since the early days of Stalin, Russia's literary bureaucrats had unleashed a vitriolic flood that had brought the entire Socialist Realist vision into question. "It was we ourselves, with our own hands, who ill-advisedly set in motion the scandal over Pasternak," the well-known writer and critic Konstantin Paustovskii wrote ruefully some years afterward. "There is nothing hostile to the Soviet system in *Doctor Zhivago*," he concluded. "[Why] must we always view any criticism of our shortcomings as a calumny or a crime?"[144]

Both in the Soviet Union and the West, the bitter debate over *Doctor Zhivago* showed that the monolithic façade of Stalin's Russia had begun to crack. Like the thin edges of ice that begin to melt on those sunny late-winter days that herald the coming of spring in Moscow, the first droplets released by the impending thaw had appeared even before Stalin had died, and by the time Khrushchev took power three years later they had begun to gather into ever-enlarging pools. When the easing tensions of the early Khrushchev years reestablished some of the points of contact between Soviet and émigré life that had flourished in the

1920s, men and women whose sense of the past, present, and future had been compressed into the rigid Socialist Realist mold began to learn that another world of Russian artistic experience had created treasures of which they had remained entirely ignorant throughout the High Stalinist Era.

Ready to be alienated as younger generations so often are, Russia's amazed sons and daughters of the late 1950s and 1960s began to discover that their fathers and mothers had kept from them the creations of Chagall, Kandinskii, Stravinskii, and Nabokov. They began to hear again of Bunin and Zamiatin, and also to discover from scattered and whispered conversations just how many people of talent had been destroyed in the quarter-century just ended. At the same time, the new avenues of communication with the outside world that had opened at the beginning of the Khrushchev era allowed Western intellectuals to understand more clearly what had happened to the many men and women whose vision of the future had differed from their Stalinist mentors'. Then the crude brutality of the Pasternak Affair had cut these first hesitant contacts short. Yet without reviving the full-fledged terror of the Stalin era, the Soviet authorities could not sever these new bonds entirely. Especially when the heavy hand that had tried to crush Pasternak reached out to seize Aleksandr Solzhenitsyn and a whole new generation of dissidents who had grown up after World War II, the Western intellectuals and writers who had been so quick to make apologies for the brutality of the Bolsheviks' efforts to build a brave new world in the 1930s started to speak out. No longer were they so willing to disdain any art and literature that conflicted with their sympathy for the Soviet experiment. The forces of public opinion that had worked to prevent Nabokov's novels from being translated, and had once protested the Book-of-the-Month Club's adoption of a Russian émigré novel, no longer enjoyed the same uncritical support that they had found in earlier times.

Combined with a new and more energetic dissident movement, the wave of émigrés that flowed from Russia to the West in the late 1960s and 1970s maintained closer ties to the art and literature in the Soviet Union than had either the opponents of Socialist Realism in Russia Abroad or those segments of Western opinion that had demanded uncritical sympathy for Stalin's Russia in the 1930s. This, too, helped to restore the connections between Soviet and émigré art that had been so much a part of life in Berlin, Prague, Paris, and Moscow before Stalin's rigid absolutism had wiped them away. Aleksandr Solzhenitsyn and the poet Joseph Brodsky both were a part of his new movement, and so were scores of other Russians who sought freedom to practice their art. Yet, unlike the founders of Russia Abroad, the dissidents who left the Soviet Union and those who remained at home both shared a sense that émigré and Soviet art could be blended. The merging cultural currents they represented helped to restore the common ground that Stalinism, Socialist Realism, and the bitterness that had shaped the art and literature of Russia Abroad had all but wiped away in the 1930s and 1940s.

The tumultuous Khrushchev years and the stolid era of Brezhnev thus eventu-

ally opened the way to reuniting the parts of Russia's artistic experience that had been split apart by the Bolshevik Revolution, and the currents that had flowed in different directions for half a century began to merge. As a common artistic experience that all Russians once again could claim as their own began to take shape, it revealed that even the heavy weight of the Soviet cultural establishment had not eradicated the creativity that had once made Russian art and letters so brilliant. During the stagnant years of the Brezhnev regime, new gems of literature, art, and theater emerged from such unlikely corners as crumbling pre-revolutionary movie houses, antiquated mimeograph machines, and the faraway villages of Siberia that would give new meaning and depth to the artistic life of the Russians.

# MERGING
# CURRENTS

꧁❈꧂

*WHAT, IN FACT,* had Russia's artistic experience created during the Stalin era, and how could the acclaimed products of Socialist Realism be used to shape the arts in the future? A few days after the secret speech that Khrushchev made against Stalin and his Cult of Personality at the Twentieth Party Congress in February 1956, the much-revered Mikhail Sholokhov answered those questions with such bluntness that no one could mistake his meaning. Claiming that there was nothing of value that any writer could learn from the ideological pedants who had ruled the world of literature, art, and music in Stalin's time, Sholokhov summed up the failings of the entire era in one simple sentence followed by a single brief question. "In twenty years, a thousand authors' pens have produced ten good books," he said. "Not much, is it?"[1] As if to confirm Dostoevskii's deepest fears that all of human society might one day be transformed into an anthill that stifled creativity in the name of collective well-being,[2] the efforts of novelists, poets, painters, and filmmakers to probe the real meaning of Soviet life in the decade that followed reinforced Sholokhov's criticism. The principles that had underlain Soviet society since the Bolshevik Revolution were not yet being called into question, but a number of writers who followed Sholokhov's lead made it clear that the monolithic, sterile vision of Socialist Realism could not continue unchallenged.

As if in response to these questionings of Stalinist orthodoxy, new works that asked if there were not better ways to reach Lenin's vision of the future emerged from the desk drawers and closets to which their authors had consigned them and began to circulate in the underground literary world of *samizdat*. Heroes

and heroines ceased to use the formal, semibureaucratic language that had set them apart from the realm of everyday human experience in Stalin's time, and men and women began to speak in down-to-earth words to express the universal human feelings and values that had had no place in the stereotyped creations that literary bureaucrats still demanded. Novels that portrayed collective farms as vicious arenas of self-interest, greed, and corruption, paintings that embodied the abstract and formalist forms that Stalin had so despised, and plays that portrayed the evils of power in a Soviet context all began to appear as the uncertainty of high officials combined with the carelessness of censors to let creations that could never have come to light in Stalin's time enter the public domain.

As Russia moved from the 1960s to the 1970s, the line that divided acquiescence from dissent became unclear, and the gray area of life in which things were neither openly permitted nor expressly forbidden grew larger. By the 1970s, there seemed to be nothing that the Soviet establishment could suppress entirely, either in terms of homegrown Russian creations or the ideas and art that trickled in from the West in the suitcases of tourists, scholars, and diplomats. Because the Soviet Union's rivalry with the West on the stage of world politics meant that contact with non-Soviet life and art could no longer be suppressed, foreign influences became progressively stronger as the postwar era moved ahead. For Russians living in Moscow or Leningrad, there was no time after 1960 when contact with Western, émigré, and dissident art, literature, music, and political commentary could not be easily made, although it continued to be dangerous.

The increasing openness that culminated in the *glasnost* of the Gorbachev era stemmed from a process that began more than thirty years earlier, when the first daring criticisms of the Stalin era opened the way for much broader dissent in years to come. Set alongside novels and poems whose titles continued to reflect the now-empty visions of Socialist Realism, one of the first literary works to take on that task drew its title from Christ's admonition that "man shall not live by bread alone." Just as Christ had denied Satan's temptations, so Vladimir Dudintsev urged his readers to remember that basic human decency should never yield to the precepts that had shaped the society of which they were all unavoidably a part.

Despite its disconnected narrative, one-dimensional characters, and flat, all too predictable dialogue, Vladimir Dudintsev's *Not by Bread Alone* (1956) revealed for the first time in Soviet Russian fiction that the very qualities of mind and heart that the Stalinist vision extolled threatened to prevent the Bolshevik utopia from ever taking shape. As part of the generation that had been born during the Civil War and had its adolescent impressions shaped by the first Five Year Plans and the purges of the 1930s, Dudintsev had grown up dismissing Tolstoi as outdated and rejecting Dostoevskii as unreadable. Mobilized in 1941 and wounded the following year, he had spent the rest of the Second World War serving on military courts, where he saw the human and tragic side of Russia's military effort. Convinced that "rational thinking is not enough,"[3] he had set out to write a novel that would restore people to their rightful places in history by

allowing their inner thoughts to shape the world around them. Because human rights belonged to each and every person, he argued, the individual could not be set aside in the name of the masses. Men and women who allowed caprice to guide them in achieving Communism's higher goals were no less guilty of oppression than the tyrants who had reigned from on high in earlier times.

Dudintsev shaped his novel around the conflict between one Leonid Drozdov, a builder of Communism, who manages a workers' collective in Siberia, and Dmitrii Lopatkin, an ordinary schoolteacher and inventor, whom the purveyors of bureaucratic mediocrity try to suppress when his genius threatens to deprive them of the comforts they habitually lavish upon themselves. If Dudintsev had followed the Socialist Realist model, Lopatkin would eventually have seen the error of his ways and joined Drozdov's group to become a part of its struggle to build Socialism, but instead he portrayed Lopatkin as working apart while the establishment threatens to crush him. By combining determination and native wit with the moral force of other common people who support him, Lopatkin overcomes his enemies. His success allows the course set by Lenin and the Bolsheviks in 1917 to prevail, even though his bureaucratic foes survive and the conflict between the individual and the collective continues to fester.

At the dawn of the Khrushchev era, Lopatkin's struggle against the collective's institutionalized mediocrity showed the ferocity with which people dedicated to creating oases of middle-class comfort in Russia's Socialist desert could defend their way of life.[4] As the inevitable products of a system that reveled in false accomplishments, such men and women possessed neither Christian virtues nor Socialist morality. Without higher principles, they wielded power only for personal gain, and stood ready to destroy whoever threatened to expose their mediocrity. The novelist and critic Konstantin Paustovskii made clear the danger such bureaucratic managers posed to the arts in Russia when he told the members of the Moscow Writers' Union that Dudintsev's book was a warning to them all. "We cannot imagine what an infinite number of talents, minds, and remarkable men have disappeared," he told his listeners that day. "If these men were still living, our culture would be in full bloom!"[5]

Along with Not by Bread Alone, Ehrenburg's Thaw, and Sholokhov's speech to the Twentieth Party Congress, Paustovskii's remarks showed that the turmoil following Stalin's death had made it possible for differing views to compete in Russia's literary arena for the first time since the 1920s. Yet, even as these daring men and women called for the freedom to embrace inspiration at the expense of Party dogma, the political climate changed. In the fall of 1956, Hungary exploded in revolt against Soviet rule, and the Party tightened its grip on Russia's writers again. Early in 1957, Khrushchev told a meeting of the Writers' Union that his "hand would not tremble" if they dared to follow the Hungarian example, and scores of high officials repeated his warnings. Then, when the successful launching of Sputnik carried the Russians into outer space later that year, the literary establishment's defenders used the accomplishments of Soviet science to attack Dudintsev's claim that mediocrity held sway over Soviet life. "The earth's

gravity has been overcome," the literary critic and philologist Viktor Shklovskii wrote soon afterward. *Sputnik*'s success had affirmed the brilliance of the collective over the individual in science. "What we find in Dudintsev's work," Shklovskii added, "is directly contradicted by [recent] . . . scientific events."[6]

Even as their efforts called down the establishment's wrath, Dudintsev, Ehrenburg, and their defenders strived to revive the Socialist artistic vision by renewing the readiness to experiment with untried courses that had drawn Gorkii, Pasternak, and Aleksei Tolstoi back to Russia when the Civil War had ended. Calling for sincerity to replace deceit and for artificial triumphs to make way for genuine human heroism, these men urged their countrymen to set aside the pervasive suspicions that had allowed Russia's crassly uncultured Drozdovs to reign for so long and to build a truly just society instead. Certainly that was the hope of Evgenii Evtushenko, an idealistic young poet who had just turned twenty when Stalin died. Using the art form most closely allied with political protest and moral outrage throughout Russia's modern history, Evtushenko cursed the superficiality of the world his parents had brought into being and asked why greed and mediocrity had triumphed over talent and virtue. To young men and women born on the eve of World War II, whom a young avant-garde Soviet poet of the 1980s once called "the children of Russia's boring years,"[7] his words about the failings of Soviet life had the force of Tsvetaeva's and Maiakovskii's in earlier times. But unlike the Russians who had helped to build Stalinism, the people of Evtushenko's generation were ready to heed his warnings and share his anger.

Born in Siberia at the beginning of the Second Five Year Plan, Evtushenko eventually came to speak both for dissent and the established order, as the Soviet authorities used his outbursts to claim to the outside world that the monolithic literary restraints of Stalin's time had faded into tolerance. But whatever compromises he may have made so as to let his words be heard, his poetry spoke the truth. "I'm no fraud. I'm the real thing," he wrote just a few months before Khrushchev's famous speech. "Just look inside me!"[8] As a spokesman for Russia's postwar youth, Evtushenko hungered for new experiences and had a passion for foreign places. Russian to the core, he became a citizen of the world, but unlike the generation for whom he spoke, he moved in circles that few of his countrymen could ever hope to enter. He met and talked with Jacqueline Kennedy, Maria Schell, Robert Kennedy, and Ernest Hemingway, called Fidel Castro his friend, confronted Khrushchev, and declaimed his verse in a world which, for a time, greeted him as Russia's premier poet. "I don't want borders," he insisted.[9] "I am like a train / rushing for many years now / between the city of Yes / and the city of No."[10]

Concerned to restore feelings that had withered in Stalin's time, Evtushenko spoke passionately about things still wrapped in shame and silence. He wrote of the horrors that had been visited upon the Jews of Russia and Europe, of the legacy of terror that Stalin had bequeathed to the Russians, and cursed those of Stalin's followers who had killed "millions in the war against the people" of Russia.[11] So long as such men lived, he warned, the legacy of Stalin would torment

every man and woman who had known the fear of midnight arrests and the terror of anonymous denunciations. "While the heirs of Stalin / are still alive on this earth," he exclaimed in anger, "it will seem to me / that Stalin still lives in the mausoleum."[12]

Evtushenko's passion to speak for his generation allowed him to see beyond the evils of the past to the promise of the future. He saw this at the Siberian frontier town of Bratsk, on which tens of thousands of eager Russian volunteers descended in the late 1950s to begin work on a huge power station that would conquer the wilderness. The challenge of building the world's largest hydro-electric dam on the Angara River, where the scorching heat of summer gave way to temperatures of forty degrees below zero, fired imaginations from Khrushchev down to those "conquerors"[13] who shoveled away millions of cubic feet of dirt and poured concrete in its place. Seized by the force of their vision, Evtushenko in 1964 wrote 170 pages of verse that placed the Russians squarely among the builders of the pyramids and other great wonders of the ancient and modern world, and called it *The Bratsk Power Station*. Here, in the young men and women who gave a year of their lives to building the dam that would open Siberia's eastern lands, the Socialist collective achieved triumphs to which individuals could never aspire. For precisely that reason, Evtushenko warned that the triumph of Socialist labor at Bratsk would lose its human dimension if the individual slipped out of focus.

Evtushenko called history's blessings down upon the builders of the Bratsk Dam and dedicated their labor to a bright and glorious future, "in which Communism will be built among us not according to self-interest but in keeping with Lenin's teachings." Like the swarms who moved earth, blasted rock, and poured concrete, he thought that the Bratsk Dam would transform Soviet life "so that women won't bear orphans, so there will be bread enough for everyone, so that innocent people won't be locked up in jail, [and] so that no one will ever shoot himself again."[14] At Bratsk, the Soviet vision seemed to have changed the course of history. To Evtushenko, its huge dam showed what Siberia and the entire Soviet Union might become if the idealism that moved his generation could overcome the taint of self-serving bureaucrats who preferred the sham of false accomplishments to the real sacrifices needed to build a better future.

The dream of portraying life as it really was dominated the novelists and poets who struggled to breathe new life into Russia's failing Socialist Realist vision after Stalin's death, but there could be no return to the literary techniques that Bulgakov, Mandelshtam, and Akhmatova had used so brilliantly in earlier times. Nor could Russians of Evtushenko's generation assimilate the new forms that Bunin and Nabokov had explored in the West before the Second World War. "In 1958," a critic once concluded, "it was still true that Joyce, Proust, Kafka, and Freud might as well never have existed for all the influence they exerted on Soviet writing,"[15] for novelists and poets still could not separate themselves from the Party's overarching concern with politics. That had been the task which Pasternak had undertaken at such peril during the decade before he published

*Doctor Zhivago.* And it was in trying to follow Pasternak in portraying Soviet life as it really was that Aleksandr Solzhenitsyn produced the explosive visions of Stalinst society that undermined the foundations upon which the Soviet literary establishment rested so heavily.

Except perhaps for Lenin and Marx, whose writings paved the way for the Bolshevik Revolution and shaped the beginnings of the Soviet vision, it is difficult to think of any author whose work had a more explosive impact on modern Russian life than Solzhenitsyn. Certainly his novels never rivaled the raw power of Dostoevskii's, the majestic sweep of Tolstoi's, or the measured, elegant detachment of Turgenev's, for the power of Solzhenitsyn's best work stemmed from the ruthless manner in which he stripped away the false façades that ornamented the harsh realities of Soviet life. As Dostoevskii had done in his *Notes from the House of the Dead*, so Solzhenitsyn let his readers see the numbing terror of life without hope, as he took them on a voyage to the hundreds of prison-islands that comprised the Soviet Union's terrible GULag archipelago.

No one in Russia had ever painted a more fearsome portrait, for Solzhenitsyn showed not only the brutality of prison life, but also endowed the legions of faceless bureaucrats who had helped to wage Stalin's war against the Russians with personalities and identities. Solzhenitsyn left no doubt that for every man or woman who shared the early Bolshevik spirit of sacrifice and the youthful idealism that Evtushenko had praised in *The Bratsk Power Station*, there had been several others who had reveled in the mediocre blessings that Stalinism had bestowed upon its loyal followers. After reading his terrible accounts, no one could doubt that the Stalinist system had perverted an entire nation and that its willing participants had numbered not in the thousands but the millions.

With obsessive attention to detail, Solzhenitsyn painted a world in which the fat content of gruel, the amount of crust on bread, and the chance to stay sheltered rather than work in the open held the keys to life and death. His heroes had no place in literary portraits that emphasized friendly Socialist competition, never-ending progress, and achievements that bridged the chasm between the real and the impossible. Solzhenitsyn wrote of men and women to whom fate had been perpetually unkind in a world in which only the rawest reality of life prevailed. Loyal to Russia's Socialist future in earlier times, the devotion of such unfortunates now earned them only exhaustion and death. In Solzhenitsyn's agonizing portraits of the human condition, hard work meant survival at best, and the reward for living through one day was to suffer again in the next.

Born in the North Caucasus resort town of Kislovodsk to a woman whose husband had been killed in a hunting accident just a few months before, Solzhenitsyn began life in a world torn by strife. The weeks surrounding his birth in 1918 saw Red and White detachments fight their way in and out of town several times, and only a run of unexpected good luck allowed his mother, who belonged to one of the town's richest families, to nourish him through infancy. By the time Solzhenitsyn turned six, poverty had forced his mother, aunts, uncles, and grandparents to go their separate ways, and mother and son, therefore, spent

the next twelve years in a crumbling one-room shack in the southern port city of Rostov, where poverty remained the abiding theme of their lives. "Until 1941, I didn't know what a house was," he recalled many years later. "We lived in huts which were constantly assailed by the cold. Never enough fuel [and] . . . no water in the room where we lived. . . . [But] in some mysterious way," he concluded, "all these things struck me as more or less normal."16

In school, Solzhenitsyn stood at the head of his class despite the disabilities that his upper-class origins imposed. From the novels of Gladkov, Furmanov, and Ostrovskii, he drew all the appropriate lessons about the value of self-discipline, dedication to Communism's Great Purpose, and the virtue of sacrifice in the cause of building a better world, and he became a dedicated follower of Marx, Engels, and Lenin. At the University of Rostov, he studied physics and mathematics, joined the Komsomol, and allowed the gospels of Socialist revolution to light his way. "I suffer no doubts, no hesitations—life is crystal clear to me," he wrote. When he married a beautiful chemistry student in the spring of 1940, the two dedicated their lives so entirely to serving the Communist dream that Solzhenitsyn read Marx's *Das Kapital* on their honeymoon. He assembled a volume of *Remarks on Dialectical Materialism and Art*, wrote poetry, and continued his studies, while he and his wife looked for a way to escape from the provinces and settle in Moscow. Then when the war broke out, Solzhenitsyn joined the army. "How difficult it was to leave home on that day," he confessed to his wife some years later. "But it was only on that day that my life began."17

Like tens of millions of his countrymen, Solzhenitsyn spent the next three years at war. He began in the 74th Horse-drawn Transport Battalion of the Stalingrad Army command, moved on to become an artillery officer, and in 1943 and 1944 marched with the victorious Red Army from Orel through Ukraine and Belorussia into Poland and East Prussia. While he was at the front, his mother died, leaving him, as he wrote to his wife, Natalia, "with all the good she did for me and all the bad I did for her."18 As the war ground on, he managed to visit Natalia on several occasions and write of the world around him, but most of all he thought of the future and how he and his friend Nikolai Vitkevich might overcome the baneful influence of Stalin in Russia. For more than a year, in letters they sent to each other from different parts of the Front, the two young men discussed their plans for setting Russia back onto the path that Lenin had mapped out. Perhaps made naïvely reckless by the continued presence of death in their daily lives, neither of them realized that their letters were being intercepted and read until, at the beginning of 1945, Solzhenitsyn was arrested just as Russia's armies were beginning their drive into Germany.

A few days after his arrest at the Front, the military authorities sent Solzhenitsyn to Moscow's fearsome Lubianka Prison, from which he began an eight-year journey through the forced-labor camps of the GULag archipelago. Released in 1953 and exiled "in perpetuity" to the remote lands of Kazakhstan, he spent the next three years fighting a cancer that had returned after being clumsily cut out by a prison doctor two years earlier. To find the solitude he needed to sort out

the roller coaster of emotions that had accompanied his rapid progress from student, to artillery officer, to prison inmate, to cancer patient, to ordinary citizen, he won permission from the authorities to become a schoolmaster in a sprawling peat-works town some fifty miles from Moscow, where he found lodgings in the crumbling cottage that some years later would form the framework for "Matrëna's Place," one of his greatest stories.

Between 1956 and 1961, Solzhenitsyn remarried the woman who had divorced him while he was in prison, moved to the larger provincial town of Riazan, and worked on a novel about prisoners who lived in the first—or top—circle of hell, *The First Circle*. He wrote three plays on the theme of brutality as seen in the behavior of Soviet troops advancing through Germany, the viciousness of SMERSH (the Soviet counterespionage service) during the war, and the abuse of political prisoners by common criminals in the labor camps.[19] Then in the summer of 1959, a moment of inspiration drove him to set all these tasks aside to write *Shch-854*, a short novel about a single day in a prisoner's life that would become known throughout the world as *One Day in the Life of Ivan Denisovich*.

Desperate to write—for he did not know then if his cancer had been cured or only temporarily arrested—Solzhenitsyn discouraged all visitors except for a handful of prison-camp comrades and worked day and night while his wife copied his corrections and typed his drafts, always being careful to destroy the ones that had been superseded.[20] In those days, they both lived in perpetual fear of having his work discovered by the police. "I had to adapt my whole life to the need for tight security," he later explained. "I couldn't afford to let a single scrap of what I had hidden escape from the flat, or allow an observant eye inside for a moment."[21]

The mass rehabilitations that filled the half-decade after Solzhenitsyn's return from Kazakhstan riveted the attention of Russia's writers and artists on life in Stalin's forced-labor camps. Powerful and bitter memoirs began to circulate in manuscript among the intelligentsia of Moscow, whose ranks included very few who did not have at least one close friend or relative who had suffered the agony of prison-camp life. Yet, while Moscow talked and read, the press stayed silent. Not even the powerful Aleksandr Tvardovskii, the poet son of a village blacksmith, who as editor of the influential *Novyi Mir* literary journal had risen to become a candidate member of the Central Committee of the Communist Party, dared to publish anything about the camps that had formed the many islands of the GULag archipelago.

The lost years that had left dark, empty holes in the biographies of hundreds of thousands of living Russians made no mark in print until the fall of 1961, when Khrushchev vowed at the Twenty-second Party Congress to raise a monument "to the memory of the comrades who fell victims to arbitrary power," and promised to "tell the truth to the Party and our people" about Stalin's crimes. A few days later, Tvardovskii called for Russia's writers to show "the labors and ordeals of our people in a manner that is totally truthful and faithful to life."[22]

Plagued by doubts and still not certain whether he was opening the door to fame or sticking his head into a noose, Solzhenitsyn decided to submit *Shch-854* to Tvardovskii for publication and took the manuscript to Moscow at the beginning of November.

Delivered by the wife of a prison-camp friend, Solzhenitsyn's manuscript seared Tvardovskii's heart. "A great writer has just been born," he exclaimed after reading it twice in a single night. "He's got a wonderful, pure, and great talent," he told a friend. "Not a drop of falsehood in it." By the time he met Solzhenitsyn a few days later, Tvardovskii could barely contain his enthusiasm. "Everything there is to say about prison has been said [in this story]," he exclaimed. "In some ways . . . [it] is even better than [Dostoevskii's] *House of the Dead!*"23

Like editors everywhere, Tvardovskii recommended that the title (which was the prison number of Solzhenitsyn's hero) be changed, and suggested *One Day in the Life of Ivan Denisovich.* Then, to bypass the censors, he took the manuscript directly to Khrushchev, who gave him permission to publish it. In late October 1962, just a week after *Pravda* printed a daring poem in which Evtushenko warned against those "heirs of Stalin" who "secretly consider their retirement temporary,"24 Solzhenitsyn received his final proofs. Three weeks later, the story that was to liberate the subject of Stalin's camps from the realm of guarded whispers appeared in print. Tvardovskii later recalled how the staff of *Novyi Mir* lined up silent, "just like in church," to buy extra copies before the subscriptions were mailed out.25 Everyone sensed that a milestone in Soviet literature had been reached and that a process had been set in motion that would change all their lives.

*One Day in the Life of Ivan Denisovich* burst upon Soviet readers like a starshell exploding over moonless trenches. Headlines greeted it as "A Bitter but Necessary Truth" about events that "Must Not Happen Again." Written "In the Name of Truth, In the Name of Life,"26 it focused attention on Stalin's crimes as Khrushchev had intended, but it also reminded the Russians that life outside the camps differed only in degree from that within. In less than a month, Solzhenitsyn was made a member of the Writers' Union, invited to a special reception at which he met Khrushchev, and flooded by the Soviet and foreign press with questions he dared not answer. Yet even then the brief liberal interlude that had followed his story into print was about to end. Faced by a fierce attack from conservatives, who criticized his handling of the Cuban missile crisis, Khrushchev had no choice but to turn sharply to the right, and he made that clear at the beginning of December 1962, when he visited an exhibition celebrating Thirty Years of Moscow Art at Moscow's Manège Gallery. Even in the days of Lenin, abstract art had found few supporters among the Bolsheviks' leaders, and Khrushchev, who had risen through the Party's ranks during the High Stalinist Era, had never been among them. Outraged at a small collection of modern, abstract works that occupied three small rooms of the large exhibit hall, the Party's Gen-

eral Secretary made it clear (in the crudest language possible) that the Party's tolerance had reached its limit.

Just as the signal of writers' rehabilitation after Stalin's death had been the sudden appearance of their work in anthologies and new editions, so the reappearance of paintings by Matisse, Modigliani, and Picasso on the walls of Russia's great Pushkin and Hermitage museums marked an easing of the rigid constraints that had stifled the visual arts in Stalin's time. Following that lead—but failing to notice that curators rehung the paintings of Malevich, Tatlin, and Kandinskii much more slowly than those of their Western counterparts—artists working at the Moscow studio of Ilia Beliutin had begun to paint abstract works, and these had appeared at the end of November 1962 in three small rooms near the main hall of the Manège Gallery's exhibition.[27] To the dismay of Moscow's liberals, Khrushchev's reaction to the abstract paintings was uncompromising, blunt, and swift. "If government funds have been paid for this picture," he said of one modern work, "the person who authorized it will have the sum deducted from his salary . . . [because] we aren't going to spend a kopek on this dog shit." Insisting that such works could never advance the cause of Communism, and angry that such artists had been educated at state expense, Khrushchev mixed high moral tone with crude outrage. "Gentlemen, we are declaring war on you," he told the stunned artists who had been summoned to meet him. "The people and government have taken a lot of trouble with you," he added as he turned away, "and you pay them back with this shit."[28] When Evtushenko tried a few days later to defend the artists by pointing out that, in a more permissive atmosphere, the "formalistic tendencies in their work will be straightened out in time," Khrushchev bluntly snapped that "the grave straightens out the hump-backed," and left the matter to fester until he returned to it some two months later.[29]

On March 8, 1963, Khrushchev told a meeting of Party leaders, writers, and artists that all forms of art must "serve the people and our common cause." Painting and literature, he went on, must "reproduce in bright artistic imagery the great and heroic epoch of Communist construction," cinema must provide a "truthful reflection of the real world in all the diversity of its colors," and music must be "melodious . . . and give rise to strong feelings." It was the task of the arts, he said, to shape the minds of the young, show only the bright side of life, and celebrate the certainty that Communism would be fully realized within the life span of the present generation. In the weeks that followed, others called upon Russia's artists, writers, and composers to "glorify, sing, and inculcate heroism," "hold the course," "remember the cause we serve," and launch an "offensive" against those whose creative efforts, "like carrion," served only to attract "huge fat flies and all kinds of bourgeois scum . . . from abroad."[30] Taken together with their very pointed personal attacks against Ehrenburg, Evtushenko, and the sculptor Ernst Neizvestnyi, these marked, in the words of one critic, "the most sweeping statement on literature and the arts" since Andrei Zhdanov had attacked Akhmatova and Zoshchenko in the summer of 1946.[31]

Widely known to have been published with Khrushchev's approval, *One Day in the Life of Ivan Denisovich* had drawn little hostile comment from conservative critics when it first appeared. But in the fall of 1963, the grim portrayals of present-day Soviet life that Solzhenitsyn published under the titles of "Matrëna's Place," "For the Good of the Cause," and "Incident at Krechetovka Station" all brought the wrath of the Party faithful down upon him. Such resentment cost him the Lenin Prize for which Tvardovskii nominated him that year, but Solzhenitsyn buried his disappointment and continued to work on manuscripts that would be even more explosive. He did not know then that, with the exception of one short story, he would never be allowed to publish another piece of fiction in Russia until the Soviet Union crumbled. Yet, even as he bought what he later described as "the first patch of ground I had ever been able to call my own" and settled into the rough summer cottage that stood upon it, the tightening nooses of circumstance and the KGB were beginning to lead him irrevocably to that realization.[32] When the KGB raided the apartment of friends with whom he had left copies of some of his most controversial unpublished work in the fall of 1965, they carried away three copies of *The First Circle* and a blatantly anti-Soviet play to which he had given the title *Feast of the Conquerors*.[33] "[It] was the greatest misfortune in all my forty-seven years," Solzhenitsyn wrote when he recalled how the KGB had reappeared in his life. "I felt as though it were a real, unhealing physical wound [and] . . . the slightest stirring within me (perhaps a memory of some line or other from my impounded archive) caused a stab of pain."[34]

The seizure of Solzhenitsyn's "archive" was part of a wider attack that the KGB launched against Russia's writers and artists just before and after Khrushchev fell from power in the fall of 1964. At one point, rumor had it that its agents had been ordered to arrest a "thousand intellectuals" as a precautionary measure,[35] and no one was certain what fate the arts would suffer under Khrushchev's successors. Certainly the recantations and public apologies that *Pravda* printed from writers who had followed too quickly the trail blazed by Ehrenburg, Evtushenko, and Solzhenitsyn created a powerful sense of foreboding. Evtushenko spoke of having made an "irreparable mistake" in allowing the "French bourgeois weekly *L'Express*" to publish his *Precocious Autobiography*, and others wrote contritely of the need to create images of "true sons of the times," who would "embrace all of the magnificence, optimism, and complexity of our Communist epoch"[36] in place of the negative images they had painted with words and on canvas during the now-ended thaw. But if the apologies and self-criticisms were disheartening, the arrests and trials of writers now labeled "dissident" became downright terrifying. These—and the sentences at hard labor that followed—made it seem that the days of Stalin were about to return. Perhaps nothing made that point among Russia's writers more emphatically than the public trial of a young poet who had never seen even one of his verses published in the Soviet Union.

Now widely acclaimed as one of the most important poets of the twentieth

century, the twenty-three-year-old Joseph Brodsky was the first to fall to the So-
viet authorities' new campaign against writers late in the winter of 1964. Born
just a year before Hitler's armies invaded Russia, he had left school at fifteen,
educated himself by reading books begged from libraries and dug out of garbage
cans, and long before he turned twenty had dedicated his life to poetry and the
weaving of words. Believing that poetry was a timeless conversation going on
across the centuries of human experience, he was to spend his life speaking in in-
timate terms with his Russian forebears Pushkin, Mandelshtam, and Tsvetaeva,
but he also conversed with Homer, Virgil, and Dante, not to mention such still-
living poets as his "keening muse" Akhmatova, Czeslaw Milosz, Seamus Heaney,
and Derek Walcott. Precisely and constantly attuned to the meaning and rhythm
of words, his was a powerful poetic voice that reached above and beyond his
times to readers dead and yet unborn. He wanted neither to be anti- nor pro-
Soviet, for as Czeslaw Milosz once pointed out, he had set firmly aside Marxism,
Leninism, Nationalism, Nietzscheanism, Freudianism, Surrealism, and a dozen
other "isms" that many of his contemporaries thought made up the true meaning
of the twentieth century. Yet, as one of the essays written in his honor a few days
after he died made clear, that did not prevent him from believing that "as long as
the state permits itself to interfere with the affairs of literature, literature had the
right to interfere with the affairs of the state."[37]

From his early teens until his death in January 1996, Brodsky took a passion-
ate part in what he once called the "relay race of human history."[38] Like Solzhe-
nitsyn, whose moral strength he admired but whose feeling that an artist could
not create art outside his homeland he did not share, he wanted to know what it
meant to be righteous and just, and he set a very austere standard for measuring
the evil that he saw in every human heart. He thought that language counted for
as much as—perhaps even more than—virtue, and because he revered that
which was elevated and was unconcerned about all that was base, he measured
poets by their art, not their human failings. "It is the people who should speak
the language of literature," he once concluded, not the poet who should "make
use of the language of the street."[39]

Not officially a poet in Russia because he had not been allowed to join the
Writers' Union, Brodsky lived from hand to mouth during his adolescent days in
Leningrad, and he often went for months on end without finding work. When
the authorities arrested him as a "semiliterary parasite" who was not engaged in
"useful labor," he defended himself by arguing that even though he had no offi-
cial source of income, he was a hardworking poet. His remark provoked a
memorably sarcastic exchange with his unsympathetic judge that highlighted the
sterility of the official Soviet attitude to art.

"Who has said you're a poet? Who ranked you as a poet?" a smuggled
trial transcript reported the judge asking the defendant who slouched
against the courtroom wall.

"Have you studied this?" the judge went on, pointing out as she did so

that Brodsky had dropped out of school and had no university education at all. "Have you tried to do a course where you are prepared . . . where you're taught [to write poetry]?"

"I didn't think that came with education," Brodsky answered.

"What, how [does it come] then?"

"I think," he replied, "that it comes from God."[40]

Sentenced to five years of penal servitude in Russia's Far North for being a social "parasite," Brodsky was set free after eighteen months, in large measure because Russian and Western intellectuals (including such Soviet sympathizers as Jean-Paul Sartre) had campaigned so strenuously on his behalf. After that, he published his poetry abroad when he could find no outlet at home, until he was deported from Russia in 1972 and quickly rose to the crest of the new wave of writers being driven from their homeland.[41] Far removed from his native land but still able to capture the essence of his past and present with a brilliance that few émigrés other than Tsvetaeva and Nabokov had ever equaled, he became a poet in exile, won the Nobel Prize in 1987, and taught for the last fifteen years of his life at Mount Holyoke College in central Massachusetts. Ultimately, he became America's only foreign-born poet laureate, but one, as a critic recently wrote, "whose primary audience is in another language and culture, and in some cases not even of this world."[42] Nowadays, Russian teenagers find Brodsky's poetry—written with none of the "obligatory compromises" that virtually all Soviet authors had to make—a vital and indispensable part of life.

Brodsky's conviction pointed the way for the trials of others, one of which solved a mystery that had first come to light in the summer of 1959, when an anonymous essay bearing the title *On Socialist Realism* had stunned Western intellectuals and critics. Set by his admirers in the West among that group of "evangelically pure men and women [who are] fearless in condemning evil and fully aware that that which is to be rendered unto God is not the same as that which is to be rendered unto Caesar," the author of *On Socialist Realism* wrote under the pseudonym of Abram Tertz, which offered no clues to his identity beyond linking him to a character in a student song that had recently been banned in Moscow.[43] Tertz claimed that Socialist Realism had carried the seeds of its own destruction from the moment of its birth because it could neither create the heroes that Communism required nor project the moral and social vision that its creators had intended. Nor, he insisted, could it ever have been otherwise, for truth in art could only be found through perpetual doubts and ceaseless searching, and never through dogmatic formulas.

Dripping with irony and poisonous subtleties, Tertz's essay condemned the dogmatic self-assurance that Socialist Realism demanded from its practitioners, and bemoaned the energy wasted by "a thousand critics, theoreticians, art experts, pedagogues . . . beating their heads and straining their voices to justify, explain, and interpret its material existence and dialectical character." The product of such efforts, Tertz pointed out sarcastically, was a smooth, conforming unifor-

mity that erased each nuance in thought and restrained every artistic attempt to express new ideas. "Yes, we really are all alike and we are not ashamed of it," he wrote. "There can be no substantial differences of opinion in a country where even the anti-Party elements confess their errors and wish to rectify them as soon as possible. . . . Least of all [can there be such differences] among positive heroes who think only of spreading their virtues all over the world and of reeducating the few remaining dissidents into unanimity."

In the Soviet Union, such rigid conformity had produced what Tertz called "a loathsome literary salad" that was "none too socialist and not at all realist," and it had left the Russian artistic experience "marking time between an insufficient realism and an insufficient classicism." The time had come, he concluded, to move away from "realism" to "phantasmagoric art" and learn from Dostoevskii, Chagall, Hoffmann, and scores of others "how to be truthful with the aid of the absurd and the fantastic." "May we thus invent something marvelous?" he asked at the end of his essay. "Perhaps," he answered, "but it will no longer be Socialist Realism."[44]

Cast in a form that at times left readers uncertain about "whether an assertion is serious or tongue-in-cheek," Tertz's essay has been called "a savage attack on Stalinism."[45] The extent to which he spoke with tongue in cheek had to remain unclear so long as his anonymity stayed intact and readers could not set him firmly into the context of Soviet life. Then, toward the end of 1965, the KGB revealed that Tertz was Andrei Siniavskii, a distinguished critic and literary scholar who had written a sophisticated introduction to Pasternak's poetry and a highly acclaimed book on Picasso. Although identified with progressive opinion in Moscow, Siniavskii had never approached the line at which the discussion of Soviet art and life crossed from conformity into dissent, nor had he ever been openly associated with any of the incidents that challenged the fundamental truths of Socialist Realism. He had saved such criticisms for his life as Tertz, for which the authorities brought him to trial at the beginning of 1966 and sentenced him to a term of penal servitude from which he was not released until 1971.

Even as the Russians took their first steps in space and posed as the champions of national liberation in Asia, Africa, and Latin America, fears of the written word continued to torment their leaders beyond all reason and out of all proportion to the number of writers involved. "They have to set up an earth barrier, a dam, even a huge hydroelectric dam to keep manuscripts and books from getting through," Siniavskii said after he fled to the West. This had made literature "a forbidden area and dangerous." Because the government had made all who disputed the prescriptions of Socialist Realism into criminals, underground literature had become "all the more fascinating."[46]

As Tertz, Siniavskii also had written several short stories and a pair of short novels, entitled *The Trial Begins* and *Liubimov* (translated in the West as *The Makepeace Experiment*). Both of them highlighted the bizarre qualities of everyday life in Soviet Russia that transformed normal men and women into grotesque caricatures similar to those that Gogol had created during the repressive days of

the Emperor Nicholas I. Like Gogol, Siniavskii turned the certainties of everyday life upside down as he transformed river water into champagne, toothpaste into pâté, and mineral water into vodka in a fantasy world in which water nymphs got stuck in urban plumbing and thoughts of suicide stripped sexual activity of all its romance. Girlfriends betrayed the men who loved them in the name of "our future," and impotent men tried to seduce beautiful women whom they knew they could never conquer.

But there was more to Siniavskii's prose than portrayals of people rendered impotent by the perversities of Soviet life. In his works, Soviet fiction found for the first time a truly literary writer, whose references, innuendoes, and puns demanded that readers have a thorough knowledge of literature and the leisure to think about its deeper, more subtle meanings. In keeping with his contorted vision of the world around him, Siniavskii's call for fantasy in the end became a summons to realism, for the Soviet way of life he portrayed seemed so unreal by human standards that readers needed truthful reality to counteract it.[47]

Cruelty and caprice so ruled Soviet life that, when the rose-colored lenses of Socialist Realism were stripped away, reality seemed nearly as perverse as Siniavskii's grotesque visions. For that reason, the supremely realistic portraits of Russian life that Solzhenitsyn fashioned between 1965 and 1973 seemed nearly as fantastic as Siniavskii's surrealistic ones. "What an imagination you've got to dream up something like that," Tvardovskii exclaimed while he was reading the draft of *The First Circle* that Solzhenitsyn showed him in the summer of 1964. "It's absolutely amazing," he continued. "You begin to believe it all!"[48] Yet, as a critic once noted, Solzhenitsyn's portrait of life applied to so many millions that "we may be tempted to apply to *The First Circle* the old Marxist bromide about realism as 'typical characters in typical situations.' "[49] In the Soviet context, there was absolutely nothing out of the ordinary about the events it described. That Tvardovskii failed to understand such a simple fact showed how isolated the men who stood close to Russia's rulers had become.

With *The First Circle* in hand, Tvardovskii raced to announce that it was about to appear. Then, when Khrushchev's fall postponed its publication, Solzhenitsyn turned to *samizdat,* the means by which dissident literary works circulated among the Russian intelligentsia in typescript. Concerned with anything banned by the censors, and able to distribute substantial numbers of typewritten and handwritten poems, novels, and such political documents as the transcript of Brodsky's trial in defiance of the authorities' prohibitions, *samizdat* by the mid-1960s had also become a clandestine conduit that carried contraband literary works to the West. Some of Brodsky's early poems had been published in that way, and as the Khrushchev era moved toward its end, the number of dissident Soviet works being published in the West increased. In Russia, eager readers shared Akhmatova's still-forbidden *Requiem* and Pasternak's *Doctor Zhivago* with trusted friends, and scores of other works passed from hand to hand in Leningrad, Moscow, and a dozen other cities. But Solzhenitsyn was not yet ready to release his novel to *samizdat*'s many anonymous readers. He therefore limited

the circulation of *The First Circle* in the fall of 1964 to a handful of copies and insisted that they be read only in the apartments of trusted friends, even as he sent a microfilm of it to the West, where the KGB could not hope to seize or destroy it. Only when it became certain that Tvardovskii could not win approval for the novel to appear in Russia did Solzhenitsyn make plans to publish it in the West.[50] Because Pasternak and Siniavskii had already found how thorny that path could be, he wanted to make certain that he had no other course before he followed in their footsteps.

While he weighed the pros and cons of a headlong collision with the Soviet literary establishment, Solzhenitsyn learned that his recently completed *Cancer Ward* had been denied publication, too. At the beginning of April 1967 he decided to publish *The First Circle* in America first, and he met with the woman who was to be its editor. The daughter and granddaughter of well-known Russian writers and highly respected as a journalist interested in Russian literature, Olga Carlisle became the first person from the West to whom Solzhenitsyn confided his hopes for his novel and his fears of what might follow its publication. "It is a big book," he told her, a book that was going to "stun public opinion throughout the world [and] let the true nature of the scoundrels be known."[51] But he wanted his involvement in its publication to be kept secret for the time being. All but certain that the authorities would never agree to publish his works in Russia, he was not yet ready to burn all his bridges.

The next eighteen months saw *The First Circle* and *Cancer Ward* move toward publication in the West amidst a tangle of maneuverings that involved rival publishers, translators, literary agents, and the shadowy hand of the KGB. Because what Solzhenitsyn claimed to be unauthorized copies of both novels had circulated through the *samizdat* underground for the better part of two years, it was difficult for Western publishers to tell which of the copies that filtered through Soviet border crossings represented the definitive text and which may have been planted by Solzhenitsyn's enemies. While they, their agents, and their attorneys struggled to resolve that question, Solzhenitsyn worked on *The GULag Archipelago*, which was to become his personal tribute to the millions of Russians who had perished from Stalin's tyranny. Then early in the summer of 1968, on the very day that he and his wife finished typing its final copy, he received word that Harper & Row had published *The First Circle* in Russian in New York and was rushing to bring out its English translation. At about the same time, he learned that the firm of Mondadori had published the Russian text of *Cancer Ward* in Italy along with an announcement that an Italian translation was soon to come. Just before Soviet tanks crashed into the streets of Prague late that summer, those two events burned the last of the tottering bridges that still connected Solzhenitsyn to the Soviet literary establishment. When he received word a few days later that a microfilm of his fifteen-hundred-page *GULag Archipelago* manuscript was safely in the West, the stage was set for the events that would propel him from the turmoil of Moscow into the quiet hills of southern Vermont.[52]

In the text that was published in 1968, *The First Circle* tells the story of four

days in Christmas week during which an ordinary man does a single good deed in a world awash with evil. It then becomes the task of the police to run him to ground by means of devices developed by prisoners who have been put into a special research institute called a *sharashka,* where they are ordered to place their scientific talents at the government's disposal. Yet the plot is more broad and far-reaching than that, for Solzhenitsyn weaves into his novel the biographies of the *sharashka's* inmates, all of which tell of shattered hopes, broken lives, and immense pain as the Soviet experiment moves through the bloodbath of collectivization and the shining hopes of the first Five Year Plans to the bitter torment of the purges and the slaughter of the Second World War. Tvardovskii had been right to say that Solzhenitsyn refused to "forgive the Soviet regime anything . . . [or] to forget anything,"[53] for the novel relentlessly chronicled one ruined life after another. Perhaps most disturbing of all, *The First Circle* made it clear that all Soviet citizens were caught in the same moral and physical trap, which rendered the difference between life in and out of prison to be only a question of degree.

Presented by different means and from another point of view, the theme of ruin wrought by the Soviet experience dominates *Cancer Ward* as well. Here a proletarian by the name of Rusanov has risen to become a successful bureaucrat, only to be struck down by a cancer so malignant that he has no time to use his connections to get to Moscow for special treatment. Driven by his fear of death to seek help in the cancer ward of an out-of-the-way provincial hospital among common men and women whom he sees as universally inferior, Rusanov finds that all measures of status and achievement of the outside world have no meaning in the cancer ward, where he must confront the human ruin wrought by the system to which he has sold his loyalty.

As in *One Day in the Life of Ivan Denisovich* and *The First Circle,* the biographies of the men and women in the cancer ward tell of lives ruined and hopes destroyed by a system that abuses its citizens in the name of the common good. Of none among the ward's inmates is that more true than Kostoglotov, the perpetual exile, who has been called "Solzhenitsyn's most fully developed hero . . . [and his] finest tribute to the nobility and endurance of the human spirit."[54] Because the system has already robbed him of family, education, career, and freedom because he had chosen to think and speak independently, cancer no longer holds the terror for Kostoglotov that it does for Rusanov. A victim of Stalin's camps who has been condemned to live the rest of his days in the remote corners of the Soviet Union, Kostoglotov has long since moved into that realm in which the human spirit reigns supreme. He has become indifferent to life and death, while Rusanov struggles to live in order to regain the comforts that the system had bestowed upon him in return for his betrayal of others.

The foreign publication of *The First Circle* and *Cancer Ward* stirred such outrage against Solzhenitsyn in official circles that the KGB even interrogated the people who sent him greetings on his fiftieth birthday.[55] At the same time, the two novels built an immense following for him in the West, and that helped to protect him against the worst of the recriminations that less visible writers con-

tinued to suffer. Then, while the tension between state and writer festered in the fall of 1970, the Swedish Academy announced that he was to receive the Nobel Prize, and his announcement that he intended to accept it in Stockholm "as a tribute to Russian literature and to our troubled history"[56] created a new crisis. As if forgetting the embarrassments they had suffered during the Pasternak Affair fifteen years earlier, the Soviet authorities once again responded to the Swedish announcement in a way that seemed to confirm all the crudest stereotypes about brutal bureaucrats who placed dogma ahead of art.

In the fall of 1970, the Soviet press unleashed a flood of invective that described Solzhenitsyn as a "run-of-the-mill writer with an exaggerated idea of his own importance" and accused the Swedish Academy of having made its decision on the basis of "speculative political considerations." Surely, one article stated, Solzhenitsyn must "realize that his literary gifts are not only below those of the greats of the past but also inferior to many of his Soviet contemporaries."[57] Aside from a handful of brave human-rights activists and GULag survivors with whom Solzhenitsyn had shared the torments of Stalin's camps, few Russians dared to send congratulations for fear of KGB reprisals. "Barbed wire and automatic weapons prevent us from expressing to you personally the depth of our admiration for your courageous creative work in upholding the sense of human dignity and exposing the trampling of the human soul and the destruction of human values," one smuggled greeting announced.[58] "We jealously cherish our friend, our cell-mate, our comrade of the prison trains," another clandestine message added. "We hotly dispute the Swedish Academy's claim to have been the first to appreciate your valor as a writer and as a citizen at its true worth."[59]

Denied permission to leave Russia and return, Solzhenitsyn did not attend the Nobel Prize ceremonies and sent some brief remarks to be read on the occasion instead. During the next three years, his conflict with the Soviet authorities continued, escalating at some moments and retreating into an uneasy truce at others. Then in August 1973, Solzhenitsyn spoke for the first time to reporters from the Associated Press and the French newspaper *Le Monde* of the threats of violence with which the authorities continued to torment him. "If it is announced that I have been killed or have suddenly met a mysterious end," he stated flatly, "you can infallibly conclude, with one hundred percent certainty, that I have been killed by the KGB or with its approval." He concluded the interview with a threat, the magnitude of which the KGB could not yet comprehend. "Immediately after my death or immediately after I have disappeared or been deprived of my liberty by whatever means," he told the correspondents, "my literary last will and testament will irrevocably come into force . . . and then the main part of my works will start being published, works I have refrained from publishing all these years."[60] Here Solzhenitsyn had in mind a huge secret of which the KGB still remained entirely ignorant. Not only did they not know that he had sent a complete copy of *The GULag Archipelago* out of the country, but they had yet to learn that he had written it.

Ever since Solzhenitsyn had received word in the summer of 1969 that the

microfilm of *The GULag Archipelago* was safely in the West, he had vacillated about when to publish it. Hesitant to set in motion events that might lead to his expulsion from Russia before he completed the research for his massive novel-history of the First World War and the Revolution, he delayed what promised to be the greatest of all confrontations between author and police for another four years. Then, at the beginning of September 1973, the Leningrad KGB searched the flat of Solzhenitsyn's sixty-seven-year-old typist, found a copy of *The GULag Archipelago* manuscript, and took her—sick, lame, and utterly terrified—to their headquarters to be interrogated, after which she returned to her room and hanged herself. And "so fate hung one more corpse before the covers of this book of martyrs," Solzhenitsyn later wrote. In the poor woman's death, he "glimpsed the finger of God," and he saw in it a sure sign that the time had come for him to unleash the most powerful of his literary weapons. Exclaiming "It is Thy will!" he at that moment ordered his Western agent to publish *The GULag Archipelago* immediately. "I let it loose," he wrote in recalling how the publishers had set the already edited and translated manuscript into type at top speed. "God's hand was in it!"[61]

Less than four months later, the YMCA Press published *The GULag Archipelago* in Paris. Six weeks after that, the KGB arrested Solzhenitsyn, held him overnight at Moscow's Lefortovo Prison, and then deported him to Germany. Learning the fate of her husband only after he telephoned her from the West on February 14, 1974, Solzhenitsyn's second wife, Natalia Svetlova, and their children joined him in Switzerland two months later, bringing as many of his papers with them as they could carry. Hoping to end the confrontations that had so darkened hopes for *détente* with the West, Solzhenitsyn's Soviet foes had cast him adrift. Whether their plan would succeed remained to be seen, for by sending him to join Brodsky and Siniavskii in the West, the Soviets had unleashed a powerful new literary wave that would undercut some of the most vital underpinnings of a government still struggling to bend the arts to its purpose.

As the instrument that revealed to the world the full brutality of the war that Stalin and his heirs had waged against the people of the Soviet Union, Solzhenitsyn's *GULag Archipelago* has been called "one of the most profound human epics," and the work of an artist "consciously engaged on the side of Ultimate Good and against Evil."[62] Their title derived from the acronym for *Glavnoe Upravlenie Ispravitel'no-trudovykh Lagerei* (Central Administration of Corrective Labor Camps), the three volumes presented a documentary record of the torments inflicted upon millions of victims who moved between those islands of evil that had formed themselves into an archipelago that dotted the length and breadth of the Soviet Union. Political opponents done to death in the 1920s, peasants killed by government-caused famines and the brutal process of forced collectivization in the early 1930s, victims of the purges, Russian prisoners of war sent from Germany directly to the camps after World War II, and entire nationalities—Crimean Tatars, Chechens, and Volga Germans—all form a part of the vast narrative with which Solzhenitsyn draws his readers into the GULag's darkest corners. A work

with neither forebears nor descendants in Russian literature, *The GULag Archi-pelago* in the end becomes a monument to an evil so profound as to touch upon the unimaginable. Never had the modern world seen suffering on such a scale. And it was to the task of its chronicling that Solzhenitsyn had dedicated his heart and soul from the moment he emerged from prison in 1953 until he was driven out of Russia twenty-one years and five days later.

Many of those who shaped the world Solzhenitsyn described with such relent-less hatred belonged to that urban upper middle class, which between 1930 and 1990 enjoyed the limited comforts and privileges that the Soviet system be-stowed upon those who placed their learning and loyalty at its disposal. By and large, Solzhenitsyn portrayed such men and women as being concerned only with bettering their lives in the material sense at the cost of their self-respect and their souls. Yet, if they all had been as selfish and self-interested as he described, what had happened to the vision that had driven Bolsheviks to feats of valor and sacrifice in the 1920s and early 1930s? Certainly Russia's struggle against Nazi Germany had called forth self-sacrifice and idealism on a massive scale. Had such feelings died with the war's end or had they survived through the late Stalin years into the 1950s?

As the son of a high-ranking Bolshevik who had spent his entire childhood in the world of men and women devoted to the service of the Party and Soviet Rus-sia, Iurii Trifonov was uniquely well-situated to answer those questions. As a stu-dent at the Gorkii Literary Institute, starting in 1944 when he was declared unfit for military service because of poor eyesight, Trifonov entered the postwar era certain that the way of life he had known as a child in the comfortable govern-ment "house on the embankment" held the promise of a better future. He there-fore dedicated the next thirty years to exploring how well the men and women who spoke of devoting their lives to the Party and Russia had realized that vision.

Trifonov's first effort to confront the meaning of life among Russia's urban up-per middle class took the form of *Students*, a novel that appeared in *Novyi Mir* in 1949 and won the Stalin Prize two years later. In it, he tried to show that idealism still flourished among educated Russians, who, in the hope of building a better world from the ruins of World War II, had dedicated themselves to The Cause to which their mothers and fathers had given so much. As portrayed in Trifonov's *Students*, idealistic young Russians devoted their lives to building a better world during the fifteen years after the war's end. For them, the goal was in sight. To bring the Socialist Realist utopian vision into being required only dedication, hard work, and a few more years of sacrifice.

*Students* portrays Soviet student life as a collective in which high principles and a sense of responsibility lead serious young Russians to learn how to better serve their nation and its people. Its heroes seem to prefer principles to personal benefits and accomplishments to empty privileges. In contrast to the spartan sur-roundings portrayed in the earlier works of Socialist Realism, Trifonov's students live in a world of modern subways and newly built apartments, and they see it as their mission to bring these comforts to all Soviet people. Beneath their dedica-

tion is the unspoken certainty that their effort will be rewarded by prospects so magnificent that even that handful of self-centered rarities among them who prefer personal advancement to working in the name of The Cause soon will come to see the error of their ways.[63] To them all, it seems almost certain that the time is not far away when everyone will live in comfort. In the 1930s, the Socialist Realist vision had stood on the distant horizon. By 1950, the dedication and hard work of Soviet men and women had moved it to the near edge of the not-very-distant future.

Not out of selfishness but as a consequence of dedicating their lives to The Cause that will benefit all humankind, Trifonov's students seem about to enter the life of privilege and comfort that Solzhenitsyn so despised. Yet, even though there were young Russians who genuinely pursued the dream of building a better world in the revived idealist setting of postwar reconstruction, the forces that had corrupted their parents overcame them, too. As self-interest replaces idealism, Trifonov's students discover in middle age that they themselves have become the heart of the corrupt bureaucracy that has limited what they could (or hoped to) accomplish from the very first. Seeing that their disillusionment bred bitterness, and that bitterness led to cynicism of the most malignant sort, Trifonov then set out to discover what the students of the late 1940s had really hoped to accomplish and how genuine their idealism had been in the first place.

Just as Trifonov had claimed to set forth the hopes of the men and women who came to Russia's universities from the Front in *Students*, so he portrayed them as an intelligentsia bereft of ideals, principles, and dreams in *The House on the Embankment*, which he published in 1976. The novel presents his own aging generation by comparing what its members think they once had been with what they have actually turned out to be, and it becomes clear in retrospect that the heroes of *Students* were in fact motivated by cynicism and self-interest all along. From the more sober perspective of middle age, they come to see that all of them have made compromises with the system that has ruled their lives. The moral erosion that those compromises have required has made them into self-serving people who, as one of them confesses cynically, have dedicated their lives to becoming "the cherry on the top of a cake of shit."[64]

Certainly Stalinist terror played a part in the terrible process that transformed so many Russian artists, writers, and intellectuals from men and women who searched for the essence of the Russian soul into soulless cultural bureaucrats. But so did the ways of everyday life, which demanded countless small lies and deceptions to be made in the name of convenience, comfort, and success. Trapped in a society in which citizens enjoyed almost no meaningful rights, personal rights became whatever the individual could claim by default in that formless huge gray area of human experience that extended from the few things that were expressly permitted to the handful of others that were strictly forbidden. For that reason, Soviet Russian society by the 1970s had still not found firm moral anchors to replace those that had been uprooted by the revolutionary

events of 1917–1921, and that lack of values continued to keep its people from becoming fixed firmly in time and place.

As the turmoil caused by urbanization, Stalin's purges, war, and postwar reconstruction swept the land, Russians from one end of the Soviet Empire to the other found themselves being transported to factories, virgin lands, labor camps, and barren wilderness sites in ways that separated them from their past and left them fixed only in the present. "I'm not yet really a citizen of the town, but I don't belong to the country anymore either," the Siberian peasant writer Vasilii Shukshin confessed as he neared forty. "That's worse than falling between two stools," he continued. "It's like having one leg on the shore and the other in a boat. You can't stay where you are, but you're afraid to jump into the boat."[65]

Born on a collective farm in southwestern Siberia during the summer of 1929, Shukshin grew up in a rough-and-ready world peopled by strong pioneers. He knew at first hand the hard lot of Russia's rural toilers, and like them he learned early in life how to extract enjoyment from simple pleasures. As Russia began to rebuild after the war, hunger drove him to the cities, where he tried his hand at several trades before joining the Red Navy in 1949. Five years later, he entered Moscow's Institute of Cinematography, where Mikhail Romm, the screenwriter and friend of Eisenstein, became his teacher. It was Romm who convinced him to publish his first short story in 1958.[66]

Shukshin drew his characters from among those millions of "disoriented and bewildered, by turns aggressive and timid, arrogant and insecure" Russians who were no longer comfortable in one milieu and not yet settled in another.[67] Like their creator caught somewhere between city and village, these people live for those all-too-rare moments of leisure when they can reestablish contact with their inner selves and contemplate the ways of the alien and hostile world around them. Almost unique in Soviet literature, they are "peasants with the nervous systems of intellectuals," as one critic recently wrote.[68] As people, they know their worth but are uncomfortable with the world in which they live.

Like the students Trifonov had described just a few years earlier, Shukshin made his compromises with the system, even as he struggled to seek the truth in his writings. He never spoke out in support of such writers as Solzhenitsyn, Brodsky, or Siniavskii, but he never spoke against them, either. Instead of becoming a dissident or a Party hack, he kept his attention focused on that ever-changing river of human emotion that spills its contents across his pages in a torrent of those absurd, hurtful, and pathetic conflicts that form the fabric of Soviet life. As Shukshin's characters speak past each other in their desire to express their frustration, longing, and loneliness, human contact often fails. Even the shared experiences that might draw such rootless men and women together tend to be undercut by pettiness and personal conflicts. People seek to create happiness out of cruelty and violence. Men drive away the women they love by petty quarrels, and people in search of success find only frustration and failure.

Because the plans and goals of Soviet bureaucrats constantly shifted, the men

and women upon whose labor their realization depended saw their lives being changed as well, and this instability forms the fabric of Shukshin's best-known story, *Snowball Berry Red*, which later became a Lenin Prize–winning film that featured Shukshin as author, principal actor, and director. *Snowball Berry Red* centers upon the experiences of Egor Prokudin, who as a consequence of the turmoil created by the shifting plans and purposes of Russia's rulers never manages to find a true sense of direction. After growing up in a small Siberian village and becoming separated from his mother during one of the famines that ravaged the Soviet countryside during the 1920s and 1930s, Prokudin turns to a life of crime, is sentenced to a term in a prison camp, and then takes up a way of life for which he has neither inclination nor understanding. Despite the help of a simple peasant woman who takes him under her wing, he fails to make the transition. Only after he has been killed by members of the gang he had vowed to leave behind does he become reunited with the land that he had found it so difficult to come to terms with in life. "There he lay, a Russian peasant on his native steppe, not far from home," Shukshin concluded. "He lay with his cheek pressed to the earth as though he were listening to something that only he could hear. That was how he had listened to telegraph poles in his childhood."[69]

Breaking sharply with the Stalinist view that portrayed traditional peasant ways as degrading and backward, some of the greatest Russian writers of the 1960s and 1970s shared Shukshin's fascination with village life. Unlike those city-born novelists and playwrights who celebrated the triumphs of collectivization during the Stalin era, these "Village Prose" writers had been born and raised on the land, and they saw in the peasant way of life virtues that Party hacks anxious to acclaim the accomplishments of modernization had always disdained.[70] Their writings touched a sympathetic chord in millions of Russian city readers, for whom a brief return to the village they had long since left behind gave new meaning to lives spent in the rootless Soviet world of progress and ideology. "Our generation is probably the last to see with its own eyes a thousand-year-old way of life out of which nearly all of us have grown," one such Siberian peasant writer explained midway through the Brezhnev era. "If we cannot describe it and the decisive changes that have transformed it in a very short time, then who can?"[71] From the peasant world Solzhenitsyn had extracted that single virtue without which, as he wrote in "Matrëna's Place," "no village can stand. Nor any city. Nor the world itself." Following in his footsteps, the Village Prose writers created a far-ranging literary portrait that presented the peasant community as a receptacle of solid values long since pushed aside by progress, city life, and the dogmatic rigidity of the Soviet system.

Central to the Village Prose vision is the village itself, that "center of the universe" that is like "no other place in the whole world." Here children reach adulthood untouched by the city and the hand of progress. Primitive and apart from the turmoil of modern life, the village is a "warm, golden land" filled with treasured memories and mysteries that grow more precious with the passing of time. Here, the Socialist Realist vision of progress in a brave new world has no

place, and the unwanted incursions of Soviet ideology and Socialist values are dismissed as foreign and strange. Set apart from an alien way of life shaped by dogma, lip service to progress, and stereotyped promises of a better life, the stories and novels of Russia's Village Prose writers tell of communities ruled by superstition and popular wisdom, in which a rich array of peasant dialects takes precedence over the drab, Sovietized prose that had erased all local color from rural life in late Socialist Realist novels. "It's . . . as if all my ancestors, the peasants, the plowmen, plowing the soil from birth to death, bringing forth bread and new lives, buried in forgotten country churchyards . . . are praying—not for themselves but . . . for Rus—to a mysterious god, to kindly Saint Nikolai," one writer explained. "[It's] as if my grandmother is praying, as if I can hear my mother in her sleep."[72]

Of all the Village Prose writers of the 1960s and 1970s, Valentin Rasputin best combined a vision of village life with a study of peasant feelings. Born and raised in a small east Siberian river village about three hundred miles north of Irkutsk, he grew up in love with nature and the land. Convinced that the main task of literature was to "facilitate the improvement of humanity and correct the disfigurement of humanity,"[73] he wrote of the gulf that separated city and village, and emphasized the chasm of misunderstanding that yawned wide between the two. That theme stood at the center of *Money for Mariia*, his first major novella, and he used it to contrast the emptiness of city life with the greater human warmth to be found in Siberia's villages. Yet, for Rasputin the distinction between town and country is more significant than an abstract idealization of the past and far more complex than a blanket hatred of modern life. Certain that "the inner life of millions of people is changing . . . and [that] tomorrow will not be the same as today," he knows that progress has come to stay but hopes to moderate its impact upon tradition and honest values. It was "very important," he once said, "that a person not lose the significant and beautiful moral achievements of the past and that he remain spiritually good and open hearted." For that reason, and because "a person does not stand firmly, does not live confidently without . . . closeness to the activity and fate of his forefathers," he insists that tradition and a sense of the past have to be preserved. "Alienation is the most dangerous thing that can happen in the character of a person," he warns his readers. To avoid that, a writer must "reconcile the soul with life," and remember that "a person's feelings and thoughts comprise the major part of his life."[74]

Rasputin believed that modern-day writers must "locate the nerve endings on that huge body that we call 'the people,' " and he sought them in the rich diversity of peasant life. Women—particularly old women—stand at the very center of his village portraits, and he often sees in them a depth of compassion and moral fortitude that men almost never possess. "Old women of the countryside have an internal beauty and fascination," he once wrote. "Women possess an amazing sensitivity to the misfortunes of others," he added. "Their fellow villagers know them, [and] come to them for advice, sympathy, and support."[75] Rasputin's women stand at the opposite pole from those men whose cowardice and selfish-

ness so often destroy their lives, and they provide the moral moorings that lend stability to an increasingly volatile world. These women of strong character form living ties to the traditions from which Russian peasants have drawn their strength since the days of Ivan the Terrible, and become modern-day embodiments of the warm, fertile, all-caring Mother Russia that had embraced the Russians since ancient times.

Nowhere does Rasputin bind Mother Russia and Mother Earth more closely than in *Farewell to Matëra*, the novella in which he tells of the death of a Siberian village whose very name conjures up those warm and comforting images. The power of women, the solidity of tradition, the sin of defiling the earth, and the inevitability of progress all come together in this tale of a three-hundred-year-old village destined by planners in faraway Moscow to be flooded as part of building a huge hydroelectric dam on Siberia's Angara River. Once again, the hero is an old woman who stands as a living embodiment of the values and traditions of the past, and believes that God is in everyone, even in officials whose only concern is to carry out the plan handed down from on high. Here on the river island upon which Matëra stands is a self-sufficient land, "from end to end, from shore to shore [with] . . . enough expanse and wealth, enough beauty and wilderness,"[76] all of which will be obliterated by man's efforts to transform nature. As the villagers are moved to a modern workers' collective on the mainland and Matëra is flooded by the waters backed up from the dam, lives will be ruined and the landscape devastated in the name of progress before a fresh world will emerge. Modern apartments, running water, and indoor toilets will replace Matëra's ancient cottages. But the question still remains—as the heroine's son asks at the end: "Is the price to be paid for change too high?"[77]

While the Party bureaucrats who shaped Siberia's Soviet future answered that question with a dogmatic "no," Rasputin and the Village Prose writers of the 1960s and 1970s replied with an insistent "yes." Doing so put them at odds with the Soviet vision of progress, yet, unlike Solzhenitsyn, Brodsky, and Pasternak, they found it possible to publish in leading magazines and presses even as they applauded those ancient ways of life the Party wanted to destroy. The answer to why such stern, moralistic criticisms of Soviet progress continued to appear in legitimate channels throughout the Brezhnev era is still not entirely clear, but the reluctance of the literary establishment to drive authors with a mass following into the underground channels of *samizdat* was certainly a factor. On a more subtle level, Soviet leaders during the Brezhnev era continued to be sensitive about appearing to be heavy-handed and insensitive enemies of art and literature. In their minds, the openly published work of the Village Prose writers that criticized the central government, the bureaucracy, collectivization, and a dozen other aspects of Soviet life stood as clear proof that art that did not conform to the sacred axioms of Socialist Realism had a place in Soviet Russia. That very fact, the regime's apologists could argue, indicated that there must be something truly pernicious in those works that were driven underground or smuggled abroad to be published.

A similar concern for permitting limited criticism of the all-too-obvious failings of Soviet life accounts for the twenty-year survival of the famed Taganka Theater, which the controversial director Iurii Liubimov created out of the failing remains of Moscow's old Theater of Drama and Comedy in 1964.[78] Born in the provinces in the year of the Bolshevik Revolution, Liubimov grew up in Moscow in a family of ruined tsarist entrepreneurs, who had found refuge not far from the famed square on which his Taganka Theater was to stand. During the 1930s, he studied at Moscow's Vakhtangov Theater, watched some of Meyerhold's rehearsals, and chose the dictum that "the artist thinks everything up himself" to guide his artistic life.[79] As a well-acclaimed young actor, he spent the Second World War serving as master of ceremonies in the NKVD Ensemble of Song and Dance, which Lavrentii Beria, the head of Russia's dreaded security police, organized to raise the morale of troops at the Front. From being part of Beria's entourage, Liubimov returned to the Vakhtangov Theater after the war to win the Stalin Prize as one of its leading actors.

During the years that followed, Liubimov became known all across the Soviet Union for his performances in some of the most popular plays of the postwar era. Then, just before Khrushchev fell in 1964, the Moscow City Committee of the Communist Party invited him to take over the rundown Theater of Drama and Comedy, which performed in a crumbling prerevolutionary movie theater on Taganka Square. Hungry to create new art, Liubimov accepted the offer. It was then, his friend Iurii Trifonov said some years later, that he simply "stopped tolerating things" and set out to enliven the near wasteland of stale and stereotyped productions that the Soviet theater had become. In an auditorium of just over six hundred seats, he would create daring, innovative productions that would become the talk of Moscow. Artists, intellectuals, and simple people in search of relief from the monotony and stagnation that festered around them crowded his theater at every performance.[80]

As director of the Taganka Theater, Liubimov won the Party's consent to create an entirely new repertoire to be performed by actors of his own choosing. Among the first he invited to join his new company was Vladimir Vysotskii, whose grating, growling "voice torn from despair"[81] soon would sound a rallying cry for Russians living through the soul-deadening Brezhnev years. A people's poet and a brilliant actor, Vysotskii was destined to become, in the words of one critic, "the living soul and conscience of his time . . . [and] the tuning fork for Soviet artists . . . [who] checked their own voices and actions against his."[82] To the urgently strummed chords of his six-stringed guitar, he sang songs of protest that won the hearts of millions as they circulated through Russia on contraband, privately produced audiocassettes. As an actor in Liubimov's company he created some of the Taganka's greatest roles. By the time a heart attack killed him in 1980, Vysotskii had become a national monument, and his grave at that same ancient Holy Trinity Monastery in which Feofan Grek and Andrei Rublev had once practiced their art became a national shrine.

With Vysotskii and a handful of the students he had taught at the Vakhtangov

Theater, Liubimov set out to create productions that were passionate, daring, innovative, and modern. He began with Brecht's *Good Woman of Szechuan*, and moved from that to *Ten Days That Shook the World*, which he based on themes from John Reed's famous account of the October Revolution. Moscow's handful of liberal critics cheered his effort as a "really staggering" production and wrote eloquently of the emotions it stirred. "There's psychological drama, caricature, the grotesque, farce, low farce, slogans, pantomime, circus and shadow theater," one of them raved in amazement. "The emotional scope of this production is enormous." Convinced that "form is the more expressive way of saying the truth," and convinced that theater was "an art that is not only aural but visual," Liubimov amazed his early audiences by greeting them with jovial Red Guards, chanting revolutionary sailors, and torch singers who blended sarcasm with wit while they mixed bold metaphors with innuendos.[83] Often relying on Vysotskii's street charm and raw genius, he challenged all preconceptions and stereotypes, drawing the audience directly into the production in ways not seen even in the days of Vakhtangov and Meyerhold. Defenders of the theatrical establishment called him to account again and again, lamenting the absence of dogma and the comfortable clichés that had ruled Soviet theater since Meyerhold's death. Such critics used Moscow's major newspapers as their pulpits. For the moment, no one listened.

Over the next two decades, Liubimov put together a repertoire of plays by Maiakovskii, Gorkii, Brecht, Shakespeare, Chekhov, Pushkin, and more than a dozen other playwrights acclaimed for their brilliance. Air-raid sirens, exploding hand grenades, elevators that ran horizontally, blood-soaked corpses, blaring military bands, and scores of other unexpected, obtrusive sights and sounds assaulted the Taganka's audiences as its director created impressions of everything from street theater to battlefields on his theater's tiny stage. Again and again, Liubimov skirted the line between the forbidden and the permissible, managing always to stop just one step short of the censor's ban, even as establishment critics howled their disapproval. Then, when he presented an explosive stage version of Bulgakov's *Master and Margarita* in the spring of 1977, and *Pravda's* theater critic charged him with "petty bourgeois narrow-mindedness," it seemed that he had crossed the line. For the next four years, it was forbidden to write in the Soviet press about Liubimov or the Taganka, but his productions continued to be discussed wherever thoughtful Russians gathered. On the street outside the theater, the lines of people trying to buy tickets grew longer.[84]

As the tensions between Liubimov and the authorities increased over his controversial staging of Iurii Trifonov's *House on the Embankment* during the summer of 1980, Vysotskii's sudden death commanded national attention. Tens of thousands of mourners clamored to say farewell to the poet and actor whose caustic satires had enlivened the stagnant times in which he had lived, and his funeral became, as an observer wrote, "a spontaneous, national referendum on the freedom from censorship in Russian art."[85] Devotion to the actor's memory made the banning of Liubimov's tribute to *The Poet Vladimir Vysotskii* on the

first anniversary of his death all the more explosive. Forbidden by the Minister of Culture and then grudgingly approved by the KGB's head, Iurii Andropov, for performance only on the anniversaries of Vysotskii's birth and death, the production actually managed to have only two performances before it was closed forever. When Brezhnev died and Konstantin Chernenko came to power at the end of 1982, Liubimov enraged the authorities by using Pushkin's "comedy about an imposter," *Boris Godunov*, to question the new General Secretary's legitimacy. As they had done with *The Poet Vladimir Vysotskii*, the censors banned *Boris Godunov*, this time against the ominous backdrop of Chernenko's warning that "there are truths that are not subject to examination [and] there are problems that have been decided unequivocally once and for all."[86]

Six months later, with Chernenko dead and Andropov in power, Liubimov accepted an invitation to direct *Crime and Punishment* in London. On the day the production opened, he told a correspondent for the *London Times* that at age sixty-five he no longer had time to wait for Russia's censors to "finally arrive at an understanding of a culture that will be worthy of my native land." When he added that he could not allow the best of the Taganka's productions to be shut down by unthinking censors, the Soviet ambassador to London responded at a public reception by telling him that "the crime is completed . . . [and] punishment will follow."[87] A few months later, Moscow's Board of Culture dismissed Liubimov as the Taganka's director, and during the summer of 1984, the Soviet authorities stripped him of his citizenship.

The crude persecution of Liubimov came when the Soviet Union stood less than two years away from the new era of "openness" and "restructuring" that would lead to the breakup of the massive experiment upon which the Bolsheviks had embarked in 1917. Thanks to the powers of patronage and coercion exercised by those Party-dominated unions of writers, artists, composers, and filmmakers that had commanded the production of literature and art for the better part of six decades, dogma had long since elevated mediocrity into a sanctioning principle in the arts. Yet, even as they denounced dissident writers and artists as traitors, drove them from their native soil, and struggled to prevent their works from being seen, heard, or read, the cultural bureaucrats who feared free expression saw the tide of dissent rise against them. Efforts to erect barriers against the West had never been entirely effective, even in the days of Stalin. Now, as the ways of communicating across national frontiers multiplied, what had once been difficult became impossible.

In ways not even imagined in the days of Stalin, modern communications broke down geographical and political barriers by beaming television programs and radio broadcasts from Finland and the West, while the flood of people attending the Moscow Olympic Games in 1980 brought a tidal wave of novels, poetry, art books, historical works, and audiocasettes. Quickly spreading outward from the select ranks of the Moscow and Leningrad intelligentsia, which had maintained a sense of the West even at the height of Stalinism, these brought into sharper focus for less sophisticated Russians the image of a non-Soviet world in

which artistic freedom was taken for granted and artistic expression could be shaped by visions untainted by dogma and ideology. As in the long-ago days of the secular revolution, Russians had the chance to cross the barriers that separated them from the Western world of individualism and artistic freedom at the very moment when the forces that held those obstacles in place were weakening. Once again, dogma had lost its power to rule society and shape the arts.

As the power of its unions of artists and writers to define orthodoxy and dispense patronage crumbled in the Soviet Union, volumes written and consigned to the oblivion of a thousand desk drawers by men and women who never expected their work to see the printed page suddenly came to light, and works that had circulated clandestinely through the underground channels of *samizdat* rose to the surface. New art—unmarked by censorship and unblemished by ideological requirements—took shape almost overnight as Russia engaged in an orgy of publishing on a scale never before seen. Between 1985 and 1990, the circulation of *Novyi Mir*, the monthly magazine that once had dared to publish Solzhenitsyn's *One Day in the Life of Ivan Denisovich*, soared from 430,000 copies to more than 2 1/2 million. Other journals and periodicals kept pace as writers, journalists, historians, and political commentators committed to print the ideas they had guarded in silence for so long.[88]

By the time the Soviet Union fell at the end of 1991, Russia's artistic life was in turmoil, not as a result of being deprived of the firm precepts that had guided it during the Soviet era, but precisely because so many long-separated currents were flowing together at a speed unimagined even a decade before. By the early 1990s, *Doctor Zhivago* had appeared in a score of Russian editions, all with large printings that placed within reach of anyone with a handful of rubles the novel that men and women had risked prison to read in tattered manuscript copies just a quarter of a century earlier. The same was true of the long-silenced voices of the poets Gumilev, Mandelshtam, and Akhmatova, not to mention a score of others. Suddenly, Russians could read the uncensored text of Bulgakov's *Master and Margarita* and contemplate from an entirely new perspective the meaning of his remark that "manuscripts don't burn."

Men and women who had lived through Stalin's reign of terror, who had known the torments of the GULag, or had been married to political opponents executed by Stalin now told their stories in memoirs. Among them, the poet Mandelshtam's wife Nadezhda, Akhmatova's close and long-suffering friend Lidiia Chukovskaia, and Anna Larina, whose husband Nikolai Bukharin had thought in the 1920s that Russia ought to take a different path to Communism, all told the Russians of the terrible events about which they had been forced to keep silent for so long. Highly acclaimed in the West as the best novel ever written in Russia about World War II, Vasilii Grossman's *Life and Fate* finally appeared in Russia in 1988, twenty-eight years after he had finished it. *White Robes*, the novel in which Dudintsev had dared to portray an academic-scientific empire built on anti-Western, anti-Semitic principles by means of the Stalinist practices of spying, denouncing rivals, and falsifying data and evidence appeared at about the

same time. Parodies of Stalinism, satires of Soviet life, and bitter remembrances of lives spoiled and talents destroyed by men who placed ideology ahead of humanity all poured forth, as people finally had their say after lifetimes spent in silence.

At the same time, a flood of new books brought to the Russians the treasures of the artists and writers who had been driven abroad because they had refused to work within the dogmatic framework dictated by Soviet rulers. In the space of scarcely more than half a decade, men and women whose awareness of their national artistic experience had been confined within narrow Soviet boundaries discovered the brilliant works of Nabokov and Bunin, the émigré poetry of Tsvetaeva, the paintings of Kandinskii and Chagall, and the music of Stravinskii. Russians came to know Solzhenitsyn's *GULag Archipelago* in all its murderous, painful, heroic detail, and they once again began to hear of Diagilev and learned of the accolades that his Ballets Russes had won for Russian art during the 1920s. No longer were Chagall and Kandinskii condemned as formalist perversions of Russia's true artistic experience, and books about their work appeared in printings that ran to tens of thousands of copies. By the time that the Soviet Union broke apart in December 1991, the merging currents of émigré art and literature had combined with those long suppressed in the Soviet Union to create a massive new force in Russian life.

Divided into "émigré" and "Soviet," "capitalist" and "Communist" for three-quarters of a century, Russia's artistic experience regained the integrity that had been so brutally torn apart in the 1920s. Now artists, writers, and critics, who had for so long defined innovation by noting the extent to which art diverged from the precepts of Socialist Realism, had to confront the postmodernist dilemmas that shaped the work of their counterparts in the West. "The vertical, hierarchical, rough, and classified image of the world is being replaced today by the horizontal, pluralistic, flexible, and the destructive," one of them wrote. "Everything flows," he added with a sense of resignation. "Such are the times."[89] What the times would yield remained a mystery as the Soviet Union dissolved and the Commonwealth of Independent States announced its birth at the beginning of 1992. Without the Party to serve as the chief patron of the arts, modern-day Russians faced the problems of living on what their art earned for the first time in nearly a century, and that posed questions that their Soviet predecessors had never had to face. For freedom and independence had a price—and that price began to reshape the contours of the nation's artistic experience even more quickly than the ideological precepts of Soviet life had done.

Once again, the Russians had seen the values that underlay their society shattered, and, as they had in the days of Kiev's Grand Prince Vladimir, Peter the Great, and Stalin, they had to seek new values around which to shape their art. What did it mean to be Russian? How should Russians relate to the world that lay beyond their frontiers? And how could values shaped outside the framework of the Communist experience be applied to Russia once the Soviet experiment had failed? No one faced that latter dilemma more directly than Solzhenitsyn

himself, who in 1994 returned from the West with a political and artistic vision that had been blended in the crucible of prison-camp suffering, bitter conflict with the Soviet authorities, and the struggle to remain morally pure once he had been cast adrift in the seductive seas of Western ideas and material affluence. "There is no escaping the fact that our country has cruelly forfeited the entire twentieth century," Solzhenitsyn had written just three months before Gorbachev received the Nobel Peace Prize in 1990. "Our much-trumpeted achievements all have turned out to be illusory. From a flourishing condition we have been hurled back to a state of semi-barbarity, and we sit amid the wreckage."[90]

Ironically, or perhaps symbolically, Solzhenitsyn's comments appeared in *Komsomolskaia Pravda*, the Moscow newspaper that had taken its name from the once-powerful Communist Youth League many years before. "Time has run out for Communism," he warned its readers, and Russians would now have to "take care not to be crushed beneath its rubble instead of gaining liberty." But what would come in Communism's wake was far from certain. "We have passed through bottomless pits . . . [and] have experienced . . . [an] utter exhaustion of human resources," an anonymous young Russian wrote in a volume of essays entitled *From Under the Rubble*. "In glorious destitution, in utter defenselessness in the face of suffering," he concluded, "our hearts have been kindled by an inner spiritual warmth and have opened to new, unexpected impulses." What those impulses would yield in the way of reshaping Russia's artistic experience could become clear only with time, for as it struggled to become the first nation in the world's history to throw off the weight of its three-quarter-century-long experiment with Communism, no one knew what the future held. "The end of Communism," Czechoslovakia's President Vaclav Havel wrote as he looked east from Prague toward the fallen colossus that had once crushed his nation, "is, first and foremost, a message to the human race. It is a message," he concluded in 1992, "that we have not yet fully deciphered and comprehended."[91]

Nor have the Russians done so yet. What it means to become "Russian" after three-quarters of a century of being "Soviet" still remains uncertain, and how the artistic creations of the Soviet era will be blended with those of the past has yet to be seen. "I did not come here because this country is flourishing . . . or because people were calling me a prophet," Solzhenitsyn said when he returned to his homeland in 1994. "I came because of my conscience. It would have been unconscionable to sit and search for new literary genres" while Russia was in torment. Therein lies the key to how the Russians will reconnect past, present, and future. In a nation whose writers "have rarely," in Solzhenitsyn's words, "stood aside from political life,"[92] consciences and passions have shaped the arts. As writers and artists who have not yet come to grips with the present-day turmoil seek to define their place in a tradition that began a thousand years ago when there were no Russians, no Russian language, and no Russia, it will be their consciences combined with a sense of the past and a vision of the future that will shape Russia's artistic experience in the decades that lie ahead.

# NOTES

❦

*CHAPTER I*
PROLOGUE

1. Quoted in Edvard Radzinsky, *The Last Tsar: The Life and Death of Nicholas II*, trans. from the Russian by Marian Schwartz (New York, 1992), p. 51.

2. V. I. Nemirovich-Danchenko, "Moskva v mae 1896 goda," *Niva*, No. 20, pp. 505–506; No. 21, p. 523; H.S.H. The Princess Romanovsky-Krassinsky, *Dancing in Petersburg: The Memoirs of Kschessinska*, trans. by Arnold Haskell (New York, 1961), p. 58; Robert K. Massie, *Nicholas and Alexandra* (New York, 1967), pp. 53–54; Radzinsky, *Last Tsar*, p. 51.

3. Nemirovich-Danchenko, "Moskva," *Niva*, No. 19 (1896), p. 448.

4. Winston S. Churchill, *The World Crisis, 1911–1914* (London, 1923), p. 188.

5. S. S. Ol'denburg, *Tsarstovanie Imperatora Nikolaia II* (Belgrade, 1939), I, pp. 59–61; Nemirovich-Danchenko, "Moskva," *Niva*, No. 20 (1896), pp. 496–497; B. A. Rybakov, ed., *Treasures in the Kremlin* (London,

Prague, and Moscow, 1962), pp. 118 (plate 119), 127.

6. B. A. Romanov, *Russia in Manchuria (1892–1906)*, trans. by Susan Wilbur Jones (Ann Arbor, 1952), pp. 81–93; Andrew Malozemoff, *Russian Far Eastern Policy, 1881–1904. With Special Emphasis on the Causes of the Russo-Japanese War* (Berkeley and Los Angeles, 1958), pp. 76–84, and note 74, pp. 402–403.

7. Thus the Emperor Nicholas I had written to his brother a few days after the famed Decembrist revolt. Pis'mo Nikolaia I k v. k. Konstantinu Pavlovichu, 14–16 dekabria 1825g., in Th. Schiemann, *Die Ermordung Pauls und die Thronbesteigung Nikolaus I. Neue Materialen* (Berlin, 1902), p. 103.

8. Nemirovich-Danchenko, "Moskva," *Niva*, No. 19 (1896), pp. 448, 451. On workers' wages and working conditions, see N. K. Druzhinin, ed., *Usloviia byta rabozhikh v dorevoliutsisonnoi Rossii* (Moscow, 1958), pp. 28–34, 102–104; M. K. Rozhkzova, "Zarabotnaia plata rabochikh trekhgornoi manufaktury v 1892–1913gg.," in M. V. Nechkina et

al., eds., *Iz istorii rabochego klassa i revoliutsionnogo dvizheniia. Pamiati akademika Anny Mikhailovny Pankratovoi* (Moscow, 1958), pp. 333–341.

9. See especially the reports filed by the correspondent for the St. Petersburg magazine *Niva* (summarized by Harrison Salisbury in *Black Night, White Snow: Russia's Revolutions, 1905–1917* [New York, 1978], pp. 51–54). These provide an unusually vivid sense of the excitement of life in Moscow at the time. See Nemirovich-Danchenko, "Moskva," *Niva*, No. 19 (1896), pp. 448–451; No. 20 (1896), pp. 496–506; No. 21 (1896), pp. 525–527; No. 22 (1896), pp. 561–572; No. 23 (1896), pp. 586–591.

10. Nemirovich-Danchenko, "Moskva," *Niva*, No. 19 (1896), pp. 448–451.

11. Vladimir Nemirovitch-Dantchenko, *My Life in the Russian Theatre*, trans. from the Russian by John Cournos, foreword by Oliver M. Sayler (Boston, 1936), pp. vii–viii.

12. Nemirovich-Danchenko, "Moskva," *Niva*, No. 19 (1896), p. 450.

13. Karl Baedeker, *Baedeker's Russia 1914* (London, 1971), p. 299.

14. Nemirovich-Danchenko, "Moskva," *Niva*, No. 20 (1896), pp. 505–506; No. 21, p. 507.

15. Ibid., No. 21, pp. 525–526.

16. *Ministerstvo Finansov, 1802–1902* (St. Petersburg, 1902), pp. 624–627.

17. Nemirovich-Danchenko, "Moskva," No. 20 (1896), pp. 496–506; No. 21, pp. 523–524.

18. Ibid., No. 21, p. 527.

19. "Vysochaishe utverzhdennyi Tseremonial sviashchennago koronovaniia ikh Imperatorskikh Velichestv Gosudaria Imperatora Nikolaia Aleksandrovicha Samoderzhtsa Vserossiiskago i Gosudarynia Imperatritsy Aleksandry Feodorovny," *Niva*, No. 19 (1896), p. 442.

20. Massie, *Nicholas and Alexandra*, p. 54.

21. Quoted in Radzinsky, *Last Tsar*, p. 43.

22. W. Bruce Lincoln, *The Romanovs: Autocrats of All the Russias* (New York, 1981), p. 631; "Poslednii samoderzhets (Materialy dlia kharakteristiki Nikolaia II)," in *Nikolai II: Materialy dlia kharakteristiki lichnosti i tsarstvovaniia* (Moscow, 1917), pp. 60–62.

23. Quoted in Radzinsky, *Last Tsar*, p. 48.

24. Quoted in Pierre Gilliard, *Le Tragique destin de Nicolas II et de sa famille* (Paris, 1938), p. 35.

25. Quoted in S. S. Ol'denburg, *Tsarstvovanie Imperatora Nikolaia II* (Belgrade, 1939), I, p. 61.

26. Ibid., p. 60.

27. Ibid.

28. Nemirovich-Danchenko, "Moskva," No. 21 (1896), p. 535.

29. Baroness Sophie Buxhoeveden, *The Life and Tragedy of Alexandra Feodorovna, Empress of Russia* (London, 1928), pp. 656–666; Massie, *Nicholas and Alexandra*, p. 57.

30. Nemirovich-Danchenko, "Moskva," No. 22 (1896), p. 564.

31. Ibid.

32. Pierre d'Alheim, "Khodinskii uzhas (iz vospominanii)," in *Nikolai II*, pp. 105–106.

33. Ibid.; Nemirovich-Danchenko, "Moskva," No. 22 (1896), pp. 564–565.

34. Nemirovich-Danchenko, "Moskva," No. 22 (1896), pp. 565, 567.

35. d'Alheim, "Khodinskii uzhas," pp. 106–107.

36. John Foster Fraser, *The Real Siberia, Together with an Account of a Dash through Manchuria* (New York, 1904), pp. 159–160.

37. *The Russian Primary Chronicle*, trans. and ed. by Samuel Hazzard Cross and Olgerd P. Sherbowitz-Wetzer (Cambridge, Mass., 1953), p. 97.

38. d'Alheim, "Khodinskii uzhas," p. 108, quoted in Lincoln, *Romanovs*, p. 625.

39. Nemirovich-Danchenko, "Moskva," No. 22 (1896), p. 565.

40. d'Alheim, "Khodinskii uzhas," pp. 108–109, quoted in Lincoln, *Romanovs*, p. 625.

41. Nemirovich-Danchenko, "Moskva," No. 22 (1896), p. 566.

42. Ibid., pp. 568–569.

43. Ibid., p. 568.

44. Ibid., p. 570.

45. N. P. Eroshkin, "Administrativno-

politseiskii apparat," in A. M. Pankratova, ed., *Istoriia Moskvy* (Moscow, 1955), V, pp. 665–666.

46. "Poslednii samoderzhets," p. 59.

47. S. Iu. Witte, *Vospominaniia* (Moscow, 1960), II, p. 74.

48. d'Alheim, "Khodinskii uzhas," p. 114.

49. Ibid., p. 113.

50. Ol'denburg, *Tsarstovanie Nikolaia II*, I, p. 61.

51. "Koronatsionnye torzhestva," *Niva*, No. 23 (1896), p. 587.

52. Nemirovich-Danchenko, "Moskva," No. 23 (1896), p. 587.

CHAPTER II
GENESIS

1. *Russian Primary Chronicle*, pp. 96–113.

2. John Meyendorf, *Byzantium and the Rise of Russia: A Study of Byzantino-Russian Relations in the Fourteenth Century* (Crestwood, N.Y., 1989), pp. 3–5; James H. Billington, *The Icon and the Axe: An Interpretive History of Russian Culture* (London, 1966), pp. 4–5.

3. L. V. Cherepnin, *Russkaia paleografiia* (Moscow, 1956), pp. 92–111; Francis Dvornik, "The Significance of the Missions of Cyril and Methodius," *Slavic Review*, XXIII (1964), pp. 195–211; Francis Dvornik, *The Slavs: Their Early History and Civilization* (Boston, 1956), pp. 80–102, 166–169; Francis Dvornik, *Byzantine Missions Among the Slavs* (New Brunswick, 1970), pp. 103–104, 160–193; F. Dvornik, *Les Slaves, Byzance et Rome au IX siècle* (Paris, 1926), pp. 162–164; Ihor Sevcenko, "Three Paradoxes of the Cyrillo-Methodian Mission," *Slavic Review*, XXIII, No. 2 (1964), pp. 220–236, especially pp. 225–234; N. K. Gudzy, *History of Early Russian Literature*, trans. from the second Russian edition by Susan Wilbur Jones, with an introduction by Gleb Struve (New York, 1949), pp. 22–83.

4. P. N. Miliukov, *Ocherki po istorii russkoi kul'tury*, 3rd ed. (St. Petersburg, 1902), II, pp. 9–16; P. Fedotov, *The Russian Religious Mind: Kievan Christianity from the Tenth to the Thirteenth Centuries* (New York, 1960), pp. 142–157.

5. N. N. Voronin, "Zodchestvo kievskoi rusi," in I. E. Grabar, ed., *Istoriia russkogo iskusstva* (Moscow, 1953), I, pp. 117–120 (cited hereafter as *Istoriia russkogo iskusstra*); P. P. Tolochko, *Drevniaia Rus': Ocherki sotsial'no-politicheskoi istorii* (Kiev, 1987), pp. 70–75; Janet Martin, *Medieval Russia, 980–1584* (Cambridge, 1995), pp. 9–10.

6. Quoted in Samuel H. Cross, in collaboration with H. V. Morgilevski and K. J. Conant, "The Earliest Mediaeval Churches of Kiev," *Speculum*, XI, No. 4 (1936), p. 491. See also George Heard Hamilton, *The Art and Architecture of Russia* (New Haven and London, 1983), p. 25.

7. The best description of the Cathedral of St. Sofiia in English, along with considerable material on its early Soviet excavations and reconstructions, can be found in Cross, Morgilevski, and Conant, "The Earliest Mediaeval Churches of Kiev," pp. 490–499. See also N. N. Voronin, "Zodchestvo Kievskoi Rusi," in I. E. Grabar, ed., *Istoriia russkogo iskusstva* (Moscow, 1953), I, pp. 127–135, E. Golubinskii, *Istoriia russkoi tserkvi* (Moscow, 1901), vol. I, book 2, pp. 95–106; and Hamilton, *Art*, pp. 65–73.

8. John Baggley, *Doors of Perception: Icons and Their Spiritual Significance* (Crestwood, N.Y., 1988), p. 9; Leonid Ouspensky and Vladimir Lossky, *The Meaning of Icons* (Crestwood, N.Y., 1989), p. 53.

9. N. S. Trubetzkoy, "Introduction to the History of Old Russian Literature," *Harvard Slavic Studies*, II (1954), p. 101; *Russian Primary Chronicle*, p. 205.

10. Ouspensky and Lossky, *Meaning*, pp. 38–39.

11. Ibid., p. 60; Baggley, *Doors*, p. 91.

12. Billington, *Icon and the Axe*, pp. 33–34. See also N. Sperovskii, "Starinnye russkie ikonostassy," *Khristianskoe Chtenie*, No. 6 (Nov–Dec. 1891), pp. 346–348; Baggley, *Doors*, pp. 91–92; Ouspensky and Lossky, *Meaning*, pp. 59–67.

13. Hamilton, *Art*, p. 108. See also pp.

99–107, and Ouspensky and Lossky, *Meaning*, p. 25.

14. *The Song of Igor's Campaign: An Epic of the Twelfth Century*, trans. from the Old Russian by Vladimir Nabokov (New York, 1960), pp. 13, 6. See also A. E. Presniakov, *Lektsii po russkoi istorii* (Moscow, 1938), I, pp. 228–240; V. O. Kliuchevskii, *Kurs russkoi istorii*, in *Sochineniia* (Moscow, 1956), I, pp. 316–327.

15. Nabokov, *Song*, lines 339–342.

16. B. D. Grekov and A. Iu. Iakubovskii, *Zolotaia orda i ego padenie* (Moscow and Leningrad, 1950), pp. 214–217.

17. John of Plano Carpini, "History of the Mongols," in Christopher Dawson, ed., *The Mongol Mission* (New York, 1955), pp. 29–30.

18. N. M. Karamzin, *Istoriia gosudarstva rossiiskago*, 5th ed. (St. Petersburg, 1842), IV, cols. 9–12; A. N. Nasonov, *Mongoly i Rus' (istoriia tatarskoi politiki na Rusi)* (Moscow and Leningrad, 1940), pp. 14–20, 50–68.

19. V. N. Lazarev, *Drevnerusskie mozaiki i freski, XI–XV vv.* (Moscow, 1973), pp. 173–180; Hamilton, *Art*, pp. 39–42; William Craft Brumfield, *A History of Russian Architecture* (Cambridge, 1993), pp. 27–31. Brumfield's study is the best summary volume on the history of Russian architecture available in any language.

20. See, for example, the entries for the years 1179, 1195, and 1196 in *The Chronicle of Novgorod, 1016–1471*, translated from the Russian by Robert Michell and Nevill Forbes, Camden Third Series, XXV (London, 1914), pp. 30, 38, 39; Brumfield, *History*, pp. 27–33.

21. Quoted in Billington, *The Icon and the Axe*, p. 26. See also K. N. Lazarev, *Iskusstvo Novgoroda* (Moscow, 1947), pp. 52–62; M. K. Karger, "Novgorodskoe zodchestvo," in I. E. Grabar (ed.), *Istoriia russkogo iskusstva* (Moscow, 1954), II, pp. 24–63; Hamilton, *Art*, pp. 41–43. The best summary treatment of Russian wooden architecture is in Brumfield, *History*, pp. 501–520.

22. Billington, *The Icon and the Axe*, p. 16.

23. Quoted in Brumfield, *History*, p. 47.

24. Hamilton, *Art*, p. 56; Brumfield, *History*, pp. 44–51.

25. V. N. Lazarev, "Skul'ptura Vladimiro-Suzdal'skoi Rusi," in I. E. Grabar (ed.), *Istoriia russkogo iskusstva* (Moscow, 1953), I, pp. 410–426; Hamilton, *Art*, pp. 59–61, 75–78; Brumfield, *History*, pp. 51–65.

26. V. N. Lazarev, *Drevnerusskie mozaiki i freski XI–XVvv* (Moscow, 1973), pp. 50–55; Hamilton, *Art*, pp. 119–127.

27. Tamara Talbot Rice, *A Concise History of Russian Art* (New York, 1963), p. 120.

28. V. N. Lazarev, *Feofan Grek i ego shkola* (Moscow, 1961), pp. 7–45.

29. Quoted in Michael Cherniavsky, *Tsar and People: Studies in Russian Myths* (New Haven and London, 1961), p. 27.

30. D. S. Likhachev, *Kul'tura Rusi vremeni Andreia Rubleva i Epifaniia Premudrogo (konets XIV–nachalo XV v.)* (Moscow-Leningrad, 1962), p. 90.

31. Quoted in N. K. Gudzii, *Istoriia drevnei russkoi literatury*, 6th edition (Moscow, 1956), p. 222.

32. Serge A. Zenkovsky (ed.), *Medieval Russia's Epics, Chronicles, and Tales* (New York, 1974), p. 217.

33. Nabokov, *Song*, p. 16. See also pp. 15, 17, and Victor Terras, *A History of Russian Literature* (New Haven and London, 1991), p. 65.

34. Zenkovskii, *Epics*, pp. 223, 221.

35. Lazarev, *Feofan Grek i ego shkola*, p. 69.

CHAPTER III
HOLY MOSCOW

1. Quoted in S. J. Freedberg, *Painting in Italy, 1500–1600* (Middlesex and Baltimore, 1975), p. 21.

2. Ibid., pp. 50–53; P. Kovalevsky, *Saint Serge et la spiritualité russe* (Paris, 1958), *passim*; Robert O. Crummey, *The Formation of Muscovy 1304–1613* (London and New York, 1987), pp. 189–190.

3. Lazarev, *Feofan Grek*, p. 69: V. N. Lazarev, *Andrei Rublev* (Moscow, 1960), pp. 19–20.

4. V. N. Lazarev, *Andrei Rublev i ego shkola* (Moscow, 1966); M. V. Alpatov, ed., *Andrei Rublev i ego epokha* (Moscow, 1971); M. V. Alpatov, *Andrei Rublev* (Moscow, 1959); and V. Sergeev, *Rublev* (Moscow, 1981).

5. N. A. Demina, *Andrei Rublev i khudozhniki ego kruga* (Moscow, 1972), pp. 57–63; Crummey, *Formation*, 191–192; Hamilton, *Art*, pp. 136–138; and the compiled commentary in G. I. Vzdornov, ed., *Troitsa Andreia Rubleva: Antologiia* (Moscow, 1989). Very recently, some Russian art historians have called Rublev's authorship of the Trinity icon into question, but the matter is by no means settled.

6. Crummey, *Formation*, pp. 198–199; Hamilton, *Art*, pp. 153–158; Tatiana V. Tolstaia, "Between Heaven and Earth: The Eternal Beauty of Moscow Icons," in W. Bruce Lincoln, comp., *Moscow: Treasures and Traditions* (Seattle, 1990), pp. 72–74.

7. Quoted in Crummey, *Formation*, p. 133. See also Dimitri Stremooukhoff, "Moscow the Third Rome: Sources of the Doctrine," in Michael Cherniavsky, ed., *The Structure of Russian History* (New York, 1970), p. 111.

8. Quoted in Crummey, *Formation*, p. 135.

9. V. Snegirev, *Aristotel' Fioravanti i perestroika Moskovskogo Kremlia* (Moscow, 1935), pp. 25–39; S. M. Zemtsov and V. L. Glazychev, *Aristotel' Fioravanti* (Moscow, 1985), pp. 40–65; S. M. Zemtsov, "Arkhitektory Moskvy vtoroi poloviny XV i pervoi poloviny XVI veka," in Iu. S. Iaralov, ed., *Zodchie Moskvy XV–XIX vv.* (Moscow, 1981), pp. 46–49; Martin, *Medieval Russia*, pp. 273–277.

10. M. A. Il'in, P. N. Maksimov, and V. V. Kostochkin, "Kamennoe zodchestvo epokhi rassveta Moskvy," in Grabar, ed., *Istoriia*, III, pp. 300–303; Brumfield, *History*, pp. 95–96; Zemtsov, "Arkhitektory," pp. 49–59.

11. Snegirev, *Aristotel' Fioravanti*, pp. 78–90; Lincoln, comp., *Moscow*, pp. 29–30; Il'in, Maksimov, and Kostochkin, "Kamennoe zodchestvo," pp. 300–306; M. Il'ina, *Moskva: Pamiatniki arkhitektury XIV–XVII vekov* (Moscow, 1973), pp. 17–18; Brumfield, *History*, pp. 95–99.

12. Il'ina, *Moskva*, pp. 21–22; Il'in et al., "Kamennoe zodchestvo," pp. 321–324.

13. Il'in et al., "Kamennoe zodchestvo," p. 308; Zemtsov, "Arkhitektory," pp. 59–68; Brumfield, *History*, pp. 99–101.

14. Adam Olearius, *The Travels of Olearius in Seventeenth-Century Russia*, ed. and trans. Samuel H. Baron (Stanford, 1967), pp. 62–63.

15. K. Waliszewski, *Ivan the Terrible*, trans. from the French by Lady Mary Loyd (London, 1904), p. 358.

16. Il'ina, *Moskva*, pp. 24–26; Il'in et al., "Kamennoe zodchestvo," pp. 325–326.

17. Quoted in Il'in et al., "Kamennoe zodchestvo," p. 310. Also see especially S. P. Bartenev, *Moskovskii Kreml' v starinu i teper'* (Moscow, 1912), pp. 29–42.

18. Il'in et al., "Kamennoe zodchestvo," pp. 326–330; Hamilton, *Art*, pp. 194–196; Brumfield, *History*, pp. 101–105.

19. Billington, *Icon and the Axe*, p. 39.

20. Edward V. Williams, *The Bells of Russia: History and Technology* (Princeton, 1985), pp. 44–45; James Bakst, *A History of Russian-Soviet Music* (New York, 1966), p. 11.

21. Quoted in Riasanovsky, *History*, p. 115. See also Williams, *Bells*, pp. 41–42.

22. Paul of Aleppo, *The Travels of Macarius. Extracts from the Diary of the Travels of Macarius, Patriarch of Antioch, Written in Arabic by His Son Paul, Archdeacon of Aleppo in the Years of Their Journeying, 1652–1660*, selected and arranged by Lady Laura Ridding (London, 1937), p. 27.

23. Quoted in Billington, *Icon and the Axe*, p. 39.

24. Williams, *Bells*, pp. xv, 148–157.

25. See especially E. Duchesne, ed. and trans., *Le Stoglav ou les cent chapitres* (Paris, 1920), *passim*, and I. U. Budovnits, *Russkaia publitsistika XVI veka* (Moscow-Leningrad, 1947), pp. 230–256.

26. Tolstaia, "Between Heaven and Earth," p. 76.

27. Quoted in Hamilton, *Art*, pp. 161, 242.

28. Tolstaia, "Between Heaven and Earth," pp. 75–78; M. V. Alpatov, *Drevnerusskaia ikonopis'* (Moscow, 1984), pp.

18–21; and O. I. Podobedova, *Moskovskaia shkola zhivopisi pri Ivane IV* (Moscow, 1972), *passim*.

29. *Baedeker's Russia, 1914*, p. 299. See also N. I. Brunov, *Khram Vasiliia Blazhennogo v Moskve: Pokrovskii Sobor* (Moscow, 1988), *passim*; and Brumfield, *History*, pp. 122–129.

30. For some examples, see V. V. Kolesov, ed., *Domostroi* (Moscow, 1990), pp. 47–49, 117. See also Carolyn J. Pouncy, "The Origins of the *Domostroi*: A Study in Manuscript History," *The Russian Review*, XLVI (1987), pp. 357–374; and Paul Bushkovich, *Religion and Society in Russia: The Sixteenth and Seventeenth Centuries* (New York and Oxford, 1992), pp. 135, 137.

31. S. F. Platonov, *Moskva i zapad v XVI–XVII vekakh* (Leningrad, 1925), p. 58.

32. George Tuberville, "Verse Letters from Russia," in Lloyd E. Berry and Robert O. Crummey, eds., *Rude and Barbarous Kingdom: Russia in the Accounts of Sixteenth-Century English Voyagers* (Madison, 1968), p. 83.

33. Quoted in Adam Olearius, *The Travels of Olearius in Seventeenth-Century Russia*, translated and edited by Samuel H. Baron (Stanford, 1967), p. 133.

34. See the title of Berry and Crummey, eds., *Rude and Barbarous Kingdom*.

35. Quoted in Olearius, *Travels*, p. 163.

36. Aleksandr Morozov, *Mikhail Vasil'evich Lomonosov, 1711–1765* (Leningrad, 1952), pp. 9–44; B. N. Menshutkin, *Russia's Lomonosov,* (Princeton, 1952), pp. 7–12; G. F. Miller, *Istoriia Sibiri* (Moscow-Leningrad, 1937), I, pp. 206–208; A. A. Vvedenskii, "Anika Stroganov v svoem Sol'vychegodskom khoziaistve," p. 107; A. A. Vvedenskii, *Dom Stroganovykh v XVI–XVII vekakh* (Moscow, 1962), pp. 19–53; T. S. Willan, *The Early History of the Russia Company, 1553–1603* (Manchester, England, 1956), *passim*; and W. Bruce Lincoln, *The Conquest of a Continent: Siberia and the Russians* (New York, 1994), pp. 37–40.

37. Hamilton, *Art*, pp. 243–250; Iu. N. Dmitriev, " 'Stroganovskaia shkola' zhivopisi," in Grabar, ed., *Istoriia*, III, pp. 643–675.

38. Baron Augustin von Meyerberg, *Baron Meierberg i puteshestvie ego po Rossii* (St. Petersburg, 1827), p. 233. See also M. A.

Il'in, "Kamennoe zodchestvo vtoroi chetverti XVII veka," in Grabar, ed., *Istoriia*, IV, pp. 121–126; M. A. Il'in, "Kamennoe zodchestvo tret'ei chetverti XVII veka," in Grabar, ed., *Istoriia*, IV, pp. 200–212; N. N. Voronin, *Ocherki po istorii russkago zodchestva XVI–XVII vv.* (Leningrad, 1934), pp. 129–130; Hamilton, *Art*, pp. 211–214.

39. M. A. Il'in, "Kamennoe zodchestvo kontsa XVII veka," in Grabar, ed., *Istoriia*, IV, pp. 217–278; Hamilton, *Art*, pp. 216–224.

40. P. N. Miliukov, *Ocherki po istorii russkoi kul'tury* (St. Petersburg, 1901), II, pp. 42–44.

41. N. F. Kapterev, *Patriarch Nikon i Tsar Aleksei Mikhailovich* (Sergiev Posad, 1909), I, pp. 308–393. See also Pierre Pascal, *Avvakum et les débuts du raskol* (Paris–The Hague, 1963).

42. Archpriest Avvakum, *The Life Written by Himself*, translations, annotations, commentary, and a Historical Introduction by Kenneth N. Brostrom (Ann Arbor, 1979), p. 104.

43. Quoted in Hamilton, *Art*, p. 253.

44. Quoted in N. K. Gudzii, *Istoriia drevnei russkoi literatury*, 6th ed. (Moscow, 1956), p. 474.

## CHAPTER IV
### RUSSIA'S SECULAR REVOLUTION

1. A. N. Pypin, *Istoriia russkoi literatury* (St. Petersburg, 1911), II, pp. 170–172; A. S. Orlov, ed., *Istoriia russkoi literatury* (hereafter, with different editors, cited as *Istorria russkoi literatury*) (Moscow-Leningrad, 1948), vol. II, book 2, pp. 342–353; L. Maikov, *Ocherki iz istorii russkoi literatury XVII i XVIIIvv.* (St. Petersburg, 1898), pp. 1–162.

2. William Edward Brown, *A History of Seventeenth-Century Russian Literature* (Ann Arbor, 1980), pp. 117–118.

3. B. Varneke, *Istoriia russkogo teatra XVII–XIX vekov* (Moscow-Leningrad, 1939), p. 23.

4. Quoted in Lindsey Hughes, *Sophia Regent of Russia, 1657–1704* (New Haven and London, 1990), pp. 37–38.

5. Simon Karlinsky, *Russian Drama from*

*Its Beginnings to the Age of Pushkin* (Berkeley and Los Angeles, 1986), pp. 37–48; N. Findeizen, *Ocherki po istorii muzyki v Rossii s drevneishikh vremen do kontsa XVIII veka* (Moscow-Leningrad, 1928), I, pp. 315–323. See also André Mazon and Frederic Cocron, *La Comédie d'Artaxerxes (Artaxerxovo deistvo) presentée en 1672 au tsar Alexis par Gregorii le Pasteur* (Paris, 1954), and the introductory essay by I. M. Kudriavtsev in *Artakserksovo deistvo* (Moscow, 1959).

6. Ivan Zabelin, *Domashnii byt russkikh tsarei v XVI i XVII st.* [volume I of *Domashnii byt russkago naroda v XVI i XVII st.*] (Moscow, 1895), pp. 481–549; Ivan Zabelin, *Opyty izucheniia russkikh drevnostei i istorii* (Moscow, 1873), II, pp. 283–307; S. V. Bakhrushin and S. K. Bogoiavlenskii, "Podmoskovnye uzad'by XVII v.," in S. V. Bakhrushin et al., eds., *Istoriia Moskvy* (Moscow, 1952), I, pp. 527–532; Princess Zinaida Schakovskoy, *La vie quotidienne à Moscou au XVIIe siècle* (Paris, 1963), pp. 258–260; Lincoln, *Romanovs*, pp. 99–101.

7. Hamilton, *Art*, p. 235; Zinaida Schakovskoy, *The Fall of Eagles: Precursors of Peter the Great*, trans. from the French by J. Maxwell Brownjohn (New York, 1964), p. 67.

8. Zabelin, *Domashnii byt russkikh tsarei*, I, pp. 444–486; Lincoln, *Romanovs*, pp. 100–102; Hamilton, *Art*, p. 227; Iakov Reitenfel's, "Skazaniia svetleishemu gertsogu Toskanskomu Kos'me Tret'emu o Moskovii," *Chtenie v obshchestve istorii i drevnostei rossiiskikh pri Imperatorskom Moskovskom universitete*, No. 3 (1905), pp. 92–94.

9. V. O. Kliuchevskii, *Kurs russkoi istorii* (Moscow, 1958), pp. 352–353.

10. Zabelin, *Domashnii byt russkikh tsarei*, I, pp. 549–566; Hughes, *Sophia*, pp. 170, 176–177; S. M. Solov'ev. *Istoriia Rossii s drevneishikh vremen* (Moscow, 1962), bk. VII (vols. 13–14), pp. 365–368.

11. Evgenii Anisimov, *Vremia petrovskikh reform* (Leningrad, 1989), p. 14.

12. W. Bruce Lincoln, *In War's Dark Shadow: Russia and the Russians Before the Great War* (New York, 1983), pp. 60–61.

13. James Cracraft, *The Petrine Revolution in Russian Architecture* (Chicago, 1988),

p. 175. See also S. P. Luppov, *Istoriia stroitel'stva Peterburga v pervoi chetverti XVIII veka* (Moscow-Leningrad, 1957), pp. 15–17, 80–83; G. E. Kochin, "Naselenie Peterburga do 60-kh godov XVIIIv.," in M. P. Viatkin, ed., *Ocherki istorii Leningrada* (Moscow-Leningrad, 1955), I, pp. 94–95.

14. Friedrich Christian Weber, *The Present State of Russia*, trans. from the High-Dutch (London, 1722; reprinted 1968), I, pp. 4, 307, 302.

15. Luppov, *Istoriia*, p. 23.

16. Brumfield, *History*, pp. 205–208. See also M. V. Iogansen, "Ob avtore general'nogo plana Peterburga petrovsksogo vremeni," in T. V. Alekseeva, ed., *Ot srednevekov'ia k novomu vremeni* (Moscow, 1984), pp. 50–72; Cracraft, *Petrine*, pp. 150–157; V. F. Shilkov, "Arkhitektory-inostrantsy pri Petre I," in Grabar, ed., *Istoriia*, V, pp. 84–115.

17. Irina Lisaevich, *Pervyi arkhitektor Peterburga* (Leningrad, 1971), pp. 39–40; I. E. Grabar, "Osnovanie i nachalo zastroiki Peterburga," in Grabar, ed., *Istoriia*, V, pp. 71–73; Cracraft, *Petrine*, pp. 155–158; and T. T. Rice, "The Conflux of Influences in Eighteenth-Century Russian Art and Architecture: A Journey from the Spiritual to the Realistic," in J. E. Garrard, ed., *The Eighteenth Century in Russia* (Oxford, 1973), pp. 270–271.

18. Brumfield, *History*, 204–212; Cracraft, *Petrine*, pp. 156–160; Lisaevich, *Pervyi arkhitektor*; N. Krashennikova and V. Shilkov, "Proekty obratsovykh zagorodnykh domov D. Trezzini i zastroika beregov Fontanki," *Arkhitekturnoe nasledstvo* (1951), I, pp. 5–12; and Shilkov, "Arkhitektory-inostrantsy," pp. 86–90.

19. Brumfield, *History*, p. 218–223.

20. Quoted in Pypin, *Istoriia*, III, p. 192. See also pp. 189–195.

21. Ibid., pp. 195–210; G. V. Plekhanov, *Istoriia russkoi obshchestvennoi mysli* (Moscow, 1915), II, pp. 104–106; E. Vinter, "Feofan Prokopovich i nachalo russkogo prosveshcheniia," in D. S. Likhachev et al., eds., *Roli i znachenie literatury XVIII veka v istorii russkoi kul'tury* (Moscow-Leningrad, 1966), pp. 43–46; James Cracraft, "Feofan Prokopovich: A Bibliography of His Works,"

*Oxford Slavonic Papers*, VIII (1975), pp. 1–36; and James Cracraft, *The Church Reform of Peter the Great* (London, 1971).

22. Lincoln, *Romanovs*, pp. 278–279; Miliukov, *Ocherki*, pp. 186–188; V. O. Kliuchevskii, *Kurs*, IV, pp. 250–251; Eugene Schuyler, *Peter the Great, Emperor of Russia* (reprinted, New York, 1967), II, pp. 434–435.

23. D. D. Blagoi, *Istoriia russkoi literatury XVIII veka* (Moscow, 1961), pp. 121–135; Hans Rogger, *National Consciousness in Eighteenth-Century Russia* (Cambridge, Mass., 1960), pp. 49–50; Lincoln, *Romanovs*, pp. 279–281.

24. Quoted in Anthony Cross, ed., *Russia Under Western Eyes, 1517–1825* (New York, 1971), p. 163. See also pp. 189–190.

25. Miliukov, *Ocherki*, III, p. 207; M. M. Shtrange, *Demokraticheskaia intelligentsia Rossii v XVIII veke* (Moscow, 1965), p. 11.

26. Gary Marker, *Publishing, Printing, and the Origins of Intellectual Life in Russia, 1700–1800* (Princeton, 1985), pp. 59–60; Miliukov, *Ocherki*, II, pp. 296–299.

27. Marker, *Publishing*, pp. 37, 59, 52.

28. V. V. Sipovskii, "Iz istorii russkoi literatury XVIII veka (opyt statisticheskikh nabliudenii)," *Izvestiia otdeleniia russkago iazyka i slovesnosti Imperatorskoi Akademii Nauk* (1901), VI, pp. 162–166.

29. Pypin, *Istoriia*, III, pp. 195–210, 351–353, 359–363; James Cracraft, "Feofan Prokopovich," in J. G. Garrard, ed., *The Eighteenth Century in Russia* (Oxford, 1973), 95–101; Marc Raeff, *Imperial Russia, 1682–1825: The Coming of Age of Modern Russia* (New York, 1971), pp. 132–133.

30. Pypin, *Istoriia*, III, pp. 363–383; Raeff, *Imperial Russia*, pp. 133–134.

31. Quoted in Rogger, *National Consciousness*, p. 93. See also pp. 91–95.

32. Marker, *Publishing*, p. 47.

33. Lincoln, *Conquest*, pp. 117–118.

34. B. N. Menshutkin, *Mikhailo Vasil'evich Lomonosov: Zhizneopisanie* (St. Petersburg, 1911), pp. 21–23.

35. Quoted in Rogger, *National Consciousness*, pp. 95, 99.

36. Quoted in ibid., p. 97. See also Marker, *Publishing*, p. 51.

37. Quoted in ibid., p. 53.

38. Quoted in Menshutkin, *Mikhailo Vasil'evich Lomonosov*, p. 129.

39. Quoted in Menshutkin, *Russia's Lomonosov*, p. 34.

40. Quoted in Menshutkin, *Mikhailo Vasil'evich Lomonosov*, p. 132.

41. Quoted in Rogger, *National Consciousness*, p. 103.

42. Quoted in Menshutkin, *Mikhailo Vasil'evich Lomonosov*, pp. 130–131.

43. A. S. Pushkin, *Polnoe sobranie sochinenii* (hereafter *PSS*) (Moscow, 1962–1966), VII, p. 28.

44. Quoted in G. V. Plekhanov, *Istoriia russkoi obshchestvennoi mysli* (Moscow, 1915), II, pp. 213–214.

CHAPTER V

THE AGE OF ELIZABETH

1. Mrs. William Vigor, *Letters from a Lady Who Resided Some Years in Russia* (London, 1777), pp. 94–95. See also Brumfield, *History*, pp. 230–231.

2. B. R. Vipper, "V. V. Rastrelli," in Grabar, ed., *Istoriia*, V, pp. 174–208; B. R. Vipper, *Arkhitektura russkogo barokko* (Moscow, 1978), pp. 71–83; Hamilton, *Art*, pp. 277–288; Brumfield, *History*, pp. 232–248; V. I. Loktev, "Rastrelli i problemy Barokko v arkhitekture," in A. V. Lipatov, A. I. Rogov, and L. A. Sofronova, eds., *Barokko v slavianskikh kul'turakh* (Moscow, 1982), pp. 299–315; and I. M. Ovsiannikov, *Franchesko Bartolomeo Rastrelli* (Leningrad, 1982).

3. D. E. Arkin, *Rastrelli* (Moscow, 1954), pp. 36–38; Ovsiannikov, *Rastrelli*, pp. 72–73; Vipper, "V. V. Rastrelli," p. 186.

4. Cross, ed., *Russia*, p. 193.

5. Quoted in Hamilton, *Art*, p. 437.

6. Vipper, "V. V. Rastrelli," pp. 191–196; Arkin, *Rastrelli*, pp. 17–26; Brumfield, *History*, pp. 235–237; Lincoln, *Romanovs*, pp. 255–256.

7. Vipper, "V. V. Rastrelli," pp. 196–200; Arkin, *Rastrelli*, pp. 103–107; Hamilton, *Art*, p. 283.

8. Quoted in Vipper, "V. V. Rastrelli," p. 189.

9. Ibid., pp. 198–199; A. N. Petrov, *Pushkin: Dvortsy i parki* (Moscow-Leningrad, 1964), pp. 32–35; Christopher Marsden, *Palmyra of the North: The First Days of St. Petersburg* (London, 1942), pp. 228–232.

10. Petrov, *Pushkin*, pp. 59–61; Marsden, *Palmyra*, pp. 228–237; Lincoln, *Romanovs*, pp. 256–257.

11. Brumfield, *History*, p. 241.

12. Ibid., Marsden, *Palmyra*, p. 240; Hamilton, *Art*, p. 283.

13. Quoted in Vipper, "V. V. Rastrelli," p. 202. See also Brumfield, *History*, pp. 250–253; Lincoln, *Romanovs*, p. 257; Hamilton, *Art*, pp. 279–283.

14. Brumfield, *History*, pp. 243–248; Arkin, *Rastrelli*, pp. 44–59; Lincoln, *Romanovs*, pp. 257–258.

15. Brumfield, *History*, p. 254. See also pp. 209–243.

16. I. E. Grabar, "D. V. Ukhtomskii i moskovskaia arkhitektura serediny XVIII veka," in Grabar, ed., *Istoriia*, V, pp. 244–271.

17. Marsden, *Palmyra*, p. 133.

18. The foregoing discussion of the extravagance of Elizabeth's court has been drawn from Miliukov, *Ocherki*, III, pp. 188–190; R. E. F. Smith and David Christian, *Bread and Salt: A Social and Economic History of Food and Drink in Russia* (Cambridge, 1984), pp. 173–179, 237–245; E. A. Ivanova, *Russkie samovary* (Leningrad, 1971), pp. 7–11; Marsden, *Palmyra*, pp. 131–155; Tamara Talbot Rice, *Elizabeth, Empress of Russia* (New York, 1970), pp. 134–137.

19. For an eyewitness account, see Andrei Bolotov, *Zhizn' i prikliucheniia Andreia Bolotova opisannye samim im dlia svoikh potomkov* (Moscow-Leningrad, 1931), I, pp. 136–137. Also, Zoë Oldenbourg, *Catherine the Great*, trans. from the French by Anne Carter (New York, 1966), p. 105; Rice, "The Conflux of Influences," pp. 285–286; Marsden, *Palmyra*, pp. 152–153.

20. Menshutkin, *Lomonosov*, pp. 57–65; N. N. Kovalenskaia, "Zhivopis' pervoi poloviny XVIII veka," in Grabar, ed., *Istoriia*, V, pp. 350–353.

21. Kovalenskaia, "Zhivopis'," p. 312. See also pp. 311–315.

22. Ibid., pp. 358–367.

23. Ibid., pp. 367–380.

24. Ibid., pp. 380–395.

25. A. N. Radishchev, *Izbrannye filosofskie i obshchestvenno-politicheskie proizvedeniia*, ed. by I. Ia. Shchipanov (Moscow, 1952), pp. 125, 130.

26. Rogger, *National Consciousness*, p. 104.

27. On Trediakovskii's biography, see Pypin, *Istoriia*, III, pp. 457–472; G. A. Gukovskii and V. A. Desnitskii, eds., *Istoriia russkoi literatury* (Moscow-Leningrad, 1941), III, pp. 215–263; and D. D. Blagoi, *Istoriia russkoi literatury XVIII veka* (Moscow, 1951), pp. 143–172.

28. Prince D. S. Mirskii, *A History of Russian Literature from the Earliest Times to the Death of Dostoyevsky* (New York, 1927), p. 57.

29. Ibid. See also Rogger, *National Consciousness*, p. 114.

30. Karlinsky, *Russian Drama*, pp. 73–74.

31. For Lomonosov's literary biography see: Gukovskii and Desnitskii, eds., *Istoriia*, III, pp. 264–348; Blagoi, *Istoriia*, pp. 173–224; Pypin, *Istoriia*, III, pp. 489–540; and I. Z. Serman, *Mikhail Lomonosov: Life and Poetry*, trans. by Stefan Hoffman (Jerusalem, 1988).

32. V. V. Danilevskii, *Russkoe zoloto: istoriia otkrytiia i dobychi do serediny XIXv.* (Moscow, 1959), pp. 55–58; A. A. Kuzin, *Istoriia otkrytii rudnykh mestorozhdenii v Rossii do serediny XIXv.* (Moscow, 1961), pp. 277–279.

33. On Lomonosov as a scientist, see especially Menshutkin, *Russia's Lomonosov*, pp. 15–84, 100–126; and Aleksandr Morozov, *Mikhail Vasil'evich Lomonosov, 1711–1765* (Leningrad, 1952), pp. 50–388.

34. Quoted in Menshutkin, *Russia's Lomonosov*, p. 48.

35. M. V. Lomonosov, "Morning Meditation on the Majesty of God," in Harold B. Segal, ed., *The Literature of Eighteenth-Century Russia* (New York, 1967), p. 207.

36. M. V. Lomonosov, "Evening Meditation on the Majesty of God on the Occasion

of the Great Northern Lights," in Segal, ed., *Literature*, p. 205.

37. Quoted in G. V. Plekhanov, *Istoriia russkoi obshchestvennoi mysli* (Moscow, 1915), II, pp. 214, 213.

38. Quoted in Menshutkin, *Russia's Lomonosov*, p. 175.

39. On Sumarokov's literary biography, see Blagoi, *Istoriia*, pp. 225–260; Pypin, *Istoriia*, III, pp. 472–488; Gukovskii and Desnitskii, eds., *Istoriia*, III, pp. 349–417.

40. Blagoi, *Istoriia*, p. 228.

41. A. P. Sumarokov, "O blagorodstve," in I. V. Malyshev, ed., *N. I. Novikov i ego sovremenniki. Izbrannye sochineniia* (Moscow, 1961), p. 372.

42. A. P. Sumarokov, "Son—schastlivoe obshchestvo," in ibid., pp. 354–357.

43. Quoted in Rogger, *National Consciousness*, pp. 104–105. See also pp. 103–107.

44. Karlinsky, *Russian Drama*, pp. 65–66.

45. Ibid., p. 69.

46. Quoted in ibid., p. 70.

47. Ibid., p. 70.

48. A. N. Radishchev, *Puteshestvie iz Peterburga v Moskvu*, in *Izbrannye*, p. 211.

49. V. N. Vsevolodskii-Gerngross, *Istoriia russkogo dramaticheskogo teatra* (Moscow, 1977), I, pp. 76–164; B. Varneke, *Istoriia russkogo teatra XVII–XIX vekov,* 3rd ed. (Moscow-Leningrad, 1939), pp. 47–60.

50. N. Findeizen, *Ocherki*, II, pp. 57–58, lists thirty-nine operas and ballets, not counting Elizabeth's coronation festivities. See also T. Livanova, *Russkaia muzykal'naia kul'tura XVIII veka v ee sviazakh s literaturoi, teatrom i bytom* (Moscow, 1953), pp. 115–120; Joel Spiegelman, "Style Formation in Early Russian Keyboard Music," in Garrard, ed., *Eighteenth Century*, pp. 311–320; Alfred and Jane Swan, "The Survival of Russian Music in the Eighteenth Century," in ibid., pp. 300–310.

51. Findeizen, *Ocherki*, II, pp. 44–45; Marc Slonim, *Russian Theater from the Empire to the Soviets* (New York, 1962), p. 24.

52. N. D. Chechulin, ed., *Nakaz Imperatritsy Ekateriny II, dannyi kommissii o sochinenii proekta novago ulozheniia* (St. Petersburg, 1907), p. 3.

*CHAPTER VI*
THE ARTS AND CATHERINE THE GREAT

1. K. Waliszewski, *The Romance of an Empress: Catherine II of Russia* (New York, 1894), p. 206.

2. These are the words of the English diplomat Sir George Macartney, quoted in Isabel de Madariaga, *Catherine the Great: A Short History* (New Haven, 1990), p. 205.

3. Quoted in John T. Alexander, *Catherine the Great: Life and Legend* (New York, 1989), pp. 47–48.

4. Quoted in ibid., p. 100.

5. A. J. Q. Beuchot, ed., *Oeuvres complètes de Voltaire* (Paris, 1832), LIX, p. 110.

6. Quoted in Michael T. Florinsky, *Russia: A History and an Interpretation* (New York, 1967), I, p. 505.

7. Chechulin, ed., *Nakaz*, p. 4.

8. Pis'mo imperatritsy Ekateriny II k Mel'khioru Grimmu, 23 avgusta 1779g., in Ia. Grot, ed., Pis'ma Imperatritsy Ekateriny II k Grimmu (1774–1796), *Sbornik Imperatorskago Russkago Istoricheskago Obshchestva* (hereafter *SIRIO*) (1878), XXIII, p. 157.

9. Lincoln, *Romanovs*, p. 294.

10. Quoted in Waliszewski, *Romance*, p. 346.

11. Pis'mo Ekateriny II k D'Alemberu s predlozheniem priekhat' v Peterburg i zaniat'sia vospitaniem Velikago Kniazia Pavla Petrovicha, 13 noiabria 1762g., *SIRIO*, VII (1871), p. 179.

12. Quoted in Waliszewski, *Romance*, p. 332. See also p. 331; and Lincoln, *Romanovs*, pp. 294–295.

13. Ian Watt, *The Rise of the Novel: Studies in Defoe, Richardson, and Fielding* (Berkeley and Los Angeles, 1967), p. 36.

14. Miliukov, *Ocherki*, II, pp. 327–328.

15. Marker, *Publishing*, pp. 68, 72; A. G. Dement'ev, A. V. Zapadov, M. S. Cherepakhov, eds. *Russkaia periodicheskaia pechat' (1702–1894)* (Moscow, 1959), pp. 14–95.

16. N. M. Karamzin, "O knizhnoi torgovle i liubvi ko chteniiu v Rossii," in N. M. Karamzin, *Izbrannye sochineniia* (Moscow-Leningrad, 1964), II, pp. 117, 179.

17. A. T. Bolotov, *Zhizn' i prikliucheniia*, I, pp. 446–447.

18. N. M. Karamzin, "O sluchaiakh i kharakterakh v rossiiskoi istorii, kotorye mogut byt' predmetom khudozhestv," in Karamzin, *Izbrannye sochineniia*, II, p. 198.

19. Rogger, *National Consciousness*, p. 48.

20. Quoted in D. D. Blagoi, *Istoriia russkoi literatury XVIII veka*, 2nd ed. (Moscow, 1951), p. 436.

21. Quoted in Rogger, *National Consciousness*, p. 131. See also pp. 129–132.

22. M. M. Kheraskov, "The Rossiad," in Segal, ed. and trans., *Literature*, II, pp. 115, 114.

23. Karlinsky, *Russian Drama*, pp. 84–92.

24. Ibid., pp. 142–145; Gerald R. Seaman, *History of Russian Music from Its Origins to Dargomyzhsky* (New York, 1967), pp. 94, 105.

25. Quoted in Karlinsky, *Russian Drama*, pp. 140–141.

26. Ibid., p. 142.

27. Ibid., pp. 151–157; K. V. Pigarev, *Tvorchestvo Fonvizina* (Moscow, 1954), pp. 91–111. On the first productions of *The Brigadier*, see V. V. Kallash and N. E. Efros, eds., *Istoriia russkago teatra* (Moscow, 1914), pp. 357–360; Segal, ed. and trans., *Literature*, II, pp. 318–320.

28. Pigarev, *Tvorchestvo*, pp. 258–275; P. N. Berkov, *Istoriia russkoi komedii XVIII v.* (Leningrad, 1977), pp. 242–252; Kallash and Efros, eds., *Istoriia*, pp. 360–364.

29. Quoted in Karlinsky, *Russian Drama*, p. 169.

30. Quoted in ibid., p. 162.

31. For an earlier statement of Fonvizin's views on this topic, see D. I. Fonvizin, "Poslanie k slugam moim Shumilovu, Van'ke i Petrushke," in I. Ia. Shchipanov, ed., *Izbrannye proizvedeniia russkikh myslitelei vtoroi poloviny XVIII veke* (Moscow, 1952), II, pp. 219–222.

32. Quoted in Blagoi, *Istoriia*, p. 481. See also pp. 483–488, and Marc Slonim, *The Epic of Russian Literature: From Its Origins Through Tolstoy* (New York, 1969), p. 35; Richard Wortman, *The Development of a Rus-*

sian Legal Consciousness (Chicago, 1976), pp. 97–98, 100–101; G. R. Derzhavin, "Zapiski, 1743–1812," *Sochineniia Gavrila Romanovicha Derzhavina* (St. Petersburg, 1871), VI, pp. 542–546; *Istoriia russkoi literatury* (Moscow-Leningrad, 1947), IV, pp. 383–388.

33. G. R. Derzhavin, "Ode to the Wise Princess Felitsa of the Kirghiz-Kazakh Horde, Written by a Certain Murza, Long a Resident of Moscow, but Now Living in St. Petersburg Because of His Affairs," in Segal, ed. and trans., *Literature*, II, pp. 270–271, 274, 279.

34. G. R. Derzhavin, "The Waterfall," in Segal, ed. and trans., *Literature*, II, pp. 296, 302, 296. See also Evelyn Bristol, *A History of Russian Poetry* (Oxford, 1991), pp. 73–78; *Istoriia russkoi literatury*, IV, pp. 383–429; and Blagoi, *Istoriia*, pp. 481–527; and Wortman, *Development*, pp. 96–119.

35. G. R. Derzhavin, "Country Life," in Segal, ed. and trans., *Literature*, II, p. 314.

36. Terras, *History*, p. 136. See also pp. 134–135.

37. N. Kovalenskaia, *Russkii klassitsizm: Zhivopis', skulptura, grafika* (Moscow, 1964), pp. 78–79, 90–98.

38. Hamilton, *Art*, p. 347.

39. Quoted in A. N. Savinov, "Istoricheskaia zhivopis'," in *Istoriia russkogo iskusstva*, VII, p. 182. See also pp. 167–181.

40. A. N. Savinov, "F. S. Rokotov," in *Istoriia russkogo iskusstva*, VII, pp. 7–39; Kovalenskaia, *Russkii klassitsizm*, pp. 166–167.

41. N. M. Gershenzon-Chegodaeva, *Dmitrii Grigor'evich Levitskii* (Moscow, 1964), pp. 39–129; N. M. Chegodaeva, "D. G. Levitskii," in *Istoriia russkogo iskusstva*, VII, pp. 40–48; Hamilton, *Art*, pp. 348–349.

42. Hamilton, *Art*, p. 349.

43. Ibid., pp. 349–350; Gershenzon-Chegodaeva, *Levitskii*, pp. 130–162.

44. For a complete listing of Levitskii's nearly two hundred portraits, see Gershenzon-Chegodaeva, *Levitskii*, pp. 385–437.

45. Ibid., pp. 272–330.

46. T. V. Alekseeva, *Vladimir Lukich Borovikovskii i russkaia kul'tura na rubezhe 18–19 vekov* (Moscow, 1975), pp. 49–330; T. V. Alekseeva, "V. L. Borovikovskii," in

*Istoriia russkogo iskusstva*, VII, pp. 93–142; Hamilton, *Art*, pp. 351–353; Kovalenskaia, *Russkii klassitsizm*, pp. 169–172.

47. Egorov, *Architectural Planning of St. Petersburg*, pp. 57–59; A. N. Petrov, S. A. Zombe, and T. M. Sitina, "Gradostroitel'stvo," in *Istoriia russkago iskusstva*, VI, pp. 243–246; Lincoln, *Romanovs*, p. 261; Brumfield, *History*, pp. 266–268.

48. I. E. Grabar, S. S. Bronshtein, and G. G. Grimm, "U istokov russkogo klassitsizma," in *Istoriia russkogo iskusstva*, VI, pp. 68–70; D. A. Kuchariants, *Antonio Rinaldi* (Leningrad, 1976), pp. 9–10; Louis Hautecoeur, *L'Architecture classique à Saint-Petersbourg à la fin du XVIIIe siècle* (Paris, 1912), pp. 24–25; Hamilton, *Art*, pp. 292–294.

49. Kuchariants, *Rinaldi*, pp. 22–60; Brumfield, *History*, pp. 274–275; Lincoln, *Romanovs*, pp. 262–263.

50. Pis'mo imperatritsy Ekateriny II k Mel'khioru Grimmu, 22 iiunia 1781g., p. 207.

51. G. G. Grimm, *Arkhitektura perekrytii russkogo klassitsizma* (Leningrad, 1939), pp. 59–61; Isobel Rae, *Charles Cameron: Architect to the Court of Russia* (London, 1971), pp. 46–49.

52. Brumfield, *History*, p. 278. See also pp. 277–279; V. N. Taleperovskii, *Charl'z Kameron* (Moscow, 1939), pp. 103–115; Hamilton, *Art*, pp. 305–306.

53. Brumfield, *History*, pp. 279–280.

54. Hamilton, *Art*, p. 307. See also G. G. Grimm and A. N. Petrov, "Peterburgskie zodchie poslednei chetverti XVIII veka," in *Istoriia russkago iskusstva*, VI, pp. 215–225.

55. Pis'mo imperatritsy Ekateriny II k Mel'khioru Grimmu, 30 sentiabria 1782g., p. 251.

56. Ibid., 28 oktiabria 1785g., p. 365.

57. Quoted in Hamilton, *Art*, pp. 309–310.

58. Ibid., p. 310.

59. Ibid., p. 311.

60. Brumfield, *History*, pp. 290–302; Grimm and Petrov, "Peterburgskie zodchie poslednei chetverti XVIII veka," pp. 195–215; M. F. Korshunova, *Dzhakomo Kvarengi* (Leningrad, 1977), pp. 26–86, 111–137.

61. The account of Starov's life and work that follows is drawn from: A. N. Petrov,

"I. E. Starov," in *Istoriia russkago iskusstva*, VI, pp. 166–185; N. N. Belekhov and A. N. Petrov, *Ivan Starov: Materialy k izucheniiu tvorchestva* (Moscow, 1950), *passim*; A. I. Kudriavtsev and G. N. Shkoda, *Aleksandro-Nevskaia Lavra: Arkhitekturnyi ansambl' i pamiatniki Nekropolei* (Leningrad, 1986), pp. 25–30; Brumfield, *History*, pp. 275–276; Hamilton, *Art*, pp. 300–304.

62. I. E. Grabar and G. I. Gun'kin, "Osnovopolozhniki russkogo klassitsizma: V. I. Bazhenov," in *Istoriia russkago iskusstva*, VI, pp. 85–93.

63. Ibid., pp. 96–102; A. I. Mikhailov, *Bazhenov* (Moscow, 1951), pp. 49–109; Brumfield, *History*, pp. 322–323.

64. Brumfield, *History*, p. 324.

65. Ibid., pp. 323–326; Grabar and Gun'kin, "V. I. Bazhenov," pp. 105–111.

66. Brumfield, *History*, pp. 326–327; Grabar and Gun'kin, "V. I. Bazhenov," pp. 113–115; Mikhailov, *Bazhenov*, pp. 202–230.

67. My account of Kazakov's life and work comes mainly from the following sources: M. A. Il'in, *Kazakov* (Moscow, 1955), *passim*; A. I. Vlasiuk, A. I. Kaplun, and A. A. Kiparisova, *Kazakov* (Moscow, 1957), *passim*; M. A. Il'in, "M. F. Kazakov," in *Istoriia russkago iskusstva*, VI, pp. 130–165; Brumfield, *History*, pp. 328–335; Hamilton, *Art*, pp. 323–324.

68. N. M. Karamzin, "O bogatstve iazyka," in Karamzin, *Izbrannye*, II, p. 142.

69. Prot. Georges Florovskii, *Puti russkago bogosloviia* (Paris, 1937), p. 128.

70. N. M. Karamzin, "Otchego v Rossii malo avtorskikh talantov?," in N. M. Karamzin, *Izbrannye*, II, p. 185; and A. I. Efimov, *Istoriia russkogo literaturnogo Iazyka* (Moscow, 1957), pp. 206–211.

71. Quoted in Rogger, *National Consciousness*, p. 121.

72. Quoted in ibid.

CHAPTER VII
TRAPPINGS OF EMPIRE

1. L. Vicomte de Puibusque, *Lettres sur la guerre de Russie en 1812; sur la ville de Saint-*

*Petersbourg, les moeurs, et les usages des habitans de la Russie et de la Pologne* (Paris, 1817), p. 271.

2. Quoted in Rogger, *National Consciousness*, pp. 74–75.

3. Egorov, *Architectural Planning*, pp. 193–195.

4. M. A. Il'in, "A. D. Zakharov," in *Istoriia russkogo iskusstva*, vol. VIII, book 1, pp. 92–93.

5. Brumfield, *History*, p. 358.

6. Quoted in ibid.

7. Hamilton, *Art*, p. 322.

8. Il'in, "A. D. Zakharov," pp. 86–104; G. Grimm, *Arkhitektor Andreian Zakharov* (Moscow, 1940), pp. 7–62; Brumfield, *History*, pp. 356–358; V. I. Piliavskii and N. Ia. Leiboshits, *Zodchii Zakharov* (Leningrad, 1963); Lincoln, *Romanovs*, pp. 461–463.

9. F. F. Vigel', *Zapiski*, ed. by S. Ia. Shtraikh (Moscow, 1928), reprinted, with a new introduction by Allen McConnell, by Oriental Research Partners (Newtonville, Mass., 1974), II, p. 90.

10. Hamilton, *Art*, pp. 331, 440; Egorov, *Architectural Planning*, pp. 157–166.

11. N. F. Khomutetskii and N. A. Evsina, "Arkhitektura," in *Istoriia russkogo iskusstva*, vol. VIII, book 2, pp. 463–467; Brumfield, *History*, pp. 400–403.

12. Quoted in Brumfield, *History*, p. 359.

13. Quoted in V. I. Piliavskii, *Zodchii Rossi* (Moscow-Leningrad, 1951), p. 13. See also M. Z. Taranovskaia, *Karl Rossi: Arkhitektor, Gradostroitel', khudozhnik* (Leningrad, 1980), pp. 9–18.

14. Quoted in Hamilton, *Art*, p. 327. See also Vigel', *Zapiski*, II, pp. 85–86; Piliavskii, *Zodchii Rossii*, pp. 11–20; and N. Veinert, *Rossi* (Moscow-Leningrad, 1939), pp. 9–20; and Taranovskaia, *Rossi*, pp. 18–22.

15. G. G. Grimm, M. A. Il'in, and Iu. A. Egorov, "K. I. Rossi," in *Istoriia russkogo iskusstva*, vol. VIII, book 1, pp. 132–138, 151–157; Veinert, *Rossi*, pp. 99–130; Taranovskaia, *Rossi*, pp. 96–156.

16. Veinert, *Rossi*, pp. 57–85; Egorov, *Architectural Planning*, pp. 137–154; Taranovskaia, *Rossi*, pp. 71–85; Grimm, Il'in, and Egorov, "K. I. Rossi," pp. 129–144; Lincoln,

Romanovs, pp. 466–467; Piliavskii, *Rossi*, pp. 83–94.

17. Brumfield, *History*, p. 366.

18. Grimm, Il'in, and Egorov, "K. I. Rossi," pp. 158–161; Lincoln, *Romanovs*, p. 467; Piliavskii, *Zodchii Rossi*, pp. 95–98; Veinert, *Rossi*, pp. 131–141; Taranovskaia, *Rossi*, pp. 86–92; Egorov, *Architectural Planning*, pp. 166–182.

19. I. E. Grabar, "T. Tomon," in *Istoriia russkogo iskusstva*, vol. VIII, book 1, pp. 111–112; Hamilton, *Art*, p. 313; Korshunova, *Kvarengi*, pp. 42–43.

20. Hugh Honour, *Neo-classicism* (Harmondsworth, 1968), p. 109.

21. Pavel Svin'in, *Dostopamiatnosti Sanktpeterburga i ego okrestnostei* (St. Petersburg, 1816), II, p. 111. See also pp. 98–109.

22. The preceding paragraph draws upon my earlier account in *Romanovs*, p. 459. See also Grabar, "T. Tomon," pp. 106–122; Brumfield, *History*, pp. 352–354. For a detailed account of de Thomon's work on the Bourse, see G. D. Oshchepikov, *Arkhitektor Tomon* (Moscow, 1950), pp. 18–50.

23. S. Bezsonov, *Krepostnye arkhitektory* (Moscow, 1938), pp. 39–54; V. Panov, *Arkhitektor A. N. Voronikhin* (Moscow, 1937), pp. 25–30; M. A. Il-in, "A. N. Voronikhin," in *Istoriia russkogo iskusstva*, vol. VIII, book 1, pp. 62–64; Brumfield, *History*, pp. 348–349.

24. Quoted in Il'in, "A. N. Voronikhin," p. 76.

25. Ia. I. Shurygin, *Kazanskii Sobor* (Leningrad, 1987), pp. 7–41, 89–96; G. G. Grimm, *Arkhitektor Voronikhin* (Leningrad-Moscow, 1963), pp. 33–58; Il'in, "A. N. Voronikhin," pp. 74–80; Lincoln, *Romanovs*, pp. 458–459; Svin'in, *Dostopamiatnosti Sanktpeterburga*, I, pp. 52–57.

26. V. Shkvarikov, *Ocherk istorii planirovki i zastroiki russkikh gorodov* (Moscow, 1954), pp. 95–97; Walter Hanchett, "Tsarist Statutory Regulations of Municipal Government in the Nineteenth Century," in Michael F. Hamm, ed., *The City in Russian History* (Lexington, 1976), pp. 91–93.

27. Quoted in Brumfield, *History*, p. 346.

28. A. S. Pushkin, "Mednyi Vsadnik: Peterburgskaia povest'," in A. S. Pushkin,

*Polnoe sobranie sochinenii,* 3rd ed. (hereafter *PSS*), (Moscow, 1963), pp. 380, 395.

29. V. N. Petrov, "M. I. Kozlovskii," in *Istoriia russkogo iskusstva,* VI, pp. 400–405; V. N. Petrov, "Dalneishee razvitie printsipov klassitsizma v tvorchestve F. F. Shchedrina i I. P. Prokof'eva," in *Istoriia russkago iskusstva,* VI, pp. 436–438; N. N. Kovalenskaia, T. V. Alekseeva, V. N. Petrova, "I. P. Martos," in *Istoriia russkogo iskusstva,* vol. VIII, book 1, pp. 287–288; and N. Kovalenskaia, *Martos* (Moscow-Leningrad, 1938), pp. 23–30.

30. Petrov, "Kozlovskii," p. 433. See also V. A. Evseev, A. G. Raskin, and L. P. Shaposhnikova, *Monumental'naia i dekorativnaia skul'ptura Leningrada* (Leningrad, 1991), pp. 24–25.

31. Ibid., pp. 433–435.

32. A. L. Kaganovich, *Feodosii Fedorovich Shchedrin, 1751–1825* (Moscow, 1953), pp. 23–38, 60–67.

33. Ibid., pp. 78–83; Shurygin, *Kazanskii Sobor,* pp. 64–65.

34. Baron N. N. Vrangel', *Istoriia skul'ptury* [Volume V of I. E. Grabar, ed., *Istoriia russkago iskusstva*] (Moscow, 1914), pp. 119–128; Petrov, "Dalneishee razvitie printsipov klassitsizma v tvorchestve F. F. Shchedrina i I. P. Prokof'eva," pp. 436–442, 458–470.

35. Kovalenskaia, *Martos,* pp. 31–63, 64–81; A. L. Kaganovich, *Skul'ptor Martos. Pamiatnik Mininu i Pozharskomu* (Leningrad, 1964), pp. 5–17; Kovalenskaia, Alekseeva, and Petrova, "I. P. Martos," pp. 302–309.

36. N. M. Karamzin, *Istoriia Gosudarstva Rossiiskago,* 5th ed. (St. Petersburg, 1842), I, p. ix.

37. "History of the Russian State" (extracts), in J. L. Black, ed., *Essays on Karamzin: Russian Man-of-Letters, Political Thinker, Historian, 1766–1826* (The Hague, 1975), p. 208.

38. Ibid., pp. 214–215.

39. Karamzin, *Istoriia Gosudarstva Rossiiskago,* I, p. x.

40. "History of the Russian State" (extracts), p. 214.

41. Ibid., p. 213.

42. Quoted in Billington, *Icon and the Axe,* p. 264.

43. N. L. Rubinshtein, *Russkaia istoriografiia* (Moscow, 1941), p. 186.

44. Quoted in ibid.

45. Quoted in ibid.

46. K. F. Ryleev, *Dumy* (Moscow, 1975), p. 72.

47. Quoted in Bakst, *History* (New York, 1966), p. 64.

48. Ryleev, *Dumy,* pp. 69–72; Seaman, *History,* pp. 146–147, 155–161.

49. Quoted in Bakst, *History,* p. 53.

50. Quoted in G. Abramovskii et al., *100 Oper: Istoriia sozdaniia, siuzhet, muzyka* (Leningrad, 1964), p. 283.

51. Quoted in Gerald Abraham, *On Russian Music* (London, 1946), p. 7.

52. Quoted in ibid., p. 10.

53. Quoted in ibid., p. 11. See also pp. 9–17, and O. Levasheva, Iu. Keldysh, and A. Kandinskii, *Istoriia russkoi muzyki,* 2nd ed. (Moscow, 1973), I, pp. 407–409.

54. Quoted in Abramovskii et al., *100 Oper,* p. 281.

55. Quoted in Levasheva, Keldysh, and Kandinskii, *Istoriia,* I, p. 410.

56. For a brilliant exposition of this point, see Cherniavsky, *Tsar and People,* pp. 139–141, and, more generally, 128–158.

57. V. M. Glinka and A. V. Pomarnatskii, *Otechestvennaia voina 1812 goda v khudozhestvennykh i istoricheskikh pamiatnikakh iz sobranii Ermitazha* (Leningrad, 1963), pp. 9–10.

58. The material about Dawe in the foregoing paragraphs has been drawn from ibid., and from V. M. Glinka and A. V. Pomarnatskii, *Voennaia galeria Zimnego Dvortsa* (Leningrad, 1981), pp. 7–28.

59. M. P. Pogodin, *Istoriko-politicheskie pis'ma i zapiska v prodolzhenii Krymskoi voiny, 1853–1856* (Moscow, 1874), p. 254.

60. M. P. Pogodin, "Pis'mo k gosudariu Tsesarevichu, Velikomu Kniaziu Aleksandru Nikolaevichu v 1838 godu," in ibid., p. 2.

## CHAPTER VIII
### RUSSIA'S ROMANTIC AGE

1. Quoted in Henry M. Nebel, Jr., *N. M. Karamzin: A Russian Sentimentalist* (The Hague and Paris, 1967), p. 174.

2. Richard Pipes, *Karamzin's Memoir on Ancient and Modern Russia* (Cambridge, Mass., 1959), p. 29.

3. N. M. Karamzin, *Letters of a Russian Traveler, 1789–1790*, trans. and abridged by Florence Jonas with an Introduction by Leon Stilman (New York, 1957), pp. 182, 195, 261–262, 279–280.

4. Quoted in Wortman, *Development*, p. 133.

5. Quoted in C. E. Shatalov, "Romantizm Zhukovskogo," in A. S. Kurilov, ed., *Istoriia Romantizma v russkoi literature: Vozniknovenie i utverzhdenie romantizma v russkoi literature (1790–1825)* (Moscow, 1979), p. 113.

6. Quoted in Wortman, *Development*, p. 135.

7. The best summary of Zhukovskii's life and thought is in ibid., pp. 132–141. See also Marcelle Erhard, *V. A. Joukovskii et le préromantisme russe* (Paris, 1938); P. N. Sakulin, "V. A. Zhukovskii," in D. N. Ovsianniko-Kulikovskii, ed., *Istoriia russkoi literatury XIX veka* (Moscow, 1908), I, pp. 136–146; and A. N. Veselovskii, *V. A. Zhukovskii: Poeziia chuvstva i "serdechnego voobrazheniia"* (Petrograd, 1918).

8. Quoted in Veselovskii, *V. A. Zhukovskii*, p. 192. See also Iu. D. Levin, "Angliiskaia poeziia i literatura russkogo sentimentalizma," in M. P. Alekseev, ed., *Ot klassitsizma i romantizmu: Iz istorii mezhdunarodnykh sviazei russkoi literatury* (Leningrad, 1970), pp. 247–249.

9. V. G. Belinskii, "Literaturnye mechtaniia (Elegiia v proze)," in *Sobranie sochienii V. G. Belinskago* (Peterburg, 1919), I, col. 56.

10. Terras, *History*, p. 200.

11. Ibid.

12. Quoted in Wortman, *Development*, p. 134.

13. Quoted in ibid., pp. 147–148.

14. Quoted in ibid., p. 147.

15. Quoted in ibid., p. 138.

16. Martin Malia, *Alexander Herzen and the Birth of Russian Socialism, 1812–1855* (Cambridge, Mass., 1961), pp. 43, 41.

17. "Delo ob otstavnom Podporuchike Ryleeve," in M. N. Pokrovskii, ed., *Vosstanie dekabristov: Materialy* (Moscow-Leningrad, 1925), I, p. 186.

18. Quoted in Anatole G. Mazour, *The First Russian Revolution, 1825. The Decembrist Movement: Its Origins, Development, and Significance* (Berkeley, 1937), p. 271.

19. Quoted in William Edward Brown, *A History of Russian Literature of the Romantic Period* (Ann Arbor, 1986), I, p. 99.

20. "Delo o polkovnike Pestele," in Pokrovskii, ed., *Vosstanie dekabristov: Materialy*, IV, p. 90.

21. Quoted in Slonim, *Epic*, p. 77. On Ryleev's confession after his arrest, see "Delo ob otstavnom Podporuchike Ryleeve," in Pokrovskii, ed., *Vosstanie dekabristov: Materialy*, I, pp. 149–218.

22. Quoted in Slonim, *Epic*, p. 78.

23. Quoted in ibid., p. 79.

24. Quoted in Lauren G. Leighton, *Russian Romanticism: Two Essays* (The Hague, 1975), p. 70.

25. Brown, *History*, II, p. 95.

26. Ibid., II, pp. 89–99.

27. Quoted in ibid., II, p. 98.

28. Quoted in I. D. Iakushkin, *Zapiski, stat'i, pis'ma I. D. Iakushkina*, ed. by S. Ia. Shtraikh (Moscow, 1951), pp. 80–83.

29. A. S. Pushkin, "Volnost. Oda," in *Polnoe sobranie sochinenii* (Moscow, 1962), I, p. 321; A. S. Pushkin, "Derevnia," in ibid., p. 361.

30. Ernest J. Simmons, *Pushkin* (Cambridge, Mass., 1937), p. 5.

31. Slonim, *Epic*, p. 82.

32. Quoted in David Magarshack, *Pushkin: A Biography* (New York, 1969), p. 61.

33. "Pis'mo A. I. Turgeneva k kniaziu Viazemskomu," 18-go iiunia 1819g., in Count S. D. Sheremetev, ed., *Ostaf'evskii arkhiv knia-zei Vyazemskikh* (St. Petersburg, 1899), I, p. 253. On Pushkin's early life see also V. V. Kunin, ed., *Zhizn' Pushkina: Rasskazannaia im samim i ego sovremennikami* (Moscow, 1987), I, pp. 69–73; Georgii Chulkov, *Zhizn' Pushkina* (Moscow, 1938), pp. 5–10; Simmons, *Pushkin*, pp. 7–16.

34. Quoted in Simmons, *Pushkin*, p. 236.

35. Pushkin, "Skazki: Noël," in *Polnoe sobranie sochinenii*, I, p. 343; "Volnost. Oda," I, pp. 322–323; "Derevnia," I, p. 360.

36. Iakushkin, *Zapiski, stat'i, pis'ma*, pp. 41–42.

37. Quoted in Magarshack, *Pushkin*, p. 87. See also "Pis'mo A. I. Turgeneva k kniaziu Viazemskomu," 4-go sentiabria 1818g., in Sheremetev, ed., *Ostaf'evskii arkhiv*, I, p. 119; and "Pis'mo A. I. Turgeneva k kniaziu Viazemskomu," 18-go dekabria 1818g., p. 174.

38. Quoted in Brown, *History*, III, p. 19.

39. Quoted in V. V. Gippius, et al., "Pushkin," in B. S. Meilakh, ed., *Istoriia russkoi literatury* (Moscow-Leningrad, 1953), VI, p. 182.

40. Quoted in ibid., p. 187.

41. See especially Z. A. Babaitseva, et al., *Pushkin na iuge; Trudy Pushkinskikh konferentsii Kishineva i Odessy* (Kishinev, 1958, 1961), 2 vols.; Gippius et al., "Pushkin," pp. 187–230; Chulkov, *Zhizn' Pushkina*, pp. 80–152; and Simmons, *Pushkin*, pp. 102–248.

42. Larisa Kertselli, *Mir Pushkina v ego risunkakh* (Moscow, 1988), especially pp. 29–225.

43. Quoted in Brown, *History*, III, p. 45.

44. Ibid., pp. 27–46.

45. Quoted in Gippius et al., "Pushkin," p. 226.

46. Quoted in ibid., p. 248.

47. Quoted in Simmons, *Pushkin*, p. 253.

48. Quoted in D. S. Mirskii, *Pushkin* (New York, 1963), p. 138.

49. Quoted in William Mills Todd III, *Fiction and Society in the Age of Pushkin: Ideology, Institutions, and Narrative* (Cambridge, Mass., 1986), p. 106.

50. A. S. Pushkin, "Evgenii Onegin: Roman v stikhakh," in Pushkin, *Polnoe sobranie sochinenii*, V, p. 189.

51. Brown, *History*, III, p. 83. See also pp. 65–84, and William Mills Todd's brilliantly conceived chapter on "Eugene Onegin: 'Life's Novel,' " in his *Fiction and Society*, pp. 106–136.

52. V. A. Sollogub, "Iz 'vospominanii,' " in N. L. Brodskii et al., ed., *Pushkin v vospominaniiakh sovremennikov* (Moscow, 1950), p. 473.

53. Quoted in Simmons, *Pushkin*, p. 340.

54. Quoted in Magarshack, *Pushkin*, p. 264.

55. Quoted in Slonim, *Epic*, p. 106.

56. A. S. Pushkin, "Mednyi vsadnik," in Pushkin, *Polnoe sobranie sochinenii*, IV, pp. 381, 389, 380, 389.

57. Pushkin, "Evgenii Onegin," p. 132.

58. Quoted in Magarshack, *Pushkin*, pp. 306–307.

59. M. Iu. Lermontov, "Smert' poeta," Lermontov, *Sochineniia* (Moscow, 1970), pp. 298–299.

60. I. S. Turgenev, *Literaturnye i zhiteiskie vospominaniia*, in I. S. Turgenev, *Sobranie sochinenii* (hereafter *SS*) (Moscow, 1962), X, p. 117.

61. Quoted in Slonim, *Epic*, p. 113.

62. Quoted in ibid., p. 116.

63. Quoted in ibid., p. 117. On Lermontov, see also Brown, *A History*, IV, pp. 139–261; and John Mersereau, Jr., *Mikhail Lermontov* (Carbondale, 1962).

64. Quoted in ibid., pp. 118, 119.

65. M. Iu. Lermontov, "1831-go iiunia 11 dnia," in Lermontov, *Sochineniia*, I, p. 152.

66. Mirskii, *History*, p. 175.

67. M. Iu. Lermontov, "Demon: Vostochnaia povest'," in Lermontov, *Sochineniia*, I, p. 747.

68. Terras, *History*, pp. 230–231.

69. M. Iu. Lermontov, *Geroi Nashego vremeni*, in Lermontov, *Sochineniia*, II, pp. 694–695.

70. Quoted in Brown, *History*, IV, p. 251.

71. Ibid., p. 265.

72. Vladimir Nabokov, *Nikolai Gogol* (New York, 1961), p. 8.

73. Pis'mo N. V. Gogolia k P. P. Kosiarovskomu, 3-go oktiabria 1827g., in N. V. Gogol', *Sobranie sochinenii* (hereafter *SS*) (Moscow, 1959), VI, p. 273.

74. Victor Erlich, *Gogol* (New Haven and London, 1969), p. 79.

75. N. V. Gogol', "Nevskii Prospekt," in Gogol', *SS*, III, pp. 43, 42.

76. Nabokov, *Nikolai Gogol*, p. 55.

77. Quoted in Brown, *History*, IV, p. 325.

78. Quoted in Slonim, *Epic*, p. 170.

79. Quoted in Erlich, *Gogol*, p. 108.

80. Pis'mo N. V. Gogolia k P. A. Pletnevu, 7 ianvaria 1842g., in Gogol', *SS*, VI, p. 262.

81. Quoted in Slonim, *Epic*, p. 176.

82. Quoted in Erlich, *Gogol*, pp. 184–185.

83. Quoted in Lincoln, *Romanovs*, pp. 501–502.

84. Quoted in Erlich, *Gogol*, p. 185.

85. Quoted in ibid., p. 192.

86. Quoted in ibid., p. 195.

87. N. V. Gogol, "Teatral'nyi raz"ezd posle predstavleniia novoi komedii," in Gogol, *SS*, IV, p. 269.

88. Lincoln, *Romanovs*, p. 502.

89. M. Gershenzon, *Istoricheskie zapiski (o russkom obshchestve)* (Moscow, 1910), p. 88.

90. Alexandre Benois, *The Russian School of Painting* (New York, 1916), p. 71.

91. Mikhail M. Allenov, "Capital Without a Court: Moscow Painting, 1700–1900," in Lincoln, comp., *Moscow*, p. 185.

92. Quoted in Benois, *Russian School*, p. 73.

93. On Kiprenskii, see especially, V. M. Zimenko, *Orest Adamovich Kiprenskii, 1782–1836* (Moscow, 1988); D. V. Sarab'ianov, *Orest Adamovich Kiprenskii* (Leningrad, 1982); V. S. Turchin, *Orest Kiprenskii* (Moscow, 1975); E. N. Atsarkina, *Orest Kiprenskii* (Moscow, 1948); and T. V. Alekseeva, "O. A. Kiprenskii," in *Istoriia russkogo iskusstva*, vol. VIII, book 1, pp. 396–470.

94. N. N. Kovalenskaia and A. N. Savinov, "V. A. Tropinin i portretisty nachala XIX veka," in *Istoriia russkogo iskusstva*, vol. VIII, book 1, pp. 514–518. See also A. Amshinskaia, *Vasilii Andreevich Tropinin, 1776–1857* (Moscow, 1970), pp. 20–40.

95. Allenov, "Capital Without a Court," p. 186.

96. On Tropinin's work and career, see especially Amshinskaia, *Tropinin*; M. M. Rakova, ed., *Vasilii Andreevich Tropinin: Issledovaniia, materialy* (Moscow, 1982); and

Kovalenskaia and Savinov, "V. A. Tropinin i portretisty nachala XIX veka," pp. 514–540.

97. Quoted in Tatiana Alekseeva, *Venetsianov and His School*, translated from the Russian by Carolyn Justice and Iurii Kleiner (Leningrad, 1984), pp. 10–11. See also Z. N. Fomicheva, *Tvorchestvo A. G. Venetsianov v pervoi chetverti XIX veka* (Leningrad, 1949), pp. 13–24; T. V. Alekseeva, "A. G. Venetsianov i razvitie bytovogo zhanra," in *Istoriia russkogo iskustva*, vol. VIII, book 1, pp. 546–560; T. V. Alekseeva, *Khudozhniki shkoly Venetsianova* (Moscow, 1982), pp. 44–66; Dement'ev et al., eds., *Russkaia periodicheskaia pechat*, p. 127.

98. E. N. Atsarkina, "K. P. Briullov," in *Istoriia russkogo iskusstva*, vol. VIII, book 2, pp. 47–49; O. Liasovskaia, *Karl Briullov* (Moscow-Leningrad, 1940), pp. 3–10.

99. Ibid., pp. 79–81; M. Rakova, *Russkaia istoricheskaia zhivopis' serediny deviatnadtsatogo veka* (Moscow, 1979), pp. 40–54; Hamilton, *Art*, p. 363; Atsarkina, "K. P. Briullov," pp. 49–75.

100. N. V. Gogol', "Poslednii den' Pompei," in Gogol', *SS*, VI, p. 77.

101. Quoted in Atsarkina, "K. P. Briullov," p. 84.

102. Quoted in G. K. Leont'eva, *Karl Briullov* (Leningrad, 1983), p. 4.

103. Quoted in Billington, *Icon and the Axe*, p. 341.

104. On Ivanov's life before he went to Rome, see also M. V. Alpatov, *Aleksandr Andreevich Ivanov* (Leningrad, 1983), pp. 5–24; and M. Alpatov, *Aleksandr Andreevich Ivanov: Zhizn' i tvorchestvo* (Leningrad, 1956), I, pp. 11–57; Billington, *Icon and the Axe*, pp. 341–342; Hamilton, *Art*, pp. 365–366.

105. Quoted in ibid., p. 343.

106. Quoted in Slonim, *Epic*, pp. 296–297.

107. Quoted in Billington, *Icon and the Axe*, p. 343. See also pp. 341–344.

108. A. Druzhinin, *Vospominaniie o russkom khudozhnike Pavle Andreeviche Fedotove* (Moscow, 1918), pp. 3–9; E. N. Atsekina, "P. A. Fedotov," *Istoriia russkogo iskusstva*, vol. VIII, book 2, pp. 299–302.

109. See especially the plates in D. V.

Sarab'ianov, *Pavel Fedotov* (Leningrad, 1985), and in F. I. Bulgakov, *P. A. Fedotov i ego proizvedeniia: fotograficheskoe i avtotipicheskoe izdanie* (St. Petersburg, 1893).

CHAPTER IX
THE RISE OF REALISM

1. Pis'ma V. A. Zhukovskago k F. P. Litke, *Russkii arkhiv*, Nos. 5–8 (1885), p. 335.

2. V. G. Belinskii, *Sobranie sochinenii V. G. Belinskago*, ed. Ivanov-Razumnik (Petrograd, 1919), III, cols. 822, 827.

3. Ibid., I, p. 38.

4. Ibid., cols. 979, 989, 992, 972.

5. Slonim, *Epic*, p. 183.

6. Quoted in Milton Ehre, *Oblomov and His Creator: The Life and Art of Ivan Goncharov* (Princeton, 1973), p. 22. On Goncharov, see also V. E. Evgenev-Maksimov, *I. A. Goncharov* (Moscow, 1925); E. A. Liatskii, "Ivan Aleksandrovich Goncharov," in D. N. Ovsianiko-Kulikovskii, ed., *Istoriia russkoi literatury XIX veka* (Moscow, 1909), III, pp. 252–277; N. K. Piksanov, "Goncharov," in M. P. Alekseev, ed., *Istoriia russkoi literatury* (Moscow-Leningrad, 1956), vol. VIII, book 1, pp. 400–461; and Alexandra and Sverre Lyngstad, *Ivan Goncharov* (New York, 1971).

7. Ivan Goncharov, *Oblomov*, trans. by Natalie Duddington (London, 1962), p. 64.

8. N. A. Dobroliubov, "What Is Oblomovshchina?," in N. A. Dobroliubov, *Selected Philosophical Essays*, trans. by J. Fineberg (Moscow, 1956), p. 205.

9. L. M. Lotman et al., "Proza shestidesiatykh godov," in Alekseev, ed., *Istorria*, vol. VIII, book 1, pp. 316–319; A. E. Gruzinskii, "Ivan Sergeevich Turgenev," in Ovsianiko-Kulikovskii, ed., *Istoriia*, III, pp. 278–280.

10. Quoted in A. S. Popov, ed., *Pis'ma k A. V. Druzhininu (1850–1863gg)* (Moscow, 1948), p. 11.

11. Quoted in A. G. Dement'ev, *Ocherki po istorii russkoi zhurnalistiki, 1840–1850gg* (Moscow-Leningrad, 1951), p. 105.

12. Quoted in Slonim, *Epic*, p. 253.

13. Quoted in Avrahm Yarmolinsky, *Turgenev: The Man, His Art and His Age* (New York, 1959), p. 109.

14. Quoted in ibid., p. 175.

15. I. S. Turgenev, *Nakanune*, in *Sobranie sochinenii* (hereafter *SS*) (Moscow, 1961), III, p. 104.

16. Ibid., p. 79.

17. Lincoln, *Romanovs*, pp. 505–506.

18. I. S. Turgenev, *Ottsy i deti*, in *SS*, III, pp. 162, 142, 139, 162, 159, 162.

19. Quoted in Yarmolinsky, *Turgenev*, p. 206.

20. Quoted in ibid., p. 205.

21. D. I. Pisarev, in *Sochineniia* (Moscow, 1955), II, p. 11.

22. P. V. Annenkov, *Literaturnye vospominaniia* (Moscow, 1960), p. 381.

23. Quoted in Leonard Schapiro, *Turgenev: His Life and Times* (Oxford, 1978), p. 31.

24. Quoted in Victor Ripp, *Turgenev's Russia: From "Notes of a Hunter" to "Fathers and Sons"* (Ithaca, 1980), p. 78.

25. Quoted in Slonim, *Epic*, p. 251.

26. Quoted in Ripp, *Turgenev's Russia*, p. 78.

27. Lincoln, *Romanovs*, pp. 509–511.

28. Konstantin Mochulsky, *Dostoevsky: His Life and Work*, trans., with an introduction by Michael A. Minihan (Princeton, 1967), p. 652.

29. F. M. Dostoevskii, *Zimnye zametki o letnikh vpechatleniiakh*, in F. M. Dostoevskii, *Polnoe sobranie sochinenii v tridtsati tomakh* (hereafter *PSS*) (Leningrad, 1973), V, pp. 50–51, 59.

30. Ibid., pp. 79, 76, 69, 79.

31. Ibid., p. 80.

32. Joseph Frank, *Dostoevsky: The Stir of Liberation, 1860–1865* (Princeton, 1986), p. 310.

33. F. M. Dostoevskii, *Zapiski iz podpol'ia*, in *PSS*, V, pp. 99, 101.

34. Quoted in Slonim, *Epic*, p. 275.

35. Quoted in Mochulsky, *Dostoevsky*, pp. 241, 240.

36. Pis'mo F. M. Dostoevskogo k A. E. Vrangeliu, 31-martah/14 aprelia 1865g., in *PSS*, XXVIII, bk. 2, pp. 116–117.

37. Ibid., p. 119.

38. Pis'mo F. M. Dostoevskogo k M. N. Katkovu, 10–15 sentiabria 1865g., in *PSS*, XXVIII, bk. 2, p. 136.

39. Ibid., p. 137.

40. F. M. Dostoevskii, *Prestuplenie i nakazanie*, in *PSS*, VI, pp. 211, 200.

41. L. Grossman, *Dostoevskii* (Moscow, 1965), pp. 331–332.

42. Quoted in ibid, p. 344.

43. Dostoevskii, *Prestuplenie i nakazanie*, p. 6.

44. Ibid., p. 11. See also Lincoln, *Romanovs*, p. 513.

45. Dostoevskii, *Prestuplenie i nakazanie*, pp. 321, 320, 322, 318.

46. Ibid., p. 422.

47. Grossman, *Dostoevskii*, pp. 290, 378–383.

48. F. M. Dostoevskii, *Igrok*, in *PSS*, V, p. 312.

49. Dostoevskii, *Zapiski iz podpol'ia*, p. 119.

50. F. M. Dostoevskii, *Letters of Dostoyevsky to His Wife*, trans. from the Russian by Elizabeth Hill and Doris Mudie (London, 1930), pp. 25, 27.

51. Pis'mo F. M. Dostoevskogo k A. N. Maikovu, 31 dekabria 1867g/12 ianvaria 1868g., in *PSS*, XXVIII, bk. 2, pp. 239, 241.

52. Pis'mo F. M. Dostoevskogo k A. N. Maiakovu, 21 iiulia/2 avgusta 1868g., in *PSS*, XVIII, bk. 2, p. 310.

53. Pis'mo F. M. Dostoevskogo k A. N. Maikovu, 26 oktiabria/7 noiabria 1868g., in *PSS*, XXVIII, bk. 2, p. 321.

54. F. M. Dostoevskii, *Idiot*, in *PSS*, VIII, p. 184.

55. Lincoln, *Romanovs*, pp. 513–514.

56. Pis'mo F. M. Dostoevskogo k A. N. Maikovu 26 oktiabria/7 noiabria 1868g., in *PSS*, XXVIII, bk. 2, pp. 321–322.

57. Dostoevskii, *Idiot*, p. 510.

58. Pis'mo F. M. Dostoevskogo k N. N. Strakhovu, 24 marta/5 aprelia 1870g., in *PSS*, XXIX, bk. 1, pp. 112–113.

59. Pis'mo F. M. Dostoevskogo k A. N. Maikovu, 9/21 oktiabria 1870g., in ibid., p. 145.

60. Lincoln, *Romanovs*, p. 515.

61. Quoted in Mochulsky, *Dostoevsky*, p. 432.

62. Billington, *Icon and the Axe*, p. 421.

63. Mochulsky, *Dostoevsky*, p. 464.

64. F. M. Dostoevskii, *Besy*, in *PSS*, X, pp. 514–516.

65. Quoted in Grossman, *Dostoevskii*, pp. 487, 484.

66. Quoted in Cherniavsky, *Tsar and People*, p. 201.

67. Pis'mo F. M. Dostoevskogo k S. D. Ianovskomu, 17 dekabria 1877g., in *PSS*, XXIX, bk. 2, p. 178.

68. F. M. Dostoevskii, *Zapiski iz mertvogo doma* in *PSS*, IV, pp. 15–16, 195. See also the careful discussion of this episode in Robert L. Belknap, *The Genesis of The Brothers Karamazov: The Aesthetics, Ideology, and Psychology of Text Making* (Evanston, 1990), pp. 57–63.

69. F. M. Dostoevskii, *Brat'ia Karamazovy*, in *PSS*, XIV, p. 286.

70. Ibid., XIV, pp. 100; XV, pp. 128, 31.

71. Ibid., XV, pp. 128, 126.

72. Lincoln, *Romanovs*, p. 517.

73. F. M. Dostoevskii, *Dnevnik pisatelia, 1881*, in *PSS*, XXVII, p. 22.

74. Dostoevskii, *Brat'ia Karamazovy*, XIV, pp. 18, 20, 24; XV, p. 125.

75. Quoted in David Magarshack, *Dostoevsky* (New York, 1961), p. 388.

76. Dostoevskii, *Brat'ia Karamazovy*, XV, p. 197.

77. F. M. Dostoevskii, *PSS*, XXVI, pp. 137, 147–148.

78. Quoted in Grossman, *Dostoevskii*, p. 581.

79. Pis'mo F. M. Dostoevskogo k A. G. Dostoevskoi, 8 iiunia 1880g., *PSS*, XXX, bk. 1, pp. 184–185.

80. Quoted in Mochulsky, *Dostoevsky*, p. 647.

81. Quoted in Magarshack, *Dostoevsky*, p. 388.

82. Ernest J. Simmons, *Leo Tolstoi* (New York, 1960), I, p. 360.

83. Quoted in Richard F. Gustafson, *Leo Tolstoy: Resident and Stranger* (Princeton, 1986), p. 3.

84. Quoted in ibid., pp. 12, 15, 16, 18, 19.

85. Lincoln, *Romanovs*, pp. 519–520; B. I. Burtsov and L. D. Opul'skaia, "Lev Tolstoi," in *Istoriia russkoi literatury*, IX, bk. 2, pp. 436–450; V. Shklovskii, *Lev Tolstoi* (Moscow, 1967), pp. 18–135.

86. L. N. Tolstoi, *Dnevniki, 1847–1894gg.*, in *Sobranie sochineniia v dvadtsati tomakh* (hereafter *SS*) (Moscow, 1965), XIX, entry for March 29, 1852, p. 88.

87. Ibid., entry for July 17, 1855, p. 157.

88. Quoted in Simmons, *Tolstoy*, I, p. 140.

89. Tolstoi, *Dnevniki*, entry for July 31, 1857, *SS*, XIX, p. 196.

90. Quoted in Simmons, *Tolstoy*, I, p. 258.

91. Tolstoi, *Dnevniki*, entries for May 6, 1861, and September 8, 1862, *SS*, XIX, pp. 246, 252.

92. S. A. Tolstaia, *The Diaries of Sofia Tolstaya* (New York, 1985), p. 90.

93. Gustafson, *Tolstoy*, p. 217.

94. S. A. Tolstaia, *Diaries*, p. 34.

95. Quoted in Simmons, *Tolstoy*, p. 295.

96. Quoted in B. M. Eikhenbaum, *Lev Tolstoi* (Leningrad, 1931), II, p. 268.

97. Tolstoi, *Dnevniki*, entry for March 19, 1865, *SS*, XIX, p. 267.

98. Quoted in Eikhenbaum, *Tolstoi*, II, pp. 262, 266.

99. Quoted in ibid., p. 261.

100. Quoted in Simmons, *Tolstoy*, p. 312.

101. Donna Tussing Orwin, *Tolstoy's Art and Thought, 1847–1880* (Princeton, 1993), p. 101.

102. For some important analyses of Tolstoi's view of history, see ibid., pp. 100–140; Gary Saul Morson, *Hidden in Plain View: Narrative and Creative Potentials in "War and Peace"* (Stanford, 1987), pp. 83–99; Gustafson, *Tolstoy*, pp. 217–276; Edward Wasiolek, *Tolstoy's Major Fiction* (Chicago and London, 1978), pp. 65–128; and Isaiah Berlin, *The Hedgehog and the Fox: An Essay on Tolstoy's View of History* (New York, 1953).

103. Pis'mo L. N. Tolstogo k S. A. Tolstoi, 4 sentiabria 1869g., in *SS*, XVII, p. 332.

104. "Zapiski sumashedshego," in ibid, XII, pp. 48–49.

105. Quoted in Simmons, *Tolstoy*, I, p. 347.

106. Ibid., pp. 130–131.

107. Tolstoi, *Dnevniki*, entry for June 14, 1884, *SS*, XIX, p. 329.

108. Quoted in A. N. Wilson, *Tolstoy* (New York, 1988), p. 371.

109. Tolstoi, *Dnevniki*, entry for July 7, 1884, *SS*, XIX, p. 333.

110. Quoted in Simmons, *Tolstoy*, II, p. 112.

111. S. A. Tolstaia, *Diaries*, p. 88.

112. Quoted in Simmons, *Tolstoy*, II, p. 211.

113. L. N. Tolstoi, "O golode," *SS*, XVI, p. 438.

114. Slonim, *Epic*, p. 344.

115. Wasiolek, *Tolstoy's Major Fiction*, p. 191.

116. Quoted in Simmons, *Tolstoy*, II, pp. 281–282.

117. Quoted in ibid., p. 303.

118. L. N. Tolstoi, "Otvet na opredelenie sinoda ot 20–22 fevralia i na poluchenie mnoiu po etomu sluchaiu pis'ma," *SS*, XVI, pp. 548–549.

119. Pis'mo L. N. Tolstogo k Nikolaiu II, 16 ianvaria 1902g., *SS*, XVIII, p. 293.

120. L. N. Tolstoi, "Ne mogu molchat'," *SS*, XVI, p. 565.

121. Quoted in ibid., p. 489.

122. Tolstoi, *Dnevniki*, entry for October 28, 1910, *SS*, XX, p. 434.

123. Pis'mo L. N. Tolstogo k S. A. Tolstoi, 30–31 oktiabria 1910g., *SS*, XVIII, p. 508.

124. S. L. Tolstoi, "V Astapove," in S. A. Makashin, ed., *L. N. Tolstoi v vospominaniiakh sovremennikov* (Moscow, 1978), II, p. 449. See also pp. 441–448.

125. Slonim, *Epic*, p. 312.

126. Quoted in Aylmer Maude, *The Life of Tolstoy* (New York, 1910), II, p. 653.

127. Pis'ma I. E. Repina k V. D. Polenovu, 8 dekabria 1877 i 20 ianvaria 1878gg., in I. Repin, *Izbrannye pis'ma* (Moscow, 1969), I, pp. 186, 191.

128. N. G. Chernyshevskii, "The Aesthetic Relation of Art to Reality," in N. G. Chernyshevskii, *Selected Philosophical Essays* (Moscow, 1953), pp. 380–381, 379.

129. S. H. Gol'dshtein, *Ivan Nikolaevich Kramskoi: Zhizn' i tvorchestvo* (Moscow, 1965), p. 36.

130. Abbott Gleason, *Young Russia: The Genesis of Russian Radicalism in the 1860s* (New York, 1980), p. 295.

131. Quoted in ibid., pp. 295–296.

132. Gol'dshtein, *Ivan Nikolaevich Kramskoi*, pp. 44–71.

133. Quoted in V. P. Ziloti, *V dome Tret'iakova* (New York, 1954), p. 238. See also A. P. Botkina, *Pavel Mikhailovich Tret'iakov v zhizni i iskusstve* (Moscow, 1960), pp. 174–185, 273–274; JoAnn Ruckman, "The Business Elite of Moscow: A Social Inquiry," (Ph.D. dissertation, Northern Illinois University, 1975), p. 177.

134. Botkina, *Tret'iakov*, pp. 249–252; Elizabeth Valkenier, *Russian Realist Art. The State and Society: The Peredvizhniki and Their Tradition* (New York, 1989), pp. 64–67.

135. Quoted in T. I. Kurochkina, *Ivan Nikolaevich Kramskoi* (Moscow, 1980), p. 5.

136. Gol'dshtein, *Kramskoi*, pp. 125–238.

137. Quoted in Hamilton, *Art*, p. 376. See also E. Gomberg-Verzhbinskaia, *Peredvizhniki* (Leningrad, 1970), pp. 45–54.

138. Valkenier, *Russian Realist Art*, pp. 43–44.

139. T. N. Gorina, "Nikolai Nikolaevich Ge," in A. I. Leonov, ed., *Russkoe iskusstvo: Ocherki o zhizni i tvorchestve khudozhnikov. Vtoraia polovina deviatnadtsatogo veka* (Moscow, 1962), I, p. 454.

140. Quoted in N. N. Kovalenskaia, "N. N. Ge," in *Istoriia russkogo iskusstva*, IX, pt. 1, p. 247.

141. Valkenier, *Russian Realist Art*, p. 38.

142. Quoted in Simmons, *Tolstoy*, II, p. 141.

143. Quoted in ibid., p. 189. See also Kovalenskaia, "N. N. Ge," pp. 252–259; and Gorina, "Nikolai Nikolaevich Ge," pp. 454–462.

144. Pis'mo L. N. Tolstoi k P. M. Tret'iakovu, 7–14 iiunia 1894g., in *Nikolai Nikolaevich Ge: Pis'ma, stat'i, kritika, i vospominaniia sovremennikov* (Moscow, 1978), pp. 198–199; Simmons, *Tolstoy*, II, p. 189.

145. Quoted in N. G. Mashkovtsev, "Vasilii Ivanovich Surikov," in Leonov, ed., *Russkoe iskusstvo*, II, p. 104.

146. V. S. Kemenov, "V. I. Surikov," in *Istoriia russkogo iskusstva*, IX, pt. 2, p. 20.

147. V. Kemenov, *Istoricheskaia zhivopis' Surikova, 1870–1880-e gody* (Moscow, 1963), pp. 119–202.

148. Ibid., pp. 259–445.

149. Quoted in ibid., p. 335.

150. E. Gomberg-Verzhbinskaia, *Peredvizhniki*, pp. 80–81; I. E. Grabar, "Chuguevskie uchitelia Repina," in I. E. Grabar and I. S. Zil'bershtein, eds., *Khudozhestvennoe nasledstvo* (Moscow-Leningrad, 1948), I, pp. 16–17; Igor Grabar, *Repin* (Moscow, 1937), I, pp. 9–20.

151. Grabar, *Repin*, I, pp. 39–82; Valkenier, *Ilya Repin*, pp. 23–34; G. Pribul'skaia, *Repin v Peterburg* (Leningrad, 1970), pp. 5–103.

152. Quoted in D. V. Sarab'ianov, "I. E. Repin," in *Istoriia russkogo iskusstva*, IX, pt. 1, pp. 462–463.

153. Quoted in Gomberg-Verzhbinskaia, *Peredvizhniki*, p. 84.

154. Valkenier, *Ilia Repin*, pp. 37–39.

155. I. E. Repin, *Dalekoe blizkoe* (Moscow, 1949), p. 280.

156. Dostoevskii, *Dnevnik pisatelia, 1873*, in *PSS*, XXI, p. 74.

157. For details of Repin's effort, see O. A. Liaskovskaia, *Il'ia Efimovich Repin: zhizn' i tvorchestvo* (Moscow, 1982), pp. 181–212.

158. Ibid., pp. 213–240.

159. Quoted in Valkenier, *Ilya Repin*, p. 119.

160. Quoted in Liaskovskaia, *Il'ia Efimovich Repin*, p. 244. See also pp. 245–262.

161. Pribul'skaia, *Repin v Peterburg*, pp. 164–169.

162. Quoted in ibid., p. 169.

163. Liaskovskaia, *Il'ia Efimovich Repin, passim*.

164. M. P. Musorgskii, *M. P. Musorgskii: Pis'ma i dokumenty*, A. N. Rimskii-Korsakov, ed. (Moscow-Leningrad, 1932), p. 252.

165. Pis'mo M. P. Musorgskogo k I. E. Repinu, 13 iiunia 1873g., in ibid., p. 251.

CHAPTER X
THE MIGHTY HANDFUL AND CHAIKOVSKII

1. Iu. V. Keldysh et al., *Istoriia russkoi muzyki* (Moscow, 1989), VI, pp. 167–168.

2. Quoted in ibid., p. 171.

3. Quoted in M. D. Calvocoressi and Gerald Abraham, *Masters of Russian Music* (New York, 1936), p. 119.

4. Ibid., pp. 170–187; L. Barenboim, *Anton Grigor'evich Rubinshtein: Zhizn', artisticheksii put', tvorchestvo, muzykal'no- obshchestvennaia deiatel'nost'* (Leningrad, 1957), I, pp. 234–270.

5. Barenboim, *Rubinshtein*, pp. 242–246.

6. N. A. Rimskii-Korsakov, *Letopis moei muzykal'noi zhizni* (Moscow, 1955), p. 18.

7. A. Orlova, ed., *Trudy i dni M. P. Musorgskogo: Letopis' zhizni i tvorchestvo* (Moscow, 1963), pp. 79–80. See also Edward Garden, *Balakirev: A Critical Study of His Life and Music* (New York, 1967), pp. 81–155.

8. Quoted in Calvocoressi and Abraham, *Masters*, pp. 151–152. See also A. F. Nazarov, *Tsezar' Antonovich Kiui* (Moscow, 1989). Cui is given only passing attention in the English-language histories of Abraham, Calvocoressi, and Leonard.

9. Oskar von Riesemann, *Musorgsky*, trans. from the German by Paul England (New York, 1935), p. 10.

10. Quoted in M. D. Calvocoressi, *Modest Musorgsky: His Life and Works* (Fair Lawn, N.J., 1956), p. 21.

11. Pis'mo M. P. Musorgskogo k M. A. Balakirevu, 23 iiunia 1859g., in N. A. Rimskii-Korsakov, ed., *M. P. Musorgskii: Pis'ma i dokumenty* (Moscow-Leningrad, 1932), pp. 48–49.

12. V. V. Stasov, "Modest Petrovich Musorgskii: Biograficheskii ocherk," in *Izbrannye sochineniia* (Moscow, 1952), I, pp. 173–174; N. Tumanina, *M. P. Musorgskii: Zhizn' i tvorchestvo* (Moscow-Leningrad, 1939), pp. 65–74.

13. Quoted in Calvocoressi, *Musorgsky*, p. 65.

14. Pis'mo V. V. Stasova k M. A. Bal-

akirevu, 17 maia 1863g., in V. Karenin, ed., *Perepiska M. A. Balakireva s V. V. Stasovym* (Petrograd, 1917), I, p. 173, and Pis'mo M. A. Balakireva k V. V. Stasovu, 3 iiunia 1863g., in ibid., p. 183.

15. Quoted in Richard Anthony Leonard, *A History of Russian Music* (New York, 1957), p. 101.

16. Pis'mo M. P. Musorgskogo k N. A. Rimskomu-Korsakovu, 15 avgusta 1868g., in Rimskii-Korsakov, ed., *Pis'ma*, p. 153.

17. Pis'mo M. P. Musorgskogo k I. E. Repinu, 13 iiunia 1873 g., in ibid., p. 251. For a brilliant commentary and analysis of the text and characters of *Boris Godunov*, see Caryl Emerson, *Boris Godunov: Transpositions of a Russian Theme* (Bloomington, 1986), pp. 142–198.

18. Quoted in Emerson, *Boris Godunov*, p. 180.

19. Quoted in Leonard, *History*, p. 103.

20. Pis'mo Iu. F. Platonova k V.V. Stasovu, 29 noiabria 1885g., in Orlova, ed., *Trudy*, pp. 314–315. See also Calvocoressi, *Musorgsky*, pp. 137–173; and Tumanina, *Musorgskii*, pp. 75–100.

21. Orlova, ed., *Trudy*, pp. 339, 336, 341, 360.

22. Quoted in Leonard, *History*, p. 103.

23. Emerson, *Boris*, pp. 180–190.

24. Quoted in Calvocoressi, *Musorgsky*, p. 182.

25. Tumanina, *Musorgskii*, pp. 200–203.

26. Pis'mo M. P. Musorgskago k. V. V. Stasovu, 18 oktiabria 1827g., in Rimskii-Korsakov, ed., *Pis'ma*, p. 232

27. Quoted in Leonard, *History*, p. 117. See also pp. 116–118.

28. Repin, *Dalekoe blizkoe*, p. 295.

29. Quoted in Calvocoressi, *Musorgsky*, p. 209.

30. Rimskii-Korsakov, *Letopis*, p. 12.

31. Quoted in Gerald Abraham, *Rimsky-Korsakov: A Short Biography* (New York, 1976), p. 25.

32. Rimskii-Korsakov, *Letopis*, p. 20.

33. Ibid., p. 69.

34. Ibid., pp. 70–80, 148; A. Solovtsov,

*Nikolai Andreevich Rimskii-Korsakov: Ocherk zhizni i tvorchestva* (Moscow, 1984), pp. 72–83, 118–122.

35. Quoted in Abraham, *Rimsky-Korsakov*, pp. 55–56.

36. Leonard, *History*, pp. 150–151.

37. Calvocoressi and Abraham, *Masters*, p. 422.

38. Rimskii-Korsakov, *Letopis*, p. 131.

39. Ibid., pp. 133–134.

40. Ibid., pp. 137, 134.

41. Ibid., p. 146.

42. Ibid., p. 139.

43. S. A. Dianin, *Borodin: Zhizneopisanie, materialy, i dokumenty* (Moscow, 1960), pp. 27–28.

44. Quoted in Leonard, *History*, pp. 126–127.

45. Rimskii-Korsakov, *Letopis*, p. 36.

46. Quoted in Dianin, *Borodin*, p. 60.

47. Ibid., pp. 62–81.

48. Quoted in Leonard, *History*, p. 141.

49. Quoted in Dianin, *Borodin*, p. 109.

50. Quoted in ibid., p. 110.

51. Quoted in ibid., pp. 111–155.

52. Quoted in Calvocoressi and Abraham, *Masters*, p. 176.

53. Quoted in Iuri Keldysh, "Tchaikovsky: The Man and His Outlook," in Dmitrii Shostakovich et al., *Russian Symphony: Thoughts About Tchaikovsky* (Freeport, New York, 1969), pp. 20, 22.

54. Quoted in Leonard, *History*, p. 197.

55. Quoted in Abraham, *Rimsky-Korsakov*, p. 106.

56. Calvocoressi and Abraham, *Masters*, p. 332.

57. Lawrence and Elizabeth Hanson, *Tchaikovsky: The Man Behind the Music* (New York, 1966), p. 363.

58. Quoted in David Brown, *Tchaikovsky: The Early Years, 1840–1874* (New York, 1978), p. 178.

59. Quoted in G. Dombaev, *Tvorchestvo Petra Il'icha Chaikovskogo v materialakh i dokumentakh* (Moscow, 1958), p. 343.

60. Brown, *Early Years*, p. 195.

61. Roland John Wiley, *Tchaikovsky's Ballets: Swan Lake, Sleeping Beauty, Nutcracker*

(Oxford, 1985), pp. 25–91; David Brown, *Tchaikovsky: The Crisis Years, 1874–1878* (London, 1982), pp. 68–86; Iakovlev, "The Ballets of Tchaikovsky," in Shostakovich et al., *Russian Symphony*, pp. 136–141.

62. Brown, *Crisis Years*, pp. 137–158; and, for Chaikovskii's own account, Pis'ma P. I. Chaikovskogo k N. F. fon-Mekk, 20 oktiabria/1 noiabria 1877g., i 25 oktiabria/6 noiabria 1877g., in P. I. Chaikovskii, *Perepiska s N. F. fon-Mekk* (Moscow, 1934), I, pp. 53–59

63. Quoted in Hanson, *Tchaikovsky*, p. 188.

64. Dombaev, *Tvorchestvo*, p. 63. See also N. Tumanina, *Chaikovskii: Put' k masterstvu, 1840–1877* (Moscow, 1962), pp. 490–548.

65. Quoted in Tumanina, *Chaikovskii*, p. 490.

66. Pis'mo P. I. Chaikovskogo k N. F. fon-Mekk, 16/28 dekabria 1877g., in P. I. Chaikovskii, *Perepiska*, I, p. 124.

67. Pis'mo P. I. Chaikovskogo k N. F. fon-Mekk, 9/21 fevralia 1878g., in P. I. Chaikovskii, *Perepiska*, I. p. 205.

68. Pis'mo P. I. Chaikovskogo k N. F. fon-Mekk, 17 fevralia/1 marta 1878 g., in P. I. Chaikovskii, *Perepiska*, I, pp. 217–218.

69. Brown, *Crisis Years*, p. 167.

70. V. V. Kolodkovskii, *Dom v Klinu* (Moscow, 1959), pp. 49–54.

71. Pis'mo P. I. Chaikovskogo k N. F. fon-Mekk, 16 fevralia 1885g., in P. I. Chaikovskii, *Perepiska*, III, p. 344.

72. Quoted in Kolodkovskii, *Dom v Klinu*, p. 5.

73. Quoted in Catherine Drinker Bowen and Barbara von Meck, *"Beloved Friend": The Story of Tchaikowsky and Nadejda von Meck* (New York, 1937), p. 419.

74. Quoted in David Brown, *Tchaikovsky: The Final Years* (New York and London, 1991), pp. 80–81.

75. Dombaev, *Tvorchestvo*, p. 240.

76. Quoted in ibid.

77. Pis'mo P. I. Chaikovskogo k N. F. fon-Mekk, 25 iiulia 1889g., in P. I. Chaikovskii, *Perepiska*, III, p. 580.

78. Quoted in Wiley, *Tchaikovsky's Ballets*, p. 189.

79. Quoted in ibid., pp. 191–192.

80. Pis'mo P. I. Chaikovskogo k N. F. fon-Mekk, 26 dekabria 1889g., in P. I. Chaikovskii, *Perepiska*, III, p. 590.

81. Dombaev, *Tvorchestvo*, pp. 190–191.

82. Ibid., p. 192.

83. Mirskii, *History*, p. 153.

84. Brown, *Final Years*, p. 270.

85. Alexandra Orlova, *Tchaikovsky: A Self-Portrait*, trans. by R. M. Davison (Oxford and New York, 1990), p. 367.

86. Ibid., pp. 384, 391–392.

87. Quoted in Brown, *Final Years*, 288–289. See also Calvocoressi and Abraham, *Masters*, p. 325, and Orlova, *Tchaikovsky*, pp. 374–376.

88. Orlova, *Tchaikovsky*, p. 397.

89. Quoted in Brown, *Final Years*, p. 403.

90. Orlova, *Tchaikovsky*, p. 399.

91. Quoted in Brown, *Final Years*, p. 404.

92. Orlova, *Tchaikovsky*, p. 401.

93. Dombaev, *Tvorchestvo*, p. 433.

94. Orlova, *Tchaikovsky*, p. 403.

95. Quoted in Brown, *Final Years*, p. 459.

96. Orlova, *Tchaikovsky*, p. 403.

97. Quoted in Brown, *Final Years*, p. 461.

98. This account has been drawn from the two most recent, scholarly, and reliable accounts of Chaikovskii's death: Brown, *Final Years*, pp. 478–487, and Orlova, *Tchaikovsky*, pp. 406–414.

99. Quoted in Brown, *Final Years*, p. 487.

### CHAPTER XI
### ART IN THE NAME OF THE PEOPLE

1. N. A. Nekrasov, "Na Volge," in N. A. Nekrasov, *Sobranie sochinenii v vos'mi tomakh* (hereafter *SS*) (Moscow, 1965), I, pp. 353–354.

2. Quoted in V. P. Kranikhfel'd, "Nikolai Alekseevich Nekrasov," in D. N. Ovsianiko-Kulikovskii, ed., *Istoriia*, III, p. 383.

3. Nekrasov, "Avtobiograficheskie zapiski," in Nekrasov, *SS*, I, p. 424.

4. Quoted in Slonim, *Epic*, p. 232.

5. V. E. Evgen'ev-Maksimov, "Nekrasov," in *Istoriia russkoi literatury* (Moscow-Leningrad, 1956), VIII, pt. 2, pp. 64–69.

6. Quoted in Slonim, *Epic*, p. 233. See also p. 232, and Mirsky, *History*, p. 297.

7. I. S. Turgenev, *Zapiski okhotnika*, in *SS*, I, p. 189.

8. Nekrasov, "Komu na Rusi zhit' khorosho?" in *SS*, III, p. 399.

9. Nekrasov, "Plach detei," in *SS*, I, p. 359. The poem was written just a few months before the Emancipation was decreed.

10. Nekrasov, "Zheleznaia doroga," in *SS*, II, p. 119.

11. Quoted in Sigmund S. Birkenmayer, *Nikolaj Nekrasov: His Life and Poetic Art* (Paris–The Hague, 1968), p. 139.

12. Nekrasov, "Komu na Rusi zhit' khorosho?," p. 399.

13. Turgenev, *Dym*, in *SS*, IV, pp. 26–27.

14. Quoted in Cathy A. Frierson, *Peasant Icons: Representations of Rural People in Late Nineteenth-Century Russia* (New York, 1993), p. 32. Frierson's thoughtful study sensitively explores in detail how peasants were perceived by Russian writers, journalists, and painters during the quarter-century after the Emancipation.

15. Vera Figner, *Zapechatlennyi trud* (Moscow, 1964), I, pp. 153–155.

16. Quoted in Richard S. Wortman, *The Crisis of Russian Populism* (Cambridge, 1967), p. 58.

17. Jeffrey Brooks, *When Russia Learned to Read: Literacy and Popular Literature, 1861–1917* (Princeton, 1985), p. 61.

18. Ibid., pp. 269–294.

19. W. Bruce Lincoln, *Passage Through Armageddon: The Russians in War and Revolution, 1914–1918* (New York, 1986), pp. 268–269.

20. Alexander Kaun, *Maxim Gorky and His Russia* (New York, 1931), p. 260. See also pp. 3–259; Barry P. Scherr, *Maxim Gorky* (Boston, 1988), pp. 1–6; Irwin Weil, *Gorky: His Literary Development and Influence on Soviet Intellectual Life* (New York, 1966), pp. 3–8.

21. Nemirovitch-Dantchenko, *My Life in the Russian Theatre*, pp. 229–230.

22. Quoted in Konstantin Stanislavskii, *My Life in Art* (Moscow, n.d.), p. 303.

23. Quoted in Scherr, *Gorky*, p. 59.

24. Ibid., p. 62.

25. M. Gor'kii, "Na Dne," in M. Gor'kii, *Polnoe sobranie sochinenii: khudozhestvennye proizvedeniia v dvadtsati piati tomakh* (hereafter *PSS*) (Moscow, 1970), VII, p. 173.

26. Ibid., p. 177.

27. Stanislavskii, *My Life*, p. 308.

28. Dan Levin, *Stormy Petrel: The Life and Work of Maxim Gorky* (New York, 1965), p. 95.

29. M. Gor'kii, "9-oe ianvaria," in I. P. Donkov, I. M. Mishakova, and N. V. Senichkina, eds., *Pervaia russkaia . . . Sbornik vospominanii aktivnykh uchastnikov revoliutsii, 1905–1907gg.* (Moscow, 1975), p. 10.

30. Valerii Briusov, "Griadushchie gunny," in *Sobranie sochinenii* (hereafter *SS*), (Moscow, 1973), I, p. 433.

31. Quoted in Levin, *Stormy Petrel*, pp. 132, 128.

32. Ibid., p. 132.

33. M. Gor'kii, *Mat'*, in *PSS*, VIII, p. 346.

34. Maxim Gorky, *Reminiscences of Tolstoy, Chekhov, and Andreev*, trans. from the Russian by Katherine Mansfield, S. S. Koteliansky, and Leonard Woolf (London, 1934), pp. 78–79.

35. Lincoln, *Passage Through Armageddon*, p. 272; Viktor Shklovsky, *Mayakovsky and His Circle*, ed. and trans. by Lily Feiler (New York, 1972), p. 88.

36. M. Gor'kii, *Delo Artamonovykh*, in *PSS*, XVIII, p. 370.

37. Quoted in A. P. Botkina, *Pavel Mikhailovich Tret'iakov v zhizni i iskusstve* (Moscow, 1960), p. 228.

38. Beverly Whitney Kean, *All the Empty Palaces: The Merchant Patrons of Modern Art in Pre-Revolutionary Russia* (New York, 1983), p. 69.

39. Quoted in N. V. Polenova, *Abramtsevo: Vospominaniia* (Moscow, 1922), pp. 17–18. See also pp. 5–16, and Stuart R. Grover, *Savva Mamontov and the Mamontov Circle, 1870–1905: Art Patronage and the Rise of Nationalism in Russian Art* (Ph.D. Dissertation, University of Wisconsin, 1971), pp. 7–51.

40. "Mamontovskii kruzhok," *Stolitsa i usad'ba*, No. 23 (1914), pp. 5–9; A. P. Marke-

vich, *Stasov: Grazhdanin, kritik, demokrat* (Kiev, 1969), pp. 167–196. See also Polenova, *Abramtsevo* pp. 22–25; Grover, *Savva Mamontov*, pp. 51–65; M. Kopshitser, *Savva Mamontov* (Moscow, 1972), pp. 26–40; and G. Iu. Sternin, *Russkaia khudozhestvannaia kul'tura vtoroi poloviny XIX-nachala XX veka* (Moscow, 1984), pp. 184–206.

41. Pis'mo S. I. Mamontova k V. D. Polenovu, 12 iiulia 1873g., in E. V. Sakharova, *Vasilii Dmitrievich Polenov i Elena Dmitrievna Polenova: Khronika sem'i khudozhnikov* (Moscow, 1964), p. 99.

42. "Vospominaniia V. M. Vasnetsova o S. I. Mamontove," in N. A. Iaroslavtseva, ed., *Viktor Mikhailovich Vasnetsov: Pis'ma, Dnevniki, Vospominaniia* (Moscow, 1987), pp. 243–244; D. Z. Kogan, *Mamontovskii kruzhok* (Moscow, 1970), pp. 5–111; and V. S. Mamontov, *Vospominaniia o russkikh khudozhnikakh* (Moscow, 1950), pp. 22–25.

43. Quoted in Polenova, *Abramtsevo*, pp. 42–43. See also pp. 22–41.

44. L. A. Bespalova, *Apollinarii Mikhailovich Vasnetsov* (Moscow, 1956), and Bahan D. Barooshian, *V. V. Vereshchagin: Artist at War* (Gainesville, 1993).

45. On Viktor Vasnetsov and his work, see Iaroslavtseva, ed., *Viktor Mikhailovich Vasnetsov*; Vladislav Bakhrevskii, *Viktor Vasnetsov* (Moscow, 1989); and N. N. Kovalenskaia, "V. M. Vasnetsov," in *Istoriia russkogo iskusstva*, IX, bk. 2, pp. 93–118.

46. V. A. Leniashin, *Portretnaia zhivopis' V. A. Serova 1900-kh godov* (Leningrad, 1980), pp. 15–40; M. Kopshitser, *Valentin Serov* (Moscow, 1967), pp. 5–105; Igor Grabar, *Valentin Aleksandrovich Serov: Zhizn' i tvorchestvo, 1865–1911* (Moscow, 1965), pp. 11–89.

47. Iu. Samarin, "V. A. Serov v Abramtseve," *Iskusstvo*, XXVIII, No. 3 (1965), pp. 63–66; "Mamontovskii kruzhok," *Stolitsa i usad'ba*, No. 23 (1914), pp. 5–6; Leniashin, *Portretnaia zhivopis' V. A. Serova 1900-kh godov, passim*.

48. Hamilton, *Art*, p. 399; Camilla Gray, *the Great Experiment: Russian Art 1863–1922* (New York, 1962), p. 19.

49. Hamilton, *Art*, p. 399.

50. Pis'mo Aleksandra Bloka k materi, 4 aprelia 1910g., in M. A. Beketova, ed., *Pis'ma Aleksandra Bloka k rodnym* (Moscow-Leningrad, 1932), II, p. 68.

51. Quoted in Kean, *All the Empty Palaces*, p. 43.

52. John E. Bowlt, "Two Russian Maecenases: Savva Mamontov and Princess Tenisheva," *Apollo* (December 1973), p. 447.

53. On the evolution of Vrubel's art, see P. K. Suzdalev, *Vrubel'* (Moscow, 1991), pp. 257–342.

54. P. K. Suzdalev, *Vrubel': Lichnost', mirovozzrenie, metod* (Moscow, 1984), pp. 80–103.

55. B. P. Shkafer, *Sorok let na stsene russkoi opery* (Leningrad, 1936), pp. 132–133; Bowlt, "Two Russian Maecenases," pp. 448–450; Grover, *Savva Mamontov and the Mamontov Circle*, pp. 171–217, 293–342.

56. Quoted in Lincoln, *In War's Dark Shadow*, p. 354.

57. Quoted in Ellen Terry, *The Russian Ballet* (London, 1913), p. 42.

58. Lincoln, *In War's Dark Shadow*, pp. 96–97; Polenova, *Abramtsevo*, 82–83, 86–96; Kogan, *Mamontovskii kruzhok*, pp. 164–173; Alison Hilton, *Russian Folk Art* (Bloomington, 1995), pp. 232–238.

59. Quoted in Bowlt, "Two Russian Maecenases," p. 450.

60. Quoted in Janet Kennedy, *The "Mir Iskusstva" Group and Russian Art, 1898–1912* (New York and London, 1977), p. 1; Kniaginia M. K. Tenisheva, *Vpechatleniia moei zhizni* (Leningrad, 1991), pp. 160–169; Larisa Zhuravleva, *Kniaginia Mariia Tenisheva* (Smolensk, 1992), pp. 98–110.

61. Tenisheva, *Vpechatleniia*, pp. 133–134.

62. Ibid., 160–169; Zhuravleva, *Kniaginia Mariia Tenisheva*, pp. 81–98, 102–115; Bowlt, "Two Russian Maecenases," p. 452.

63. Zhuravleva, *Kniaginia Mariia Tenisheva*, pp. 150–164; Tenisheva, *Vpechatleniia*, pp. 125–132; Bowlt, "Two Russian Maecenases," pp. 451–452; Hilton, *Russian Folk Art*, pp. 239–241.

## CHAPTER XII
## IMPERIAL TWILIGHT

1. Michael F. Hamm, ed., *The City in Late Imperial Russia* (Bloomington, 1986), pp. 2–3; W. Bruce Lincoln, *Conquest*, pp. 261, 266.

2. G. Berdnikov, *Chekhov* (Moscow, 1974), pp. 5–43; David Magarshack, *Chekhov: A Life* (London, n.d.), 15–43.

3. A. P. Chekhov, "Skuchnaia istoriia: Iz zapisok starogo cheloveka," in A. P. Chekhov, *Sobranie sochinenii* (hereafter *SS*) (Moscow, 1970), IV, p. 282.

4. For a list of Shekhtel's buildings, see E. Kirichenko, *Fedor Shekhtel'* (Moscow, 1973), pp. 138–140.

5. S. S. Koteliansky, trans. and ed., *Anton Tchekhov: Literary and Theatrical Reminiscences* (New York, 1965), pp. xxvi–xxxii.

6. Chekhov's letter of January 14, 1887, to Mariia Kiseleva, in Michael Heim and Simon Karlinsky, trans. and ed., *Letters of Anton Chekhov* (New York, 1973), p. 62.

7. A. P. Chekhov, "Muzhiki," in Chekhov, *SS*, VI, pp. 225–226.

8. Quoted in Marc Slonim, *From Chekhov to the Revolution: Russian Literature, 1900–1917* (New York, 1962), p. 65.

9. Quoted in ibid., p. 69.

10. A. P. Chekhov, *Tri sestry*, in Chekhov, *SS*, VII, p. 271.

11. Quoted in David Magarshack, "Purpose and Structure in Chekhov's Plays," in Eugene K. Bristow, ed., *Anton Chekhov's Plays* (New York, 1977), p. 261.

12. Quoted in Magarshack, *Chekhov*, pp. 288–289.

13. Pis'mo A. F. Koni k A. P. Chekhovu, 7 noiabria 1896g., in A. F. Koni, *Sobranie sochineniia*, (hereafter *SS*) (Moscow, 1969), VIII, p. 136

14. A. P. Chekhov, *Chaika*, in Chekhov, *SS*, VII, pp. 168, 167.

15. Quoted in Magarshack, *Chekhov*, p. 297.

16. Quoted in Heim and Karlinsky, trans. and ed., *Letters*, p. 283.

17. Pis'mo A. F. Koni k A. P. Chekhovu, 7

noiabria 1896g., in A. F. Koni, *SS* (Moscow, 1969), VIII, p. 136

18. Constantin Stanislavsky, *My Life in Art*, trans. from the Russian by J. J. Robbins (Boston, 1935), p. 356.

19. N. Efros, "Tchekhov and the Moscow Art Theater," in Koteliansky, trans. and ed., *Anton Tchekhov*, pp. 123, 125.

20. Ibid., p. 127.

21. A. P. Chekhov, *Diadia Vania*, in Chekhov, *SS*, VII, p. 245.

22. A. P. Chekhov, *Tri sestry*, in Chekhov, *SS*, VII, p. 311.

23. Quoted in Heim and Karlinsky, trans. and ed., *Letters*, p. 386.

24. Quoted in Magarshack, *Chekhov*, p. 383.

25. For a successful attempt to show that many of Russia's aristocrats did not follow Ranevskaia's path, see Seymour Becker, *Nobility and Privilege in Late Imperial Russia* (DeKalb, 1985).

26. Quoted in ibid., p. 461.

27. Quoted in Eugene K. Bristow, ed., *Anton Chekhov's Plays*, p. 159.

28. Quoted in ibid., p. 160.

29. K. S. Stanislavskii, *Moia zhizn' v iskusstve* (Moscow, 1962), pp. 324–329.

30. Quoted in Eugene K. Bristow, ed., *Anton Chekhov's Plays*, p. 161.

31. A. P. Chekhov, *Vishnevyi sad*, in Chekhov, *SS*, VII, p. 370. See also Donald Rayfield, *Chekhov: The Evolution of His Art* (London, 1975), p. 225.

32. Chekhov, *Vishnevyi sad*, p. 370.

33. Quoted in Magarshack, *Chekhov*, p. 386.

34. Quoted in Heim and Karlinsky, trans. and ed., *Letters*, p. 475.

35. Nemirovitch-Dantchenko, *My Life*, p. 83.

36. Stanislavskii, *Moia zhizn'*, pp. 230, 234–235.

37. Ibid., p. 231.

38. Ibid., p. 222.

39. Stanislavsky, *My Life*, p. 330.

40. Constantin Stanislavski, *Creating a Role*, translated by Elizabeth Reynolds Hapgood (New York, 1961), pp. 44, 83.

41. Stanislavskii, *Moia zhizn'*, p. 244. See also pp. 242–245.

42. Ibid., p. 238.

43. Quoted in Marc Slonim, *Russian Theater: From the Empire to the Soviets* (Cleveland and New York, 1961), p. 133.

44. Quoted in ibid., p. 135.

45. Stanislavski, *Creating*, p. 150.

46. A. A. Fedorov-Davydov, *Isak Il'ich Levitan: Zhizn' i tvorchestvo* (Moscow, 1966), pp. 7–36.

47. Camilla Gray, *The Great Experiment: Russian Art, 1863–1922* (New York, 1962), p. 17.

48. For a survey of Levitan's works that reproduces most of his best paintings and supplies a brief commentary in English, see A. A. Fedorov-Davydov, *Levitan* (Leningrad, 1988).

49. Pis'mo I. I. Levitana k A. P. Chekhovu, vesna 1887, in A. A. Fedorov-Davydov, ed., *I. I. Levitan: Pis'ma, dokumenty, vospominaniia* (Moscow, 1956), p. 30.

50. Quoted in Valkenier, *Russian Realist Art*, p. 79.

51. V. Vsevolodskii (Gerngross), *Istoriia russkogo teatra* (Leningrad-Moscow, 1929), II, pp. 44–53; Sergei Lifar', *Istoriia russkogo baleta ot XVIII veka do "Russkago Baleta" Diagileva* (Paris, 1945), pp. 21–101, 114–121; V. Krasovskaia, *Russkii baletnyi teatr ot vozniknoveniia do serediny XIX veka* (Leningrad, 1958), pp. 100–212.

52. Lifar', *Istoriia*, pp. 124–129; Krasovskaia, *Russkii baletnyi teatr*, pp. 213–244.

53. Quoted in Krasovskaia, *Russkii baletnyi teatr*, p. 248.

54. Quoted in Lifar', *Istoriia*, pp. 185, 189. See also Natalia Roslavleva, *Era of the Russian Ballet* (New York, 1966), p. 89.

55. Roslavleva, *Era*, pp. 85–86.

56. Krasovskaia, *Russkii baletnyi teatr*, II, pp. 36, 229, 277.

57. Tamara Karsavina, *Theatre Street: The Reminiscences of Tamara Karsavina* (New York, 1931), p. 151.

58. Ibid., p. 69. See also pp. 63–70; Bronislava Nijinska, *Early Memoirs*, trans. and

ed. by Irina Nijinska and Jean Rawlinson (New York, 1981), pp. 112–114; and Mathilde Kschessinska, *Dancing in Petersburg: The Memoirs of Kschessinska* (New York, 1961), pp. 24–25.

59. Karsavina, *Theatre Street*, pp. 70–71. See also the materials referred to in the preceding note.

60. Nijinska, *Early Memoirs*, pp. 90–91, 94–95.

61. Kschessinska, *Dancing*, p. 24.

62. Quoted in ibid, p. 28. See also Roslavleva, *Era*, pp. 101–103; Karsavina, *Theatre Street*, p. 124.

63. Kschessinska, *Dancing*, p. 29.

64. Ibid., pp. 29–30.

65. Ibid., p. 44.

66. Ibid., pp. 46, 47, 125, 69, 124.

67. Karsavina, *Theatre Street*, p. 169.

68. Kschessinska, *Dancing*, p. 124.

69. Quoted in V. Dandre, *Anna Pavlova in Art and Life* (London, 1932), p. 378.

70. Quoted in A. H. Franks, ed., *Pavlova: A Biography* (London, 1956), p. 32.

71. V. Svetloff, *Anna Pavlova*, trans. from the Russian by A. Grey (New York, 1974), p. 46.

72. Quoted in Franks, ed., *Pavlova*, p. 33.

73. Anna Pavlova, "Pages of My Life," in Svetloff, *Pavlova*, p. 121. See also, Krasovskaia, *Russkii baletnyi teatr*, II, pp. 228–234.

74. Pavlova, "Pages of My Life," pp. 123–124, 129.

75. Quoted in Svetloff, *Pavlova*, pp. 156, 154.

76. Quoted in Oleg Kerensky, *Anna Pavlova* (New York, 1973), pp. 13–16.

77. Quoted in Svetloff, *Pavlova*, p. 85.

78. Ibid., pp. 87, 85.

79. Svetloff, *Pavlova*, p. 92.

80. Kerensky, *Pavlova*, p. 80.

81. Dandre, *Pavlova*, p. 360.

82. Henry Charles Bainbridge, *Peter Carl Fabergé: Goldsmith and Jeweller to the Russian Imperial Court and the Principal Crowned Heads of Europe* (London, 1949), pp. 9–12; Suzanne Massie, *Land of the Firebird: The Beauty of Old Russia* (New York, 1980), p. 375.

83. See the selection of works illustrated in Gerard Hill, ed., *Fabergé and the Russian Master Goldsmiths* (New York, 1989).

84. Ibid., plates 75–93.

85. Bainbridge, *Fabergé*, p. 121.

86. Ibid., plates 18, 27; Hill, ed., *Fabergé*, pp. 46–47, and plates, 245–251, 267–268.

87. Quoted in Bainbridge, *Fabergé*, p. 71. See also Hill, ed., *Fabergé*, p. 54 and plate 17.

88. Quoted in Bainbridge, *Fabergé*, p. 36. The foregoing discussion of Fabergé's Easter eggs has been drawn largely from Bainbridge, *Fabergé*, pp. 67–78; and Hill, ed., *Fabergé*, pp. 54–63, and plates 17 through 73.

89. Hill, ed., *Fabergé*, plates 64–72.

90. Quoted in Bernice Glatzer Rosenthal, *Dmitri Sergeevich Merezhkovsky and the Silver Age: The Development of a Revolutionary Mentality* (The Hague, 1975), p. 89.

91. Nicolas Berdyaev, *Dream and Reality* (New York, 1951), p. 141.

92. Quoted in Zinaida Gippius-Merezhkovskaia, *Dmitrii Merezhkovskii* (Paris, 1951), p. 208.

93. Andrei Belyi, *Petersburg*, trans., annotated, and introduced by Robert A. Maguire and John E. Malmstad (Bloomington and London, 1978), p. 65.

## CHAPTER XIII
### THE BIRTH OF THE AVANT-GARDE

1. K. Mochul'skii, *Vladimir Solov'ev: Zhizn' i uchenie* (Paris, 1951), p. 127. Marc Slonim, *From Chekhov*, p. 104; and Oleg A. Maslenikov, *The Frenzied Poets: Andrey Biely and the Russian Symbolists* (Berkeley and Los Angeles, 1952), pp. 52–53. Along with the one that follows, this chapter includes elaborations of some of the source materials that I presented a number of years ago in *In War's Dark Shadow*, pp. 349–388; *Passage Through Armageddon*, pp. 261–282; and *Red Victory: A History of the Russian Civil War* (New York, 1989), pp. 329–358.

2. This is Diagilev's phrase. Quoted in Janet E. Kennedy, *The "Mir Iskusstva" Group*

*and Russian Art, 1898–1912* (New York and London, 1977), p. 1.

3. Billington, *Icon and the Axe*, p. 476.

4. Quoted in Avril Pyman, *The Life of Aleksandr Blok: The Distant Thunder, 1880–1908* (Oxford, London, New York, 1979), p. 157.

5. Kennedy, *"Mir Iskusstva,"* p. 2.

6. Quoted in John E. Bowlt, "The World of Art," *Russian Literature Triquarterly*, No. 4 (1972), p. 191.

7. Aleksandr Benua (Benois), *Vozniknovenie "Mira Iskusstva"* (Leningrad, 1928), p. 42.

8. Ibid., pp. 5–18; Lincoln, *In War's Dark Shadow*, pp. 352–353.

9. Quoted in Arnold L. Haskell, in collaboration with Walter Nouvel, *Diaghileff: His Artistic and Private Life* (New York, 1935), p. 60.

10. Benua, *Vozniknovenie*, p. 27.

11. Quoted in Haskell, *Diaghileff*, p. 103.

12. Quoted in John E. Bowlt, *The Silver Age: Russian Art of the Early Twentieth Century and the "World of Art" Group*, 2nd ed. (Newtonville, Mass., 1982), p. 60.

13. Quoted in Haskell, *Diaghileff*, p. 87.

14. Quoted in Richard Buckle, *Diaghilev* (New York, 1979), p. 72.

15. Quoted in I. N. Prizhan, *Lev Samoilovich Bakst* (Leningrad, 1975), p. 35.

16. Renato Poggioli, *The Poets of Russia, 1890–1930* (Cambridge, Mass., 1960), pp. 76–77, 122.

17. The phrase is Andrei Belyi's. Andrei Belyi, *Nachalo veka* (Moscow-Leningrad, 1933), p. 173.

18. Bernice Glatzer Rosenthal, *Merezhkovsky* (The Hague, 1975), p. 106.

19. Quoted in ibid., p. 108. See also pp. 106–109.

20. C. Harold Bedford, *The Seeker: D. S. Merezhkovskii* (Lawrence, Manhattan, Wichita, 1975), pp. 60–62.

21. Quoted in ibid., p. 62.

22. Ibid., pp. 66–67.

23. Quoted in Rosenthal, *Merezhkovsky*, p. 101.

24. Quoted in ibid., p. 104.

25. Belyi, *Nachalo veka*, p. 434.

26. Ibid., pp. 173–174; Maslenikov, *Frenzied Poets*, p. 130; Olga Matich, *Paradox in the Religious Poetry of Zinaida Gippius* (Munich, 1972), p. 9.

27. Quoted in Matich, *Paradox*, p. 72. See also Kathryn L. McCormack, *Images of Women in the Poetry of Zinaida Gippius* (Ph.D. dissertation, Vanderbilt University, 1982), pp. 168–200; and Vladimir Zlobin, *A Difficult Soul: Zinaida Gippius*, ed., annotated, and with an introductory essay by Simon Karlinsky (Berkeley and Los Angeles, 1980).

28. Quoted in Slonim, *From Chekhov*, p. 101.

29. Matich, *Paradox*, p. 56, and Temira Pachmuss, *Zinaida Hippius: An Intellectual Profile* (Carbondale and Edwardsville, 1971), pp. 103–105.

30. Matich, *Paradox*, p. 49.

31. K. Mochul'skii, *Andrei Belyi* (Paris, 1955), p. 75. On the Merezhkovskiis' salon, see also, Belyi, *Nachalo veka*, pp. 189–192, 418–426; Andrei Belyi, "Vospominaniia o Bloke, *Epopeia*, No. 1 (1922), pp. 181–189.

32. Belyi, *Nachalo veka*, p. 191.

33. Quoted in Mochul'skii, *Andrei Belyi*, p. 76.

34. Berdyaev, *Dream and Reality*, p. 145.

35. Slonim, *From Chekhov*, p. 90.

36. Quoted in Konstantin Mochul'skii, *Valerii Briusov* (Paris, 1962), p. 43. See also Andrei Belyi, *Lug zelenyi* (New York and London, 1967), pp. 200, 178; and Martin P. Rice, *Valery Briusov and the Rise of Russian Symbolism* (Ann Arbor, 1975), p. 60.

37. Quoted in Joan Delaney Grossman, *Valery Bryusov and the Riddle of Russian Decadence* (Berkeley and Los Angeles, 1985), pp. 106–107. See also pp. 104–110.

38. Valerii Briusov, *Dnevniki, 1891–1900* (Moscow, 1927), entry for March 4, 1893, p. 12.

39. Rice, *Briusov*, p. 59.

40. Belyi, *Lug*, p. 205.

41. Quoted in Rice, *Briusov*, p. 136.

42. Quoted in Joan Delaney Grossman, ed. and trans., *The Diary of Valery Bryusov (1893–1905), with Reminiscences by V. F.*

*Khodasevich and Marina Tsvetaeva* (Berkeley and Los Angeles, 1980), p. 4.

43. Quoted in Mochul'skii, *Belyi*, p. 42. See also Maslenikov, *Frenzied Poets*, p. 107.

44. Quoted in Maslenikov, *Frenzied Poets*, pp. 106–107.

45. Quoted in Ada Steinberg, *Word and Music in the Novels of Andrei Bely* (Cambridge and London, 1982), p. 34.

46. Ibid., p. 35.

47. Quoted in Vladimir E. Alexandrov, *Andrei Bely: The Major Symbolist Fiction* (Cambridge, Mass., 1985), p. 22.

48. Belyi, *Lug*, p. 205.

49. Quoted in Mochul'skii, *Belyi*, pp. 42–43. See also Belyi, *Nachalo veka*, pp. 183–189.

50. Quoted in Mochul' skii, *Belyi*, p. 43.

51. Quoted in Pyman, *Distant Thunder*, p. 27. See also pp. 1–39; and M. A. Beketova, "Aleksandr Blok i ego mat'," in V. N. Orlov, ed., *Aleksandr Blok v vospominaniiakh sovremennikov* (Moscow, 1980), I, pp. 39–69.

52. Sergei Solov'ev, "Vospominaniia ob Aleksandre Bloke," in Orlov, ed., *Blok*, I, p. 118.

53. Quoted in Pyman, *Distant Thunder*, pp. 96, 121.

54. Quoted in K. Mochul'skii, *Aleksandr Blok* (Paris, 1948), p. 57.

55. Aleksandr Blok, "Iz zapisnykh knizhek i dnevnikov," in Aleksandr Blok, *Sobranie sochinenii v shesti tomakh* (hereafter *SS*) (Moscow, 1971), VI, p. 121.

56. This was the phrase that Oleg Maslenikov wove into the title of his book *Frenzied Poets*.

57. Quoted in Mochul'skii, *Blok*, p. 64.

58. Pis'mo A. Blok k A. Belomu, 17 ianvaria 1903, in V. N. Orlov, ed., *Aleksandr Blok i Andrei Belyi: Perepiska* (Moscow, 1940), p. 15.

59. Quoted in Pyman, *Distant Thunder*, p. 122.

60. Belyi, *Nachalo veka*, p. 278. See also Mochul'skii, *Belyi*, pp. 46–57.

61. Quoted in Mochul'skii, *Belyi*, p. 50.

62. Briusov, *Dnevniki*, entry for September 18, 1894, p. 19, entry for 17–22 March 1899, p. 64; Mochul'skii, *Belyi*, p. 55.

63. Belyi, *Nachalo veka*, p. 276.

64. Ibid., p. 286.

65. Quoted in Mochul'skii, *Belyi*, pp. 58–66.

66. Quoted in Pyman, *Distant Thunder*, p. 140.

67. Quoted in ibid., pp. 175, 155.

68. Andrei Belyi, "Vospominaniia ob Aleksandre Aleksandroviche Bloke," in Orlov, ed., *Blok*, I, pp. 231, 235–236, 232.

69. Quoted in Mochul'skii, *Belyi*, p. 67.

70. Solov'ev, "Vospominaniia ob Aleksandre Bloke," in Orlov, ed., *Blok*, I, pp. 118–119.

71. Belyi, "Vospominaniia," in Orlov, ed., *Blok*, I, pp. 252–254.

72. Quoted in Pyman, *Distant Thunder*, p. 155.

73. A. Belyi, "Apokalipsis v russkoi poezii," in Belyi, *Lug*, pp. 223–227.

74. Beketova, *Blok*, p. 101.

75. Quoted in Salibury, *Black Night*, p. 91.

76. Quoted in Maslenikov, *Frenzied Poets*, p. 170.

77. Belyi, *Nachalo veka*, pp. 421–426.

78. Ibid., p. 458.

79. A. A. Blok, "Neznakomka," in Blok, *SS*, II, pp. 158–159; Belyi, *Lug*, pp. 8–9. See also A. A. Blok, *Dnevnik Al. Bloka, 1917–1921*, ed. P. N. Medvedev (Leningrad, 1928), entry for August 15, 1917, II, p. 72; Pis'mo A. Blok k A. Belomu, 5 iiunia 1904g., in Orlov, ed., *Blok*, p. 95; Samuel Cioran, *The Apocalyptic Symbolism of Andrei Belyi* (The Hague and Paris, 1973), pp. 103–107; Maslenikov, *Frenzied Poets*, p. 162.

80. Quoted in Pyman, *Distant Thunder*, p. 205.

81. Maslenikov, *Frenzied Poets*, pp. 177–188.

82. Quoted in Pyman, *Distant Thunder*, p. 220.

83. Andrei Belyi, *Mezhdu dvukh revoliutsii* (Leningrad, 1934), p. 188.

84. Quoted in Grossman, *Bryusov*, pp. 267, 279, 281, 297, 299, and 283.

85. Quoted in ibid., pp. 297, 299, 302, 301.

86. Valerii Briusov, "Griadushchie gunny," in *SS*, I, p. 433.

87. Benua (Benois), *Vozniknovenie "Mira Iskusstva,"* p. 27.

88. Quoted in Haskell, *Diaghileff*, p. 137.

89. Quoted in William Richardson, *"Zolotoe Runo" and Russian Modernism* (Ann Arbor, 1986), pp. 61, 154.

90. Ibid., pp. 37–81; *Zolotoe Runo*, I, No. 1 (January 1906), p. 142; Belyi, *Mezhdu*, pp. 245–254; Lincoln, *In War's Dark Shadow*, pp. 370–371.

91. Poggioli, *Poets*, p. 161; Maslenikov, *Frenzied Poets*, p. 202; Salisbury, *Black Night*, p. 177; V. I. Ivanov, *Po zvezdam* (Moscow, 1909), pp. 285–290.

92. Belyi, *Nachalo veka*, p. 309.

93. Ibid., pp. 321–323.

94. Quoted in Maslenikov, *Frenzied Poets*, p. 202.

95. Quoted in Avril Pyman, *The Life of Aleksandr Blok: The Release of Harmony, 1908–1921* (Oxford, 1980), p. 241.

96. Belyi, *Nachalo veka*, p. 323.

97. Viacheslav Ivanov, *Po zvezdam: stat'i i aforizmy* (St. Petersburg, 1909), p. 372; Mochul'skii, *Belyi*, p. 91.

98. V. F. Khodasevich, *Nekropol': Vospominaniia* (Brussels, 1939), p. 14.

99. Neil Granoien, *Mixail Kuzmin: An Aesthete's Prose* (Ph.D. dissertation, University of California at Los Angeles, 1981), pp. 15–16. For an English translation of *Wings*, see Neil Granoien and Michael Green, ed. and trans., *Wings: Prose and Poetry by Mikhail Kuzmin* (Ann Arbor, 1972).

100. Catriona Kelly, *A History of Russian Women's Writing, 1820–1992* (Oxford, 1994), p. 157; Pamela Davidson, *The Poetic Imagination of Vyacheslav Ivanov: A Russian Symbolist's Perception of Dante* (Cambridge and New York, 1989), p. 121.

101. Andrei Belyi, *Mezhdu*, pp. 197–198; Laura Engelstein, *The Keys to Happiness: Sex and the Search for Modernity in Fin-de-Siècle Russia* (Ithaca, 1992), pp. 10–211, 274–284.

102. Mikhail Artsybashev, *Sanine. A Russian Love Novel*, trans. Percy Pinkerton (London, 1914), pp. 119–120, 63, 315.

103. Ibid., p. 167.

104. Richard Stites, *The Women's Liberation Movement in Russia: Feminism, Nihilism, and Bolshevism, 1860–1930* (Princeton, 1978), p. 183.

105. Ibid., p. 187.

106. Gippius, *Merezhkovskii*, p. 208.

107. Salisbury, *Black Night*, p. 198.

108. Belyi, *Mezhdu*, pp. 140–189; Gippius, *Merezhkovskii*, pp. 153–209.

109. Andrei Belyi, *Serebrianyi golub'* (Munich, 1967), II, pp. 95–96.

110. Andrey Biely, *The Silver Dove*, trans. from the Russian by George Reavey (New York, 1974), p. ix.

111. Belyi, *Serebrianyi golub'*, I, pp. 280–281, 283–284.

112. Ibid., p. 281, II, pp. 9–10, 140; I, p. 177.

113. This phrase belongs to Samuel D. Cioran. See *The Apocalyptic Symbolism of Andrej Belyj* (The Hague, 1973), pp. 112–136.

114. Quoted in Mochul'skii, *Belyi*, pp. 163–166.

115. Cioran, *Apocalyptic Symbolism*, p. 127.

116. Belyi, *Mezhdu*, p. 354.

117. A. A. Blok to A. Belyi, March 3, 1911, in Orlov, ed., *Blok i Belyi*, p. 249.

118. Maslenikov, *Frenzied Poets*, p. 124.

119. Quoted in Mochul'skii, *Belyi*, p. 179.

120. Ibid., p. 172.

121. Andrei Belyi, *Peterburg* (Munich, 1967), I, pp. 125, 12.

122. Ibid., II, p. 85; I, pp. 31, 27, 31.

123. Quoted in Billington, *The Icon and the Axe*, p. 507.

124. Belyi, *Peterburg*, I, pp. 31, 30, 121, 99, 59; II, pp. 13, 12.

125. David M. Bethea, *The Shape of Apocalypse in Modern Russian Fiction* (Princeton, 1989), pp. 104–144.

126. Belyi, *Peterburg*, I, p. 12.

127. Kean, *Empty Palaces*, pp. 125–138, 155–157.

128. Ibid., p. 152.

129. Ibid., pp. 143–152; Gray, *Great Experiment*, pp. 63–65.

130. Quoted in Kean, *Empty Palaces*, p. 176. See also pp. 176–210.

131. Natalia Goncharova, "Preface to Catalogue of One-Man Exhibition," 1913, in John E. Bowlt, ed. and trans., *Russian Art of the Avant-Garde: Theory and Criticism* (London, 1988), p. 60.

132. Aleksandr Shevchenko, "Neoprimitivism: Its Theory, Its Potentials, Its Achievements," 1913, in Bowlt, ed. and trans., *Russian Art*, pp. 45, 44. See also pp. 46–54.

133. Gray, *Great Experiment*, p. 97.

134. Goncharova, "Preface to Catalogue of One-Man Exhibition," pp. 57–58, 61.

135. Natalia Goncharova, "Cubism," in Bowlt, ed. and trans., *Russian Art*, p. 78.

136. Katherine S. Dreier, *Burliuk* (New York, 1944), pp. 46–48.

137. Benedikt Livshits, *The One and a Half-Eyed Archer*, trans. and annotated by John E. Bowlt (Newtonville, Mass., 1977), p. 90.

138. Quoted in Jelena Hahl-Koch, *Kandinsky*, trans. from the German by Karin Brown (New York, 1993), p. 138.

139. Quoted in Gray, *Great Experiment*, p. 121.

140. Livshits, *The One and a Half-Eyed Archer*, pp. 91–92.

141. Mikhail Larionov, "Rayonist Painting," in Bowlt, ed. and trans., *Russian Art*, pp. 96, 98–100.

142. Mikhail Larionov and Natalia Goncharova, "Rayonists and Futurists: A Manifesto," in ibid., pp. 88–90.

143. Quoted in Larissa A. Zhadova, *Malevich: Suprematism and Revolution in Russian Art, 1910–1930* (London, 1982), p. 11.

144. Larionov and Goncharova, "Rayonists and Futurists," p. 89.

145. Quoted in Zhadova, *Malevich*, p. 24.

146. K. S. Malevich, *Essays on Art, 1915–1928*, ed. by Troels Andersen, and trans. by Xenia Glowacki-Prus and Arnold McMillin (Copenhagen, 1968), I, p. 38.

147. Zhadova, *Malevich*, p. 22.

148. Malevich, *Essays*, I, p. 37.

149. Quoted in Bowlt, ed. and trans., *Russian Art*, p. xxxiii.

150. Malevich, *Essays*, I, pp. 34–40.

151. Quoted in Haskell, *Diaghileff*, p. 176.

152. Ibid., p. 185. See also Karsavina, *Theatre Street*, pp. 235–236.

153. Quoted in Haskell, *Diaghileff*, p. 185.

154. Quoted in ibid., p. 186.

155. Quoted in Charles Spencer, *Leon Bakst* (New York, 1973), p. 60.

156. *Diaghilev: Les Ballets Russes* (Paris, 1979), pp. 19–26; *Les Ballets Russes de Serge de Diaghilev, 1909–1929* (Strassbourg, 1969), pp. 41–57.

157. Karsavina, *Theatre Street*, p. 243.

158. Quotes from Serge Lifar, *Serge Diaghilev: His Life, His Work, His Legend. An Intimate Biography* (New York, 1940), pp. 158–160. See also the detailed discussion of the Ballets Russes' reception in Joan Ross Acocella, *The Reception of Diaghilev's Ballets Russes by Artists and Intellectuals in Paris and London 1909–1914* (Ph.D. dissertation, Rutgers University, 1984), pp. 303–385.

159. Quoted in Karsavina, *Theatre Street*, p. 242.

160. Quotes from Lifar, *Diaghilev*, pp. 161–162; Haskell, *Diaghileff*, pp. 187–188.

161. Karsavina, *Theatre Street*, p. 244.

162. Lifar, *Diaghilev*, p. 160.

163. Quoted in Terry, *Russian Ballet*, p. 42.

164. Quoted in Bowlt, *Silver Age*, p. 222.

165. Prizhan, *Bakst*, pp. 9–52; Bowlt, pp. 216–224; Kennedy, *"Mir Iskusstva,"* pp. 277–278.

166. Quoted in S. L. Grigoriev, *The Diaghilev Ballet, 1909–1929* ed. and trans. by Vera Bowen (London, 1953), p. 8.

167. Quoted in Lifar, *Diaghilev*, p. 165.

168. Prizhan, *Bakst*, pp. 124–134; Spencer, *Bakst*, pp. 49–67.

169. Quoted in Poggioli, *Poets*, p. 262.

170. Quoted in Lincoln, *Passage*, p. 270.

171. Quoted in Terras, *History*, p. 410.

172. Quoted in Edward J. Brown, *Mayakovsky: A Poet in Revolution* (Princeton, 1973), pp. 42–45.

173. Ibid., pp. 40–51; Victor Terras,

*Vladimir Mayakovsky* (Boston, 1983), pp. 6–8, 55–58.

174. Quoted in Terras, *Mayakovsky*, p. 55.

175. Quoted in Billington, *Icon and the Axe*, pp. 476–477; and Dreier, *Burliuk*, pp. 62–64.

176. Stravinsky, *Poetics*, p. 84.

177. Quoted in Calvocoressi and Abraham, *Masters*, p. 458. See also pp. 450–459, and Faubion Bowers, *Scriabin: A Biography of the Russian Composer, 1871–1915* (Tokyo and Palo Alto, 1969), I, pp. 99–155.

178. Bowers, *Scriabin*, I, p. 134.

179. Ibid., pp. 156–342.

180. Quoted in Calvocoressi and Abraham, *Masters*, p. 475.

181. Quoted in Bowers, *Scriabin*, II, p. 50. 54, 58.

182. Quoted in Calvocoressi and Abraham, *Masters*, pp. 472–473.

183. Quoted in Bowers, *Scriabin*, II, pp. 54, 58.

184. Quoted in ibid., II, pp. 130–131, 135. See also Gerald Abraham et al., eds., *Russian Masters: 2* (New York, 1986), p. 61.

185. Quoted in Bowers, *Scriabin*, II, p. 195.

186. Quoted in Faubion Bowers, *The New Scriabin: Enigma and Answers* (New York, 1973), pp. 16–17.

187. James M. Baker, *The Music of Alexander Scriabin* (New Haven and London, 1986), pp. 215–216.

188. Quoted in Bowers, *Scriabin*, II, p. 196.

189. Quoted in ibid., II, p. 194.

190. Ibid., II, pp. 206–207; Billington, *Icon and the Axe*, pp. 478–479.

191. Quoted in Bowers, *Scriabin*, II, p. 205. See also pp. 204–207, and Calvocoressi and Abraham, *Masters*, pp. 486–487.

192. Bowers, *Scriabin*, II, p. 207.

193. Quoted in ibid., pp. 207–210. See also N. Vol'ter, "Simbolika 'Prometeia,' " in S. Markus, ed., *Aleksandr Nikolaevich Skriabin: Sbornik k 25-letiiu so dnia smerti* (Moscow-Leningrad, 1940), pp. 116–144.

194. Quoted in Bowers, *Scriabin*, II, p. 266.

195. Quoted in ibid., p. 95.

196. Quoted in ibid., pp. 278, 280.

197. Hugh McDonald, *Skryabin* (London and New York, 1978), pp. 67–68.

198. Igor Stravinsky, *Stravinsky: An Autobiography* (New York, 1936), pp. 3–36; Neil Tierney, *The Unknown Country: A Life of Igor Stravinsky* (London, 1977), pp. 15–35.

199. Quoted in Karsavina, *Theatre Street*, p. 256. See also Tierney, *Unknown*, pp. 39–41.

200. Quoted in Tierney, *Unknown*, p. 47. See also pp. 39–43.

201. Stravinsky, *Autobiography*, p. 48.

202. Tierney, *Unknown*, p. 50.

203. Quoted in Massie, *Land*, p. 442.

204. Quoted in Tierney, *Unknown*, p. 51. See also J. Douglas Clayton, *Pierrot in Petrograd: The Commedia dell'Arte/ "Balagan" in Twentieth Century Russian Theater and Drama* (Montreal and Kingston, 1993), p. 137; Catriona Kelly, *Petrushka: The Russian Carnival Theatre* (Cambridge, 1990), pp. 167–169.

205. Stravinsky, *Autobiography*, p. 47.

206. Quoted in Tierney, *Unknown*, p. 61.

207. Quoted in Massie, *Land*, p. 448. Also Tierney, *Unknown*, pp. 56–62.

208. Minna Lederman, ed., *Stravinsky*, p. 21.

209. M. Montagu-Nathan, *Contemporary Russian Composers* (New York, 1917), p. 141.

210. Quoted in Tierney, *Unknown*, p. 63.

211. Louis Andriessen and Elmer Schönberger, *The Apollonian Clockwork: On Stravinsky*, trans. from the Dutch by Jeff Hamburg (Oxford and New York, 1989), p. 139.

212. Ilya Ehrenburg, *People and Life: Memoirs of 1891–1917*, trans. by Anna Bostok and Yvonne Kapp (London, 1961), p. 173.

213. Richard Aldington, *Death of a Hero* (New York, 1929), p. 323. See also Lincoln, *Red Victory*, pp. 26–27.

214. Hanna Hafkesbrink, *Unknown Germany: An Inner Chronicle of the First World War Based on Letters and Diaries* (New Haven, 1948), p. 67.

215. Quoted in Slonim, *From Chekhov*, p. 226.

216. V. V. Maiakovskii, "Voina i mir," in *SS*, I, pp. 160, 164, 170, 173–175, 187, 189. This translation and part of the commentary included with it first appeared in Lincoln, *Passage*, pp. 272–273.

CHAPTER XIV
SEEKING NEW VISIONS

1. Quoted in Barbara W. Tuchman, *The Proud Tower: A Portrait of the World Before the War, 1890–1914* (New York, 1966), p. 463.
2. Livshits, *The One and a Half-Eyed Archer*, p. 217.
3. Ibid., pp. 214–219; A. A. Mgebrov, *Zhizn' v teatre* (Moscow-Leningrad, 1932), II, pp. 157–173; Harold B. Segal, *Turn-of-the-Century Cabaret: Paris, Barcelona, Berlin, Munich, Vienna, Cracow, Moscow, St. Petersburg, Zurich* (New York, 1987), pp. 309–318.
4. V. E. Meyerhold, "The New Theatre Foreshadowed in Literature," in Edward Braun, trans. and ed., *Meyerhold on Theatre* (New York, 1969), p. 39.
5. Quoted in Edward Braun, *The Theatre of Meyerhold: Revolution on the Modern Stage* (London, 1979), p. 34.
6. Ibid., pp. 28–35; Marjorie L. Hoover, *Meyerhold: The Art of Conscious Theater* (Amherst, 1974), pp. 22–26.
7. Braun, *Theatre*, pp. 17–22, 75–80, 111–118; Segal, *Cabaret*, p. 304.
8. Segal, *Cabaret*, p. 305.
9. Ibid., pp. 305–307, 313–315; Livshits, *The One and a Half-Eyed Archer*, pp. 214–219; Roberta Reeder, *Anna Akhmatova: Poet and Prophet* (New York, 1994), pp. 65–68.
10. Quoted in Segal, *Cabaret*, pp. 307–308.
11. Quoted in Reeder, *Akhmatova*, p. 44.
12. Aleksei Tolstoi, *Khozhdenie po mukam* in *Sobranie sochinenii v desiati tomakh* (hereafter *SS*) (Moscow, 1959), V, pp. 10, 12.
13. Quoted in Segal, *Cabaret*, p. 310.
14. Viktor Shklovsky, *Mayakovsky and His Circle*, ed. and trans. by Lily Feiler (New York, 1972), p. 68.
15. Georgy Adamovich, "Meetings with Anna Akhmatova," in Konstantin Polivanov, ed., *Anna Akhmatova and Her Circle*, trans. from the Russian by Patricia Beriozkina (Fayetteville, 1994), p. 64.
16. Quoted in Amanda Haight, *Anna Akhmatova: A Poetic Pilgrimage* (New York and London, 1976), p. 29.
17. Quoted in ibid, p. 29.
18. Quoted in Reeder, *Akhmatova*, p. 36.
19. Quoted in ibid., p. 38.
20. Quoted in ibid., p. 69.
21. Anna Akhmatova, *Stikhi* (Moscow, 1988), p. 50.
22. Ibid., p. 132.
23. Quoted in Reeder, *Akhmatova*, p. 79.
24. Robert C. Williams, *Artists in Revolution: Portraits of the Russian Avant-garde, 1905–1925* (Bloomington, 1977), pp. 9–10.
25. Quoted in E. Usievich, *Vladimir Maiakovskii: Ocherki zhizni i tvorchestva* (Moscow, 1950), p. 37.
26. V. V. Maiakovskii, "Ne babochki, a Aleksandr Makedonskii," in *Sobranie sochinenii v vos'mi tomakh* (hereafter *SS*) (Moscow, 1968), I, p. 364.
27. V. V. Maiakovskii, "Vam!," in *SS*, I, p. 73.
28. V. Pertsov, *Maiakovskii: Zhizn' i tvorchestvo (1893–1917)*, pp. 213–215; Brown, *Mayakovsky*, p. 91; Wiktor Woroszylski, *The Life of Mayakovsky*, trans. from the Polish by Boleslaw Taborski (New York, 1970), p. 140; Reeder, *Akhmatova*, p. 81.
29. Pertsov, *Maiakovskii*, pp. 357–363; Shklovsky, *Mayakovsky*, p. 88.
30. V. V. Maiakovskii, "Voina i mir," in *SS*, I, pp. 160, 164, 170, 173–175, 187, 189. This translation and part of the commentary included with it first appeared in Lincoln, *Passage*, pp. 272–273.
31. Shklovsky, *Mayakovsky*, p. 87.
32. V. V. Maiakovskii, "Chelovek," in *SS*, I, pp. 190–217.
33. Shklovsky, *Mayakovsky*, p. 93.
34. V. V. Shul'gin, *Dni* (Belgrade, 1925), p. 76.
35. Quoted in E. D. Chermenskii, *IV gosudarstvennaia duma i sverzhenie tsarizma v Rossii* (Moscow, 1976), p. 277.
36. Quoted in Tsuyoshi Hasegawa, *The*

*February Revolution: Petrograd, 1917* (Seattle and London, 1981), pp. 183–184.

37. Quoted in Raymond Pearson, *The Russian Moderates and the Crisis of Tsarism, 1914–1917* (London, 1977), pp. 132–133.

38. Shklovsky, *Mayakovsky*, pp. 97, 95.

39. Zinaida Gippius, *Siniaia kniga: Peterburgskii dnevnik, 1914–1918* (Belgrade, 1929), p. 111.

40. Gippius, *Siniaia kniga*, p. 112.

41. Andrei Belyi, *Lug*, p. 201; Rosenthal, *Merezhkovsky*, pp. 210–211.

42. V. F. Khodasevich, "Bryusov," in Grossman, ed., *Diary*, pp. 158–159.

43. Ibid., pp. 159–160.

44. Quoted in Mochul'skii, *Belyi*, pp. 204–205, 207.

45. Quoted in Pyman, *Release*, pp. 243, 249, 255, 268–269, 281, 282.

46. Maxim Gorky, *Untimely Thoughts: Essays on Revolution, Culture, and the Bolsheviks, 1917–1918*, trans. from the Russian by Herman Ermolaev (New York, 1968), p. 138.

47. Quoted in Slonim, *From Chekhov*, p. 210.

48. Pyman, *Release*, pp. 284–285.

49. Ibid., p. 288.

50. Quoted in ibid., p. 285.

51. A. A. Blok, "Dvenadtsat'," in *SS*, III, pp. 233–243.

52. James von Geldern, *Bolshevik Festivals, 1917–1920* (Berkeley and Los Angeles, 1993), pp. 136–137, 208–212.

53. Quoted in Nikolai A. Gorchakov, *The Theater in Soviet Russia*, trans. by Edgar Lehrman (New York, 1958), p. 109.

54. Quoted in Slonim, *Russian Theater*, p. 241.

55. Ibid., pp. 240–242.

56. Quoted in ibid., p. 266.

57. Quoted in Nick Worrall, *Modernism to Realism on the Soviet Stage: Tairov, Vakhtangov, Okhlopov* (Cambridge, 1989), p. 78.

58. Quoted in ibid., pp. 100–101. See also pp. 98–102.

59. Huntly Carter, *The New Spirit in the Russian Theater, 1917–1928* (New York, 1970), p. 181.

60. Quoted in Worrall, *Modernism*, p. 127.

61. Ibid., p. 128.

62. Quoted in ibid., p. 130. See also pp. 129–131.

63. Quoted in ibid., p. 78.

64. Quoted in Gorchakov, *Theater*, p. 253.

65. Quoted in Worrall, *Modernism*, pp. 139, 78.

66. Ibid., p. 76.

67. Quoted in Braun, *Theatre*, pp. 146–147.

68. Quoted in ibid., p. 149.

69. Marjorie L. Hoover, *Meyerhold: The Art of Conscious Theater* (Amherst, 1974), p. 112.

70. Quoted in Braun, *Theatre*, p. 151.

71. Quoted in Slonim, *Russian Theater*, p. 244.

72. Quoted in ibid.

73. Gorchakov, *Theater*, p. 153.

74. Quoted in Braun, *Theatre*, p. 154.

75. Quoted in ibid., p. 165.

76. Quoted in Dmitri V. Sarabianov and Natalia L. Adaskina, *Popova*, trans. from the Russian by Marian Schwartz (New York, 1990), p. 254.

77. Ibid., pp. 245–257. See also Georgii Kovalenko, "The Constructivist Stage," in Nancy Van Norman Baer, ed., *Theatre in Revolution: Russian Avant-Garde Stage Design, 1913–1935* (London, 1991), pp. 145–154.

78. Quoted in Braun, *Theatre*, p. 157.

79. Ilya Ehrenburg, *First Years of Revolution, 1918–1921*, trans. by Anna Bostok and Yvonne Kapp (London, 1962), pp. 62–63, 69.

80. Ibid., pp. 63–64. See also Arthur Ransome, *Crisis in Russia* (New York, 1920), pp. 140–141.

81. Lincoln, *Red Victory*, pp. 348–349; S. D. Spasskii, "Moskva," in V. V. Grigorenko et al., eds., *V. Maiakovskii v vospominaniiakh sovremennikov* (Moscow, 1963), pp. 161–177; Ehrenburg, *First Years*, pp. 38–40, 62–69.

82. Quoted in Terras, *Mayakosvky*, p. 37.

83. Spasskii, "Moskva," pp. 166, 174.

84. V. D. Bonch-Bruevich, "Vladimir Il'ich i ukrashchenie krasnoi stolitsy," in V. D. Bonch-Bruevich, *Vospominaniia o Lenine*, 2nd ed. (Moscow, 1969), p. 409.

85. Ehrenburg, *First Years*, p. 55.

86. Ibid., pp. 55–56; Bonch-Bruevich, "Vladimir Il'ich i ukrashchenie krasnoi stolitsy," pp. 409–411; Lincoln, *Red Victory*, p. 350.

87. Ransome, *Crisis*, p. 34.

88. Billington, *Icon and the Axe*, pp. 538–539.

89. V. V. Maiakovskii, "Vystuplenie na mitinge ob iskusstve," 24 noiabria 1918 goda, in *SS*, I, p. 402.

90. Quoted in Lincoln, *Passage*, p. 270.

91. V. V. Maiakovskii, "Radovat'sia rano," in *SS*, I, p. 248; Maiakovskii, "Prikaz po armii iskusstva," in *SS*, I p. 247.

92. V. V. Maiakovskii, "Otkrytoe pis'mo rabochim," in *SS*, I, p. 395.

93. V. V. Maiakovskii, "Levyi marsh (matrosam)," in *SS*, I, pp. 255–256.

94. V. V. Maiakovskii, "S tovarishcheskim privetom, Maiakovskii," in *SS*, II, p. 8.

95. Brown, *Mayakovsky*, p. 205.

96. V. V. Maiakovskii, "150,000,000," in *SS*, II, p. 51.

97. Quoted in Lincoln, *Red Victory*, p. 352.

98. Quoted in Brown, *Mayakovsky*, pp. 206, 205.

99. Quoted in Lincoln, *Red Victory*, p. 351.

100. Quoted in Reeder, *Akhmatova*, p. 172.

101. Anna Akhmatova, "Ne s temi ia, kto brosil zemliu," *Stikhi* (Moscow, 1988), p. 114.

102. Quoted in Reeder, *Akhmatova*, pp. 171, 170.

103. Quoted in ibid., p. 169.

104. Quoted in Brown, *Mayakovsky*, p. 370.

105. Quoted in ibid., pp. 292, 506.

106. Peter Kenez, *Cinema and Soviet Society, 1917–1953* (New York, 1992), pp. 11–30; N. M. Zorkaia, *Na rubezhe stoletii. U istokov massovogo iskusstva v Rossii 1900–1910 godov* (Moscow, 1976), pp. 54–92.

107. Kenez, *Cinema*, p. 10.

108. A. V. Lunacharskii, "Beseda s V. I. Leninym o kino," in A. M. Gak, ed., *Samoe vazhnoe iz vsekh iskusstv: Lenin o kino* (Moscow, 1973), p. 164.

109. Sergei M. Eisenstein, *Immoral Memo-ries: An Autobiography*, trans. by Herbert Marshall (Boston, 1983), p. 8.

110. Braun, ed. and trans., *Meyerhold*, p. 198.

111. Quoted in Jay Leyda, *Kino: A History of the Russian and Soviet Film*, 3rd ed. (Princeton, 1983), p. 181.

112. Ibid., p. 182.

113. Quoted in ibid., p. 183.

114. *The Complete Films of Eisenstein* (London, 1974), p. 31.

115. Quoted in Leyda, *Kino*, p. 198.

116. A. Karaganov, *Vsevolod Pudovkin* (Moscow, 1973), pp. 9–46.

117. Quoted in Richard Taylor, *Film Propaganda: Soviet Russia and Nazi Germany* (London and New York, 1979), p. 82.

118. Ibid., pp. 83–89.

119. Quoted in ibid., p. 89.

120. Quoted in Leyda, *Kino*, p. 211.

121. Ibid.

122. Denise J. Youngblood, *Soviet Cinema in the Silent Era*, 1918–1935 (Ann Arbor, 1985), p. 151.

123. Quoted in Leyda, *Kino*, p. 236.

124. Taylor, *Film Propaganda*, pp. 93–100, and James Goodwin, *Eisenstein, Cinema, and History* (Urbana and Chicago, 1993), pp. 82–97.

125. Quoted in Taylor, *Film Propaganda*, pp. 92–93.

126. Ibid., p. 101.

127. Quoted in ibid.

128. Quoted in Gleb Struve, *Soviet Russian Literature, 1917–1950* (Norman, 1951), p. 220.

CHAPTER XV
THE UTOPIA OF SOCIALIST REALISM

1. Quoted in Jeffrey Brooks, "Socialist Realism in *Pravda*: Read All About It!," *Slavic Review*, LIII, No. 4 (Winter 1994), p. 978.

2. Quoted in A. Kemp-Welch, *Stalin and the Literary Intelligentsia, 1928–1939* (London, 1991), p. 131.

3. Katerina Clark, *The Soviet Novel: History as Ritual* (Chicago, 1981), pp. 3–15.

4. Quoted in Gorchakov, *Theater*, p. 360.

5. Quoted in Kemp-Welch, *Stalin*, p. 129.

6. Edward J. Brown, *Russian Literature Since the Revolution* (Cambridge, Mass., 1982), p. 87.

7. Jeffrey Brooks, "Socialist Realism," p. 991.

8. G. Vladimirov, *Tvorcheskii put' Furmanova* (Tashkent, 1953), pp. 7–152; E. Naumov, *D. A. Furmanov: Kritiko-biograficheskii ocherk* (Moscow, 1954), pp. 5–122.

9. Patricia Carden, *The Art of Isaac Babel* (Ithaca, 1972), pp. 1–52; Richard Hallett, *Isaac Babel* (New York, 1973), pp. 1–30; James E. Falen, *Isaac Babel: Russian Master of the Short Story* (Knoxville, 1974), pp. 3–56.

10. Ilya Ehrenburg, *Truce: 1921–1933*, trans. by Tatiana Shebunina (London, 1963), pp. 110–111.

11. Quoted in K. Paustovskii, *Povest' o zhizni*, in K. Paustovskii, *Sobranie sochinenii v vos'mi tomakh* (hereafter *SS*) (Moscow, 1968), V, pp. 139–141.

12. Quoted in Carden, *Art of Babel*, p. 93.

13. Hallett, *Babel*, p. 42.

14. Quoted in ibid.

15. Roy A. Medvedev, *Problems in the Literary Biography of Mikhail Sholokhov* trans. by A. D. P. Briggs (Cambridge, 1977), p. 197.

16. Quoted in Vera Alexandrova, *A History of Soviet Literature*, trans. by Mirra Ginsburg (Westport, 1974), p. 217.

17. Geir Kjetsaa, Sven Gustavsson, Bengt Beckman, and Steinar Gil, *The Authorship of "The Quiet Don"* (Oslo and Atlantic Highlands, 1984), pp. 152–153.

18. Struve, *Soviet Russian Literature*, p. 131.

19. N. V. Gogol, *Taras Bul'ba*, in *SS*, II, pp. 48–49.

20. Alexander Berkman, *The Bolshevik Myth. Diary, 1920–1921* (New York, 1925), pp. 167–168.

21. Robert A. Maguire, *Red Virgin Soil: Soviet Literature in the 1920s* (Princeton, 1968), pp. 319–322.

22. Quoted in ibid., p. 322.

23. Fedor Gladkov, *Tsement* (Moscow, 1964), p. 47.

24. Ibid., pp. 255–256.

25. Quoted in Clark, *Soviet Novel*, pp. 72–73.

26. Nikolai Ostrovskii, *Kak zakalialas' stal'*, in *Sobranie sochinenii* (hereafter *SS*) (Moscow, 1955), I, pp. 399, 400. See also Clark, *Soviet Novel*, pp. 131–133.

27. S. Tregub, *Nikolai Alekseevich Ostrovskii* (Moscow, 1950), pp. 7–262.

28. Anna Karavaeva, "Zhil on radostno i gordo," in I. Kiriushkin and P. Ostrovskaia, eds., *Vospominaniia o Nikolaia Ostrovskom* (Moscow, 1974), pp. 156, 160, 159.

29. Tregub, *Ostrovskii*, pp. 7–8, 263–364.

30. Clark, *Soviet Novel*, pp. 136–141.

31. Quoted in Alexandrova, *History*, p. 31.

32. Quoted in Brown, *Russian Literature*, pp. 134–136.

33. V. Ozerov, *Aleksandr Fadeev: Tvorcheskii put'* (Moscow, 1960), pp. 188–232.

34. Quoted in Gleb Struve, *Russian Literature Under Lenin and Stalin, 1917–1953* (Norman, 1971), p. 136.

35. V. Ozerov, "A Saga of Undaunted Courage," in Aleksandr Fadeev, *The Young Guard* (Moscow, 1973), I, p. 8.

36. Ibid., p. 13.

37. A. Fadeev, *Molodaia gvardiia* (Moscow, 1946), p. 3.

38. Clark, *Soviet Novel*, pp. 159–160.

39. Quoted in Braun, *Theatre*, p. 232.

40. Quoted in Gorchakov, *Theater*, p. 218.

41. Quoted in Slonim, *Russian Theater*, p. 326.

42. Quoted in ibid., p. 328, and Braun, *Theatre*, p. 269.

43. Quoted in Slonim, *Russian Theater*, p. 330.

44. Quoted in ibid., pp. 329, 328.

45. Brown, *Russian Literature*, pp. 50–69.

46. Quoted in Gorchakov, *Theater*, p. 287.

47. Ibid., p. 286.

48. Quoted in Kenez, *Cinema*, p. 141.

49. Quoted in ibid., p. 157.

50. Alexander S. Birkos, comp., *Soviet Cinema* (Hamden, 1976), p. 153.

51. Kenez, *Cinema*, p. 172.

52. Quoted in David Bordwell, *The Cinema of Eisenstein* (Cambridge, Mass., 1993), p. 204.

53. Quoted in Harlow Robinson, *Sergei Prokofiev: A Biography* (New York, 1987), p. 350.

54. Quoted in Bordwell, *Cinema*, p. 210.

55. Marie Seton, *Sergei M. Eisenstein: A Biography* (London, 1978), pp. 383–384.

56. Quoted in Robinson, *Prokofiev*, p. 351.

57. Quoted in Israel V. Nestyev, *Prokofiev*, trans. from the Russian by Florence Jonas (Stanford, 1960), p. 294.

58. Rufus W. Mathewson, Jr., *The Positive Hero in Russian Literature*, 2nd ed. (Stanford, 1975), p. 190.

59. Quoted in Robinson, *Prokofiev*, p. 403.

60. Quoted in Nestyev, *Prokofiev*, p. 355.

61. Quoted in Leyda, *Kino*, p. 382.

62. Quoted in Bordwell, *Cinema*, p. 252.

63. Quoted in Valkenier, *Russian Realist Art*, p. 169.

64. Quoted in Matthew Cullerne Bown, *Art Under Stalin* (Oxford, 1991), p. 93.

65. Lincoln, *Red Victory*, pp. 371–374; Anatole Kopp, *Town and Revolution: Soviet Architecture and City Planning, 1917–1935*, trans. by Thomas E. Burton (New York, 1970), p. 31.

66. L. Kritsman, *Geroicheskii period velikoi russkoi revoliutsii* (Moscow, 1924), p. 162.

67. Quoted in Catherine Cooke, "Professional Diversity and Its Origins," in Andreas C. Papadakis, ed., *The Avant-Garde: Russian Architecture in the Twenties* (London, 1991), p. 14.

68. Quoted in Christina Lodder, *Russian Constructivism* (New Haven and London, 1983), pp. 55–56, 60.

69. Vladimir Tatlin, "The Work Ahead of Us," in Bowlt, ed., *Russian Art*, p. 207.

70. Quoted in Lodder, *Russian Constructivism*, p. 61.

71. Quoted in Kenneth Powell, "Modernism Divided," in Papadakis, ed., *The Avant-Garde*, p. 7.

72. Quoted in Lodder, *Russian Constructivism*, p. 60.

73. N. A. Miliutin, *Sotsgorod: The Problem of Building Socialist Cities*, trans. from the Russian by Arthur Sprague (Cambridge, Mass., 1974), p. 50.

74. Quoted in S. Frederick Starr, *Melnikov: Solo Architect in a Mass Society* (Princeton, 1978), pp. 73–74.

75. Ibid., pp. 78–79.

76. V. E. Khazanova, *Sovetskaia arkhitektura pervykh let Oktiabria, 1971–1925gg.* (Moscow, 1970), pp. 163–164.

77. Starr, *Melnikov*, p. 249.

78. Quoted in John E. Bowlt, "From Avant-Garde to Avant-Garde," in Lincoln, comp., *Moscow: Treasures and Traditions*, p. 226.

79. Quoted in Bown, *Art Under Stalin*, p. 175.

80. Ibid., p. 178.

81. Feofan Prokopovich, "Sermon on the Interment of Peter the Great," in Segal, ed., *Literature*, pp. 142, 144.

82. Matthew Cullerne Bown, "Aleksandr Gerasimov," in Matthew Cullerne Bown and Brandon Taylor, eds., *Art of the Soviets: Painting, Sculpture, and Architecture in a One-Party State, 1917–1992* (Manchester, 1993), p. 131.

83. Ibid., pp. 121–138.

84. V. P. Sysoev, *Aleksandr Deineka: Monografiia* (Moscow, 1989), I, p. 16.

85. Quoted in Vladimir Sysoev, ed., *Alexander Deineka: Paintings, Graphic Works, Sculptures, Mosaics, and Excerpts from the Artist's Writings* (Leningrad, 1982), p. 6.

86. Quoted in ibid., p. 8.

87. Quoted in ibid., facing plate 10. See also Sysoev, *Aleksandr Deineka: Monografiia*, I, pp. 32–85; and Bown, *Art Under Stalin*, p. 42.

88. Quoted in Sysoev, ed., *Alexander Deineka*, facing plate 98.

89. Quoted in ibid., facing plate 161.

90. Sysoev, *Aleksandr Deineka: Monografiia*, I, pp. 186–195.

91. Quoted in Sysoev, ed., *Alexander Deineka*, facing plate 185.

92. Quoted in ibid., text beneath plate 180.

93. Ibid., plates 186–189; Sysoev, *Aleksandr Deineka: Monografiia*, I, pp. 230–233.

94. Sysoev, *Aleksandr Deineka: Monografiia*, I, pp. 238–316.

95. Quoted in Kopp, *Town*, p. 225.

96. Brumfield, *History*, p. 491.

97. Ibid., p. 492.

98. Dostoevskii, *Zimnye zametki o let-nykh uproshcheniiakh*, p. 76.

## CHAPTER XVI
### ÉMIGRÉS AGAINST UTOPIA

1. Marc Raeff, *Russia Abroad: A Cultural History of the Russian Emigration, 1919–1939* (New York and Oxford, 1990), p. 203.
2. Gippius, *Siniaia kniga*, p. 221; Pachmuss, *Hippius*, p. 199.
3. Quoted in p. 216.
4. Raeff, *Russia Abroad*, pp. 3–5; Gleb Struve, *Russkaia literatura v izgnanii*, 2nd ed. (Paris, 1984), pp. 18–19.
5. Quoted in Peg Weiss, *Kandinsky and Old Russia: The Artist as Ethnographer and Shaman* (New Haven, 1995), p. 4.
6. Quoted in Marcel Brion, *Kandinsky* (New York, 1962), p. 19.
7. Weiss, *Kandinsky*, pp. 1–32.
8. Quoted in Jelena Hahl-Koch, *Kandinsky*, trans. from the German by Karin Brown, Ralph Harratz, and Katharine Harrison (New York, 1993), pp. 23–24.
9. Quoted in Brion, *Kandinsky*, p. 19.
10. Peg Weiss, *Kandinsky in Munich: The Formative Jugendstil Years* (Princeton, 1979), p. 3.
11. Quoted in ibid., p. 7.
12. Quoted in Rose-Carol Washton Long, *Kandinsky: The Development of an Abstract Style* (Oxford, 1980), p. 2.
13. Quoted in Hahl-Koch, *Kandinsky*, p. 172.
14. Quoted in ibid., p. 151.
15. Quoted in ibid., p. 178.
16. Vasilii Kandinskii, "Content and Form, 1910," in Bowlt, ed., *Russian Art*, pp. 19–22.
17. Quoted in Weiss, *Kandinsky in Munich*, p. 115.
18. Quoted in Brion, *Kandinsky*, p. 79.
19. Quoted in Long, *Kandinsky*, p. 2.
20. Quoted in ibid., p. 6.
21. Quoted in ibid., p. 4.
22. Quoted in Weiss, *Kandinsky*, p. 114.
23. Quoted in ibid., p. 74.
24. Quoted in ibid., p. 124.

25. Ibid., pp. 113–128.
26. Quoted in Robert C. Williams, *Culture in Exile: Russian Émigrés in Germany, 1881–1941* (Ithaca, 1972), p. 308.
27. Quoted in ibid., p. 309.
28. Quoted in ibid., p. 311.
29. Quoted in Brion, *Kandinsky*, p. 83.
30. Weiss, *Kandinsky*, p. 172.
31. Ibid., pp. 175–210.
32. Quoted in Isaac Kloomok, *Marc Chagall: His Life and Work* (New York, 1951), p. 7.
33. Marc Chagall, *My Life*, trans. from the French by Elisabeth Abbott (New York, 1960), pp. 105, 100, 107.
34. Quoted in Franz Meyer, *Marc Chagall: Life and Work* (New York, n.d.), pp. 96–98.
35. Chagall, *My Life*, pp. 103, 116, 110.
36. Quoted in Meyer, *Chagall*, pp. 114, 206.
37. Chagall, *My Life*, p. 123.
38. Meyer, *Chagall*, pp. 217–256.
39. Chagall, *My Life*, pp. 145, 170, 174; and Walter Erben, *Marc Chagall* (New York, 1966), pp. 66–68. See also Meyer, *Chagall*, pp. 265–313.
40. Quoted in Erben, *Chagall*, p. 88.
41. Charles Sorlier, *Marc Chagall et Ambroise Vollard* (Paris, 1981), pp. 21–73.
42. Quoted in Meyer, *Chagall*, p. 378.
43. Quoted in Kloomok, *Chagall*, p. 22.
44. Chagall, *My Life*, p. 39.
45. Meyer, *Chagall*, p. 384.
46. Quoted in Erben, *Chagall*, p. 103.
47. Sorlier, *Marc Chagall*, pp. 127–167; Kloomok, *Chagall*, pp. 74–77.
48. Quoted in Meyer, *Chagall*, p. 386.
49. Quoted in ibid., p. 432; and Kloomok, *Chagall*, p. 89.
50. Quoted in Meyer, *Chagall*, p. 432.
51. Simon Karlinsky, "Who Are the Émigré Writers?," in Simon Karlinsky and Alfred Appel, Jr., eds., *The Bitter Air of Exile: Russian Writers in the West, 1922–1972* (Berkeley and Los Angeles, 1977), p. 7.
52. Ibid., pp. 6–7.
53. Maxim Gorky, *Untimely Thoughts: Essays on Revolution, Culture, and the Bolsheviks, 1917–1918*, trans. from the Russian with

an introduction and notes by Herman Ermolaev (New York, 1968) p. 173.

54. Hilde Hardeman, *Coming to Terms with the Soviet Regime: The "Changing Signposts" Movement among Russian Émigrés in the Early 1920s* (DeKalb, 1994), pp. 12–14; N. V. Riasanovsky, "The Emergence of Eurasianism," *California Slavic Studies*, No. 4 (1967), pp. 39–53; Jane Burbank, *Intelligentsia and Revolution: Russian Views of Bolshevism, 1917–1922* (New York, 1986), pp. 215–222.

55. Quoted in Hardeman, *Coming*, p. 30.

56. Quoted in ibid., pp. 143–144.

57. Vladimir Nabokov, *Speak Memory: An Autobigraphy Revisited* (New York, 1966), p. 281.

58. For example, see her poem "Toska po rodine!" ("Homesickness"), in Marina Tsvetaeva, *Izbrannye proizvedeniia*, ed. by A. Eifron and A. Saakiants (Moscow-Leningrad, 1965), pp. 304–305.

59. Quoted in Simon Karlinsky, *Marina Cvetaeva: Her Life and Art* (Berkeley and Los Angeles, 1966), p. 32.

60. Ibid., pp. 15–41; Simon Karlinsky, *Marina Tsvetaeva: The Woman, Her World and Her Poetry* (Cambridge and New York, 1985), pp. 1–91; Elaine Feinstein, *A Captive Lion: The Life of Marina Tsvetayeva* (London, 1987), pp. 23–82.

61. Quoted in Karlinsky, *Tsvetaeva*, pp. 227.

62. Quoted in ibid., p. 236.

63. Albert C. Todd and Max Hayward, eds., *Twentieth Century Russian Poetry*, selected, with an introduction, by Yevgeny Yevtushenko (New York, 1993), p. 225.

64. Quoted in Karlinsky, *Tsvetaeva*, p. 78.

65. Quoted in ibid., p. 81.

66. Quoted in ibid., p. 82.

67. Quoted in Feinstein, *Captive*, p. 99.

68. Marina Tsvetaeva, *Lebedinnyi stan. Perekop* (Paris, 1971), p. 46.

69. Ehrenburg, *First Years*, p. 26.

70. Quoted in ibid., p. 23.

71. Quoted in Feinstein, *Captive*, p. 114.

72. Nabokov, *Speak Memory*, p. 276; Raeff, *Russia Abroad*, p. 77; Williams, *Culture in Exile*, p. 114.

73. Brian Boyd, *Vladimir Nabokov: The Russian Years* (Princeton, 1990), p. 198.

74. Quoted in Meyer, *Chagall*, p. 316.

75. Nina Berberova, *Kursiv moi: Avtobiografiia* (Munich, 1972), pp. 175–176; Struve, *Russkaia literatura*, pp. 24–29.

76. Quoted in Feinstein, *Captive*, pp. 125, 131.

77. Quoted in ibid., pp. 127, 135, 128.

78. Ibid, p. 129.

79. Quoted in ibid., pp. 168–169.

80. Karlinsky, *Cvetaeva*, p. 212; Karlinsky, *Tsvetaeva*, p. 141.

81. Karlinsky, *Cvetaeva*, pp. 211–214.

82. Ibid., p. 233; Michael Makin, *Marina Tsvetaeva: Poetics of Appropriation* (Oxford, 1993), pp. 239–261.

83. Mark Vishniak, *Gody emigratsii: Parizh-N'iu Iork, 1919–1969gg.* (Stanford, 1970), p. 9.

84. Quoted in Karlinsky, *Tsvetaeva*, p. 150.

85. Quoted in Feinstein, *Captive*, p. 177.

86. Quoted in ibid., p. 211.

87. Quoted in ibid., p. 224.

88. Quoted in ibid., p. 243.

89. Quoted in ibid., pp. 254, 256.

90. Quoted in ibid., p. 256.

91. Berberova, *Kursiv moi*, pp. 277–289.

92. Quoted in Pachmuss, *Hippius*, p. 240.

93. Quoted in ibid., pp. 244–245.

94. Quoted in Serge Kryzytski, "Ivan Alekseevich Bunin," *Modern Encyclopedia of Russian and Soviet Literature* (Gulf Breeze, 1979), III, p. 173.

95. Ivan Bunin, *Memories and Portraits*, trans. by Vera Traill and Robin Chancellor (New York, 1968), p. 14; Thomas Gaiton Marullo, ed., *Ivan Bunin: From the Other Shore, 1920–1933* (Chicago, 1995), p. 296; and Kryzytski, "Ivan Alekseevich Bunin," p. 172.

96. Bunin, *Memories*, p. 16.

97. Ibid., p. 15.

98. I. A. Bunin, "Nesrochnaia vesna," in *Sobranie sochinenii* (hereafter *SS*), V, p. 126.

99. Marullo, ed., *Bunin*, p. 127.

100. Quoted in James B. Woodward, *Ivan Bunin: A Study of His Fiction* (Chapel

Hill, 1980), p. 164; Berberova, *Kursiv moi*, p. 288.

101. Marullo, ed., *Bunin*, p. 83.

102. Ibid., p. 143.

103. Kryzytski, "Ivan Alekseevich Bunin," p. 179.

104. Nabokov, *Speak Memory*, pp. 287–288.

105. Boyd, *Russian Years*, pp. 15–67; Andrew Field, *VN: The Life and Art of Vladimir Nabokov* (New York, 1986), pp. 5–12.

106. Boyd, *Russian Years*, pp. 86–160; Field, *VN*, pp. 40–59.

107. Boyd, *Russian Years*, p. 121.

108. Marina Turkevich Naumann, *Blue Evenings in Berlin: Nabokov's Short Stories of the 1920s* (New York, 1978), pp. 6–7.

109. Quoted in Field, *VN*, p. 109; Nabokov, *Strong Opinions*, pp. 10–11; Nabokov, *Speak Memory*, p. 268.

110. Vladimir Nabokov, *Bend Sinister* (New York, 1964), p. 168.

111. Boyd, *Russian Years*, pp. 319–320. See Boyd's stunning discussion of the problem on pp. 301–320.

112. Nabokov, *Speak Memory*, p. 281.

113. Quoted in Boyd, *Russian Years*, p. 221.

114. Nabokov, *Strong Opinions*, p. 127.

115. Boyd, *Russian Years*, pp. 212–218, 239–240.

116. Quoted in ibid., p. 277.

117. Vladimir Nabokov, *King, Queen, Knave*, trans. by Dmitri Nabokov in collaboration with the author (New York, 1968), p. viii.

118. Vladimir Nabokov, *Nikolai Gogol* (New York, 1961), pp. 63–64, 70. See also Boyd, *Russian Years*, p. 285.

119. Quoted in ibid., p. 291.

120. Vladimir Nabokov, *The Defense*, trans. by Michael Scammell in collaboration with the author (New York, 1964), p. 256.

121. Berberova, *Kursiv moi*, pp. 373–374.

122. Quoted in Boyd, *Russian Years*, p. 343.

123. Ibid., p. 351.

124. Ibid., pp. 382–389.

125. Vladimir Nabokov, *Despair* (New York, 1968), p. 171.

126. Quoted in Boyd, *Russian Years*, p. 405.

127. Vladimir Nabokov, *Invitation to a Beheading*, trans. by Dmitri Nabokov in collaboration with Vladimir Nabokov (New York, 1960), p. vii.

128. Field, *VN*, p. 145.

129. Boyd, *Russian Years*, pp. 410–417.

130. Quoted in ibid., p. 411.

131. Vladimir Nabokov, *The Gift*, trans. from the Russian by Michael Scammell with the collaboration of the author (New York, 1963), p. 10.

132. Andrew Field, *Nabokov: His Life in Art* (Boston, 1986), p. 249.

133. Field, *VN*, p. 173.

## CHAPTER XVII
### UTOPIA'S OPPONENTS AT HOME

1. J. V. Stalin, *Works* (Moscow, 1955), XIII, pp. 40–41.

2. Kemp-Welch, *Stalin*, pp. 225–226.

3. Published in Russian under the titles *Vospominaniia* (New York, 1970), and *Vtoraia kniga* (Paris, 1972), these were translated into English as *Hope Against Hope* and *Hope Abandoned*.

4. Clarence Brown, "Introduction," in Nadezhda Mandelstam, *Hope Against Hope: A Memoir*, trans. from the Russian by Max Hayward (New York, 1970), p. xi.

5. Osip Mandelstam, *The Noise of Time*, in Clarence Brown, trans., *The Prose of Osip Mandelstam* (Princeton, 1965), p. 79.

6. According to the recollections of Mikhail Karpovich, an émigré who later taught Russian history at Harvard. See Clarence Brown, *Mandelstam* (Cambridge, 1973), p. 32.

7. Quoted in ibid., p. 50.

8. Quoted in Reeder, *Akhmatova*, p. 41.

9. Quoted in ibid., p. 42.

10. Quoted in Brown, *Mandelstam*, p. 57.

11. Ehrenburg, *First Years*, p. 105.

12. Gregory Freiden, *A Coat of Many Colors: Osip Mandelstam and His Mythologies of Self-Presentation* (Berkeley and Los Angeles, 1987), pp. 99–123.

13. Ehrenburg, *First Years*, p. 105.

14. Victor Shklovsky, *Sentimental Journey: Memoirs, 1917–1922*, trans. by Richard Sheldon (Ithaca, 1984), p. 237.

15. Quoted in Brown, *Mandelstam*, p. 88.

16. Quoted in Clare Cavanagh, *Osip Mandelstam and the Modernist Creation of Tradition* (Princeton, 1995), p. 137.

17. Brown, *Mandelstam*, p. 102.

18. Quoted in ibid., p. 125.

19. Osip Mandelstam, "Fourth Prose," in Jane Gray Harris, ed., *Mandelstam: The Complete Critical Prose and Letters*, trans. by Jane Gray Harris and Constance Link (Ann Arbor, 1979), pp. 316, 321.

20. Ibid., p. 321.

21. Cavanagh, *Mandelstam*, p. 194.

22. Quoted in Brown, *Mandelstam*, 126.

23. See the Russian text in Osip Mandelshtam, *Eyesight of Wasps*, p. 129.

24. Quoted in Lincoln, *Red Victory*, p. 524. See also Mandelstam, *Hope Against Hope*, for a note on an earlier version, which includes the reference to Stalin as a "murderer and peasant slayer."

25. Mandelstam, *Hope Against Hope*, p. 27.

26. Quoted in Ehrenburg, *First Years*, p. 108.

27. Osip Mandelshtam, *Eyesight of Wasps*, p. 136. See also Mandelstam, *Hope Against Hope*, pp. 3–157, for the details of Mandelstam's arrest, interrogation, and exile.

28. Ehrenburg, *First Years*, pp. 108–109.

29. Quoted in Alex M. Shane, *The Life and Works of Evgenij Zamjatin* (Berkeley and Los Angeles, 1968), pp. 9, 15.

30. Evgenii Zamiatin, "On Literature, Revolution, Entropy, and Other Matters," in Mirra Ginsburg, ed., *A Soviet Heretic: Essays by Yevgeny Zamyatin* (Chicago and London, 1970), p. 110.

31. Evgenii Zamiatin, "Scythians?," in Ginsburg, ed., *Soviet Heretic*, pp. 32, 23.

32. Struve, *Russkaia literatura*, pp. 17–19.

33. Quoted in Shane, *Zamjatin*, pp. 46, 49.

34. Ibid., p. 48.

35. Quoted in ibid., p. 76.

36. Quoted in Brown, *Russian Literature*, p. 169. See also Evgenii Zamiatin, "Letter to Stalin, June 1931," in Ginsburg, ed., *Soviet Heretic*, pp. 305–309.

37. Ibid., p. 55.

38. E. Zamiatin, *My* (New York, 1952), p. 56.

39. For the significance of colors in Zamiatin's novel, see Christopher Collins, *An Interpretive Study of the Major Fiction of Evgenij Zamjatin* (Ph.D. dissertation, Indiana University, 1968), pp. 55–70.

40. Zamiatin, *My*, pp. 197, 200, 149.

41. Leslie Milne, *Mikhail Bulgakov: A Critical Biography* (Cambridge and New York, 1990), p. 1.

42. Ibid., pp. 76–77; A. Colin Wright, *Mikhail Bulgakov: Life and Interpretations* (Toronto, 1978), pp. 5–7.

43. Baedeker, *Russia 1914*, p. 378.

44. Wright, *Bulgakov*, p. 87.

45. Serge Orlovskii, "Moscow Theaters, 1917–1941," in Martha Bradshaw, ed., *Soviet Theaters, 1917–1941* (New York, 1954), p. 56.

46. Quoted in Wright, *Bulgakov*, pp. 89–90.

47. Quoted in Milne, *Bulgakov*, p. 112.

48. Gorchakov, *Theater*, p. 187.

49. Quoted in Wright, *Bulgakov*, p. 68.

50. Ibid., pp. 93–94.

51. Boris Pasternak, *Doktor Zhivago* (Ann Arbor, 1967), p. 43.

52. Milne, *Bulgakov*, pp. 228–257; Wright, *Bulgakov*, pp. 258–273; Ellendea Proffer, *Bulgakov: His Life and Work* (Ann Arbor, 1984), pp. 525–565.

53. Israel Nestyev, *Prokofiev*, trans. from the Russian by Florence Jonaqs (Stanford, 1960), p. 9.

54. Sergei Prokof'ev, *Avtobiografiia*, ed. by M. G. Kozlova (Moscow, 1973), p. 95.

55. Quoted in Victor Seroff, *Sergei Prokofiev: A Soviet Tragedy* (New York, 1968), p. 54.

56. Ibid., pp. 65–66.

57. Quoted in Claude Samuel, *Prokofiev*, trans. by Miriam John (New York, 1971), p. 58.

58. Quoted in Seroff, *Prokofiev*, pp. 92–93.

59. Quoted in ibid., p. 130.

60. Quoted in Robinson, *Prokofiev*, p. 211.

61. Quoted in Seroff, *Prokofiev*, p. 147.

62. Quoted in ibid., pp. 166–167.

63. Quoted in Robinson, *Prokofiev*, pp. 272, 271.

64. Quoted in Seroff, *Prokofiev*, p. 167.

65. Quoted in Robinson, *Prokofiev*, p. 314.

66. Dmitrii Shostakovich, *Shostakovich About Himself and His Times* (Moscow, 1981), p. 46.

67. Quoted in Victor Ilyich Seroff, *Dmitri Shostakovich: The Life and Background of a Soviet Composer* (New York, 1943), p. 198.

68. Ibid., p. 200; Dmitri and Ludmilla Sollertinsky, *Pages from the Life of Dmitri Shostakovich*, trans. by Graham Hobbs and Charles Midgley (New York, 1980), p. 76; Elizabeth Wilson, *Shostakovich: A Life Remembered* (Princeton, 1994), pp. 94–97.

69. Quoted in Seroff, *Shostakovich*, pp. 205–207.

70. Quoted in ibid., p. 208.

71. Quoted in Wilson, *Shostakovich*, p. 114.

72. Quoted in Seroff, *Shostakovich*, p. 211.

73. Quoted in Ilia Ehrenburg, *Eve of War, 1933–1941*, trans. by Tatiana Shebunina (London, 1963), p. 96.

74. Quoted in Wilson, *Shostakovich*, p. 111.

75. Quoted in Seroff, *Prokofiev*, p. 189.

76. Ibid., pp. 197–198.

77. Quoted in ibid., p. 226.

78. Quoted in Robinson, *Prokofiev*, pp. 359–360.

79. Seroff, *Prokofiev*, pp. 228–229.

80. Quoted in ibid., p. 234.

81. Quoted in ibid., p. 232.

82. Wilson, *Shostakovich*, pp. 148–152.

83. Quoted in Robinson, *Prokofiev*, p. 472, and Seroff, *Prokofiev*, p. 280.

84. Quoted in Robinson, *Prokofiev*, p. 473.

85. Brown, *Russian Literature*, p. 215.

86. Quoted in Guy de Mallac, *Boris Pasternak: His Life and Art* (Norman, 1981), pp. 23–24.

87. Ibid.

88. Quoted in ibid., pp. 356, 346, 339, 341, 31.

89. Boris Pasternak, *Avtobiograficheskii ocherk*, in Boris Pasternak, *Proza 1915–1958. Povesti, rasskazy, avtobiograficheskie proizvedeniia* (Ann Arbor, 1961), p. 13.

90. Quoted in de Mallac, *Pasternak*, p. 69.

91. Boris Pasternak, *Safe Conduct: Autobiography*, in Boris Pasternak, *Selected Writings* (Norfolk, 1949), p. 69.

92. Pasternak, *Avtobiograficheskii ocherk*, p. 31.

93. Quoted in de Mallac, *Pasternak*, p. 74.

94. Reeder, *Akhmatova*, pp. 337–344; Lazar Fleishman, *Boris Pasternak: The Poet and His Politics* (Cambridge, Mass., 1990), pp. 39–89; Henry Gifford, *Pasternak: A Critical Study* (Cambridge, 1977), pp. 29–47.

95. Quoted in de Mallac, *Pasternak*, p. 89.

96. Mandelstam, *Hope Against Hope*, p. 190.

97. Quoted in Fleishman, *Pasternak*, p. 109.

98. Quoted in de Mallac, *Pasternak*, pp. 89–90.

99. Pasternak, *Safe Conduct*, pp. 84–85.

100. N. L. Meshcheriakov, "O chastnykh izdatel'stvakh," *Pechat' i revoliutsiia*, III, (iiul'-avgust 1922g), p. 129.

101. Viktor Shklovskii, *Zoo, or Letters Not About Love*, trans. and ed. by Richard Sheldon (Ithaca, 1971), pp. 62–63.

102. Quoted in de Mallac, *Pasternak*, p. 109.

103. Fleishman, *Pasternak*, pp. 135–137.

104. Ibid., p. 143–144.

105. Quoted in de Mallac, *Pasternak*, p. 119.

106. Quoted in ibid.

107. Quoted in ibid., pp. 126, 131.

108. Quoted in ibid., p. 129.

109. Quoted in Fleishman, *Pasternak*, p. 161.

110. Quoted in ibid., pp. 188, 194, 192–193, 213.

111. Quoted in Gifford, *Pasternak*, p. 152.

112. Quoted in de Mallac, *Pasternak*, p. 145. See also ibid., pp. 135–138; Fleishman, *Pasternak*, pp. 211–223; Gifford, *Pasternak*, pp. 147–161.

113. Quoted in de Mallac, *Pasternak*, pp. 158–159.

114. Brown, *Russian Literature*, pp. 78. 83.

115. David M. Glantz and Jonathan House, *When Titans Clashed: How the Red Army Stopped Hitler* (Lawrence, 1995), pp. 285–286; Nicholas V. Riasanovsky, *A History of Russia* (New York, 1977), pp. 584–585.

116. Quoted in Bordwell, *Cinema*, p. 252.

117. Quoted in de Mallac, *Pasternak*, p. 184.

118. Ilia Ehrenburg, *Post-War Years, 1945–1954*, trans. by Tatiana Shebunina (London, 1966), p. 44.

119. Quoted in Brown, *Russian Literature*, pp. 183–184.

120. Quoted in Fleishman, *Pasternak*, p. 254.

121. Quoted in de Mallac, *Pasternak*, p. 202.

122. Quoted in George Gibian, *Interval of Freedom: Soviet Literature During the Thaw, 1954–1957* (Minneapolis, 1960), p. 6.

123. Brown, *Russian Literature*, p. 202.

124. Quoted in Gibian, *Interval*, pp. 9–10.

125. de Mallac, *Pasternak*, p. 196.

126. Quoted in ibid., p. 185.

127. Quoted in ibid., p. 188.

128. Quoted in Gifford, *Pasternak*, p. 181.

129. Boris Pasternak, "Zimniaia noch'," in Boris Pasternak, *Doktor Zhivago* (Ann Arbor, 1967), p. 550.

130. Ibid., p. 513.

131. Quoted in de Mallac, *Pasternak*, p. 196.

132. Pasternak, *Doktor Zhivago*, p. 66.

133. Brown, *Russian Literature*, pp. 218–219.

134. Quoted in de Mallac, *Pasternak*, p. 224.

135. Quoted in Robert Conquest, *The Pasternak Affair: Courage of Genius* (Philadelphia and New York, 1962), pp. 53, 56.

136. de Mallac, *Pasternak*, p. 242.

137. Quoted in Conquest, *Affair*, pp. 131, 133–134, 165, 168–170.

138. Quoted in Fleishman, *Pasternak*, p. 290.

139. Quoted in Conquest, *Affair*, pp. 97, 101.

140. Quoted in de Mallac, *Pasternak*, p. 248.

141. Ibid., p. 249.

142. Fleishman, *Pasternak*, p. 314.

143. Olga Ivinskaya, *A Captive of Time* (New York, 1978), pp. 366–367.

144. Quoted in ibid., p. 366.

CHAPTER XVIII
MERGING CURRENTS

1. Quoted in Conquest, *Affair*, p. 67.

2. Dostoevskii, *Zimnye zametki*, pp. 69–79.

3. Quoted in Alexandrova, *History*, p. 319.

4. Vera Dunham's *In Stalin's Time: Middle-Class Values in Soviet Fiction* (Durham and London, 1990) provides an eloquent and provocative account of how this phenomenon was portrayed in late Stalinist fiction.

5. Konstantin Paustovskii, "The Drozdovs," in Hugh McLean and Walter N. Vickery, ed. and trans., *The Year of Protest, 1956: An Anthology of Soviet Literary Materials* (New York, 1961), pp. 157–159.

6. Quoted in Brown, *Russian Literature*, pp. 213–214.

7. Quoted in Yevgeny Yevtushenko, "Compiler's Introduction," in Albert C. Todd and Max Hayward (with Daniel Weissbort), eds., *Twentieth Century Russian Poetry. Silver and Steel: An Anthology*, selected with an introduction by Yevgeny Yevtushenko (New York, 1993), p. lxii.

8. Evgenii Evtushenko, "I Am a Purse," in ibid., p. 803.

9. Quoted in Brown, *Russian Literature*, p. 337.

10. Evgenii Evtushenko, "The City of Yes and the City of No," in Todd et al., eds., *Russian Poetry*, p. 809.

11. Quoted in Deming Brown, *Soviet Russian Literature Since Stalin* (Cambridge and New York, 1978), p. 115.

12. Evgenii Evtushenko, "The Heirs of Stalin," in Todd et al., ed., *Russian Poetry*, p. 809.

13. "Pis'mo Geroia Sotsialisticheskago Truda C. E. Nemasova o tom, kak on stal geroiem," 24 dekabria 1961g., in V. F. Mal'tsev, ed., *Bratskaia GES: Sbornik dokumentov i materialov* (Irkutsk, 1965), II, p. 26.

14. Evgenii Evtushenko, *Stikhi i poema: Bratskaia GES* (Moscow, 1967), p. 183. For background, see Lincoln, *Conquest*, pp. 378–384.

15. Gibian, *Interval*, p. 159.

16. Quoted in Michael Scammell, *Solzhenitsyn: A Biography* (New York, 1984), p. 73.

17. Quoted in ibid., pp. 91, 105, 111. See also pp. 74–110.

18. Quoted in ibid., p. 129.

19. Ibid., p. 376.

20. Natalia Reshetovskaya, *Sanya: My Life with Alexander Solzhenitsyn*, trans. by Elena Ivanoff (Indianapolis, 1975), pp. 199–200.

21. Alexander Solzhenitsyn, *The Oak and the Calf*, trans. by Harry Willetts (New York, 1979), p. 6.

22. Quoted in Scammell, *Solzhenitsyn*, pp. 406–407.

23. Quoted in ibid., pp. 414–416.

24. Evtushenko, "The Heirs of Stalin," p. 808.

25. Reshetovskaya, *Sanya*, p. 255.

26. Quoted in Scammell, *Solzhenitsyn*, p. 450.

27. Priscilla Johnson, *Khrushchev and the Arts: The Politics of Soviet Culture, 1962–1964* (Cambridge, Mass., 1965), pp. 7–10.

28. Quoted in ibid., p. 103–105.

29. Quoted in ibid., p. 121.

30. Quoted in ibid., pp. 157, 152, 155, 174, 180, 190, 198, 181.

31. Ibid., p. 147.

32. Solzhenitsyn, *The Oak and the Calf*, p. 202.

33. Ibid., pp. 105–106; Scammell, *Solzhenitsyn*, pp. 516–527.

34. Solzhenitsyn, *The Oak and the Calf*, pp. 103–104.

35. Scammell, *Solzhenitsyn*, p. 524.

36. Quoted in Johnson, *Khrushchev*, pp. 206, 209.

37. Quoted in David Remnick, "Perfect Pitch," *The New Yorker* (February 12, 1996), p. 43. See also pp. 38–45; Czeslaw Milosz, "Joseph Brodsky," *Partisan Reivew*, No. 2 (1966), pp. 184–187; and Solomon Volkov, *St. Petersburg: A Cultural History* (New York, 1995), pp. 476–482, 510–518.

38. Joseph Brodsky, "A Halt in the Desert," in George L. Kline, trans., *Joseph Brodsky: Selected Poems*, with a foreword by W. H. Auden (London, 1973), p. 132.

39. Quoted in Mary Jo Salter, "The Tune of Joseph Brodsky," *Anseo*, II, No. 1 (Winter 1996), p. 3.

40. Quoted in Valentina Polukhina, *Joseph Brodsky: A Poet for Our Time* (Cambridge, 1989), p. 22.

41. Brown, *Russian Literature*, pp. 354–358; Deming Brown, *Soviet Russian Literature Since Stalin*, pp. 136–140.

42. David M. Bethea, *Joseph Brodsky and the Creation of Exile* (Princeton, 1994), p. 6. For additional insights and thoughts on Brodsky, I am especially indebted to Professor Samuel Ramer of Tulane University.

43. Abram Tertz, *On Socialist Realism*, with an introduction by Czeslaw Milosz, and trans. by George Dennis (New York, 1960), p. 21.

44. Ibid., pp. 24, 52, 91, 93–95.

45. Deming Brown, *Soviet Russian Literature*, p. 333.

46. Quoted in Brown, *Russian Literature*, p. 240.

47. Ibid., pp. 239–249; Deming Brown, *Soviet Russian Literature*, pp. 331–351.

48. Quoted in Scammell, *Solzhenitsyn*, p. 504.

49. Quoted in Brown, *Russian Literature*, p. 259.

50. Scammell, *Solzhenitsyn*, pp. 496–541.

51. Quoted in Olga Carlisle, *Solzhenitsyn and the Secret Circle* (New York, 1978), pp. 18–19.

52. Scammell, *Solzhenitsyn*, pp. 563–629.

53. Quoted in Solzhenitsyn, *The Oak and the Calf*, p. 156.

54. Deming Brown, *Soviet Russian Literature*, p. 318.

55. Scammell, *Solzhenitsyn*, p. 704.

56. Leopold Labedz, ed., *Solzhenitsyn: A Documentary Record*, enlarged ed. (Bloomington, 1973), pp. 240, 299.

57. Ibid., pp. 241–242.

58. Ibid., p. 244.

59. Quoted in Solzhenitsyn, *The Oak and the Calf*, p. 307.

60. Quoted in ibid., pp. 518, 517. See also pp. 516–529.

61. Ibid., pp. 349–350.

62. Brown, *Russian Literature*, p. 268.

63. Dunham, *In Stalin's Time*, pp. 46–47; Geoffrey Hosking, *Beyond Socialist Realism: Soviet Fiction Since "Ivan Denisovich"* (New York, 1980), pp. 180–181; Nina Kolesnikoff, *Yuri Trifonov: A Critical Study* (Ann Arbor, 1991), pp. 9–21.

64. Quoted in ibid., p. 84. See also pp. 79–87; Josephine Woll, *Invented Truth: Soviet Reality and the Literary Imagination of Iurii Trifonov* (Durham, 1991), *passim*; and Hosking, *Beyond*, pp. 180–195.

65. Quoted in Hosking, *Beyond*, p. 162.

66. Mikhail A. Pozin, *Vasilii Shukshin: The Writer and His Times* (University of Illinois, Ph.D. dissertation, 1991), pp. 5–21.

67. Hosking, *Beyond*, p. 163.

68. Kathleen Parthé, "Shukshin at Large," in Vasilii Shukshin, *Stories from a Siberian Village*, trans. by Laura Michael and John Givens (DeKalb, 1996), p. ii.

69. Vasilii Shukshin, *Snowball Berry Red*, trans. by Donald M. Fiene, in Vasilii Shukshin, *Snowball Berry Red and Other Stories* (Ann Arbor, 1979), p. 198.

70. See Kathleen Parthé's truly outstanding study, *Russian Village Prose: The Radiant Past* (Princeton, 1992), pp. 3–4; Brown, *Since the Revolution*, p. 294; E. A. Shubin, *Sovremennyi russkii rasskaz: Voprosy poetiki zhanra* (Leningrad, 1974), pp. 62–66; and N. N.

Shneidman, *Soviet Literature of the 1970s: Artistic Diversity and Ideological Conformity* (Toronto, 1979), pp. 16–18; Hosking, *Beyond*, pp. 50–51.

71. Quoted in Hosking, *Beyond*, p. 53.

72. Quoted in Parthé, *Village Prose*, pp. 25, 22, 23, 31.

73. Quoted in Valentin Rasputin, *Siberia on Fire*, trans. with an introduction, by Gerald Mikkelson and Margaret Winchell (DeKalb, 1989), p. xviii.

74. Quoted in Teresa Polowy, *The Novellas of Valentin Rasputin: Genre, Language, and Style* (New York, 1989), pp. 30, 10–11, 29, 12.

75. Quoted in ibid., pp. 11, 63.

76. Quoted in ibid., pp. 108–109.

77. Quoted in Shneidman, *Soviet Literature of the 1970s*, p. 82.

78. I owe this explanation for the Taganka's survival to Professor Alma Law, the foremost authority on Liubimov in Russia and the West.

79. Quoted in Alexander Gershkovich, *The Theater of Yuri Lyubimov: Art and Politics at the Taganka Theater in Moscow*, trans. by Michael Yurieff (New York, 1989), p. 39.

80. Quoted in ibid., p. 56. See also pp. 33–47.

81. Quoted in ibid., p. 132.

82. Ibid., p. 129.

83. Quoted in ibid., pp. 57, v, 7.

84. Quoted in ibid., p. 3. See also pp. 4–6, and *passim*.

85. Ibid., p. 113.

86. Quoted in ibid., p. 154.

87. Quoted in ibid., p. 153.

88. N. N. Shneidman, *Russian Literature, 1988–1994: The End of an Era* (Toronto, 1995), pp. 26–27.

89. Quoted in ibid., p. 43.

90. Aleksandr Solzhenitsyn, *Rebuilding Russia* (New York, 1991), p. 45.

91. Quoted in Edward Ericson, Jr., *Solzhenitsyn and the Modern World* (Washington, D.C., 1993), pp. 275, 358.

92. Quoted in Jonathan Steele, "Solzhenitsyn Slides into His Place in Russia's Pantheon," *The Guardian*, May 31, 1994, p. 1; Brown, *Russian Literature*, p. 354.

# INDEX

## FOR THE BEST IN PAPERBACKS, LOOK FOR THE

In every corner of the world, on every subject under the sun, Penguin represents quality and variety—the very best in publishing today.

For complete information about books available from Penguin—including Puffins, Penguin Classics, and Arkana—and how to order them, write to us at the appropriate address below. Please note that for copyright reasons the selection of books varies from country to country.

**In the United Kingdom:** Please write to *Dept. EP, Penguin Books Ltd, Bath Road, Harmondsworth, West Drayton, Middlesex UB7 0DA.*

**In the United States:** Please write to *Penguin Putnam Inc., P.O. Box 12289 Dept. B, Newark, New Jersey 07101-5289* or call 1-800-788-6262.

**In Canada:** Please write to *Penguin Books Canada Ltd, 10 Alcorn Avenue, Suite 300, Toronto, Ontario M4V 3B2.*

**In Australia:** Please write to *Penguin Books Australia Ltd, P.O. Box 257, Ringwood, Victoria 3134.*

**In New Zealand:** Please write to *Penguin Books (NZ) Ltd, Private Bag 102902, North Shore Mail Centre, Auckland 10.*

**In India:** Please write to *Penguin Books India Pvt Ltd, 11 Panchsheel Shopping Centre, Panchsheel Park, New Delhi 110 017.*

**In the Netherlands:** Please write to *Penguin Books Netherlands bv, Postbus 3507, NL-1001 AH Amsterdam.*

**In Germany:** Please write to *Penguin Books Deutschland GmbH, Metzlerstrasse 26, 60594 Frankfurt am Main.*

**In Spain:** Please write to *Penguin Books S. A., Bravo Murillo 19, 1° B, 28015 Madrid.*

**In Italy:** Please write to *Penguin Italia s.r.l., Via Benedetto Croce 2, 20094 Corsico, Milano.*

**In France:** Please write to *Penguin France, Le Carré Wilson, 62 rue Benjamin Baillaud, 31500 Toulouse.*

**In Japan:** Please write to *Penguin Books Japan Ltd, Kaneko Building, 2-3-25 Koraku, Bunkyo-Ku, Tokyo 112.*

**In South Africa:** Please write to *Penguin Books South Africa (Pty) Ltd, Private Bag X14, Parkview, 2122 Johannesburg.*